ITALIAN RENAISSANCE ART

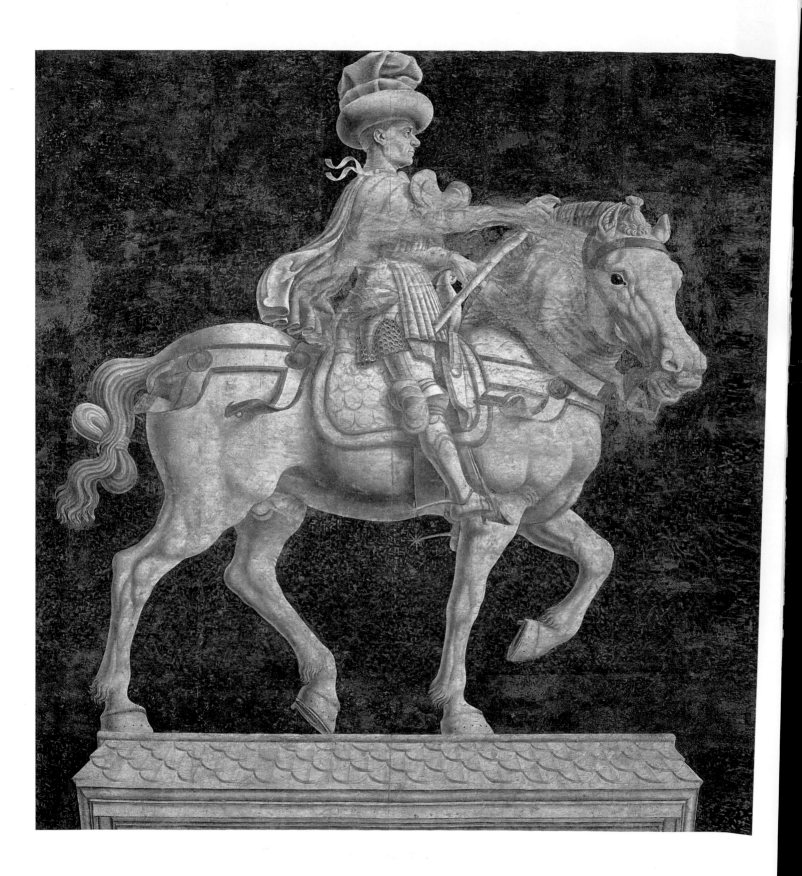

ITALIAN RENAISSANCE ART

LAURIE SCHNEIDER ADAMS

Icon Editions

Westview Press

A Member of the Perseus Books Group

Published in 2001 in the United States of America by
Westview Press, 2465 Central Avenue, Boulder, Colorado
80301-2877, and in the United Kingdom by Westview Press,
12 Hid's Copse Road, Cumnor Hill, Oxford OX2 9JJ

Visit us on the World Wide Web at www.westviewpress.com

A CIP catalog record for this book is available from the
Library of Congress.
ISBN 978-0-8133-3691-6
 0-8133-3691-0

10 9 8 7 6 5

This book was designed and produced by
Laurence King Publishing, Ltd. London
www.laurenceking.co.uk

Editor: Nell Webb
Picture researcher: Sue Bolsom
Designer: Ian Hunt Design

Cover pictures: Fra Angelico, *Annunciation* (detail on front
cover), c. 1432–1434. Tempera and gold on panel. Museo
Diocesano, Cortona. INDEX/Tosi, Florence.

Frontispiece: Andrea del Castagno, *Niccolò da Tolentino*
(detail), finished 1456. Fresco transferred to canvas. Florence
Cathedral.

Also by
Laurie Schneider Adams

Giotto in Perspective, editor (1974)
Art on Trial (1976)
Art and Psychoanalysis (1993)
A History of Western Art (1993)
The Methodologies of Art (1996)
Art across Time (1999)
Key Monuments of the Italian Renaissance (2000)
Key Monuments of the Baroque (2000)

Contents

PART THREE

THE CINQUECENTO

Preface

The precise chronology of the Italian Renaissance, its character and context, has been a topic of considerable discussion among scholars. Some date its beginnings to the generation of Masaccio, Donatello, and Brunelleschi that flourished from around 1400; others—the view reflected in this text—believe that the revolutionary work of Giotto in the early fourteenth century marks the origins of the period. The close of the Renaissance has also been elusive. Mannerism, for example, is variously considered a distinct style, an aspect of Renaissance style, and a distinct style within the period of the Renaissance.

The Renaissance was first defined in a systematic way in the sixteenth century by the *Lives* of the Mannerist architect and painter Giorgio Vasari. Virtually a biographical encyclopedia of Renaissance artists, the *Lives* has itself been controversial as an approach but is a valuable source of information. Other, more "modern" methodological approaches to the Renaissance have proliferated in the course of the late nineteenth and twentieth centuries. These include economic (Marxist), social (feminist), formal, iconographic, semiotic, and psychoanalytic methods of reading works of art. In an ideal scholarly world, such approaches are not taken to be mutually exclusive, but rather, like the Renaissance itself, are synthesized into a totality. That is the aim of this text.

Any study of the Renaissance invites a consideration of the factors that produce periods of unusual genius. This text thus gives the greatest weight to the innovators and to works that had a significant impact on other artists or on the social context of the time. The limitations of a written text, in contrast to the vast and dynamic aspects of a living history, necessarily restrict the content. This means that certain artists and works of art have had to be omitted or discussed only briefly.

I begin with certain image types that precede and influence the early Renaissance such as the thirteenth-century Crucifix and the Enthroned Madonna with the infant Christ. The text continues through the High Renaissance in the sixteenth century and concludes with the evolution of Mannerist trends. Because of the synthetic nature of the Renaissance, examples of earlier styles that influenced its character—notably Classical, Hellenistic, and Roman—are illustrated for purposes of comparison. In addition, because of the importance of Italy's commercial and artistic ties with the North, a few works by fifteenth-century Netherlandish painters are included.

Media, techniques, and cultural background information are presented in boxed asides. There are also boxes devoted to the scholarly controversies that have arisen in the past one and a half centuries over matters of attribution, interpretation, and, more recently, restoration. These illustrate the changing assessment of works over time. Glossary terms, which are boldface at their first mention in the text, and a timeline and select bibliography appear at the back of the book.

Several people have been extremely helpful in the preparation of this book. John Adams, Carla Lord, and Bruce Cole have read the entire text, offering critical comments and eliminating errors along the way. Mark Zucker did a thorough vetting of the manuscript, checking dates, locations, biographical details, and taking issue with some of my interpretations; he has improved the text immensely. The expert copy editing of Carol Flechner has also been invaluable. And without the support and oversight of my editor, Cass Canfield, Jr., this project would never have gotten off the ground.

I would also like to thank the production team at Calmann and King in London: Lee Ripley Greenfield, who agreed to undertake the project; Nell Webb, who oversaw all phases of production; Sue Bolsom, who did an excellent job of researching the pictures; Ian Hunt, who designed the book; Judy Rasmussen, the Production Director; and freelance editor Ursula Payne.

For
Cass Canfield, Jr.

PRECURSORS OF THE RENAISSANCE

The Thirteenth Century

The Italian Renaissance, roughly comprising the period from the early fourteenth century to the late sixteenth century, defines an era of remarkable genius in the history of Western art. The period produced a large number of great artists, who worked in an atmosphere that encouraged the production of art and architecture for religious, political, and personal enhancement. An important aspect of the Renaissance context was a new kind of collaboration between artists and **patrons**, between religious and civic institutions, and between the perceived relationship of past to present. The significant characteristics of Renaissance culture included an emphasis on the potential of human beings; a belief in the power of a liberal, **Classical** education to produce a well-rounded individual—a "Renaissance man," a man of action as well as one versed in literature and philosophy; the development of a skeptical and free-ranging mode of thought; and the use as models of Greek and Latin art and literature. In considering the complexity of sources from which the Renaissance evolved, one looks back over the period, attempts to identify its precursors, reads from contemporary sources and later authors, and studies its cultural legacy.

Books, unlike historical eras, begin on page 1. They are bound by the rules of their structure—a beginning, middle, and end as well as a finite length—in contrast to the more dynamic character of history. The writing of history, therefore, involves the task of assembling events within the framework of chapters and of translating them into written language.

We begin with a chapter that deals with events and monuments of the thirteenth century in Italy, also known as the dugento (the 1200s). In a history of the art of the Middle Ages, the thirteenth and fourteenth centuries would mark high points of **Gothic** style. For a history of Italian Renaissance art, the dugento and trecento (1300s) are formative. They are foundations of the early Renaissance.

The Context

The geographical context of the Renaissance and its precursors is the Italian peninsula (**1.1**), which, throughout most of the second millennium, was divided into various political entities before becoming a unified nation in the nineteenth century. In the thirteenth century, these entities consisted of city-states, some of which—such as Florence, Siena, Pisa, and Lucca in Tuscany, and Venice on the east coast—were republican communes. Mantua was a marquisate from the fourteenth century; Milan became a duchy in 1395, as did Urbino in the fifteenth century. The Papal States, ruled from Rome, were located in central Italy; the kingdom of Naples and Sicily was in the south. Economic and territorial rivalry among these cities was continual; and within the cities, rival factions vied for control.

Politics

Politically, the two main parties competing for power from the thirteenth century were the Guelphs, who supported the pope in Rome, and the Ghibellines, who supported the Holy Roman emperor. These factions

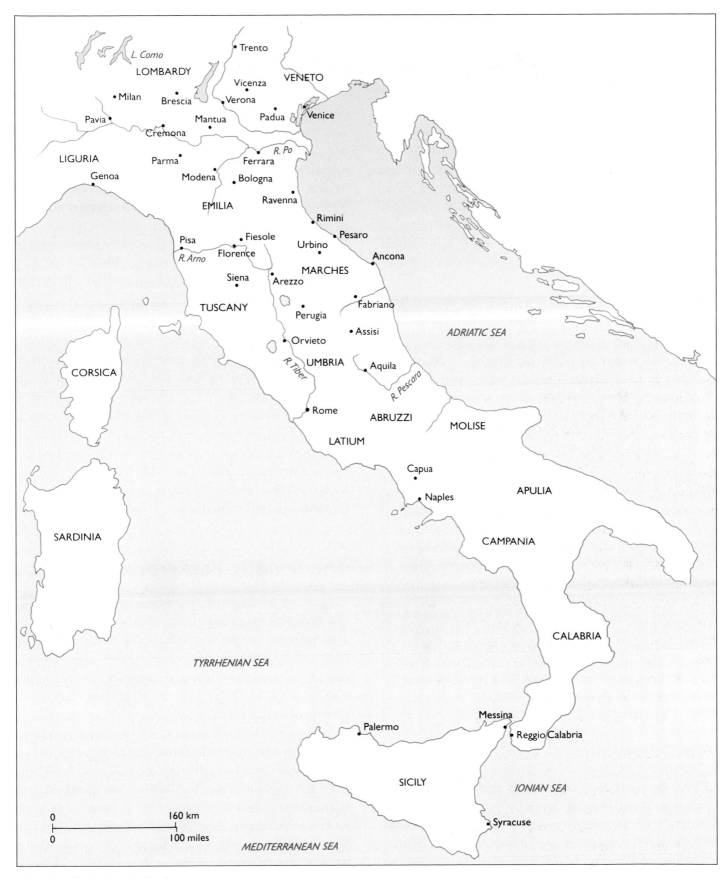

1.1 Map of Italy showing leading art centers.

remained a source of political and class conflict in Italy for over a century. They also exacerbated the rivalry between Florence and Siena that, on occasion, erupted into outright warfare. At the battle of Montaperti in 1260, for example, Siena defeated Florence, and nine years later Florence routed Siena in the battle of Colle di Val d'Elsa. In the closing years of the thirteenth century, the pope revoked papal banking privileges from Siena because of its Ghibelline sympathies and conferred them instead on Florence. This was a major factor in Florence's becoming the leading economic and political power in Tuscany at the turn of the fourteenth century.

Guelphs and Ghibellines

The struggle between these two political parties originated in the twelfth century in south Germany with the rivalry of the Hohenstaufen dukes of Swabia and the dukes of Bavaria. When the Hohenstaufen emperor claimed possession of central Italy, his supporters became known as the Ghibellines (after *Waiblingen*, the name of a Hohenstaufen castle, which was apparently used as a battle cry). His enemies, the Guelphs (from the German *Welf*, a family name of the dukes of Bavaria), supported the pope.

In the thirteenth century, the Hohenstaufen emperor Frederick II competed with the pope for control of Europe as well as of central Italy. The death of Frederick II in 1250, followed by those of his successors in the 1260s, strengthened the position of the pope.

Florence was generally considered a Guelph city, while Siena was Ghibelline. Nevertheless, the lines between the two factions were never clear-cut. Within Florence, the Guelphs were the party of the merchant class and the guilds, and presented themselves as the upholders of liberty; but there was also a Ghibelline faction that generally represented the interests of the nobility.

The Guilds

Of great importance to the economies of city-states in central and northern Italy were the guilds, which exerted considerable influence on civic governments. These were associations of workers, in existence in Naples since the sixth century and particularly strong during the Middle Ages, that set standards of work and prices, and protected the rights of workers and their families.

The seven major guilds (Arti Maggiori) were the most active participants in government. These were the Giudici e Notai (judges and lawyers), Arte della Lana (woolen cloth manufacturers), Calimala (wool refiners), Seta (silk workers), Cambio (bankers and money changers), Pelliciai (furriers), and Medici e Speziali (physicians and apothecaries). The fourteen minor guilds (Arti Minori), mainly composed of the artisanal class, provided a balance of power. Five of these joined the Arti Maggiori in government participation. In Florence, where guilds were particularly powerful, membership in a guild was a requirement for public office.

Artists, who were classified as artisans throughout the Middle Ages and well into the Renaissance, did not have their own guild. In 1314, painters were admitted to the Medici e Speziali because their pigments were considered chemical substances. Goldsmiths and sculptors in bronze belonged to the Seta, and sculptors in wood and stone were members of the Arte dei Maestri di Pietra e Legname (masters of stone **carving** and wood carving). Among the many functions of the guilds, depending on the city in which they were located, was artistic patronage. Guilds commissioned work for their own buildings, such as Or San Michele in Florence (see 3.24), as well as for churches and **cathedrals**.

The Stylistic Background

The synthetic character of the Italian Renaissance was a significant source of its genius. In the visual arts, some of the greatest works of Western art emerged from a convergence of styles. These different styles had a long history, which is helpful in understanding the background of Renaissance style.

Traces of the Classical tradition, which had declined along with the Roman Empire, began to reappear in Rome in the twelfth and thirteenth centuries. In ancient Greece, Classical artists had striven for **idealized**, but **naturalistic, three-dimensional** human form, and **symmetry**. Ideal nudity, especially of male figures (**1.2**) and later of females, reflects the organic structure of the body. Classical draperies define form just as Classical flesh defines anatomy (**1.3**). Greek naturalism, especially in the **Hellenistic** period (late fourth century B.C. –first

century B.C.), was revived during the Roman Empire (late first century B.C.–fourth century A.D.).

The evidence of antiquity, in the form of works of art and texts, persisted throughout the Italian peninsula long after the decline of Rome. But these surviving works were overshadowed by the rise of Christianity. It

was not until the twelfth and thirteenth centuries that the influence of antiquity, particularly in Rome itself, began to reemerge in monumental works of art. Roman artists influenced by these developments worked at Assisi, in Umbria, and influenced developments in Tuscany and northern Italy.

Concurrent with the decline of Rome beginning in the fourth century, the **Byzantine** Empire, with its capital at Constantinople, rose to power. Byzantine artists produced works that emphasize the power and immaterial spirituality of the Christian Church. Interiors of Byzantine churches radiate light from the gold backgrounds of **mosaic** decoration. Depicted forms are typically **two-dimensional**, and **frontal** figures are suspended on a flat, gold surface, whose light denotes divine presence. Drapery folds consist of rhythmic **linear** gold patterns. Rich color defines robes and jewels that proclaim the wealth and dominion of the empire.

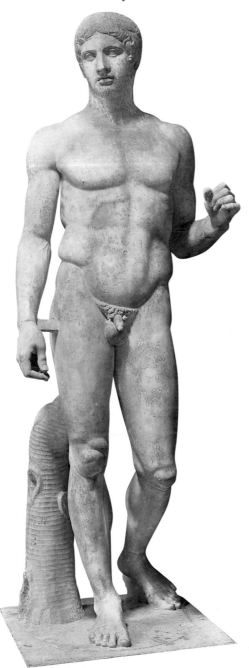

1.2 Polykleitos, *Doryphoros* (*Spear Bearer*), c. 440 B.C. Marble copy of bronze original; 6 ft. 11½ in. (2.12 m) high. Museo Nazionale Archeologico, Naples.

1.3 *Nike Adjusting her Sandal*, from the balustrade of the temple of Athena Nike, 410–409 B.C. Pentelic marble; 3 ft. 5¾ in. (1.06 m) high. Acropolis Museum, Athens.

Early Christianity and the Life of Christ

Jesus Christ was a Jew, born around 1 B.C. in Bethlehem. He was crucified outside Jerusalem in the year A.D. 33. After his death, the appeal of his teachings reached an ever-increasing population. One source of Christ's appeal was the promise of salvation to anyone who had faith and was willing to repent. His apostles (the twelve men who followed him during his lifetime) and other disciples helped to spread his message throughout the Mediterranean world. Although outlawed and persecuted by the Romans for refusing to worship the emperor, the early Christians pursued their faith in secret, hiding in the underground catacombs of Rome.

Christianity differed from the pagan cults around the Mediterranean by retaining blood sacrifices only in symbolic form and by eliminating orgiastic rites. It was similar to Judaism in being monotheistic (believing in a single god), in emphasizing the importance of faith, and in being based on scriptures (written texts). But Christianity differed from Judaism in the importance it accorded to saints and martyrs (witnesses to Christ's teaching who die for the faith). Missionary work and conversion to the faith was also stressed by Christians. The main difference between Christians and Jews, however, is that Christians believe in Christ as the Messiah whereas the Jews are still waiting for the Messiah.

The rituals of Christianity developed in the first two centuries after Christ's death. One of the first was the Last Supper (the Jewish Passover ceremonial meal), Christ's last meal with his twelve apostles, during which he declared that the bread was his body and the wine his blood and asked his apostles to repeat the meal in his memory. Re-creations of Christ's Last Supper were originally performed in dining rooms but, by the second century, the table had become the altar and the ritual, the Mass. During the liturgy of the Mass (also called the Eucharist, "thanksgiving" in Greek), which is performed by a priest, a wafer and wine stand for Christ's body and blood, respectively.

In the year 313, the Roman emperor Constantine legalized Christianity, thus ending the persecutions of Christians and causing the new religion to expand further and become the official religion of Rome. New buildings were then needed to accommodate the growing number of adherents. The Roman **basilica**, an important part of every Roman **forum** during the empire, became the architectural basis of the Early Christian church. The latter was typically oriented so that the main altar was in the apse at its eastern end. This orientation was meant to replicate the geographical relation of western Europe to Jerusalem, both Jerusalem and the altar being situated in the east; the crucifix on the altar facing the congregation replicated Christ's Crucifixion and the tradition that he himself faced west on the Cross.

The liturgy performed at the altar is based on the liturgical calendar. This is organized according to the day on which an event occurred, rather than according to the year. As a result, the liturgical calendar is cyclical, in contrast to the historical calendar, which is sequential. Liturgical events are celebrated every year on the same date; for example, the Annunciation is celebrated on March 25, exactly nine months before Christ's birth on December 25.

There are a number of important texts—the Scriptures—on which Christianity is based. The main texts form the Bible. The Christian Bible is organized so that the Jewish Bible, also called the Hebrew Scriptures, comes at the beginning and opens with Creation in the book of Genesis. The New Testament, which was in place by the fourth century, consists of the four Gospels (written by the evangelists Matthew, Mark, Luke, and John), the Acts (recounting the efforts of the apostles to spread Christ's Word), the Epistles (letters generally thought to have been written by the apostle Paul), and Revelation (an apocalyptic book written by Saint John the Divine, describing the end of the world and the Second Coming of Christ).

Scenes in Christian art are drawn from various sources, but the Bible is the most widely used. Other important sources include the Old and New Testament Apocrypha (Scriptures that are not accepted as the Word of God) and legends of the saints. Of the latter, the so-called *Golden Legend*, compiled in the thirteenth century by the Dominican Jacobus de Voragine, was particularly popular with Renaissance artists. In it, saints and events are organized according to liturgical, rather than historical, dates.

The Life of Christ in Art and in the Scriptures

The following is a list of frequently depicted scenes from the life of Christ, accompanied by a brief description of the event taking place in each one.

The Birth and Childhood of Christ

The Annunciation Mary is told by the archangel Gabriel that she has miraculously conceived and will be the mother of Jesus (the Incarnation). A ray of light or a white dove symbolizing the Holy Spirit (also known as the Holy Ghost) is usually shown entering the scene.

The Visitation When Mary is three months pregnant, she visits her aged cousin Elizabeth, who has also miraculously conceived. Elizabeth is six months pregnant with John the Baptist and usually welcomes Mary with an embrace.

The Nativity Christ is born in Bethlehem. The Holy Family, consisting of Mary, Christ, and Joseph (Christ's earthly father), are shown in a stable with an ox, an ass, and sometimes a midwife.

The Annunciation to the Shepherds Angels announce the birth of Christ to shepherds guarding their flocks.

The Adoration of the Magi (also called the Epiphany) Three kings (or wise men) from the East follow a star that leads them to Bethlehem.

The Presentation in the Temple Christ is brought to the Temple in Jerusalem and presented to the high priest Simeon, whose prayer to see the Savior is thus fulfilled.

The Massacre of the Innocents King Herod decrees the execution of all infant boys in order to thwart the prophecy that one will overthrow his kingdom.

The Flight into Egypt Warned by an angel of Herod's plan, Joseph takes Mary and Christ to Egypt.

Christ Among the Doctors Christ is twelve years old. As a sign of his superior intelligence and future ministry, he disputes with the scholars in the Temple of Jerusalem.

The Ministry and Miracles of Christ

The Baptism John the Baptist baptizes Christ in the river Jordan. This is the prototype of the rite of baptism, by which converts enter the Christian faith.

The Calling of Matthew Christ calls Matthew, a tax collector, to his service.

The Calling of Peter and Andrew Christ calls the fishermen brothers Peter and Andrew to his service, saying, "I will make you fishers of men."

The Storm in the Sea of Galilee (called the *Navicella* in Italian art) Jesus walks on water and calms a wind threatening the apostles' boat. When Peter leaves the boat, he begins to sink and Christ rescues him.

The Marriage at Cana Christ turns water into wine.

The Resurrection of Lazarus Beseeched by Mary and Martha, Christ restores their brother, Lazarus, to life.

The Transfiguration Christ takes the apostles Peter, James, and John to Mount Tabor to pray. There he is transfigured in white light and flanked by Moses and Elijah. The voice of God declares that Christ is his son.

The Expulsion of the Money Changers Christ drives people engaged in commerce from the Temple in Jerusalem.

The Passion of Christ

The Entry into Jerusalem Christ enters Jerusalem, riding a donkey and followed by his disciples. The citizens of Jerusalem gather palm leaves and welcome him (Palm Sunday).

The Last Supper Christ institutes the ritual of the Eucharist and announces that one of his apostles will betray him.

The Washing of the Feet Christ washes the feet of the apostles as an example of humility.

The Agony in the Garden Christ fears death but struggles to follow his divine path. The apostles sleep nearby.

The Betrayal Judas accepts thirty pieces of silver in exchange for agreeing to identify Christ to the Romans.

The Kiss of Judas Judas identifies Christ with a kiss, and Christ is arrested by Roman soldiers.

Christ Before Caiaphas After his arrest, Christ is taken before the high priest Caiaphas. He also appears before Pontius Pilate, the Roman governor. Christ is condemned.

The Flagellation Christ is tied to a column and whipped.

The Mocking of Christ Christ is mocked with a crown of thorns for claiming to be king of the Jews.

The Road to Calvary Christ carries his own Cross to Golgotha, the Hill of the Skull (also known as Calvary). The so-called Stations of the Cross refer to fourteen incidents from the time of Christ's condemnation to his Entombment.

The Crucifixion Christ is crucified between two thieves. Witnessing his death are Mary, John the Apostle, Mary Magdalen (the reformed prostitute who anoints the feet of Christ), Roman soldiers, and others. Christ's mother faints and is supported by John. The Roman soldier Longinus pierces Christ's side with his lance, and a drop of Christ's blood cures him of an eye affliction.

The Deposition Christ is taken down from the Cross.

The Lamentation Christ's followers mourn over his dead body. (The *Pietà* is the scene in which Mary alone mourns the dead Christ, who is on her lap.)

The Entombment Christ is placed in his tomb (also known as the Holy Sepulchre).

The Harrowing of Hell Christ descends into Limbo to lead Adam, Eve, and other Old Testament personages to Heaven.

The Resurrection Christ rises from his tomb as the Roman guards sleep.

The Three Marys at the Tomb The Virgin Mary, Mary Magdalen, and Mary the mother of the apostle James find that Christ's sepulchre is empty.

The *Noli Me Tangere* (literally, "Do not touch me") A reference to Christ's words to Mary Magdalen, who reaches out to touch him after the Resurrection.

The Supper at Emmaus On the day of his Resurrection, Christ dines with two of his apostles who do not, at first, recognize him. When he breaks the bread, they know him and he disappears.

The Incredulity of Thomas Christ proves his Resurrection to the doubting apostle Thomas by allowing him to touch the wound in his side.

The Ascension Christ rises physically from the Mount of Olives to Heaven; his mother and apostles witness the event.

The Pentecost The apostles receive the gift of tongues, which allows them to speak in many languages and carry Christ's message throughout the world.

The Last Judgment (also the Second Coming) At the end of time, Christ returns to earth and makes his final judgment about the fate of all souls. The saved are received in Heaven, and the damned descend to Hell for eternity.

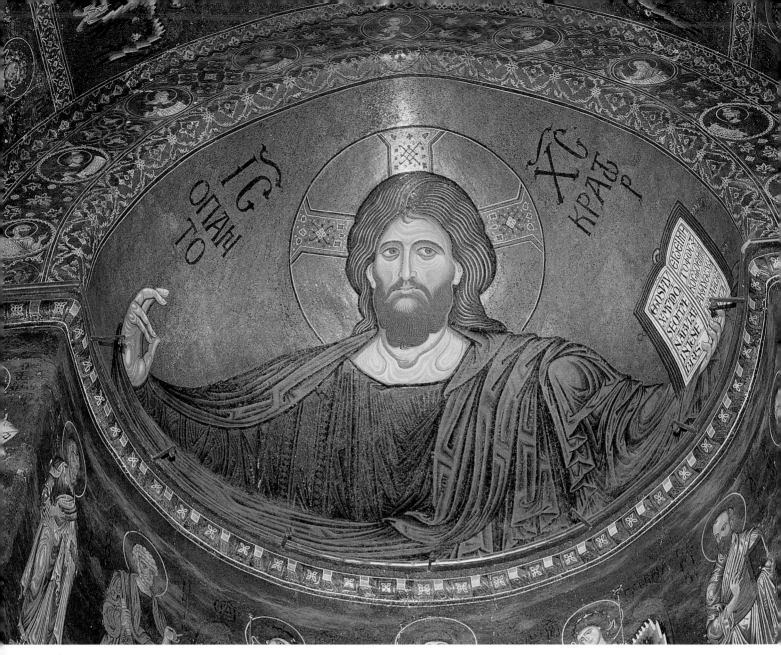

1.4 *Pantokrator*, 12th century. From the abbey church of Monreale, Palermo.

Monumental images such as the *Pantokrator* (**1.4**) (literally, "ruler of all") expand across the curved **apses** of Byzantine churches. The power of Christ is revealed by the large scale of his form, his stern physiognomy, and his direct confrontation with the viewer. His domination of architectural space was a metaphor for his rule over the universe (see Box, pp. 6–7).

In Europe, the decline of Rome was followed by several centuries of migration and invasion. But in the early part of the second millennium, the growing number of pilgrims increased the need for larger churches. There was a dramatic rise in monumental **Romanesque** architecture, the **round arches** and **barrel vaults** of which would have a profound impact on the Renaissance. And the Renaissance, in turn, would often mistake certain

Romanesque structures, such as the Florentine **baptistery** (see 1.9), for buildings of Roman origin. In contrast to Byzantine art, monumental sculpture proliferated in Romanesque churches.

By the thirteenth century, a new humanity appears in Gothic sculpture, especially in France. This developed in conjunction with the cult of the Virgin and an emphasis on her maternal role. Compared with Romanesque sculpture, Gothic begins to move toward naturalism, although never to the degree found in the Classical style. The influence of Gothic on Italian art was strongest during the fourteenth century, following the establishment of the French Angevin court in Naples and Sicily. In the fifteenth century, the most innovative artists were inspired by Classical models.

Vasari's *Lives* and the "Framing" of the Renaissance

In the sixteenth century, the **Mannerist** artist and architect Giorgio Vasari (1511–1574) constructed a framework for Renaissance art. This took the form of a series of biographies of artists—*Lives of the Most Excellent Painters, Sculptors, and Architects*—which was first published in 1550 and revised and expanded in 1568; the second edition concludes with Vasari's autobiography. At the outset, he declares his purpose—namely, to preserve the memory and works of the major artists of the period. Written toward the end of the Renaissance, Vasari's account sets the artists and their works in context, as seen from the vantage point of the mid-sixteenth century. His approach summarizes some of the key elements grounded in the time and place of Renaissance culture. These include the new focus on humanity, as opposed to the more spiritual emphasis of the Middle Ages; the notion of achieving immortality through fame; the preservation of the past by writing about it; and vivid descriptions of human nature.

The *Lives* are as much a work of art as any of the works they describe. They combine art theory with art history, fact with fiction, allegory with legend, and firsthand observation of works of art with hearsay and gossip. Generally, Vasari succeeds in capturing the **style** and personality of his subject. His recourse to anecdotes—stories that are not necessarily factually correct, but that contain essential elements of truth—sprang from the Classical tradition and became a biographical convention of the Renaissance.

Historians of the Renaissance and its art cannot ignore the *Lives*, although some object to

Vasari's conception of both history and art while others are disturbed by his inaccuracies. Vasari conceived of Renaissance art as an evolution in three stages—from infancy, to youth, and finally to maturity. The high point of the third, in his view, was his good friend from near Arezzo, Michelangelo Buonarroti. Historians who object to the view of stylistic development as a progression from a "lower" to a "higher" stage take issue with Vasari's assessment of art out of context, although his *Lives* in fact situate individual works within their cultural setting. Whatever one's opinion of the *Lives*, they remain an invaluable resource of the period, both in terms of the works they describe and as a literary tour de force in their own right.

Cimabue

Vasari begins his history of Renaissance artists with the life and work of the painter Cenni di Pepi (active 1272–1302), known as Cimabue. For Vasari, Cimabue marks the end—and also the culmination—of Byzantine style. Little is known of Cimabue's life, but he was probably from Florence and also worked in Rome, Assisi, and Pisa. His style indicates that he had absorbed elements of Classical **plasticity** and a late medieval tendency to express emotion through surface patterns of rich color and **gold leaf** as well as through content.

During the 1270s, Cimabue painted a monumental crucifix (**1.5**) for the Church of San Domenico in Arezzo. The work is consistent with Vasari's view of Cimabue,

1.5 Cimabue, crucifix, 1270s. Tempera on panel; 11 ft. 2⅜ in. × 8 ft. 8 in. (3.41 × 2.64 m). Church of San Domenico, Arezzo.

for it reflects certain changes in a traditional subject, while also retaining much that characterizes Byzantine style. In showing the dead Christ, Cimabue was in tune with recent **iconographic** developments, which departed from the previously prevailing image of a living Christ on the Cross—the so-called *Christus triumphans* (**1.6**). Such portrayals were intended to convey Christ's majestic triumph over death. The *Christus patiens*, or "suffering Christ," of Cimabue's crucifix (see 1.5), on the other hand, did not become widespread in Italy before the thirteenth century. The rectangular **apron** panels extending from the vertical of the Cross are decorated with rich abstract patterns, whereas earlier examples had depicted figurative scenes. Likewise, the *cimasa*, or *finial* (from the Italian *cima*, meaning "top" or "crest")—the rectangular panel above the Cross—in Cimabue's crucifix contains an inscription in place of the earlier narrative scenes.

Cimabue's Christ is somewhat **elongated**, his body composed of the graceful S-shape that is characteristic of Byzantine forms. The **stylized** patterning of the anatomy, which is rendered as surface design rather than as underlying structure, is similarly Byzantine. Also Byzantine is the taste for **curvilinear** rhythms, evident in the gold threaded through Christ's red drapery. The richness of color, achieved by the **medium** of **tempera** painting, is organized to enhance sharp, dramatic contrasts.

Cimabue creates a tight **chromatic** orchestration of reds, golds, and blacks repeated throughout the image, as well as a **formal** geometric unity. Christ's body is thrown into relief against the dark

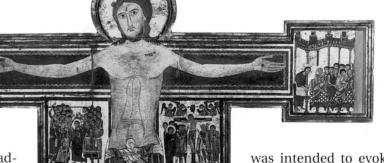

1.6 School of Pisa, *Cross No. 15*, late 12th century. Tempera on panel; 9 ft. 3 in. × 7 ft. 9¾ in. (2.82 × 2.38 m). Museo di San Matteo, Pisa.

background of the Cross, whose shape is repeated at the crossed feet. The extended arms lead the viewer's eye to the panels containing waist-length figures of the Virgin, at Christ's right (our left), and the apostle John, at Christ's left. Their poses and gestures denote mourning and are derived from ancient Greek grave monuments such as the fifth-century-B.C. Attic grave **stela** showing the sailor Democleides mourning his own death at sea (**1.7**). Like Mary and John, Democleides rests his head against his hand, his inward gaze conveying the timeless quality of death.

The empathetic union of the mourners with Christ is shown formally in their halos' overlapping the dark space of the arms of the Cross and in the penetration by Christ's fingers of the gold backgrounds. Repeating the circle of halos is the **tondo** at the top of the crucifix, which contains a figure of the living Christ surmounting the inscription.

In Italy, crucifixes of this type were often suspended over an **altar** and related to the liturgy performed there. The congregation thus faced the image of transubstantiation, the Christian rite in which the wafer and wine became the literal body and blood of Christ. This, in turn, was intended to evoke identification with the humanity of Christ's suffering on the Cross. Worshipers also witnessed the Resurrection through the juxtaposition of the dead Christ on the Cross with the living Christ in the tondo.

The heightened emotional quality of Cimabue's crucifix reflects the late Gothic development of increasing emphasis on humanity in art. Christ slumps to one side, rather than standing vertically in triumph. His **S** shape suggests the contortions of physical suffering. This emotional—but not classically formal—naturalism evoked

Tempera Painting and the *Bottega*

The medium of tempera, made by mixing ground pigments with water and egg yolk, was primarily used for painting on wood panel. The panel itself, usually of poplar, was made by carpenters. It was glued and reinforced at the back with wooden strips; it was then **sized** (sealed with layers of glutinous material) and sanded until its surface was smooth. Linen strips were added to strengthen the wood against warping, and **gesso** (a type of water paint thickened with size and chalk) was applied to the surface.

The outlines of forms were applied in charcoal with small, animal-hair brushes to the prepared panel. Ink was added to accentuate the outlines (or the outlines were incised in the gesso), followed by the application of gold for halos, surface designs, and background. These were polished, especially if they were for **altarpieces**, to ensure that they would reflect light and glow in the dark church interiors. The picture was then ready to be painted in tempera. A finished painting sometimes took as long as a year to dry completely, after which it was **varnished**.

Panel paintings were generally made in the workshop, or *bottega*, of a master artist, who had apprentices to assist him. Apprentices began their training early in adolescence and did the preparatory work, whereas carpenters made the actual panel. Apprenticeship lasted around six years, and gradually an apprentice would be allowed to paint more and more areas of a master's work. Eventually the apprentice would submit a work himself—his **masterpiece**—in order to qualify for entry into the Medici e Speziali.

Renaissance artists were commissioned to make works of art to fulfill specific functions in designated locations, such as an altarpiece for a particular chapel. (Altarpieces were generally constructed of more than one panel—a **diptych** had two panels, a **triptych** had three, and a **polyptych** could have any number of panels over three.) The terms of a commission were defined by a legal contract that stipulated the pigments and the amount of gold leaf that would be used, the size, shape, quality, and subject matter of the work. The delivery date and the artist's payment were also part of the contract.

Renaissance artists were often from artistic families and a *bottega* handed down from father to son. Marriages and other business arrangements between such families were common. This workshop tradition was one of the factors accounting for the view of the artist as a craftsman or artisan rather than as a creator worthy of theoretical consideration. In the course of the Renaissance this would change, and by the end of the period academies would replace the apprenticeship system.

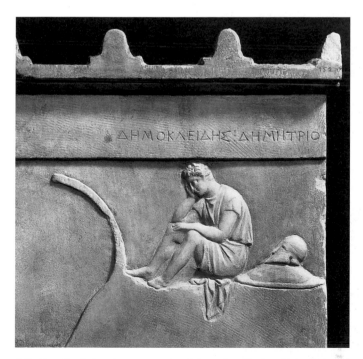

1.7 Detail of an attic grave stela of the sailor Democleides, 5th century B.C. Marble. National Museum, Athens.

viewers' identification with the gruesome reality of death by crucifixion.

Around 1285, Cimabue was commissioned to produce a large *Enthroned Madonna and Child* for the church of Santa Trinità in Florence (**1.8**). More than 12½ feet high, this would have towered over the altar, proclaiming the majesty of Mary and Christ. Like the crucifixes, the subject of Mary and Christ both evoked the empathy of the worshiper and conveyed certain explicit messages about the nature of Christian belief.

In Cimabue's *Enthroned Madonna*, Mary is seated on a sturdy, stepped, jeweled throne that denotes her role as the Heavenly Queen and is a metaphor for the stairway to heaven. Her drapery, like that of the crucified Christ in figure 1.5, conveys the impression of folds through rhythmic gold patterns. She gestures toward Christ, who carries a scroll in his left hand and blesses with his right. Christ is the embodiment of the miraculous Christian "baby king," childlike in size but adult in his proportions, comportment, and intelligence.

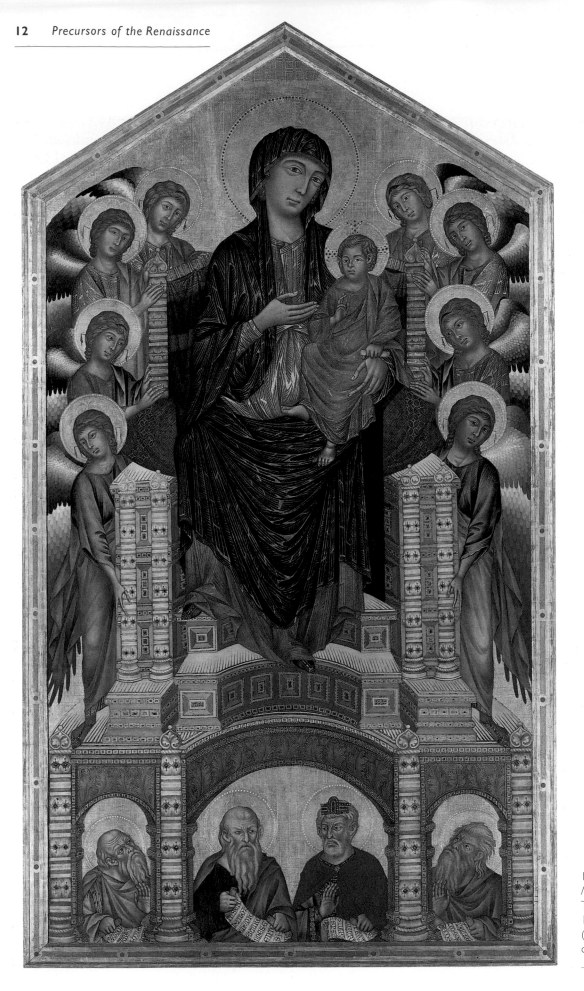

1.8 Cimabue, *Enthroned Madonna and Child*, c. 1285. Tempera on panel; 12 ft. 7 in. × 7 ft. 4 in. (3.84 × 2.24 m). Galleria degli Uffizi, Florence.

Flanking the throne are elongated angels with colorful wings echoing the red and blue of Mary's robes. The two lowest angels appear to be holding onto the throne, alluding to the heavenly setting, whose immateriality is reinforced by the flat gold background. The round arches of the throne frame four Old Testament figures—Abraham, David, Jeremiah, and Isaiah—with scrolls that are **attributes** of their prophetic power. The presence of these figures below the throne has **typological** meaning.

In the biblical account, the Old Testament patriarch Abraham proves his faith in God by obeying the command to sacrifice his son Isaac. An angel intervenes and instructs Abraham to substitute a ram for Isaac. This story became a **type** for the death and resurrection of Christ, showing that by God's will one may be rescued from death. The Old Testament hero David was also typed with Christ, and David's victory over Goliath was paralleled with Christ's triumph over Satan. David was also the ancestor of Joseph, whose genealogy is traced to the House of David in the opening verses of the Gospel of Matthew. Isaiah and Jeremiah were prophets, later interpreted as having foretold the coming of Christ.

The typological conception of history, which imbues much of Christian art, is part of Cimabue's iconographic message in the *Enthroned Madonna*. Not only are the Old Testament figures represented here either types for Christ or prophets of his birth and mission, but their placement also signifies their role as precursors. It is intended to show pictorially that they preceded Christ in time and that they are the foundation on which the New Dispensation (the Christian era following Christ's birth) rests. The scrolls reinforce the fact that the foundation itself is built on the written text of the Bible and its prophetic books. Word and image are thus combined to show worshipers at the altar that Christ and his message were part of a grand plan encompassing all of time.

Saints Dominic and Francis: Mendicant Friars

It is possible that the stylistic changes in late thirteenth-century Italian art were influenced in part by the teachings of two important religious figures: Saint Dominic (1170–1221) and Saint Francis (1181/2–1226). Although very different in their approach to the visual arts as well as in certain attitudes and practices, both encouraged the faithful to identify with Christ's poverty and suffering. Both also founded religious Orders—Dominican and Franciscan, respectively—that had a significant effect on the construction and decoration of churches as well as on Renaissance culture generally.

Typology

Typology is a Christian system of pairing events and personages of the Old Testament with those of the New Testament. It originates in the Bible itself when, for example, Christ asserts that he is a new Solomon who is greater than Solomon. This is meant to show that Christ is a spiritual rather than an earthly king and that his message is both new and rooted in tradition. Just as Solomon, known for his wisdom and riches, had built the Temple in Jerusalem, so Christ's teachings would be the metaphorical foundation of a new architecture—namely, the Christian Church. Christ was also paired with Moses, and his New Law was seen as having superseded the Old Law. Likewise, he became the new Adam, and Mary the new Eve; by Christ's birth, death, and resurrection, the Fall of Man was redeemed.

Such parallels continued to proliferate so that each event of Christ's life was seen to have been prefigured by an Old Testament event. For example, the story of Jonah's three days in the whale was paralleled with Christ's three days in the tomb; Christ rose from the tomb just as Jonah had been expelled from the whale. Prophecy and fulfillment thus became an important theme in the typological view of history.

Eventually, in order to show that the coming of Christ had been God's grand scheme for the universe, typological thinking expanded to include pagan personages and events as well as Old Testament ones. The pagan sibyls, who presided over the ancient oracles, were paired with the prophets, and some were interpreted as having foretold Christ. In the Early Christian period, the Greek god Apollo was conflated with Christ, and both were represented as the sun. In medieval art, and more so in the Renaissance, certain contemporary political events were paired with biblical events. In this way, Christian interpreters produced a revisionist system designed to create the image of Christ as the force around whom all of history revolved.

Saint Dominic was born in Old Castile, in Spain, and founded the Order of Friars Preachers (the Dominican Order). (In England, they are called Black Friars after their black mantles.) According to the rules of the Order, Dominicans were forbidden to own property and had to obtain everything by begging—hence the term *mendicant friars*. The institutions of the Order were allowed to own only their houses and churches. Dominic's inclusion of women led to the foundation of a Second and Third Order of nuns. The former were restricted to a cloistered, contemplative life, whereas the latter were engaged with society and led a more active life.

Saint Dominic was a zealous reformer who devoted himself to stamping out heresy and converting heretics to orthodoxy. His rules for communal, monastic life were rigorous; they were spelled out in two thirteenth-century tracts, the *Dominican Constitutions* and the *Vitae Fratrum* [Lives of the Brothers]: friars had to sleep on straw, wool, or sackcloth; they were forbidden to remove their clothes, and had to keep their belts tied throughout the night. Self-punishment and self-denial were regularly practiced.

Saint Francis was the son of a wealthy cloth merchant from Assisi. In 1202, Francis was taken prisoner in a political dispute and suffered a long illness. When he recovered, he decided to renounce his father's wealth and devote his life to the poor. In 1209, he established the Order of the Friars Minor, based on the rule of poverty and a simple life in imitation of Christ. Like the Dominicans, Franciscans were not permitted to own property and had to live by begging. A corresponding Order for women, the Poor Clares, was founded in Assisi by the noblewoman Clare, who was later canonized.

The defining miracle of Saint Francis' life, and the one most often illustrated in medieval and Renaissance painting, is the stigmatization, in which he receives the wounds, or stigmata, of Christ. Around 1225, Francis wrote the *Canticle of the Sun*, a long hymn praising God's presence in nature. His designation of the sun as "Brother Sun" reflects his personal identification with nature as well as with Christ-as-Sun. Francis's sense of communion with nature led to the tradition that he was able to talk to birds and other animals. Today, as in the thirteenth century, flocks of birds continually fly over Assisi, a fact that seems to lend credence to the legend.

The Dominican Order placed greater emphasis on the Virgin than on the all-encompassing divinity of nature or the identification with Christ's life. Dominican friars devoted themselves to the Virgin and conceived of her as a spiritual "abbess" and protector of their Order. In this, they reflected the popularity of the cult of Mary that developed in the thirteenth century.

Both Franciscans and Dominicans sought to reform the secluded isolation of the medieval Orders. By including women, Dominic and Francis expanded their constituency and brought their views more into the general cultural consciousness. Friars of both Orders worked with the urban poor and became actively involved in building churches within the cities, which led to the need for church decoration. As patrons, the Dominicans tended to commission images of the more mystical Christian events from artists to whom such subjects were congenial. The Franciscans, on the other hand, typically worked with monumental artists interested in integrating the natural with the spiritual world.

Nicola and Giovanni Pisano

Consistent with the Franciscan interest in nature was a fledgling revival of classicism in the south of Italy, especially at the court of Frederick II (1194–1250) in Naples. There the sculptor Nicola Pisano (active 1258–1278)—probably born in Apulia but named after the city of Pisa, where he lived for many years—had become familiar with Classical forms. He executed two elaborate monumental **pulpits**, one for Siena Cathedral, the other for the baptistery in Pisa (**1.9**). Both pulpits are decorated with marble **relief sculpture** illustrating scenes from Christ's life and reflect the influence of French Romanesque and Gothic style; the Pisa version, however, shows more evidence of Classical form.

The cathedral, baptistery, and cemetery at Pisa form an unusual architectural complex, which began with the cathedral, constructed in celebration of a Pisan naval victory over Muslim forces. The building campaign was primarily financed by valuable goods looted from the boats. The cathedral itself has an arcaded lower façade surmounted by four colonnaded

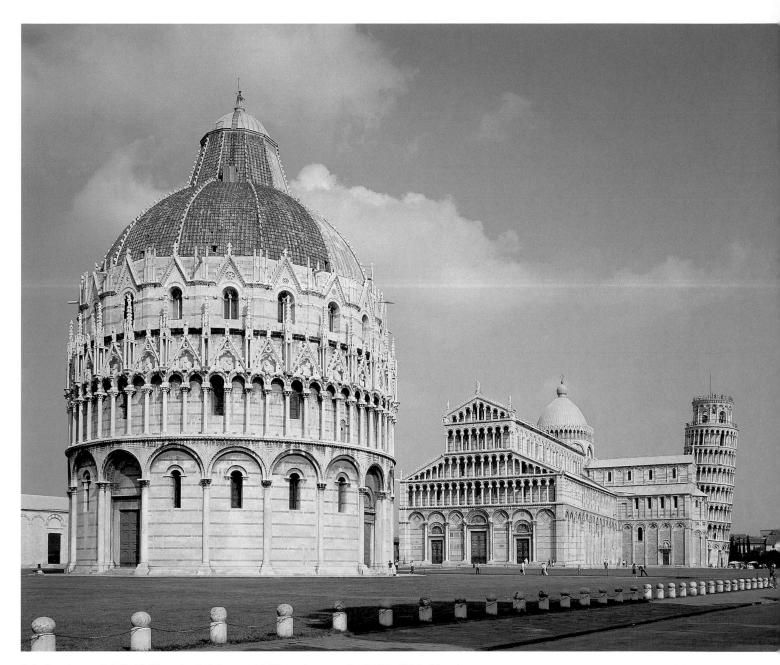

1.9 Baptistery (1153–1265), cathedral (begun 1063), and campanile (1174–1271), Pisa.

levels continuing into the crowning pediment. Roman granite columns were imported from Elba for the façade, and the marble walls are decorated with carvings and inscriptions. The circular baptistery has a somewhat cone-shaped dome. Its lower story, like that of the cathedral, is accented by an arcade of round Romanesque arches. The upper parts, which are Gothic, were designed by Nicola Pisano from 1260 to 1265. Arcaded galleries are repeated in six levels on

the cylindrical *campanile*, popularly known as the Leaning Tower of Pisa. Its tilt has increased over time because it was constructed on a weak foundation; today it is 13 feet out of plumb (off its vertical axis) and is being stabilized by adding lead to the foundation. The Campo Santo, or cemetery, is immediately to the northwest of the complex.

The hexagonal Pisa pulpit (**1.10**), some 15 feet in height, is supported by alternating longer and shorter

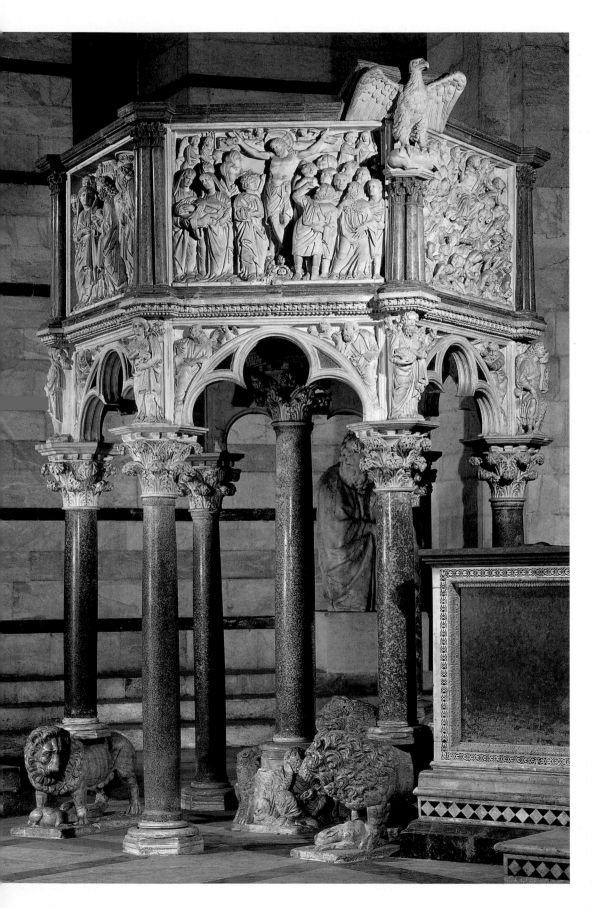

1.10 Nicola Pisano, pulpit, c. 1260. Marble; 15 ft. (4.6 m) high. Baptistery, Pisa. Nicola signed the pulpit, asserting that he was the greatest living sculptor. His son, Giovanni, later signed a pulpit in Pistoia and declared that he had surpassed his father.

foliate Corinthian columns of colored marble and granite. Each short column rests on the back of a white marble lion. The five rectangular panels at the top (the sixth side was left open so that the priest could enter the pulpit) depict scenes from the life of Christ. This arrangement, like the figures at the base of Cimabue's throne, indicates that the foundation of Christianity is the Old Testament. Since the setting of the pulpit is a baptistery, where the rite of admission to Christianity is performed, it is particularly appropriate to refer to the transition from the Old (pre-Christian) Dispensation to the New. The central column rests on a **base** decorated with reliefs of seated figures. Visible in the illustration is a figure in the Classical pose of mourning—here an allusion to the death of Christ.

The architectural character of the pulpit is enhanced by the Gothic **trilobed arches** between the columns as well as by the support function of the columns themselves. White marble reliefs over the columns and in the **spandrels** of the arches depict prophets, Virtues, and evangelists. John the Evangelist, for example, is visible in the left spandrel of the arch facing us in figure 1.10; he can be identified by his eagle attribute. The motif is repeated in the larger eagle supporting the priest's lectern. By its proximity to the marble relief of the Crucifixion, the eagle with outspread wings also denotes resurrection by association with the ancient Roman custom of releasing eagles at the funeral of an emperor. In the latter case, the flight of eagles signified the emperor's apotheosis, or transformation into a god.

The scene of the *Adoration of the Magi* (**1.11**), in which the three kings arrive from the East to worship the newborn Christ, is crowded with figures. It shows the influence of heavy Roman drapery folds that define

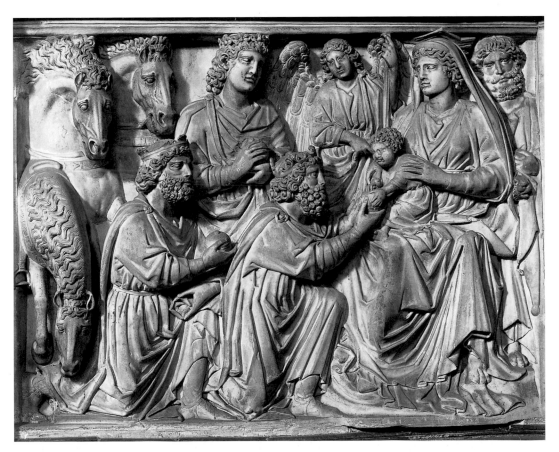

1.11 Nicola Pisano, *Adoration of the Magi*, c. 1260. Marble; approximately 34 in. (86.4 cm) high. Baptistery pulpit, Pisa.

form. The horses at the left are rendered with the suggestion of **organic** anatomical structure, but their size, in relation to the human figures, is unnaturally small. Likewise, the two kneeling kings have a quality of anxious forward movement, and their drapery is angular; both are characteristic of Byzantine and Romanesque style.

Christ is somewhat babylike, having a round, fleshy face; but his **proportions** are more like those of an adult, and his curly hair echoes the patternistic beards of the kings. The Virgin, inspired by antique sculptures of earth mothers and a direct quotation of a Roman **sarcophagus** figure of the Greek tragic heroine Phaedra, towers over the kneeling kings. Her large size is symbolic, denoting her role as the Church building and the House of Christ.

The figure of *Fortitude* standing on top of a support column exemplifies the transitional character of Nicola's style (**1.12**). It is a heroic nude, the earliest surviving of its type in Italy since antiquity. Classical influence is apparent in the figure's organic anatomy as well as in its derivation from a figure of Hercules on a Roman sarcophagus. Since Hercules was himself an image of fortitude in Classical mythology, Nicola's *Fortitude*, like the Virgin in the *Adoration*, indicates that when artists quoted ancient figures, they were drawn to iconographic, as well as to formal, similarities. Despite his evident study of Roman sculpture, Nicola retains the oversized head and feet typical of Romanesque proportions.

Nicola's son, Giovanni Pisano (c. 1250–c. 1314), who inherited the family workshop after his father's death, worked with him on the slightly later pulpit in the cathedral of the walled Tuscan city of Siena. Giovanni was named chief architect and sculptor of the cathedral, whose **façade** he was commissioned to execute (**1.13**). By around 1299, before leaving Siena, he had completed the lower half and much of its exterior sculpture. The striped marble is characteristic of Italian Gothic cathedrals, while the **pointed arches** and **pinnacles**, elaborate **tracery**, and abundance of detail show the influence of northern European Gothic taste. Giovanni also carved a number of the statues of saints, sibyls, and prophets for the façade. In these, as in Nicola's *Fortitude*, the large proportions of the heads are inspired by Romanesque sculpture, while also taking into account the fact that they are meant to be seen from below.

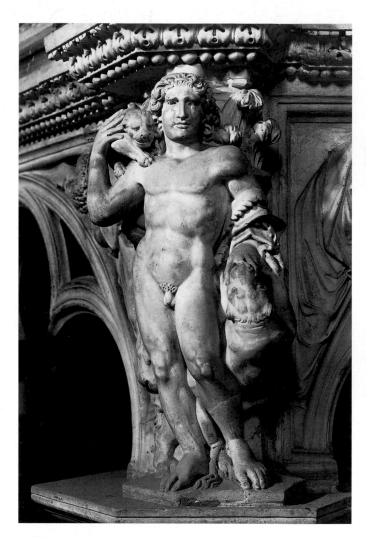

1.12 Nicola Pisano, *Fortitude*, c. 1260. Marble; 22 in. (55.9 cm) high. Baptistery pulpit, Pisa.

Duccio di Buoninsegna: The *Rucellai Madonna*

In monumental painting, Siena, a thriving commercial and banking center, enters the art-historical stage in the thirteenth century. The most significant Sienese painter at the turn of the fourteenth century, Duccio di Buoninsegna (b. 1255/60; active from c. 1278; d. 1319), ironically produced his most important late thirteenth-century work for the leading Dominican church in Florence, Santa Maria Novella.

The *Rucellai Madonna* (**1.14**), which Vasari wrongly attributed to Cimabue, was commissioned in 1285 by the Company of the Laudesi, a Dominican lay

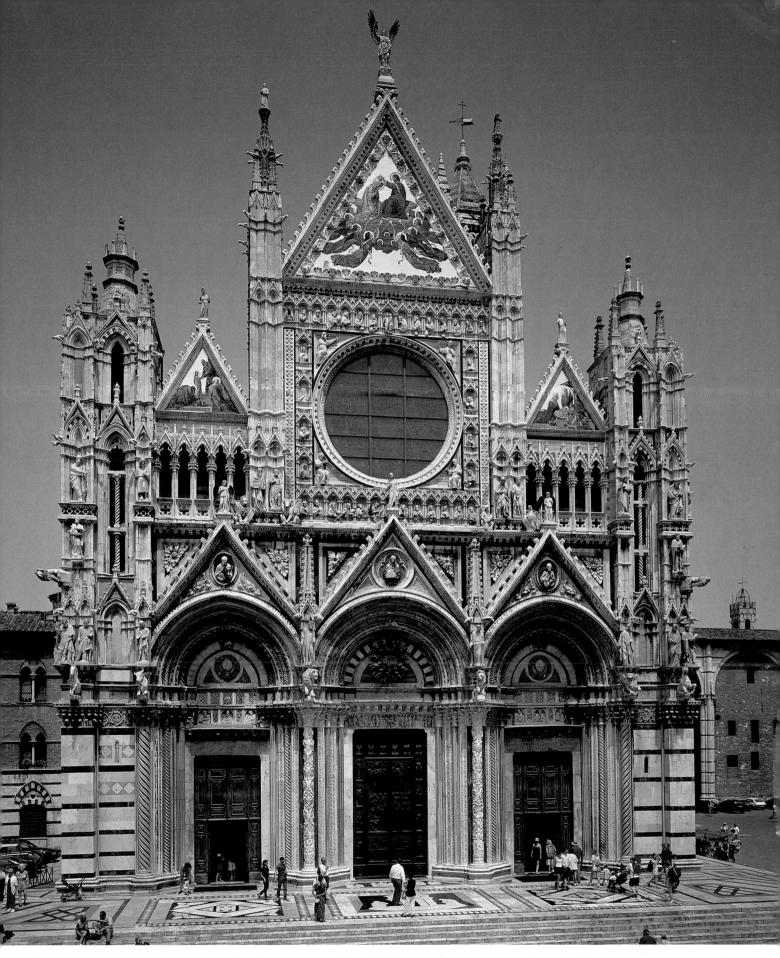

1.13 Façade of Siena Cathedral; lower half by Giovanni Pisano, 1284–1299.

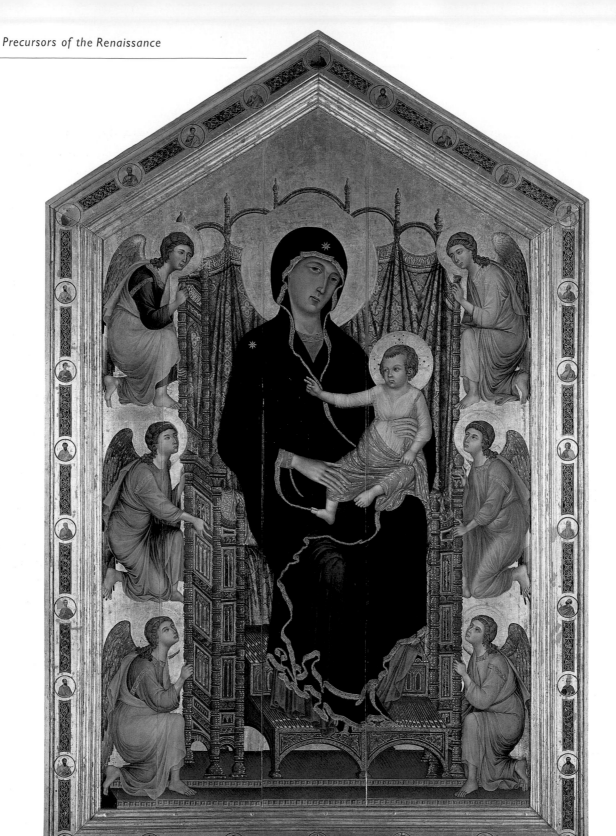

1.14 Duccio di Buoninsegna, *Rucellai Madonna*, 1285. Panel; 14ft. 9⅞ in. × 9ft. 6⁹⁄₁₆ in. (4.52 × 2.90 m). Galleria degli Uffizi, Florence. Duccio had several run-ins with the Sienese authorities in the course of his successful life as an artist. Documents indicate that he was fined on several occasions: for failure to obey certain civic laws, for avoiding military service, and possibly for witchcraft. When he died, he left a widow, seven sons, and a daughter. The boys renounced their inheritance, probably to escape responsibility for Duccio's debts.

confraternity devoted to charity and involved in the cult of the Virgin. The contract with Duccio stipulated that he paint a beautiful picture and that he himself provide **pigments** and gold, while the Laudesi would supply the wood panel and 150 lire in gold florins (the monetary unit of Florence). The work itself is so named because it was transferred from its original setting in the chapel belonging to the Laudesi to the Rucellai Chapel.

At nearly 15 feet high, the *Rucellai Madonna* is the same height as Nicola Pisano's Pisa pulpit and the largest painting of the subject to date. The richness of its colors and the variety of elegant materials make Duccio's painting a fitting expression of the patron's devotion to the Virgin. Compared with Cimabue's *Enthroned Madonna* (see 1.8), Duccio's reveals a new emphasis on three-dimensional form, both in the positioning of the throne and in the use of ***chiaroscuro***, or **shading**.

Duccio's throne, in contrast to Cimabue's, stands on a horizontal surface and is turned at an oblique angle to the **picture plane**. The gold threads indicating drapery folds recur on Christ's red robe but are absent from the Virgin's drapery, where gold is reserved for the edges of her rich, dark-blue robe and the neck and sleeve of her red undergarment. Christ seems to sit firmly on the lap of Mary, who has raised her left leg in order to support his weight. In placing her left hand around his waist, she pulls the drapery across her torso. There is thus an interplay of weight, pose, and gesture that affects the physical materiality of the drapery in a new way.

This emphasis on naturalism reflects the influence of Roman painting and of Roman painters working in Assisi. At the same time, however, the chromatic organization of the picture creates patterning that flattens the image. The interlocking colors of the angels are repeated in the brocade cloth behind the Virgin that hides the image's three-dimensionality. Likewise, the layered placement of the angels, four of whom kneel in the flat gold Byzantine background, disregards the natural force of gravity. Duccio's figures and their space are both of this world and beyond it. He has created a new conflation of earthly time and space with spiritual timelessness and weightlessness. Mary looks down on human time and space, while the stars on her robe and the throne held aloft by angels identify her as Queen of Heaven.

The thirty **medallions**—a Byzantine feature—accentuate the role of the frame by framing the central image with figures related to the main image. The Old and New Testament figures on the top and sides establish a typological framework—all twelve apostles appear on the left (Mary's right) and are opposite the Old Testament patriarchs, kings, and prophets on the right (Mary's left). On the bottom frame, the medallions are more specific to the iconography, setting, and patronage of this particular Enthroned Madonna. Saint Augustine, whose rule was adopted by Saint Dominic for his Order, is at the center. Dominic is to Augustine's right, and Zenobius, patron saint of Florence, is to his left. Saint Catherine of Alexandria, who, like Mary herself, became Christ's bride in a mystical marriage, is at the left, below the kneeling angel. Beneath the angel at the right is Saint Peter Martyr, the Dominican founder of the Laudesi.

Duccio's frame is thus a kind of "time frame." By virtue of the medallion figures, it spans the time from Abraham, through the era of the prophets and the New Dispensation, right up to the thirteenth century. Implied in the appearance of Peter Martyr is the patronage of the painting, which takes the time of the frame to 1285. Just as Duccio's central image conflates divine with earthly space, his frame condenses time.

Siena and Florence in 1300

Italy celebrated its jubilee year in 1300. That year was, therefore, viewed with special interest, both at the time and later. As a result, events associated with 1300 assumed mythic proportions. The Florentine banker and historian Giovanni Villani (c. 1275–1348) wrote, incorrectly, that he had been inspired to compose his chronicle of the city in that year. The poet Dante Alighieri (1265–1321) claimed to have begun his journey through the *Inferno* in 1300 (see Box, p. 22). And in the mid-sixteenth century, Vasari attributed special artistic significance to the year 1300; in his view, it marked the start of a new era in art that opened with the work of the Florentine artist Giotto di Bondone (c. 1267/77–1337).

In Florence, the leading Dominican church of Santa Maria Novella on the west side of town and the

Dante Alighieri

Dante was a Florentine poet of enormous importance, whose works were discussed throughout the Renaissance in Italy. Around 1295, he wrote the *Vita nuova*, describing his love for Beatrice, which persisted despite her marriage to someone else and her death. The *Convivio* of about 1306–1308 was a philosophical treatise, and the *Monarchia* (1310–1313) a political tract. Dante wrote in the vernacular (that is, contemporary Italian) rather than in Latin, as had been customary in the Middle Ages. In 1304–1306, he wrote a treatise in Latin on the Italian language (the *De vulgari eloquentia*).

He is best known for the *Divina Commedia* [*Divine Comedy*] of around 1300 to 1321, a long, three-part poem consisting of the *Inferno* [*Hell*], the *Purgatorio* [*Purgatory*], and the *Paradiso* [*Paradise*]. In the year 1300, he is led by the Roman poet Virgil through the seven circles of Hell until he reaches the lowest realm of Satan. He then climbs the mountain of Purgatory to Heaven, where Beatrice takes over as his guide and presents him to the Virgin. In addition to its considerable literary value, the *Divine Comedy* is a resource of contemporary history, for Dante allocates to various historical figures, including his own friends and enemies, the rewards or punishments he believes they deserve.

leading Franciscan church of Santa Croce on the east side were well under construction by 1300. The cathedral, Santa Maria del Fiore, had been designed in 1296 by Arnolfo di Cambio (c. 1245–1302), who had trained under Nicola Pisano, but would not be completed until 1436. To a large extent, the development of Florence Cathedral mirrors the emergence of the city from the Middle Ages to the Renaissance. As in the medieval cathedral towns of France, Santa Maria del Fiore (see 3.2) was the central religious structure as well as a civic symbol supported financially by taxes and by the guilds, especially the Arte della Lana. Opposite the cathedral's entrance stood the Romanesque baptistery, built from around 1060 to 1150, its ceiling decorated with Byzantine mosaics.

In 1299, the foundation stone of the imposing Palazzo Vecchio was laid; it was completed by 1310, a short time for such a monumental building (**1.15**). As the seat of government, the sturdy, blocklike structure, with its rough exterior surface, stood as a sign of civic power and durability. It was constructed as the crowning feature of a square opened up as a result of a violent uprising in 1258 that destroyed the surrounding houses. The upper windowed story of the Palazzo Vecchio projects outward, surmounting a slanted **arcade** supported by **corbels**. At the top, **crenellations** reinforce the castlelike, defensive character of the building, while the bell tower dominates the surrounding area.

In Siena, the lower half of the cathedral had been completed since the previous year, and the construction of the Palazzo Pubblico—the town hall—had begun two years earlier. The Campo, or main square (**1.16**), was the first instance of town planning since Roman antiquity. The cathedral and the Palazzo Pubblico would become the two central institutions of Siena, where art, politics, and religion intersected.

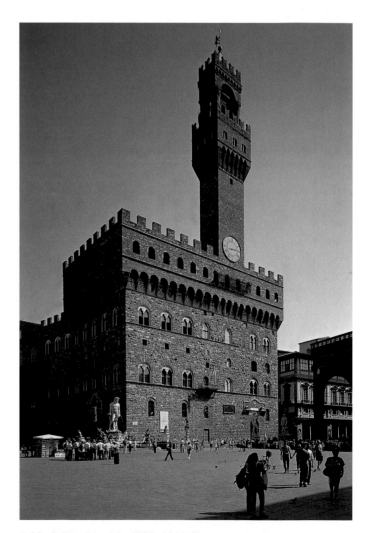

1.15 Palazzo Vecchio, 1299–1310. Florence.

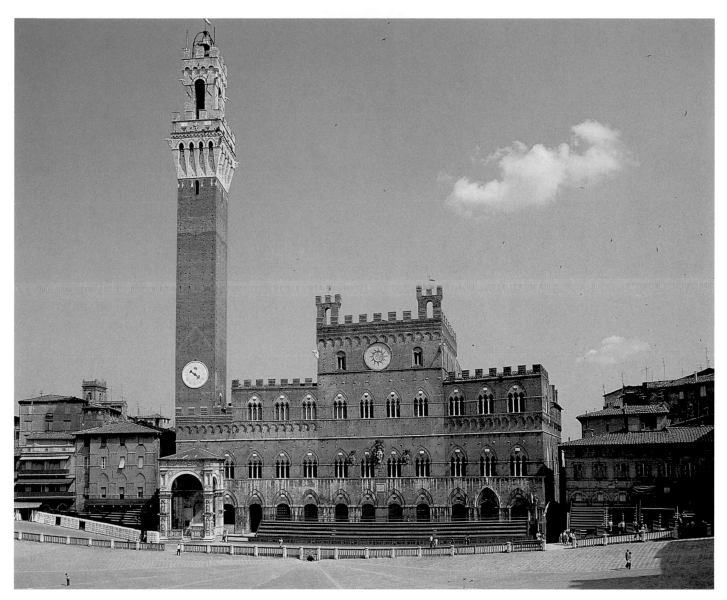

1.16 View of the Palazzo Pubblico and the Campo. Siena.

Giotto: The Santa Maria Novella Crucifix

Some fifteen years after Duccio was commissioned to paint the *Rucellai Madonna*, Giotto executed a monumental crucifix, also for the church of Santa Maria Novella (**1.17**). The revolutionary character of the image was widely recognized, and, even though it was one of the last of the monumental crucifixes, its influence was widespread.

The type is the same as Cimabue's Arezzo crucifix (see 1.5), with the Virgin and John occupying panels at the end of each arm, but the figure of Christ is radically different. He is no longer in the S-shaped pose of the Byzantine style; instead he slumps forward and, in contrast to the Cimabue, his arms are stretched thin by the natural pull of gravity. The anatomical structure of his body is organically rendered, unlike the surface stylization of Cimabue's Christ. Transparent drapery defining his body has replaced the elegant reds and golds preferred by his predecessor.

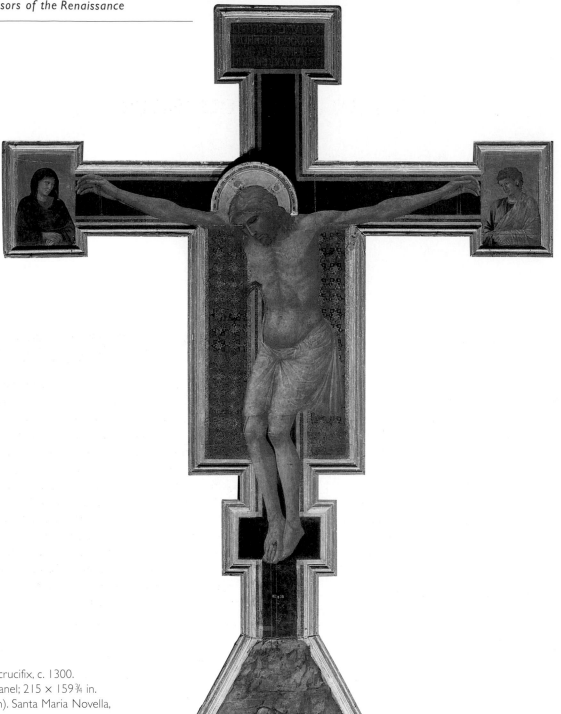

1.17 Giotto, crucifix, c. 1300.
Tempera on panel; 215 × 159¾ in.
(5.46 × 4.06 m). Santa Maria Novella,
Florence.

As in Cimabue's crucifix, Giotto repeats the cruciform shape at Christ's feet. But here Giotto has added a new element to reinforce both the structural and iconographic logic of the work—the base is now a trapezoid framing the image of a rock. On the one hand, the base creates the impression of a real support, and, on the other, the rock is a visual abbreviation of Golgotha, where Christ was crucified. In addition, the rock alludes to a future time, when the Church as the Rock of Ages becomes a metaphor for eternity.

Giotto's naturalism, his attention to the laws of gravity, and the complex layers of meaning in the Santa Maria Novella crucifix mark a major step toward Renaissance style. Worshipers viewing this image could not only identify physically as well as emotionally with the dead Christ, but they also confronted a new synthesis of spirituality and human form. The power of Giotto's style was felt throughout Italy. His work was highly praised by authors and artists alike, and his reputation today is on a par with the greatest western painters.

2
Trecento Precursors

Giotto di Bondone

In the fourteenth century, Giotto was credited with having brought painting out of the darkness of the Middle Ages into the light of a new day. Dante's famous lines in the *Purgatory* state the light/dark metaphor in comparative terms, noting that Giotto's reputation *obscured* that of Cimabue:

> O empty glory of human powers! How short the time
> its green endures at its peak, if it be not
> overtaken by crude ages! Cimabue thought to hold
> the field in painting, and now Giotto has the cry,
> so that the fame of the former is obscured." [1]

Not only was Cimabue seen, as he would be by Vasari over two hundred years later, as the end of an era associated with darkness, but his fame also dimmed in contrast with Giotto's light. This comparison was one that would reverberate throughout the Renaissance in works of literature and history as well as in writing on art and artists. For the author Giovanni Boccaccio, Giotto had restored light to the art of painting by resurrecting it from the grave. By this, Boccaccio meant that Giotto had restored a degree of naturalism to his works that had not been seen since the fall of the Roman Empire.

The *Ognissanti Madonna*

Boccaccio's meaning is clear from a comparison of Giotto's monumental *Enthroned Madonna* (**2.1**) for the high altar of the Ognissanti (All Saints') Church in Florence with Cimabue's version of the same subject

Giovanni Boccaccio

Giovanni Boccaccio (1313–1375) was probably born in Florence but spent his youth in Naples. Contacts with the French court of Anjou encouraged his literary pursuits; he wrote poetry and fiction, and became a leading fourteenth-century humanist. His psychological novel, the *Fiammetta* (1340s), is somewhat autobiographical, reflecting the new interest in biography and autobiography. The famous *Decameron* of around 1350 was written in the vernacular and presents a remarkable panorama of contemporary Italian life. Boccaccio became a friend of Petrarch, whom he greatly admired, and began to write in Latin. His later works include a *Genealogy of the Gods* inspired by Classical mythology, a biography of Dante, and commentaries on the *Divine Comedy*.

(see 1.8) and with Duccio's *Rucellai Madonna* (see 1.14). Giotto's space is more purely cubic, with the throne and figures firmly set on horizontal surfaces. The throne does not rise, as Cimabue's does, and the angels, unlike Duccio's, seem to occupy natural space. Giotto retains the gold background and flat halos of Byzantine style, and his throne is elegantly Gothic, with pointed arches, delicate surface designs, and a marbleized step. Nevertheless, both the throne and figures are weighty and seem to obey the laws of gravity. The greater **foreshortening** of the arms of the throne compared to the versions by Cimabue and Duccio also emphasizes the three-dimensionality of Giotto's pictorial space.

Mary's drapery, in contrast to that of the earlier altarpieces, falls in a horizontal **plane** parallel to the floor of her throne. The space between her knees is identified as

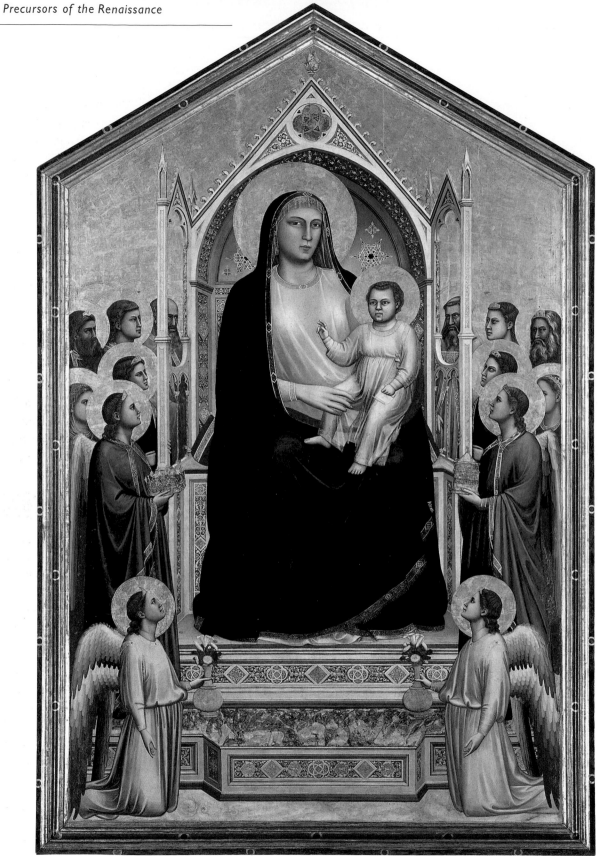

2.1 Giotto, *Enthroned Madonna (Ognissanti Madonna)*, c. 1305–10. Tempera on panel; 10 ft. 8 in. × 6 ft. 8¼ in. (3.25 × 2.03 m). Galleria degli Uffizi, Florence. Giotto's reputation for having brought painting into light merged, in a popular anecdote, with his proverbial ugliness and his wit. One day, Dante encountered Giotto and asked how his children could be so ugly when his paintings were so beautiful. Giotto replied that he painted by daylight but procreated in the dark.

a void by folds rendered in *chiaroscuro*. This definition of voids, as well as of solids, is a characteristic of Giotto's style and accentuates the monumental effect of his figures. The curve of Mary's white drapery across her torso indicates that she is not completely frontal, but turns slightly with a suggestion of *contrapposto*.

Christ himself has become more babylike than his predecessors, having rolls of fat around his wrists and a chubbier face. He seems to rest his weight firmly on Mary's knee. Although less of a miniature man and more like a child, Giotto's Christ continues to project the medieval image of a miraculous infant, endowed with superior wisdom. Here, as in Cimabue's picture, Christ holds a scroll in his left hand and blesses with his right. In both images, this arrangement alludes to the transition from the Old Dispensation, symbolized by the scroll of prophecy, to the New Dispensation, symbolized by Christ's kingship. The transition also refers to Christ's Second Coming and the Last Judgment, in which the saved will be on his right and the damned on his left.

Such right-left symbolism had, by the fourteenth century, become an established **convention** of Christian iconography. What distinguishes Giotto's image from Cimabue's, however, is that Giotto confines the metaphor to the person of Christ, whereas Cimabue retains the Old Testament figures at the base of the throne. As a result, in Giotto's version, Christ becomes the formal and iconographic focus of the pictorial message. This sense of focus on Christ reinforces his significance as the one responsible for the transition from the Old to the New. Despite Mary's formal centrality and monumental scale, it is to Christ that all eyes turn. One can see this by observing the gazes of the figures on either side of the throne: those in the back row incline their heads, consistent with their placement in space, in such a way that their attention is directed to Christ. Even more clearly, the angels kneeling in the foreground gaze upward.

For the viewer, the angels and other figures flanking the throne function as a Greek chorus, responding to—and reinforcing—a central dramatic event. A second transition, both formal and iconographic, from viewer to image is thus created. The kneeling angels, for example, define a spatial passageway in a progression of horizontal planes from the picture surface, past the painted floor, up the steps, to the Virgin and Christ. The angels also extend vases of lilies and roses, the former being symbols of the Virgin's purity and the latter (which were believed to have grown without thorns in the Garden of Eden) of her role in the redemption of Eve's sin.

Although, as we have seen, Giotto did not single-handedly revive naturalism, his works have a formal and psychological power that was new. Born in the Mugello Valley, north of Florence, he reportedly worked in various Italian cities, including Rome, Ravenna, Assisi, Padua, Florence, and possibly also in Avignon. In Naples, his reputation resulted in his being appointed a *familiare*—meaning "friend" or "close acquaintance"—of the court. In Rome, he executed a famous mosaic of the *Navicella* (now destroyed), illustrating the Storm in the Sea of Galilee. And in Florence, he painted **fresco cycles** for chapels belonging to the Bardi and Peruzzi banking families in the church of Santa Croce. But the acknowledged surviving masterpiece of Giotto's career is the fresco cycle in the Arena Chapel in Padua.

Fresco Painting

Fresco, Italian for "fresh," was the technique used for painting on walls during the Renaissance. It called for advance preparation and, in contrast to tempera, speed of execution. The term **buon fresco** is used to describe the application of pigments mixed in water to damp lime plaster. As the plaster dries, the paint bonds with the wall.

Preparation of the wall requires a preliminary rough layer of **arriccio** (a mixture of lime and sand). The next layer is a coat of **intonaco** (fine plaster), which forms the **ground** for the painting. The artist applies just enough *intonaco* for a single day of painting—the *giornata*—because plaster dries in a day. Sometimes artists made preliminary drawings on the *arriccio*; these are called **sinopie**, after the red chalk from the town of Sinope, on the Black Sea.

Certain colors had to be applied **a secco**, or onto dry plaster, because they are affected by chemical reactions with the lime. Blue, for example, turns green when mixed with lime. *Secco* painting is not as durable as *buon fresco* and flakes off the wall; as a result, the blue sky of many frescoes—such as Giotto's in the Arena Chapel—has worn away. Sometimes artists added details in tempera—and, later in the Renaissance, in oil—for rich or luminous effects.

The Arena Chapel

In the fourteenth century, the university town of Padua, near Venice and later part of it, was a republican commune and an important center of the Classical revival. This revival, which included the study of ancient texts as well as the visual arts, became a pervasive cultural phenomenon in the Renaissance known as the humanist movement. It was an integral part of the revolutionary character of Giotto's art.

In the *Inferno*, Dante had consigned to Hell one Reginaldo Scrovegni, a citizen of Padua, who had made a fortune as a usurer. Dante describes moneylenders from Padua and Florence, with money pouches around their necks, as suffering the eternal torture of burning sands in the Seventh Circle of Hell. Around 1300, Reginaldo's son Enrico purchased the site of an old Roman arena for his palace and a chapel. Since the Church considered usury a sin, Enrico dedicated the chapel as an offering of atonement. He hired Giotto to

The Emergence of Humanism

Humanism, in the Renaissance, refers to aspects of the Classical revival, echoing the ancient Greek maxim "Man is the measure of things." Humanists collected, translated, and wrote commentaries on Classical texts—at first Latin texts, and eventually Greek texts as well. By the end of the thirteenth century, Paduan lawyers had become interested in the legal writings of Cicero, the Roman orator and statesman. In imitation of the ancient Roman ceremony, Albertus Mussatus was crowned poet of Padua in 1314 for plays written in the style of Seneca. And by 1390, a professorship in Greek studies was established at the university of Florence.

The driving force of the emerging humanist movement in fourteenth-century Italy was Francesco Petrarca (1304–1374) —Petrarch in English. He rediscovered many of Cicero's texts and amassed a renowned private library of Classical manuscripts, including those of Homer and Plato. He wrote biographies of famous Romans, creating a new interest in human achievement and fame. His epic poem *Africa*, describing the second Punic War between Rome and Carthage, was inspired by Virgil's *Aeneid*.

In a famous literary passage describing his ascent of Mount Ventoux, in France, Petrarch revived the ancient Roman view that nature was revivifying and the countryside conducive to peaceful contemplation. In the fifteenth century, this notion would inspire wealthy families to build country villas as the Romans had done. Such villas provided a means of escape from the urban ravages of the plague, as well as being places of entertainment and relaxation.

A new humanist curriculum designed to demonstrate human dignity was developed in certain elite schools. This was a radical departure from the medieval view that the physical body was impure and corrupt. Eventually, the notion of the dignity of the human body, as well as the mind, would be elaborated in the fifteenth century to become an integral part of Renaissance culture. The humanist schools trained the body and the mind, educated girls alongside boys, and occasionally awarded scholarships to bright students from less wealthy families. The curriculum differed from medieval study in its inclusion of history, poetry, grammar, rhetoric, and moral philosophy. In the course of the Renaissance, one result of the Classical revival was a rise in literacy; another was a change in the social status of the artist, gradually evolving from that of a craftsman to that of an intellectual and a gentleman.

Although most humanists were devout Christians, few saw any conflict between their religion and their admiration for pagan antiquity. Their enthusiasm for the Classical revival included works of art as well as texts. Artists studied ancient paintings and sculpture in their efforts to achieve the illusion of naturalism. Their study of Roman architecture, whose ruins were readily visible on Italian soil, led to a new style and a more human scale of building. Collectors also began to acquire ancient works, sending buyers to Greece and Constantinople on their behalf.

Writing on art, like history writing and biography, also changed as a result of humanism. Hagiography was replaced by biographies of famous people, histories began to rely on documentation, and art theory developed. Classical histories were taken as models for the new approach, and humanists resorted to antiquity as a means of reinforcing their views. In contemporary politics, this was particularly evident in the emergence of civic humanism and the establishment of republican governments in which citizens were expected to participate. Florence, for example, was called a "new Athens" in the fifteenth century, and cities would increasingly trace their origins to ancient gods and heroes. Likewise, artists would be compared to Greek and Roman predecessors— Giotto, for example, was compared to Apelles, the **portrait** painter of Alexander the Great, for his skill in depicting naturalism; for his proverbial ugliness, he was compared to Socrates.

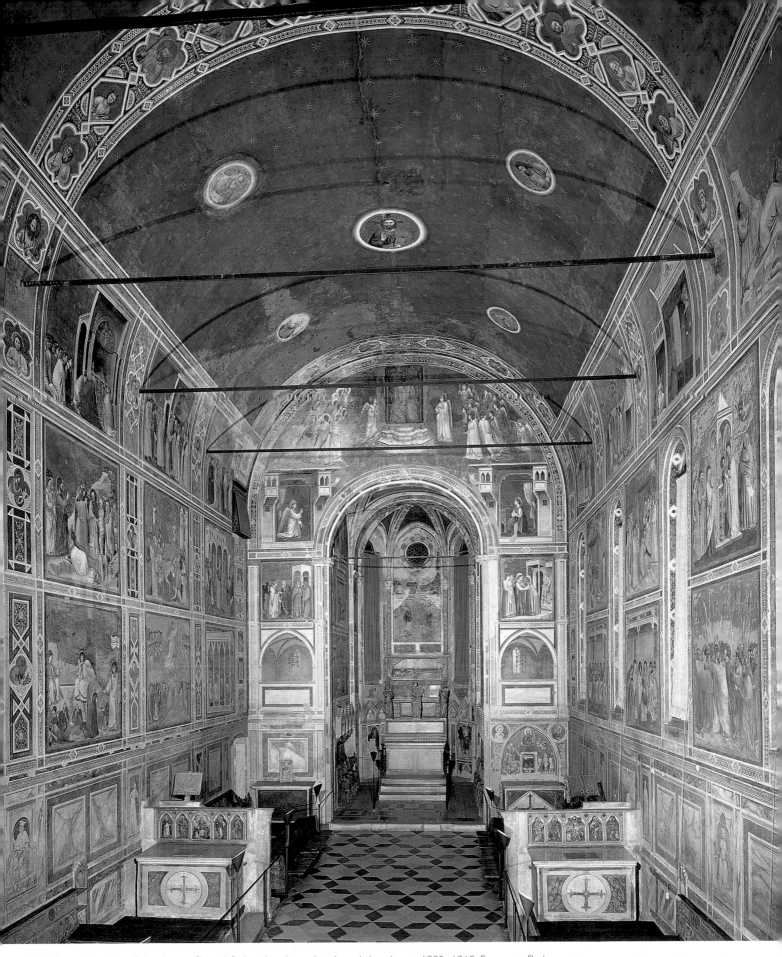

2.2 Giotto, interior of the Arena Chapel facing the chancel arch and the altar, c. 1305–1310. Frescoes. Padua.

decorate the simple, barrel-vaulted interior with frescoes illustrating the lives of Mary's parents (Anna and Joachim), of Mary herself, and of Christ. Figure **2.2** is a view of the interior facing the **chancel** arch, as it is seen when one enters the chapel.

The rich, sky-blue ceiling is studded with gold stars and contains two sets of tondos. The group visible here shows Christ in the center surrounded by the four evangelists. The other group, which is closer to the entrance wall, depicts Mary with the infant Christ at the center of four Old Testament prophets. Giotto thus merges the typological tradition of prophecy and fulfillment with a natural blue sky. The latter is repeated in each of the narrative scenes as well, emphasizing Giotto's departure from the typical gold backgrounds of Byzantine style.

There are three horizontal rows of scenes on the side walls, the only windows being on the right wall. In the right top row are scenes from the lives of Anna and Joachim and, at the left, scenes from the Virgin's life. The frames of each of these scenes depict prophets in **quatrefoils**, three of which extend into the ceiling. The remaining narratives represent the life of Christ, and each is typologically paired with an Old Testament event on the frame to the left. On the **dado** painted in imitation marble, which is below the narratives, are personifications of the Seven Virtues and Vices. Their right-left disposition, respectively—like the relationship of the main scenes to those on the frames—continues the Christian iconographic tradition of placing what is old, or negative, on the left and what is new, or positive, on the right.

Visible on the chancel arch is the beginning of the New Dispensation—at the very top, a wooden panel of an enthroned God has been inserted into the wall. His throne, like the Virgin's in the *Ognissanti Madonna*, rests on horizontal foreshortened steps that appear naturally three-dimensional despite their heavenly setting. God summons the angels and entrusts to the archangel Gabriel his mission of informing Mary that she will be the mother of Jesus.

The *Annunciation* is separated by the top of the arch's opening, with Gabriel on the viewer's left and Mary on the right. Indicating that Gabriel is God's messenger, the bearer of figurative light, is the light that radiates from him. Mary receives his news, and the Incarnation

is depicted as light pouring into her room from the upper left—an allusion to Christ as the Light of the World. Both figures kneel in a cubic space, each focusing intently on the other. Gabriel holds the scroll of prophecy, and Mary holds a book, an apocryphal detail indicating that the angel's arrival has interrupted her reading. Her crossed arms allude to Christ's Crucifixion, a reference to her foreknowledge of her son's Passion and Death. The blocklike, sculptural quality of the figures and their sense of weight and solidity are characteristic of Giotto's style.

Below Gabriel is the *Betrayal*, showing Judas accepting a bag of silver, and below Mary is the *Visitation*. The chancel-arch scenes thus prefigure the future events in Christ's life and function as a prologue to the story unfolding on the side walls. The *Visitation* prefigures the births of Christ and John the Baptist, while the *Betrayal* warns of Christ's destiny to die on the Cross. Presiding over the chancel-arch scenes is God the Father, revealing his divine plan to the host of heaven.

Below the scenes on the arch are two **illusionistic** chapels, painted as if they are actual spaces behind the wall surface. Illusionistic effects also appear in the *Annunciation*, in the four projecting balconies and the cloths that seem to swing into their open arches. Giotto's interest in illusionism marks the beginning of a development that would continue throughout the Renaissance. The appeal of an image's appearance of reality distinguished Renaissance aesthetics from the medieval and Byzantine styles, and was an aspect of the Classical revival. Comparisons of Giotto with such Classical illusionist painters as Apelles and Zeuxis emphasized their ability to create *trompe-l'oeil* effects—that is, images that fool the viewer into thinking they are real.

According to Vasari, Cimabue was Giotto's teacher and, while this was most probably not the case, their master-pupil relationship became a Renaissance myth and the basis of popular anecdotes. In one of these, Giotto reportedly painted on the nose of one of Cimabue's figures a fly that appeared so real that Cimabue tried to brush it off. On the one hand, this anecdote recapitulates the lines of Dante's *Purgatory*, for the fly literally obscures Cimabue's work (if only a small piece of it) by virtue of being painted on the nose. On the other hand, the placement of the fly can be

read as a metaphor for Giotto's "thumbing his nose" at his master. The incident encapsulates Giotto's mastery over Cimabue—he has been able to fool him—illustrating both his skill in illusionism and his reputation for humor.

Vasari also relates the popular recognition story in which Cimabue discovers Giotto as a boy drawing a sheep on a rock. So impressed is Cimabue by Giotto's naturalistic depiction of the sheep that he obtains permission from the boy's father to train him as a painter. The persistence of this story, despite the relatively unnaturalistic character of Giotto's sheep in the Arena Chapel frescoes, reflects the force of myth. Interestingly, the Virgin's father, Joachim, is portrayed as

a shepherd—as Christ himself will be in the future—and the narrative of Giotto's cycle opens with an event involving a baby lamb.

In the *Expulsion of Joachim from the Temple* (**2.3**), directly to the right of the *Annunciation*, Giotto has depicted a remarkable synthesis of form, psychology, and traditional Christian typology. Joachim, who is aged and childless, has brought a lamb to the Temple in Jerusalem as an offering in the hopes of having a child of his own. The priest, appalled at Joachim's presumption, expels him from the Temple. The thrust of the priest's gesture seems literally to have the weight and authority of the Temple behind it. Joachim's conflicted reaction is shown by his twisted pose, as he simultaneously turns

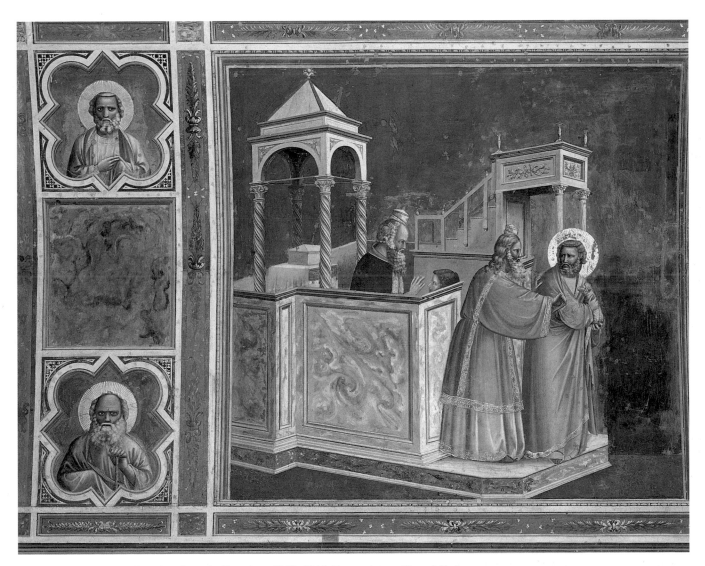

2.3 Giotto, *Expulsion of Joachim from the Temple*, c. 1305–1310. Fresco. Arena Chapel, Padua.

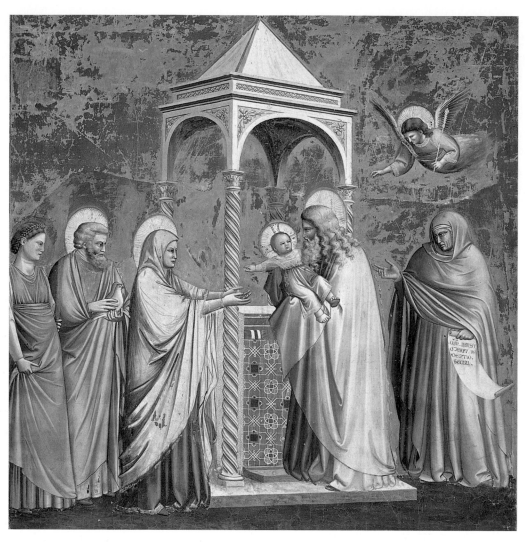

2.4 Giotto, *Presentation in the Temple*, c. 1305–1310. Fresco. Arena Chapel, Padua.

toward the priest and protects the lamb from his aggression. The dejection experienced by Joachim at being roughly rejected is symbolized by the blue void at the right. It is also a metaphor for the emptiness he feels in not having produced children. His rejection is accentuated by the presence in the Temple of a second priest, who is blessing a much younger man.

The architecture, which defines the cubic space of the setting, also contains typological metaphors. At the left, for example, the structure over the altar is supported by four twisted columns; these identify the building as Solomon's Temple. The structure at the right is supported by two Corinthian columns, reflecting the revival of Classical forms. In the context of the humanist movement, these columns denote newness and thus the

future events of the New Dispensation. Their placement frames Joachim's head and refers to his role as progenitor of the New Dispensation by virtue of being Mary's father. The lamb alludes to the miracle by which his barren wife will conceive the Virgin as well as to the sacrificial nature of Christ's earthly mission.

The formal characteristics of the *Expulsion of Joachim* recur throughout the cycle. Figures are solidly sculptural; draperies are weighty and fall to the ground in obedience to the law of gravity. The blue sky and three-dimensional space reinforce the appearance of a natural setting. The stagelike quality of the architecture, which is small in comparison to the scale of the figures, recurs throughout the cycle. It is possible that this, together with the dramatic character of Giotto's scenes,

reflects the contemporary revival of Roman theater, particularly the plays of Seneca, in Padua. As in Classical drama, Giotto's frescoes maintain a unity of place and a continuity in the formal and psychological portrayal of the figures.

A brief consideration of two scenes from the life of Christ on the right wall will illustrate this point. In the *Presentation in the Temple* (2.4), the structure with twisted columns is similar to that in the *Expulsion of Joachim* and accentuates the three central figures: Mary, the infant Christ, and the old priest Simeon. Here, rather than being ejected from the Temple, Christ—the New Lamb—is welcomed with open arms. Ironically, it is Christ who rejects the priest. In an insightful portrayal of the so called "stranger reaction," Giotto reveals his observation of normal child behavior. Christ's eyes are riveted to Simeon's, alluding to God's promise that the priest would *see* the Savior before his death. At the same time, however, Christ tries to squirm toward his mother, as his outstretched arms, foreshortened left foot, and twist at the waist indicate.

The architecture reinforces the figures here as it does in Joachim's *Expulsion*. The round arch repeats the curve of Simeon's head, and the back columns accentuate Mary and Christ, the latter referring forward in time to the column of the Flagellation. Emphasizing Mary's gesture is the foremost column, while the blue space between her hands and Christ's represents the frustration of their efforts to reunite. Here, as in the *Expulsion*, the void has psychological meaning.

Whereas in the *Expulsion of Joachim*, the priest blessing the young man in the Temple is a foil for the rude treatment of Joachim, in the *Presentation* the figures on either side of the central event reinforce it. At the left, Joseph carries the traditional offering of pigeons, while an unidentified woman behind him watches intently. The gestures of the woman, Joseph, and Mary form a progression that leads the viewer from left to right—the direction of the narrative in the cycle as a whole—until counteracted by Christ's reaction to Simeon. At the right, echoing Christ's gesture, are an angel and a prophetess with a scroll. The prophetess turns toward the central event, but her scroll curves to the right, leading to the next scene in the narrative. In the poses, gestures, and gazes of the onlookers, Giotto creates the equivalent of a Greek chorus that both reacts to, and reinforces, the principal drama and also moves the story along.

The *Kiss of Judas* (2.5) is the dramatic climax of Giotto's narrative, and what follows is dénouement. It is located on the right wall directly below the *Presentation*, to which it is related formally and psychologically. Again, there is a dramatic confrontation at the center of the scene, and the main characters are locked in a riveting gaze. Here, however, Christ accepts his fate, willingly overpowered by the enveloping yellow cloak of his betrayer—the same that Judas wears in the chancel-arch *Betrayal*.

In both scenes, the central confrontation arrests the action momentarily, with significant minor movements and countermovements related to the narrative. In the *Kiss*, which is literally a scene of arrest, crowds enter from left and right. Christ faces right; and the curve of Saint Peter's right arm, cutting off the ear of Malchus, servant of the high priest, is a forceful thrust toward the right. At the same time, a counterforce occurs in the three foreground figures. The man in purple at the right points toward the center (echoing the prophetess in the *Presentation*), followed by Judas turned in three-quarter view away from the picture plane, to the hooded figure seen in back view. The latter foreshadows Christ's death by association with the hooded executioners of medieval Europe.

In contrast to the *Presentation* and the *Expulsion of Joachim*, the *Kiss of Judas* is devoid of architecture. In place of the round arch and columns framing the infant Christ and Simeon, Christ's head is now framed by the radiating stakes and ominous curve of Roman helmets as the soldiers converge to make their arrest. Christ seems to have momentarily lost the freedom of movement he displays in the *Presentation*, but his moral superiority over Judas is indicated by his higher position. He now looks down on Judas, whereas in the *Presentation* he looked up at Simeon. At the left, Peter's gesture echoes both the aggression—with greater force—of the priest expelling Joachim and the form of Mary's welcoming gesture in the scene above.

Relating the *Kiss* with the *Expulsion* are the two hands holding the clubs raised over Christ's head. They accentuate his formal centrality and his victimization by the crowd, and also refer to the death of Christ prefigured in the sacrificial lamb carried by Joachim. By repeating the

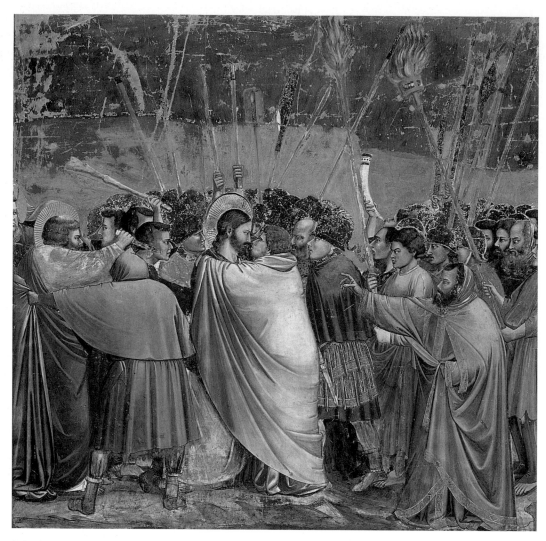

2.5 Giotto, *Kiss of Judas*, c. 1305–1310. Fresco. Arena Chapel, Padua.

arrangement of the columns behind Joachim in the *Expulsion*, Giotto reminds viewers that the Crucifixion was foreordained. The death and resurrection of Christ are thus the fulfillment of God's promise to Joachim and of the event with which the narrative opens.

The dramatic character of the Arena Chapel frescoes marked a revolution in the approach to painted space. Each scene is set like a narrow stage, with the picture plane functioning as the theater's fourth wall. Figures turn freely in space—Giotto was the first artist since antiquity to depict figures in back view—and act and react according to the requirements of the narrative. As a result, the viewer identifies physically and psychologically with both the form and content of the scenes.

As visitors to the Arena Chapel turn to leave, they confront the huge *Last Judgment* on the entrance wall (**2.6**). Framed at the top by a band of Old Testament prophets in quatrefoil frames referring to the distant past, the scene shows the Second Coming of Christ at the end of time. Seated in a blaze of heavenly gold light, Christ is surrounded by a **mandorla** from which angels blow the Last Trump. On either side, the twelve apostles are enthroned in Heaven. Their curved horizontal platform is a visual echo of the curved apse behind the chancel arch facing the *Last Judgment*. And Christ, with his arms extended and the stigmata readily visible, echoes the crucifix originally on the altar. The triple-arched window, a source of natural light above the painted gold light radiating from Christ, replicates the arrangement of a Roman **triumphal arch**.

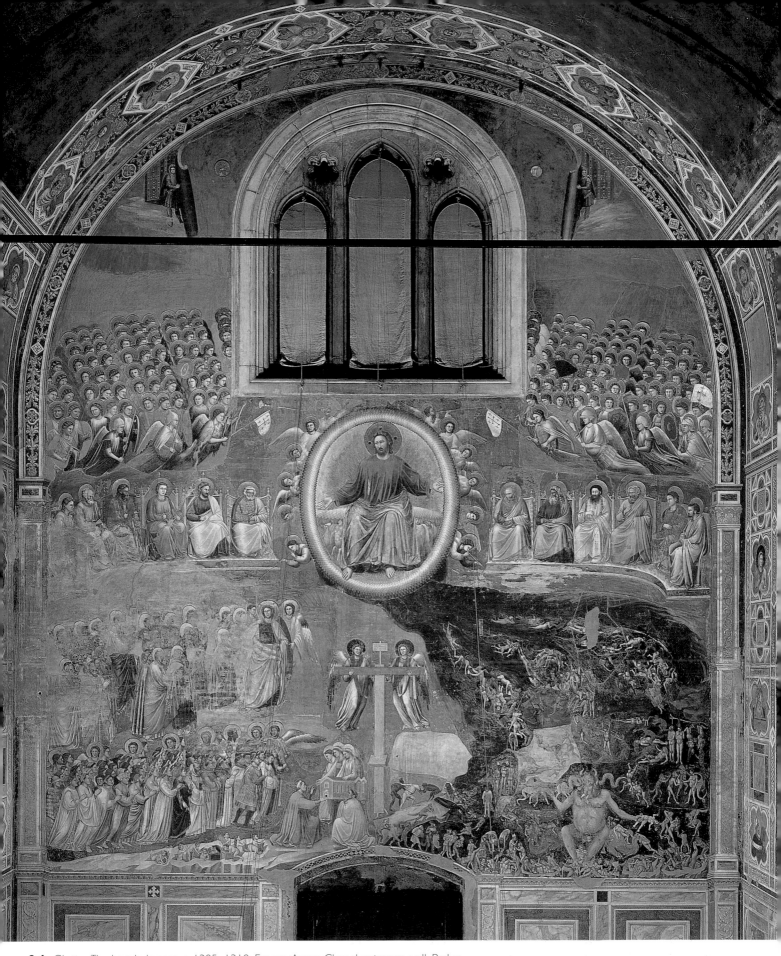

2.6 Giotto, *The Last Judgment*, c. 1305–1310. Fresco. Arena Chapel entrance wall, Padua.

At Christ's right (the viewer's left), the saved climb from their tombs and, monitored by angels, rise in two orderly groups toward Heaven. Leading the upper group is Mary, who acts as intercessor on their behalf. Directly below Christ, two angels support the Cross separating the saved from the damned. Giotto's penchant for humor appears in the little soul hiding behind the Cross, attempting to sneak away from Hell and join the saved.

Also on the side of the saved is the **donor**, Enrico Scrovegni, one of the early Renaissance examples of the patron's presence in a work. With the assistance of a friar, Scrovegni hands a model of the chapel to three figures generally identified as Gabriel, the Virgin, and Charity. The friar's white habit is painted illusionistically as if falling out of the picture onto the arch over the doorway. As visitors exit, they are thus treated to

the same kind of *trompe l'oeil* play as the anecdotal fly painted on the nose of Cimabue's painted figure.

The four rivers of Hell flow from Christ's mandorla to his left. The damned, tortured by red (signifying fire) and blue (signifying ice) devils, tumble downward. In contrast to the neat, orderly arrangement of the saved, the panic-stricken damned are disordered. At the bottom of Hell is Satan himself, a large monster endlessly swallowing and expelling nude souls. The emphasis on hanging, a form of death that requires gravity, is consistent with the traditional view of Hell as being at the depths of the universe. Judas has hanged himself and holds the bag of silver for which he betrayed Christ. His placement is roughly opposite the scene of the *Betrayal* on the chancel arch, while the saved are opposite the *Visitation*—the event heralding the births of Christ and John the Baptist. Among the several figures in Hell with

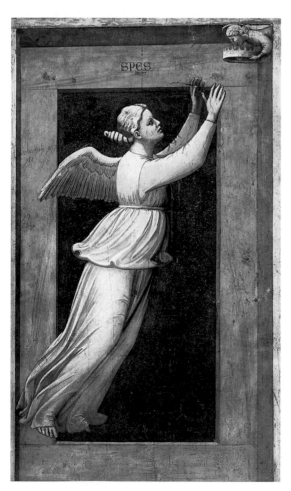

2.7 Giotto, *Hope*, c. 1305–1310. Fresco. Arena Chapel, Padua.

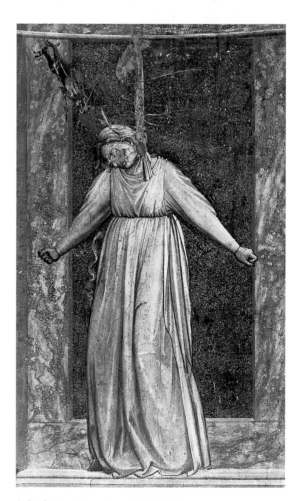

2.8 Giotto, *Despair*, c. 1305–1310. Fresco. Arena Chapel, Padua.

money pouches—a reminder of the original motive for the commission—is a corrupt bishop to the left of Satan.

At the top of the *Last Judgment*, two symmetrical groups of military angels carry banners of the Crusades. Above are symbols of the sun and moon, and two angels rolling up the sky, just as stagehands close the curtain at the end of a play. Behind them, the golden vaults of Heaven are visible, offering viewers a glimpse of eternity as they leave the chapel.

In the Virtues and Vices on the dado of the side walls, Giotto reiterates some of the principles found elsewhere in the cycle. In the opposition of *Hope* (**2.7**) and *Despair* (**2.8**), for example, Giotto juxtaposes the upward movement of the Virtue with the downward pull of the hanged Vice, corresponding to the disposition of the saved and the damned in the *Last Judgment*. Awaiting *Hope* is an angel with a crown, while *Despair* is accom-

panied by a little demon flying downward. Both are represented in **grisaille**, or imitation sculpture, which is formally related to the simulated marble of the dado. In being represented as stone, the Virtues and Vices have a quality of permanence, denoting the durability of the characteristics they personify. They are exemplars that persist through time, whereas the flesh-and-blood actors in the narrative scenes evoke the viewer's identification with their time and space, and, therefore, with their mortality.

Giotto's Virtue of *Justice* (**2.9**) and Vice of *Injustice* (**2.10**) personify good and bad government, respectively. As such, they reflect the new spirit of civic humanism inspired by the Classical revival and the fact that Padua, as well as Florence, was a republic. *Justice* is a queen enclosed by a Gothic throne that seems to open its arms in a gesture of welcome. In her right hand, Justice holds

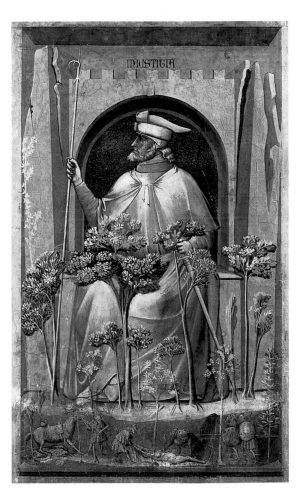

2.9 Giotto, *Justice*, c. 1305–1310. Fresco. Arena Chapel, Padua.

2.10 Giotto, *Injustice*, c. 1305–1310. Fresco. Arena Chapel, Padua.

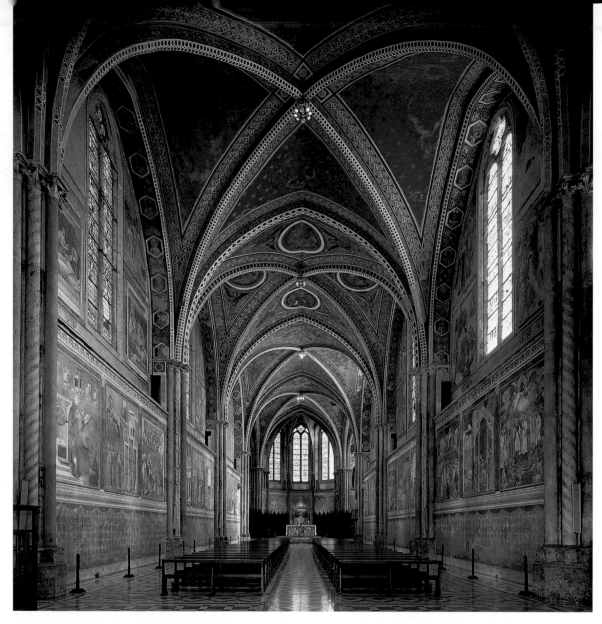

2.11 View of the nave of the Upper Church, basilica of Saint Francis, Assisi, begun 1228. The basilica, whose lavish decoration and wide interior are characteristic of papal architecture, was the burial place of Saint Francis.

a Nike, the Greek goddess of victory, and in her left an avenging angel slays an unidentified, damaged enemy. The effects of good government are shown at the base of the throne: peace, dancing, and unhindered travel. *Injustice* is a bearded tyrant who needs protection from his own subjects. He is enthroned in a crenellated fortress, protected by rows of trees; but the walls are cracking under the strain of tyranny. On the front of the rock below *Injustice*, the effects of bad government are warfare, rape, and plunder.

When the Arena Chapel frescoes were completed, Giotto returned to Florence. There, in the 1320s, he painted fresco cycles in the Bardi and Peruzzi chapels in Santa Croce. Those cycles are less well preserved than the Arena Chapel frescoes, although they are securely attributed to Giotto. More controversial is the issue of

Giotto's early style, which has revolved around the frescoes in the huge basilica of Saint Francis in Assisi (see Box, p. 39).

During the thirteenth century, Assisi had become an important religious site because of its association with Saint Francis. The Franciscan Order, with the assistance of the pope, financed the construction of the large, two-story basilica of Saint Francis. The Upper Church was consecrated in 1253. On the side walls of the wide nave, which has no aisles, two sets of scenes are depicted (**2.11**). Those on the top row are Old Testament events on the left wall juxtaposed with the life of Christ on the right. The bottom row is decorated with twenty-eight scenes from the life of Saint Francis. Their authorship has been one of the most persistent controversies of early Italian Renaissance painting.

Giotto and the Assisi Frescoes

According to a fourteenth-century source, Giotto painted the Saint Francis legend on the **nave** walls of Assisi's Upper Church. Throughout the Renaissance, Giotto was assumed to have worked in Assisi. Vasari repeated the tradition of Giotto's authorship of the Saint Francis scenes, which was widely accepted until serious objections were raised in the nineteenth century. Proponents of Giotto's authorship argued that the Saint Francis cycle represented a pre-Paduan stage in the artist's career, which accounted for stylistic differences. To a certain extent, opinions followed national lines, with the Italians supporting Giotto's authorship and non-Italians suggesting a Roman artist as the more likely candidate.

In the twentieth century, even the English critic Roger Fry accepted the Saint Francis cycle as Giotto's. But other scholarly voices—for example, Richard Offner in 1939—were raised against this view. In 1960, the art historian Millard Meiss argued that Giotto was the so-called Isaac Master and had painted several of the Old Testament scenes rather than the Saint Francis cycle at Assisi. Nevertheless, some scholars continue to insist on Giotto's authorship of the Saint Francis scenes.

On September 26, 1997, Assisi and the Upper Church were damaged by an earthquake that caused several of the frescoes to collapse. Two contemporary art historians who visited the basilica a few months afterward have once again concluded that the Saint Francis legend must be the work of a Roman painter. In so doing, they propose relinquishing the Florentine bias that tends to favor Giotto and recommend a greater acknowledgment of the contributions of Rome to early Renaissance painting.[2]

A comparison of the Arena Chapel *Expulsion of Joachim from the Temple* (see 2.3) with *Saint Francis Exorcising Demons from Arezzo* (**2.12**) illustrates the unlikelihood of Giotto's authorship of the latter. Despite such similarities as the narrow, three-dimensional space, the natural blue sky, and the volumetric figures defined by drapery, these works do not appear to have been conceived by the same artistic mind. The physiognomies and proportions of the figures differ considerably. Saint Francis and his companion are disproportionately large compared to the figures under the arches of the city wall. The wall itself is nearly on the same plane as Saint Francis, which does not rationally account for the diminished scale of the figures. In the *Expulsion*, although the figures are large in relation to the Temple, they are proportionate to each other.

The detailed visual description of the church on the left of *Saint Francis Exorcising Demons* does not square with the generalized architecture in the Arena Chapel frescoes. Whereas Giotto's buildings consistently reinforce the figures, those in the Assisi fresco are the product of an artist interested in architecture for its own sake. The fanciful colored buildings representing the city of Arezzo have little in common with Giotto's simplified, abbreviated structures. Likewise, the demons are the work of an artist delighting in the portrayal of the imaginative batlike wings.

Finally, there is not the intense dramatic focus on Saint Francis's miracle that would be characteristic of a scene by

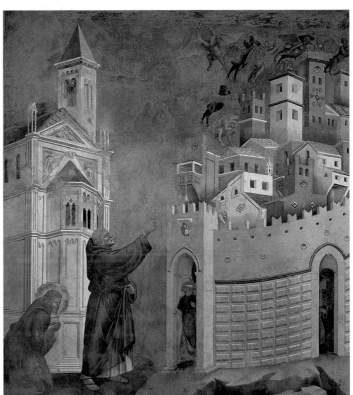

2.12 *Saint Francis Exorcising Demons from Arezzo*, c. 1290s. Fresco. Upper Church, basilica of Saint Francis, Assisi.

Giotto. Nor is there the quality of inner struggle evident—for example, in Joachim's reaction to his expulsion. The figures under the arches of Arezzo's wall do not glance at Saint Francis any more than his companion does. In contrast to the Arena Chapel frescoes, the dramatic possibilities of the exorcism are subordinated to surface details and architectural tour de force.

Sienese Painting in the Fourteenth Century

Siena produced a remarkable group of painters in the first half of the fourteenth century. From 1285, after the nobility were expelled from office, Siena was ruled by a council known as the *Nove*—the Nine. Representing the wealthy merchant class, they maintained a relatively secure grip on power until 1335. This was a period of prosperity, which encouraged extensive artistic patronage. To a large degree, Siena attempted to rival Florence in the arts as well as in economics and politics. The two main sources of patronage in the city, the Palazzo Pubblico and the cathedral, reflected the interdependence of politics and religion and the efforts of both to use the arts to enhance their respective images.

Duccio's *Maestà*

In 1308, Duccio contracted to produce for the cathedral a monumental altarpiece known as the *Maestà* (literally, "majesty"; in this context, referring to the majesty of the Virgin). Completed three years later and carried in a triumphant, citywide procession from Duccio's workshop to the cathedral, the altarpiece has since been dismantled. Parts of it are in museums in Europe and the United States, while others have disappeared completely. Most of the panels, however, are in Siena.

In addition to its enormous scale, Duccio's *Maestà* was unusual in being decorated with narrative panels on the back as well as on the front. It was originally located below the **dome** of the cathedral, rather than in the more conventional position with its back to the wall of a chapel. As a result, the *Maestà* was visible from all sides, illuminated by light from the windows of the dome. Figures **2.13** and **2.14** show the main panel on the front and scenes of the Passion on the back.

Mary's central role in Siena is reflected in the iconography of Duccio's altarpiece. She dominates the front panel, at once the Queen of Heaven and an earthly queen surrounded by a courtly entourage of angels, saints, and apostles. Like the throne of the *Rucellai Madonna*, this one reflects Duccio's attempt to convey three-dimensional space. But here its purpose is to welcome the faithful in a city dedicated to the Virgin's cult—

Mary was the patron of Siena, which had designated itself *vetusta civitas virginis* [the Virgin's ancient city]. The *Maestà* throne is depicted frontally, a metaphor for Mary herself and the Church, emphasizing the accessibility of its queen to the citizens of Siena.

The four kneeling saints in the foreground are patrons of Siena, who pray for the Virgin's intercession. Their robes and feet overlap the lower edge of the band with their names inscribed in gold. Standing prominently between the patron saints are John the Baptist on the right and John the Evangelist on the left. Their presence is specifically related to Christ, whose proportions are slightly more babylike than in the *Rucellai Madonna*, and whose drapery folds, suggesting the influence of Giotto, are rendered in *chiaroscuro* rather than in gold.

The two Saints John frame the adult life of Christ and in the painting stand in strong vertical planes, wearing rich red robes. John the Baptist, Christ's second cousin, carries the long, thin cross that is one of his conventional attributes. His raised right hand, the traditional gesture by which he indicates Christ, echoes his gesture at the baptism, in which Christ is initiated into his ministry. John the Evangelist holds a book, denoting the Gospel that records Christ's ministry. Presiding over the holy court in a horizontal row are ten of the apostles.

In a blaze of rich color and gold leaf, Duccio has produced a *Maestà* that embodies Siena's devotion to the Virgin as the mother of Christ and the patron of their city. He has interwoven the civic and religious messages of the altarpiece, proclaiming Siena worthy of the Virgin's intercession and protection. In the inscription on the base of the throne, he entreats the Virgin to bring peace to Siena and life to himself for having painted her in this way. Such a request indicates Duccio's own importance to the image of the city. It also heralds efforts by Renaissance artists to elevate the status of painting from a craft to a liberal art.

In the narrative panels, the differences between Duccio and Giotto are clear. Duccio retains the gold sky—partly because the *Maestà* is an altarpiece, and thus on panel, and partly because of the persistence of Byzantine taste in Siena. Compared with the Arena Chapel frescoes, these scenes give greater emphasis to the events of Christ's arrest and interrogation as well as

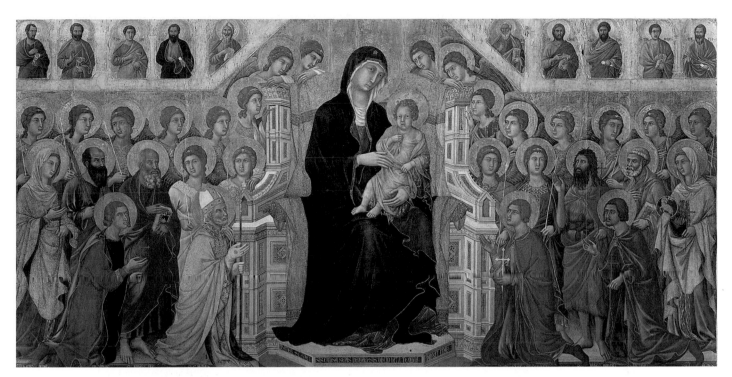

2.13 Duccio, *Maestà*, front, 1308–1311. Tempera and gold leaf on panel; 7 × 13 ft. (2.13 × 3.96 m). Museo dell'Opera del Duomo, Siena. Originally the **predella** panels, those on the base of the altarpiece, depicted scenes of Christ's childhood. Above the Virgin on the pinnacles were scenes from her life surmounted by angels.

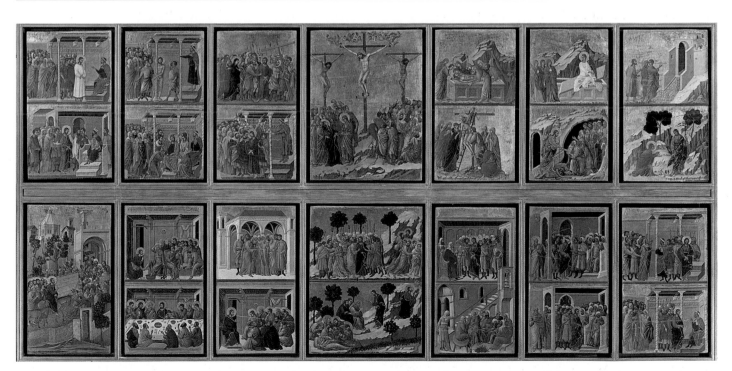

2.14 Duccio, *Maestà*, back of Figure 2.13. The main section of the back of the *Maestà* illustrated here shows Christ's Passion. Symbolizing the foundation of Christ's power, the predella scenes depicted his ministry and miracles. The pinnacles portrayed events following Christ's death. There is thus a conscious coordination of the scenes' location with their content.

to the mystical events following his death. Giotto focuses more on the human drama of Christ's life.

Compare, for example, Duccio's *Noli Me Tangere* (**2.15**) with Giotto's (**2.16**). In this scene, Christ has risen from his tomb, and Mary Magdalen catches sight of him. In order to know if he is real, she reaches out to touch him, and he says, "Do not touch me." Duccio's landscape is more descriptive than Giotto's. The sky is gold, and Christ's drapery folds, denoting the otherworldliness of his resurrected state, are gold as well. Mary's, in contrast, are conveyed by more naturalistic *chiaroscuro*, indicating that she is still of the human world. Duccio's interest in chromatic effects is evident in the Magdalen's bright red-orange cloak, Christ's banner, and the red fruit of the flowering tree.

Giotto eliminated from his cycle the Entombment and the Three Marys at the Tomb (in which the three Marys find the tomb empty after the Resurrection), both of which Duccio includes in the *Maestà*. In the *Noli Me Tangere*, therefore, Giotto depicts the tomb with two angels and sleeping soldiers. The latter are foils for the dramatic encounter between Christ and Mary Magdalen; in contrast to the angels, who are aware of the encounter, the soldiers sleep. In this iconography, they are shown as unseeing and, therefore, ignorant and sinful. The diagonal of the rock that continues the plane of the angel's wing leads the viewer to Christ and Mary; Duccio's rocks are more Byzantine, engaging the viewer in their rhythmic patterns.

Duccio's Christ is nearly frontal, displaying his gold drapery folds, whereas Giotto's Christ reveals his resurrected state with a plain white robe. The void between the gestures of Duccio's Mary and Christ is filled by a triangular rock. In Giotto's picture, the emptiness of the

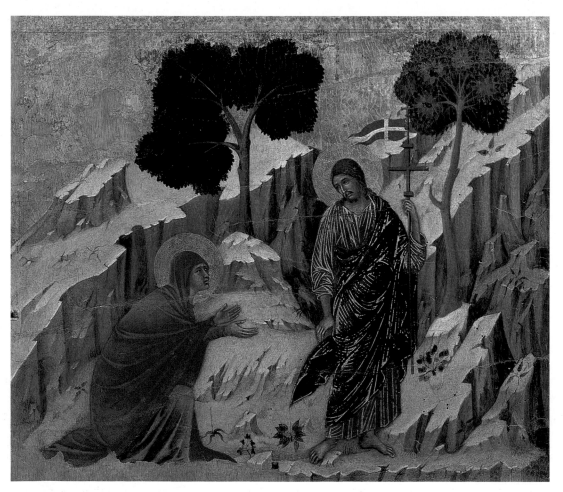

2.15 Duccio, *Noli Me Tangere*, 1308–1311. Panel from the back of the Maestà. Museo dell'Opera del Duomo, Siena.

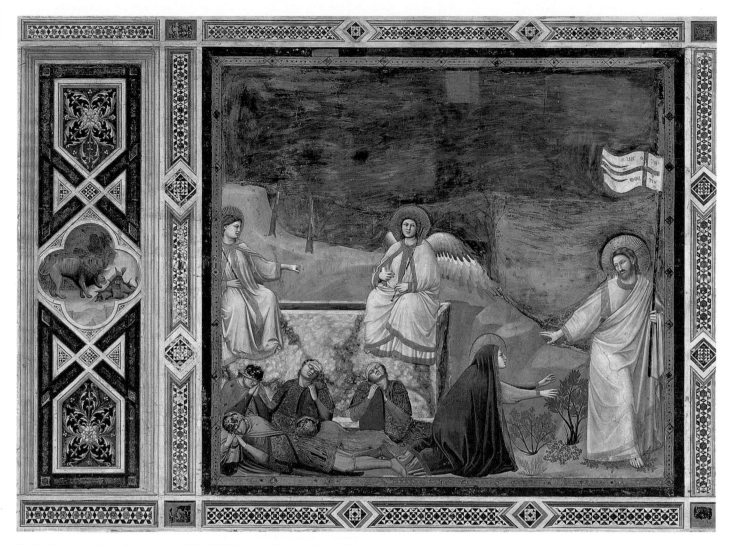

2.16 Giotto, *Noli Me Tangere*, c. 1305–1310. Fresco. Arena Chapel, Padua.

void is accentuated—as it had been in the *Expulsion of Joachim* and the *Presentation in the Temple*—for psychological effect. Above Mary's frustrated embrace is the hand of Christ, creating a pyramidal void.

The dramatic character of Giotto's scene resides in the human relationship between Christ and Mary Magdalen. As she reaches out, Christ reaches back, his turn and his inner ambivalence forcefully indicated by *contrapposto*. Also indicating ambivalence are the two drapery folds curving toward Mary's hands; Christ is shown coming and going simultaneously, a visual portrayal of conflict. Compared with Duccio, Giotto suppresses surface detail and chromatic richness, and places greater emphasis on the psychology of his figures.

Simone Martini

Simone Martini (c. 1285–1344), another of Siena's leading painters, worked in both the Palazzo Pubblico and the cathedral of that city, as well as in the basilica of Saint Francis in Assisi, in Naples for the French king, and in Avignon. In 1315, the town hall of Siena commissioned him to paint a huge *Maestà*, nearly 35 feet wide, on the end wall of the council chamber (**2.17**). With this commission, the Virgin's patronage of Siena was made explicit by her position in the chamber as well as by the inscriptions on the painting. This is an early work by Simone, still under the influence of Duccio; but given its function and location, Simone's *Maestà* was a more secular image.

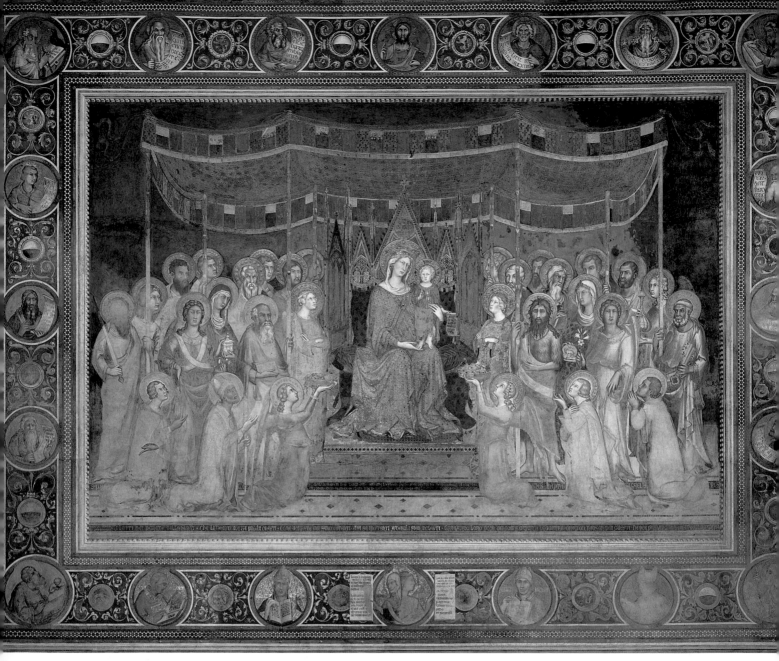

2.17 Simone Martini, *Maestà*, 1315. Fresco; end wall 34 ft. 8½ in. × 32 ft. ⅝ in. (10.58 × 9.77 m). Palazzo Pubblico, Siena. Simone was a friend of Petrarch, who compared the artist to the Greek sculptor Polykleitos in one of his sonnets. Not even Polykleitos, wrote Petrarch, could have captured the beauty of Laura (Petrarch's deceased beloved) as skillfully as Simone, who must have seen her in Paradise. Apparently Simone painted a portrait of Laura, which is now lost.

The canopy, whose eight poles are supported by saints, defines the three-dimensional space occupied by the figures. French Gothic influence appears in the sharply pointed arches of the throne as well as in the brocaded draperies, ermines, and chivalric courtliness of the image. The written inscriptions (now lost) in the painting consist of two "spoken" by the Virgin and four by the kneeling patron saints of Siena in the foreground. This combination of word and image was designed to create a diplomatic "dialogue" between the Queen of Heaven and four "ambassadors" from the earthly city of Siena.

At the base of Mary's throne, the inscription states that she is not more impressed by the flowers of heaven than by just government. The *Maestà* thus conveys a message of civic harmony; the Virgin asserts the virtue of justice and opposes tyrannny. In so doing, she is identified with Siena itself and with the council members who sit in the very chamber dominated by her image.

Simone's *Annunciation* of 1333 (**2.18**) is a mature work, commissioned for the altar of Saint Ansano in the cathedral. Painted after Simone's stay in Naples, the *Annunciation* reflects French Gothic influence even more clearly than does the *Maestà*, notably in the elon-

gated figures of Mary and Gabriel, their curvilinear drapery, and the tilted marbleized floor.

Mary pulls back, assuming an S-shaped pose. The vase of lilies denoting her purity and passion creates a pattern of delicate **silhouetted** shapes against the gold background. Gabriel's wreath and branch are also patterned silhouettes—Zacharias had prophesied that a man called the Branch would be the savior of mankind. Particularly elaborate are Gabriel's detailed feathers and the gold embroidery on his cloak. The halos are **tooled** and stand out slightly from the smooth gold background. Hovering over the center of the scene in a circle of angels with crossed wings is the dove of the Holy Spirit.

As in the Palazzo Pubblico *Maestà*, the written word plays a significant role in the iconography of Simone's *Annunciation*. Not only does Mary's traditional book indicate that she herself has been reading a text, but four prophets displaying scrolls for the viewer to read appear in the tondos over the arches. (It is likely that the empty central tondo originally depicted God the Father.) Emerging from Gabriel's mouth in gold against the gold background is the **embossed** text of his announcement: *Ave gratia plena dominus tecum*—[Hail (Mary) full of grace, the lord is with thee].

By incorporating Gabriel's words into the iconography, Simone refers to the medieval tradition that Mary was impregnated through her ear by the Word of God.

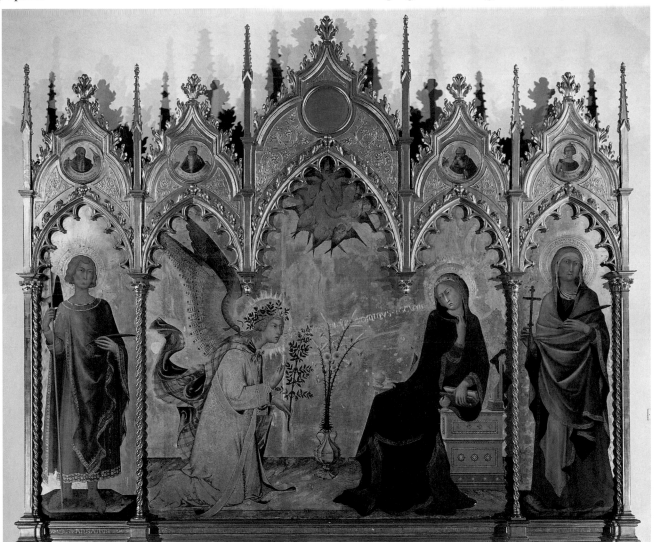

2.18 Simone Martini, *Annunciation*, 1333. Tempera and gold leaf on panel; 42½ × 43½ in. Galleria degli Uffizi, Florence. Parts of the altarpiece were apparently painted by Lippo Memmi, Simone's assistant and brother-in-law, for both artists signed the painting.

In the Gospel of John, Christ is called the Word of God made flesh. This reflects the logocentric belief in God's power to concretize words as well as the universal childhood notion that words are things. Just as, in the Book of Genesis, God made the world by speaking words—"Let there be light" made light—so Gabriel's words, for he is God's messenger, create the transition from the idea of Christ to the reality of Christ (the Incarnation). As an artist, Simone Martini concretizes the transition by making it visible in paint.

Ambrogio Lorenzetti: *Allegories of Good and Bad Government*

Perhaps the most monumental fourteenth-century images reflecting the new interest in civic humanism are the huge frescoes of Ambrogio Lorenzetti (active c. 1305–1348) in Siena's Palazzo Pubblico. Located in the Sala della Nove (Hall of the Nine), these were the *Allegories of Good and Bad Government* (**2.19**), commissioned in 1338–1339. Their explicitly political message embodies the humanist views already evident in Simone's *Maestà* and Giotto's *Justice* and *Injustice*.

Figure **2.20** shows the entire length of the *Effects of Good Government* in a republican commune. The city is at peace, its prosperity shown by the balanced combination of work, study, and play in its midst. At the left, figures dance in the street (as they do beneath Giotto's *Justice*), business is conducted in the storefronts, a class is in progress in a schoolroom, and builders are at work on the rooftops. The skyline of the commune is packed with architecture, and builders are engaged in construction.

There is also bustling trade between the city and the country in times of peace, which leads to the economic prosperity that encourages patronage of the arts.

2.20 (*below*) Ambrogio Lorenzetti, *Effects of Good Government in the City and the Country*, 1338–1339. Fresco; entire length approximately 46 ft. (14 m). Sala della Nove, Palazzo Pubblico, Siena.

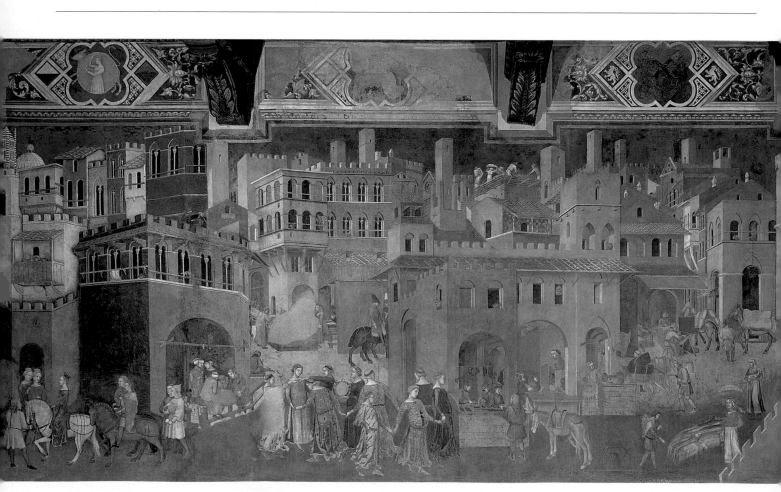

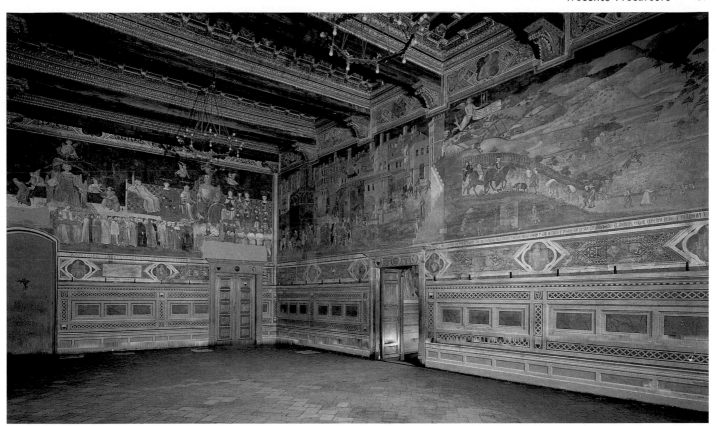

2.19 (*above*) Ambrogio Lorenzetti, view of the Sala della Nove, Palazzo Pubblico, Siena. Although a Sienese painter, Ambrogio worked in Florence, where he joined the guild of physicians and pharmacists in 1329. The influence of Giotto, whose frescoes Ambrogio would have seen in Florence, is apparent in the blocklike solidity of his figures, who turn freely in three-dimensional space. Ambrogio is generally believed to have died of plague in 1348. His brother, Pietro, was also a leading painter in Siena.

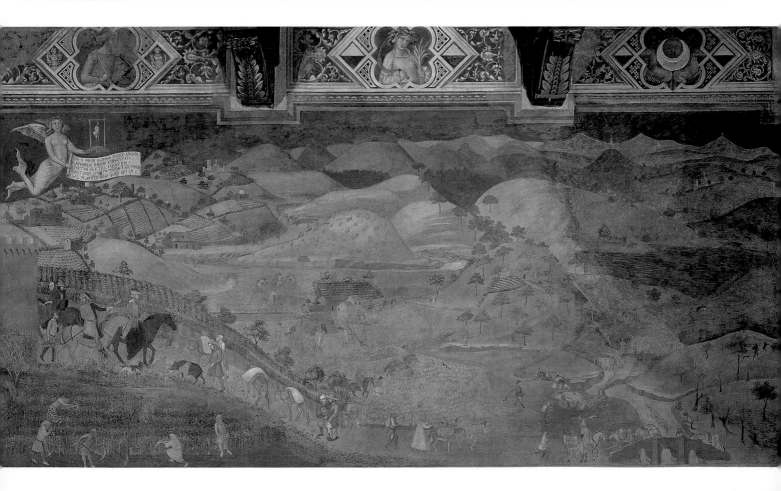

Merchants bring their wares from the country to sell in the city, while a hunting party leaves by the city's gate. Juxtaposed with the densely populated and built-up town is open country—the first expansive painting of a landscape since antiquity. Neatly plowed fields typical of Tuscany extend as far as the eye can see—another product of the peacetime economy. They exemplify Ambrogio's use of naturalism in the service of political allegory.

Siena's links with antiquity are made explicit in the statue of the she-wolf nursing the twins Romulus and Remus, the legendary founders of Rome. Projecting from the crenellated medieval wall of Siena, the ancient Roman totem symbolically protects the city, while keeping an eye on the countryside. It also alludes to the tradition of Siena's descent from Senius, the son of Remus.

The nose of the she-wolf nearly touches the toes of the allegorical figure of Securitas (Security) hovering over the tilled fields. Depicted in white as an ancient Greek Victory, Securitas carries an inscription that states the advantages of good government.

> Without fear every man may travel freely and each may till and sow, so long as this commune shall maintain this lady [Justice] sovereign, for she has stripped the wicked of all power. [3]

In her left hand, Security holds an example of the punishment awaiting anyone who disrupts the peace: a figure hanging from a gallows.

Figure **2.21** depicts the destructive effects of bad government. Building activity has ceased, and the rooftops are bare. The shops are empty. Despite the damage to

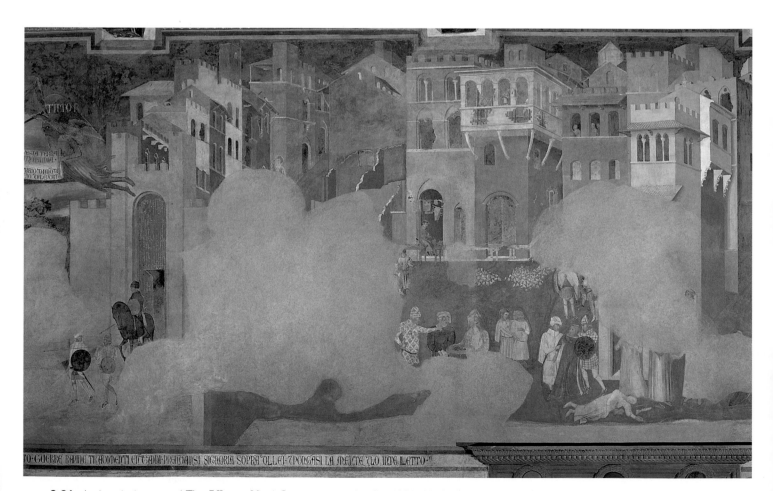

2.21 Ambrogio Lorenzetti, The *Effects of Bad Government in the City*, 1338–1339. Fresco. Sala della Nove, Palazzo Pubblico, Siena.

this fresco, it is still possible to make out soldiers manhandling one woman (in orange) and choking another. In contrast to the hunting party exiting the city in the *Effects of Good Government*, a group of soldiers rides out into the countryside. Flying over the battlements of the unjustly governed city at the far left and gazing on the destroyed landscape is Fear, a ragged woman in dark gray brandishing a sword. Her inscription reads:

> Because each seeks only his own good, in this city,
> Justice is subjected to Tyranny;
> Wherefore, along this road
> nobody passes without fearing for his life,
> since there are robberies outside and inside the
> city gates.[1]

Figure **2.22** is the *Allegory of Bad Government*. The

frontal personification of Bad Government, identified by an inscription as Tyranny, is enthroned in a fortress reminiscent of Giotto's *Injustice*. Tyranny's distorted, satanic physiognomy—fangs, crossed eyes, and horns—reflects the perversion inherent in tyrannical rule. The black goat at his feet alludes to Christ's separation of the faithful sheep from the heretic goats in the Gospel of Matthew (25:31–46). The Vices of Avarice, Pride, and Vainglory circle around his head. Seated at his right are Cruelty (holding an infant strangled by a snake), Treason (a combination of a lamb and a scorpion), and Fraud (with a cudgel, bat wings, and clawed feet); Frenzy (the agitated black centaur with a wolf's head), Discord (who saws herself in two), and War (clad in armor) are to his left. Justice, her scales broken, is tied up and enslaved below the platform of Tyranny.

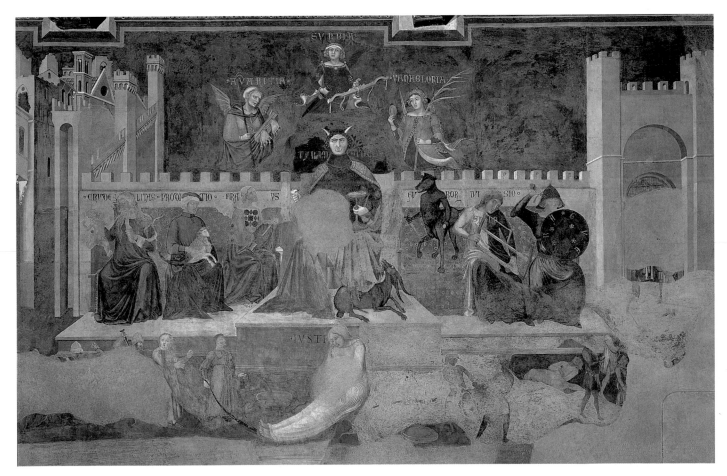

2.22 Ambrogio Lorenzetti, *Allegory of Bad Government*, 1338–1339. Fresco. Sala della Nove, Palazzo Pubblico, Siena.

The Sala della Nove was the chamber in which the Nine convened. Because of their location, the frescoes could be seen as a mirror of the rulers' political philosophy. As a secular image extolling republicanism, Ambrogio's scenes correspond to the will of the Virgin in Simone's *Maestà*. They are a visual testimony to the good government of Siena and to the Nine's repudiation of the evils of tyranny.

1348: The Black Death

In 1346, the first rumors of a disastrous epidemic in the Far East began to arrive in Europe through the trade routes. In 1347, ships from eastern Europe carrying rats infested with plague-bearing fleas entered the port city of Messina in Sicily. Soon people were dying by the thousand from the so-called Black Death, as the bubonic plague of 1347 to 1350 is known. Efforts to contain the disease proved fruitless, and it was not long before ships entering Genoa, Venice, and Pisa brought the Black Death to the entire Italian peninsula. The summer of 1348 saw the peak of the epidemic, which began to abate by winter of that year. During the next two years, the plague spread throughout Europe, reaching Scandinavia by 1350. Recurrences would break out periodically through the sixteenth century, but never so virulently as in the early years.

At the time, no one knew the source of the plague. Contemporary theories attributed it to bad air, contagion, divine retribution, anomalies in the behavior of the planets, and the Antichrist. In the medieval period this last was a fantasy of an embodiment of evil that would destroy the world and cause universal destruction at the end of time.

Unrest, social tension, and the loss of untold talent were among the social consequences of the epidemic. The most vivid fourteenth-century descriptions of the plague are found in Boccaccio's first book of the *Decameron*. He wrote that the laws of society had broken down, as hundreds of people died daily. The

CONTROVERSY
The Impact of the Black Death

In 1951, American art historian Millard Meiss argued in his classic work *Painting in Florence and Siena After the Black Death* that the devastation of the plague caused a regression in artistic style and content. In the work of Andrea di Cione, called Orcagna (active c. 1343–c. 1368), of Andrea da Firenze, and others, Meiss saw a return to the more conservative two-dimensional space and hierarchical composition that had characterized dugento painting. He also believed that their iconography reflected the desperation and panic resulting from the plague.

Since the publication of Meiss's study and following new research, opposition to his argument has arisen. Although Meiss also cited economic factors as having affected stylistic change, his critics give these factors more weight. They emphasize the fact that, even before 1348, economic growth had slowed throughout Europe; that in Florence the Peruzzi bank failed in 1343, followed by the Bardi and Acciaiuoli banks in 1345; and that crops suffered from bad weather in 1346–1347. Shortages of produce resulted, inflation increased, and trade declined. At the same time, however, Meiss's critics note that the economic crisis in Florence was somewhat eased by government intervention aimed at supporting the old families. In Siena as well, despite the deaths of some 50,000 people, financial stability was maintained.

A new generation of artists, according to these more recent views, had appeared in the 1330s, and the so-called regressive tendencies were already discernible at that time. The rise of Dominican orthodoxy is also seen as a factor in the increased spirituality of style and content as well as the function and location of works such as Andrea da Firenze's frescoes in the Spanish Chapel of Santa Maria Novella and Orcagna's Or San Michele tabernacle.

The views of Meiss and his critics are not mutually exclusive and can be seen as different facets of a general cultural phenomenon. They do, however, highlight a certain tension between art historians prone to a contextual approach to works of art and those favoring formalist or iconographic approaches. Embedded in the reactions of Meiss's critics is a revisionist view of Vasari and an objection to seeing style as progressive—that is, having high points and low points. These historians tend to believe that trecento style after Giotto has been neglected and insufficient attention paid to function and context.

symptoms of the disease included black boils, rashes, and lesions; some of the victims coughed blood and became like madmen as their bodies had a toxic reaction to the infection. Physical contact with the sick was avoided, and corpses were quickly burned. Two types of psychological responses were evident: either a "seize the day" mentality or an attitude of penance, accompanied by fear and panic. Some 60 percent of the population of Tuscany died, including as many as 40,000 citizens of Florence.

The effects of the Black Death on the arts have been a controversial topic of discussion among Renaissance art historians. Some argue that it led to a regressive style in which artists returned to the flat space, decorative patterning, and spiritual emphasis of the dugento. Others believe that style after the Black Death is due to a confluence of factors and is too complex to be explained by a single historical occurrence. Two works for the church of Santa Maria Novella exemplify the stylistic changes that seem to call for explanation.

Andrea da Firenze: *Way of Salvation*

Around the middle of the century, Andrea Bonaiuti, known as Andrea da Firenze (active 1346–1379), was commissioned by the wealthy merchant Buonamico Guidalotti to decorate the chapter house of the convent—now known as the Spanish Chapel—off Santa Maria Novella's cloister in Florence. Guidalotti himself is buried in front of the altar, and three of the walls are devoted to scenes glorifying the Dominican Order. Of these, the most impressive is the *Way of Salvation*, also called the *Triumph of the Church* and the *Dominican Order as a Saver of Souls* (**2.23**), on the right wall.

The hieratic organization of the fresco in levels of increasing divinity reflects Dominican orthodoxy and, at the same time, is consistent with the view of a regression following the plague. Its message—namely, that the Dominican Order is the route to salvation—both projects an image of Dominican zeal in converting heretics and also conforms to the notion of renewed anxiety about the fate of one's soul.

At the very top, Christ the Judge with a book and the papal keys appears in a golden mandorla. Flanked by a host of angels, he presides over the Dominican triumph. Directly below Christ, a white lamb lies on a throne on either side of which are the four apocalyptic symbols described by Saint John the Divine in Revelation: the eagle of John, the winged ox of Luke, the winged lion of Mark, and the angel of Matthew.

The next level down on the left (Christ's right) shows Saint Peter at the gate of Paradise. He ushers the saved through the gate after they have been blessed by a Dominican. At the right (Christ's left) are scenes of earthly life, including musicians, dancers, and figures in an orange grove. The huge church is the medieval cathedral of Florence, which did not yet have the dome shown here. Seated at the center of its flank is the pope, with the Holy Roman emperor to his left and a Dominican diplomat to his right. The pope's centrality and higher placement reflect Dominican support of his supremacy over the emperor. At the feet of the pope are sheep and goats, denoting his association with Christ, who separates the sheep from the goats.

In the foreground, closest to the space of the viewer and, therefore, the most earthly level of the fresco, is a group of the faithful kneeling before the pope. At the right, black and white dogs guard white sheep, which represent souls in need of watching over. The dogs, a visual pun on *Domini canes* (Latin for "dogs of the Lord") and *Dominicani* (Italian for "Dominicans"), also attack the heretic wolves. Three Dominican saints, including Peter Martyr and Thomas Aquinas, are debating with and converting Jews, Muslims, and other infidels at the lower right.

Visible in the vault above the *Way to Salvation* is the *Navicella*, the subject of Giotto's lost mosaic in Old Saint Peter's. There, as here, the ship was a metaphor for the state of the Church, and for the Church as State in dangerous times. Just as Christ rescued Peter from drowning in the stormy waters, so his triumph in the fresco below is also the triumph of the Church and of the Dominican Order devoted to it. The Spanish Chapel was the room in which Dominican novices officially entered the Order and confessed their sins. Echoing these purposes in Andrea's fresco is Saint Peter's reception of the saved after they have made their confession to a Dominican friar.

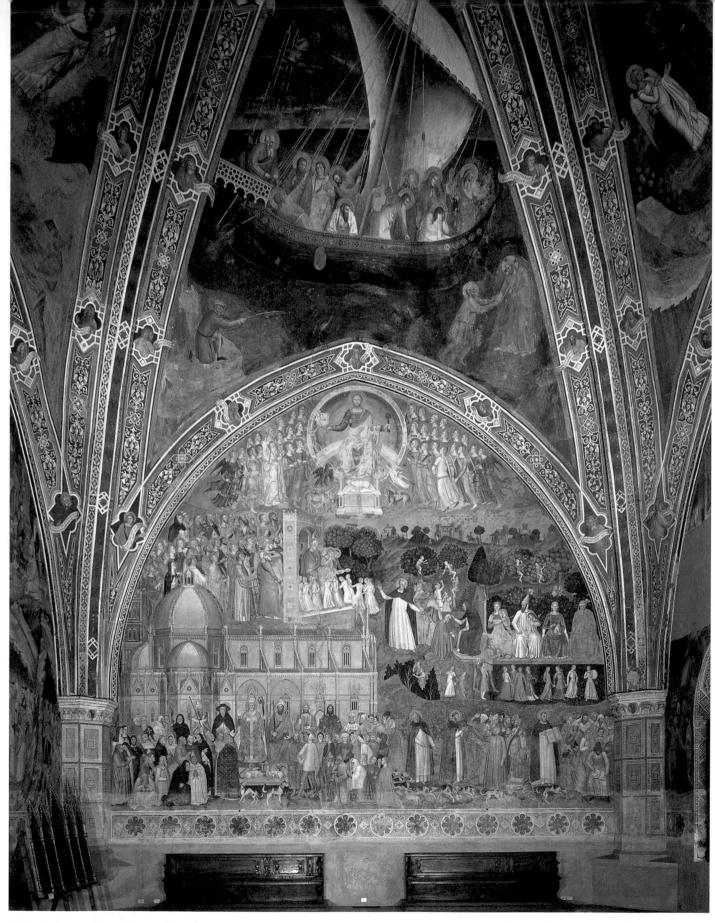

2.23 Andrea da Firenze, *Way of Salvation* (or *Triumph of the Church*), 1348–1355. Fresco; 38 ft. (11.6 m) wide. Spanish Chapel, Santa Maria Novella, Florence. The chapel served a funerary purpose and was also a Dominican chapter house. In the sixteenth century, it was used for worship by Spaniards living in Florence—hence its name.

Andrea di Cione (Orcagna)

The Strozzi Altarpiece

Orcagna's Strozzi Altarpiece (**2.24**) in Santa Maria Novella depicts Christ as both Judge and King. Situated in front of a *Last Judgment* frescoed on the wall of the Strozzi Chapel, the hieratic character of the altarpiece conforms to its site. Christ is flanked by Mary as Queen and a frontal John the Baptist, both of whom gesture toward him. The mandorla is composed of red seraphim alternating with blue cherubim; the golds accentuate the flat, timeless space in which Orcagna's Christ is suspended. Represented on the outer **wings** of the altarpiece, in a shallow, three-dimensional space defined by the red-and-gold brocade carpet, are four saints. At the left, Saint Michael stands over the defeated dragon (rep-

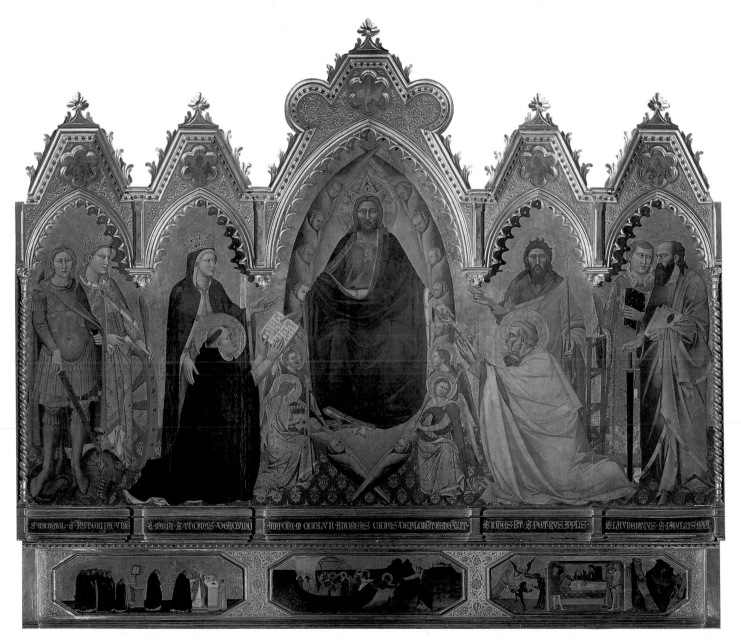

2.24 Andrea di Cione (known as Orcagna), Strozzi Altarpiece, 1354–1357. Tempera on panel; 9 ft. × 9 ft. 8 in. (2.74 × 2.95 m). Strozzi Chapel, Santa Maria Novella, Florence.

resenting Satan) and Catherine of Alexandria holds the wheel on which she was martyred. At the right are Saints Lawrence with the grill of his fiery martyrdom and Paul with the sword of his martyrdom and a book of his writings.

Kneeling before Christ, on either side of the crossed angels, are Saints Thomas Aquinas, one of the most important of all medieval Dominicans, and Peter. Christ hands a book to Aquinas, reinforcing the saint's role as a doctor of the Church and an author. To Saint Peter, wearing a sharply defined yellow robe, he gives large gold and silver keys to the kingdom of Heaven. There is a quality of urgency in the two kneeling saints, which, along with the frontality of Christ and John the Baptist, appears stylistically regressive. But if one considers the Dominican context of the altarpiece, Orcagna's image is a remarkably apt medium for conveying the message of the Order's orthodoxy.

The Or San Michele Tabernacle

In Florence, the curious building known as Or San Michele was the site of Orcagna's elaborate tabernacle (**2.25**), which was built to enclose a miracle-working image of the Virgin. The tabernacle is signed and dated 1359. In this case, the location, function, and history of the work are inextricably tied to its form.

The building itself stood on the old site of the church of Saint Michael in the Garden (San Michele in Orto), later the location of the Florence grain market. The original picture of the Virgin dated from the 1280s or 1290s and was elevated on a **pilaster** inside a brick building that housed the grain market. Shortly after its installation, miracles were attributed to the image, which attracted large numbers of pilgrims. In 1304, the building burned down, and a copy of the miraculous Virgin was made. In 1336, the guild-controlled government of Florence commissioned the present building, consist-

ing of a **loggia** at street level and, after 1348, a second and third story for storing grain.

The painting of the Virgin presently enclosed by the tabernacle is the third such image. Dated to 1347, the year of the plague's arrival in Italy, it is the work of Bernardo Daddi (active c. 1312–1348), who had been trained by Giotto. Although Daddi has followed Giotto in the intense focus of the angels on Christ, in the horizontal floor, and in the volumetric figures, he has revived certain late thirteenth-century features. These include the elaborate **crockets** on the throne, the patterned material behind the Virgin, the weightless quality of Christ, and the rich gold background. During the height of the plague, Daddi's picture again drew large numbers of pilgrims and, with them, more donations to the confraternity responsible for the building.

The confraternity's newfound wealth made possible its patronage of Orcagna's tabernacle, which, at 86,000 florins, was enormously expensive. The tabernacle was commissioned around 1355 to 1359 and is a dazzling structure of marble, **inlaid** gold, stones, and glass, all of which once reflected the natural light that originally poured in through the open loggia. (After about 1380, the loggia was walled in.) Vertical pinnacles at each corner of the structure rise nearly to the vaulted ceiling. Their Gothic flavor is repeated in the surface animation of the tabernacle's intricate carving. Gold inlay repeats the gold of the painting, and the crockets on the gable repeat those on Daddi's throne. Likewise, the round arches of the tabernacle match the frame of Daddi's picture.

Orcagna decorated the base of the tabernacle with reliefs illustrating the life of the Virgin, unifying the structure iconographically with the painting it encloses. A comparison of the *Presentation of Christ in the Temple* (**2.26**) with Giotto's fresco in the Arena Chapel (see 2.4) is revealing. Orcagna's draperies define the underlying forms of the figures, as Giotto's do, and the space they occupy is three-dimensional. But the large scale of the

2.25 (*right*) Andrea di Cione (Orcagna), tabernacle, c. 1355–1359. Marble, stone inlay, and glass. Or San Michele, Florence. Orcagna worked as a sculptor and architect as well as a painter. By 1356 he was chief architect of Or San Michele and two years later held the same post at the cathedral in Orvieto, near Rome. He was from an artistic family that included two artist brothers, Jacopo and Nardo.

heads in proportion to the bodies is a Romanesque feature and the **quatrefoil** on the front of the altar is a Gothic form. The floor at the center slants forward so that the altar is not foreshortened. And the human drama of Giotto's *Presentation* is absent. As in Daddi's painting, therefore, Orcagna's sculptural style combines elements of naturalism with features that appear to hark back to earlier styles.

The tabernacle itself became a church in miniature, embodying the traditional notion of Mary *ecclesia*, or Mary as the Church building in her aspect as the House of God. Likewise, her role as a maternal source of nourishment—not only of Christ, but of all mankind—is consistent with the setting of her miraculous image in the city's grain market.

The dome of the tabernacle has been related to the fictive dome in Andrea da Firenze's *Way to Salvation*. Both may have reflected actual proposals for the dome of Florence Cathedral. At the time, however, no one had been able to design a dome that would cover such a large space. This problem would occupy the Florentines during the first decades of the fifteenth century, when a new generation of young artists emerged in force. The Renaissance developed as a widespread cultural phenomenon around 1400, and the central city in that development was Florence.

2.26 Andrea di Cione (Orcagna), *Presentation of Christ in the Temple*, c. 1355–1359. Relief from the base of the Or San Michele tabernacle, Florence. The reliefs are blocked from view in figure 2.25 by the protective railing added in 1366. Scenes at the base of the tabernacle replicate the traditional altarpiece structure in which a large central image surmounts narrative predella panels.

THE QUATTROCENTO

3
Architecture and Sculpture in Florence: 1400–1430

During the fifteenth century the Renaissance was the dominant cultural force in Florence (3.1). Then, as today, Florence was a city of art. But it was also an intellectual and mercantile center, and these factors converged with new efforts to integrate the arts into the social fabric of the city. In the last decades of the fourteenth century and the early years of the fifteenth, the humanist movement gained momentum. This new approach to the world included the conviction that human development and achievement were paramount in the creation of a secure and virtuous state.

The chancellor of Florence, Coluccio Salutati (1331–1406), had been a friend of Petrarch and a proponent of civic humanism. Himself an author with an interest in Latin and Greek, Salutati became known, like Petrarch, for his letters. He demonstrated his commitment to humanist studies by arranging for the Byzantine scholar Manuel Chrysoloras (c. 1350–1415) to occupy the Greek professorship at the university of Florence (the Studium) from 1397 to 1400.

Under Salutati's chancellorship, Florence was ruled by an oligarchy. This consisted of a few powerful families that had secured control after quelling the so-called Ciompi rebellion of 1378, an attempt by the lowest class of workers in the wool trade to gain the right to join a guild and obtain the benefits of membership. These families exercised their control through the Guelph party (the party of the nobility) and through membership in the seven major guilds.

Internal unrest was overshadowed in the first years of the quattrocento by repeated threats from other parts of Italy. First, the republic of Florence had to resist the expansionist ambitions of the Visconti family, who ruled Milan. By 1401, the Visconti controlled most of northern Italy, with the exception of Genoa and Venice, and a large part of central Italy, including Siena. Florence was practically surrounded, and by the summer of 1402 Giangaleazzo Visconti's army was poised to invade the city. However, before his plans could be realized, an outbreak of plague killed Giangaleazzo and a number of his troops. The Milanese army dispersed, and Florence was spared.

Ten years later another threat arose from the south. Ladislas, king of Naples, had subdued Rome and parts of Umbria. He, too, had designs on Florence that were thwarted by his death in 1414. In the 1420s, the Visconti reemerged under the leadership of Giangaleazzo's son, Filippo Maria. He defeated the Florentine army in several engagements, but never entered the city. This threat led Florence in 1427 to introduce the *catasto*, a property-based system of tax assessment, whose immediate purpose was to finance the war against Milan.

Salutati was determined to defend the republican character of Florence against tyranny. He ordered the city gates closed, thereby subjecting the citizens to food shortages and curtailing the freedom of travel depicted by Giotto and Ambrogio Lorenzetti as signs of peace and prosperity. Salutati's humanist rhetoric declared Florence the heir of the ancient Roman republic in its stand against the imperial ambitions of despots.

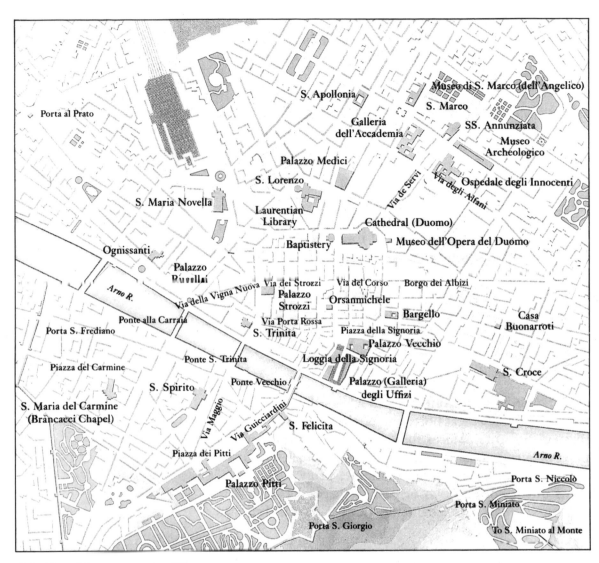

3.1 Map of the monuments of Florence.

The *Catasto* of 1427

The first of its kind in western Europe, the *catasto* was a tax on property, not income. It was instituted in Florence in 1427 largely to finance the defense of the republic. The head of every household was required to produce a written list of all assets (such as property and investments). He also had to list the age of every member of his household. Taxes were calculated at a rate of 0.5 percent of assets, minus debts and deductions. The latter were allowed for one's primary residence, elderly dependents, and children. The terms of the tax were revised in 1430 and 1433.

Because the Florentines kept meticulous records, the *catasto* is a useful source of information about artists and their patrons.

In some of its themes, civic art patronage in this period reflected the city's determination to survive as a republic. There was a new enthusiasm for public art, which was patronized by the guilds, wealthy citizens, and the Church. The leading sculptors were commissioned to produce works that were visible to average Florentines going about their daily routines. Painters continued to decorate church interiors that were open to the public, as well as fulfilling more private commissions. This surge in artistic activity created a dialogue between the Florentines and their art that persists today. Much of the public art of the early fifteenth century can still be seen in its original location. The principal sites of these works were the medieval Gothic

cathedral (Santa Maria del Fiore), its bell tower (***campanile***) designed by Giotto, the Romanesque baptistery (**3.2**), and the guild-owned church of Or San Michele. As new buildings were constructed in the fifteenth century, they too contributed to the character of the city and provided important contexts for works of art.

The Competition of 1401

In 1401, the Opera del Duomo (Cathedral Board of Works) announced a competition for a pair of bronze doors for the baptistery. A fourteenth-century pair illus-

trating the life of John the Baptist was already in place on the south side of the building. The new pair was planned for the eastern entrance facing the cathedral, and its subject was to be scenes from the Old Testament. The competition was supervised by the wool refiners' guild (Arte del Calimala) and decided by thirty-four judges, including clerics and representatives of the laity. Each competing artist was required to submit a bronze relief illustrating the Sacrifice of Isaac. In Genesis 22, Abraham is instructed by God to sacrifice his son Isaac as proof of his faith. At the last minute, God sends an angel to prevent the slaying and to order Abraham to substitute a ram for Isaac.

The choice of this event has been related to the polit-ical situation in Florence and the city's desire to be

3.2 Complex of cathedral, bell tower, and baptistery, Florence.

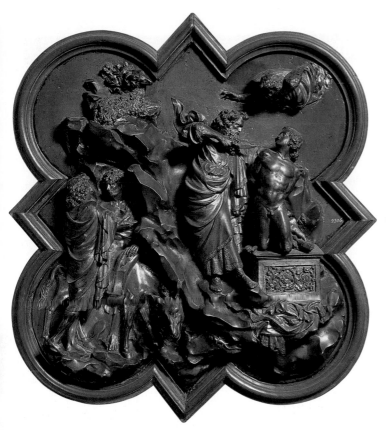

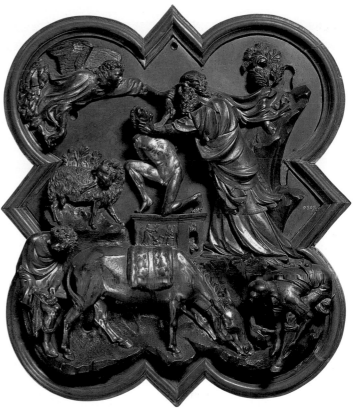

3.3 Lorenzo Ghiberti, *Sacrifice of Isaac*, competition relief, 1401–1402. Gilt bronze; 21 × 17½ in. (53.3 × 44.4 cm) inside molding. Museo Nazionale del Bargello, Florence. According to Ghiberti, he won the competition unanimously, whereas a late-fifteenth-century biography of Brunelleschi declared the competition a tie.

3.4 Filippo Brunelleschi, *Sacrifice of Isaac*, competition relief, 1401–1402. Gilt bronze; 21 × 17½ in. (53.3 × 44.4 cm) inside molding. Museo Nazionale del Bargello, Florence.

saved from the Milanese troops. Two of the competition reliefs survive, and both reflect the emergence of the new Renaissance style (**3.3** and **3.4**), although their quatrefoil frames are Gothic. Figure 3.3, by the goldsmith Lorenzo Ghiberti (1378–1455), is the more elegant, its forms more restrained and graceful than those of Filippo Brunelleschi (1377–1446) (3.4), the sculptor and architect. Brunelleschi's relief, however, is the more powerful of the two; his angel forcefully grasps Abraham's arm as the patriarch is about to plunge his knife into Isaac's neck. In Ghiberti's version, the angel calls out to Abraham, as he does in the biblical text, and there is less sense of firm physical contact between father and son.

The dynamic force of Brunelleschi's angel is countered by the strong diagonal of his Abraham pushing Isaac forward into a contorted pose. Ghiberti's Isaac, in contrast, is a graceful Classical nude, rendered with

slight *contrapposto*, gazing into his father's face. Both scenes are set in natural landscape, with the oblique planes of the altars accentuating the sense of three-dimensional space. But Ghiberti pays more attention to rhythmic patterns in the rock formations, whereas Brunelleschi, like Giotto, focuses intensely on dramatic relationships. In the positioning of the ram, for example, this distinction is clear: Ghiberti's perches on a rock at the upper left, patiently awaiting its fate, while Brunelleschi's stands beside Isaac and echoes his twisted, agitated pose. The mule in Ghiberti's relief curves rhythmically in response to the plane of the rock. Brunelleschi's extends across the scene in a horizontal plane that repeats the planes of the ram and the altar, while the diagonal of his extended neck opposes Abraham's diagonal plane and also repeats his lower drapery curves.

Bronze Casting

Italian sculptors in the fifteenth century cast bronze by the **lost-wax (*cire-perdue*)** method, which had also been used in antiquity. The artist made a model of his work in clay or plaster and then covered it with a mold of wax and inserted wax rods into the model. Another layer of plaster was added to the wax and attached with pins. When the plaster dried, the entire piece was heated. This caused the wax to melt and flow through holes formed when the wax rods melted.

The artist then poured molten bronze into the mold and, when the bronze cooled and hardened, cut away the plaster.

At this point the bronze could be finished. This was a process of smoothing the surface with a file, engraving or **chasing** (embossing) the surface with details, and polishing. Sometimes, as in the competition reliefs for the baptistery doors, the surface was **gilded** (coated with gold leaf).

The naturalism and Classical form present in both reliefs place them in the forefront of the new style. That artists studied ancient statues for content as well as for form is evident in Brunelleschi's seated figure behind the mule. This is a visual quotation from a well-known ancient Roman statue, the *Spinario*, or *Thorn Puller* (**3.5**), depicting a nude boy removing a thorn from his foot. In Brunelleschi's relief, the notion of a knife penetrating Isaac's neck is displaced onto the thorn. The boy's action of pulling the thorn from his foot is thus an iconographic echo of Abraham withdrawing the knife.

The commission was awarded to Ghiberti, although there is no record of the judges' deliberations. Ghiberti's more elegant, graceful style mitigated the violence of child murder. This and the fact that his submission had been cast in one piece (Brunelleschi's was cast in seven pieces), making it less expensive to produce, were probably factors in his victory. He signed the contract for the doors in 1403, by which time the subject had been changed from the Old Testament to the life of Christ, which occupies the top twenty scenes. The eight lower panels represent the four evangelists, who wrote Christ's life, and the four doctors of the Church, who interpreted Christ's life. All are shown working at their desks. As in the fourteenth-century door, the scenes are framed by medieval quatrefoils, but they are constructed as if rationally supported on a horizontal surface. Although the space is shallow, it is conceived three-dimensionally.

In 1424, the doors were installed on the east side of the baptistery (**3.6**). At the corner of each panel, Ghiberti has depicted a

3.5 *Thorn Puller (Spinario)*, c. 1st century B.C. Bronze; life-size. Palazzo dei Conservatori, Rome.

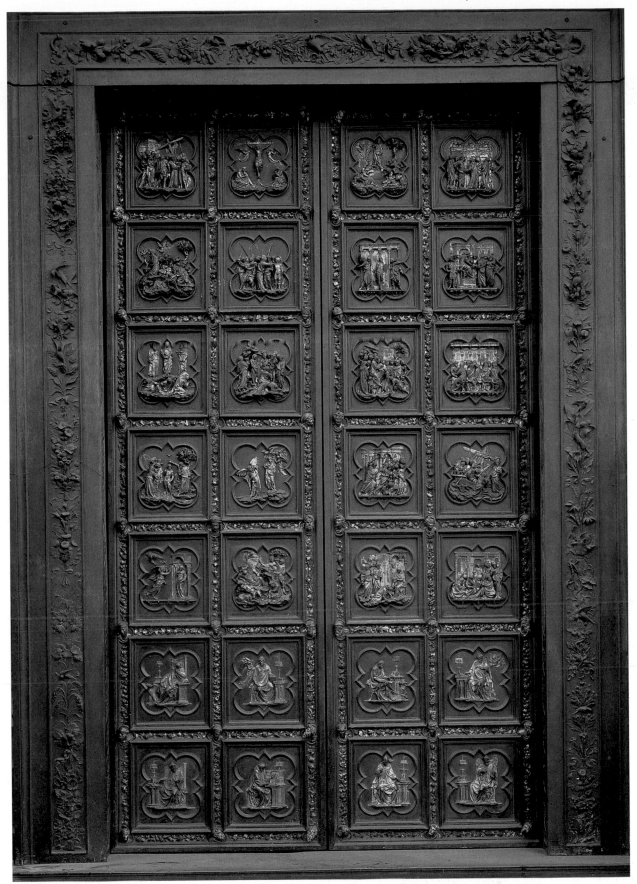

3.6 Lorenzo Ghiberti, north doors, 1403–1424. Gilt bronze. Baptistery, Florence. Although originally on the east side of the building, these doors were transferred to the north side in 1454 when Ghiberti completed another set to face the cathedral entrance.

projecting male head, including his own **self-portrait** between the *Annunciation* and *Nativity* in the central vertical of the left door (**3.7**). Whereas Giotto had represented the donor in the lower section of his *Last Judgment*, Ghiberti represents himself, heralding the Renaissance practice of "signing" works with self-images. Consistent with the development of self-portraiture in the Renaissance was the new interest in autobiography, and both were outcomes of the belief in the significance of individual achievement.

3.7 Lorenzo Ghiberti, *Self-Portrait*, detail of Figure 3.6. Ghiberti exemplified the medieval-workshop tradition; trained in his stepfather's workshop, he in turn trained his two sons to be goldsmiths. His lifestyle reflected not only the efforts of artists trying to rise above the level of craftsmen, but also the flourishing economy of Florence. By 1427, he owned a house and a shop in the city, a vineyard in the country, and his investments amounted to over 700 florins. Four years later, he was the owner of a sheep farm and a pharmacy. Eventually, he bought a patrician manor house with a tower, moat, and drawbridge.

Ghiberti's *Commentarii*

Some twenty-five years after completing the doors, Ghiberti wrote the *Commentarii*, which included the first autobiography of the Renaissance and a brief history of art from antiquity through his own era. In Book One, he reads ancient art in contemporary terms, citing the famous competition between the Greek painters Apelles and Protogenes to see who could draw the finest line. Reflecting the Renaissance interest in naturalism, Ghiberti interpreted this as a contest over **perspective** (see Box, p. 89). Book Two contains a brief history of art, mainly as a prelude to his own life and work. Discussing his recent predecessors, Ghiberti agrees with Boccaccio that Giotto resurrected painting and also declares his admiration for Ambrogio Lorenzetti.

Book Three, which is fragmentary, discusses the technical training of sculptors and recommends a Classical education for artists. Although Ghiberti himself knew no Greek and his Latin was minimal, his views reflect the synthetic character of Renaissance culture. In the *Commentarii*, he combines different approaches to the visual arts, including history, theory, technique, and autobiography. The comparisons with ancient models are, like Salutati's parallel of Florence with the Roman republic, typical of humanism.

Public Sculpture: The Exterior of Florence Cathedral

While Ghiberti was at work on the baptistery doors, the Opera del Duomo began commissioning marble statues for the exterior **niches** of the cathedral. These were supervised by the cloth manufacturers' guild (Arte della Lana), which was in competition with the Arte del Calimala for power and influence in Florence. As noted above, it was the latter that oversaw the competition of 1401 and helped finance construction of the doors. Like the Calimala, the Lana hired the most important emerging artists to execute its commissions.

Donatello's Marble *David*

In 1408, Donato di Niccolò di Betto Bardi, known as Donatello (c. 1386–1466), was commissioned to carve a figure of David for a **buttress** of the cathedral (**3.8**). Donatello's *David* is a triumphant youth standing in a relaxed *contrapposto* pose over the head of Goliath. Circling the *David*'s head is a wreath of amaranth, a symbol of the everlasting fame of heroes in antiquity.

The interest in fame, which is also a feature of self-portraiture and autobiography, was an important aspect of the humanist movement. Donatello's marble *David* is an early expression of the Renaissance practice of depicting heroes, especially youthful ones, engaged in the activity that made them famous. Renaissance artists imbued the traditional medieval image, which portrayed David as a bearded prophet and which emphasized his typological role as a precursor of Christ, with new layers of meaning that related his victory over Goliath to contemporary issues.

Donatello's statue never left his workshop, apparently rejected by the Opera. In 1416, it was moved to the Palazzo Vecchio, where, in its association with the Signoria, it came to embody the triumph of republican Florence over the tyranny of foreign states. This was the first of several representations of the triumphant David as the symbol of Florence and protector of its civic ideals. In the Signoria, the *David* was set against a blue wall decorated with Florentine lilies and carried an inscription declaring that the gods assist those who fight for their country, even against the most terrible enemies.

Donatello's *John the Evangelist*

Around 1409, the Arte della Lana decided on seated statues of the four evangelists, two on either side of the central portal, for the façade of the cathedral. Donatello executed the huge marble *John the Evangelist* (**3.9**), which is nearly 7 feet high. Designed to be seen from below, the torso is elongated and the drapery massive. It covers not only the figure of John, but also his seat, thereby forming a rectangular base from which the torso rises. The curvilinear, deeply carved folds seem to sweep upward toward the book on which the saint's relaxed left hand rests. From the hand, thin curved folds

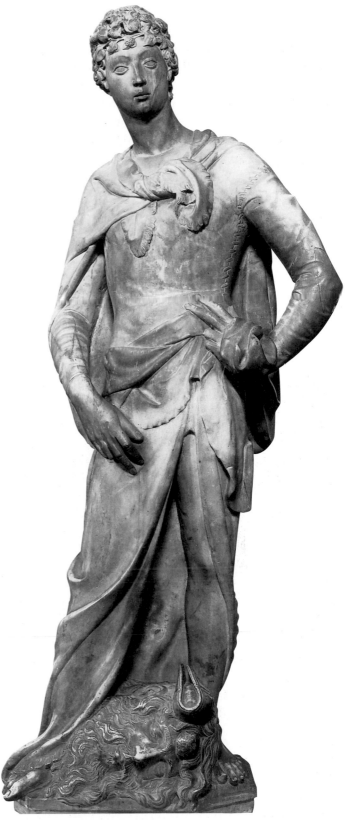

3.8 Donatello, *David*, 1408–1409. Marble; 6 ft. 3 in. (1.91 m) high. Museo dell'Opera del Duomo, Florence. Donatello's contract with the Opera del Duomo stipulated that he be paid 100 florins, in installments, for the statue.

across the torso and the long beard lead the eye to the head. The viewpoint creates the impression that John gazes upward, as if caught up in a visionary experience that would be consistent with his writings. Donatello's portrayal of the evangelist reflects a new trend among the most monumental artists of conveying character in addition to natural, organic form.

3.9 Donatello, *John the Evangelist*, c. 1409–1411. Marble; 6 ft. 11 in. (2.1 m) high. Museo dell'Opera del Duomo, Florence. The Opera del Duomo commissioned three evangelists by three sculptors, saying that the best would carve the fourth. Although this never came to pass, the incident shows the spirit of competition among artists as well as among guilds in early fifteenth-century Florence.

The Architecture of Brunelleschi

Filippo Brunelleschi created the transition in architecture from the Middle Ages to the Renaissance. According to Vasari, after losing the competition of 1401 to Ghiberti, Brunelleschi accompanied Donatello to Rome to study ancient ruins. In contrast to Donatello, however, Brunelleschi was said to have renounced sculpture and to have turned his genius to architecture. By 1417, he had returned to Florence. There he designed the dome (or **cupola**) for the cathedral and submitted a model of it the following year. Construction began in 1420, but the dome was not completed until the summer of 1436. Its crowning feature, the **lantern**, which was designed to admit daylight into the interior, was executed according to Brunelleschi's plan after his death.

The Dome

With a diameter of nearly 140 feet, the space of the cathedral's octagonal **crossing** was larger than any that had been spanned since the construction of the Pantheon in Rome (**3.10**) in the second century. But whereas the Pantheon had a circular **drum**, the fourteenth-century octagonal drum of the cathedral precluded a perfectly hemispherical dome. The problem of spanning such a space had baffled architects since the middle of the fourteenth century. In 1418, Brunelleschi proposed a solution that eliminated the need for **centering**, the wooden scaffolding that was normally built from the floor upward for vaulting large spaces (there were no trees large enough to

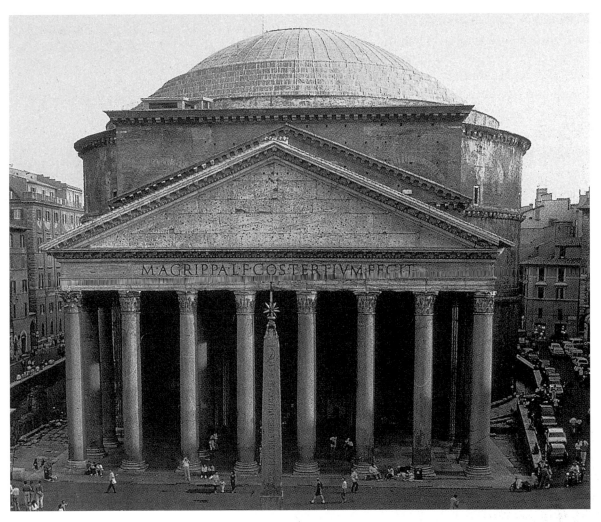

3.10 Pantheon, A.D. 125–128, Rome.

enough to provide the necessary wood). He proposed constructing a skeleton of eight large **ribs**, which are visible on the exterior (**3.11**), each extending from one angle of the octagon to the base of the lantern. Eight pairs of thinner, invisible ribs alternated with the large ribs, all of which were connected by nine sets of horizontal ties. The latter absorbed the pressure caused by the thrust of the ribs against the wall of the dome.

The wall was composed of an inner and outer shell, both attached to the eight major ribs and concealing the thinner ribs and the horizontal ties (**3.12**). The material used was brick, which is lighter than stone, and the use of a double shell with a space in between also reduced the weight of the structure. The interlocking, herringbone arrangement of the individual bricks provided additional support and minimized breakage. When the

dome was about one-third completed, Brunelleschi proceeded upward one horizontal **course** at a time. His scaffold was **cantilevered** out from the base of the drum and moved up course by course. He continued until he reached the open circle—the **oculus**—at the top, where he locked in the ribs to prevent them from **springing** outward. The result is a slightly conical dome. In 1445, the lantern was in place, completed by the architect Michelozzo di Bartolomeo (1396–1472), who had previously worked with Ghiberti and Donatello. The lantern itself is supported by external buttresses, miniature versions of those on Gothic cathedrals, which are connected to the large, visible ribs.

According to Vasari, Ghiberti shared the commission of the dome with Brunelleschi, but their collaboration was fraught with difficulty. Brunelleschi resented

Ghiberti and thought him undeserving of the salary. In order to prove his point, Brunelleschi pretended to be ill and stayed home. The warden went to consult him on a technical matter and was told to ask Ghiberti's advice. To this the warden replied that Ghiberti would do nothing without Brunelleschi. Brunelleschi countered by

3.11 Filippo Brunelleschi, detail of the dome and lantern, Florence Cathedral.

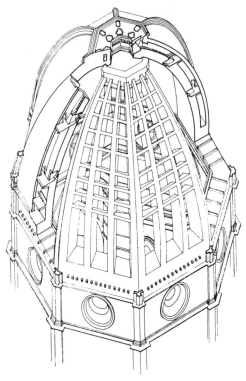

3.12 Axonometric section of the dome, Florence Cathedral. Brunelleschi's gifts in engineering served him on other occasions besides this one. He was active in designing and advising on military fortifications outside Florence and also devised stage sets for theatrical productions and civic celebrations.

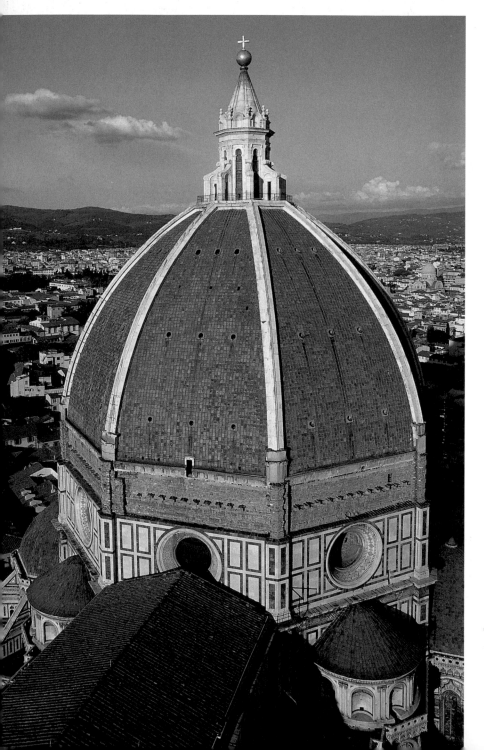

saying that he, on the other hand, could do a lot better without Ghiberti.

Ghiberti's account is quite different. Never particularly modest, in the *Commentarii* he claimed responsibility for most of the important works in Florence, and asserted that the dome was executed jointly by himself and Brunelleschi and that they intended to collaborate on an architectural treatise. In fact, Ghiberti was dismissed from work on the dome in 1425 but, because of his political connections, continued to receive a salary until the project was finished.

The Hospital of the Innocents

As the construction of the dome proceeded, Brunelleschi worked on other major build-

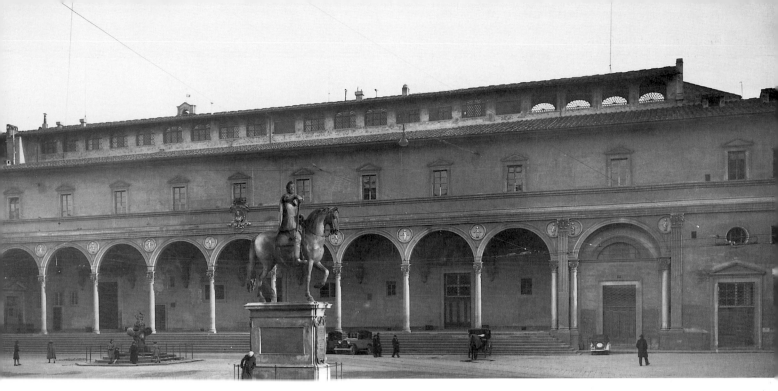

3.13 Filippo Brunelleschi, Hospital of the Innocents, begun 1421. Piazza Santissima Annunziata, Florence. In the first half of the fifteenth century, the number of foundlings was on the rise. As a result, by 1448 the Arte della Seta decided that one *soldo* of each lira paid to silk winders and two *soldi* of each lira paid to damask weavers would be reserved—after deducting a third of the total for the Weavers' Congregation—for the hospital. In addition, the priors of Florence levied a tax for the benefit of the hospital of one *soldo* for each load of produce (except grain and building material) brought to the city by horse, mule, or donkey.

ing projects in Florence. Around 1419, the Arte della Seta (guild of silk workers and goldsmiths) commissioned him to design a foundling hospital—the Hospital of the Innocents (Ospedale degli Innocenti) (**3.13**). It was to be located in the Piazza Santissima Annunziata near the church of the same name, where pilgrims gathered to worship an image of the Virgin that was believed to produce miracles. By association, therefore, the Virgin's maternal role would extend to infants left at the Hospital.

Construction began in 1421, and in October of that year the Arte della Seta petitioned the priors of the commune for official recognition of their sole patronage of the Hospital as representatives of the citizens of Florence. They pointed out the advantages to the republic and to themselves of engaging in charitable acts. Giovanni di Bicci de' Medici, banker to the papacy, who may have been a judge in the 1401 competition for the baptistery doors, assisted in the financing of the Hospital. Having founded the enormously powerful Medici bank, Giovanni began lavish spending on works

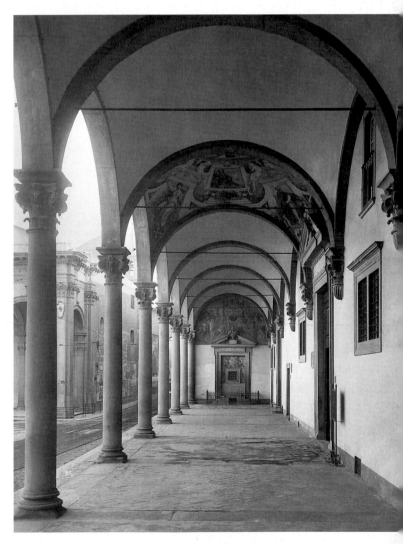

3.14 View of the Hospital of the Innocents, showing the modular space between the colonnade and the solid wall.

of art both for personal advantage and for the embellishment of the city.

With the Hospital, it is possible to discern Brunelleschi's revolutionary approach to architecture. It is a long horizontal, two stories high, with **pedimented** windows on the second story. The loggia is based on simple, regular shapes—the cube and the hemisphere—in both its **plan** and its **elevation**. Between the exterior **colonnade**, consisting of round arches supported by

The Medici in the Fifteenth Century

The Medici were the single most influential family in fifteenth-century Florence. They came, like Giotto, from the Mugello Valley, not far from the city. Giovanni di Bicci de' Medici (1360–1429) established the Medici fortune through his banking skills and by marrying Piccarda de' Bueri, who came from an old, wealthy family. His sons, Cosimo (1389–1464) and Lorenzo (1395–1440), increased his fortune and expanded the operations of the bank. Cosimo was especially important—Florence designated him *pater patriae*, "father of his country," after his death. He married Contessina de' Bardi of the Bardi banking family. Their son Piero (1416–1469) married Lucrezia Tornabuoni, who took an active part in his political, literary, and artistic pursuits. She encouraged the same interests in their son Lorenzo, known as "The Magnificent" (1449–1492), whose financial and political acumen were the equal of his grandfather's.

Like Cosimo, both Piero and Lorenzo spent enormous amounts of money on the arts, engaging in the practice of *magnificentia*. This was a conscious effort to adorn the city with architectural projects and public art that would accrue to the benefit of both citizens and patron. Most of the Medici men, and a few of the women, were educated according to the humanist curriculum and they attracted the leading fifteenth-century intellectuals to their circle. In addition to artists and architects, the Medici were patrons of philosophers, poets, antiquarians, and Classical scholars.

Medici power continued to expand: in 1492, Columbus sailed to the New World on Medici ships; a daughter of Piero and Lucrezia married the head of the Medici bank in Lyons, France, and two of their grandsons became popes—Leo X (1475–1521) and Clement VII (1478–1534). A great-great-granddaughter, Catherine (1519–1589), and her daughter, Marie (d. 1642), both became queens of France by marrying Henry II and Henry of Navarre (later Henry IV), respectively.

Corinthian columns, and the solid wall are spaces surmounted by hemispherical domes. Supporting the arch of the dome against the solid wall are corbels, each of which is exactly opposite the **capital** of an exterior column (**3.14**).

Classical influence, absorbed during Brunelleschi's trip to Rome, is evident in the horizontal **entablature** and projecting **cornice** that extends the length of the loggia, as well as in the columns. Formal symmetry, another Classical feature, contributes to the harmonious effect of the façade. Brunelleschi also used smooth **shafts** for his columns, reserving **flutes** for the pilasters (see Box, p. 71 and **3.15**). These rectangular supports attached to a solid wall function as framing devices that accentuate the symmetrical organization of the loggia. Brunelleschi's taste for regularity and his use of proportion are evident in the design of the loggia: the height of the columns, for example, is equal to the distance between each one and to that between the columns and the solid wall.

The Church of San Lorenzo

In church architecture, Brunelleschi rejected the soaring verticals of Gothic and brought the experience of space down to a more human scale. Around 1418, he was commissioned to replace a Romanesque church located behind the Medici residence. Brunelleschi died before the project was complete, and the nave was altered after 1442 under the patronage of Cosimo de' Medici. Nevertheless, the similarity of the nave (**3.16**) to the Hospital loggia reflects Brunelleschi's impact on the final building.

The vaults of medieval churches have been replaced by a flat, **coffered** ceiling, lowering the height of the nave. Separating the nave from the **side aisles** are colonnades of round arches supported by Corinthian columns, as at the hospital. The horizontal entablature and highlighting of the architectural accents of gray stone framing the white **stucco** wall surfaces also recur at San Lorenzo. But the **impost block** over the capital has developed into a mini-entablature, a more Classical solution than that achieved for the Hospital. Natural outdoor light enters San Lorenzo through round windows over the arches of the side walls and in the dome over the crossing as well as through the round-topped

The Orders of Architecture

Shown in the diagram are the **Orders of architecture** known in the Renaissance. Reading from left to right, they are **Doric**, Ionic, Corinthian, **Tuscan**, and **Composite**.

Doric, Ionic, and Corinthian are the original Greek Orders, whereas Tuscan and Composite were developed later in the Roman period. During the Renaissance, artists revived the Orders, sometimes combining them in new ways.

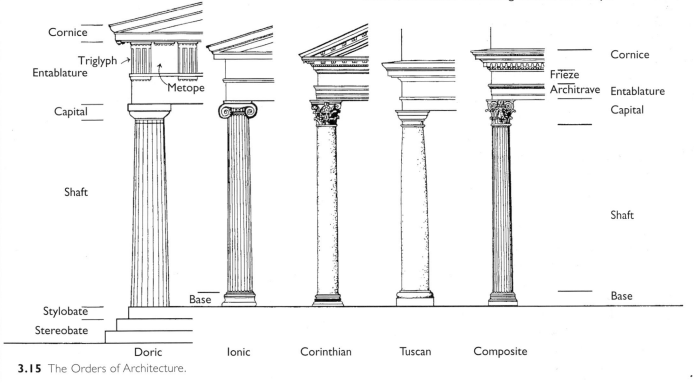

3.15 The Orders of Architecture.

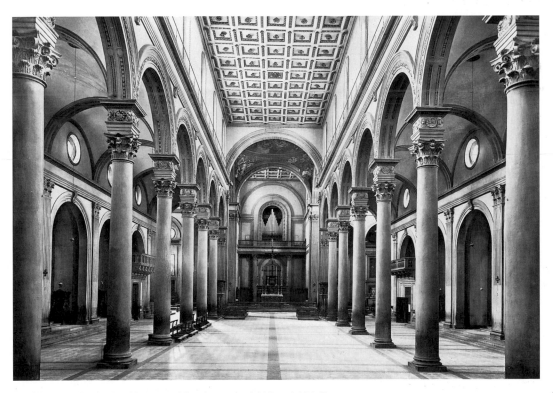

3.16 Filippo Brunelleschi, nave of San Lorenzo, 1418–c. 1466. Florence.

rectangular windows over the arches of the **nave arcade**. This is a departure from the more complex Gothic use of monumental **stained glass** that transported church interiors into a spiritual realm removed from nature.

Giovanni di Bicci commissioned Brunelleschi to design a sacristy inside San Lorenzo to serve as a family **mausoleum** (burial place) for the Medici. Now known as the Old Sacristy, it is a square room located at the south end of the **transept** (**3.17**). The view illustrated here shows the symmetrical arrangement of the altar wall. Accenting the corners are fluted pilasters supporting an entablature that extends around the entire room. Two doorways are framed by **Ionic** columns also supporting entablatures with crowning **pediments**.

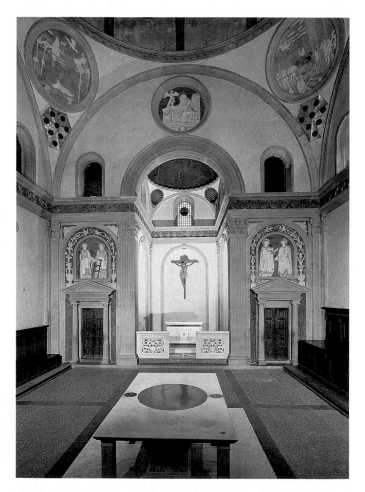

3.17 Filippo Brunelleschi, interior of the Old Sacristy, 1418–1428. San Lorenzo, Florence. The reliefs on the walls are by Donatello. They were commissioned in the 1430s by Cosimo de' Medici and his brother Lorenzo. The two reliefs shown here represent Saints Lawrence and Stephen on the left and Cosmas and Damian on the right, the latter two being patron saints of the Medici family.

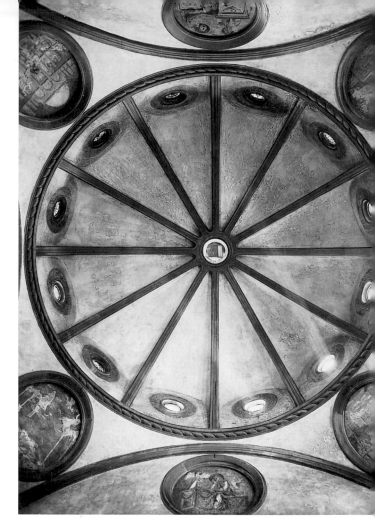

3.18 Filippo Brunelleschi, interior of the dome of the Old Sacristy, 1418–1428. San Lorenzo, Florence.

The ceiling over the altar is domed and, like the central dome of the room (**3.18**), rests on **pendentives**, an element of Byzantine architecture. The corners of the pendentives of the central dome are decorated with tondos that repeat the circular windows in the twelve sections of the dome. Twelve was the number of apostles as well as of the gates of Jerusalem, while the circle was considered the most divine shape. The tomb of Giovanni and his wife, Piccarda, is directly below the dome; the circle on the marble table covering the tomb echoes the oculus under the lantern, which itself was formally related to a structure erected on the Holy Sepulchre in Jerusalem.

The Church of Santo Spirito

Brunelleschi's mature style is best known from his last major commission—namely, rebuilding the church of Santo Spirito, located to the south of the Arno River (**3.19**). Although it was barely started before Brunelleschi's death in 1446, both the plan (**3.20**) and

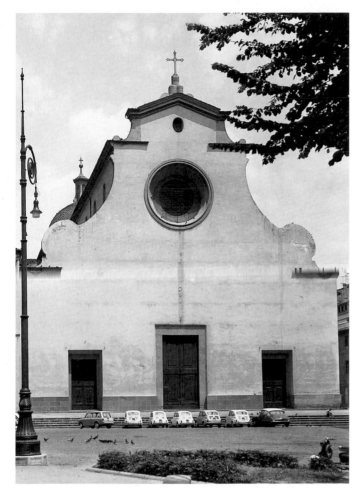

3.19 Façade of Santo Spirito, second half of the 15th century. Florence. In the original plan, Brunelleschi oriented the façade to face the Arno across an open square. This was later altered by 180 degrees so that the nave now runs parallel to the river.

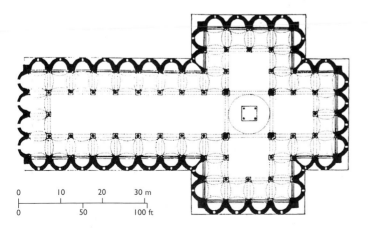

3.20 Filippo Brunelleschi, plan of Santo Spirito, begun 1428. Florence.

the existing nave (**3.21**) reveal his intentions. The plan is a unified **Latin cross** with a symmetrical transept the same size and shape as the **choir**. Forty chapels along the **aisles** continue at the sides of the transept and the far end of the choir. Had he lived, Brunelleschi planned to repeat the chapels on the entrance wall, creating a unique and unifying border of chapels around the entire structure.

As in the Hospital, Brunelleschi based the plan on the harmonious proportions of the square. From the crossing, three arms of equal length extend—the choir and the two arms of the transept. The fourth arm is the nave, which consists of two squares, each the size of the square crossing. The height of the nave is twice its width. The aisles are defined by square **bays**, the height of which is also twice their width.

The preference for solid form and geometric shapes, already evident in the Hospital, reached a new intensity at Santo Spirito. Brunelleschi intended to convey a sense of dynamic tension between the flat wall and the

3.21 (*below*) Filippo Brunelleschi, nave of Santo Spirito, completed second half of the 15th century. Florence.

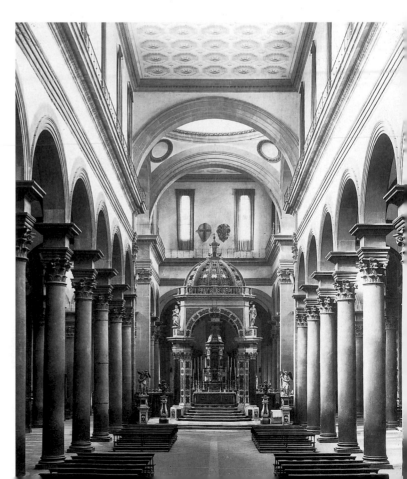

hemispherical planes of the repeated chapels. In the nave, as at San Lorenzo, Corinthian columns with smooth shafts support round arches. Along the aisle walls, engaged columns between each chapel echo those of the nave colonnade, thereby creating a stronger plastic unity between wall and arcade than in either the hospital or San Lorenzo. This last feature was new in its concretization of space, reflecting the physical experience of the worshiper. As such, it corresponded to the Renaissance conception of man in nature and his role as the "measure of things."

Late Work: Santa Maria degli Angeli and the Ideal of the Circular Plan

Conceived as a sixteen-sided polygon, Brunelleschi's much restored and complex oratory of Santa Maria

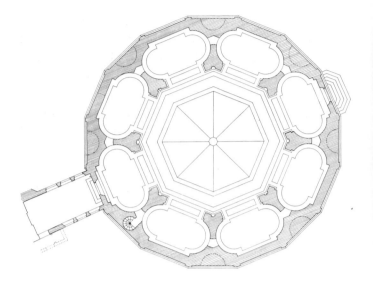

3.22 Filippo Brunelleschi, plan of Santa Maria degli Angeli, begun 1434. Florence.

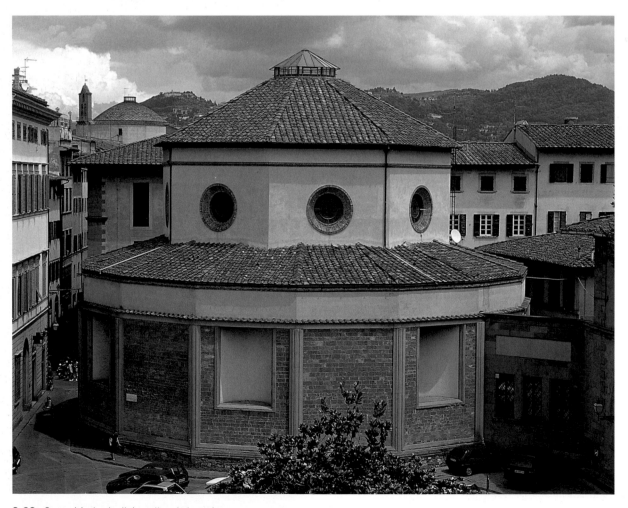

3.23 Santa Maria degli Angeli as it is today.

degli Angeli was the earliest nearly circular plan of the Renaissance (**3.22** and **3.23**). It heralded the humanist vision of the ideal church building as being in the shape of a circle, which was considered divine. The interior space under the dome, supported by **piers**, was octagonal; it contained seven **radiating chapels** and a vestibule space at the entrance that matches the chapel opposite.

Originally a private commission, it was taken over by the Calimala on behalf of the Camaldolese convent of Santa Maria degli Angeli. In 1431 the humanist cleric Ambrogio Traversari (1356–1439) was appointed to head the Order, and in 1434 Brunelleschi signed the contract for the oratory. Traversari's contacts with the Medici circle and his fluency in Greek and Latin were consistent with the innovative character of the commission. The oratory was a significant precursor to the Renaissance ideal of the circular plan, which became a prominent subject of discussion in architectural treatises of the fifteenth century.

CONTROVERSY
Brunelleschi's Sources

The issue of Brunelleschi's historical sources has been much debated by scholars. The dome of Florence cathedral, for example, has been called both a revival of Classical precedents and a continuation of Gothic vaulting, while the brick-work and the use of the double shell have been identified as Persian.

In the case of Santa Maria degli Angeli, the situation is complicated by extensive restoration. On the one hand, the **rotunda** is strikingly similar to ancient buildings that Brunelleschi would have seen in Rome. But it was also reminiscent of Charlemagne's ninth-century palace chapel at Aachen, itself the product of a Classical revival. In the Early Christian period, Byzantine churches constructed on the plan of the **Greek cross**, such as San Vitale in Ravenna, were also centralized. Some scholars believe that the oratory's plan was derived from circular Gothic apses, which argues for medieval inspiration. It is likely, given the synthetic genius of humanism and of Brunelleschi himself, that, as in his earlier buildings, he combined various historical precedents to arrive at new architectural solutions.

Or San Michele:
The Exterior Niches

Going south from the space between the cathedral and the baptistery, one soon arrives at the guild church of Or San Michele (**3.24**), which previously housed the city's grain market. By 1406, the main structure had been completed, but nine of the exterior Gothic niches on the first story were still empty. A resolution issued by the

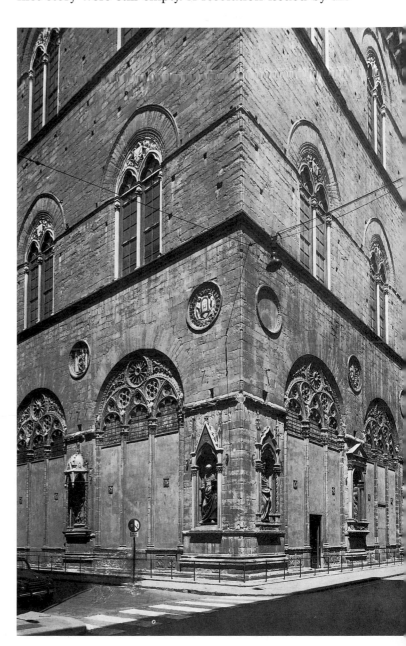

3.24 View of Or San Michele, 1337–1380. Florence.

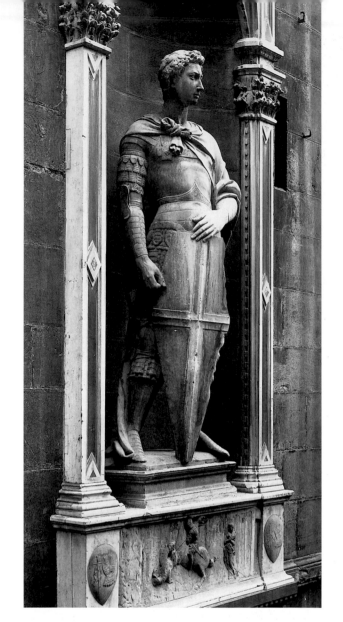

3.25 Donatello, *Saint George*, 1410–1415. Marble; height of figure: 6 ft. 10¼ in. (2.09 m). Formerly on the north wall of Or San Michele, Florence. Museo Nazionale del Bargello, Florence. The original sword and helmet were real, reflecting the activity of the armorers' guild.

Signoria in that year gave the guilds owning the empty niches ten years to fill them with statues of their patron saints. With the spirit of competition in mind, the Signoria warned that failure to comply would result in the reassignment of the niches to a guild that did not have any.

As with the exterior sculptures of the cathedral, bell tower, and baptistery, the guilds awarded the commissions mainly to the leading young artists of the time. Donatello, Ghiberti, and Nanni di Banco (c. 1374/90–1421) produced statues that, like those on the cathedral, are only a few feet above the level of the street. As a result, they seem to communicate with the citizens of Florence. In so doing, they reinforce the city's view of the mediating power of imagery, expressing the religious beliefs and economic and political concerns of Florence.

Sometime between 1410 and 1415, the guild of armorers and sword makers (Arte dei Corazzai) commissioned from Donatello a marble statue of Saint

3.26 Donatello, *Saint George Slaying the Dragon*, detail of Figure 3.25, 1410–1415. Marble; 15¼ × 47¼ in. (39 × 120 cm).

3.27 Donatello, *Saint Mark*, 1411–1413. Marble; height of figure: 7 ft. 8¾ in. (2.36 m). Formerly on the south wall of Or San Michele, Florence.

George (**3.25**). His firm stance, accentuated by the slight twist of his shoulder, is reinforced by the shield. Another example of a youthful hero who achieved fame, Saint George is nonetheless slightly apprehensive; his intense gaze and furrowed brow suggest a wary focus on impending danger. The military iconography probably alludes to a combination of factors—the armor produced by the guild, the medieval chivalric tradition, and the determination of Florence to repel hostile forces.

In the marble relief on the base of the niche, Donatello represented the feat that made Saint George famous: killing the dragon to rescue a princess (**3.26**). This is the earliest example of Donatello's revolutionary depiction of space in relief sculpture. He departed from the age-old technique of carving relief, in which the surface plane was flat and forms projected from it in varying degrees. Instead, Donatello varied the background surface with forms carved in very shallow relief, in contrast to the deeper relief of the saint spearing the dragon. Appearing to stand slightly farther back in space is the princess, whose relief is not quite as deep as that of Saint George. This technique, known as *schiacciato* (literally "squashed"), creates an impression of distant landscape and of a receding arcade at the right; it was soon to be taken up by the leading Renaissance painters.

Between 1411 and 1413, Donatello worked on the niche figure of Saint Mark (**3.27**) for the guild of linen weavers (Arte dei Linaiuoli). The relaxed *contrapposto* pose, similar to that of the marble *David* for the cathedral, reflects Classical influence. Here, however, the drapery is also Classical, its folds revealing the anatomy of the figure. This can be seen by comparing the stance of the saint with a Classical Athena, the Greek goddess of war, wisdom, and weaving (**3.28**). In both works, the drapery of the right supporting leg is designed to resemble the grooved flutes of a column, relating the organic support of the human body to architectural structure.

Saint Mark is rendered as an introspective thinker, carrying his Gospel in a powerful, veined hand that emphasizes the relationship of the saint to his written text. In a tondo at the top of the niche, a figure of Christ holds up a book denoting the triumph of his teachings. Below, a little winged lion, Saint Mark's apocalyptic symbol, also has a book.

Whereas the formal movement of the *Saint Mark*'s drapery falls naturally according to the laws of gravity, the drapery of Ghiberti's bronze *John the Baptist* (**3.29**) sweeps upward in a series of rhythmic curves. Commissioned by the Calimala, which had also supervised the baptistery doors, the *John the Baptist* is somewhat elongated, compared with the more Classically proportioned *Saint Mark*. Ghiberti's figure stands in a similar pose, with the left leg providing the support and the right knee bent, but the *contrapposto* is nearly hidden under the voluminous drapery patterns. Surface

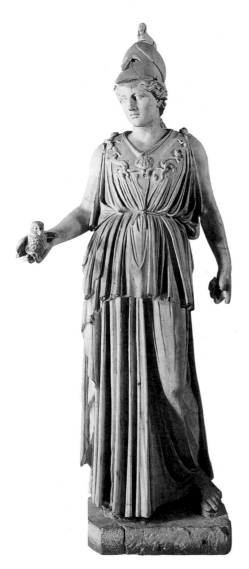

3.28 *Athena Ince,* copy of a version of the *Athena Parthenos* by Phidias, c. 400 B.C. Marble; 5 ft. 5¾ in. (1.67 m) high. Liverpool Public Museums.

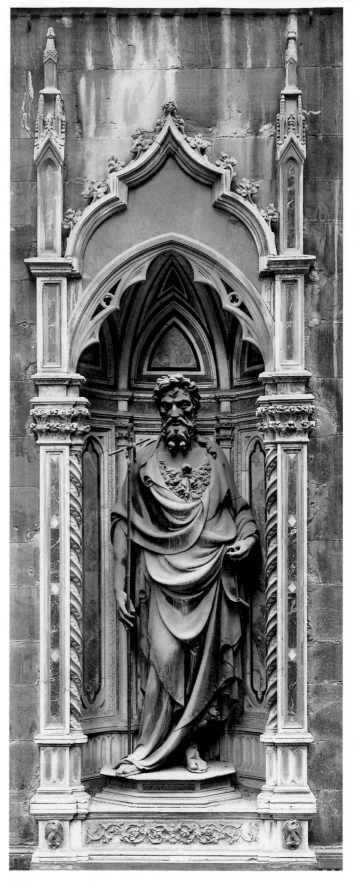

3.29 Lorenzo Ghiberti, *John the Baptist,* 1412/13–1417. Bronze with gilding; 8 ft. 4¼ in. (2.55 m) high. Formerly on the east wall of Or San Michele, Florence. Ghiberti signed the work on John's hem: "OPUS LAUR[E]NTII" [the work of Lorenzo].

patterning is repeated in the saint's hair and beard as well as in the hair shirt visible above the robe. Clearly, the Calimala had an affinity for the elegance that had also characterized Ghiberti's work on the baptistery doors. The bronze medium, which was more expensive than marble, appealed to the image of wealth the guild wished to project.

The *Four Crowned Saints* (*Quattro Coronati*) (**3.30**), commissioned by the guild of the masters of stone carving and wood carving (Arte dei Maestri di Pietra e Legname), was executed by Nanni di Banco around 1414 to 1416 for Or San Michele's north wall. A promising young artist who died prematurely, Nanni preferred the monumental tradition in which Donatello worked to Ghiberti's more elegant style. His subject was four Christian sculptors and architects who defied an order from the Roman emperor Diocletian to carve a pagan image of Aesculepius, the Greek god of medicine. The artists became martyrs and were beheaded; this accounts for their nickname, a reference to the crowns of martyrdom they received in heaven.

Not surprisingly, Nanni's figures resemble Roman portraits. Their varying physiognomies and ages identify them as distinct individuals, and their unity of purpose is reinforced by their formal unity; their semicircular arrangement repeats the curve of the niche. Their gestures, serious expressions, and heavy draperies reflect the gravity of the decision they are about to make. Defying the emperor, especially one known for his tyrannical persecution of Christians, would have been identified in fifteenth-century Florence with republican sentiments.

In the relief below the niche, Nanni depicted the activities of the guild. From left to right, members construct a wall, drill a spiral **colonnette**, measure a capital with dividers, and carve a *putto*. The four guild workers appear to be the four *Coronati* themselves; their refusal to work for the emperor is ironically juxtaposed with their concentration in the present. By condensing time in this way, Nanni reinforces the

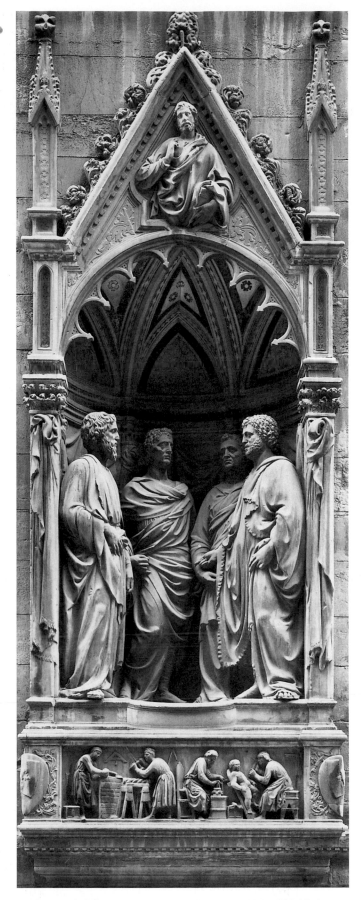

3.30 Nanni di Banco, *Four Crowned Saints*, c. 1414–1416. Marble; height of figures: 6 ft. (1.83 m). Formerly on the north wall of Or San Michele, Florence.

connection between defying a tyrannical emperor and the republic of Florence. The nude *putto* reflects the contemporary interest in organic nude form that was an aspect of the Classical revival.

The most unusual statue at Or San Michele was Donatello's gilded bronze *Saint Louis of Toulouse* (**3.31**). Scholars have debated the date of this work, but it is now generally thought to have been made between 1423 and 1425. Commissioned by the Guelph party, it occupied a large niche on the east wall, the only niche not owned by a guild. Also a subject of debate is the architecture of the niche itself, which has been variously attributed to Brunelleschi, Michelozzo, and Donatello. Regardless of who designed the niche, its elements are derived from Classical forms and the baptistery, which was believed to be a Roman temple dedicated to the war god Mars.

Classical features include the Corinthian and Ionic capitals, the entablature and pediment, as well as the *putti* reliefs and swags. The spiraling design on the columns and vertical flutes of the pilasters had been used in the baptistery. Merging Classical and Christian iconography, as would become more and more characteristic of the Renaissance, is the image of the Trinity in the pediment and the Classical quality of the niche. The scallop-shell ceiling derives from Roman sarcophagi, the motif of the scallop shell becoming a Christian symbol of rebirth, resurrection, and pilgrimage. (For a view of the entire niche see 10.9)

Donatello's bronze represents the Franciscan saint as a youth enveloped in massive drapery that monumentalizes his form. The complex figure, which was cast in eleven pieces, is hollow at the back. Louis is shown wearing heavy robes and a miter. He carries a crozier and raises his right hand in a gesture of blessing, as if communicating directly with the people of Florence.

The Guelph party had gained control of Florence after the Ciompi rebellion, but its power began to decline early in the fifteenth century. By commissioning a very expensive statue for Or San Michele, the Guelphs tried to emphasize their party's political importance. Their self-image as defenders of republicanism is consistent with Saint Louis's renunciation of kingship (see caption). In addition, as a Franciscan, Louis could be seen as a "man of the people"—for the Guelphs, a felicitous symbol of democratic appeal—and, as a bishop, an image of ecclesiastical authority.

The detail of the crozier in figure **3.32** is as enigmatic as it is a sign of Renaissance synthesis. It resembles a miniature round temple with six scallop-shell niches alternating with Corinthian pilasters. They, in turn, support a circular entablature and six pediments. Projecting from the pilasters are solid buttresses, between three of which are nude *putti* that reappear in various guises in many of Donatello's works. Their origin is purely Classical, they reflect the new interest in nudity, and they have a curious playful quality, all of which might seem to be at odds with a serious statue of a bishop-saint. Each *putto* holds a shield, possibly an allusion to the Guelphs as defenders of political freedom.

The apparent incongruity of Donatello's iconography seems to call for a text. Unfortunately, none has been identified to explain the juxtaposition of Saint Louis with the pagan *putti*. Nevertheless, it is clear that the very newness of such combinations, including the miniature round building composed of Classical elements, is part of what imbued the early Renaissance with its self-conscious sense of difference from a medieval past.

3.31 Donatello, *Saint Louis of Toulouse*, c. 1423. Bronze; figure 8 ft. 8¾ in. (2.66 m) high. Originally on the east wall of Or San Michele, Florence. Museo di Santa Croce, Florence. According to Vasari, the statue struck some viewers as awkward and clumsy. Donatello, typically characterized by Vasari as quick-witted, replied that Saint Louis (formerly Louis IX of France) must have been a clumsy fool to renounce his kingdom to become a friar. In 1296, when he was elected a bishop, Louis abdicated in favor of his younger brother, Robert of Anjou.

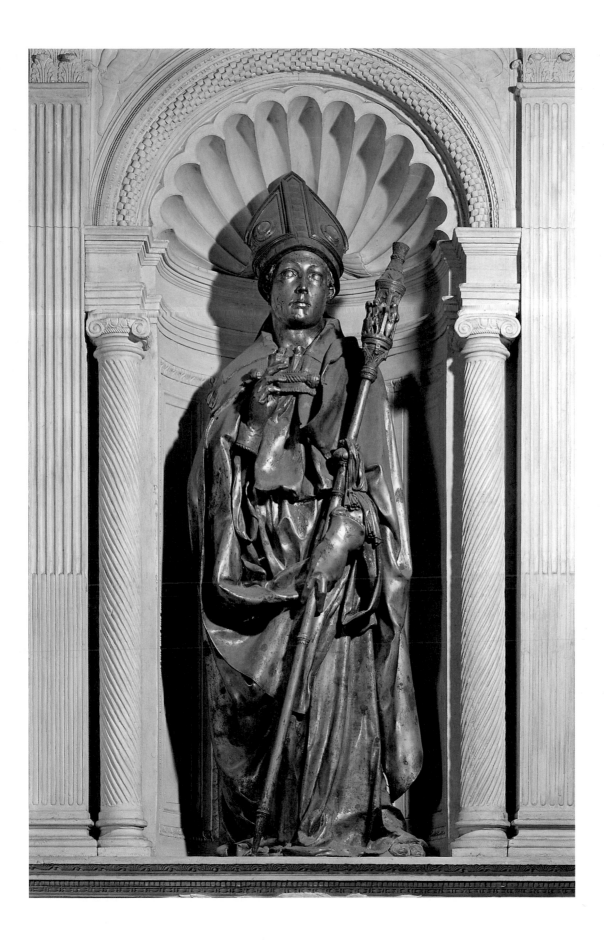

3.32 Donatello, Saint Louis's crozier, detail of Figure 3.31. This detail shows Donatello's superior craftsmanship as a bronze caster, even though most of his works to date had been marble. The total cost of the sculpture was 449 florins, and the gilding was extra. In the 1450s the Guelph party sold the niche, and the *Saint Louis* was transferred to the Franciscan church of Santa Croce.

4
Painting in Florence: 1400–1430

In the first three decades of the fifteenth century in Florence, styles of painting, sculpture, and architecture fluctuated. Gothic trends coexisted with revolutionary developments in the depiction of space and in the increasing sense of naturalism. The innovations of Giotto, Donatello, Nanni di Banco, and Brunelleschi had the greatest impact on artists working in the newer style, while Ghiberti seems to have appealed to those continuing the Gothic tradition.

Lorenzo Monaco's
Coronation of the Virgin

Piero di Giovanni (c. 1370–1423/24), known as Lorenzo Monaco (or Lorenzo the Monk), produced the most significant late Gothic monumental altarpiece in Florence. In 1414, he completed a *Coronation of the Virgin* (**4.1**) for the Camaldolese Order, a branch of the Benedictines; it was to be located above the high altar of the Camaldolese church of Santa Maria degli Angeli. (Twenty years later, Brunelleschi would design the first nearly circular plan of the Renaissance for the oratory of the same church; see 3.22 and 3.23.)

The very subject of the *Coronation*, in which Christ crowns Mary Queen of Heaven, reflects the mystical character of the Camaldolese Order. Through the rich golds, elaborate frame, and blaze of brilliant color, Lorenzo Monaco conveys the glory of the moment that heralds the dominion of mother and son over eternal time and space. Mary and Christ are seated on a combination throne and Gothic tabernacle with a bright gold-

en dome, which is set on an unusual white floor. They are surrounded by a host of angels, who, like the saints under the side arches of the frame, are engaged in animated conversation. At the left, Saint Peter, wearing yellow and blue, carries the gold key to the Church. He gazes at John the Baptist, who gestures toward the Coronation, his hair shirt partially covered by a soft pink robe.

The series of star-studded blue arcs identifies the celestial setting and partially encircles the three foreground angels, two swinging censers and one playing a now-damaged organ. The colors are dazzling, arranged in patterns that maximize the painting's spiritual message. The reds, blues, yellows, and whites describing the robes of the holy figures are combined in the multicolored wings of the angels, their prominence alluding to the Church itself—Saint Mary of the Angels.

The leitmotif of white—the robes of the Virgin, the angels flanking the Coronation, and Saints Romualdo (founder of the Order) and Benedict—accentuates the otherworldly quality of the scene. It also relates Mary to the Camaldolese friars, whose habits are white, and is consistent with the Order's special relationship with her. Lorenzo's fluid, curvilinear drapery inspired by Ghiberti is defined by contrasts of light and shade, but the folds seem to take on a life of their own as they create rhythms independent of human form. As in Ghiberti's draperies, Lorenzo's often sweep upward, echoing the more general upward movement of the altarpiece.

Continuing the upward pull of the picture are the large pinnacles. Gabriel and Mary of the *Annunciation* flank a frontal, hieratic Christ as Redeemer. He is

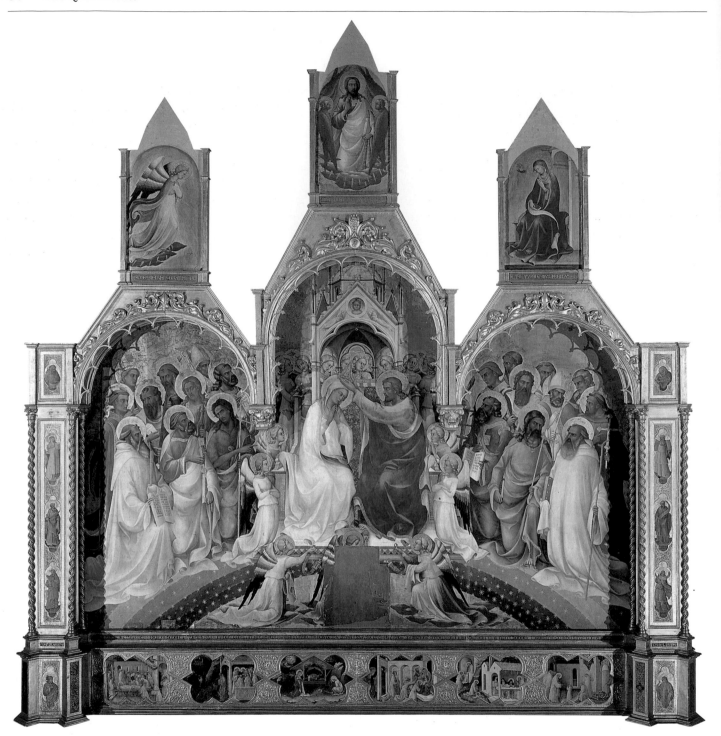

4.1 Lorenzo Monaco, *Coronation of the Virgin*, 1414. Tempera on panel; 16 ft. 9½ in. × 14 ft. 9 in. (5.12 × 4.50 m). Galleria degli Uffizi, Florence. Little is known of Lorenzo Monaco. He worked mainly in Florence, though his place of birth is not documented. In 1391, he entered the Camaldolese Order and by 1402 was a member of the Arte dei Medici e Speziali.

Saint Romualdo was a tenth-century Benedictine monk in Ravenna. Because he believed in a more ascetic life than the Benedictines, he founded the Camaldolese Order, which imposed vows of solitude and silence. He dreamed of men in white robes ascending a ladder to heaven, which he read as a sign that his monks should wear white.

surrounded by a mandorla of bright red seraphim reminiscent of Orcagna's Strozzi Altarpiece (see 2.24). The predella panels, which occupy expanded Gothic quatrefoil frames, depict four scenes from the life of Saint Benedict on either side of the *Nativity* and the *Adoration of the Magi*. The central arrangement of the latter two functions visually and iconographically as the foundation of the main scene.

Gentile da Fabriano's *Adoration of the Magi*: 1423

In contrast to the spiritual space and mystical impact of Lorenzo Monaco's *Coronation*, Gentile da Fabriano (c. 1370/85–1427) depicted the physical world of surface textures. He engaged viewers in the sights and sounds of courtly splendor, particularly in his masterpiece of 1423, the *Adoration of the Magi* (**4.2**), commissioned by Palla

Strozzi, the wealthiest man in Florence. Gentile's reputation for lavish paintings in the courtly tradition was well established and appealed to Palla Strozzi's wish to project an image of magnificence vis-à-vis the Medici. For although Cosimo and Palla were initially friends and fellow humanists, Palla allied himself with the Albizzi, who were politically opposed to the Medici. Ten years after the completion of this altarpiece, in 1433 to 1434, Cosimo's exile from Florence was engineered by the Albizzi. On his return to the city, Cosimo arranged

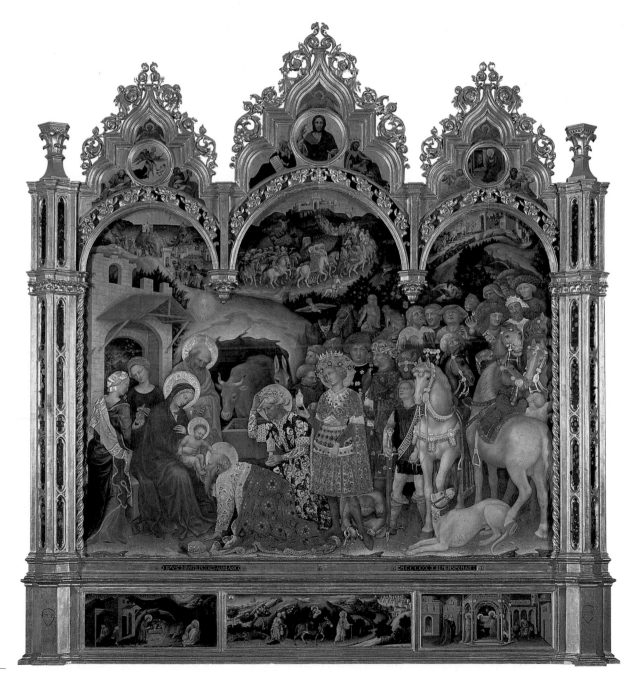

4.2 Gentile da Fabriano, *Adoration of the Magi*, 1423. Tempera on panel; 9 ft. 10 in. × 9 ft. 3 in. (3.00 × 2.82 m). Galleria degli Uffizi, Florence.

for the exile of all male members of the Strozzi family, including Palla, who spent the remainder of his life in Padua.

Gentile was born in the Marches and had worked in Venice before coming to Florence. Much of his work is lost, but what survives shows the influence of International Gothic. This was the style of the European courts, with their taste for elegant materials, exotic foreign elements, crowded picture planes, and late Gothic interest in details of nature. There is also evidence of Northern and Venetian influence in Gentile's soft textures and atmospheric landscapes.

The patron, whose wealth came from the Strozzi bank, was, like Giovanni di Bicci, involved in awarding the commission of the baptistery doors to Ghiberti. Competition between the Medici and Strozzi families may have contributed to the lavish display of Palla's wealth in Gentile's painting. The altarpiece was unusual in depicting a narrative scene in the main panel—more static events such as the Coronation of the Virgin or single images such as the Madonna Enthroned were more common.

Gentile's subject, a procession from the East, associated in Renaissance Italy with luxury, lends itself to a show of splendor that also reflects the wealth and magnificence of Palla's patronage. The abundance of gold brocade, exotic animals—monkeys, leopards, and falcons—and landscape detail are characteristic of the International Gothic style. Compared with the crisp linear quality of Lorenzo Monaco's forms, Gentile's subtle shifts of light and dark endow his surfaces with softer, more varied textures.

The textual basis of the image is the Gospel of Matthew 2:1–12: King Herod of Jerusalem had been warned that a newborn boy would cause the downfall of the Jews. He asks three Magi (wise men, or kings) from the East to inform him of Christ's whereabouts. The three kings follow a star, which appears in the upper left of Gentile's *Adoration*, to Bethlehem.

At the bottom of the picture plane, the Magi offer Christ royal presents of gold, frankincense, and myrrh. In the Gospel text, God appears to the Magi in a dream and instructs them not to return to Herod's court. They obey and depart in another direction; this is shown in the painting by the abrupt shift of the procession. Under the central arch of the frame, the procession ascends a

hill toward a walled city, whereas in the right foreground it moves forward, stopping at the picture plane. Accentuating the sense of arrested movement at this point are the poses of the animals and the foreshortened page removing a spur from the young king (**4.3**). Gentile seems to have conceived of the picture plane as an invisible window, where the procession is forced to come to a halt.

In the predella panels, Gentile also juxtaposes arrest and movement. The *Nativity* at the left and the *Presentation in the Temple* at the right are scenes of stillness, whereas the *Flight* in the center is about travel. In the *Flight*, the Holy Family, like the upper part of the procession of the Magi, advances toward a walled hilltown. In the *Presentation*, they have arrived inside the city and are framed by the round arches of the Temple.

4.3 Gentile da Fabriano, detail of Figure 4.2 showing the page removing a spur from the young king.

All three scenes correspond visually and thematically to the main panel: the *Nativity* is set in the same locale as the *Adoration*, the *Flight* is below the most active part of the procession, and the more static *Presentation* is below the stopping point of the procession.

Gentile was the first painter to adopt Donatello's *schiacciato* to create the illusion of distance (see 3.26). The night sky of the *Nativity*, the first of its kind in the Renaissance, is softly illuminated by the divine light of the angel announcing Christ's birth to the shepherds. This corresponds to the scene with the Magi at the very top of the main panel.

The *Adoration of the Magi* was commissioned for the **sacristy** of Santa Trinità, where members of the Strozzi family were buried. It was also the room in which the priest dressed in preparation for bringing the Host (the body of Christ in the form of the wafer) to the altar. The transformative character of this ritual finds an echo in the transformations taking place in Gentile's painting. The procession, for example, changes from a group of animated travelers to three kings whose gazes are fixed by the sight of the Holy Family.

A corresponding change from the wealth and splendor of the procession to the simplicity of the Holy Family also takes place. This is accentuated by the traditional ox and ass, the former focused on the Adoration and the latter pricking up his ears and attracted by the sights and sounds of the crowd. Perhaps the most significant transformation is from the Old Dispensation, embodied by the kneeling king, to the New Dispensation incarnate in the newborn Christ. From the point of view of the patron, this iconography allows Palla Strozzi to display his combination of enormous wealth with personal piety.

Masaccio

Unlike Lorenzo Monaco and Gentile da Fabriano, Tommaso di ser Giovanni (1401–1428), known as Masaccio (or "Big Tom"), was born in the new century. In a short career ended by his death before the age of twenty-seven, Masaccio revolutionized the art of painting. His work, in contrast to that of Lorenzo and Gentile, is virtually free of Gothic influence. Known in his own time and described by Vasari as a painter of truth, Masaccio was heir to Giotto's formal monumentality, dramatic portrayal of character, and humanist intellect. In his use of perspective, he was influenced by Donatello and Brunelleschi, and his heroic figures are akin to Nanni di Banco's *Four Crowned Saints* (see 3.30).

The Pisa Altarpiece:
The Virgin and Child

Masaccio's chronology has been disputed, but his polyptych, the Pisa Altarpiece, is securely dated to 1426. The center panel, which depicts *The Virgin and Child* (4.4), provides an instructive comparison with the thirteenth-century *Ognissanti Madonna* of Giotto (see 2.1). Masaccio retains the gold background used for altarpieces, but his throne is no longer Gothic. In place of pointed arches, the throne is constructed as a perspectival box, the sides of which form **orthogonals** leading to a **vanishing point** (see Box, p. 89). Miniature architectural Orders—Corinthian columns on the arms of the throne and Ionic columns on the back—reflect Masaccio's interest in the Classical revival.

The number of angels, compared with the *Ognissanti Madonna*, has been reduced to four. Two play musical instruments at the base of the throne, creating, like Giotto's corresponding angels, an avenue of space from the picture plane to the Virgin and Christ. Masaccio's Virgin is more voluminous than Giotto's, filling up the space of the throne, her rich blue cloak expanding sideways. In contrast to Giotto, Masaccio was drawn to blond, fair-skinned facial types. The blond, chubby Christ is more babylike, being entirely nude and proportioned as an infant. His radically foreshortened halo shows Masaccio's command of three-dimensional space.

Christ is eating grapes, which Mary offers him. This unusual iconography is, on the one hand, a sign of infantile oral pleasure as Christ seems to enjoy sucking on his fingers. On the other hand, however, grapes are a source of wine, which stands for Christ's blood in the Eucharist. These particular grapes allude to Christ's death on the Cross and the subsequent ritual of the Mass. Masaccio's reputation for truthfulness in painting thus refers to his psychological accuracy as well as to his formal naturalism.

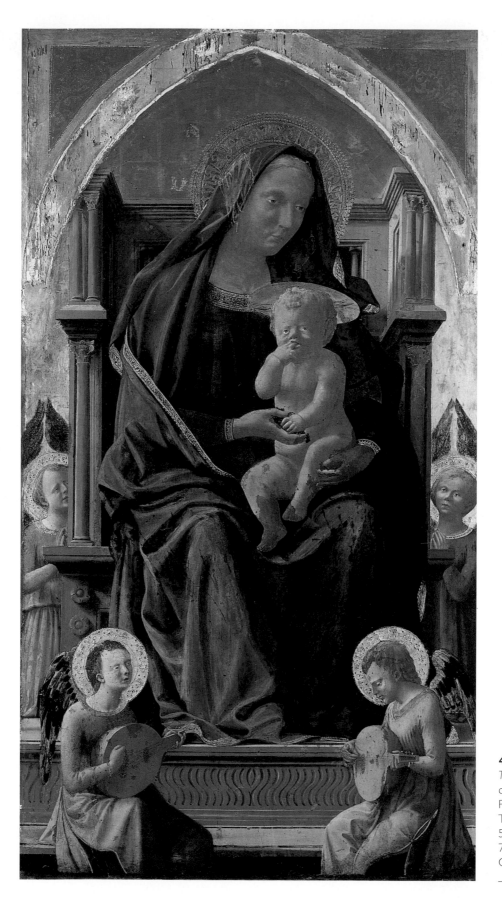

4.4 Masaccio, *The Virgin and Child*, center panel of the Pisa Altarpiece, 1426. Tempera on panel; 53 × 28¾ in. (135 × 73 cm). National Gallery, London.

Brunelleschi's Perspective System

Brunelleschi is credited with having invented a new mathematical theory of perspective, the purpose of which was to create the illusion of depth on the flat picture plane. He fixed the viewpoint of the viewer at the same location as that of the artist. For Brunelleschi, this was primarily for architectural purposes, based on the fact that the small size of a person in relation to a building results in a low viewpoint, from which one looks up at the architecture. This is diagrammed in figure **4.5**, in which lines of sight radiate from the viewer (A) through a vertical axis (B) to points on the baptistery and surrounding buildings.

Painters and sculptors of relief transformed Brunelleschi's construction into a system of linear perspective. This system was diagrammed in the 1430s by Leon Battista Alberti (**4.6**) (see Chapter 5). The surface plane of a picture or relief was conceived of as similar to a windowpane through which viewers saw the depicted image as they would see natural objects. The view through the window was like a box, with a floor parallel to a ceiling or some other horizontal feature, such as the horizon or sky, and vertical walls or trees perpendicular to the floor and ceiling. As a method of controlling and directing the viewer's line of sight, artists chose a vanishing point, where lines of sight converged. These lines—orthogonals (literally, "right angles")—were aligned with the edges of walls or other architectural features demonstrably perpendicular to the picture plane. When there is a single vanishing point, as in Alberti's diagram (VP), the system used is known as

onepoint perspective. To create the illusion of a natural recession in space, forms diminish in scale as they approach the vanishing point.

Because Renaissance artists aspired to naturalism, this method of constructing pictures and reliefs had enormous appeal. It allowed Renaissance painters to pierce the picture plane and create the illusion of three-dimensional space on a surface that in reality was two-dimensional. Over time, painters refined and developed Brunelleschi's original construction.

4.6 Leon Battista Alberti's perspective diagram.

4.5 Filippo Brunelleschi's perspective diagram.

The *Trinity*

Masaccio's fresco of the *Trinity* (**4.7**) on the left nave wall of Santa Maria Novella is the first Renaissance painting to follow completely Brunelleschi's new one-point system of perspective. It represents an illusionistic chapel, cut into the wall, which is occupied by the Trinity, Mary, and Saint John. God the Father stands on a ledge and towers over the crucified Christ. Hovering in the space between their heads is the dove of the Holy Spirit. Kneeling on the outside step are the donors, generally thought to be members of the politically powerful Lenzi family. The male donor wears the robes of *Gonfaloniere*, the office of standard-bearer to the republic of Florence.

Below the step, a skeleton lies on top of a sarcophagus and, through the written inscription, issues a warning to viewers: "I was once what you are, and what I am you will also be." This derives from the medieval tradition of the Quick and the Dead, admonishing the living to beware the temptations of material pleasures and their ultimate transience. In the context of the *Trinity*, however, the skeleton contains a simultaneous promise of salvation, for according to tradition Christ was crucified on the very site of Adam's burial, often indicated by the skull of Adam at the base of the Cross. Whether or not the skeleton was intended as a literal substitute for the skull, its presence below the Crucifixion evokes the typological pairing of Christ and Adam. It

4.7 Masaccio, *Trinity*, c. 1425–1428. Fresco; 21 ft. 10⅝ in. × 10 ft. 4¾ in. (6.67 × 3.17 m). Santa Maria Novella, Florence. There had probably been an altar in front of the fresco, where Mass was regularly performed. The burial of a member of the Lenzi family was marked by a tomb slab in the floor below the fresco.

serves as a reminder that through Christ's death the sins of Adam, and by extension those of mankind, are redeemed.

Masaccio's dissolution of the wall, following Giotto's precedent in the illusionistic chapels on the Arena Chapel's chancel arch (see 2.2), separates the sacred space of the holy figures from the worldly space of the viewer. Creating a transition between the two are the donors, who belong to the earthly world but aspire to salvation. Mary gazes outward, indicating her son on the Cross. He turns toward her, recapitulating their intimate relationship, whereas John gazes raptly at Christ and God stares straight ahead. The holy figures are thus linked by an orchestration of gaze and gesture that finds an echo in the tight chromatic alternations of red and blue.

The architecture of the fictive niche shows the impact of Brunelleschi on the young Masaccio. Fluted Corinthian pilasters frame the exterior and support an entablature with a projecting cornice. Supporting the round arches of the barrel-vaulted interior are Ionic columns with smooth shafts of the type used in the Hospital of the Innocents (see 3.14). Orthogonals are clearly aligned with the sides of the coffers and of the **abaci** over the Ionic **volutes**, and even the nails of the Cross (**4.8**). They lead to a vanishing point at the center of the bottom step, which corresponds to the eye level of the average person.

The perspective and geometry of the *Trinity* are as tightly organized as the color and, with the poses and gestures

4.8 Masaccio's *Trinity* with superimposed perspective lines.

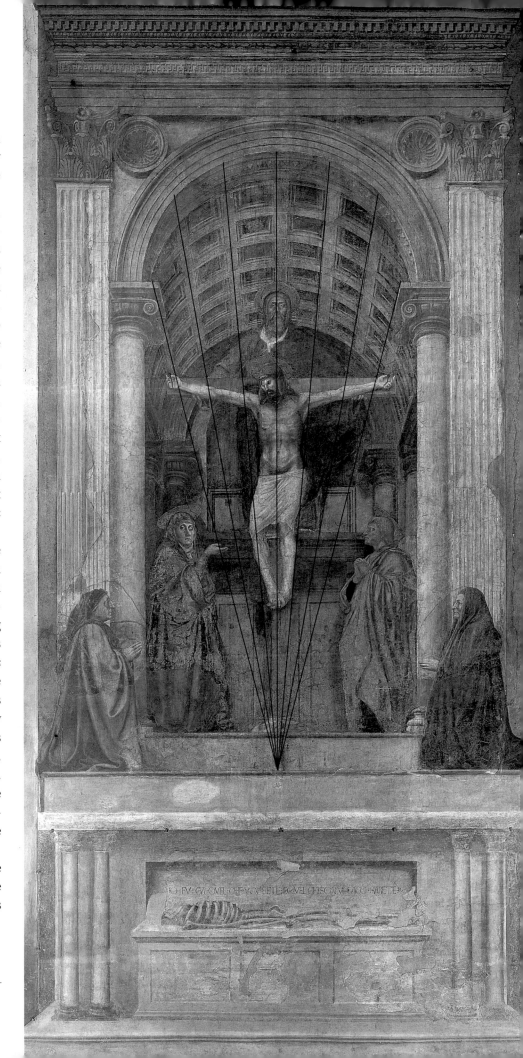

of the figures, are integrated into its meaning. Masaccio has constructed a hierarchical figural pyramid with his contemporaries closest to the viewer at the base. God, on the other hand, is placed at the back of the interior in the most sacred location and is at the apex of the pyramid. The emphasis on three-sided form, echoed in the use of three colors—red, blue, and white —merges structure with iconography. By placing the vanishing point at a fixed low point, Masaccio follows Brunelleschi's system in which viewers are assumed to look upward at architecture. Just below the Cross, bisected by the central orthogonal, is an abbreviated rock of Golgotha. As in Giotto's crucifix (see 1.17), the rock signifies the literal and figurative foundation of the Church—Rock of Ages—destined to last for all time.

The Brancacci Chapel Frescoes

It is in the monumental frescoes for Santa Maria del Carmine's Brancacci Chapel (**4.9**), imbued with a remarkable synthesis of form and content, that Masaccio created his most sustained dramatic narrative. Although the history of the chapel's decoration is complicated by the fact that three artists worked on it, one can fairly easily identify Masaccio's contribution. It appears that in the early 1420s the original commission was awarded to the older artist Tommaso di Cristofano di Fino, known as Masolino (1383–c. 1440), and that Masaccio joined the project shortly thereafter. The patron is believed to have been Felice Brancacci, whose grandfather, Pietro, had financed the construction of the chapel in the fourteenth century. It served as a burial site for the Brancacci family, which had achieved its wealth in the silk business.

Pietro Brancacci's patron saint was Saint Peter, to whom the chapel was dedicated and whose life the frescoes illustrate. Figures **4.10** and **4.11** show the disposition of scenes. There are two large scenes on each side wall, four smaller scenes on the altar wall, and four scenes on the pilasters. The two upper pilaster scenes provide the chapel's typological framework, with the *Temptation of Adam and Eve* by Masolino at the right and Masaccio's *Expulsion of Adam and Eve* at the left. Their juxtaposition with the life of Peter connects the establishment of the Church attributed to him with the redemption of the Fall of Man.

Formally, the frescoes are unified with the actual architecture of the chapel. The painted Corinthian pilasters at the corners of the altar wall, for example, appear to support the real entablature. All the frescoes are painted with a light source that corresponds to the natural source of light from the window. Paintings to the right of the window are illuminated from the left; those to the left of the window are illuminated from the right. This consistent, rational organization in which visual reality and fiction are merged is also characteristic of Masaccio's *Trinity*.

The Disposition of the Scenes

The remainder of the narrative scenes illustrate events from Saint Peter's life. They constitute the first monumental cycle of the Renaissance and are based on three texts: the Gospel of Matthew, the Acts of the Apostles, and the medieval collection of legends of the saints known as the *Golden Legend*. Assembled by the Dominican bishop of Genoa, Jacobus de Voragine, in the thirteenth century, the *Golden Legend* was a popular source of iconography throughout the Renaissance.

The overview of the frescoes (see 4.10 and 4.11) shows the organization of the narrative, which is diagrammed in figure **4.12**. Originally, two scenes—the *Calling of*

4.9 (*right*) View of the Brancacci Chapel, Santa Maria del Carmine, Florence. Frescoes by Masolino and Masaccio date to the 1420s; in 1428, Masaccio died and Masolino left Florence. The cycle was completed by Filippino Lippi in the 1480s. The ceiling is later.

4.10 and **4.11** (*above and above right*) View of the Brancacci Chapel side chapels without the window.

Expulsion of Adam and Eve	Tribute Money	Saint Peter Preaching
MASACCIO 7 × 3 ft. (2.14 × 0.9 m)	**MASACCIO** 8 ft. 1¼ in. × 19 ft. 7 in. (2.47 × 5.97 m)	**MASOLINO** 8 ft. 1¼ in. × 5 ft. 6 in. (2.47 × 1.66 m)
Saint Paul Visiting Saint Peter in Prison	The Raising of the Son of Theophilus and Saint Peter Enthroned as First Bishop of Antioch	Saint Peter Healing by the Fall of His Shadow
FILIPPINO LIPPI 7 ft. 7 in. × 3 ft. (2.32 × 0.89 m)	**MASACCIO AND FILIPPINO LIPPI** 7 ft. 7 in. × 19 ft. 7 in. (2.32 × 5.97 m)	**MASACCIO** 7 ft. 7 in. × 5 ft. 3¾ in. (2.32 × 1.62 m)

4.12 (*below left and below*) Diagram of scenes in the Brancacci Chapel.

Saint Peter Baptizing	Saint Peter Healing a Cripple	The Temptation of Adam and Eve
Saint Peter Baptizing MASACCIO 8 ft. 1¼ in. x 5 ft. 7¾ in. (2.47 x 1.72 m)	Saint Peter Healing a Cripple and the Raising of Tabitha MASOLINO 8 ft. 1¼ in. x 19 ft. 3½ in. (2.47 x 5.88 m)	The Temptation of Adam and Eve MASOLINO 7 x 3 ft. (2.14 x 0.89 m)
Saint Peter Distributing Alms and the Death of Ananias MASACCIO 7 ft. 7 in. x 5 ft. 1¾ in. (2.32 x 1.57 m)	The Crucifixion of Saint Peter and Saint Peter Disputing with Simon Magus FILIPPINO LIPPI 7 ft. 7 in. x 19 ft. 3½ in. (2.32 x 5.88 m)	The Liberation of Saint Peter from Prison FILIPPINO LIPPI 7 ft. 7 in. x 3 ft. (2.32 x 0.89 m)

Peter and His Brother Andrew and the *Navicella* (see p.7)—were depicted on the **lunettes** but have disappeared. Of those that survive, the *Tribute Money*—a rarely represented event from the Gospel of Matthew—just to the right of the *Expulsion*, is next in chronological order. This is the best known of the Brancacci Chapel frescoes, and we will return to it below.

The remaining scenes occur after Christ's death, when Saint Peter carries his message, performs miracles, and finally is martyred. On the lower left wall, as related in the *Golden Legend*, Saint Peter is jailed by Theophilus, the ruler of Antioch. Saint Paul visits Peter in prison (below the *Expulsion*) to inform him that he has secured his release in exchange for a miracle. In the large scene to the right, therefore, Peter resurrects the dead son of Theophilus. At the far right, the entire city has converted to Christianity, and Peter is enthroned as its first bishop, prefiguring his traditional role as the first bishop of Rome. He is ringed by a semicircle of worshipers, including three Carmelites wearing white mantles over black tunics. In the context of fifteenth-century Italy, their presence alludes to the connections between Santa Maria del Carmine and the papacy, which the Brancacci supported. The Carmelites also traced the origins of their Order to the era of the Old Testament, endowing themselves with an ancient history that gave them a special role in the early Church.

On the right wall opposite the *Tribute Money*, in two events from Acts, Peter cures a cripple in Jerusalem and resurrects the widow Tabitha in Joppa. These regions are connected in the fresco by a fifteenth-century Italian city street, in which two fops wearing the latest fashion are deep in conversation. The elegance of their costume, denoting the pleasures of the material world, is contrasted with the poverty of the cripple and the plain clothing in the right-hand scene. Tabitha herself, known for her piety, had made the simple clothing on the floor beside her coffin.

In the large fresco by Filippino Lippi below, Peter disputes with Simon Magus (a bogus magician) before the Roman emperor Nero at the right. At the left, as a sign of his piety in not wishing to imitate Christ, Peter is crucified upside down. In Acts, Peter is jailed by King Herod and is released (below the *Temptation*) by an angel. Here the soldier guarding the prison sleeps in ignorant darkness, whereas Peter and the angel as well as the wall behind them are illuminated in a bright white light. The opposition of Peter in prison with Peter's release from prison across the space separating the pilasters is a metaphor for the journey of the soul from spiritual darkness to the light of salvation.

On the altar wall, four frescoes of equal size flank the window. The top scenes show Peter preaching at the left and baptizing converts at the right. Below, he cures by the fall of his shadow at the left and distributes alms at the right.

Temptation and *Expulsion of Adam and Eve*

Today, the Brancacci Chapel frescoes have been considerably changed from their original appearance by centuries of burning lamp oil, dampness, fire, well-meaning efforts to remove the dirt, and several misguided restorations. Nevertheless, they still convey the power of Masaccio's style. His revolutionary approach to the human figure can be seen by a comparison of his Adam and Eve with those of Masolino.

In Masolino's *Temptation* (**4.13**) Adam and Eve stand by the forbidden tree—here a fig tree—gazing at each other as Eve prepares to taste the fruit. The slim, graceful forms of the primal couple are organically rendered in delicate *chiaroscuro*, highlighted against a dark background. The serpent winding itself around the tree frames Eve, clearly identifying her as the instigator of the Fall. Both she and Adam appear to be in a state of relative calm, casually considering what they are about to do.

Masaccio's *Expulsion* (**4.14**), in contrast, is fraught with expressive tension. Adam and Eve are expelled from Eden by the sword-bearing, foreshortened avenging angel above them and by God's angry voice portrayed as rays of light emanating from the gate of Paradise. These are the earliest monumental nudes in Renaissance painting, and Masaccio accentuates their passionate responses to confronting the real world in a way that evokes the viewer's identification. In contrast to the more static Adam and Eve of Masolino enveloped by darkness, Masaccio's couple strides forward into the light of day. In so doing, their powerful forms, firmly planted on the barren earth of a new world, cast pronounced shadows back toward Paradise.

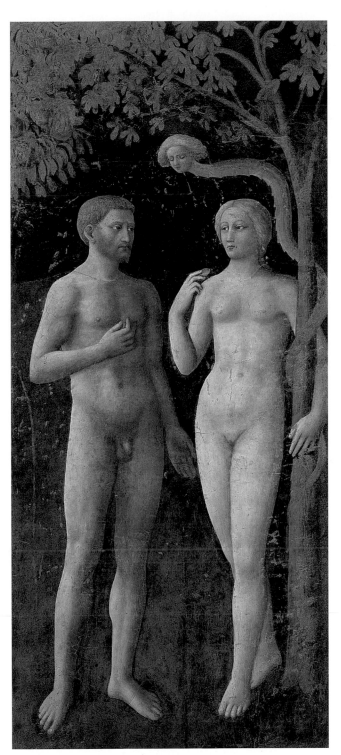

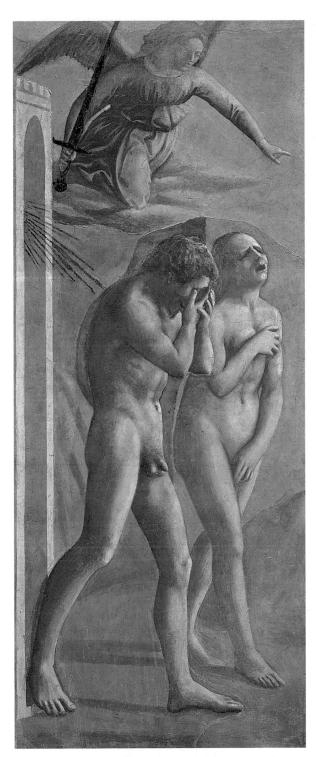

4.13 Masolino, *Temptation of Adam and Eve*, 1420s. Fresco. Brancacci Chapel, Santa Maria del Carmine, Florence. Masolino was born in Panicale in the Arno Valley, but little is known of his life. He frequently worked outside Florence—in Rome, Lombardy, and Hungary. His nickname, meaning "Little Tom," has been associated with the fact that his style is softer and more delicate than that of Masaccio ("Big Tom").

4.14 Masaccio, *Expulsion of Adam and Eve* (after restoration), 1420s. Fresco. Brancacci Chapel, Santa Maria del Carmine, Florence. In this illustration, the *giornate* are visible because some of the paint has been removed or worn away. They clearly show, for example, that the Adam was painted on a different day than the Eve.

Both the physical and emotional impact of Adam and Eve in the *Expulsion* are conveyed by Masaccio's emphasis on mass and **contour**. Adam hunches over, his exaggerated right shoulder accentuating his shame as he covers his face and draws his breath inward. The counterpoint to Adam's introversion, Eve shuts her eyes

4.15 *Medici Venus*, 1st century A.D. Marble; 5 ft. (1.53 m) high. Galleria degli Uffizi, Florence.

and wails in horror as she covers her nudity. Her pose is derived from a type of Hellenistic Venus in which the goddess modestly covers herself after bathing (**4.15**). As in Brunelleschi's borrowing of the *Spinario* (see 3.5) for the *Sacrifice of Isaac*, Masaccio's visual quotation from antiquity synthesizes form with content.

The *Tribute Money*

As with all four of the large frescoes on the side walls of the Brancacci Chapel, the *Tribute Money* (**4.17**) is divided into sections depicting different times and places. Nevertheless, a sense of rational order is maintained by either the disposition of figures or the architectural arrangement or both. The narrative sequence in the *Tribute Money* opens in Capernaum with the powerful central group of apostles surrounding Christ. A tax collector, rendered in rear view, demands tribute. Masaccio's apostles are reminiscent of Roman sculptures in their simple, massive draperies, firm stances, and portraitlike head types. The blond Saint John was certainly inspired by Roman portrait **busts**. His near double to the immediate right of the tax collector is juxtaposed with a face in shadow that probably represents Judas, who, like the tax collector, was propelled toward sinfulness by money.

The vanishing point of the painting is Christ's head, which thus draws the immediate attention of the viewer. His placement at the center of a semicircular arrangement of apostles is symbolic; it alludes to the configuration of the apse in relation to the crucifix on the altar. The tax collector, who is closest to the viewer, remains outside the sacred space. His difference from the holy figures is accentuated by his short tunic and boorish physiognomy.

The event is recorded only in the Gospel of Matthew (17:24–27), who was himself a tax collector: Christ responds to the demand for money by instructing Peter to catch a fish in the Sea of Galilee, saying that he will find the necessary amount in the fish's mouth. Peter, originally one of the fishermen to whom Christ said "I will make you fishers of men," reacts with anger. His gestures define his conflict as he both echoes Christ's outstretched hand and pulls back his foreshortened left hand. The other apostles exchange significant glances or glare at the tax collector.

CONTROVERSY
The Restoration of the Brancacci Chapel Frescoes

There has been considerable controversy over the issue of restoring works of art in Italy and elsewhere. Advocates point to the improved appearance of color with the removal of centuries of dirt and to a clearer view of the original image. Others feel that restorers have a vested interest in restoration. On the grounds that great works of art belong to the international community as well as to a particular locale, some scholars believe that independent commissions of experts should consider each potential restoration. Further, since the long-term effects of the chemicals used for cleaning have not been tested, these scholars argue that such tests should be done first on a small sample of the work. This would deny to those who financially underwrite the restorations the public-relations advantages that accompany large-scale undertakings. It would also mean that the restorers themselves would have a long wait before beginning work.

In the case of Masaccio's frescoes, opponents of the restoration object to the removal of shading that they feel is an essential characteristic of the artist's monumental style. In their view, more than dirt has been removed, and Adam has lost some of his original contour. By diminishing the effects of *chiaroscuro*, the forms are flattened. Compare, for example, figure **4.16** with the cleaned version of Masaccio's Adam (see 4.14). The uncleaned Adam has a greater sense of mass, and the contours are fuller; but advocates of the cleaning admire the clarity and crisper colors of the cleaned figure.

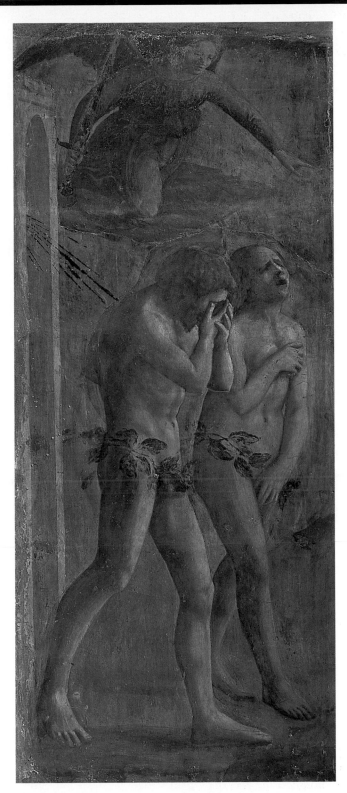

4.16 Masaccio, *Expulsion of Adam and Eve* (before restoration).

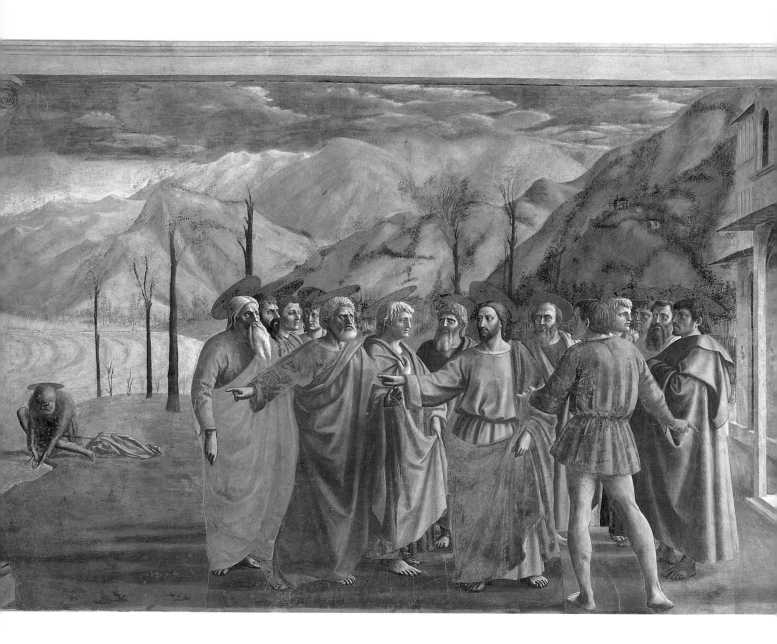

In the scene at the left, a radically foreshortened Saint Peter kneels at the edge of the Sea of Galilee. He has removed his yellow cloak and takes the tax money from the fish. Masaccio creates the illusion of distance both by **linear perspective** in the reduced scale of Saint Peter and the trees, and by **aerial** or **atmospheric perspective** in the diminishing clarity of the mountains. To the right of the *Tribute Money*, Peter pays the tax.

The Frescoes on the Altar Wall

The four smaller frescoes on the altar wall depict single events from Saint Peter's life (**4.18, 4.19, 4.20, 4.21**). At the upper left, following the *Tribute Money*, is *Saint Peter Preaching* (**4.18**), the only one of the four painted by Masolino. Described in Acts, this event takes place in Jerusalem following the Pentecost, when the apostles receive the power to speak in tongues. That is, they become fluent in different languages, enabling them to spread Christ's message throughout the world. Peter's audience includes members of the Carmelite Order— the figure at the far right seems to be a portrait, one of several in the cycle.

As the means of entry into the Christian faith, Peter urges penance and baptism. The power of his preach- ing—according to Acts, he converted some 3,000 people

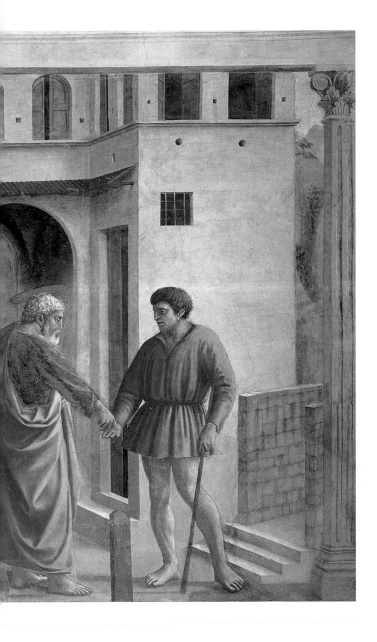

4.17 Masaccio, *Tribute Money*, 1420s. Fresco. Brancacci Chapel, Santa Maria del Carmine, Florence.

the first day—is shown in Masaccio's *Saint Peter Baptizing* (**4.19**) at the upper right. Compared with the Masolino, this rendition of Saint Peter is more fluid, the forms and head types more massive. Peter leans forward to baptize a powerful nude, who kneels solidly on the riverbed in prayer. The exaggeration of his neck and shoulder resembles that of Adam in the *Expulsion*, creating a visual echo juxtaposing the Fall with redemption through baptism.

Masaccio's attention to naturalistic detail is evident in the dripping-wet hair of the kneeling figure and in the man shivering behind him. As in some of Giotto's frescoes, Masaccio depicts stages of a single action that

define a subtext within the main scene—in this case, dressing and undressing as allusions to donning the clothes of a new faith. The man in blue, for example, his hair still wet, buttons his cloak; next to him another man pulls at his sleeve, whereas the shivering figure has already removed his clothes. At the same time, Masaccio's psychological realism emerges in the portrayal of human conflict: of the two figures between the willing converts, one gazes in a different direction and the other pulls his red robe toward himself as if refusing baptism.

In *Saint Peter Healing by the Fall of His Shadow* (**4.20**), which is below *Saint Peter Preaching*, Peter walks down

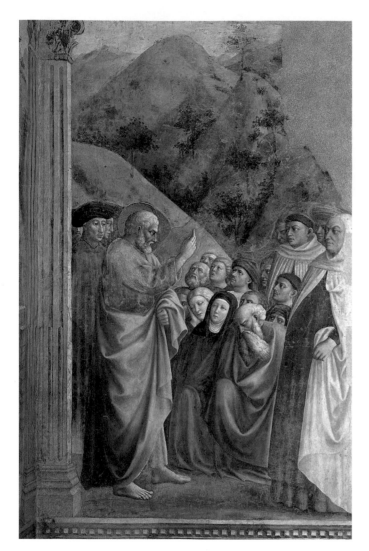

4.18 Masolino, *Saint Peter Preaching*, 1420s. Fresco. Brancacci Chapel, Santa Maria del Carmine, Florence.

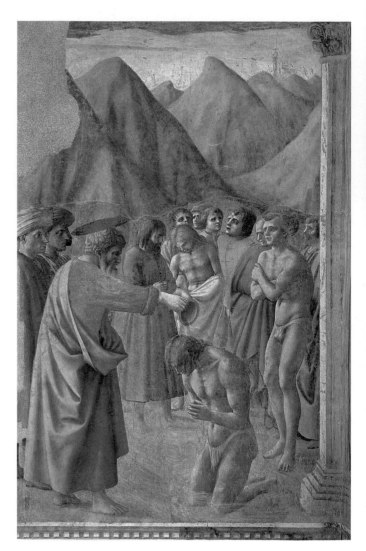

4.19 Masaccio, *Saint Peter Baptizing*, 1420s. Fresco. Brancacci Chapel, Santa Maria del Carmine, Florence.

a Florentine street, although the scene in Acts is Jerusalem—hence the Classical-style temple in the background. Saint Peter holds his right arm against his side and looks straight ahead, indicating that only his shadow touches the cripples along the buildings. As he passes, the sick are healed and the crippled walk. The miracle of light and dark that has curative power in this scene is consistent with Masaccio's interest in the power of light and dark for the creation of painted form. In addition to its formal character, the juxtaposition of light and dark, of shading and shadow, and of seeing

and not seeing, is a recurring theme in the chapel's decoration.

In the scene directly below *Saint Peter Baptizing*, Saint Peter distributes alms, and the deceitful rich man, Ananias, falls dead at his feet (**4.21**). In contrast to the scene above, this takes place in a contemporary town, with distant mountains rising in the background. Masaccio juxtaposes the poor who receive the benefits of Saint Peter's charity and live, and the rich man who dies. The mother and child would have created a significant contrast with the painting of the Virgin and Christ

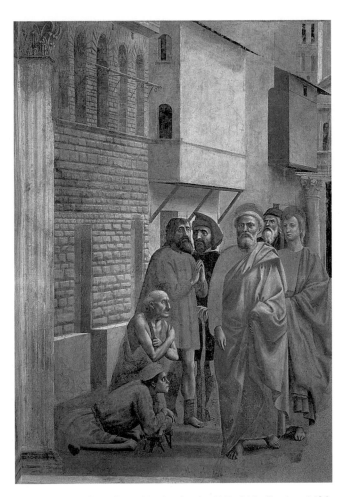

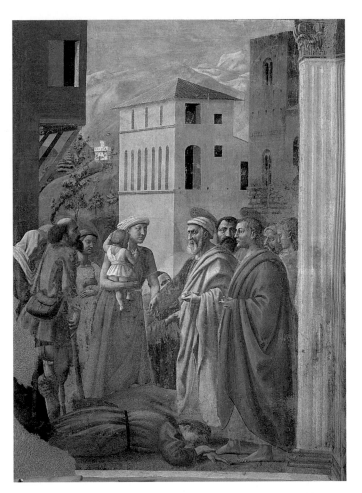

4.20 Masaccio, *Saint Peter Healing by the Fall of His Shadow*, 1420s. Fresco. Brancacci Chapel, Santa Maria del Carmine, Florence.

4.21 Masaccio, *Saint Peter Distributing Alms and the Death of Ananias*, 1420s. Fresco. Brancacci Chapel, Santa Maria del Carmine, Florence.

over the altar (see 4.9). Compared to the royal image of the miraculous infant Christ, this child is anonymous, held like a normal baby on its mother's arm, relating only to her, and turning its back on the world. The child's presence in this scene may also refer to Christ's admonition in Matthew (18:3): "Except ye be converted, and become as little children, ye shall not enter into the kingdom of heaven."

The thematic richness of Masaccio's frescoes, as well as the overall iconographic design of the cycle and the power of his form, contributed to their impact on fifteenth-century painting. Money itself, wealth and poverty, as well as the symbolic and formal significance

of light and shadow are important elements of the iconography. Theories about the commission also gravitate toward financial considerations: one theory relates the commission to the *catasto* of 1427; another links it to Felice Brancacci's interest in maritime commerce; a third cites Felice's relationship with the papacy and the fact that in 1423 Pope Martin V levied an unpopular tax on the Church in Florence. None of these theories is mutually exclusive, and all are consistent with the chapel's iconography. In the story of Saint Peter's life, he begins as a fisherman, becomes involved in a miraculous discovery of money in the mouth of a fish, and ends his life, as Christ promised, as a "fisher of men."

5
Painting in Florence: 1430–1460

Following Masaccio's death, a new generation of painters in Florence, a city where the arts were enthusiastically supported by those in power, would build on his pictorial innovations. At the same time, however, International Gothic taste appealed to patrons who wanted to display their wealth through rich materials and pageantry. The humanists preferred monumental naturalism and the inspiration of antiquity. Religious Orders as well as pious individuals tended to commission more spiritual, even mystical, works. And affairs of state continued to inspire civic iconography.

Given the political situation in Florence, patronage was closely bound up with the Medici family. In 1433 Cosimo was exiled to Venice and a year later returned as the de facto ruler of Florence. Supporting the Medici

were the populists, the so-called *popolani*, and, with Cosimo's return, his political adversaries—notably, the Strozzi and the Brancacci—were exiled. The women in those families, however, were allowed to remain behind since they were not considered a serious political threat.

The Medici remained dominant in Florence until 1494, when they were seen as tyrants and were again expelled. For most of the fifteenth century, they were lavish patrons of the arts, of architectural projects, and of humanist philosophers and poets. Their network of political and ecclesiastical connections, which they used to full advantage, was vast. They also used imagery to project an impression of themselves as pious, civic humanists, responsible for maintaining the stability and independence of the Florentine republic.

Women in the Italian Renaissance

During the Renaissance, women were wives, mothers, daughters, sisters, and grandmothers; rarely were they esteemed beyond their biological or social roles. The latter were determined by birth, and the only respectable alternative to marriage was entry into a convent. Married women were expected to produce children, preferably sons, and childbirth was often fatal. The main benefit of a daughter was her value in making an advantageous marriage and expanding the social and political connections of her family.

A woman's primary financial asset was her dowry, which she brought with her to her husband's family. In 1424, a fund was established—the *Monte delle doti*—so that a father could invest money that would accrue into a dowry for his daughter. This

was one way of permitting people who were not wealthy to increase a daughter's chances of making a good marriage. Like the Hospital of the Innocents, the *Monte* was one of several institutional indications during the Renaissance of a new social consciousness.

One effect of the humanist movement, and of the humanist curriculum in certain schools, was that a few elite women became classically educated. Some also became active in art patronage. In the fourteenth century, Boccaccio had taken up the issue of fame and had included women in his roster of famous people. To some extent, this had been inspired by the model of antiquity and the mention of several famous women in Classical texts.

Leon Battista Alberti:
On Painting

Leon Battista Alberti (1404–1474), a close friend of and adviser to the Medici family, was a key figure in Renaissance art theory and a leading intellectual. In 1435, he wrote the first Renaissance treatise, in Latin, on the theory of painting; the following year it appeared in Italian, or *volgare*, as the vernacular was called. Alberti describes himself as a painter, although no surviving paintings by him are documented. His treatise *On Painting* (*Della pittura*) reflects the view that painting is an intellectual pursuit, worthy of theoretical discussion. It is also thoroughly humanist in its continual recourse to Classical models.

Alberti was the illegitimate son of a wealthy wool merchant and a noblewoman of Genoa. His family had been exiled from Florence for political reasons, and he could not have visited the city before 1428 at the earliest, when the exile was revoked. He received a humanist education in Padua, studied law in Bologna, and became an accomplished Latinist. In 1431, Alberti entered papal service and was a member of the retinue of Pope Eugenius IV during a papal visit to Florence in 1434. While in Rome, Alberti studied the ancient ruins that later influenced his architecture (see Chapter 7) and developed an extensive knowledge of Classical texts. In addition to *On Painting*, he was the author of, among other works, an "anonymous" autobiography, the *Book of the Family* (*Della famiglia*), for which he was best known during his lifetime, a treatise on dogs, a collection of stories entitled *Dinner Pieces*, a short work on sculpture (*De statua*), and the *Ten Books of Architecture*.

In the Prologue to *On Painting*, Alberti reports that before coming to Florence he had seen nothing of interest in contemporary art. Once there, however, he witnessed the revival of all that had been lost since the fall of Rome. He dedicated the treatise first and foremost to Brunelleschi, and also to Donatello, Masaccio, Luca Della Robbia (who had worked with Donatello and was known for his glazed terra-cotta sculpture), and Ghiberti, who was then working on a second set of baptistery doors (see Chapter 7).

In *On Painting*, theory, as it generally does, follows the art; Alberti put into words much of what had already been achieved by the previous generation of artists. He describes a painting as the section of a pyramid of sight with rays converging on the viewer's eye (which is equivalent to the apex of the pyramid). These lines of vision are the orthogonals that lead to the vanishing point (see 4.6), and thus permit the painter to control the direction of vision. For this, according to Alberti, the painter has to know mathematics and geometry.

He describes constructing a *velo*, or veil, which is like a window between the eye of the painter and the section of the pyramid that is marked off in squares. This allows the painter to determine the exact size and position of his painted figures. His observation that one naturally perceives the relative, rather than the absolute, scale of human figures conforms to the notion of man as the measure of things. In order to replicate nature most accurately, Alberti argues, it is essential for the painter to create the illusion of mass and volume. To do this, light and dark have to be manipulated into the gradations of shading that appear in nature.

In matters of iconography, Alberti recommends abundance and variety, providing it is relevant to the narrative, which he calls *istoria*. Classical restraint is encouraged as consistent with human dignity, and Classical unity is required to ensure internal consistency. Actions, poses, and gestures should express the innermost character of the figures. In Alberti's view, it was Giotto's *Navicella* in Rome that best satisfied these requirements through the apostles' convincing reactions to Christ walking on water.

Alberti locates the origins of painting in nature, attributing its invention to Narcissus, the Greek youth who fell in love with his own reflection in a pool of water. Nature, like man, he believed, has to be true to itself. Draperies, such as those painted by Giotto and Masaccio, must therefore reflect the fact that in reality cloth falls to the ground. The good painting, like Narcissus's mirror image, is a reflection of man's nature and of his place in nature.

As part of the effort to elevate the status of painting, Alberti recommends that artists be well educated, technically skilled, and hard-working. The artist should also cultivate intellectual friends and patrons, and be acquainted with poets and orators who can help with the narrative underpinnings of the *istoria*. Finally, Alberti believed in the "divine force" of painting. Like

friendship, he observed, the painted image makes a person seem present and alive, thus preserving memory through a likeness. His famous request that artists paint his portrait in their works is an expression of his own narcissism as well as an allusion to the already established practice of embedding contemporary portraits and self-portraits in the *istoria*. In his view of painting as divinely inspired, Alberti implicitly presents the case for elevating its status to a liberal art. He acknowledges the power of imagery that was well understood in the Renaissance and prefigures Vasari's "deification" of the great High Renaissance artists—notably Michelangelo.

Fra Angelico

One of the clearest examples of Alberti's influence on painters can be seen in Fra Angelico's (c. 1400–1455) altarpiece for the Dominican church of San Marco (**5.1**), in Florence. Although it is now in a damaged state, its construction remains clearly visible. Its subject matter is traditional, representing the enthroned Virgin and Child surrounded by saints, but the perspective and certain iconographic features reflect the latest fifteenth-century developments.

5.1 Fra Angelico, San Marco Altarpiece, c. 1438–1440. Tempera and gold on panel; main panel: 86⅝ × 89⅜ in. (220 × 227 cm). Museo di San Marco, Florence. This altarpiece was commissioned to commemorate the rededication on January 6, 1443, of the high altar to Saints Cosmas and Damian, in addition to Saint Mark.

5.2 Leon Battista Alberti's perspective diagram superimposed over the San Marco Altarpiece.

The squares of the Turkish carpet provide orthogonals leading to the central vanishing point at the Virgin's torso (**5.2**). An equivalent of Alberti's *velo*, dividing the picture plane into thirty-six squares, is superimposed over the painting in figure **5.3**. The central line of the grid bisects the painting exactly so that the heads of the main figures (except for the Virgin) are framed by the squares.

On reviewing the painting without the superimposed "veil" and perspective diagram (see 5.1), one cannot help being struck by its formal order and symmetry. Three friars at the right are balanced by three saints at the left. The disposition and diminished size of the angels on either side of the throne are nearly mirror images of each other. And there is a clear progression of horizontal planes from the foreground, past the saints and angels, who are separated from the tree-lined distance by a decorative cloth extended across the width of the picture.

Replacing the traditional Gothic throne is a Classical niche similar to the one in Masaccio's *Trinity* (see 4.7). Fra Angelico follows Alberti by creating different kinds

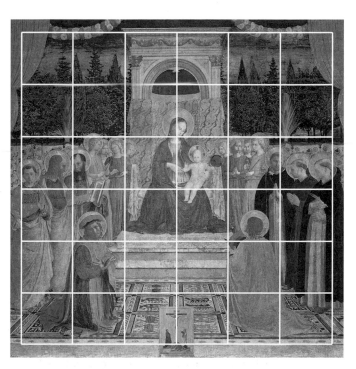

5.3 Leon Battista Alberti's "veil" superimposed over the San Marco Altarpiece.

of variety: texture, pose and gesture, character type, and setting. He has also depicted the natural force of gravity in the draperies, especially the heavy robes of the Medici patron saints Cosmas and Damian, who kneel in the foreground.

Their presence in this altarpiece is of the greatest significance, for it is an indication of Cosimo de Medici's importance as the major patron of San Marco's convent, adjacent to the church. Alluding to the red *palle* (balls) on a gold ground in the Medici coat of arms are the foreshortened red circles on the gold borders of the carpet. (It is probably no coincidence that the arms of the Cambio—the guild of bankers and money changers—are composed of a pattern of gold circles on a red ground, reversing the configuration of the Medici arms.) In the painting, Saint Cosmas—the very image of piety and penance but richly attired and in a lavish setting—turns to the viewer. Reinforcing the Medici presence are the predella panels (now in different museums) that illustrate the lives of Cosmas and Damian.

Cosimo-as-Saint-Cosmas acts as a visual intercessor between the viewer and the Virgin and Christ. His crossed hands refer to the future Crucifixion and are consistent with his air of sadness. His halo and red hat directly below the figure of Saint Mark also align him with the convent's patron saint. Mark himself holds open his own Gospel to the place in the text where Christ tells the apostles to go in pairs and heal (6:7). In Fra Angelico's iconography, this becomes an allusion to Cosmas and Damian in their role as physicians, which also resonates with the Medici name.

Fra Angelico was born Guido di Piero in the Mugello Valley. His teacher in painting is not known, but he was first trained as a **manuscript illuminator** in a **scriptorium**. In 1417 he joined a lay confraternity at Santa Maria del Carmine and sometime between 1418 and 1423 became a Dominican friar. He took the name Giovanni da Fiesole and embarked upon the rigorous life required by the Dominican *Constitutions*.

The detail in figure **5.4** shows the letter *R* of a manuscript page illuminated by Fra Angelico. The scene of the Annunciation is integrated into the structure of the *R*, with God radiating light and holding the Alpha and the Omega (the Beginning and the End) at the top of the letter. In a ray of light, the Holy Spirit descends on the Virgin, who is seated between the

5.4 Fra Angelico, *Annunciation*, detail of the letter *R* from Missal No. 558, after 1417. Museo di San Marco, Florence. According to Vasari, Fra Angelico's work was in great demand, and he could have lived in comfort; but he was driven by his piety to take the vows of a Preaching Friar. This view is borne out by his nickname, which means "angelic brother."

"legs" of the *R*. Outside the letter, emerging from the colorful foliate designs, is the angel Gabriel announcing Christ's conception.

In this image, Fra Angelico's combination of spiritual quality and Gothic delicacy with the new naturalism is apparent. The architectural function of the *R* is evident in the windowlike character of God's frame, through which a natural blue sky is visible. The "legs" of the *R* form the **portico** in which Mary typically reads; the curve steps forward as if accommodating itself to her. She is placed against a flat gold background, but the floor provides a rational horizontal support; her draperies are rendered in *chiaroscuro* and fall heavily to the ground, as recommended by Alberti. Here, as throughout his oeuvre, Fra Angelico refines naturalistic mass and volume with spiritual lightness and grace.

His training as an illuminator is consistent with his predilection for including written texts in some of his major altarpieces. In the San Marco Altarpiece, he integrates the Gospel of Mark into the iconography of Cosmas and Damian. Sometime in the early 1430s, probably before working at San Marco, Fra Angelico executed one of his most dazzling pictures, an *Annunciation* for the church of San Domenico in the Tuscan town of Cortona (**5.5**). Here, too, text is an important iconographic element.

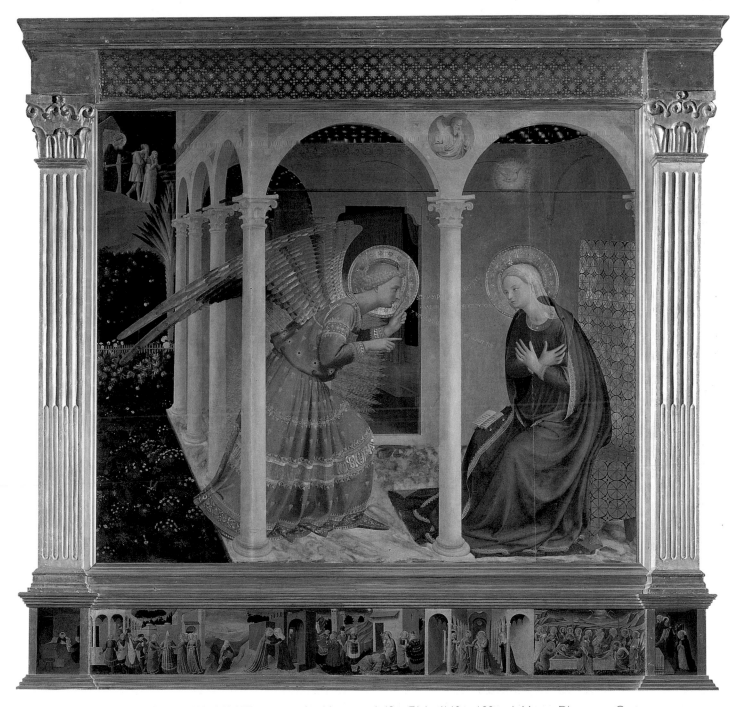

5.5 Fra Angelico, *Annunciation*, c. 1432–1434. Tempera and gold on panel; 63 × 71 in. (160 × 180 cm). Museo Diocesano, Cortona.

Framed by Corinthian pilasters, a band of star-studded blue at the top and predella panels below, this work exemplifies Fra Angelico's taste for rich textures and delicate gold patterns. The multiplicity of patterning—the marble floor, the gold cloth covering Mary's chair and the red curtain in her bedroom, and Gabriel's pink-and-gold costume—conveys a heavenly vision of Christian glory. Both Mary and Gabriel are elegantly graceful, their forms thin and delicate, and their heads framed by tooled golden halos.

The fence at the far end of the portico identifies the garden as the *hortus conclusus* [enclosed garden] of Solomon's Song of Songs, which came to signify the Virgin herself. Here the perspective of the garden leads the viewer's eye to the darkened scene of the Expulsion. Distant in time as well as in space, the darkness of the Fall of Man symbolizes the persistence of the primal couple's disobedience until the moment of the Annunciation. The latter is bathed in light, emphasizing its redemptive character and its typological role as the fulfillment of Old Testament prophecy. Represented in stone as the sign of an enduring past is the prophet in the tondo over the central column. As a reference to the Cross, the tree between the portico and the far distance is a visual, iconographic, and typological link between the two scenes.

God's creative Word that made Adam and Eve and brought them to life is depicted here as a written text extending between Mary and Gabriel; his words read from left to right: "The Holy Ghost shall come upon thee, and the power of the Highest shall overshadow thee" (Luke 1:35). Mary's response is printed upside down and reads from right to left: "Behold the handmaid of the Lord; be it unto me according to thy word" (Luke 1:38). Just as the manuscripts were conceived of as illuminating the Word of God, so here it is God's Word that illuminates the world.

Fra Angelico's taste for luminous patterns has affinities with contemporary painting in Flanders. Likewise, his precise depiction of small natural details such as the flowers in the Cortona *Annunciation*, as well as the attention to delicate golds, is found in the North. These qualities are particularly evident in the work of his Flemish contemporary (see Box, pp. 120–121).

One of the more interesting aspects of Fra Angelico is his combination of material splendor with simple draperies and sparse settings. The latter qualities characterize his most sustained group of paintings, the forty-five frescoes for the convent of San Marco, which he executed from 1338 to 1445 (**5.6**). In 1436, the reformed Observant Order had moved its headquarters from the hill town of Fiesole just outside of Florence to the city itself. Its dedication to Saints Cosmas and Damian, like the high altarpiece for the church, was a reflection of Medici patronage. In addition, the convent became a political refuge of sorts for the Medici and their allies. Cosimo had his own private cell, and when Eugenius IV was expelled from Rome in 1433, Cosimo arranged for him to stay at San Marco. In 1439, another close ally of the Medici, Fra Antonino Pierozzi (1389–1459)—later Saint Antoninus—became the prior of San Marco. Seven years later he was appointed archbishop of Florence.

The fact that these men, and the Dominicans generally, were not humanists did not preclude their Medicean alliances. Cosimo commissioned Michelozzo to redesign San Marco, which was consecrated in 1442. On January 6, 1443, this was celebrated in a lavish pageant of the Procession of the Magi from the cathedral, past Cosimo's residence on Via Larga, north to the convent. The date marked the Epiphany (the Adoration of the Magi) in the Western Church and the feast of Christ's Baptism in the Eastern Church. The importance of the Epiphany in the East determined, in part, the choice of the dedication date, which referred to the unsuccessful contemporary efforts to reunite the two branches of the Church.

Cosimo personally supported these efforts. When the Council of Churches of 1438 was transferred from Ferrara to Florence because of an outbreak of plague, Cosimo arranged housing for the delegates and their retinues. Even though the two Churches ultimately failed to reunite, the council and the elaborate costumes of the Byzantine emperor John VIII Palaeologus and his company made an enormous impression on the Florentines. Resonances of it can be seen in such elements as the Turkish carpet of the San Marco Altarpiece and the pageant of 1443. In fifteenth-century iconography, the Adoration of the Magi was typologically paired with the Council of Churches.

An important aspect of Cosimo's humanism was his interest in Classical texts. He sent antiquarians abroad,

especially to Byzantium, to acquire Greek manuscripts. In this endeavor, he helped to finance the scholar and copyist Niccolò Niccoli (1364–1437) and inherited the entire collection at Niccolò's death. The texts formed the basis of San Marco's library, the first modern public library in Europe. The view of the interior (**5.7**), designed by Michelozzo, shows the restrained Classical aesthetic of the library as well as the influence of Brunelleschi. Ionic columns support two rows of round arches. As in the Hospital of the Innocents, the shafts are smooth, and the vaults of the arcade are connected to the solid wall by corbels.

Although clearly involved with early fifteenth-century politics and generously financed by Cosimo de' Medici, life inside San Marco was conducted according to the liturgical calendar and strict rules of the Dominican *Constitutions*. This is reflected in the function and context of Fra Angelico's frescoes. In contrast to his altarpieces, the San Marco frescoes were intended for private viewing. Each cell inhabited by an individual friar contained a single scene from Christ's life, the purpose of which was to evoke prayer and meditation on the depicted event. This was consistent with the rigors of Dominican life, lived according to the liturgical

5.6 Plan of San Marco, Florence.

1 Library
2 Staircase from ground floor
3 North (lay brothers') dormitory
4 East (clerics') dormitory
5 South (novices') dormitory
6 Staircase from choir
7 Cells of Cosimo de' Medici

5.7 Michelozzo, view of the library of San Marco, finished 1444. Florence.

calendar and thus cyclical rather than historically sequenced.

The representation of time is an important feature of the San Marco frescoes. In the *Coronation of the Virgin* (**5.8**), for example, six saints—from left to right Thomas Aquinas, Benedict, Dominic, Francis of Assisi, Peter Martyr, and Mark—occupy the same celestial space as Mary and Christ. Time is condensed as the saints wear the habits of their earthly Orders, whereas Mary and Christ wear the white robes that denote their

timelessness. Although in reality virtually weightless, the clouds function as horizontal supports for weighty figures, whose robes obey the law of gravity.

The entire scene is bathed in a white light that is most intense between the rulers of Heaven. The purity of the inner circle of light takes the viewer into a realm beyond the gradations of shading in the natural world. Circles of color surrounding Mary and Christ signify the perfection of Heaven. Compared with the elaborate, Gothicizing *Coronation* by Lorenzo Monaco (see 4.1),

this is an image whose complexity is spiritual and psychological rather than material. The six saints are shown as if conjuring up the holy image through meditation and prayer, an effect specifically recommended by the *Constitutions* of the Order. This was also the desired impact of the fresco itself vis-à-vis the friar inhabiting the cell: it was intended to express the power of prayer as well as the power of imagery.

Fra Angelico's unusual *Mocking of Christ with the Virgin and Saint Dominic* (**5.9**) introduces an uncanny, surreal quality into an otherwise traditional scene. Disembodied hands slap and prod Christ, while a dis-

5.8 Fra Angelico, *Coronation of the Virgin* (cell 9), 1438–1445. Fresco; 67⅜ × 59½ in. (171 × 151 cm). San Marco, Florence.

embodied head spits at him. In the figure of Christ, Fra Angelico challenges the very boundaries of imagery, painted as well as imagined. Christ is simultaneously part of the image on the flat green cloth of honor and seated in front of it on a three-dimensional platform. Holding a mock scepter and an orb, he is blindfolded.

Part of his humiliation is in being looked at by the viewer but unable to return the gaze.

The setting of the *Mocking* is as mysterious as its space. It is undefined as to time or place, and beyond the wall is an anonymous and ominous black, possibly an allusion to the darkened sky at the Crucifixion. In the

5.9 Fra Angelico, *Mocking of Christ with the Virgin and Saint Dominic* (cell 7), 1438–1445. Fresco. 73⅝ × 59½ in. (187 × 151 cm). San Marco, Florence.

foreground, Saint Dominic meditates on a text as Mary contemplates her son's death. Seated in the conventional pose of mourning, she wears a sad expression that reveals what is portrayed as literally at the back of her mind. Her prominence in Fra Angelico's fresco program is probably related to her importance in the organization of the convent, where she was conceived of as a spiritual abbess. Her role as intercessor is implied in the *Mocking* by her spatial location between the saint and the pictured event from Christ's Passion.

After 1445, when the San Marco frescoes had been completed, Eugenius IV summoned Fra Angelico to Rome. There, Fra Angelico executed fresco cycles for Eugenius and, after the pope's death, for his successor, Pope Nicholas V.

Filippo Lippi

Fra Filippo Lippi (c. 1406–1469) was the son of a Florentine butcher with too many children to support. He and one of his brothers were therefore placed in the Camaldolese monastery of the Carmine. Unlike Fra Angelico, however, Filippo lacked the temperament of a friar. At one point, he had several nuns living in his house, allegedly using them as models. When one of the nuns, Lucrezia Buti, produced a son, Filippo was brought to trial and tortured. But he was fortunate in having the backing of Cosimo de' Medici and the humanist pope, Pius II (see Box). They arranged for him to withdraw from the Order, marry Lucrezia, and have their son Filippino legitimized. Despite Filippo's reputation as a moral reprobate, the Medici and the Church continued to patronize his work. His son became the painter Filippino Lippi, who completed the frescoes in the Brancacci Chapel.

Filippo Lippi's early style was influenced by Masaccio. According to Vasari, Filippo was so impressed with the monumental cycle of Saint Peter's life that he regularly visited the Brancacci Chapel and made drawings of Masaccio's figures. As in the work of his predecessor, Filippo's draperies are weighty and his generally blond figures have a strong physical presence. But his draperies are crisper, his figural types and material textures more delicate, and he was drawn to decorative patterns.

The *Madonna and Child* (5.10), generally dated to the 1450s, was executed at the height of Filippo's career. Mary is shown in prayer while two angels lift up Christ, forming a pyramidal figural composition. Christ himself is chubby, and the sense of his weight is clearly Masacciesque, but Mary's physiognomy is delicate and has a linear quality absent from the massive contours of Masaccio's figures. The diaphanous veils and thin, transparent halos reflect Filippo's interest in conveying subtleties of light.

Pius II

Aeneas Silvius (1405–1464) was born to an impoverished branch of the Piccolomini, a noble and influential Sienese family. One of eighteen children, he received a humanist education, became a Latinist, and studied law at the university of Siena. In his youth, Aeneas led a dissolute life; his early writings, which were in Latin and inspired by Roman authors, were overtly erotic. On his travels in Britain, he fathered an illegitimate child who was raised by his relatives in Italy.

Aeneas worked in a secretarial capacity in ecclesiastical administration and at first sided with the clergy opposing the papacy of Eugenius IV. In 1442, the Holy Roman emperor, Frederick III, appointed him his personal secretary and crowned him imperial poet laureate. Three years later, Aeneas switched allegiance and supported Eugenius.

Having repented his youthful transgressions, Aeneas embarked on a successful career in the Church. In 1446, he took vows; in 1447, he was appointed bishop of Trieste. By 1456, aged fifty-one, he was a cardinal and two years later pope. He took the name Pius, after Virgil's epithet for the Trojan hero. In humanist fashion, he merged the "Pius Aeneas" of the Roman epic with his own piety as a Christian. His official autobiography, the *Commentaries*, repudiates his dissolute youth, which is described in vivid detail. The work is a rich primary source for the man and his times.

5.10 Filippo Lippi, *Madonna and Child*, c. 1455. Panel; 35½ × 24 in. (90 × 61 cm). Galleria degli Uffizi, Florence. In his life of Filippo Lippi, Vasari recounts a tale that is consistent with two conventions of artists' biographies—namely, the impulse to create rather than to do schoolwork, and the power of talent to rescue the artist from danger. In this story, Filippo refused to study his schoolbooks, filling them instead with caricatures. Later, while sailing with friends, he was captured by Moors who took him to Barbary, keeping him and his friends chained in slavery for eighteen months. Hearing that Filippo was an artist, the slave master asked to have his portrait made. At this, Filippo took up a piece of burnt coal from the fire and drew on a white wall a full-length portrait of the master dressed in Moorish costume. The image seemed so miraculous that Filippo's captors took him to Naples, where he worked for King Alfonso.

This interest is particularly evident in the drawing study for the *Madonna and Child* (5.11). Here Filippo has concentrated primarily on the use of white to highlight the areas of light, which are then transposed into lighter shading in the painting. Following Alberti, he uses *chiaroscuro* to create a sense of relief emerging from the flat surface of the paper ground. The source of light is to the right, accentuated in the painting by Mary's cast shadow on the gray frame.

Just what the frame frames in the painting is not entirely clear. Like Fra Angelico's *Mocking*, this work plays with spatial ambiguity. The landscape background could depict a view through Alberti's veil-as-window. But the painted frame structures Filippo's painting in

Immaculate Conception of Mary, the Incarnation of Christ, and the Word of God.

Filippo Lippi's talent for creating mystical effects by manipulating light and dark led to several devotional commissions. One of the most important was the *Madonna Adoring Christ* (**5.12**) for Lucrezia Tornabuoni, the wife of Cosimo de' Medici's son Piero (see caption). The painting was commissioned for the altar of the Medici Chapel located in the family palace, and was thus intended for private viewing.

Its overwhelming mystical effect depends on the darkened forest, composed of tree and rock formations delicately edged with light. From the background gloom, the holy figures emerge in different degrees of light, increasing as they advance toward the picture plane. The darkest figure is a half-length, meditative Camaldolese monk—possibly Romualdo, who founded the Order—in a gray habit. As in the San Marco frescoes, he evokes the painted scene by an intense inward focus indicated by his lowered gaze and closed form. He prays over a log and a branch of twigs, which refer to the work of the Camaldolese who lived in the forest, subsisting on their own and cutting wood for fire. Just below the monk, the young John the Baptist gazes to the left. He is already wearing the hair shirt that signifies the penance of his ascetic life in the desert and carrying the scroll that identifies Christ as the Lamb of God.

God and the Holy Spirit penetrate the darkness in rays of light and arcs of stars. In the foreground, Christ and Mary, illuminated by the divine rays, are bathed in the purest light and richest color in the painting. A pensive Christ is the Light of the World, clothed in transparent drapery, his halo an echo of God's. Mary, too, is pensive, praying over Christ in a symbolic setting. The rocks have parted to reveal a flowering garden, the symbol of Mary herself and an allusion to the renewal of life with Christ's birth.

At the lower left corner, an ax handle is embedded in the trunk of a dead tree. Inscribed in gold on the handle is the artist's signature: "FRATER PHILIPPUS P(inxit)" [Brother Philip P(ainted) this work)]. This image is a metaphor signifying the end of the Old Dispensation and the birth of Christ as the new Tree of Life. Both the mood and iconography of the painting are designed to evoke a meditative response, while also reflecting the piety of its patron.

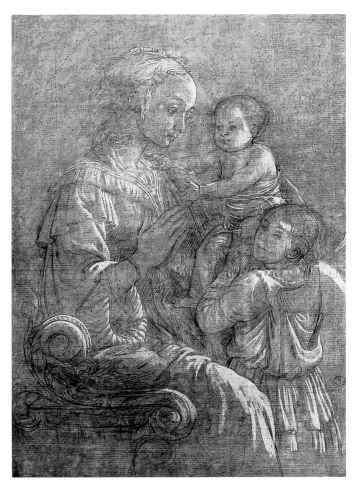

5.11 Filippo Lippi, *Madonna and Child*, c. 1455. Drawing study. Gabinetto dei Disegni e delle Stampe. Galleria degli Uffizi, Florence.

such a way that it also appears to frame the figures, who, in turn, move illusionistically in and out of its space. Filippo's *Madonna and Child* is one of several Renaissance paintings in which a landscape background is both spatially ambiguous and metaphorically related to the foreground figures.

The prominent rock formations directly behind Christ's head refer to the Church and the distant city to the heavenly Jerusalem. At the left, the landscape opens into a body of water, alluding to Mary's association with the sea. In this painting, there is a particular emphasis on the motif of the pearl, which is a product of the sea. Small pearl clasps hold together the embroidered pillowcase on the arm rest and are repeated in Mary's hair. Their spherical shape was related to the ideal Platonic form adopted by Renaissance thinkers and they also symbolize the

Relatively late in his career, in the small town of Prato near Florence, Filippo Lippi executed a monumental fresco cycle illustrating the lives of Saints Stephen and John the Baptist. The most important scene is the large *Feast of Herod* (the son of Herod who decreed the Massacre of the Innocents), which includes the *Dance of Salome* and *Salome Presenting the Head of John the Baptist to Herodias* (**5.13**). It illustrates the story of King Herod's incestuous relationship with his cousin Herodias, which was denounced by John the Baptist. In revenge, Herodias persuaded her daughter, Salome, to dance for Herod and to demand John's head on a plate.

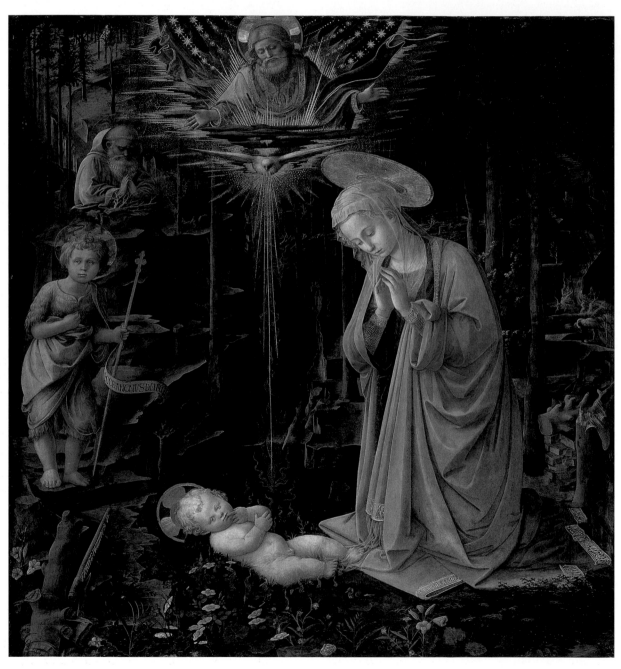

5.12 Filippo Lippi, *Madonna Adoring Christ*, 1450s. Panel; 50 × 45⅝ in. (127 × 116 cm). Gemäldegalerie, Berlin. During her marriage to Piero de' Medici, Lucrezia was involved in his patronage and well acquainted with the humanist authors of the Medici circle. After Piero's death, she became a successful businesswoman, a poet, and the most trusted political adviser to her son, Lorenzo the Magnificent.

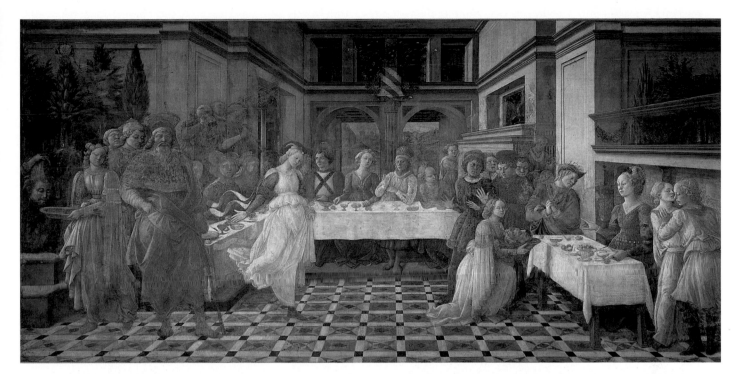

5.13 Filippo Lippi, *Feast of Herod*, 1452–1466. Fresco. Prato Cathedral. Filippo's cycle in Prato Cathedral was financed by the local Datini family, whose coat of arms is placed over the central pilaster behind Herod's table. The Datini derived their wealth from international trade, and when Francesco Datini (c. 1335–1410), the founder of the family business, died, he bequeathed 70,000 florins to the poor. At the time of Filippo's fresco cycle, the rector of the cathedral was Carlo de' Medici, the illegitimate son of Cosimo by a Circassian slave; he was raised as a member of the family and received a Classical education along with Cosimo's other children.

Structured symmetrically with readily identifiable orthogonals in the floor tiles and side walls, the fresco was clearly designed with Albertian perspective in mind. Likewise, a unity of color is achieved in the alternating reds and greens of the tiles that are repeated in the trees, draperies, and architectural entablatures. The vanishing point is located behind Herod, who presides over the central table.

As with Masaccio's *Tribute Money*, Filippo's *Feast* is divided into three scenes within a single, unified space, and it follows the same narrative sequence. The first scene is the central one: Salome, although dancing, is a study in frozen movement. At the far left, she receives the head of John the Baptist on a plate. The scene of decapitation is painted in shadow around the corner of the chapel and is thus not visible in this illustration. At the right, Salome kneels before her mother and offers her the plate.

The grisly nature of the narrative, which is mitigated by the elegance and delicate grace of Filippo's style, is nevertheless revealed in a play on the gaze. Banqueting figures both look at and avoid looking at the severed head, presented, like a meal, on a plate. In the left-hand episode, Salome turns away but glances sideways at the unseeing head. At the center, only Herod watches intently as Salome dances. And at the right, only Herodias looks directly at the head, from which Salome averts her gaze. The onlookers on either side of Herodias express their ambivalence through conflicted poses and gestures.

Filippo Lippi's final work was a fresco cycle in the apse of Spoleto Cathedral. He had left the Camaldolese Order, but continued to work for ecclesiastical patrons, and mystical subjects were not incompatible with his artistic nature. As with Fra Angelico, Filippo's style reflects the impact of the most innovative first-generation fifteenth-century artists while also revealing a taste for delicate patterns, varied surface textures, and graceful, elegant figures. Other painters contemporary with Filippo and Fra Angelico, who worked primarily in Florence, approached their art in a somewhat different manner. These are considered in the next chapter.

Jan van Eyck and the Renaissance in the Netherlands

The Netherlands in the fifteenth century, like Italy, evolved from medieval feudalism into a bourgeois mercantile economy. Both areas were prosperous in banking, wool manufacture, and trade. Commercial and artistic contact between Italy and the North was thriving; Italian courts employed Northern artists, and the North attracted businessmen from Italy. As a result, there was considerable cross-cultural interchange.

The Northern artists were affected by innovations in perspective and monumental form, but they were less influenced by the Classical revival than the Italians. Gothic tradition persisted more strongly in the North, where the use of **oil paint** lent itself to precision of execution and richness of color. Because oil dries slowly, it can be reworked and revised, whereas fresco and tempera cannot. Although some Italian artists used oil in the fifteenth century, it did not become widespread before the sixteenth century.

The leading Northern painter of the 1430s was Jan van Eyck (c. 1390–1441). Working at the court in Bruges of Philip the Good of Burgundy, he absorbed the International Style as well as the newer Renaissance developments. His *Madonna with Chancellor Nicolas Rolin* (**5.14**) for the church of Notre Dame

in Autun (in Burgundy) shows his taste for detail and texture, with which he celebrates both the heavenly and the earthly world. The chancellor kneels before an open missal, his meditations interrupted by a vision of the Virgin being crowned Queen of Heaven. Her drapery, like that of Masaccio's figures, is weighty; but the angular folds derive from Gothic rather than Classical form. Seated on the Virgin's lap is a regal infant Christ, holding the orb of the world surmounted by a jeweled Cross. His gesture of blessing echoes Rolin's praying hands, and they communicate across a space defined by the receding row of floor tiles.

The tiles lead the viewer past the triple round arches of the back wall to a detailed landscape divided by a river. To the left, on the side of Chancellor Rolin, are the plowed fields of the earthly world. On the right, the golden towers of numerous Gothic churches denoting the Heavenly City are visible beyond the Virgin and Christ. Linking the two worlds in the background is the bridge, which leads the viewer's gaze across the picture plane from Christ's raised hand toward the chancellor. Clearly, the implication is that piety and prayer are the route to salvation.

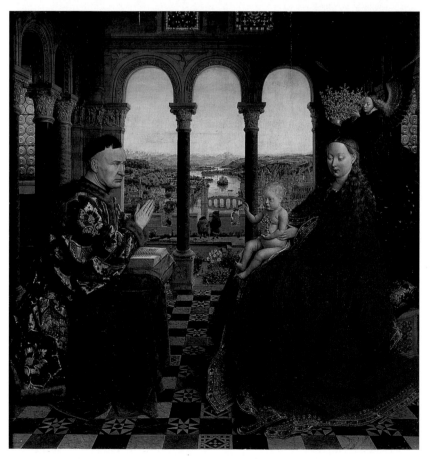

5.14 Jan van Eyck, *Madonna with Chancellor Nicolas Rolin*, c. 1435. Oil on panel; 26 × 24⅜ in. (66.0 × 61.9 cm). Musée du Louvre, Paris.

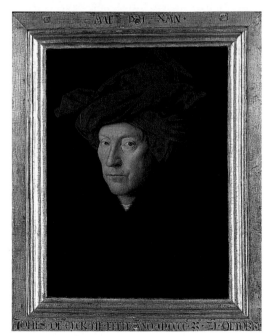

5.15 Jan van Eyck, *Man in a Turban*, 1433. Oil on panel, 13⅛ × 10⅛ in. (33.3 × 25.8 cm). National Gallery, London.

5.17 Jan van Eyck, mirror, detail of Figure 5.16.

5.16 Jan van Eyck, *Arnolfini Portrait*, 1434. Oil on panel; 32¼ × 23½ in. (81.9 × 59.7 cm). National Gallery, London.

Van Eyck reinforces the perspectival pull into the distance by the diminished scale of the landscape. Standing on a parapet between the interior sacred space of the foreground and the external world are two tiny figures gazing into the distance. The one wearing the red turban has been identified as van Eyck himself because of its similarity to his generally acknowledged self-portrait, the *Man in a Turban* (**5.15**).

Van Eyck's complex and controversial *Arnolfini Portrait* (**5.16**), which reflects the commercial ties between Italy and the North, was commissioned by a member of the Arnolfini family of Lucca. A great deal of scholarly ink has been spilled over the meaning of this unusual picture. It was read by Erwin Panofsky as a marriage document in which the artist's presence—attested by his signature on the wall ("Jan van Eyck was here") and his tiny supposed self-portrait in the mirror (**5.17**)—provides a witness to the cer-

emony. In Panofsky's view, the bride was Jeanne Cenami and the groom Giovanni Arnolfini. Later art historians have emphasized social, economic, and gender-driven aspects of the iconography.

In a 1998 publication, Lorne Campbell demonstrated that the wedding in question did not occur until 1447 and, therefore, could not be the subject of van Eyck's painting. According to this argument, the image is a double portrait and was so identified in sixteenth-century inventories. Campbell further identifies the figures as Giovanni di Nicolas Arnolfini, who lived in Bruges from at least as early as 1419, and a hypothetical second wife.

From the point of view of style, the *Arnolfini Portrait*, like the *Chancellor Rolin*, has absorbed the Renaissance interest in three-dimensional space accentuated by receding orthogonals and figures rendered in *chiaroscuro*. It also reflects Flemish attention to meticulous detail, but in a different setting. This scene takes place in a domestic interior, although it is, like that of the chancellor, a sacred space. God's presence is everywhere indicated—by the chandelier, the rosary, the light entering the window, the tiny wooden statue of Saint Margaret (patron of childbirth) on the chair-back, the scenes of Christ's Passion circling the mirror, and the mirror itself, which could symbolize the eye of God.

The emphasis on portraiture and self-portraiture in van Eyck's work is consistent with practices in Italy. Early Renaissance artists in the North as well as in the South had a new sense of themselves evident in the development of autobiography and in the increasing tendency to sign their work. Van Eyck's signature in the *Arnolfini Portrait* declares himself by word (and presumably by image), thereby becoming "present" and ensuring his own memory as Alberti would recommend in *On Painting*, published the following year.

6
Painting in Florence, II: 1430–1460

The wealth of art produced in Florence around the middle of the fifteenth century was enormous. Perhaps the most significant of the painters who were contemporaries of Fra Angelico and Filippo Lippi were Paolo Uccello, Andrea del Castagno, and Domenico Veneziano. Given their importance, remarkably little is known about their lives. Nevertheless, it is clear from their work that each, in his own way, built on the innovations of Giotto and Masaccio, and was deeply influenced by the humanist movement.

Paolo Uccello

Perspective appealed particularly to Paolo di Dono, called Uccello (1397–1475), the oldest of the three. Rather than subordinating the perspectival structure of his paintings to the content as Fra Angelico did in the San Marco Altarpiece and as Filippo did in the *Feast of Herod*, Uccello made their mathematical underpinnings manifest. This was evident to Vasari, who reported the famous anecdote in which Uccello arouses his wife's jealousy by exclaiming on the beauty of *la prospettiva*—"perspective"—a feminine noun in Italian. In the anecdote, as in the paintings, perspective becomes content.

Vasari cites Uccello's drawings of the *mazzocchio* (6.1), a geometric wire support for the popular Florentine headdress, as examples of his obsession with perspective. Two such headdresses are worn by the fops in Masolino's fresco the *Raising of Tabitha* and *Saint Peter Healing the Cripple* on the right wall of the Brancacci Chapel (see 4.11). In the perspective study of a chalice (6.2), Uccello elaborated the *mazzocchio* form into the top sections of the vessel. In reality, the chalice is static but seems to spin in the drawing; it is composed of polyhedrons but appears rounded. Uccello actually shows the geometric armature of the chalice, while also projecting a convincing image of the chalice itself. The drawing exemplifies his unique ability to fuse geometric structure with the natural contours of objects and figures.

6.1 Paolo Uccello, drawing of a *mazzocchio*, 1430s. Pen and ink. Gabinetto dei Disegni e delle Stampe, Galleria degli Uffizi, Florence.

Uccello's original use of perspective is also evident in his monumental equestrian portrait of the English *condottiere* Sir John Hawkwood (c. 1320–1394), commissioned by the Opera del Duomo for the left wall of Florence Cathedral (**6.3**). Hawkwood, known as Giovanni Acuto in Italy, had distinguished himself by defending Florence from the imperial ambitions of the Milanese tyrant Giangaleazzo Visconti. The commission was thus politically motivated, and the ecclesiastical setting of the work combined the power of the Church with civic humanism and the theme of fame in a new way.

In 1393, the Opera del Duomo had planned to honor Hawkwood with a marble tomb, but this was changed to a large fresco. Later, in 1433, the Opera decided that a new fresco was called for and held a competition for the commission. It was awarded to Uccello in 1436, but, for reasons unknown, his first version was rejected. His second version, illustrated here, was accepted.

6.2 Paolo Uccello, drawing of a chalice, 1430s. Pen and ink; 13⅜ × 9½ in. (34 × 24 cm). Gabinetto dei Disegni e delle Stampe, Galleria degli Uffizi, Florence. According to Vasari, Uccello's infatuation with perspective caused him to neglect his wife and children. His obsession produced tours de force of illusion such as this chalice, but it also left him impoverished in old age. In Vasari's view, Uccello wasted his talent, neither realizing paintings nor earning money commensurate with his abilities.

6.3 Paolo Uccello, *Sir John Hawkwood*, 1436. Fresco (transferred to canvas in the 19th century); size without frame: 24 ft. × 13 ft. 3 in. (7.32 × 4.04 m). Florence Cathedral. The frame is a 16th-century addition. As well as this work, Uccello designed stained-glass windows and a large painting of a twenty-four-hour clock for the cathedral.

Condottieri

The *condottiere* was a mercenary leader whose fame was a prominent theme in Renaissance iconography. Achievements on the battlefield were characterized as combining strategic intelligence with bravery, loyalty, and virtue. Such men were sometimes honored with an equestrian monument financed by the state they had defended. These could be bronze statues or, as in the two works illustrated in this chapter, large-scale murals.

Precedents for the equestrian monument can be traced to sixth-century-B.C. Greece, when the horseman was associated with bravery; unfortunately, all surviving Greek examples are fragmentary. In Rome, the image denoted nobility as well as valor and was reserved for emperors. During the Middle Ages, equestrian monuments were generally placed over tombs or doorways, and sometimes in churches. In 1330, the Ghibelline Scaligeri lord of Verona was depicted as a knight on horseback, elevated on a trapezoidal base over his tomb (**6.4**). His

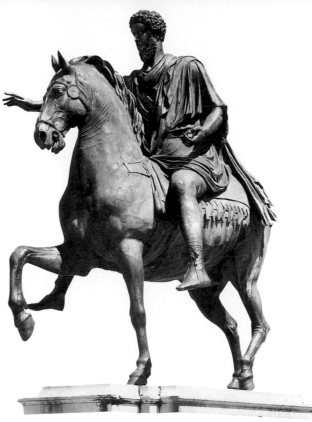

6.5 *Marcus Aurelius*, 2nd century A.D. Bronze. Originally outside the Lateran Basilica and moved to the Piazza del Campidoglio in 1538; now restored and moved to the Museo Capitolino, Rome.

6.4 *Cangrande della Scala*, 1330. Stone. Originally Santa Maria Antica; now in the Museo del Castelvecchio, Verona.

designation as *Cangrande*—literally, "the Great Khan"—like the statue itself, was designed to project an imperial image.

Compared with the monumental equestrian bronze of Marcus Aurelius (**6.5**) in Rome, Cangrande's statue appears static. The Roman emperor is shown in the combined iconography of a statesman (wearing a tunic and extending his arm in an oratory gesture) and a triumphant military leader (mounted on horseback and originally trampling an enemy cowering beneath the horse's forelegs). Formally as well as iconographically, the Roman image appealed to the republican sentiments and aesthetic tastes of fifteenth-century Florence. The horse rears and, with the emperor, turns in space. Marcus Aurelius's pose merges the ruler's authority with his role as the spokesman for the citizen of Rome. As a statesman, orator, and Stoic philosopher who wrote the *Meditations*, Marcus Aurelius was a model for Renaissance humanists.

6.6 Paolo Uccello, *Sir John Hawkwood*, c. 1436. Squared drawing in silverpoint, white, and light green; 18 × 36 in. (46 × 91 cm). Gabinetto dei Disegni e delle Stampe, Galleria degli Uffizi, Florence. By means of the grid, Uccello was able to transfer the image from the drawing to the painting. This is the earliest surviving example of a grid drawing for this purpose, but the technique is known to have been used by Brunelleschi for drawings of Roman buildings.

(**6.7**), or singing gallery, produced by Luca Della Robbia (1399/1400–1482) some two years earlier. Both make use of consoles projecting from the solid cathedral wall into the space of the viewer, but Uccello's are reduced from five to three. His image is more imposing and, despite the Corinthian pilasters of the *cantoria*, has a more antique flavor.

Uccello used his experimental approach to perspective to solve the problem of the *Hawkwood*'s viewpoint that is posed by its height. If the perspective were accurate, the view of Hawkwood would be obscured by the underside of the horse. Instead, Uccello has depicted the base as if the viewer were standing below it, as in reality would be the case. The horse and rider, on the other hand, do not conform to reality, for they are visible in profile, as if the viewer were higher up. Ironically, by altering the natural viewpoint, Uccello created a convincing illusion—that of a statue behind the plane of the cathedral wall.

In the 1440s, Uccello created his masterpiece in fresco, illustrating scenes from Genesis for the Green Cloister of Santa Maria Novella. Despite the extensive damage to these frescoes, the detail from the *Deluge* in figure **6.8** reflects Uccello's interest in monumental human form and the influence of Masaccio. The light source seems to be a bolt of lightning striking a tree in the background, which corresponds with the vanishing point. From that point forward, the winds blow with the force of a gale, signifying that the Flood is God's will. As the storm

As preparation for the fresco, Uccello made a squared drawing (**6.6**) for transferring the smaller study to the large wall painting. The final image incorporates the Opera's original plan for a sculptured tomb by depicting a statue rather than a flesh-and-blood horse and rider. The horse, rider, and base are a nearly monochrome green, varied only by the trappings and baton, the inscription and the coats of arms, set off against a dark red background. The Latin inscription on the sarcophagus describes Hawkwood's heroism, and the artist's signature—"PAULI UC[C]IELLI OPUS"—appears on the base.

As for the horse and rider, the inspiration for Uccello's base was a sculpture. It resembles the marble *cantoria*

6.7 Luca Della Robbia, *cantoria*, 1434. Marble; 10 ft. 9 in. × 18 ft. 4 in. (3.28 × 5.6 m). Museo dell'Opera del Duomo, Florence.

begins to subside, Uccello conveys the frenzy of those excluded from the safety of the ark.

Two men brandish clubs in a futile effort to defend themselves; the figure in the foreground has a *mazzocchio* around his neck, as if in the excitement it has slipped from his head and the rest of the headdress has blown away. Others grasp onto floating objects or climb onto the side of the ark. The sense of the unrelenting force of wind and water is conveyed by the animals caught up in the deluge as well as by the panicked gestures of the human figures.

In the midst of the chaos, Uccello maintains a strict perspectival organization. Both the wall of the ark and the ladder are arranged as receding orthogonals, which are formal as well as symbolic in character. The tunneling perspective of the abrupt recession increases the sense of speed from foreground to background, accentuating its counterthrust against the strong winds.

The Renaissance notion of a universal harmony based on mathematics and geometry is a latent subtext of this picture—and, indeed, is implied in all of Uccello's work. It is combined with the humanist view of man's dignity,

which is exemplified by the idealized monumental nudes. Whatever the destructive forces of nature, according to Uccello's iconography, it is the underlying geometry—the ark itself, the ladder, and the *mazzocchio*—that structures the fresco as well as the universe. This, together with the human will to survive, is the source of the powerful impact of the *Deluge*.

Uccello's most monumental panel paintings, in which geometric order is also manifest, were commissioned for a state bedroom in the Medici Palace, whether by Cosimo or his son Piero is not documented. Variously dated to the 1430s, 1440s, and 1450s, the panels were probably produced after the Santa Maria Novella cycle. They depict three episodes in the Battle of San Romano of 1432, in which the *condottiere* Niccolò da Tolentino, a friend and ally of Cosimo de' Medici, defeated the Sienese forces. All together, the paintings spanned over 34 feet across the wall of a bedroom and were arranged so that the armies on the side panels were focused toward the central battle. Today, they were in three separate museums: the National Gallery in London, the Uffizi, and the Louvre.

6.8 Paolo Uccello, *Deluge*, detail, 1440s. Fresco. Green Cloister, Santa Maria Novella, Florence. The Green Cloister derives its name from the predominantly green monochrome *terra verde* used by Uccello. For the architectural elements, he used ocher with an orange cast.

The panel originally on the left (**6.9**) depicts Niccolò da Tolentino on a rearing white horse, leading his troops into the fray. He wears a red and gold headdress supported by a *mazzocchio* and extends his baton. Above is a fluttering banner decorated with his device of the knot. The power of his army is enhanced by the unrelenting force of densely packed soldiers. In sharp contrast to the anonymity of the armored figures, a delicate page rides serenely behind his leader.

The foreground action takes place on a horizontal platform on which broken lances, pieces of armor, and a foreshortened fallen soldier are arranged as orthogonals. A sudden thrust into the distant landscape is indicated by stragglers running, fighting, or simply riding away up the hill. Their small size, which defines their distance from the main battle, indicates Uccello's studied use of linear perspective. Throughout the panel, the orange fruit in the trees, echoed in the balls on the horse trappings, refer to Uccello's Medici patrons. The oranges are actually a type of apple and a Medici symbol, the *mala medica*—"medicinal apple."

The panel at the right (**6.10**), in which a counterattack is mounted, takes place against a black background.

In contrast to the other two scenes, this one is mainly foreground. On the left, the lances are thrust toward the center scene, whereas the leader rides a rearing black horse turning to the right. At the far right, the foreshortened horses and riders in back view serve to arrest the movement, thereby creating a visual "ending" to the sequence.

The central scene (**6.11**) is the most symmetrically balanced of the three, although the narrative continues from left to right. Its centrality is accentuated by the rearing white horse, whose rider falls backward, knocked off balance by the long horizontal lance thrust at him from the left. On either side of this horse is a fallen blue horse and white and orange horses. At the left the horses advance, and at the right they are foreshortened and seen in rear view.

This episode contains the densest crowding, indicating that the troops are engaged in the height of battle. As in the *Deluge*, a geometric order underlies the surface chaos. The perspective grid of broken lances is reinforced by the fallen blue horse to left of center and by another fallen soldier at the right who is even more radically foreshortened than the one in the London panel

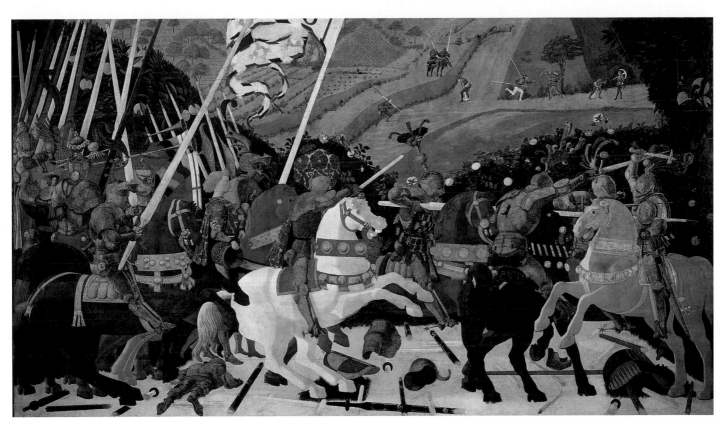

6.9 Paolo Uccello, *Battle of San Romano*, 1440s. Tempera on panel; 6 ft. × 10 ft. 6 in. (182 × 320 cm). National Gallery, London.

The Dignity of Man in the Renaissance

Beginning with fourteenth-century humanists such as Petrarch and Boccaccio, the notion of earthly fame achieved by worthy actions began to emerge. Medieval thought had emphasized the ultimate power of faith as the route to salvation; the human body, on the other hand, was considered corrupt and sinful. These views changed as humanist writings revived the Greek notion of man's centrality. The form, as well as the mind, of man became endowed with a new, ideal dignity.

Around the middle of the fifteenth century, the humanist author Gianozzo Manetti (1396–1459) completed his influential treatise on the dignity of man—*De dignitate et excellentia hominis*. He argued that man's creation in God's image granted him a superior mind and creative talents, fusing Christian tradition with the maxim "man is the measure of things." This new synthesis of mind and body, which distinguishes the Renaissance from the Middle Ages, reflected the conviction that man was capable of achieving the most dignified state of being.

(see 6.9). Four headdresses with a *mazzocchio* for support are additional reminders of Uccello's preoccupation with perspective. Likewise, the open field in the background, showing a hound chasing a hare and two other hares scattering in different directions, is sharply contrasted with the more ordered foreground. Uccello plays not only with perspective in these works, but also with colors, especially the blue horses, that accentuate the conceptual character of the figures as well as of the space.

Of the three panels, which were originally unified by a single frame, the one on the left has been least restored. As a result, the contours are softer than in the other two scenes, and the overall impression is more like that of a medieval **tapestry**. Taken as a whole, the *San Romano* panels were designed to project a specific political image. Their location—ostensibly in a private space but one that was also used for receiving official visitors, including delegates and princes from foreign states—enhanced the impact of their message. Combining power and pageantry, the scenes proclaim the presence

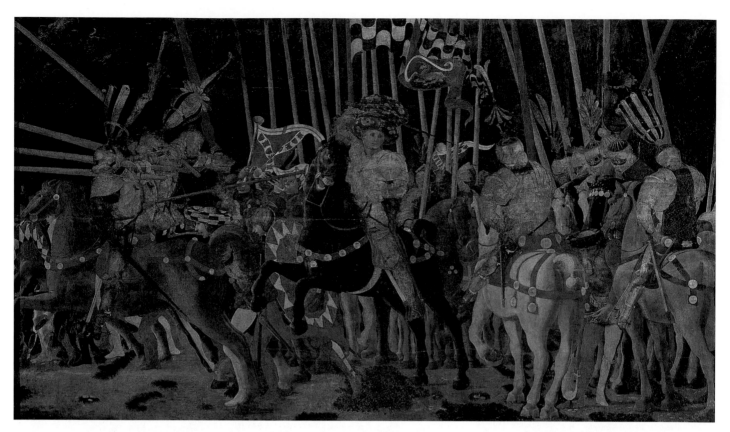

6.10 Paolo Uccello, *Battle of San Romano*, 1440s. Tempera on panel; 5 ft. 10⅞ in. × 10 ft. 4⅜ in. (180 × 316 cm). Musée du Louvre, Paris.

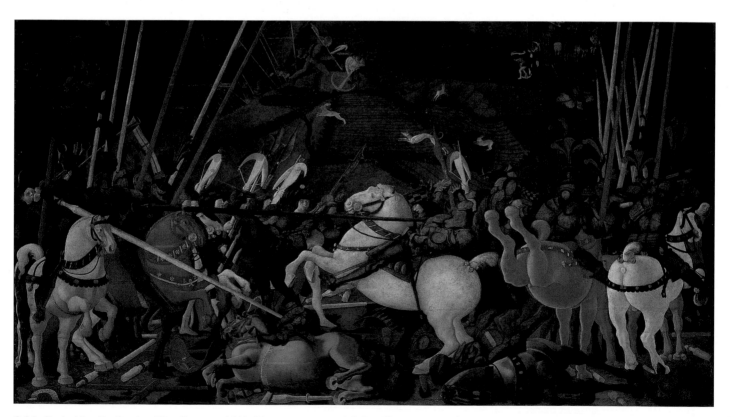

6.11 Paolo Uccello, *Battle of San Romano*, 1440s. Tempera on panel; 5 ft. 11⅝ in. × 10 ft. 6¾ in. (182 × 322 cm). Galleria degli Uffizi, Florence.

of the Medici as a powerful political force acting in defense of the Florentine republic. They also remind viewers of the Medici contribution to the magnificence of the city.

Domenico Veneziano

Uccello's younger contemporary, Domenico Veneziano (c. 1410–1461), came, as his name indicates, from Venice. Little is known of his life or the facts surrounding his commissions, but he had apparently settled permanently in Florence by 1439. A cycle of frescoes by him for the church of Sant'Egidio, located in the hospital of Santa Maria Nuova, has virtually disappeared. In a famous letter of 1438, Domenico wrote from Perugia to Piero de' Medici soliciting commissions. Although he was unsuccessful in this venture, Domenico's few surviving works reveal stylistic affinities with artists such as Fra Angelico and Filippo Lippi, who produced many pictures for Piero and his family.

A relatively early *Adoration of the Magi* (**6.12**) combines the Venetian taste for splendid fabrics with the foreshortening that appealed to Masaccio, Uccello, and other Florentine painters. In contrast to the crowded space of Gentile da Fabriano's *Adoration* (see 4.2), this opens up the distance into rolling hills, cultivated fields, wild brush, and a walled city. Tiny figures proceed along the spiral road, past flocks of

6.12 Domenico Veneziano, *Adoration of the Magi*, c. 1430s. Panel; diameter 33 in. (83.8 cm). Gemäldegalerie, Berlin.

sheep and a gallows, indicating that everyday life continues despite the miraculous event in the foreground. The sky is a natural blue, its light filtering through white clouds, replacing the gold of Gentile's altarpiece.

International Style features abound, demonstrating Domenico's contacts with courtly taste in the North and the persistence of late Gothic interest in nature. The foreground is a field of precisely rendered flowers and birds. A peacock perches on the roof of the shed, and two camels pass by the traditional ox and ass. Riding one of the camels is a black man who turns to view the sumptuously clad visitors. Some have Gothic lettering

embroidered in gold on the borders of their clothing. In contrast to the elaborate costume of the two standing kings and the man in back view with the voluminous, curvilinear cape, the kneeling king is plainly attired. A page holds his crown so that his bald head is juxtaposed with the halo worn by Christ. As in Gentile's *Adoration*, Domenico's meeting of the old king and the new king is a metaphor for the transition from the Old to the New Dispensation.

Domenico's more mature work from the 1440s, the *Madonna and Child with Saints*, also known as the Saint Lucy Altarpiece (**6.13**), was commissioned for the high

6.13 Domenico Veneziano, Saint Lucy Altarpiece (main panel), c. 1445. Oil on panel, 6 ft. 7½ in. × 6 ft. 11⅞ in. (2.02 × 2.13 m). Galleria degli Uffizi, Florence. Veneziano's Latin signature appears in gold on the riser behind John the Baptist.

altar of the small church of Santa Lucia dei Magnoli (Saint Lucy of the Magnolias). It is a *sacra conversazione* in which holy figures in a sacred space communicate through pose and gesture. Here they are in a symmetrical perspective setting, with a vanishing point slightly below center around Mary's lap. The floor is tiled with foreshortened patterns, and repeated receding triple arches allude to the triptych structure of the traditional altarpiece. Accentuating the structure of the architecture are the alternations of pink and green, the gilded capitals, and white shafts.

The unusual colors have been attributed to Venetian influence and the white light to Fra Angelico, but in fact the source of Domenico's style is not known. The white light, however, can be related to Saint Lucy herself— the name *Lucia* means "light"—whose nearly white flesh distinguishes her from the other figures. The traditional dark red and blue robes worn by Mary have become light blue and pink, with a green cloth on the throne. Saint Francis, in a gray habit rather than the more usual brown, reads a small red book, a sign of his

own writings, which leads one toward the rich redorange of John the Baptist's cape. He, in turn, gestures toward the enthroned figures, and Christ nods his head in John's direction.

The craggy, ascetic John the Baptist and the richly attired Zenobius opposite him were patron saints of Florence. Saint Zenobius, originally from a noble Florentine family and later appointed bishop, wears a jeweled red and green robe and miter. Saint Lucy, in pink and green, with red shoes that echo John's cape, holds a palm of martyrdom and a golden plate. The latter contains a pair of eyes that became her attribute as a result of the following legend: Her Roman tutor was obsessed with the beauty of her eyes. Not wishing to cause him any difficulty, she plucked out her eyes and sent them to him. Her resolve inspired him to become a Christian.

The orchestration of reds and blues in the main panel is picked up in the predella panel depicting *Saint John in the Desert* (**6.14**). Here, again, the scene is suffused with a white light that bleaches the rocky landscape,

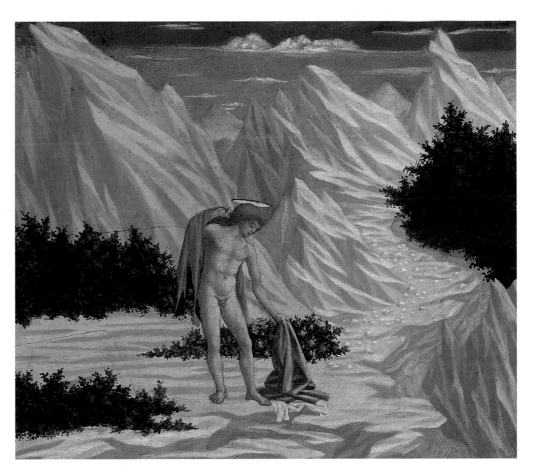

6.14 Domenico Veneziano, *Saint John in the Desert*, predella of the Saint Lucy Altarpiece, c. 1445. Oil on panel; 11 3/16 × 12 3/4 in. (28.4 × 32.4 cm). National Gallery of Art, Washington, D.C., Samuel H. Kress Collection. According to Vasari, Domenico was murdered by Castagno, who was envious of his skill as a painter. It was not until the nineteenth century that Castagno was acquitted of the charge, when it was discovered that he died some four years before his alleged victim.

varied only by a few clusters of dark foliage. John's form is clearly inspired by Greek and Roman statuary, reflecting the artist's humanist contacts and possibly evidence that he had visited Rome. In sharp contrast to the landscape is the deep blue-green sky and red cloak, both colors more densely **saturated** in the predella than in the main panel of the altarpiece. By the act of removing his richly colored clothes, whose folds echo the rock formations, and preparing to don his hair shirt, John transforms himself from a social being into an ascetic hermit.

Andrea del Castagno

Castagno's (c. 1417/1419–1457) style differs from that of his reputed murder victim (see the caption for 6.14) in his taste for stony surface textures and powerful, sculpturesque figures. A painter of scenes dominated by imposing figures whose monumentality is never subordinated to decorative patterns or soft material texture, Castagno worked directly in the tradition of Masaccio. He was born in the village of Castagno (meaning "chestnut") in the Apennine mountains, worked in Venice in his twenties, and then settled permanently in Florence. In 1444, he joined the Medici e Speziali.

According to Vasari, who, as we have seen, is not always reliable, Castagno decided to become an artist when, to avoid a sudden rainstorm, he dashed inside a country house. The sight of a painter at work inspired him to take up art. From then on, Castagno practiced by drawing on walls, and his reputation in the region grew. Eventually, a member of the Medici family sought him out and offered to provide formal training in Florence. This is a variation of the conventional recognition story in artists' biographies that Vasari also recounts in his life of Giotto. The grain of truth in such stories is the fact that most artists do reveal their talent early on, often in childhood, and that they grow up with a sense of artistic destiny.

There is no documented Medici patronage of Castagno, although he did, on occasion, work for patrons connected with the family. He arrived in Florence sometime in the late 1430s and was commissioned to paint exemplary public images of the hanged

Albizzi, who had rebelled against the Medici. These pictures have disappeared, but, like the figure of Securitas with the gallows in Lorenzetti's *Effects of Good Government* (see 2.20), they were a warning to those who would disrupt the stability of the state. They also suggest that Castagno was viewed as a supporter of Medici rule in Florence. The pictures were so well known that they gave rise to his nickname: Andrea degli Impiccati—"Andrea of the hanged men."

Castagno's early fresco of the *Crucifixion* (**6.15**) for the monastery of Santa Maria degli Angeli, where both the humanist Ambrogio Traversari and the painter Lorenzo Monaco had been monks, reflects his monumental aesthetic. Set in a classically inspired frame, the scene is entirely dominated by life-size human figures that stand out against a dark sky. Their illumination from the left is indicated, as in the Brancacci Chapel *Expulsion* (see 4.14), by the pronounced shadows cast on the narrow ground. The draperies, like Masaccio's, are devoid of surface decoration and rendered as massive and weighty.

Halos, in contrast to the delicate, transparent circles of Filippo Lippi, are solid, foreshortened metallic disks that reflect light and conform to the movement of the heads. The sense of the gravitational pull of Christ's body, as well as his pronounced muscle structure, is reminiscent of Giotto's crucifix (see 1.17) and Masaccio's *Trinity* (see 4.7). The Virgin and John gaze away from Christ, adopting poses and gestures that denote the inward character of their mourning. Mary Magdalen kneels at the foot of the Cross, her long hair a sign of her penance. In contrast to the colorful draperies and inner focus of these figures, Saints Benedict and Romualdo gaze directly at Christ, their vertical poses and fluted white robes paralleling the pilasters.

In 1447, Castagno was commissioned by the Benedictine convent of Nuns of Sant'Apollonia to paint the west wall of their refectory (**6.16**). The abbess was a member of the politically influential Donati family and possibly the sister of the chief magistrate of Florence. The magistrate's role in revoking Cosimo's exile of 1433 is another suggestion of Castagno's Medici connections. This was a major commission, although, like Fra Angelico's San Marco frescoes, Castagno's were intended for private viewing. The frescoes are a tour de force of illusionism, with the three Passion scenes—the

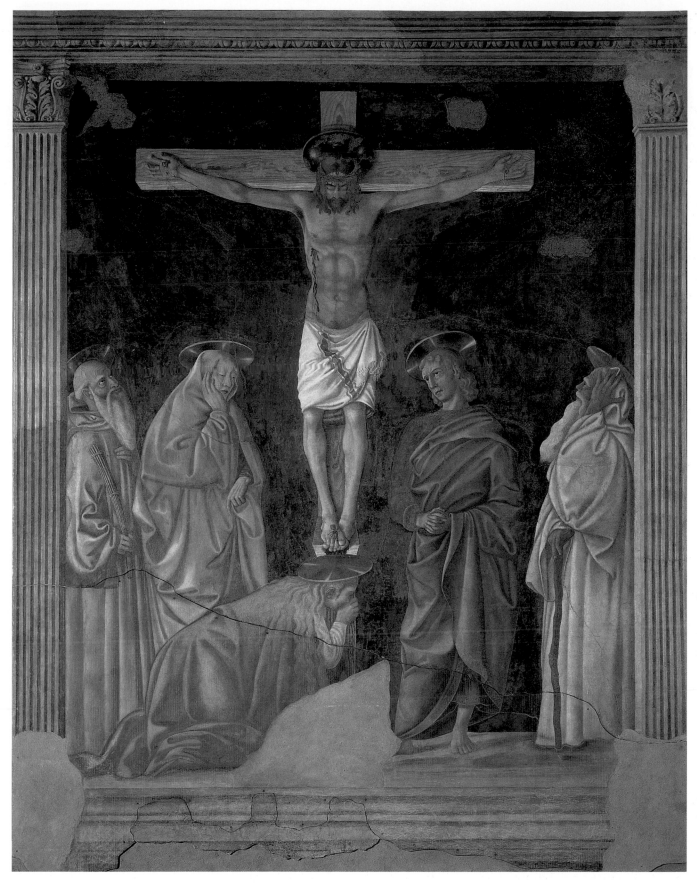

6.15 Andrea del Castagno, *Crucifixion*, c. 1445. Fresco; 10 ft. 11⅞ in. × 9 ft. 4¼ in. (335 × 285 cm). Sala della Presidenza, Hospital of Santa Maria Nuova, Florence. This and other works by Castagno have been removed from their original locations to the Hospital of Santa Maria Nuova. They were lost when the wall was whitewashed, then rediscovered in the nineteenth century, and restored. The lower section was destroyed in 1953 in a fire.

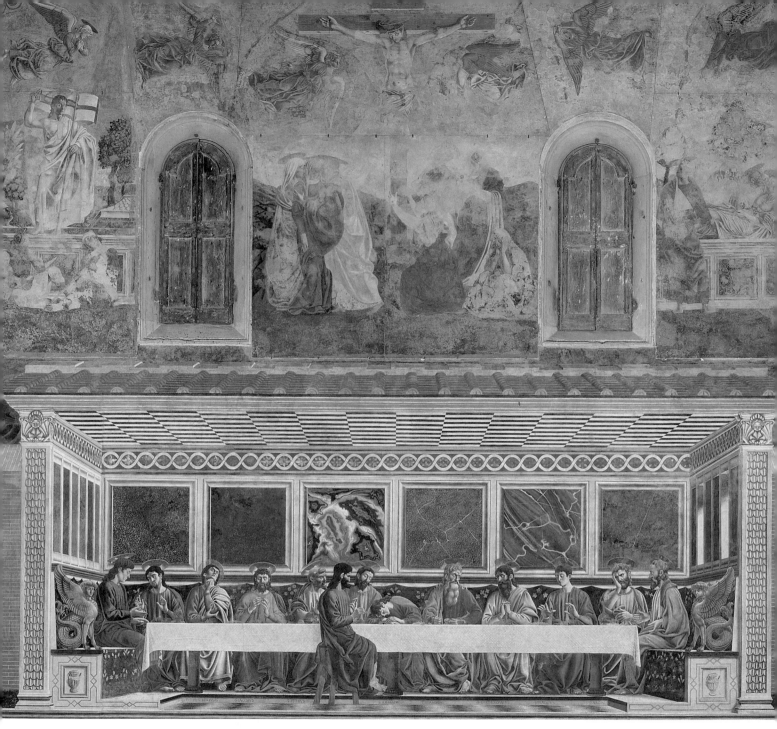

6.16 Andrea del Castagno, *Last Supper*, *Entombment*, *Crucifixion*, and *Resurrection*, c. 1450. Frescoes; total painted area: 14 ft. 9 in. × 32 ft. 1⅞ in. (4.5 × 9.8 m). West wall of the refectory of Sant'Apollonia, Florence.

Crucifixion in the center, the *Entombment* at the right, and the *Resurrection* at the left—divided from each other by actual windows. Separated from these events by a fictive projecting tiled roof is the *Last Supper*, which takes place indoors. Despite the serious damage suffered by the Passion scenes, their reductive monumentality is evident.

The function of the image in the context of the refectory was to evoke the nuns' daily identification during their own meals with Christ's Last Supper. Each pair of apostles is framed by a stone wall panel that formally mirrors their responses to Christ's announcement, fulfilled in the upper scenes, that one of them is his betrayer. In John 13:18, Christ says, "He that eateth bread with me hath lifted up his heel against me." When John and Peter ask who it is, Christ replies, "He it is, to whom I shall give a sop, when I have dipped it" (John 13:26). Christ then gives the sop to Judas Iscariot, whereupon, according to John 13:27, Satan entered into him.

of the Renaissance notion of human dignity and fame.

Embodying these themes, on the other hand, is *The Youthful David* of around 1448 (**6.18**). Painted on a leather shield that was probably used in processions, David has a sculptural quality, and his drapery seems carved from stone. The figure was inspired by antique sculpture, although no specific source has been convincingly identified. The resemblance of David's wind-blown hair to the Medusa head, however, is consistent with the context of the image. In Greek myth, Perseus decapitated the Gorgon Medusa and gave the head to Athena, who placed it on her aegis. Because Medusa's head (the Gorgoneion) turned to stone any man who looked at it, it became a traditional protective device used on shields and armor. Conflating David's head with the Medusa head as a shield device conforms to

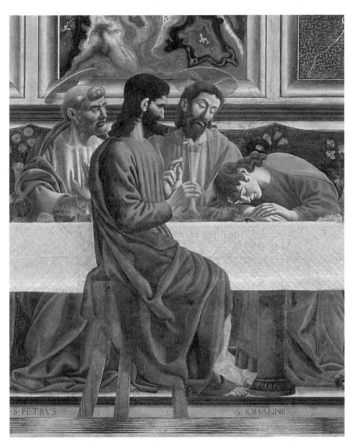

6.17 Andrea del Castagno, *Last Supper*, detail of Figure 6.16.

6.18 Andrea del Castagno, *The Youthful David*, c. 1448. Tempera on leather mounted on wood; 3 ft. 9½ in. × 2 ft. 6¼ in. × 1 ft. 4⅛ in. (115.6 × 76.9 × 41 cm). National Gallery of Art, Washington, D.C., Widener Collection.

In Castagno's image, Judas is distinguished from the other apostles by his placement on the opposite side of the table, closest to the earthly space of the convent. He is also seated on a three-legged wooden chair (possibly a reference to the Cross), while the others sit on a marble bench elevated from the floor and covered with a patterned cloth. Judas holds the sop in his right hand, his satanic physiognomy and oddly proportioned head and neck signifying his possession by evil.

The detail of the central group (**6.17**) shows the agitation of the figures displaced onto the marble panel which repeats the colors of their costumes. Peter's distress and confusion are evident in his expression as well as in the reversal of his left and right hands—a left hand seems to grow from his right arm. John slumps over in a faint as Christ gazes solemnly toward him.

Castagno has inscribed the name of each apostle on the riser below his feet. The only exception is Judas, whose act of betrayal has denied him an identity. He is condemned to anonymity, and he is the antithesis

Castagno's taste for tightly organized form and content.

The compact organization of this composition is based on the inverse repetition of the trapezoidal picture plane in the general shape of David himself. On either side of the figure, the rocky landscape is arranged in a studied symmetry. Time, as well as geometry, is tightly structured in the *David*, as two episodes fuse into one. In a dreamlike condensation, Castagno depicts the moments before and after Goliath's death simultaneously. Furthermore, the severed head itself echoes the play on the theme of decapitation expressed in the visual association of David's head with that of Medusa. From a contemporary political viewpoint, the image, like the paintings of the hanged Albizzi rebels, is exemplary. As a symbol of republicanism, the *David* warns of the fate that awaits those who challenge the security of Florence.

In another commission, which is securely dated to 1448, Castagno painted frescoes of famous men and women for the villa of the politically influential Carducci family, southwest of Florence. Filippo Carducci, who commissioned the series, was *Gonfaloniere*—"standard-bearer"—for the Council of Florence of 1439. His own humanist inclinations are evident in the nature of the commission, which is one of the earliest surviving secular murals in the region around Florence. Originally, nine famous people—three soldiers (Pippo Spano, Farinata degli Uberti, and Niccolò Acciaiuoli), three women (the Cumaean sibyl and the queens Esther and Tomyris), and three fourteenth-century poets (Dante, Petrarch, and Boccaccio)—were depicted on a wall opposite the loggia, with Mary at one end flanked by Adam and Eve. The *Famous Men and Women* have been removed to the Uffizi and are displayed as individual panels.

Illustrated here is one example from each set of three—Petrarch (**6.19**), the Cumaean sibyl (**6.20**), and Pippo Spano (**6.21**). They occupy narrow niches, from which they appear to project slightly forward, an effect enhanced by the dark stone wall behind them. All are powerfully sculpturesque, their energy barely contained by their frames. Castagno's rich, dynamic color, which is often muted by the damage his works have suffered, is particularly evident in the Carducci frescoes. In this case, it is designed to reflect the personalities of the figures.

6.19 Andrea del Castagno, *Petrarch*, 1448. Fresco; 8 ft. ½ in. × 5 ft. 5 in. (2.45 × 1.65 m). Originally on the loggia of the Villa Carducci; transferred to canvas in the nineteenth century and to plaster in 1954; now in the Galleria degli Uffizi, Florence.

Petrarch's bulk is defined by his voluminous red robe, his book and gesture of didactic discourse reflecting his humanist teachings. The subdued quality of the red accentuates his thoughtful, meditative character; he is identified in Latin on the painted ledge as a scholar—"Master Francesco Petrarca." His stance, like that of Donatello's Or San Michele *Saint Mark* (see 3.27),

6.20 Andrea del Castagno, *Cumaean Sibyl*, 1448. Fresco. From the Villa Carducci. Galleria degli Uffizi, Florence.

6.21 Andrea del Castagno, *Pippo Spano*, 1449–1451. Fresco. From the Villa Carducci. Galleria degli Uffizi, Florence.

is based on the relaxed Classical pose in which the right leg supports the body and the left is bent at the knee. The drapery folds are clearly echoes of fluted columns.

The Cumaean sibyl, depicted in more energetic colors and known in antiquity for her frenzied oracular pronouncements, is nevertheless idealized by Castagno as a dignified, youthful seeress. Her right hand is raised in a gesture of teaching, referring to the truth of her

prophecies and also directing the viewer's gaze heavenward. In the *Aeneid* (Book 6), she advised Aeneas, who stopped at her grotto on his journey from Troy to Latium, where his descendants founded Rome. The Christian authors interpreted her oracle as foretelling the coming of Christ—Castagno's inscription identifies her as the one "who prophesied the coming." She therefore exemplifies the synthesis of Classical antiquity with Christianity that appealed to fifteenth-century

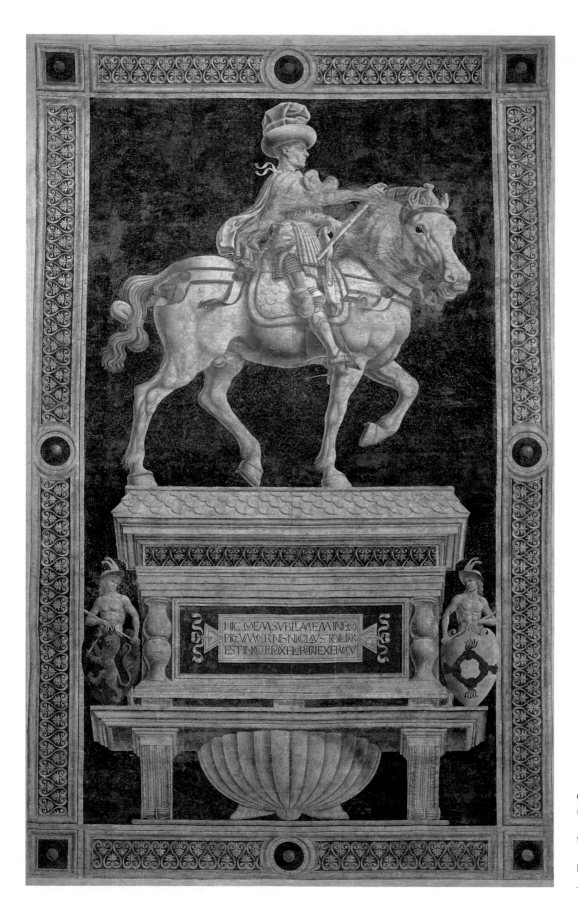

6.22 Andrea del Castagno,
Niccolò da Tolentino, finished
1456. Fresco transferred
to canvas; 27 ft. 4 in. ×
16 ft. 9⅝ in. (8.33 × 5.12 m).
Florence Cathedral.

humanists and is a reminder of the links between the city of Florence and the origins of republican Rome.

Filippo Scolari, nicknamed Pippo Spano, was a mercenary accorded a place in Filippo Villani's *Lives of Illustrious Florentines*. As a supporter of the Ghibellines, he fought in the service of Sigismund, king of Hungary, where he died. Castagno's characterization of Pippo's aggressive dynamism and proud, assertive stance is consistent with a military persona. He projects forcefully from the niche, turning as if suddenly wary of an enemy. The shine of his armor seems to draw him forward, and the chromatic variety with which he is painted adds to the sense of his inherent energy.

The year before his death, Castagno completed the monumental equestrian portrait of Niccolò da Tolentino (**6.22**)—the same *condottiere* depicted in Uccello's *Battle of San Romano* (see 6.9)—for Florence Cathedral. Like Uccello's *Sir John Hawkwood* (see 6.3), with which it is paired (**6.23**), it was planned as a marble tomb but was changed to a fresco. Niccolò himself was cremated, his ashes buried in the cathedral in 1435 in a service attended by Cosimo de' Medici's ally, Pope Eugenius IV.

The sculptural force of Castagno's style is clear from a comparison with Uccello's fresco. Monumental form, rather than perspective, is the manifest content of the Castagno. He has lowered the base so that the shifting perspective of the *Hawkwood* becomes less striking. Instead, one is impressed by the massiveness of the horse and the alert tension of the rider. By turning toward the viewer, Niccolò's horse, like the Pippo Spano, conveys an air of aggressive power and seems barely contained by the space of the picture.

The base is composed of a sarcophagus with an inscription extolling the *condottiere*, two classically inspired figures holding Niccolò's arms—the device of a knot and a gold lion on a field of silver—and a large scallop shell. The latter denotes rebirth and resurrection, which, in the context of this work, is achieved in humanist fashion through one's accomplishments on earth. Both the *Hawkwood* and the *Tolentino* are depicted as if they are statues. In this way, Uccello and Castagno not only allude to the original plan for sculptural tomb monuments, but also convey the lasting character of stone as well as of fame.

In 1457, Florence again suffered an outbreak of plague that killed Castagno and his wife.

6.23 Left wall of Florence Cathedral showing location of Uccello's *Sir John Hawkwood* and Castagno's *Niccolò da Tolentino*.

7
Sculpture and Architecture in Florence: 1430s–1460s

In fifteenth-century Florence there was a surge of theoretical writing on the visual arts that, together with the production of art, was influenced by the interest in ancient texts. Brunelleschi's theory of perspective and Alberti's writings continued to inform painting, sculpture, and architecture throughout Italy as well as in Florence. By 1452, Alberti's treatise on architecture, *De re aedificatoria libri X* [Ten Books of Architecture], had been completed. Its impact is evident in his own building designs and in those of other leading fifteenth-century architects.

In 1427, the year in which the *catasto* was instituted in Florence, Leonardo Bruni, who believed in the principles of republican government, became chancellor of the city. He, like his predecessor, Coluccio Salutati, was a humanist and had been the one to coin the term *humanitas*, referring to the humanist curriculum. Bruni translated Classical texts and was the author of the *History of the Florentine People*. Along with Alberti, Bruni believed that history is a dynamic process, largely determined by human character. In his commitment to historical dynamics, Bruni's ideas corresponded to Alberti's notion of *istoria* in the visual arts.

Bruni's Humanist Tomb

In 1444, when Leonardo Bruni died, Florence decided to honor him with a funeral modeled on those accorded heroes in ancient Rome. His marble tomb (**7.1**), commissioned by the city from Bernardo Rossellino (1409–1464), became the paradigm of the monumental humanist tomb. It is located on the right nave wall of the Franciscan church of Santa Croce, combining aspects of Bruni's biography with Christian and Classical motifs and references to its civic context.

The symmetrical structure of the tomb, with the framing Corinthian pilasters supporting a round arch, corresponds to the architectural aesthetics of Brunelleschi and Alberti. Above the arch, two winged *putti* display a laurel-wreath tondo containing a relief sculpture of a lion. This has been identified as both the *Marzocco*, the lion symbol of Florence, and the Bruni coat of arms. Below the arch, another tondo contains the Virgin and Christ.

The three red porphyry panels at the back of the tomb had funerary associations in the fifteenth century and thus merge the medium with the iconography of the work. Bruni's effigy lies on a bier supported by two eagles, which were attributes of the Greek god Zeus and his Roman counterpart, Jupiter. They were also emblems of the Roman legions and signified the apotheosis of the Roman emperor, indicated by the custom of releasing eagles at his funeral. The draped cloth is carved in a rich imitation brocade pattern.

Bruni himself rests his head on a pillow and turns toward the Florentine citizens who visit the church. He holds a book, probably to be identified as his *History of the Florentine People*, which, together with the eagles, was a reminder of the Roman origins of the city's republican character. The laurel wreath around his head is

7.1 Bernardo Rossellino, tomb of Leonardo Bruni, begun 1444. Marble; 20 ft. (6 m) high. Santa Croce, Florence. Rossellino came from a family of stonecutters and sculptors in Settignano, not far from Florence. This tomb reflects his affinities with the humanist movement. Bruni's funeral oration was delivered by Gianozzo Manetti, the humanist author of *On the Dignity and Excellence of Man* (1452).

POSTQVAM LEONARDVS EVITA MIGRAVIT
HISTORIA LVGET ELOQVENTIA MVTA EST
FERTVRQVE MVSAS TVM GRAECAS TVM
LATINAS LACRIMAS TENERE NO POTVISSE

the ancient symbol of triumph and immortality, and, like the *History*, denotes his fame. Rossellino's skill in portraiture is evident in Bruni's distinctive features and air of stately dignity, despite unmistakable signs of old age. It is even possible that, like the sculptors of ancient Roman portrait busts, Rossellino carved the head from a wax death mask.

On the sarcophagus below the bier, two airborne Victories carry an inscription stating that "history mourns and eloquence is mute; both the Greek and Latin Muses are unable to restrain their tears." Supporting the sarcophagus at either end is a lion's head on a lion's paw. Like the eagles, the motif of the lion had ancient associations relevant to contemporary Florence. Another lion's head recurs in the small tondo at the base of the tomb; it is flanked by six *putti* (three on each side) with fruit swags and is vertically aligned with the lion in the tondo above. The repetition of lions is embedded in the identity of Florence—as its symbol— and in the ancient tradition that because lions never sleep, they guard sacred spaces and royal precincts.

In addition to the historical and political implications of the leonine imagery on the tomb, the motif was personally relevant to Bruni. Not only was the lion a feature of the Bruni coat of arms and also his name (Leo), but he was himself an intellectual and political "lion" and, as chancellor and historian of Florence, was identified with the city's lion symbol. Just as he had written the historical "biography" of Florence, so the Florentines "lionized" him with a state funeral and a monumental tomb.

Alberti's Self-Portrait Plaque: An Iconographic Puzzle

The implications of the lion as a civic symbol of Florence and a name also inform the only sculpture generally attributed to Alberti. This is a bronze plaque (**7.2**) containing Alberti's self-portrait in profile view, his personal emblem of the winged eye rendered frontally below his chin, and the letters "LBAP" vertically aligned at the right. The significance of this imagery has been much discussed by scholars, and, while there is disagreement about its precise meaning, certain details are clear.

Alberti's emblem is larger and easier to see on the reverse of a medal of around 1446 to 1450 by the medalist Matteo de' Pasti (d. 1467/8) (**7.3**). Apparently commissioned for or by Alberti, the reverse depicts the eye with eagles' wings and rays extending from each corner. Below is Alberti's motto, "QUID TUM," meaning "What then?" or "What next?", which he had placed on the manuscript of *On Painting*, dedicated to Brunelleschi. Encircling the emblem is the laurel wreath of fame and Matteo's Latin signature: "OPUS MATTHAEI PASTII VERONENSIS" [the work of Matteo Pasti of Verona].

An iconographic analysis of the winged eye reveals a conflation of several elements. The eye, in the Renaissance, was a hieroglyph—inspired by ancient Egyptian hieroglyphs —for the eye of God. The rays are the sun's rays, combining allusions to the Greek, Roman, and Egyptian sky gods as

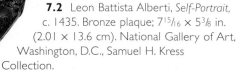

7.2 Leon Battista Alberti, *Self-Portrait,* c. 1435. Bronze plaque; 7¹⁵⁄₁₆ × 5³⁄₈ in. (2.01 × 13.6 cm). National Gallery of Art, Washington, D.C., Samuel H. Kress Collection.

The Renaissance Medal

A feature of the Classical revival in fifteenth-century Italy was the production of medals, usually made of bronze or lead. They were inspired by imperial Roman coins, which were smaller than the medals but similar in design—a bust-length profile of an emperor on the obverse, an emblem on the reverse, and an inscription. During the Renaissance, medals were commissioned by various rulers and wealthy families as a way of circulating their images in portable, relatively inexpensive form. In addition, the message conveyed by the emblem or scene on the reverse could serve the function of political propaganda. To a certain extent, the iconography of a medal and its inscription provide biographical insights into the patron. Sometimes medals were struck to commemorate the design of a building (see 8.13) in which case they can be useful architectural documents.

well as to the notion of the all-seeing eye of the Christian God. Conflations of this type were characteristic of emblems on Renaissance medals and also reflected the period's revival of interest in the hiero-glyphic tradition.

The wings refer to the ancient belief that the sun was the ancestor of the eagle. In Greek mythology, eagles submitted their young to a test of legitimacy, in which they forced their offspring to stare at the sun. The eaglets who blinked were deemed illegitimate, thrown from the nest, and killed. Alberti's personal history, particularly his illegitimate birth, which was used by his relatives to deprive him of an inheritance, is consistent with an identification with the myth of the eagle's legitimacy. On another level, the sharp eyesight of the eagle can be related to Alberti's theory of vision and the importance of the eye for viewers and creators of art.

On Alberti's self-portrait plaque, the head, like that of Bruni, conveys a strong, assertive character. A comparison of the image on the plaque with Matteo's bust on the obverse of the medal (7.4) reveals an aspect of Alberti's identification with the city of Florence. Matteo renders Alberti's hair as lying flat on the back of his head and ringed by a set of slightly longer curls. Alberti's self-portrait, however, depicts shorter hair that resembles the mane of a lion.

Without the benefits of photography or other known portraits of Alberti, it is difficult to determine which of the two images most resembled him. What is signifi-

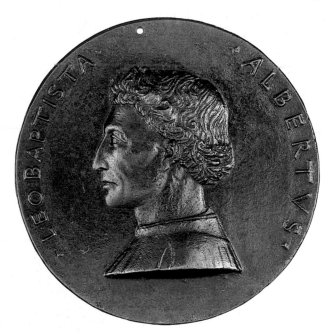

7.3 Matteo de' Pasti, medal of Leon Battista Alberti, reverse, *Winged Human Eye*, c. 1446–1450. Bronze; 3⅝ in. (9.3 cm) diameter. National Gallery of Art, Washington, D.C., Samuel H. Kress Collection.

7.4 Matteo de' Pasti, obverse of Figure 7.3.

cant, however, is that Alberti emphasized his identification with the lion in two ways. On the one hand, he gave himself leonine hair, and, on the other, he inscribed the letters "LBAP" on the plaque. These stand for "LEO BATTISTA ALBERTI PICTOR" [Leon Battista Alberti, Painter].

In contrast to Bruni, Alberti's given name was *not* "Leo"; he was christened "Battista" and later added the leonine name himself. In so doing, Alberti consciously reinforced his civic connections with Florence and its *Marzocco* symbol, which had been disrupted by his family's exile from the city. Likewise his identification with the eagle attempted to repair his illegitimate birth, which could have adverse consequences even in relatively liberal fifteenth-century Florence.

On the self-portrait plaque, in contrast to Matteo's medal, Alberti has placed his profile on the same side as the winged eye. This allows for viewing both simultaneously, without turning the object over. As such, the nature of vision itself is accentuated, which alludes to Alberti's importance as a theoretical writer on the art of seeing and on the seeing of artists. The rays of the sun allude to the sky gods and are a reminder of the need for light in order to see.

Alberti's "QUID TUM" is elusive, but the fact that it asks a question is, in itself, significant, given the intellectual context of fifteenth-century Florence. By asking a question and leaving open the answer, Alberti takes a humanist approach; he attempts to deconstruct the certitude of medieval thought. The latter had been exemplified by the warning inscribed on the sarcophagus of Masaccio's *Trinity* (see 4.7), which threatens viewers with bodily decay. Alberti's question invites speculation, opening up the human mind to ideas rather than condemning the body to physical corruption.

The iconographic complexity of Alberti's emblem is typical of Renaissance imagery, particularly that which combines autobiography with humanism and other prevailing ideas. The nature of the period itself

contributed to the synthesis of form with different modes of thought. These characteristics are also found in some of the enigmatic works by Donatello, which he executed in the middle decades of the fifteenth century, apparently for humanist patrons.

Donatello in the Mid-Fifteenth Century

Donatello's interest in antiquity, already evident in his work for Or San Michele, continued to develop. His *Bust of a Youth* (7.5), for example, reveals his acquaintance with specific Platonic texts. The figure, like those on the obverse of Renaissance medals, seems to have been influenced by Roman portrait busts. Although the head

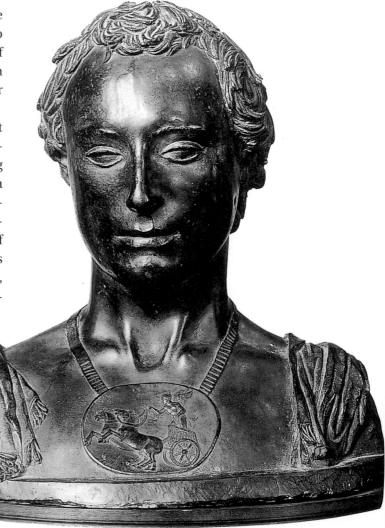

7.5 Donatello, *Bust of a Youth*, c. 1420s to 1440s. Bronze; 16½ × 16½ in. (42 × 42 cm). Museo Nazionale del Bargello, Florence.

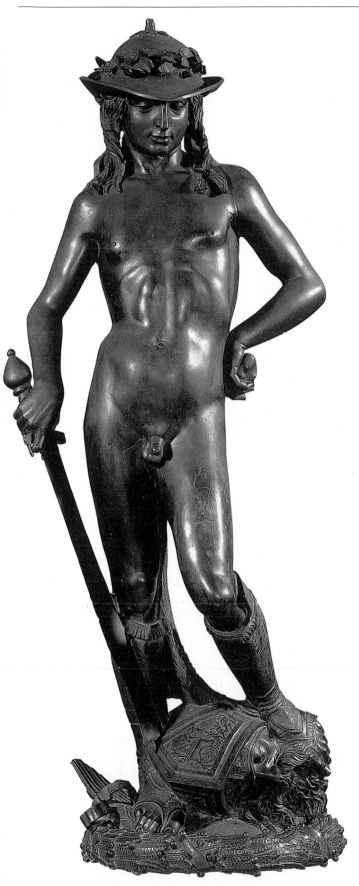

has the specific physiognomy of portraiture, its soft, idealized character suggests a Platonic source. This is confirmed by the iconography of the medallion worn around the youth's neck. It depicts an image of the soul from Plato's *Phaedrus*, which Bruni had translated in 1423. Plato's spokesman, Socrates, describes the human soul as being like two unruly horses in conflict with each other, one rearing back and the other going forward. Here they pull a chariot driven by Eros, the god of love. The horses of the divine soul, in contrast, would move together in a harmonious way. The image on the medallion, together with the idealization of the youth, identifies Donatello's figure as one of Plato's "beautiful boys," protected by Eros.

A similar use of an iconographic "key" inspired by antiquity can be found in one of Donatello's most discussed works, the bronze *David* (**7.6**). The earliest surviving, nearly life-size organic nude since antiquity, the *David* is documented as being in the courtyard of the Medici Palace as of 1469. And although, as with his bronze *Youth*, the circumstances of the commission are unknown, it is likely that both were commissioned by a member of the Medici family—probably Cosimo. His early involvement with humanism and the Platonic movement is consistent with Donatello's iconography in the mid-fifteenth century.

7.6 Donatello, *David*, 1440s, Bronze; 62¼ in. (158 cm) high. Museo Nazionale del Bargello, Florence.

7.7 Donatello, relief on Goliath's helmet, detail of Figure 7.6.

The *David's* relaxed *contrapposto* stance, like that of the *Saint Mark* (see 3.27), is based on such Classical statues as the *Doryphoros* (see 1.2). But Donatello depicts his hero as a slim, graceful, effete adolescent—an unusual conception of the biblical killer of Goliath. The *David* has a smug, self-satisfied character. Gazing down at Goliath's severed head, he holds the giant's sword in his right hand and the stone from the slingshot in his left. David's left toe plays with the hair of Goliath's beard, and a live wing from the giant's helmet rises seductively along the inside of David's right leg.

A laurel wreath rings David's shepherd's hat as well as the base of the statue, emphasizing the theme of triumph. The various meanings of David's victory exemplify the richness of the statue's complex iconography. As a type for Christ, David has

7.8 Donatello, *Gattamelata*, c. 1445–1456. Bronze; statue: 12 ft. 1 in. (3.68 m) high, pedestal and base: approximately 25 ft. 7 in. × 13 ft. 5 in. (7.8 × 4.1 m). Piazza del Santo, Padua. *Gattamelata*, meaning "honeyed cat," was the nickname of the condottiere Erasmo da Narni, who first fought for Venice in 1434. After his death in 1443, funds provided by his family were allotted in his will to the commission of the statue. Nevertheless, its location on holy ground belonging to the basilica of Saint Anthony of Padua would have required an official decree by the Venetian government.

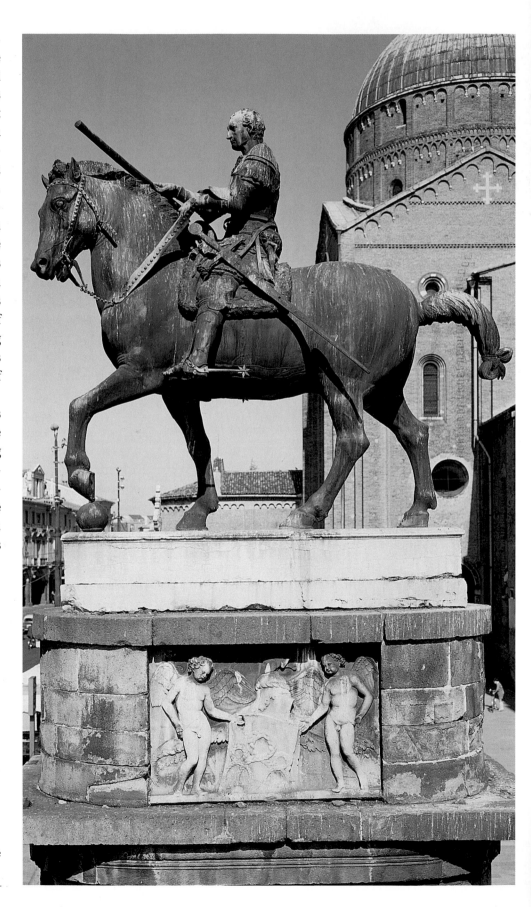

defeated Goliath-as-a-type-for-Satan. As a symbol of the republican spirit of Florence, he defeats tyrants who threaten the city. As one of Plato's "beautiful boys," he, like the figure in the bust of a youth, is under the protection of Eros. (It is also possible that this platonic concept explains the enigmatic putti on the crozier of the *Saint Louis of Toulouse* [see 3.32], which was also a politically motivated commission.)

In any case, the latter meaning of the *David* is confirmed by the relief on Goliath's helmet (**7.7**). It shows a group of winged putti—multiple figures of Eros—pulling a triumphal chariot. David's victory over Goliath is thus transformed by Donatello into a synthesis of biblical, Platonic, political, and autobiographical content. It reflects Plato's view that tyrants condemn homosexu-

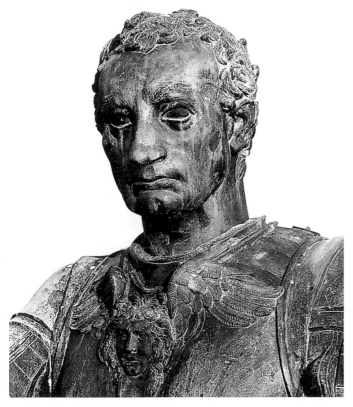

7.9 Donatello, head and Gorgoneion of the *Gattamelata*, detail of Figure 7.8. In Greek myth, the Gorgon Medusa evoked terror in men because the sight of her snaky hair and awesome physiognomy turned them to stone. Following the wise advice of Athena to look at Medusa only in the reflection of his shield, the hero Perseus decapitated the monster and gave her head to the goddess. Athena then placed the head on her aegis, where it served as a protective device, or apotropaion, symbolically turning her enemies to stone. As a result, the head of Medusa, also called the Gorgoneion, became a standard device of Western armor.

ality, whereas democracies permit its expression. That this view was congenial to Donatello's own tastes is evident from the homoerotic character of the *David*.

Plato further argues that male lovers in the Platonic sense are the bravest warriors, protected by the love god Eros. In the context of the period, the *David* stood for the Florentine struggle to maintain its independence as a republican state modeled on that of the Athenian democracy. As such, the *David* also projected the image that the Medici wished to maintain—namely, that despite being the power behind the city, they were committed to civic humanism and opposed to authoritarian forms of government.

From 1443 to around 1456, Donatello worked in Padua, where he produced his monumental bronze equestrian monument honoring the *condottiere* Erasmo da Narni, known as Gattamelata (**7.8**). This work, like the *David*, owes its impact to Donatello's genius for intellectual synthesis, technical skill, and innovative approach to form and psychology. The conception of the work, as well as the idealization of the figure, reflects Renaissance notions of the dignity of man. Gattamelata is rendered as a forceful leader mounted on a powerful war horse. His physiognomy (**7.9**) is both specific—although Donatello had never met him—and reminiscent of Roman portraiture. Here, however, Donatello has accentuated the tension of Gattamelata's air of focused concentration, presumably guarding the republic of Venice (Padua, at the time, was ruled by Venice) against its enemies. A slight frown causes downward curves in the mouth and the facial muscles, which enhance the impression of watchfulness. The horse is also alert, its mouth opened, head turned slightly, and gaze, like Gattamelata's directed forward.

In this sculpture, Donatello has merged aspects of the traditional equestrian monument with antique iconography, the function of which is to portray Gattamelata as another Platonic guardian of the state. In contrast to the self-satisfied, relaxed character of the *David*, whose victory has already taken place, the *Gattamelata* guards the state in the present and thus is continually watchful. The iconography on his antique armor reinforces this role, most aggressively the winged Medusa head on his breastplate (see caption). But elsewhere on his armor are numerous figures of Eros in various poses, some provocative, some playful, and some triumphal.

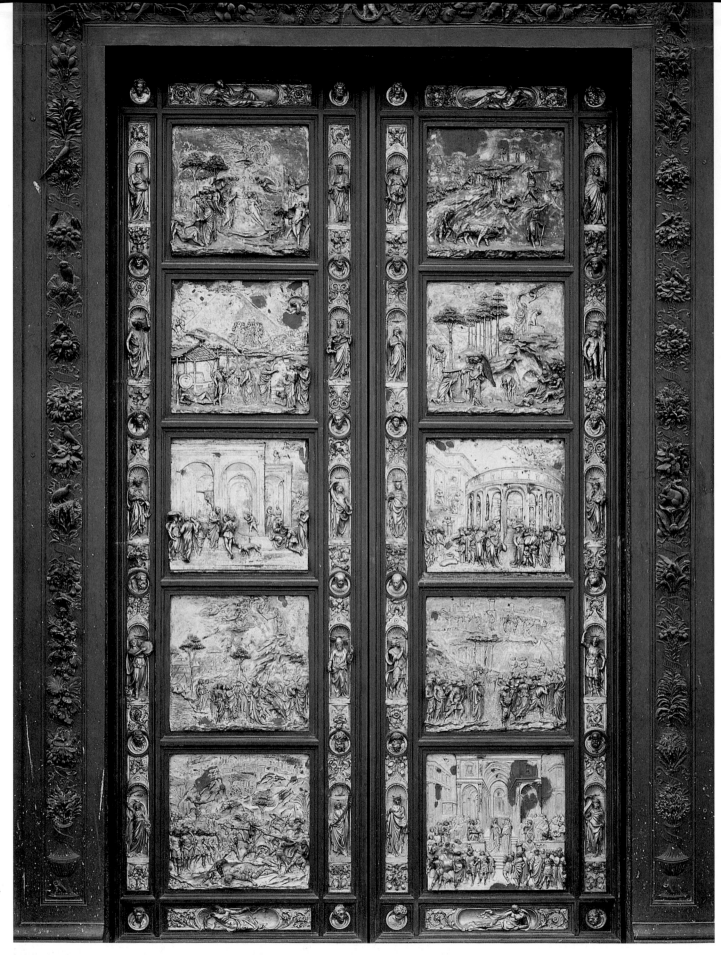

7.10 Lorenzo Ghiberti, east doors, 1425–1452. Gilt bronze. Baptistery, Florence.

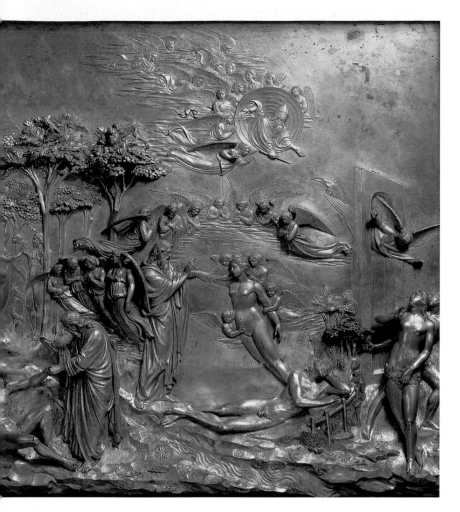

7.11 Lorenzo Ghiberti, *Genesis*, showing the Creation of Adam, the Creation of Eve, the Temptation, and the Expulsion. Detail of Figure 7.10, c. 1425. 31 ¼ × 31 ¼ in. (79 × 79 cm).

Each scene, with one exception, contains two or more events, condensing time and space within a single frame. The first scene to have been cast, and the earliest in the narrative, is at the upper left; it depicts the time span between the creation of Adam and Eve and their expulsion from paradise (**7.11**). Adam and Eve in the Temptation scene at the left are smaller than elsewhere, indicating, as Ghiberti wrote, that they are in the distance. In addition, Ghiberti has assimilated Donatello's perspective system, evident in the Or San Michele relief of *Saint George Slaying the Dragon* (see 3.26), of diminishing the degree of relief to denote spatial recession.

Ghiberti's East Doors

In 1424, when Ghiberti's first set of doors for the Florence Baptistery was completed, he was commissioned by the Calimala to produce a second set for the east side of the building (**7.10**). They are known as the *Gates of Paradise*, after the term *paradiso*, which refers to the space between a cathedral and a baptistery that was often used for burials. (Vasari says that when Michelangelo saw the doors he declared them fit to be the doors to Paradise.) According to Ghiberti's *Commentarii*, he designed ten rectangular panels depicting Old Testament scenes as follows:

> I strove to observe with all the scale and proportion (*misura*), and to endeavor to imitate Nature ... on the planes (*piani*) one sees the figures which are near appear larger, and those that are far off smaller, as reality shows.[1]

7.12 Phidias, *Dionysos*, c. 420 B.C. Marble. Originally on the east pediment of the Parthenon, now in the British Museum, London.

As in the 1401 competition relief depicting the *Sacrifice of Isaac* (see 3.3), Ghiberti's figures reflect the influence of Greek and Roman statuary, particularly in the forms and poses of Adam and Eve in the foreground. Adam in the *Creation* resembles the figure of Dionysos from the east pediment of the Parthenon (**7.12**), which recurs on Roman and Early Christian sarcophagi. Eve's pose, like that of her counterpart in the Brancacci Chapel, is a type of Hellenistic Venus (see 4.15). Ghiberti also retains his earlier taste for graceful figures and elegant patterning. The foreground landscape, for example, contains a stream composed of undulating curves. The angry God of the Expulsion appears to emerge from a circle formed of delicate celestial rings, followed by a troop of finely rendered angels.

The only panel representing a single event is the last one to be executed—namely, the *Meeting of Solomon and Sheba* (**7.13**) at the lower right. Its focused theme and more structured character show the degree to which Ghiberti's style had developed over the first half of the fifteenth century. The architectural symmetry and vanishing point between Solomon and Sheba draw the viewer's attention immediately to the meeting. As in the first panel, this one combines linear perspective with Donatello's *schiacciato*. Here, however, the draperies are weightier, the figures, like the viewers, directed to the drama of the main event; and there is greater emphasis on monumental form.

It is likely that the choice of this rarely represented subject was influenced by the political importance

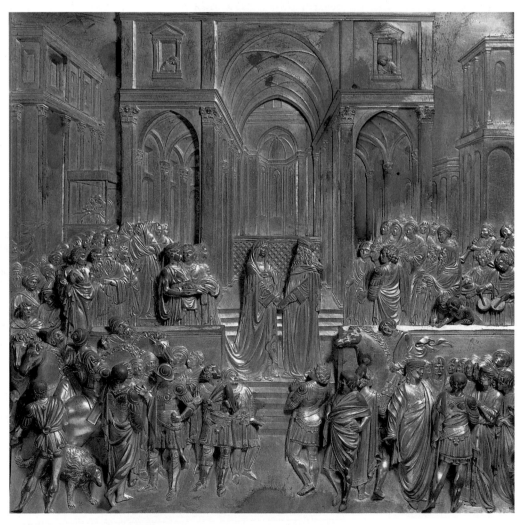

7.13 Lorenzo Ghiberti, *Meeting of Solomon and Sheba*, detail of Figure 7.10, c. 1450–1452. 31¼ × 31¼ in. (79 × 79 cm).

of contemporary efforts to reunite the eastern and western branches of the Church. Solomon was associated with western Christendom, whereas Sheba, who traveled from Arabia in the east, was associated with Byzantium. In 1438, a Council of Churches had been scheduled to meet in Ferrara but was transferred to Florence—at Cosimo de' Medici's expense—because of an outbreak of plague. This event was commemorated in the first medal cast in Renaissance Italy by the painter and medalist Pisanello.

Pisanello's Medal of John VIII Palaeologus

The importance of the Council of Churches was reflected in Pisanello's medal commemorating the event. The International Style painter Antonio Pisano, known as Pisanello (c. 1395 –1455), grew up in Verona after his father moved there from Pisa.

The obverse of the medal (**7.14**) depicts the Byzantine emperor John VIII Palaeologus, who had arrived in Ferrara in 1438 to negotiate the union of the eastern and western branches of the Church. Pisanello conveys the forcefulness of the emperor's character by his finely chiseled bone structure, assertive nose, and pointed beard. The elaborate hat, which also seems thrust forward, together with the splendid costumes of the emperor's entourage, made a great impression on the Italians.

On the reverse (**7.15**), the emperor rides horizontally across the surface plane of the medal, stopping before a roadside crucifix. At the left, a second image shows the mounted emperor and a foreshortened horse in rear view. The doubling of the image, together with the landscape setting, emphasizes the idea of travel that is a feature of both the Meeting of Solomon and Sheba and the Journey of the Magi, with which the emperor's visit to Italy was typologically paired in the fifteenth century.

This medal, like others cast in the Renaissance, has an inscription, which allowed artists to juxtapose text and image in significant ways. Pisanello signed the medal twice— "the work of the painter Pisanello"—in Greek and in Latin. He thus declared himself a humanist and also used text to denote the factions of the Church: Greek for Byzantium and Latin for the West. As such, his medal is a metaphor for the political efforts to unite the Churches.

7.15 (*below*) Antonio Pisanello, reverse of Figure 7.14.

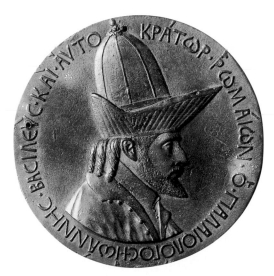

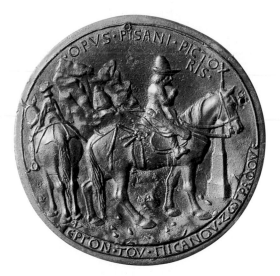

7.14 Antonio Pisanello, medal of John VIII Palaeologus, obverse, c. 1438. Bronze, diameter 4 in. (10.3 cm). Museo Nazionale del Bargello, Florence. Pisanello was an extremely popular artist, especially with the humanists, who admired the Classical aspects of his work. They dedicated many poems in Latin to him and praised his assimilation of antiquity. He was also employed by the fifteenth-century courts, particularly those of Ferrara, Mantua, and Naples. It is in his many drawings that Classical influence is most apparent, whereas his paintings maintain the Gothic flavor and rich textures favored by the North.

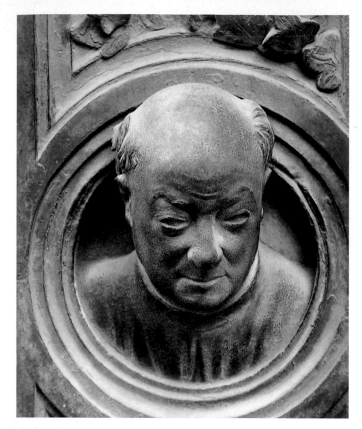

7.16 Lorenzo Ghiberti, *Self-Portrait*, detail of the east doors, 1424–1452. Gilt bronze. Baptistery, Florence.

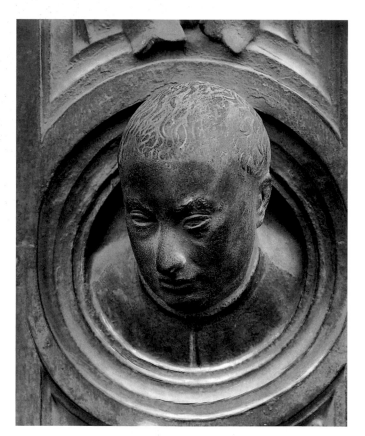

7.17 Lorenzo Ghiberti, *Vittorio Ghiberti*, detail of the east doors, 1424–1452. Gilt bronze. Baptistery, Florence.

Ghiberti's interest in biography and autobiography, evident in the *Commentarii*, persisted throughout his life. He insisted on identifying his works as his own, either by a signature or a self-portrait; in his written accounts of his career, he depicts himself in the most positive light. On the *Gates of Paradise*, Ghiberti's penchant for self-assertion recurs in his self-portrait (**7.16**) and the portrait of his son Vittorio (**7.17**). On the one hand, these images reflect the emphasis on the family in the medieval-workshop tradition, and, on the other, they proclaim the artist's authorship of, and presence in, his work. On a lighter note, Ghiberti's self-portrait on the *Gates of Paradise* has been read as a visual comment on Brunelleschi's dome, across from the east doors. In the earlier self-portrait on the north doors (see 3.7), cast before his conflicts with Brunelleschi, Ghiberti wears a turban. Here, however, his bald pate echoes the form of the dome.

Palace Architecture

One of the ways in which Renaissance families embellished their cities, while also improving their own lifestyle, was to build private palaces. The Renaissance palace stood as a tribute to a patron's concern for civic aesthetics, and also enhanced his image in the eyes of his fellow citizens. In 1444, with these and other advantages in mind, Cosimo de' Medici hired Brunelleschi to design a palace for his family. The innovative character of Brunelleschi's plan was rejected by Cosimo on the grounds that it was too ostentatious and would arouse envy. Instead, therefore, he awarded the commission to the more conservative Michelozzo. Brunelleschi, according to Vasari, was so incensed by this that he smashed his model of the new palace. As a result, Brunelleschi's plan is lost.

The Medici Palace: 1444–1460

The heavy **rustication** (roughly cut masonry) on the ground floor of the existing Medici Palace imparts a fortresslike impression (**7.18**). These massive blocks of stone, known as **quarry-faced ashlar**, were typical of medieval architecture and thus were more traditional

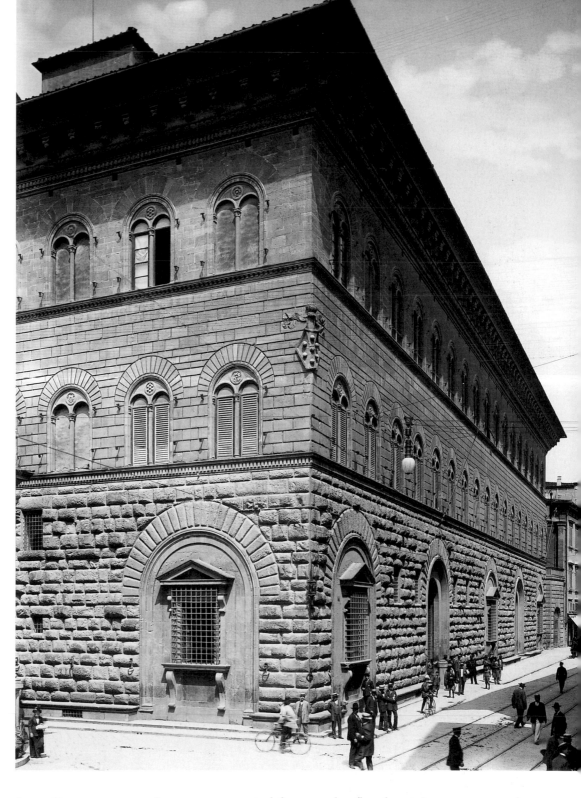

7.18 Michelozzo, exterior of the Medici Palace, 1444–1460. Florence. According to Medici tradition, the coat of arms was granted to the family by Charlemagne to commemorate the defeat of a giant monster by a Medici knight. The balls represent the areas on the knight's shield that were dented by the giant's mace. Other accounts attribute the balls variously to the pills used by Medici ancestors who had been pharmacists and to coins signifying banking and pawnbroking. In the Renaissance, as today, triple balls hung outside pawnshops.

than other features of the palace. For purposes of defense and security, small square windows were located high up on the ground floor. The larger pedimented windows are sixteenth-century additions.

The upper stories, which become progressively smoother toward the top and decrease in height, are surmounted by an imposing, classically inspired cornice. Aesthetically, the visual weight of the ground floor corresponds to structural reality in that the lower part of the building supports the upper part. The stories are separated from each other by **stringcourses**, each creating a visual platform on which the round-arched, **mullioned** second- and third-floor windows seem to rest. Corinthian colonettes at the center of the windows also show the influence of antiquity on Michelozzo's design.

In his original plan, the corner of the ground floor contained an open loggia for the Medici bank. Above, still visible today, is the Medici coat of arms, consisting of seven balls (see caption). This feature served as the

"signature" of the patron, identifying the owner of the palace and marking his place of business—a source of the money that made the construction of the palace possible and of Medici power in Florence.

The present façade is longer than that conceived by Michelozzo; additional bays were added in the seventeenth century. The plan (**7.19**) originally had a central door leading to the inner courtyard. To the left and right of the main street entrance, flights of steps led to the upper stories. At the back, the garden was filled with ancient Greek and Roman statues collected by the Medici family and made accessible to artists interested in antiquity.

The courtyard (**7.20**) was a square, surrounded by a colonnade of round arches. These rest on Corinthian columns with smooth shafts, indicating the influence of Brunelleschi but, unlike the columns at San Lorenzo, without impost blocks. Michelozzo's proportions, however, are more massive and relatively shorter than

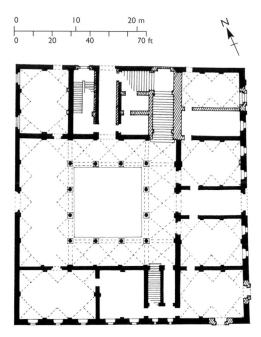

7.19 Michelozzo, plan of the Medici Palace.

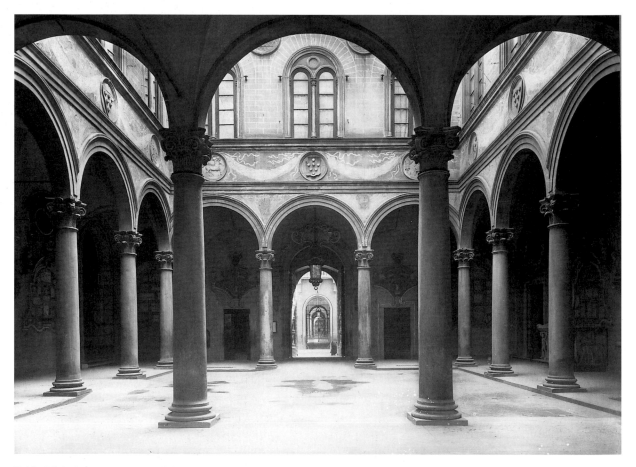

7.20 Michelozzo, courtyard of the Medici Palace.

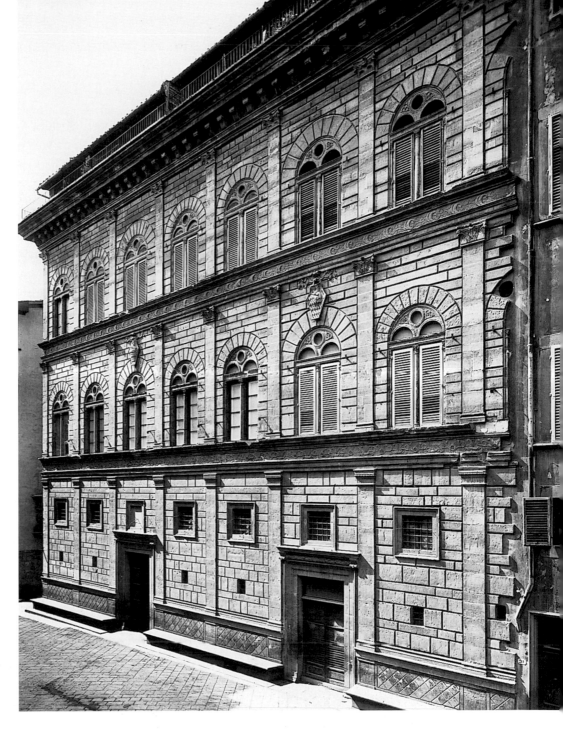

7.21 Bernardo Rossellino (according to Alberti's design), façade of the Rucellai Palace, 1446–1451, Florence. Giovanni Rucellai's fortune stemmed from the manufacture of the red dye *oricello*, which was the origin of the family name. He was a supporter of the Medici, and his son Bernardo married Lucrezia de' Medici, daughter of Piero de' Medici and Lucrezia Tornabuoni, granddaughter of Cosimo de' Medici, and sister of Lorenzo the Magnificent. Like the Medici, Giovanni Rucellai believed in spending money on the arts for the combined purpose of embellishing the city and elevating his own status.

Brunelleschi's. Above the arches, framed by two horizontal projections, are two sets of reliefs. One consists of eight medallions, two at each corner, that were inspired by antique cameos in the Medici collection. The other set consists of four Medici coats of arms, one over each central arch of the colonnade. By virtue of this arrangement, the Medici visibly identified themselves with the Classical revival.

A section of the second floor can be seen in the illustration. It is composed of a solid wall, whose double-**lancet**, mullioned windows with round arches are similar to those on the exterior. Inside and outside were thus designed to create an effect of unity. At the same time, however, the contrast between the heavy exterior ground floor and the lighter, more open courtyard is marked. As a total conception, the Medici Palace projected the desired image of the family as fortified but accessible, understated but powerful, engaged in the ongoing business of making money, and interested in promoting the arts.

The Rucellai Palace: 1450s

By the 1440s, Alberti was at work on his architectural treatise *De re aedificatoria libri X*. His aesthetic recommendations departed considerably from Michelozzo's design for the Medici Palace. In Florence, the effects of his views are most evident in the façade of the Rucellai Palace (**7.21**). His approach to architecture is of interest on two levels; aesthetically, he advocated combining certain Classical principles—particularly unity and harmony—with Renaissance features. But he also had a personal relationship to architecture that he made explicit in his popular *Della famiglia* of the late 1430s.

Alberti's Architectural Metaphor

Citing the fifth-century-B.C. Greek historian Thucydides, Alberti recommended that patrons build great palaces in order to achieve lasting fame. Drawing on his experience as the illegitimate member of an exiled family, he was convinced that an established residence would have provided him with a sense of security and physical connection to his native Florence. In addition, as part of his interest in the Classical revival, Alberti believed that ancient buildings should be saved from falling into ruin. One way in which he intended to achieve this was by writing about them. Another was to recommend that architects assimilate Classical forms into contemporary architecture.

For Alberti, a house was a metaphor for the city—houses were little cities, and cities were great houses. He compared the architect to the father of a family. Just as an architect has to design a structure that will stand up and last, so a father is responsible for the development of his children—particularly his sons (Alberti was a virulent misogynist who relegated girls to a subordinate position lest they adversely affect—and infect—the males of the household). Just as the architect oversees the construction of the house, the father should understand his sons, his watchful eye guiding their moral development, and ensuring their future as good citizens.

Alberti designed the façade of Giovanni Rucellai's palace, which was executed by Bernardo Rossellino. As with the Medici Palace, the Rucellai Palace is three stories high, but the stories are of equal height. The character of the masonry is also more uniform, although the individual blocks are larger on the ground-floor wall. Also accentuating the structual foundation of the lower part of the building are the diamond pattern at the base of the façade, which is derived from the ***opus reticulatum*** of ancient Roman buildings, and the rectangularity of the doors and ground-floor windows. The upper-floor windows, in contrast, are more elegant. They are mullioned and have round arches with a circle between each arch. The third and sixth windows on the upper floors are slightly higher and wider than the others. Projecting from the top, as in the Medici Palace, is a crowning cornice.

Horizontal unity is maintained both in the overall design and in the details. Although it is now different than Alberti's plan, the façade was planned symmetrically with eleven bays, twelve pilasters, and three doors. The Rucellai coat of arms, located over the window above the middle door, accentuates its originally central position. Commemorating the marriage of Bernardo Rucellai to Lucrezia (nicknamed Nannina) de' Medici

7.22 Colosseum, begun c. A.D. 80. Rome.

(see the caption) are the Rucellai and Medici devices decorating the friezes.

Superimposed over the wall is a unifying pattern of Classical elements that carries the viewer's gaze upward and across the façade in a harmonious manner. Three Orders of smooth pilasters support an entablature. In contrast to the stringcourses of the Medici Palace, each entablature ends in a cornice that serves as a visual platform for the the Order above. The disposition of the Orders conforms to the Roman practice, known from the Colosseum (**7.22**) and other buildings, in which a different Order is used on each story. Tuscan columns on the ground floor are the plainest and thus appear heaviest; a form of Ionic, which is lighter, is on the second floor; the more elaborate Corinthian is at the top.

Alberti's design for the Rucellai Palace, integrating Classical elements into a fifteenth-century structure, became a model for palace architecture throughout the Renaissance. Like Brunelleschi, he was concerned with measurement and proportion—for example, the Tuscan capitals are equal in width to the combined height of the **architrave** and **frieze** of either the first- or second-story entablature. Alberti's aesthetic also conformed to Brunelleschi's in his preference for regular geometric shapes such as the square and the circle. He believed, with the Classical Greek philosophers, that beauty resided in designs of which no part could be altered without altering the appearance of the whole. The Rucellai façade was Alberti's first major architectural project; in the course of the fifteenth century, he would continue to plan buildings according to the theories set forth in his architectural treatise.

The Façade of Santa Maria Novella

Alberti's second major architectural project in Florence was not begun until 1458, after he had worked on commissions in other cities (see Chapter 8). Once again, his patron was Giovanni Rucellai, whose family chapel was located in the fourteenth-century Dominican church of Santa Maria Novella (**7.23**). In designing the new façade, Alberti had to solve the problem of unifying existing Gothic elements into a new, harmonious conception. He did so by superimposing a symmetrical two-story façade composed of regular shapes integrated with green and white marble surface designs.

The ground floor is composed of a triumphal-arch motif at the central entrance, flanked by a double arcade of round arches. Below, the arches frame spaces containing sarcophagi and are surmounted by blind arches. Four large engaged Corinthian columns on pedestal bases appear to support the entablature. Above the cornice is a **mezzanine** decorated with a row of circles within squares. This appears to support the second story, which is derived from antique temple fronts. In contrast to a portico, however, Alberti's wall is solid; the columns are transformed into pilasters accentuated by alternating green and white horizontal bands, evoking the corner elements of the Florence Baptistery. What would be open spaces on a Greek or Roman temple front are closed in and decorated with diamond-shaped forms on a white ground. A second entablature over the pilasters contains the inscription identifying Giovanni Rucellai as the patron and supports the triangular pediment.

Uniting the upper and lower stories are the large, graceful volutes on either side of the temple front. They mask the disjunction between the high nave and the shorter side aisles of the Gothic structure. Alberti described this solution in a letter to Matteo de' Pasti, who was the architect supervising the construction of the façade, and enclosed a rough sketch of the volutes. He noted that any change in the details of his design would disrupt the formal harmony of the whole.

In accord with the curved arches of the lower story are the repeated circles of the upper story. The circle in the pediment contains a face emitting rays that resemble those of Alberti's winged eye. This is probably a reference to the sun disk as represented in the zodiac. Since the astrological sign of Leo is the house of the sun at its hottest point, it is possible that this unusual feature of Alberti's pediment has personal as well as zodiacal significance. As such, it conflates the Christian symbolism of Christ-as-sun with Alberti's leonine identifications.

Although Renaissance culture during the first half of the quattrocento was centered in Florence, other cities

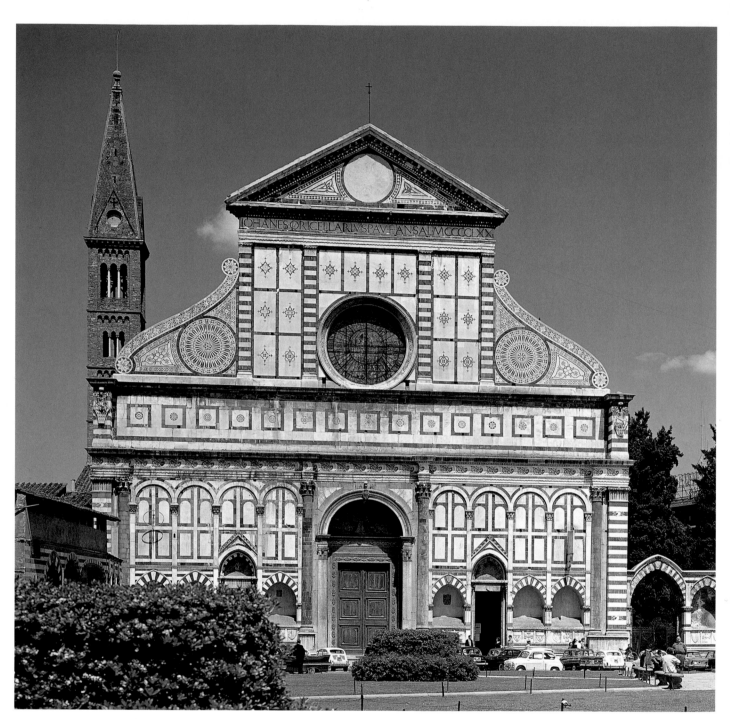

7.23 Leon Battista Alberti, façade of Santa Maria Novella, 1458–1470. Florence.

produced significant works. Not all the regions of the Italian peninsula were as dedicated to projecting a republican image as Florence was, but none could completely escape the impact of the Classical revival. Each city absorbed the new Renaissance developments, some more so than others, according to its own character. The next chapter considers some of these developments in parts of central Italy.

8
Developments in Siena, Rimini, and Pienza: 1400–1460

Throughout the Renaissance, the Italian peninsula was composed of individual cities and territories, each with a distinctive character. Siena differed from Florence politically as well as philosophically and was less affected by the Classical revival. In contrast to nominally Guelph Florence, Siena in the early decades of the quattrocento was sympathetic to the Ghibelline cause. The cult of the Virgin continued to exert a strong force on its religious thinkers, and International Gothic taste prevailed in the visual arts. At the same time, however, Siena produced the monumental sculptor Jacopo della Quercia, whose works show the influence of Masaccio. Jacopo, along with Donatello and Ghiberti, worked on the baptismal font basin for the Siena Baptistery.

The port city of Rimini, on the Adriatic Sea, was ruled by the humanist tyrant Sigismondo Malatesta (1417–1468). The single most powerful patron of the city, he commissioned Alberti to remodel the medieval church of San Francesco into a monument celebrating himself. It was aptly named the Tempio Malatestiano. In this, as in other commissions, Sigismondo's passion for, and identification with, Greek antiquity stamped his patronage with autobiographical content.

In Pienza, as in Rimini and Florence, the pervasive influence of Alberti's theory is readily apparent. The small town of Corsignano, near Siena, was the birthplace of Aeneas Silvius Piccolomini, who became Pope Pius II. He commissioned the first humanist urban plan of the Renaissance and renamed the city Pienza (after his own papal name). As with the Rucellai Palace in Florence, the execution of Pienza's plan and its new buildings was carried out by Bernardo Rossellino, but the inspiration was Albertian.

Siena

Sassetta

The major painter working in early quattrocento Siena was Stefano di Giovanni, known as Sassetta (c. 1400–1450). His most important altarpiece was for the church of San Francesco in the small Tuscan town of Borgo San Sepolcro (Village of the Holy Sepulchre). He also worked for Franciscan patrons in Assisi, in the basilica of San Francesco. In Siena, Sassetta would have known the sermons of the enormously popular Franciscan friar Bernardino (see Box, p. 164). The emphasis on penance and salvation in Bernardino's sermons is consistent with the mystical qualities of Sassetta's style.

The San Sepolcro Altarpiece is now dismantled, its panels housed in various collections. Like Duccio's *Maestà*, it was a freestanding polyptych. A *Madonna and Christ Enthroned* on the front faced the congregation, and a *Saint Francis in Ecstasy* (**8.1**) on the back was visible to the friars in the choir. As such, the image was intended to evoke their identification with the saint who identified with Christ.

Francis extends his hands in a gesture that echoes the Crucifixion and also exhibits the stigmata. His pose and expression combine exuberant energy with a sense

8.1 Sassetta, *Saint Francis in Ecstasy*, from the San Sepolcro Altarpiece, 1437–1444. Tempera on panel; 80¾ × 48 in. (2.05 × 1.22 m). Berenson Collection, Villa I Tatti, Florence.

8.2 Sassetta, *Marriage of Saint Francis to Lady Poverty*, from the San Sepolcro Altarpiece, 1437–1444. Tempera on panel; 20½ × 34⅝ in. (52 × 88 cm). Musée Condé, Chantilly.

on a boar, gazes at her reflection in a red mirror. Directly beneath the saint's feet is the sword-bearing, armed figure of Wrath lying over a lion. At the right, holding a moneybag in a wooden press over the head of a wolf, is Avarice. She is represented as an old crone in a nun's habit. The Vices seem to float in a sea that creates the illusion of a deep space by its recession toward a chain of distant mountains.

Whereas the lower section of the image reflects Sassetta's interest in nature, the upper three-fourths is flattened by the gold sky. This juxtaposition of two- with three-dimensional space accounts for the unique impression created in this panel. For the saint appears to burst forth in a blaze of mystical light, while at the same time the natural world of the viewer is made visible. Sassetta thus confronted the friars of San Francesco in Borgo San Sepolcro with a synthesis of the visionary and the real, implying that in a world of faith the two states of being coexist in harmony.

Above Saint Francis, the Virtue of Obedience bears a yoke across her shoulders and crosses her arms in a symbolic gesture related to that of the saint. Both refer to the Cross—Obedience gazes downward, her gesture closing in the form, whereas Francis gazes upward and opens space by extending his arms both to echo the Crucifixion and welcome the faithful. To the left, Chastity carries the lily of purity, and to the right is Poverty, who wears a ragged brown dress, linking her chromatically to the saint, whose life was based on a rule of poverty. The inscription on his halo proclaims him "patriarch of the poor."

Sassetta illustrated Saint Francis's marriage to Lady Poverty in one of the smaller panels from the altarpiece (**8.2**). The gold **trefoil** frame attests continuing

of peacefulness, just as the style merges the Sienese taste for delicate linear form with Florentine solidity. Enhancing the sense of mystical ecstasy are the gold halo and elaborate mandorla, consisting of somewhat worn-away red seraphim. Their disposition, surrounding a blue oval framing gold rays, is reminiscent of Orcagna's Strozzi Altarpiece (see 2.24).

Hieratic in scale, Saint Francis stands above three Vices; at the left, Lust, wearing a red dress and reclining

San Bernardino of Siena

San Bernardino (1380–1444) was a charismatic preacher whose eloquent calls for repentance struck a chord with the citizens of Siena. A member of the Albizzeschi family, he entered the Franciscan Order at the age of twenty-two. He turned his skills as an orator to the salvation of his fellow Sienese, emphasizing with Saint Francis the holy nature of poverty as well as devotion to the Holy Name of Jesus (the IHS), the evil wrought by the Jews, and the importance of civil order.

San Bernardino had a particularly intense spiritual relationship with the Virgin that was consistent with the prevalence of her cult in Siena. He revered her as a cosmic maternal force whose redemptive power was the equal of Christ's. His sermon on the Virgin's Assumption emphasized her role as Christ's dwelling place and her triumph over death. In addition to his sermons, San Bernardino owed his considerable following to his work with plague victims in Siena.

In 1427, he spoke from a pulpit set up specifically for his sermons in front of the Palazzo Pubblico. The semicircular formation of the buildings around the piazza enhanced the acoustics so that Bernardino could be heard by the vast crowds that gathered to listen. In 1450, just six years after his death, he was canonized by the humanist Sienese pope, Pius II.

Gothic taste, while the image itself shows evidence of Renaissance developments. As in the *Saint Francis in Ecstasy*, natural and visionary features are juxtaposed. A tiny city gate that is out of scale in relation to the figures is placed at the lower right, but the recession of landscape and the appearance of orthogonals produce a convincing illusion of depth.

The lower scene represents the marriage itself. Saint Francis leans toward his bride, who is flanked by two women, apparently Obedience and Chastity. He places a ring on the finger of Poverty as his companion, Brother Leo, looks on. The second episode shows the three graceful women flying heavenward toward the upper right; their lightly fluttering drapery adds a touch of naturalism to a mystical event. Poverty turns back to gaze on her own wedding ceremony, implying that the scene below is an image in her memory as well as an event depicted for viewing by an actual viewer. Here, as in the larger panel, Sassetta combines the representation of a mental picture with a picture representing nature.

Jacopo della Quercia

Of an entirely different character from Sassetta's is the work by the leading Sienese sculptor of the early fifteenth century. Jacopo della Quercia's (c. 1374–1438) style was profoundly influenced by contemporary innovations in Florence, particularly those of Masaccio, Donatello, and Nanni di Banco. Jacopo himself was highly regarded during his lifetime and is documented as having worked in Florence, Lucca, and Bologna as well as in his native Siena. In 1401, at the age of around twenty-five, he entered a relief in the competition for the Florence Baptistery doors.

The Ilaria del Carretto Tomb Monument Jacopo's most important early work is the marble Ilaria del Carretto tomb monument (8.3 and 8.4) of about 1406–1408 in the church of San Martino, in Lucca. Ilaria's death in childbirth at the age of twenty-seven inspired the commission. Her husband, Paolo Guinigi, was lord of Lucca, later ousted as a tyrant.

Although the monument has undergone various restorations and dismantlings, its impact is still felt. The figure lies on a sarcophagus, reflecting both the patron's interest in the Roman revival and the medieval tradition of placing effigies of the deceased on tomb lids with a dog at their feet. More antique are the somber nude *putti* with garlands decorating the sides of the sarcophagus. Their relaxed *contrapposto* poses and age-appropriate proportions reveal Jacopo's study of ancient sculpture.

The detail of Ilaria's head (see 8.4) shows Jacopo's skill in conveying portraitlike character and in rendering delicate surface elements. His treatment of the marble creates an impression of ivory more than of stone. Ilaria's calm repose, her head resting comfortably on a pillow, recalls the traditional association of the twin Greek gods Sleep and Death. The convincing impression that Ilaria is asleep, as well as her youthful beauty, appealed to the nineteenth-century English art critic John Ruskin. Attracted throughout his life to images of sleeping young girls, which were imbued for him with a taste for *Liebestod*, he wrote letters to his parents describing Ilaria as if she were his living fiancée.

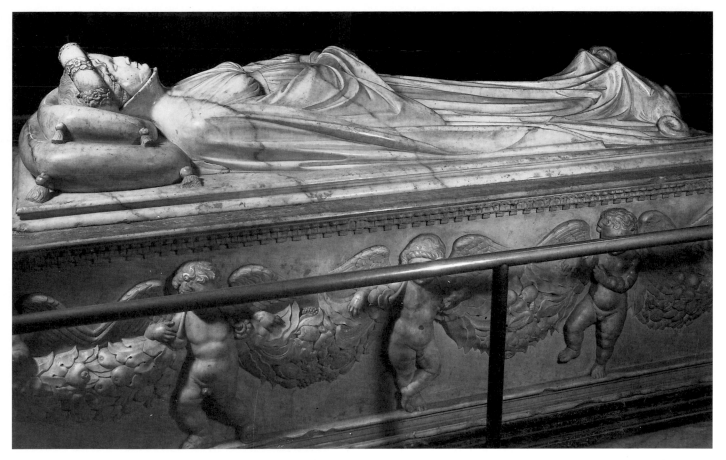

8.3 Jacopo della Quercia, Ilaria del Carretto tomb monument, c. 1406–1408. Marble; 8 ft. × 2 ft. 10⅝ in. × 2 ft. 2 in. (244 × 88 × 66 cm) with base. San Martino, Lucca. Little of Jacopo's youth and training is documented. His father was a sculptor and goldsmith who had previously been acquainted with the lord of Lucca and may have helped his son obtain the commission for the tomb monument. Jacopo was married, but his will does not mention any surviving children. His colorful life included accusations of theft and sodomy in Lucca and of embezzlement in Siena, where he was knighted by the commune.

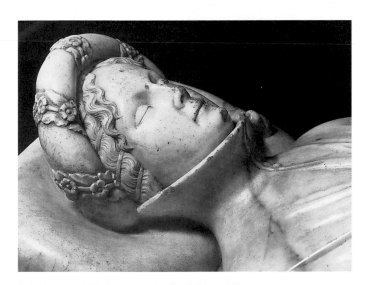

8.4 Jacopo della Quercia, detail of Figure 8.3.

The Fonte Gaia In December 1408, the priors of Siena commissioned Jacopo to remake the large fountain known as the Fonte Gaia, or "Gay Fountain," because of its sprightly water jets, in front of the Palazzo Pubblico (**8.5**). To the dismay of his patrons, Jacopo took some eleven years to finish the work amid continual disputes over payment. Today the fountain is in poor condition, and a copy has been placed in the piazza.

The iconographic program of the exterior reliefs juxtaposed Old Testament scenes with a central image of the Virgin and Christ flanked by four Virtues in round-arched niches. In this arrangement, Jacopo emphasized Mary's role as redeemer of Eve's Original Sin and Christ's role as the new Adam. The inclusion of Justice among the Virtues corresponds to the civic character of the fountain, while the prominence of the Virgin reflects her

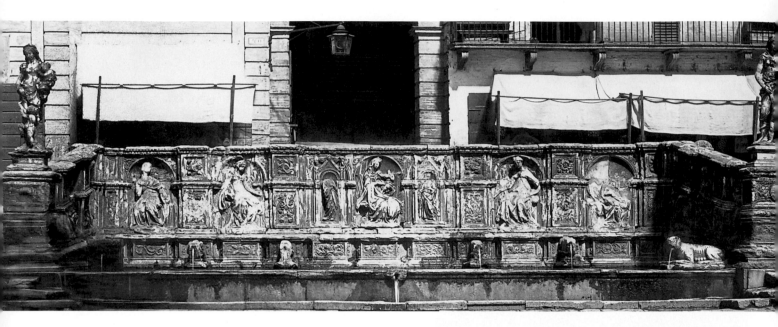

8.5 Jacopo della Quercia, Fonte Gaia, 1408–1419. Marble; center width: 333 ft. 4 in. (101.60 m). Piazza del Campo, Siena (now replaced by a copy in the piazza; the original is located in the upper loggia of the Palazzo Pubblico).

patronage of Siena. At one side stood a statue of the wolf who nursed Romulus and Remus. This, like the she-wolf projecting from the wall of Ambrogio Lorenzetti's *Effects of Good Government* (see 2.20), referred to the tradition of Siena's descent from Remus and its links to ancient Rome. Because of the extensive damage suffered by the fountain, Jacopo's relief style is considered below in the discussion of the San Petronio portal in Bologna.

The Baptismal Font The Opera del Duomo of Siena commissioned a baptismal font (**8.6**) in 1416 for the baptistery of the cathedral. Like other Renaissance projects, this was a collaborative effort. Importing an artist from their rival city of Florence, the Opera hired Ghiberti to design the structure. It consisted of a lower basin as well as a hexagonal tabernacle surmounted by a dome and an additional feature. Niches on five sides of the tabernacle contain sculptures of prophets; a sixth side represents a bronze door on which a Madonna and Christ are depicted in relief. This opened onto the interior of the tabernacle, which contained holy oil used in baptisms and for anointing newly appointed bishops.

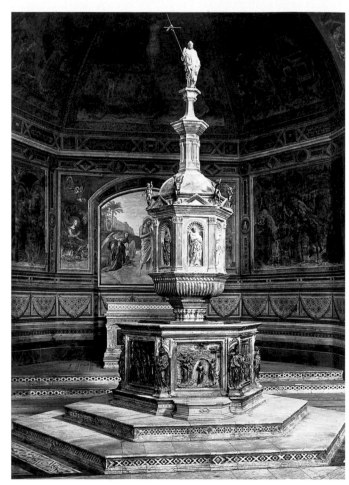

8.6 Lorenzo Ghiberti, Donatello, Jacopo della Quercia, and others, baptismal font, 1416–1430. Marble, gilded bronze, and enamel. Baptistery of San Giovanni, Siena.

Jacopo executed the prophets in the scallop-shell niches, but there is disagreement about the authorship of other parts of the tabernacle. Its design, however, shows clear evidence of Brunelleschi's influence, and the niches alternating with pilasters recall the *Saint Louis of Toulouse* (see 3.31) niche at Or San Michele. Although Jacopo was originally commissioned to produce two of the reliefs illustrating the life of John the Baptist on the basin, he only did one; the other was executed by Donatello.

Donatello's contribution to the baptismal font was the panel illustrating the Feast of Herod (**8.7**). It is the earliest-known relief that uses Brunelleschi's new perspective techniques; the orthogonals appear to converge at the center, which reinforces the symmetrical organization of the relief plane. At the right, Salome dances, her movement enhanced by the curvilinear drapery folds flowing around her left leg. The man in the right foreground conforms to the ideal proportions later described by Alberti, in which the height of a man is

8.7 Donatello, *Feast of Herod*, 1423–1427. Gilded bronze, 23½ × 23½ in. (59.7 × 59.7 cm). Baptistery of San Giovanni, Siena.

8.8 Jacopo della Quercia, main portal, 1425–1439. Marble. San Petronio, Bologna.

equal to that of seven heads. Herod is presented with John the Baptist's head, and he reacts with convincing horror. One man gestures forcefully toward the head, whereas Herod recoils and withdraws his hands as if to avoid touching it. The kneeling figure presenting the plate leans sharply backwards, nearly out of the relief plane. Two children at the far left run from the sight, but their gaze is riveted to it.

By locating the vanishing point on the inverted triangular wall space between the two sets of figural groups, Donatello merges perspective with narrative and psychology. For it accentuates the temporal division—the Baptist's beheading follows Salome's dance—and also separates the two figures at the far side of the table. The figure at the right who hides one eye and looks with the other forms a transition between those who appear unaware of the result of the beheading and those who witness it. The latter, like the figure covering one eye, exhibit ambivalence.

Architecturally, Donatello has combined his characteristic *schiacciato* with diminishing space. The arches appear to recede and they frame a series of bust-length figures, which are inspired by Roman sculpture. These are accentuated by the arches, framing a musician, five individual figures, and a single figure carrying the Baptist's head on its plate. Donatello plays on the theme of heads severed and not severed, on the attraction and revulsion of the sight of the severed head, and on looking and not looking. Likewise, the architecture is simultaneously opened and closed, and the insistent perspectival references—for example, the floor tiles—direct the gaze of the viewer.

The San Petronio Portal While Jacopo della Quercia was still at work on the baptismal font, the papal legate in Bologna commissioned him to decorate the central **portal** of San Petronio (**8.8**). He depicted Old Testament scenes on the pilasters projecting

from the door jambs and New Testament scenes on the lintel. Like Masaccio, Jacopo was drawn to monumental nudes, using landscape and architecture to reinforce the figures rather than as forms in their own right. And like Masaccio's Brancacci Chapel frescoes, Jacopo's reliefs would inspire the young Michelangelo during his formative years, and their impact on his style would reappear in the Sistine Chapel ceiling (see Chapter 16).

The first scene chronologically, the *Creation of Adam* (**8.9**), occupies the top of the left panel of the San Petronio portal. Jacopo shows God the Creator with a triangular halo denoting the Trinity, a flowing beard, and voluminous curvilinear drapery. God gathers his robe as if to emphasize the fact that he does not touch Adam. Instead, he brings him to life by the power of his will and his Word, calling him forth from the earth encompassing his form. Adam is a powerful nude; the surface of his flesh defines the organic structure below. He gazes directly at God, and his hair seems to

8.9 Jacopo della Quercia, *Creation of Adam*, detail of Figure 8.8, 1430s. Marble; 39 in. (99 cm) high.

8.10 Jacopo della Quercia, *Expulsion of Adam and Eve*, detail of Figure 8.8, 1430s. Marble; 39 in. (99 cm) high.

stand up as if he has been suddenly awakened. His transition from earth and clay to human existence is indicated by his gestures. The left hand clings to the earth whereas the right is open and raised, answering God's call to life. The fig tree in the background foreshadows the Fall.

In the *Expulsion of Adam and Eve* (**8.10**), at the center of the left pilaster, an angry angel physically pushes a protesting Adam from Paradise. The affinities with Masaccio's *Expulsion* (see 4.14) are evident in the massiveness of the nudes and the force of their reactions. Eve's pose, like that of Masaccio's figure, is derived from a type of Hellenistic Venus (see 4.15), and Adam's profile is reminiscent of Roman busts. The introverted

Adam of Masaccio's *Expulsion* has become fierce, whereas the extroverted Eve of the Brancacci Chapel has a sad, wistful expression in Jacopo's version. As in the Brancacci Chapel, the landscape is minimal, but at San Petronio Jacopo has converted Masaccio's simplified gateway into an articulated entrance with square columns and an entablature.

In *Adam and Eve at Work* (**8.11**) at the bottom of the left pilaster, Jacopo depicts the results of the Fall. Although he covers the figures with minimal drapery, Jacopo retains powerful nude forms that seem barely contained by the space of the relief. Eve holds a large spindle, denoting the work of spinning thread to make clothing, and gazes at Adam. He, in turn, drives his spade into the earth. The force of his effort is indicated by his pose, his firm grasp on the handle, and the curve of his right foot. Cain and Abel, rendered as lively toddler-age *putti*, play at Eve's feet.

8.11 Jacopo della Quercia, *Adam and Eve at Work*, detail of Figure 8.8, 1430s. Marble; 39 in. (99 cm) high.

Rimini

From 1431, when he was fifteen, until his death in 1468, Sigismondo Malatesta ruled Rimini. Located in the Romagna on the Adriatic, Rimini, like Siena, linked its history to ancient Rome. Such connections were facilitated by the presence of Roman ruins—an Arch of Augustus and a forum—in the city itself.

Sigismondo was a colorful, complex figure whose ambitions cannot be understood without a sense of the fierce competition between Renaissance courts. In contrast to the image projected by some cities such as Florence, Siena, and Venice, the courts made little pretense of republicanism. And even though they were humanist in certain respects, courts and their lords tended to identify with Roman imperialism rather than with the Roman republic.

Renaissance courts typically hired humanists in various disciplines, including literature, philosophy, and science as well as the visual arts. All helped to craft the political image desired by the ruler. How the cost of such courtiers was financed varied, but the most usual way was by the military skill of the rulers, most of whom were *condottieri*. Their success on the battlefield and their ability to make alliances and earn the respect of other rulers—including the pope—generally determined their financial power. This, in turn, determined the amount of money available for the arts.

Sigismondo was the illegitimate son of Pandolfo Malatesta, lord of Fano and himself an accomplished *condottiere*. Pandolfo died when Sigismondo was ten, and his humanist uncle, Carlo, and Carlo's wife, Elisabetta Gonzaga of Mantua (see Chapter 12), became his guardians. At the age of eleven, Sigismondo was legitimized by Pope Martin V, which made it possible for him to become lord of Rimini.

At the age of thirteen, Sigismondo's military genius asserted itself when he led troops against the papal army. But throughout his life he was his own worst enemy. Continually involved in political intrigue in order to further his aims, he fueled his adverse reputation by his actions. He was not above reneging on treaties or breaking an engagement and refusing to return the dowry. Nevertheless, his bad press exceeded the record—he was, for example, reputed to have mur-

dered two wives, although documents show that they died of other causes. He was also accused of heresy, sodomy, invading a convent and raping the nuns, one of whom he allegedly impregnated. In 1446, he took a twelve-year-old girl from Rimini, Isotta degli Atti, as his mistress and installed her at court over the protests of his legitimate wife. He married Isotta ten years later.

Like other rulers, Sigismondo participated in the competition for humanists. He hired Basinio of Parma, whose epic *Hesperides* describes his military campaigns, and Roberto Valturio, who wrote the *De re militari* to record his military architectural projects. By the age of twenty, Sigismondo had hired Brunelleschi to advise on the construction of fortresses. And by 1435, he had commissioned the renovation or creation of over a hundred forts.

As was true of other lords, Sigismondo was compared with the Classical gods—a convention of court poetry that is also evident in the iconography of monumental works of art and in medals. But Sigismondo's identification with the gods, particularly Jupiter and Apollo, had a grandiose quality and, along with his arrogance, his unreliable character, and his flagrant moral transgressions, enraged Pope Pius II. Refusing a summons to stand trial for heresy, Sigismondo became the only man who, by papal decree, was condemned to Hell during his lifetime. In 1461, he was burned in effigy in three public squares in Rome.

The Tempio Malatestiano

Around 1450, Alberti began the design for Sigismondo's Tempio Malatestiano (**8.12**), in which a Renaissance shell was remodeled around a longitudinal Latin-cross plan. Despite the fact that the façade of the Tempio was never completed, Alberti's original design is known from a medal cast by Matteo de' Pasti (**8.13**), who supervised the construction. Following his taste for regular geometric shapes and the view that Renaissance architects should assimilate Classical elements, Alberti adopted a triumphal-arch design. The larger central arch was probably derived from the Arch of Constantine in Rome, from where Alberti was advising on the project.

The Tempio's central arch frames the pedimented entrance. Alberti was also responsible for the columns and their capitals, which he considered the most

8.12 Leon Battista Alberti, Tempio Malatestiano, c. 1450. Rimini.

important decorative features of a façade. The **roundels** framed with wreaths were inspired by the Arch of Augustus in Rimini. It is evident from the medal that Alberti also planned a large curved pediment extending the width of the façade and broken at the center. At this point, he intended to place a window surmounted by another, semicircular pediment supported by small columns. Also unexecuted was the enormous dome spanning the width of the nave and chapels.

Alberti discussed the dome in his only extant letter, which he wrote to Matteo de' Pasti from Rome in 1454. He objected to the use of round windows in the dome because, he said, they should be reserved for temples dedicated to Apollo and Jupiter. He was apparently critical of Sigismondo's grandiosity in turning a Franciscan church into a personal tribute. But Alberti's letter does not mention Sigismondo's grandiose intention that his sarcophagus and that of Isotta be prominently displayed beneath the side arches of the façade—a location usually reserved for saints or other holy figures.

The lateral seven arches of the exterior are supported by piers, and the roundels of the façade are repeated between the arches. Under each arch is a sarcophagus containing the body of a humanist at Sigismondo's court. His passion for Greece inspired Sigismondo to invite George Gemisthos Plethon, the Greek scholar from Byzantium, to his court. Gemisthos Plethon declined; but years later, when Sigismondo was fighting in Mistra, Greece, he had the scholar's remains exhumed and transported to one of the Tempio sarcophagi.

8.13 Matteo de' Pasti, reverse of a medal showing the façade of the Tempio Malatestiano, 1450. Bronze; 1 9/16 in. (40 mm) diameter. Samuel Kress Collection, National Gallery of Art, Washington, D.C.

The interior of the Tempio is filled with works of art, including the sarcophagi of Sigismondo and Isotta originally intended for the façade and a tomb containing the remains of Sigismondo's ancestors. The iconography of the numerous reliefs decorating the interior has been a subject of some scholarly controversy. They are generally attributed to Agostino di Duccio (1418–1481), a sculptor from Florence who had studied with Donatello.

Agostino's reliefs reflect the identification of Sigismondo and Isotta with the gods. Figure **8.14** is *Aquarius* from a series of *Signs of the Zodiac*. It depicts a boatman in the foreground and fanciful, curvilinear waves merging into monstrous sea creatures. Two disembodied heads, possibly wind gods, seem to be spouting wind at the lower corners. In the middle ground, the island of Delos, Apollo's birthplace, is conflated with Rimini. Sigismondo's castle is visible behind the central mountain, while an elephant stands prominently at the edge of the island. The elephant crest, a Malatesta emblem, was connected to the ancient association of elephants with Roman emperors and the sun. The ancient tradition that elephants wor-

shiped the sun—and that they were capable of learning Greek—was consistent with Sigismondo's iconography in the Tempio. Elephants, which were owned in Rome only by the emperor, were also associated with immortality because of their reputation for memory ("elephants never forget"). In the Middle Ages, elephants were symbols of military might and, in manuscripts, are shown supporting crenellated towers filled with archers.

In another zodiacal relief, the moon goddess Diana (the Roman equivalent of the Greek Artemis)

8.14 Agostino di Duccio, *Signs of the Zodiac: Aquarius*, 1450s. Marble. Tempio Malatestiano, Rimini.

rides a triumphal chariot drawn by two horses (**8.15**). As Apollo's twin, Diana was conflated with Isotta, also endowing her with divine origins. These were celebrated at length by the humanist poets at the Rimini court.

The Roman soldier represented in high relief in the Tempio shows Sigismondo's identification with ancient Rome (**8.16**). Framed by pilasters with *putti* capitals, the figure holds an orb and the scallop-shell apse rises behind his head in a haloesque fashion. This

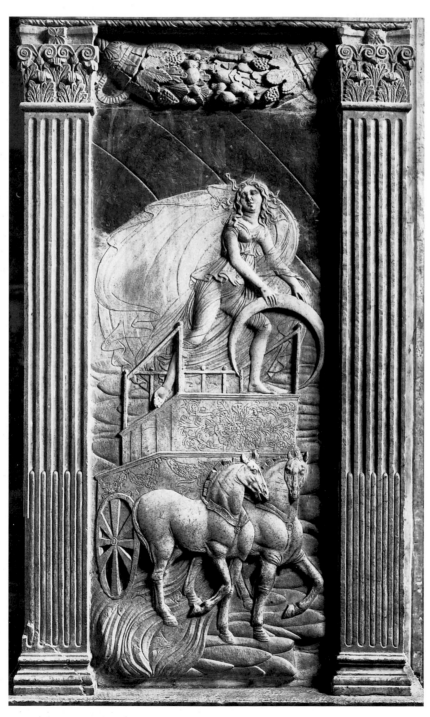

8.15 Agostino di Duccio, *Signs of the Zodiac: Diana*, 1450s. Marble. Tempio Malatestiano, Rimini.

iconography, like the island of Delos/Rimini, reflects an unusual combination of several elements—in this case, Christian and Classical—that was characteristic of works commissioned by Sigismondo. Further, the prominent shield contains the entwined letters *SI*,

which were repeated throughout the interior of the Tempio as well as below the lateral exterior arches. This monogram was probably intentionally ambiguous: the *SI* could refer to the first two letters of *Sigismondo* or to the first letter of *Sigismondo* combined with the first letter of *Isotta*. In addition, if *SI* could refer to the *Si* of *Sigismondo*, then *IS* could refer to the *Is* of *Isotta*. (The intertwined letters can be read as either *SI* or *IS*.)

Medals of Sigismondo and Isotta

Sigismondo had many medals cast, mainly by Matteo de' Pasti and Pisanello, which celebrated Isotta as well as himself. The obverse of the medal showing the façade of the Tempio (**8.17**) depicts the lord of Rimini as a Roman portrait bust wreathed with the laurel of fame and immortality. His typical persona on medals emphasizes his bellicose nature. For example, in two medals of 1445, he is shown fully armed for battle. In one (**8.18**), he is about to draw his sword and is flanked by Malatesta symbols: the elephant crest, a tree bearing the Malatesta rose, and a coat of arms with the entwined *SI*. In another (**8.19**), he is depicted in the traditional iconography of the equestrian monument, mounted on a charger and extending the baton

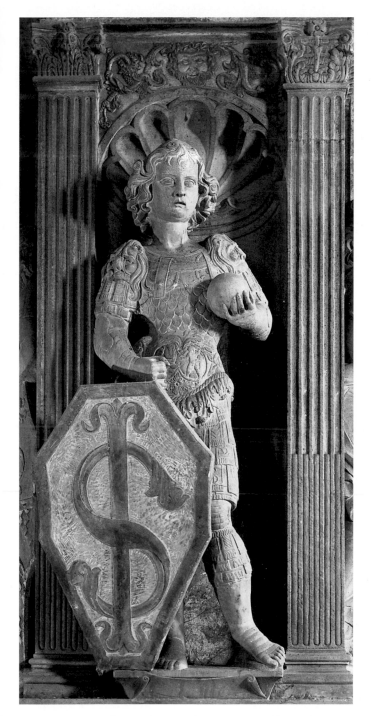

8.16 Agostino di Duccio, *Figure in Roman Armor*, 1450s. Marble. Tempio Malatestiano, Rimini.

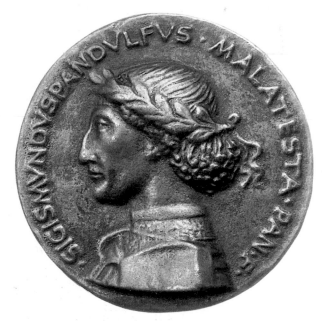

8.17 Matteo de' Pasti, obverse of Figure 8.13 showing Sigismondo as a Roman ruler, 1450. Bronze; 1⁹⁄₁₆ in. (40 mm) diameter. National Gallery of Art, Washington, D.C., Samuel H. Kress Collection.

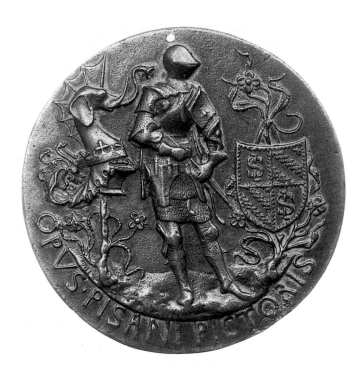

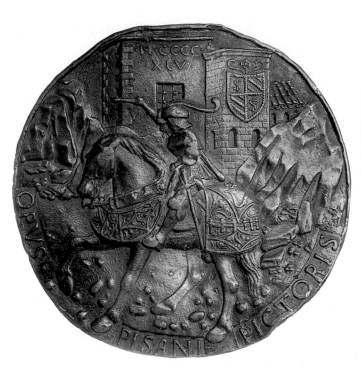

8.18 Antonio Pisanello, medal showing Sigismondo armed, reverse, 1445. Lead; 3½ in. (9 cm) diameter. National Gallery of Art, Washington, D.C., Samuel H. Kress Collection.

8.19 Antonio Pisanello, medal showing Sigismondo on a charger, reverse, 1445. Lead; 4 in. (10.4 cm) diameter. National Gallery of Art, Washington, D.C., Samuel H. Kress Collection. In 1445, Sigismondo captured the Rocca (Fortress) Contrada. Since the date is placed on the building, it may be the captured rocca.

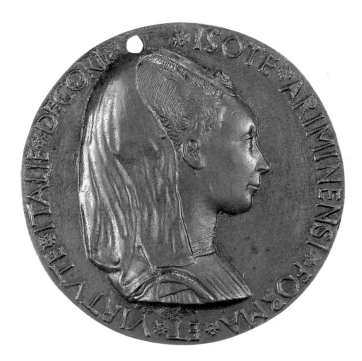

8.20 Matteo de' Pasti, medal with the bust of Isotta degli Atti, obverse, 1446. 3⅜ in. (8.4 cm) diameter. National Gallery of Art, Washington, D.C., Samuel H. Kress Collection.

8.21 Matteo de' Pasti, reverse of Figure 8.20 with the Malatesta elephant and two rosebushes in a field.

of command. In the background, set in a rocky landscape, is a fortress with the Malatesta arms on a tower and the date inscribed over the entrance.

The obverse of the medal dated 1446 depicting Isotta's bust in profile (**8.20**) exemplifies Matteo's skill as a portraitist. Cast the year that Sigismondo met Isotta, the image captures the delicate features and youthful appeal of the twelve-year-old girl. Her link with the Malatesta is celebrated, as in many other medals, by the emblem on the reverse—in this case, the elephant (**8.21**). It stands in a field, with a rosebush at its back and before its trunk. Below, the date memorializes the year of Sigismondo's first meeting with Isotta.

Pienza

Pius II, the pope responsible for condemning Sigismondo to Hell, was influenced by the artistic ideas of Alberti. His renovation of the urban plan of his native Corsignano, renamed Pienza after himself, was the first realization of the ideal city in the Renaissance. He hired Bernardo Rossellino to design and execute the piazza—the core of the plan (**8.22**)—and the surrounding buildings. These consisted of a cathedral located between the bishop's palace to the east (left) and the papal (that is, Piccolomini) palace to the west (right), and a town hall across the piazza to the north (bottom).

The façade of the cathedral (**8.23**) is composed, like the Rucellai Palace, of smooth stone blocks. In accordance with Alberti's aesthetic, the surface decoration is superimposed over the wall. On the ground floor, the triple-triumphal-arch motif recurs, with the entrance arch being larger than those on either side. As Alberti advised, Rossellino used columns as decorative elements on the first two stories, which are surmounted by a **gable**. The triple arches on the second story and the vertical repetition of the columns contribute to the

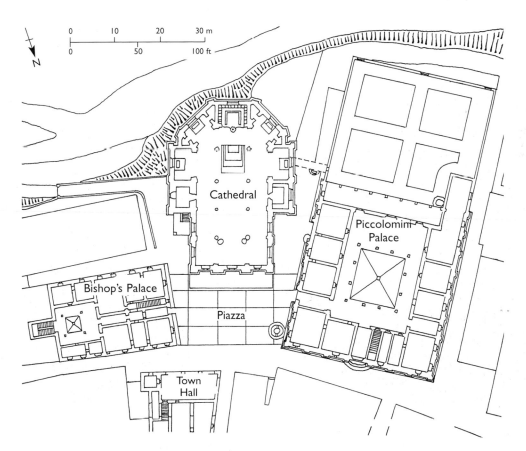

8.22 Bernardo Rossellino, plan of Pienza, c. 1462.

formal unity desired by artists working in the tradition of the Classical revival.

The crowning gable is divided by the continuation of the piers on the lower stories. Dominating its center and repeating the shape of the window below is the tondo containing the pope's coat of arms. Like those of the Medici and Rucellai palaces in Florence, the arms identify the patron. They are also a reminder of the papal office and reflect Pius's personal combination of piety with his pride in the new plan of Pienza.

To the west of the cathedral is the papal palace. Like the cathedral façade, it has three stories. The surface decorative elements consist of pilasters surmounted by entablatures, with a projecting cornice at the roof. As in the Rucellai Palace, each entablature serves as a visual platform for the round-arched windows on the next story. On the ground floor, the small square windows are for defense.

Inspired by Petrarch's fourteenth-century description of climbing Mount Ventoux and its exhilarating effect (see Box, p. 28) and the ancient Roman view that the countryside provides respite from urban tensions, Rossellino oriented the papal palace so that its south side overlooked a private garden. From there, the view spread outward to Monte Amiata in the distance, a metaphor for the expansive opening up of space—intellectual as well as formal—that characterized Renaissance humanism.

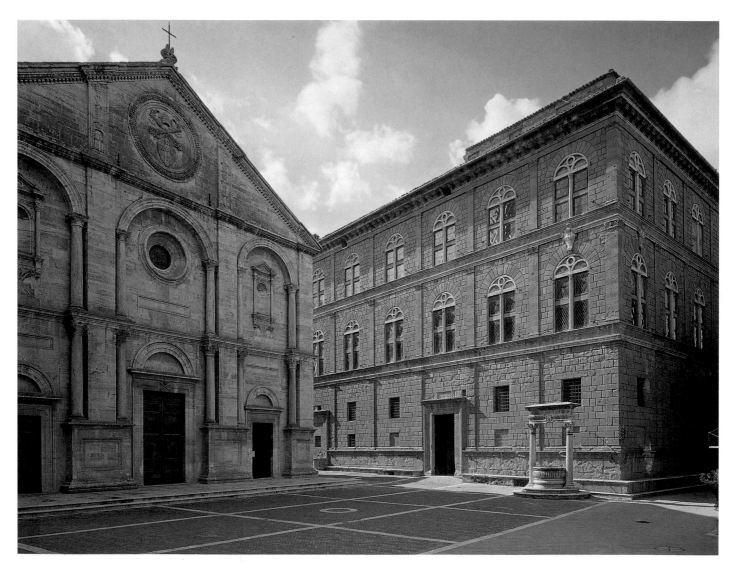

8.23 Bernardo Rossellino, piazza of Pienza showing the cathedral and the papal palace, 1460s.

9

Developments in Umbria, the Marches, and Naples: 1400s–1460s

The humanist movement spread beyond Tuscany, south through Umbria and the Marches, to Rome and the kingdom of Naples. As in Rimini, imagery was used at the courts of Urbino and Naples for both political and artistic purposes. In Naples, architecture and urban design under Alfonso I was influenced by Vitruvius, the ancient Roman engineer and architect.

The *Ideal City* (**9.1**), generally dated toward the latter part of the fifteenth century, has been attributed to various artists who worked at the Montefeltro court in Urbino. It shows the emphasis on the centralized vision of a city and the ideal of the round temple. As recommended by Alberti, the artist has assimilated ancient with contemporary forms. The imagined city seems to radiate from an identifiable center, symmetrically balanced by buildings with round arches, rectangular windows, and Corinthian columns and pilasters. In the far distance, barely visible above a partly hidden pedimented temple front at the right, is landscape. As at Pienza, this serves as a reminder

Vitruvius

Marcus Vitruvius Pollio wrote the *De architectura* in Rome during the Augustan period (30 B.C.–A.D. 14). A treatise on architecture in ten books, the work was based on a combination of Vitruvius's own experience and earlier writings by Greek and Etruscan architects. In it, Vitruvius discusses urban planning, building materials, construction systems, and the relationship of the three Greek Orders of architecture to social order. The *De architectura* was rediscovered in 1414 and became an important source for Renaissance architects interested in the revival of antiquity.

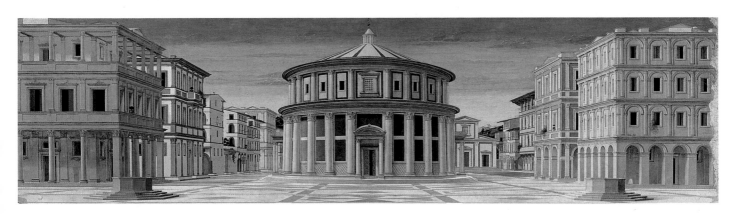

9.1 Anonymous, *Ideal City*, late 15th century. Panel; 79 × 23½ in. (200.7 × 59.7 cm). Galleria Nazionale delle Marche, Urbino.

that the Renaissance considered the countryside a respite from city life.

The pattern resembling *opus reticulatum* on the lower wall of the central round temple, which has a Renaissance lantern, is a self-conscious allusion to ancient Roman wall decoration. Accentuating the radiation from the round building are the orthogonal lines of the tiles of the piazza that lead to a single vanishing point. The crisp white light and clarity of form in the painting also characterize the architecture of Luciano Laurana and the paintings of Piero della Francesca, both of whom worked for Federico da Montefeltro, lord of Urbino. Although the *Ideal City* has, at times, been attributed to one or other of these artists, there is no evidence that either painted it.

Alfonso I of Naples

The court of Alfonso I (1396–1458) at Naples was an important center of humanism and Classical revival. Alfonso was born in the Spanish province of Aragon and, as its heir, became Alfonso V in 1416. Four years later he subdued the kingdom of Sicily and in 1443 defeated the French Angevin rulers of Naples, where he established his primary court. He used his power to develop the arts and the economy of his territories and, in turn, used the arts to reinforce his power.

One of the distinguishing characteristics of Alfonso's court was its international flavor. He commissioned works from Spanish and Flemish artists, nearly all of which—including paintings by van Eyck—have been lost. He also hired Roman sculptors, appointed Pisanello a member of his household, and greatly admired Donatello. As a collector, Alfonso had tastes that were eclectic; in addition to paintings and sculptures, he accumulated tapestries, antique gems, and Roman coins and medals.

Pisanello's Medal of Alfonso

This combination of interests is reflected on Alfonso's medal of 1449, cast by Pisanello (**9.2** and **9.3**). He is shown as a proud military figure, a regal but generous ruler, and a man of letters. Alfonso's profile bust appears

9.2 Antonio Pisanello, medal of Alfonso V of Aragon, obverse, 1449. Bronze; 4⅜ in. (11 cm) diameter. Victoria and Albert Museum, London.

9.3 Antonio Pisanello, reverse of Figure 9.2.

on the obverse (see 9.2). He wears a breastplate, and his helmet is behind him. Engraved on the helmet is an opened book illuminated by the sun's rays. At the far right is a crown. An inscription echoes Alfonso's military ambitions as well as his desire to create the image of a peaceful ruler sanctioned by divine right: DIVUS ALPHONSUS REX TRIUMPHATOR ET PACIFICUS [Divine Alfonso triumphant and peace-making king]. The date 1449 is placed above and below the crown.

On the reverse (see 9.3), an imposing eagle proclaims Alfonso's links to Rome and thus the legitimacy of his rule. A conventional symbol of royal generosity, this particular eagle towers over birds feeding on a leftover animal carcass in a rocky landscape. The iconographic message is clear: the goodwill of the king is ensured as long as he has first been satisfied. The inscription, however, is more flattering: "LIBERALITAS AUGUSTA" [Imperial generosity], the term "AUGUSTA" an allusion to imperial Rome and its first emperor, Augustus.

For military inspiration, as well as for imagery, Alfonso turned to antiquity. He read Caesar and Livy but also enjoyed the more poetic Arthurian romances. Alfonso's literary preferences reflected his character, for he was an aggressive imperialist bent on expanding his territory and allying himself with Milan. He aimed to control the entire Italian peninsula and, at the same time, was devoted to education. In addition to artists, he employed a number of leading humanist authors and built a large library of Classical texts.

The Roman scholar Lorenzo Valla (1407–1457) spent over ten years at Alfonso's court. He had taught rhetoric at Pavia and wrote on Greek and Roman philosophy. One of his important contributions to modern scholarship was in demonstrating that *The Donation of Constantine*, a text proclaiming the papal right to govern Italian territory and thus the temporal as well as the spiritual power of the pope, was a forgery. Antonio Beccadelli (1394–1471), known as Panormita after his native Palermo, was, like Valla, versed in both Greek and Latin. Known for his salacious wit, he wrote the licentious *Hermaphroditus*, which he dedicated to Cosimo de' Medici. His biography of Alfonso stressed the links between the Aragonese ruler and the so-called "good emperors" of Rome, particularly Trajan and Hadrian, the latter born in Spain. Both the Greek scholar Francesco Filelfo (1398–1481) and Aeneas Silvius

Piccolomini, the future Pope Pius II, spent time at the Naples court. And, most importantly, Gianozzo Manetti (1396–1459) published his influential *On the Dignity of Man* (see Box, p. 128) for Alfonso.

The Aragonese Arch

The design and iconography of Alfonso's most monumental commission combines a defensive medieval castle with a seemingly more accessible triumphal arch inspired by ancient Rome. Placed at the entrance to the lavishly renovated castle used by his French Angevin predecessors, and renamed Castel Nuovo, is the elaborate marble arch (9.4). Flanked by massive, crenellated towers, the arch celebrated Alfonso's victory of 1443 against the Angevins. From 1453 to 1471, artists from Italy, Spain, and Dalmatia—the coastal region of present-day Croatia, across the Adriatic Sea from Italy—worked on the arch. The structure is actually two arches, one above the other, so designed to fill the vertical space between the towers. The iconography of the upper section is allegorical, whereas that of the lower section deals with the history and political image of Alfonso himself.

On either side of the taller lower arch are pairs of Corinthian columns supporting an entablature. Above the arch, two emblematic griffins flank the Aragonese coat of arms surmounted by Alfonso's crown. Cornucopias signify the prosperity of Alfonso's reign, despite the fact that he imposed heavy taxes on his subjects to finance his expansionist ambitions. He also angered the Spaniards by the money and attentions he devoted to the Naples court.

The attic of the lower arch is decorated with a triumphal procession based on Alfonso's actual entry into Naples in 1443, which was recorded by contemporary observers. Priests, reflecting Alfonso's wish to project an image of piety, led the procession, followed by representatives of other Italian states, Spaniards, and Dalmatians. The centerpiece was a golden triumphal chariot (9.5), in the form of a fortress, that carried an enthroned Alfonso, although he would never actually be crowned king of Naples. A blazing replica of the so-called Siege Perilous was placed at the foot of the throne. This was a fiery seat at King Arthur's round table that only the purest and most invincible knights could

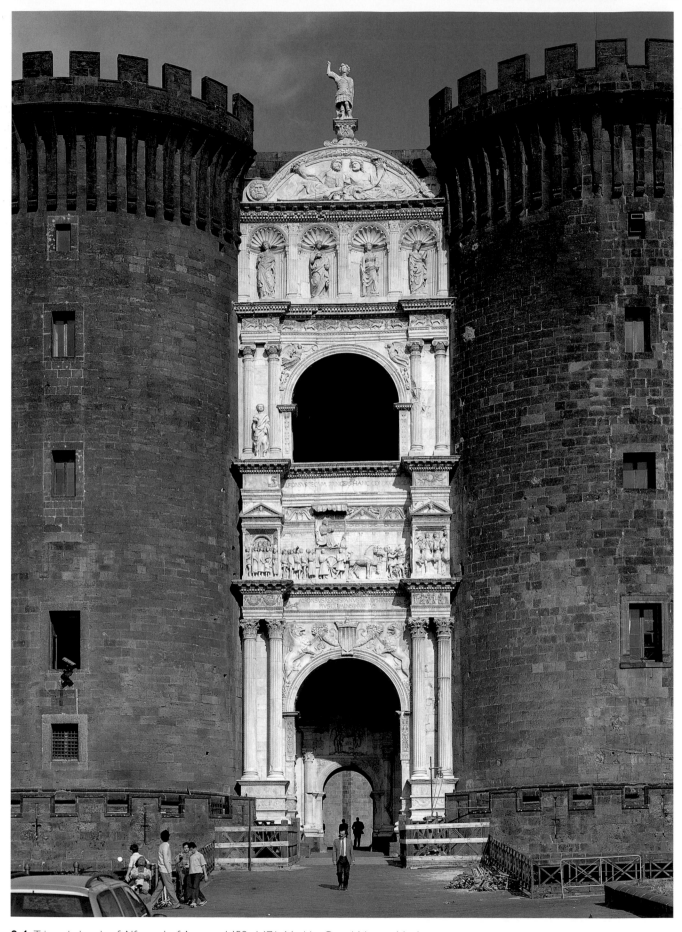

9.4 Triumphal arch of Alfonso I of Aragon, 1453–1471. Marble. Castel Nuovo, Naples.

occupy without being burned. Following in the train of Alfonso's chariot were military figures, members of the nobility, and humanists.

Also inspiring the iconography of the relief were ancient literary sources describing Roman triumphs. Alfonso is seated in a Roman-style chariot drawn by horses; he carries the orb of empire. To project his peace-loving, benevolent image, all military allusions have been eliminated. He is robed instead of armed and is accompanied by commoners, ambassadors, and musicians. Draped over his throne, as in the actual procession, is the brocaded mantle of the defeated René d'Anjou.

The shorter upper arch is flanked by Ionic columns and a pair of relief sculptures of winged Victories. In the attic above the entablature are the four Cardinal Virtues—Justice, Temperance, Fortitude, and Prudence —in scallop-shell niches. Reclining in the lunette are two river gods with cornucopias, and surmounting the entire structure is Saint Michael, the warrior archangel.

Although much of the iconography of the Aragonese arch has not been completely deciphered, its general message is clear. In its imposing height and repetition of family insignia, the arch proclaims Alfonso's power in the present as well as his historical links to antiquity. The formal and iconographic emphasis on triumph is a statement of Alfonso's personal and military victories over his enemies. And the combination of Christian and Classical content confirms his humanist persona and that of his court.

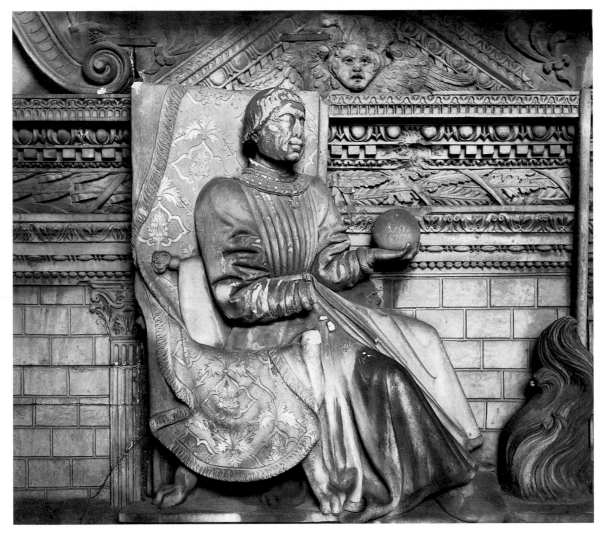

9.5 Detail of Figure 9.4.

Piero della Francesca

The major painter from central Italy in the mid-fifteenth century worked in the monumental tradition of Giotto, Masaccio, and Castagno. Piero della Francesca (c. 1420–1492) was born into a family of wool dyers in Borgo San Sepolcro. Situated in the southeastern corner of Tuscany, Borgo was then under the control of the Papal States.

Piero's earliest works are documented in and around his native town. In the 1430s he began traveling and was employed in Perugia, Loreto, Ferrara, Rome, and Florence, although he returned on occasion for commissions in and around Borgo San Sepolcro. In 1439, he worked in Florence with Domenico Veneziano, whose taste for white light, symmetry, and formal clarity he shared. Their frescoes, in the choir of Sant'Egidio, in the church of the Hospital of Santa Maria Nuova, are lost. Piero's single surviving monumental fresco cycle is in the church of San Francesco in Arezzo. He also executed two extant commissions in Rimini: an individual profile portrait of Sigismondo and a fresco in the Tempio Malatestiano showing Sigismondo kneeling before Saint Sigismund. His most sustained work at a Renaissance court, however, was in Urbino, where he worked for Sigismondo's rival and arch enemy, Federico da Montefeltro.

Disputes about the dating of many works by Piero notwithstanding, the characteristics of his style are consistent. He combined a striking white light with intense colors. Influenced by Northern artists, he added oil and tempera to his frescoes, which enriched their chromatic effects, and painted detailed landscapes. His organization of space shows the impact of Brunelleschi and Alberti, while his sculptural figures reveal a close study of antique statuary and the volumetric forms of Masaccio. Reflecting Piero's geometric style are his two treatises, both written in Latin: *De Prospectiva pingendi* [On the Perspective of Painting] and *De corporibus regularibus* on the five regular bodies (polyhedrons) of solid geometry. The complexity of his iconography, which contains multiple layers of meaning, and its integration with form and color have led to numerous interpretations of certain pictures.

The *Baptism of Christ*

Piero's *Baptism of Christ* (**9.6**), generally dated to the early 1450s, was a logical choice for the altarpiece of the church of San Giovanni Battista in Borgo San Sepolcro. Pervaded by clear white daylight, the painting is a landmark in the development of monumental figures in natural landscape.

In this case, the hillside, dotted with patches of green fields and trees, resembles the Tuscan landscape. The close attention to detail indicates the influence of Flemish painting. Christ stands in the river Jordan as John the Baptist, dressed in the hair shirt denoting his ascetic life in the desert, pours the water of baptism on his head. Hovering in perfect stillness above Christ is the white dove of the Holy Spirit, shedding rays of light. At the left, three angels witness the scene. The one behind the tree carries Christ's pink robe over his shoulder.

In the middle ground, a youth removing his shirt is related to Masaccio's neophyte in the Brancacci Chapel scene of *Saint Peter Baptizing* (see 4.19) and is similar to a figure in one of Masolino's frescoes. In the distance, a procession of bearded men moves slowly by a bend in the river. Their reflections in the mirrorlike surface of the Jordan reinforce the sense of quiet in the picture as a whole. And their relative darkness refers to their role as proponents of the old Mosaic law in contrast to the "light" of the New Dispensation. At the same time, however, the large hats have been variously identified as belonging to Jewish patriarchs and as reminiscent of John VIII Palaeologus's cortege. In either case, they denote the East, and their weighty robes contrast with the white figure removing his clothing as a sign of rebirth into Christianity through baptism.

Piero coordinates nature with the figures through chromatic and geometric parallels. Christ, for example, is in a slight Classical *contrapposto* pose, so that his white cylindrical form repeats that of the tree and the central angel. In contrast to the background tree at the left, which is darkened like the distant figures, the whiteness of the foreground tree signifies its newness and its symbolic connection with Christ in the present as well as in the future. Temporal references to the future of the Church occur in the resemblance of Christ's praying hands to an arch.

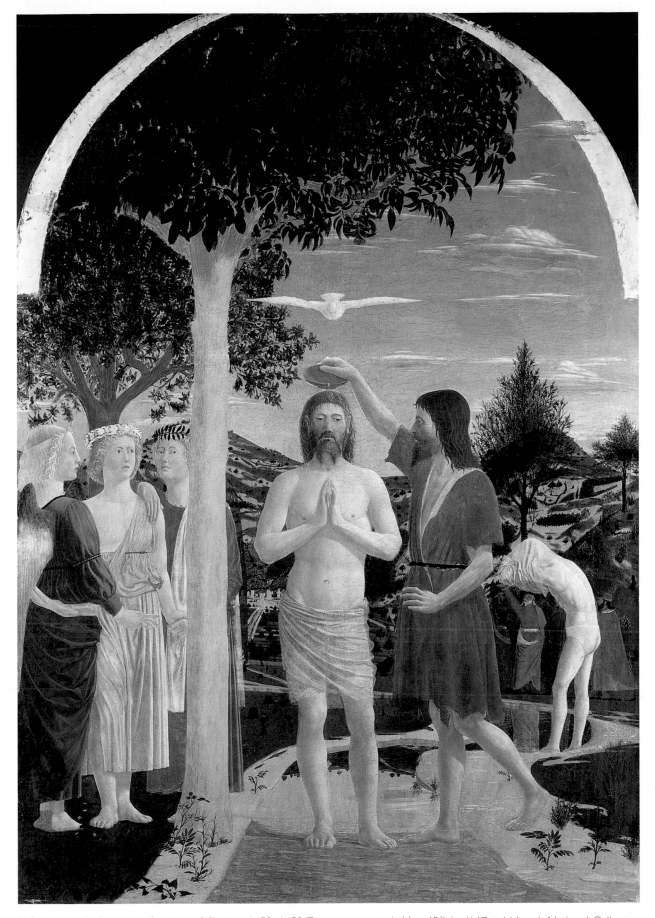

9.6 Piero della Francesca, *Baptism of Christ*, c. 1452–1453. Tempera on panel; 66 × 45¾ in. (167 × 116 cm). National Gallery, London.

The *Madonna del Parto*

In the small hill town of Monterchi, a short distance from Borgo San Sepolcro, Piero executed one of his most unusual and self-consciously geometric frescoes. The *Madonna del Parto* [Madonna of Childbirth] **(9.7)**, commissioned for the high altar of a small Romanesque church, is a rare monumental version of the pregnant Virgin. In her simplicity and volumetric massiveness, she is reminiscent of Masaccio's apostles in the *Tribute Money* (see 4.17). Her egg-shaped head, a characteristic of Piero's maternal figures, as well as the regularity of

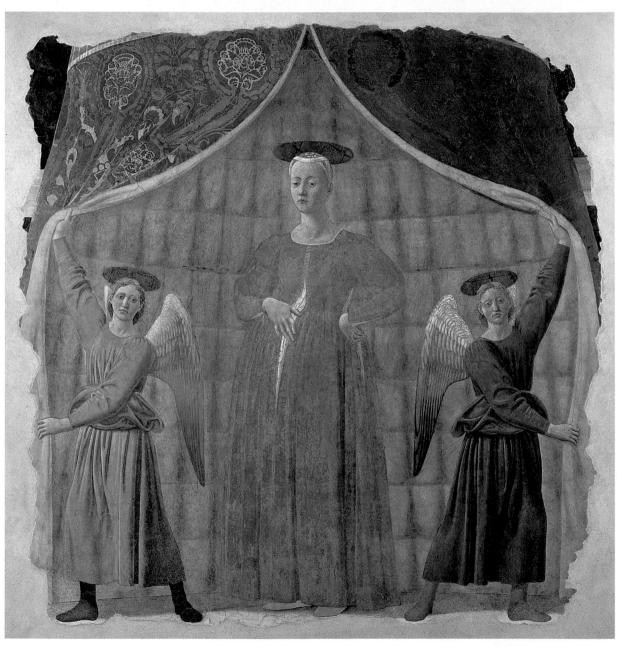

9.7 Piero della Francesca, *Madonna del Parto*. Fresco; 8 ft. 6⅜ in. × 6 ft. 8 in. (260 × 203 cm). Formerly in the Church of Santa Maria della Selva, outside Monterchi. Local tradition has it that the fresco was executed in memory of the artist's mother, who came from Monterchi.

Although there is no documentary evidence to support the tradition, it is not inconsistent with the maternal content of a cult image of the Madonna. Parts of the original fresco and its frame are lost, and there has been some overpainting by restorers.

her features, conforms to the practice set forth in the artist's treatises.

She is shown under a canopy that identifies the setting as the court of Heaven; the rich celestial-blue pigment of her drapery was made from a mixture of azurite with white lead. Reinforcing her regal status is her gesture, showing that she is pregnant by opening her robe—a traditional act of queens required to produce a legitimate heir. The revelatory content of the image is emphasized by formal and thematic repetition: the angels reveal Mary, who reveals her pregnancy; and the curved opening of the robe echoes the curves of the canopy. The mirror-image angels were executed from the same **cartoon** and reversed, their richly colored wings and robes painted in a mixture of fresco with tempera. Chiseled draperies, like those worn by the central angel of Piero's *Baptism,* show the influence of Classical sculpture.

The Cartoon

As used in painting, the cartoon (from the Italian *cartone,* meaning "a heavy paper") is a drawing or painting on *cartone* made in preparation for a fresco. It allows the artist to transfer the drawing to the wall by superimposing a grid pattern on both the drawing and the wall. By copying each square of the drawing onto the corresponding square on the wall, the artist can replicate the drawing exactly and increase or decrease the size of the preparatory image. Alternatively, the outlines of the drawing can be pricked with a sharp instrument, creating a series of holes along the edges of the forms. Powdered chalk or charcoal—called **pounce** (hence the term **pouncing**)—can then be passed through the holes, "transferring" the outlines of the drawing to the wall surface.

Mary's large size is symbolic. Like the Christ of the *Baptism,* she stands for the Church building. Here she is literally the House of God, and the whiteness of the cloth beneath her blue robe alludes to Christ as the Light of the World and the mystery of the Incarnation. Traces of porphyry in the background allude, as in Castagno's *Last Supper* and Bruni's tomb, to death—in this case, the death of Christ, who is born human in order to die.

The Arezzo Frescoes

Piero's only surviving monumental fresco cycle is dated to the 1450s (**9.8** and **9.9**). Located in the main chapel of the church of San Francesco in Arezzo, the frescoes were commissioned by the Bacci, a local family of apothecaries. Originally, a large painted crucifix was suspended over the altar, which was consistent with the subject of the frescoes, the popular medieval legend of the True Cross.

Piero's arrangement of the scenes does not follow the chronology of the narrative, which takes the wood of the Cross from the beginning of time to its Exaltation (when it is restored to Jerusalem by Heraclius) in the seventh century. Figure **9.10** shows the disposition of the main scenes and the surviving pilaster figures. From the diagram and the view of the chapel, it is clear that Piero orchestrated a complex system of formal, iconographic, historical, and liturgical parallels that supersede narrative sequence.

As in the Brancacci Chapel, the painted light in the Arezzo frescoes comes from the same direction as the actual light from the window. The two large lunettes at the top of each wall depict the beginning and the end (the Alpha and the Omega) of the legend—the *Death of Adam* on the right and the *Exaltation of the Cross* on the left. In both scenes, trees are visually related to the Cross, and in the *Death,* the central woman with outstretched arms echoes the conventional pose and gesture of Mary Magdalen at the Crucifixion. This, like the seedling planted by Seth, refers forward in time to the death of the New Adam on the Cross. At the moment of the Exaltation opposite, citizens of Jerusalem kneel to adore the Cross.

The middle level of the side walls depicts the *Meeting of Solomon and Sheba* at the right and the *Discovery and Proof of the Cross* at the left. This pairing relates the two women engaged in recognizing the wood and finding the Cross. Both scenes also juxtapose prominent foreground Albertian architecture with distant landscape. The temple front in the scene of the *Proof* combines the Greek pediment with an arch, which was also Alberti's plan for the façade of the Tempio Malatestiano (see 8.12). On the pilaster above the *Discovery* stands a figure of Cupid, an allusion to the temple of Venus destroyed by Helena in her quest for the True Cross.

On the window wall, the small fresco to the left of the *Meeting of Solomon and Sheba* shows three men preparing to bury the wood. The foremost figure is a visual quotation from scenes of the *Way to Calvary*, in which Christ struggles to carry his own Cross. Piero accentuates this parallel by the grain of the wood, which curves like a halo around the man's head. In the *Torture of Judas* on the other side of the window, three men raise Judas from the well. The fact that Judas later converts to Christianity and becomes a bishop makes his immersion in the well a prefiguration of his baptism.

Below the *Burial of the Wood* is the *Dream of Constantine*, which Piero depicts as a sleep dream

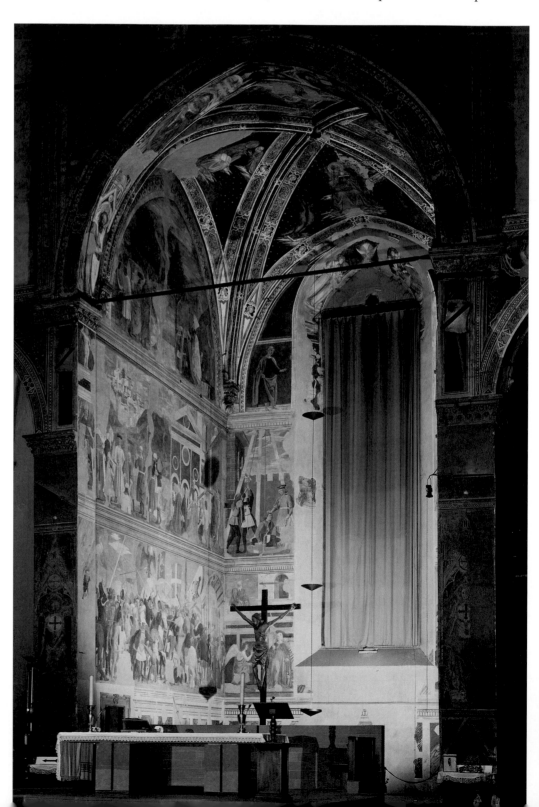

9.8 and **9.9** (*right* and *opposite*) Piero della Francesca, Cappella Maggiore frescoes illustrating the *Legend of the True Cross*, 1450s (before restoration). San Francesco, Arezzo.

rather than a waking vision. In the large scene to the right of the *Dream*, Constantine leads his army with the angel's tiny cross before him. It miraculously causes Maxentius to retreat in disarray without disturbing the serenity of the Tiber River. Constantine wears the beard and hat of John VIII Palaeologus, referring to contemporary efforts to unify the Church.

The *Annunciation* (**9.11**), which is paired with the *Dream of Constantine* (**9.12**), is the only event not included in the text of the True Cross legend (see Box, p. 190). Nevertheless, it functions in the cycle as a bridge between the Old and New Dispensations. It also provides liturgical and typological connections with other events. In the Church calendar, the feast of the

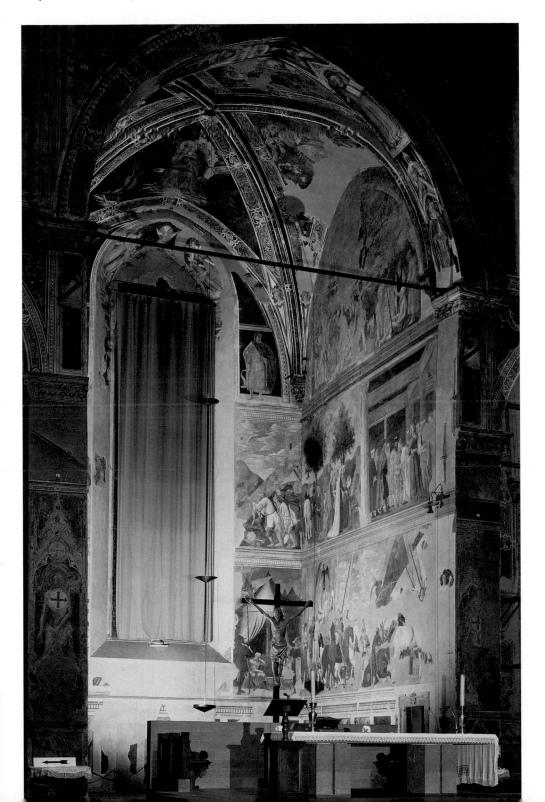

The Legend of the True Cross

The legend of the True Cross was compiled in the thirteenth-century *Golden Legend* by the Dominican friar Jacobus de Voragine. It may be summarized as follows: When Adam dies, he sends his third son, Seth, to obtain the Oil of Mercy promised by God after the Expulsion. Instead, Seth is given a seedling from the Tree of Life, which he plants at Adam's grave site. Centuries later, the grown tree is cut down by King Solomon and made into a bridge. On her way to visit Solomon, the Queen of Sheba sees the bridge and recognizes the holy nature of its wood. When she informs Solomon that the wood will cause the downfall of the kingdom of the Jews, he buries the bridge.

In the first century A.D., the wood is discovered and made into Christ's Cross. Three hundred years later, as the Roman emperor Constantine prepares for battle against his rival, Emperor Maxentius, he sees an angel carrying a small cross. The angel says, "In hoc signo vincis" [In this sign, you conquer], and Constantine carries the little cross before him into battle. When he wins without a struggle, he is convinced by the power of the sign and embraces Christianity. In so doing, he ends the Roman persecutions of the Christians and changes the course of history.

Constantine sends his mother, Helena, to Jerusalem to find the actual Cross. But only Judas, a Jew, knows its location and he refuses to divulge it. Helena has Judas thrown into a well, and after three days he relents. He directs Helena to a temple of Venus, which she destroys. Three crosses are dug up—on which Christ and the two thieves were crucified. In order to identify the True Cross, Helena places each in turn over the corpse of a young man, who is revived by Christ's Cross.

In the year 613, the Persian king Chosroes II steals the True Cross from Jerusalem and sets up a false Trinity, with himself as God the Father, the Cross as the Son, and a rooster as the Holy Ghost. The Christian emperor Heraclius defeats Chosroes in battle and restores the Cross to Jerusalem.

A. St. Augustine
B. Cupid
C. St. Louis of Toulouse
D. St. Peter Martyr
E. Angel
F. & G. Two Prophets

1. Death of Adam
2. Burial of the Wood
3. Sheba Adores the Wood
4. Meeting of Solomon and Sheba
5. Dream of Constantine
6. Battle of Constantine against Maxentius (Victory of Constantine)
7. Annunciation
8. Judas is Drawn from the Well (Torture of Judas)
9. Discovery of the Cross
10. Proof of the Cross
11. Heraclius Defeats Chosroes' Army (Victory of Heraclius)
12. Execution of Chosroes
13. Heraclius Returns the Cross to Jerusalem (The Exaltation of the Cross)

9.10 Diagram of Figures 9.8 and 9.9, with scenes numbered in chronological order.

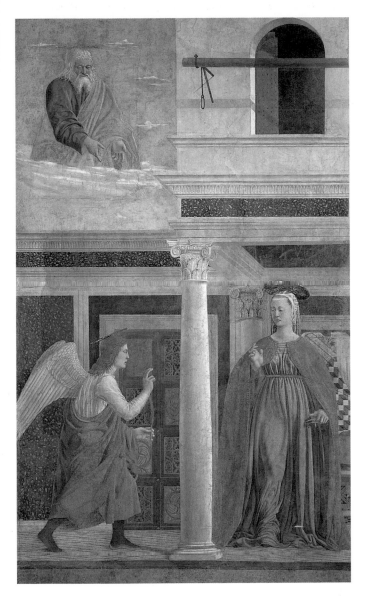

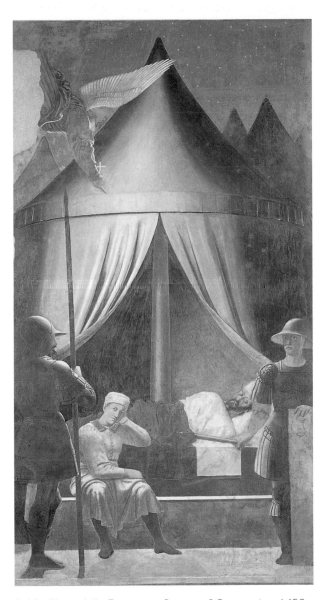

9.11 Piero della Francesca, *Annunciation*, 1450s. Fresco (after restoration). San Francesco, Arezzo.

9.12 Piero della Francesca, *Dream of Constantine*, 1450s. Fresco (after restoration). San Francesco, Arezzo.

Annunciation is celebrated on March 25, also the liturgical date of Adam's death and burial, of the Crucifixion, and of Saint Peter Martyr's martyrdom (he is the lowest figure on the left pilaster). Mary herself was paired typologically with Eve, Sheba, and Helena, all of whom figure prominently in the Arezzo cycle. And their thematic connections are emphasized by formal similarities: monumental proportions, massive sculptural draperies, and (except for Eve), white, geometrically egg-shaped heads.

The pairing of the *Annunciation* with the *Dream of Constantine* accentuates architectural geometry.

The rectilinear, classically inspired building of the former is constructed of the same white marble as Solomon's Temple in the *Meeting* and is divided by a prominent column. Likewise, Constantine's tent is divided by a cylindrical pole. Day and night are juxtaposed as settings for divine revelation. In the *Dream*, the angel shines the light of the Cross to illuminate (and dispel) the "dark," unenlightened pagan beliefs of Constantine. In the *Annunciation*, God's light enters the Virgin and becomes Christ. Subliminal allusions to the Church building enrich both scenes: Constantine's tent resembles the conventional baldachin, while Mary's

large size, as in the *Madonna del Parto*, identifies her as the House of God. The bulging column is a metaphor for her pregnancy.

The large *Victory of Heraclius* on the left wall is paired with Constantine's *Victory*, but it is a violent battle scene with flaring banners, trumpets, and killing. Liturgically, the *Victory of Heraclius* is aligned with the two large scenes above it. In the Western Church the *Victory* and the *Exaltation* are celebrated on September 14, whereas the *Proof of the Cross* is celebrated on May 3. But in the Eastern Church, all three events are celebrated on September 14, which is another allusion to the Council of Churches.

The four scenes on the lowest level of the chapel form a visual and historical foundation for the entire cycle. Insofar as both battles are fought in the name of the Cross, they are associated with the Crusades, the purpose of which was the imposition of Christianity on the pagan world. With the *Annunciation*, the New Dispensation is set into motion, and the *Dream of Constantine* marks the emergence of Christianity from the darkness of persecution into the official religion of Rome.

The Montefeltro Court in Urbino

Piero is first documented at the court of Urbino in 1469, although it appears that he had executed commissions for Federico da Montefeltro (1422–1482) on earlier occasions. The Montefeltro court, under the rule of Federico, was one of the most lavish in fifteenth-century Italy. In 1528, the witty social commentator Baldassare Castiglione, in his *Libro del cortegiano* [Book of the Courtier], called the Urbino court a "little city." According to one contemporary source, the palace had 250 rooms, 40 fireplaces, and 660 doors and windows. Federico spent more money on the arts than any other fifteenth-century Italian ruler and was the only one to hire a Flemish painter as his court artist. He employed architects, scientists, mathematicians, engineers, astrologers, and astronomers. His huge library of Christian and Classical texts was renowned. It contained a copy of Alberti's treatise on architecture and his

Della famiglia. Piero della Francesca's *De prospectiva pingendi* was dedicated to Federico and written at the court of Urbino.

Federico's expenditures were primarily financed by his talents as a *condottiere*. Having inherited a small army, he studied the martial arts with the leading commander of the day. He was a highly paid fighter, valued by his allies for his loyalty and military skill. He had also received a humanist education at the court of Mantua (see Chapter 12) and admired Classical as well as Christian authors. When he was absent from Urbino on military campaigns or diplomatic missions, the state was ruled by his classically educated second wife, Battista Sforza of Pesaro. Assisting both Federico and Battista was Federico's kinsman, Ottaviano Ubaldini, who was a more hidden—but astute—presence at court.

The precise nature of Ottaviano's relationship to Federico was clouded by confusion over Federico's paternity. He claimed to be the son of the previous count of Urbino, Guidantonio da Montefeltro, and was officially recognized as such. But he might have actually been Ottaviano's half brother, or even full brother, and the son of *his* father. Legitimized, like Sigismondo Malatesta, by the pope, Federico used all the means at his disposal to assert his right to rule Urbino. This he did by the force of his character, by the diplomatic manipulation of his allies, and, like other humanist rulers, by association with antiquity.

His assumption of power was complicated by Guidantonio's marriage to the pope's niece. She naturally favored their legitimate son, Oddantonio da Montefeltro, and exiled Federico from court when he was a child. He went to live in the countryside with the Ubaldini family, which fueled later rumors that he and Ottaviano were brothers. Nevertheless, throughout his childhood, Federico was trained by Guidantonio to assume the mantle of power.

When Oddantonio became ruler of Urbino, he ruined its economy and alienated its citizens. He was assassinated by unknown assailants, and Federico immediately stepped in, bringing his large private army with him. Once in power, Federico set about renovating the Ducal Palace and establishing a strict set of rules by which it would be run. Conforming to Alberti's observation that tyrants reside in fortresses, whereas benevolent princes rule from an accessible palace, Federico

created the image of a ruler devoted to the welfare of his subjects.

The west façade of the Urbino palace (**9.13**) reflects the order and clarity of Federico's reign. Designed primarily by Luciano Laurana (1420–1479), the architect from Dalmatia, it has twin towers on the framing frame three open loggias with large windows. A spiral staircase in one of the towers led to a balcony and provided a route for a kind of spiritual journey regularly undertaken by Federico. He began with a ritual bath—also enacted by Roman generals before battle—below the ground floor and then climbed to the so-called twin *tempietti*, or little temples, one dedicated to the Classical Muses and the other a Christian Chapel of Pardon. This juxtaposition, like the towers, is an expression of Federico's taste for political and philosophical balance and formal symmetry.

Directly over the little temples was Federico's ***studiolo*** (**9.14**), a private study to which he retired for reading and other intellectual pursuits. Since he also received visitors there, the imagery of the *studiolo*, like that in the Medici Palace, was designed to project Federico's desired public image. The lower wall was decorated with a tour de force of illusionistic ***intarsie*** depicting signs of Federico's interests and accomplishments. These included books, musical instruments, and pieces

9.13 Luciano Laurana, west view of the Ducal Palace, begun c. 1465. Urbino.

9.14 *Studiolo* of Federico da Montefeltro, 1476. Ducal Palace, Urbino. Inlaid wood *intarsie* and panel paintings (above) attributed to Justus of Ghent. The original paintings have been replaced by photographs and are now in various European museums.

193

of armor. The detail of the south wall (**9.15**) shows a fictive cupboard with books, scientific instruments, and a *mazzocchio*, reflecting the contemporary interest in perspective. As a total iconographic program, the *studiolo* presents a picture of Federico's successful combination of the Neoplatonic active and contemplative life. The paintings represent famous men—including Federico's humanist teacher in Mantua, Vittorino da Feltre—juxtaposed with Christian figures and with those from antiquity.

Federico's spiritual journey proceeded upward from the *studiolo* to an exterior balcony under the stars. Inspired by Neoplatonism, Federico replicated an ascent through different levels of existence that inte-

9.15 *Studiolo* of Federico da Montefeltro, detail of the south wall.

grated Christianity with pagan mythology. This combination, which he handled in a more balanced way than Sigismondo, characterized the iconography of his court.

Also contrasting with the fortified castle inhabited by Sigismondo was the appearance of openness produced by the architecture of Federico's palace courtyard (**9.16**). Designed by Laurana in the 1460s, the courtyard is typical of the clear, light, and classicizing style of the Ducal Palace. It is also reminiscent of the painting of the *Ideal City* and Brunelleschi's Hospital of the Innocents in Florence (see 3.13). Laurana's courtyard is five by six bays, each consisting of a round arch on Corinthian columns supporting an entablature on the ground floor. The rectangular second-story windows are flanked by Corinthian pilasters also supporting an entablature. (The two upper stories are later additions.)

Clemente's Medal of Federico da Montefeltro

Whereas Alfonso of Aragon had to overcome his Spanish birth and establish links to Rome, Federico had to combat allegations—especially from Sigismondo Malatesta but also from the pope, who was wary of Federico's growing power—of dubious legitimacy. Like Alfonso and other humanists, Federico made use of the motif of the eagle to reinforce his position. Since the eagle was also a traditional Montefeltro emblem, Federico repeated the image throughout the palace—on ceilings, doors, and fireplaces.

In 1468, Clemente da Urbino struck a lead medal in which various devices function as signs of Federico's persona. The obverse (**9.17**) shows a bust of Federico in armor. His breastplate contains a medallion scene of single combat between a Lapith and a Centaur, also a subject on a medal of Alfonso of Aragon and on the Parthenon **metopes**. Two winged Victories carrying a wreath reinforce the underlying meaning of the mythological battle—namely, that human reason (embodied by the Greek Lapith) triumphs over animal instinct (embodied by the Centaur).

The reverse of the medal (**9.18**) shows an eagle supporting a horizontal bar on its outstretched wings. Emblems on the bar refer to aspects of Federico's identity. In the center, a large sphere will roll to one side if the delicate balance is disrupted. A sword and cuirass

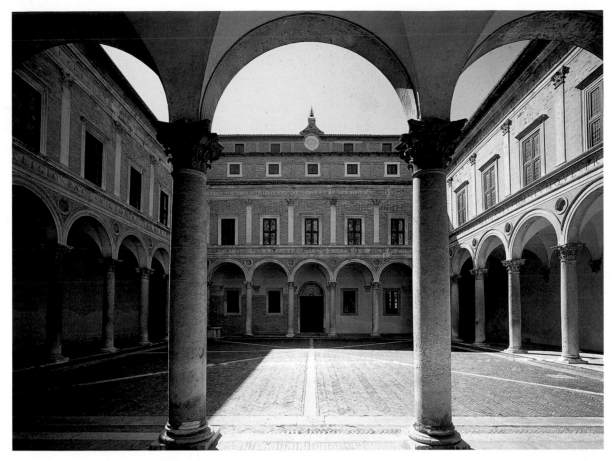

9.16 Luciano Laurana, Ducal Palace courtyard, 1460s. Urbino.

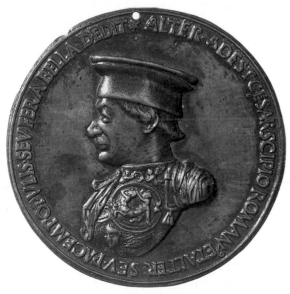

9.17 Clemente da Urbino, medal of Federico da Montefeltro, obverse, 1468. Lead; 3¾ in. (94 mm) diameter. National Gallery of Art, Washington, D.C., Samuel H. Kress Collection. The inscription "ALTER ADEST CESAR SCIPIO ROMAN[US] ET ALTER SEU PACEM POPULIS SEU FERA BELLA DEDIT" identifies Federico as embodying the virtues of two Roman leaders, Caesar and Scipio, and as a man of war and peace. The balanced character of his projected self-image is reflected in the syntactical parallelism of the text: "alter ... alter" and "seu ... seu."

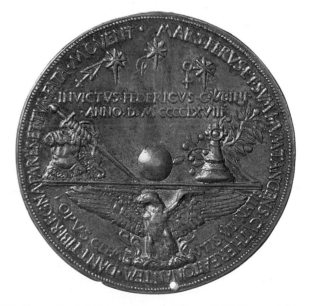

9.18 Clemente da Urbino, reverse of Figure 9.17. The medal is signed as the work of Clemente of Urbino [OPUS CLEMENTIS U[R]BINATUS] and dated 1468 [MCCCCLXVIII].

on the left allude to the Roman war god Mars, while the *scopetta* (whisk broom) on the right, a symbol repeated throughout the Ducal Palace, denotes cleanliness and purity. Just behind the *scopetta* is a branch of myrtle, an attribute of Venus, goddess of love, beauty, and fertility. According to the inscription, Mars and Venus, in conjunction with Jupiter (symbolized by the stars at the top of the image), bestow on Federico his realms and influence his destiny.

Piero's State Portraits

The mythological union of Mars and Venus produced Harmonia, which echoed the political ideal of the Urbino court. In his personal life, Federico achieved a harmo-

nious union with Battista Sforza, who ruled during his absences. Her devotion to him was constant; she bore him eight daughters before producing the long-desired male heir. Shortly after the birth of Guidobaldo, she died at the age of twenty-six. Federico's devotion to Battista is reflected in his refusal to remarry after her death.

Their harmonious union is an aspect of the famous two-sided diptych by Piero della Francesca (**9.19**) of around 1472, in which the two are seen as if on the other side of an Albertian "window." Federico and Battista gaze intently at each other, although it is probable, given the pallor of the countess, that she was already dead when the picture was executed. The viewer is excluded from the intimacy of their gaze but invited to survey the expanse of landscape that denotes the territory they rule.

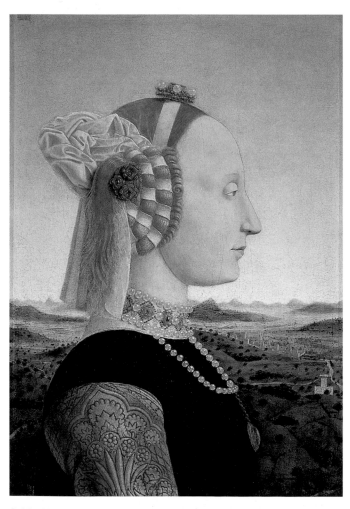 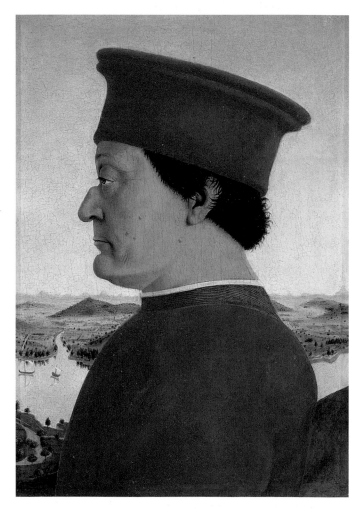

9.19 Piero della Francesca, *Battista Sforza and Federico da Montefeltro*, c. 1472 (after restoration). Oil and tempera on panel; each panel: 18½ × 13 in. (47 × 33 cm). Galleria degli Uffizi, Florence.

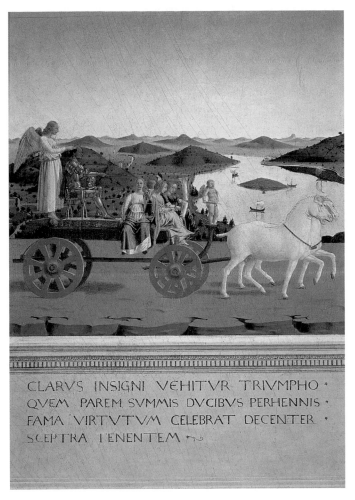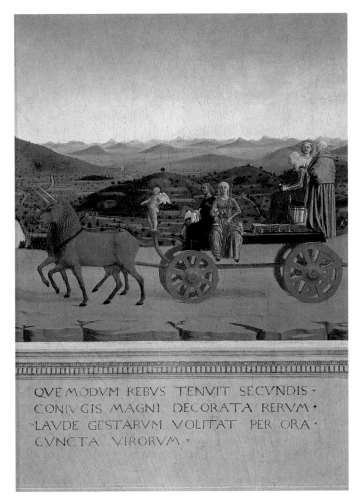

CLARVS INSIGNI VEHITVR TRIVMPHO ·
QVEM PAREM SVMMIS DVCIBVS PERHENNIS ·
FAMA VIRTVTVM CELEBRAT DECENTER ·
SCEPTRA TENENTEM ↝

QVE MODVM REBVS TENVIT SECVNDIS ·
CONIVGIS MAGNI DECORATA RERVM ·
LAVDE GESTARVM VOLITAT PER ORA ·
CVNCTA VIRORVM ·

9.20 Piero della Francesca, *Triumphs of Federico da Montefeltro and Battista Sforza*, reverse of Figure 9.19.

In this pair of portraits, Piero achieves a unique synthesis of personal and political imagery. On the one hand, the couple's mutual devotion is conveyed through their formal correspondences and identical poses. The stillness pervading both panels, a quality found in many of Piero's paintings, contributes to an impression of timelessness.

In addition to the personal rapport between Federico and Battista, Piero leaves viewers in no doubt that these are rulers. This he conveys by the parallels between the figures and the landscape as well as by certain iconographic allusions. The bust-length profile poses are, like images on medals, derived from ancient Rome. Battista's brocaded sleeve and diamond-shaped necklace patterns, for example, repeat the plowed fields. The single strand of pearls on her black vest replicates the diagonal and whiteness of the distant city walls.

Federico is dressed in the red color associated with Roman emperors. His circular hat accentuates his height in comparison to Battista, signifying that he, rather than his wife, is dominant. The light-dark patterns of his facial moles replicate the distant fields, whose precision, as in the *Baptism*, is reminiscent of Flemish painting. The shaded triangle below his chin repeats the triangular hills, and the white of his collar picks up the small sails on the river. Here, as in his other portraits, his left side is shown because he had lost his right eye in a joust. Aside from exemplifying Renaissance idealization and personal narcissism, the practice of depicting a ruler in the most favorable light harks back to ancient accounts of Apelles, the personal portrait painter to Alexander the Great.

The images on the back of the panels are triumphs, inspired by Petrarch's poetry (**9.20**). These, too, show

Federico and Battista as joined personally and political-ly through a shared landscape as well as through formal similarities. The chariots, like the portraits, face each other, and both are portrayed as if in motion despite a pervasive impression of immobility. Pulling Federico's chariot is a pair of white horses, and riding with him are the four Cardinal Virtues: Justice, Prudence, Fortitude (with the broken column), and Temperance. Standing behind him and crowning him with a laurel wreath is a winged figure, whether a Christian angel or a Classical Victory is not certain. Federico himself is armed, his helmet resting on his lap. Seated on a field stool of the type used by Roman generals, he extends the con-ventional baton of rule.

Pulling Battista's chariot are unicorns, traditional symbols of chastity. She is accompanied by Faith, who carries the chalice of the Host, and Charity, holding a pelican. This bird symbolized the Virtue of Charity, for which Battista was also known, because of the tradi-tion that it pecks its breast and feeds its own blood to its young. Battista herself is shown reading what is probably a prayer book. Reiterating the love that bound Battista and Federico are the little Cupids driving each chariot, Federico's with red wings and Battista's with white.

The *Flagellation of Christ*

It is likely that Piero painted his enigmatic *Flagellation of Christ* (**9.21**) before his arrival at the Urbino court. Structurally, the painting is divided by a prominent white Corinthian column and the white rectangle extending forward from its base. The division seems to demarcate two times and places: at the left, in a Classical setting, the biblical Flagellation of Christ before Pontius Pilate, who wears the hat of John VIII Palaeologus; at the right, contemporary figures occupy a fifteenth-century setting. Explanations for this juxtapo-sition vary widely, focusing mainly on the identity of the three figures in the foreground. They have been consid-ered members of the Montefeltro family, the dissolute Oddantonio (the blond youth) with his bad advisers, Eastern dignitaries connected with the Council of Churches, allegories of heresy, the repentance of Judas, or no one in particular. To date, the problem has not been resolved. Nor are the original location of the paint-ing, its original context, or the circumstances of its com-mission known.

What is clear, however, is that Piero has used per-spective to show that the present takes place in the foreground, whereas the past is distant both in space

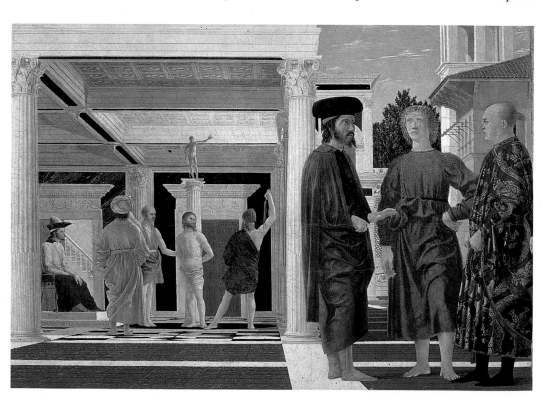

9.21 Piero della Francesca, *Flagellation of Christ*, c. 1460. Oil and tempera on panel; 23 × 32 in. (58.4 × 81.4 cm). Galleria Nazionale delle Marche, Urbino. Piero signed the painting on the plinth of Pilate's seat: "OPUS PETRI DEBURGO SCI [SANCTI] SEPULCRI" [the work of Piero from Borgo San Sepolcro].

and time. The foreshortened dark circle on which Christ stands alludes to the form of the ideal church plan and thus to the Church itself. Light is also used symbolically, for the ceiling above Christ is miraculously illuminated, denoting his role as Light of the World.

The *Madonna and Child with Saints*

Another work in which perspective and light are integrally related to iconography is the *Madonna and Child with Saints* (**9.22**), now in the Brera Museum in Milan. The influence of Domenico Veneziano's Saint Lucy Altarpiece (see 6.13) is readily apparent, both being images of a *sacra conversazione*. But Piero's space is more compact, his figures more monumental, and his colors enriched by the use of oil paint. The saints stand-

ing in a semicircle around the sleeping Christ child, here specifically related to the apse by the foreshortened space, assimilate the arrangement of Masaccio's apostles in the *Tribute Money* (see 4.17).

The three saints at the right are Francis showing the stigmata, Peter Martyr bearing the head wound of his martyrdom, and John the Evangelist with a book. On the left are Saints John the Baptist pointing to Christ, Jerome, and Bernardino. Behind the Virgin are four angels. Christ lies asleep across Mary's lap, his prominent diagonal continuing in the praying arms and paralleled in the sword of Federico. The latter, in shiny chrome armor, kneels, his helmet beside him.

Light entering from the left indicates that the scene occurs in the space of a transept, its regularity repeated in the symmetrical architectural space that is aligned

CONTROVERSY
The Question of the Egg

One of the more entertaining, and long-standing, controversies in Renaissance scholarship concerns the issue of the egg in Piero's Brera Altarpiece. In a paper delivered in 1952 and published in 1954—"*Ovum Struthionis:* Symbol and Allusion in Piero della Francesca's Montefeltro Altarpiece"—Millard Meiss cited the tradition of suspending eggs in churches (and mosques). He noted the egg's formal parallel with the Madonna's head and its location on the painting's central axis. Since it measured about six inches in length, he concluded, it must be an ostrich egg. This notion unleashed a scholarly dispute lasting over twenty-five years, most of it published in the *Art Bulletin*.

Responding to Meiss's paper in an article of 1952, Creighton Gilbert identified Piero's egg as Leda's, the product of her union with Zeus and a prefiguration of the Immaculate Conception. Gilbert also noted that eggs are ovoid weights that serve to hold in place the chains on lamps suspended over altars.

In 1971, Isa Ragusa, in "The Egg Reopened," cited another example of an egg suspended over an altar in a fresco in Lodi. This, she believed, supported Meiss's argument.

In 1974, Gilbert took issue with both Ragusa and Meiss in "The Egg Reopened Again." He restated his view that Piero's egg was Leda's on the grounds that an ostrich egg cannot be suspended as it is in the painting because it would crack.

In 1975—"Not an Ostrich Egg?"—Meiss pointed out that for twenty years he had just such an ostrich egg suspended from a chain; the egg not only did not crack, but had survived

being moved between his office and his home.

In 1976, Meiss published a revised version of his original paper (in *The Painter's Choice*) in which he reiterated that ostrich eggs are traditional symbols of birth, death, and rebirth. They are believed to be capable of being hatched by the "generative eyes" of the sun and thus symbolize Christ's birth by the True Sun. A fourteenth-century account describes eggs hatched by the sun as a type for the Virgin birth.

Relating the altarpiece to its patron, Meiss noted that the ostrich was a Federican emblem and symbol of knightly prowess. He suggested that there was a connection between the supernatural birth of the ostrich and Battista Sforza's dream before conceiving Guidobaldo—she dreamed of a phoenix flying to the sun and burning up. That sleep, death, and rebirth are themes of the painting is clear from the sleeping Christ child, who lies on the same diagonal as Federico's praying hands. Christ's coral necklace, like the scallop shell, is a symbol of resurrection. Since Battista is absent in the painting, whereas her patron saint John the Baptist is present, Meiss concludes that the work is both a memorial to the countess and a celebration of Guidobaldo's birth.

In 1980—"Piero della Francesca's Egg Again"—David Brisson argued, based on the contours of various species of eggs, that the model for the Brera egg was an ordinary chicken's egg. He did not, however, consider what Piero's iconographic intention might have been or how his findings might alter Meiss's interpretation.

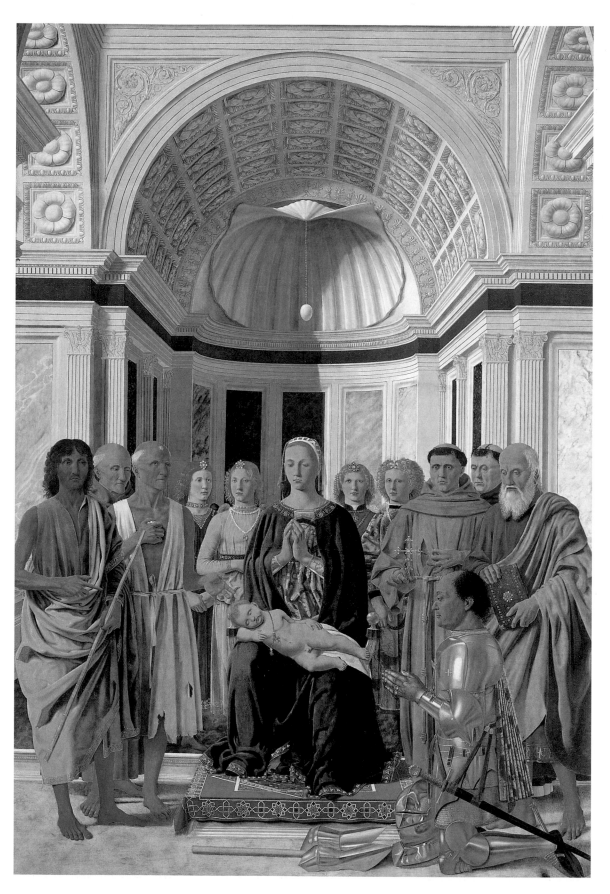

9.22 Piero della Francesca, *Madonna and Child with Saints*, c. 1472. Oil on panel; 8 ft. 3¼ in. × 5 ft. 8 in. (2.5 × 1.7 m). Brera, Milan.

with the figures. Mary herself is a towering form. She symbolizes the Church building, her hands, arched like those of Christ in the *Baptism of Christ* (see 9.6), creating a visual metaphor of a protective structure above her son. Allusions to the Virgin's aspect as Madonna of the Sea recur in the abundance of pearls, the scallop-shell apse, and Christ's coral necklace—all products of the sea.

Federico's Dynastic Iconography

Given Federico's determination to produce a male heir and to establish the legitimacy of his lineage, it is not surprising that the iconography of his court revolved around these issues. As a result, his son, Guidobaldo, appears in several paintings commissioned for dynastic purposes. In *Federico da Montefeltro and his Son, Guidobaldo* (**9.23**), Federico is again shown armed, the illusionism of his helmet reflecting his choice of artists interested in perspective. Its massive size is also a reminder of his military skill. Federico concentrates on a weighty text, enriching his role as a man of action with intellectual substance. On the lectern above is a pearl-covered miter, possibly sent by the Persian sultan. Other allusions to Federico's international renown are his honors—the Order of the Ermine conferred by the king of Naples in 1474 and the Order of the Garter, visible on his left leg, granted by the English king, Edward IV, in the same year.

That Guidobaldo is Federico's heir is evident in the composition of the image. Although a young child of around four, he seems to take seriously his destiny. He stands straight, holding in front of him the scepter of his future as the ruler of Urbino. Still dependent on his father and leaning on his knee, Guidobaldo looks and stands ahead of Federico.

He also wears a robe covered in pearls, a motif repeated on Federico's chair and in Piero's diptych portraits and *Madonna and Child with Saints*. In all cases, these are most likely an allusion to the deceased Battista, whose favorite gem was the pearl.

Guidobaldo was duke of Urbino from his father's death in 1482 until 1508, when he died without an heir. The duchy then passed to the della Rovere family, who produced Pope Julius II, patron of Raphael and Michelangelo in the new century (see Chapter 15).

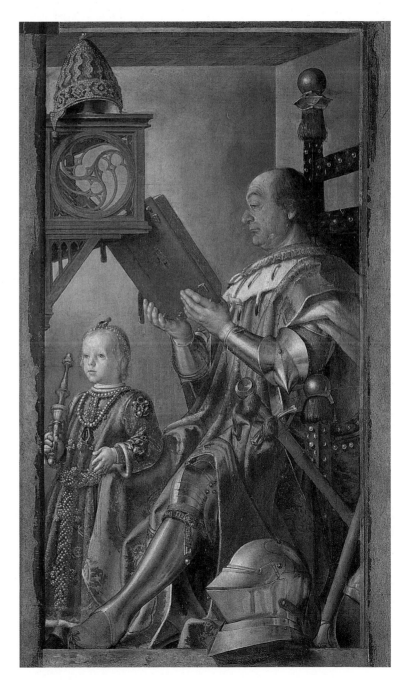

9.23 Variously attributed to Justus of Ghent and Pedro Berruguete, *Federico da Montefeltro and his Son, Guidobaldo*, c. 1476. Panel, 4 ft. 5⅛ in. × 2 ft. 5⅞ in. (135 × 76 cm). Galleria Nazionale delle Marche, Urbino.

10
Sculpture and Architecture in Florence, after 1450

By the 1450s, the Renaissance style and its cultural context were part of the fabric of Florence and, to a greater or lesser degree, had infiltrated other areas of Italy. The new trends of the first half of the fifteenth century had become a foundation on which younger artists could build and from which older artists continued to develop. At the same time, however, there was constant tension among the social, political, and religious factions of the city. In the arts as well, certain trends reflect the persistence of humanist thought and monumental form, whereas others begin to move in different, sometimes conflicting, directions.

The Medici remained the de facto rulers of Florence, but problems beset their banking interests, reflecting a general decline in the city's economy. In 1478, a conspiracy led by the Pazzi family against the Medici threatened political stability. Even though the coup failed, Cosimo's grandson Giuliano was killed and Giuliano's brother Lorenzo, who was wounded, sought revenge on the conspirators. In the religious sphere, the fire-and-brimstone sermons of Antoninus were given new credibility as a result of a serious outbreak of plague in 1448.

Toward the end of the quattrocento, the fanatic Dominican monk and prior of San Marco, Girolamo Savonarola (1452–1498), rallied anti-Medicean support. His success forced the family to leave Florence in 1494, and his apocalyptic view of the millennium terrorized many of its citizens. He gained control of the government, but several serious political errors—including an attack on Alexander IV, the Borgia pope—led to his excommunication. In 1497 and 1498, he oversaw the

"Bonfires of the Vanities" in which articles of luxury and works of art of which he disapproved were publicly burned in Florence. A short time after the second bonfire, Savonarola was arrested and executed.

Sculpture

Donatello

It is difficult to document what, if any, effect such turmoil may have had on artists and their patrons. Aspects of Donatello's style, for example, changed radically during the 1450s, but the reasons for the change are elusive. Complicating the issue is the uncertain chronology of his works after his return to Florence in 1453, by which time he had completed the *Gattamelata*.

Mary Magdalen Donatello's wooden statue of Mary Magdalen (**10.1**) of around 1454–1455 has been linked with the sermons of Antoninus, who was a close friend of Cosimo de' Medici. Inspiring the faithful were Antoninus's assertions that despite the sinfulness of the Magdalen penance had restored the spirit of her virginity. He likewise threatened with eternal damnation all those who failed to repent.

Donatello's *Magdalen*, probably commissioned for the baptistery, is the very embodiment of a penitent. In contrast to the youthfulness of the *David* and the *Gattamelata* portrayed at the height of his power, this

10.1 Donatello, *Mary Magdalen*, 1454–1455. Painted and gilded poplar; 6 ft. 2 in. (1.88 m) high. Museo dell'Opera del Duomo, Florence.

figure is aged and worn. She retains the slight *contrapposto* stance of the early *Saint Mark*, but the emphasis is no longer on idealized Classical proportions and form. Instead of a sturdy musculature, hers is thin and bony. Her frame is skeletal, her cheeks are sunken, and there are gaps between her teeth.

Donatello revived a medieval type of Magdalen in which Mary's long hair, the traditional sign of her penance, functions as drapery. This unusual rendering of the Magdalen's conventional iconography accentuates the ambivalent sinful and holy nature of her biblical character. Donatello enhanced this by the odd colors of the original paint—tan flesh and gilded hair.

The Bronze *John the Baptist* Another image of penance produced by Donatello in the 1450s is the bronze *John the Baptist*, now in Siena Cathedral (**10.2**). It is not as elongated as the *Magdalen*, but it conveys a similar sense of religious fervor. The Baptist seems to be speaking—his lips are slightly parted—and he carries the scroll of prophecy in his left hand. (The right arm was missing when the statue arrived in Siena in 1457, at which time Donatello was seventy-one years old.)

John is clothed in his traditional hair shirt, which has become all hair. It is arranged in cascading, agitated curves that reflect his inner turmoil. In contrast to the resigned, praying figure of the Magdalen, whose hair falls loosely over her worn and shapeless body, the Baptist is forceful. He has a feisty, energetic quality, despite sunken eyes and bones protruding from beneath sagging flesh.

Judith and Holofernes The 1450s were also the decade in which Donatello produced the first freestanding group statue since antiquity. His *Judith and Holofernes* (**10.3** and **10.4**) was, for a time, in the garden of the Medici Palace. This suggests that the work was made for the Medici family, although there are no surviving commission documents. In 1494, after the Medici were expelled from Florence, the statue was placed in front of the Palazzo Vecchio as a symbol of the victory of freedom over tyranny. What originally had been an image of Medici republicanism, therefore, came to stand for rebellion against Medici tyranny.

The text on which the work is based comes from the Old Testament apocryphal account of the Hebrew

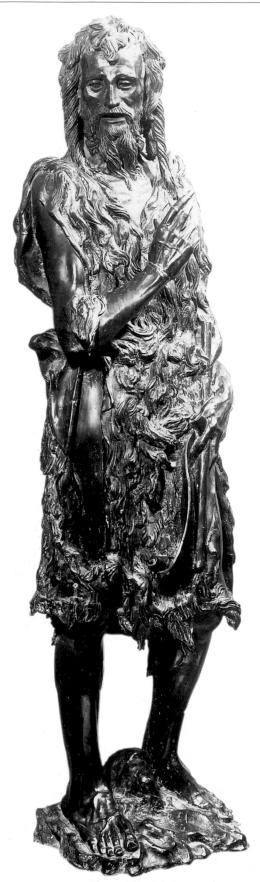

10.2 Donatello, *John the Baptist*, 1457. Bronze; 6 ft. 1 in. (1.85 m) high. Siena Cathedral.

widow of Bethulia who saved her people from the invading Assyrian army. She left her besieged city and went with her servant to the camp of Holofernes. She then enticed the Assyrian general with her charms, and he invited her to dinner. He became inebriated and returned with her to his tent. When he fell on his bed in a stupor, Judith took up his scimitar and beheaded him. She and her servant placed his head in a food bag and returned home. The head was hung outside the city walls and the Assyrians retreated in disarray.

Donatello's statue depicts the moment when a determined Judith raises the scimitar a second time, having broken Holofernes' neck with her first blow. She towers over his listless form, holding him by the hair and stepping on him—the latter being traditional signs of triumph over an enemy. Accentuating the impact of the work are the voluminous draperies that contribute to Judith's monumental power and the relatively helpless nudity of Holofernes. His medallion, inscribed "SUPERBIA," which is slung over the back of his neck, identifies him as having fallen through the sin of arrogant pride. Further reinforcing the political meaning of the work is its original inscription: "*Regna cadunt luxu, surgunt virtutibus urbes. Cesa vides humili colla superba manu*" [Kingdoms fall through opulence, cities rise through virtue. Behold the proud neck severed by a modest hand]. At a later date, Piero de' Medici added a second inscription, dedicating the statue to the freedom of Florence and the patriotic spirit of its citizens.

As with several earlier sculptures, Donatello included iconographic elements derived from antiquity that indicate the underlying meaning of the *Judith*. Each side of the triangular base supporting Holofernes' wineskin depicts an orgiastic scene in which *putti* engage in bacchanalian rites. The *Laws* of Plato, which were well known to the Medici circle of artists and intellectuals, decry drunkenness as a poor foundation for the ideal state. As such, Plato's political message is in accord with aspects of the apocryphal story, in which a powerful general is weakened by drink. Merging form with content, Donatello's sculptural base coincides with the weak foundation of Holofernes' tyrannical army.

Details of Judith's costume, such as *putti* carrying wreaths of victory on the front and back of her dress,

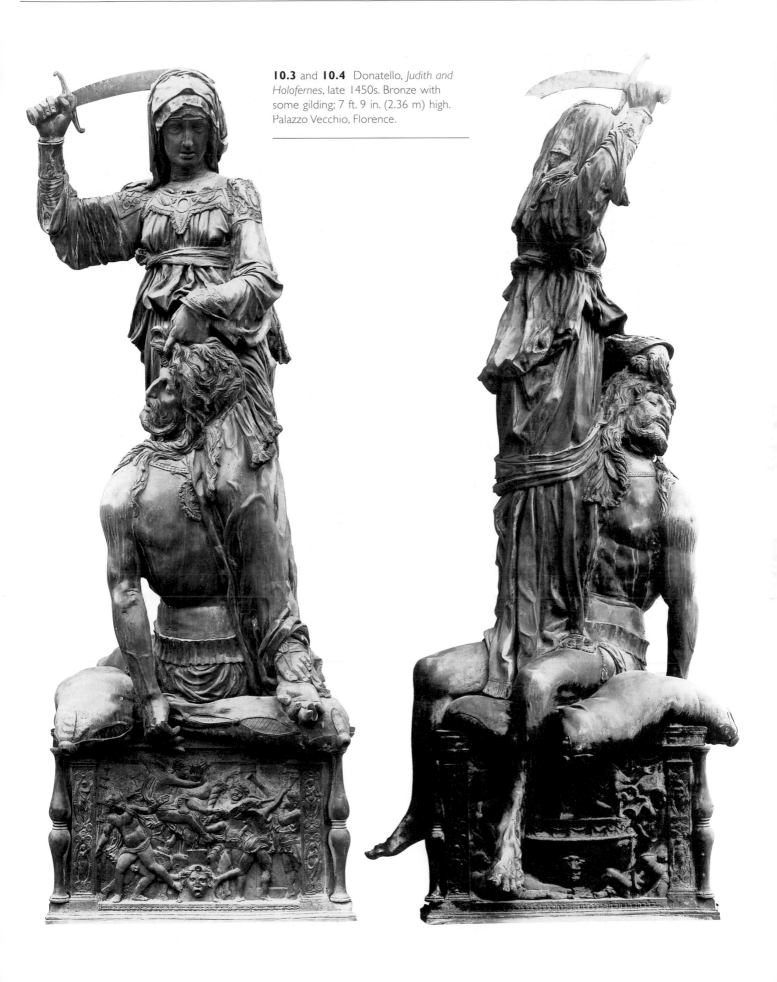

10.3 and **10.4** Donatello, *Judith and Holofernes*, late 1450s. Bronze with some gilding; 7 ft. 9 in. (2.36 m) high. Palazzo Vecchio, Florence.

identify her with triumph. She is at once a figure of vengeance and domination, destroying without hesitation the enemy of her people. Like Donatello's *Saint Louis of Toulouse*, both *David*s, and the *Gattamelata*, the *Judith* was an image of the civic humanism and republican government espoused by Florence and the Medici family. But the *Judith* differs in representing a moment of action and in a formal construction that requires multiple viewpoints. The *David*s have already committed the act of violence, whereas the *Saint Louis* and the *Gattamelata* are timeless—that is, not drawn from a narrative. All, in fact, are essentially timeless guardians—with a Platonic subtext—of a republic. In the *Judith*, it is possible that the choice of the most violent moment in the narrative was related to the apocalyptic sermons of Antoninus. It is also possible, but not demonstrable, that they represent an emerging late style of the artist.

Desiderio da Settignano

An artist who was influenced by Donatello and perhaps was his student, Desiderio da Settignano (c. 1430–1464) does not appear to have allowed the religious fervor of the period to affect his work. The generally cheerful tenor of his style and its elegance are more reminiscent of Donatello's earlier sculptures than of those after 1450. Desiderio came from a family of stonecutters in Settignano, a small town just outside Florence. He mastered Donatello's technique of *schiacciato* relief and, like Donatello, was particularly skilled in the depiction of children. His many sculptures of *putti* and of the infant Christ with the Virgin reflect the Renaissance interest in the psychology of childhood.

His marble *Little Boy* (**10.5**) of around 1460 shows the appeal of the smooth flesh of a young child. By softening the *schiacciato*, Desiderio conveys the

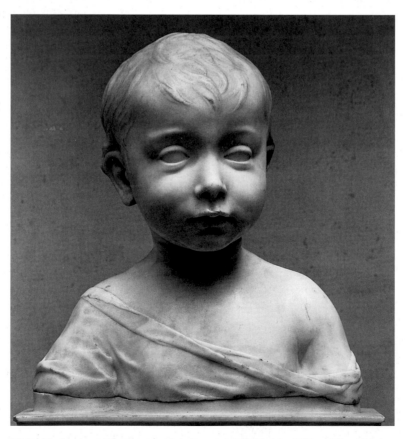

10.5 Desiderio da Settignano, *Little Boy*, c. 1460. Marble; 10⅜ × 9¾ × 5⅝ in. (26.3 × 24.7 × 15 cm). National Gallery of Art, Washington, D.C., Mellon Collection.

sense of newly grown hair, slightly puckered lips, and cheekbones that have not yet hardened into adulthood. The squeezable quality of the fleshy upper arms, as well as the soft texture of the features, evokes a tactile response in the viewer that is as psychologically accurate as the child's own character.

Desiderio's major monumental commission was the humanist tomb of Carlo Marsuppini (1399–1453) (**10.6**), who had been a papal secretary, professor of Greek, and chancellor of Florence. His tomb was intended to form a pair with Rossellino's tomb of Leonardo Bruni (see 7.1) and was located on the opposite wall of Santa Croce's nave. The overall design is similar to that of Bruni's tomb, but it is more elegant, with greater emphasis on decorative curvilinear forms. As in the earlier tomb, Marsuppini's effigy lies on a bier over his sarcophagus and holds a book. The sarcophagus itself has lion's feet that merge into elaborate relief designs on either side of the inscription. At the center is the traditional scallop shell, denoting rebirth and resurrection.

A number of Roman details energize the surfaces of Marsuppini's tomb. At the top, for example, is a Roman lamp stand from which long garlands curve around the arch, falling over the shoulders of two adolescent boys and paralleling the Corinthian pilasters. The arch frames a tondo depicting reliefs of a smiling Virgin with a jaunty Christ child. Flanking the tondo are praying angels with flowing draperies that further animate the image. Another pair of winged youths lean on shields by the base of each pilaster. The relief on the base of the tomb consists of an urn, garlands, and ribbons, with fanciful sphinxes at the corners. Such elements relieve the austerity of Bruni's tomb, appealing to a taste for lighter, more open spaces and elegant, cheerful surface design.

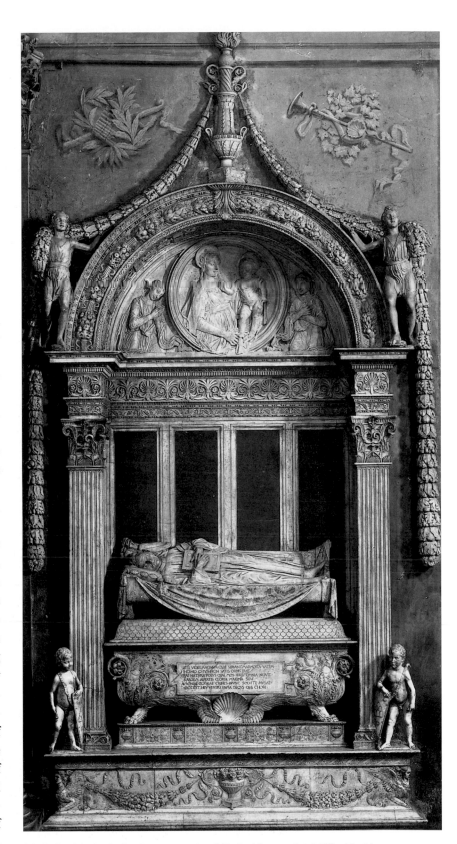

10.6 Desiderio da Settignano, tomb of Carlo Marsuppini, 1450s. Marble. Santa Croce, Florence.

Antonio del Pollaiuolo's *Hercules and Antaeus*

An entirely different mood is conveyed by Antonio del Pollaiuolo's (active c. 1457; d. 1498) small bronze sculpture *Hercules and Antaeus* (**10.7**). It is an image of struggle and conflict made possible by the artist's study of anatomy. According to Vasari, Pollaiuolo performed human dissections, a practice that would gradually become more common among artists in the late fifteenth and early sixteenth centuries. His interest in conveying the human figure as a powerful nude capable of extreme muscular tension is also found in his pictures, which are discussed in the next chapter. This work, which, like Donatello's *Judith*, has a triangular base, shows Pollaiuolo's innovative approach to the sculptural group.

The *Hercules and Antaeus* also reflects the increasing number of depictions of mythological subjects, which was consistent with the revival of Classical texts. This progressive trend contributed to some of the conservative religious backlash that fueled the turmoil of late fifteenth-century Florence. Pollaiuolo's text for the sculpture was the myth of Hercules and Antaeus, the latter the son of Gaia, the Titan earth goddess. She was the source of Antaeus's strength, and as long as he remained in contact with her, he was invincible. In order to defeat him, therefore, Hercules had to lift him from the ground. Ironically, it is Hercules, steadied by the lion skin, who is firmly planted on the ground in the sculpture. Antaeus, in contrast, flails wildly, his distress emphasized by open spaces and the zigzag planes of his limbs. The violent *contrapposto* of Hercules, who bends sharply backward, reveals the force necessary to lift his resisting opponent.

Formally, as well as iconographically, the work represents a struggle of powerful, opposing forces. It also contains a political subtext related to the traditional association of Hercules with the city of Florence. This is accentuated by the prominence of his lion-skin attribute, which is related both to the *Marzocco* and, because of the prominent frontal head, to the protective Gorgoneion. Just as Hercules' triumph over Antaeus could be read in the context of the Olympian defeat of the autocratic Titans, so it resonated with the struggles between Florence and the more tyrannical Italian states. The fact that Pollaiuolo also created a series of paintings depicting the Labors of Hercules for the Medici Palace indicates the family's political identification with the popular, and immortal, Greek hero who became a demigod.

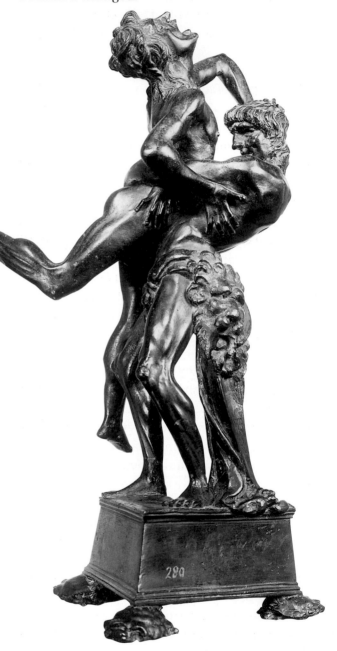

10.7 Antonio del Pollaiuolo, *Hercules and Antaeus*, c. 1475. Bronze; 18 in. (45.7 cm) high. Museo Nazionale del Bargello, Florence. Pollaiuolo's father was a poulterer (*pollaio*), hence his name. Antonio trained as a painter and goldsmith as well as a sculptor. The turtles supporting the base of the sculpture allude to the Latin maxim "Festina lente" [Make haste slowly], which was taken up by the Roman emperors Augustus and Constantine.

Andrea del Verrocchio

The leading fifteenth-century successor to Donatello was Andrea del Verrocchio (1435–1488), who also worked for the Medici. He ran a prominent workshop in Florence, which trained painters as well as sculptors. His most famous pupil was Leonardo da Vinci (see Chapter 14).

David Sometime in the mid-1460s, when Donatello's *David* was located in the courtyard of the Medici Palace, Verrocchio was commissioned to execute another bronze statue of *David* (**10.8**). Most likely the patron was Piero de' Medici, who probably had in mind an image of the family's identification with republican government. In 1476, Piero's sons Lorenzo and Giuliano sold the work to the Signoria for 150 florins; two years later Giuliano was assassinated by the Pazzi conspirators.

Compared with Donatello's *David* (see 3.8), Verrocchio's is more alert and athletic, although its pose is also based on Classical prototypes such as the *Doryphoros* of Polykleitos (see 1.2). The character of Verrocchio's *David* differs from that of Donatello's by its angular, bony form, sharp diagonals, and relatively open spaces. This figure wears a cuirass and carries a shorter sword. In contrast to the self-absorption of the Donatello, Verrocchio's youth gazes outward, away from the head of Goliath. Gone is the erotic playfulness of the Donatello as well as the iconographic allusions to Platonic ideals.

Doubting Thomas At the end of 1459, the Guelph party began negotiations to sell its marble niche on the outer wall of Or San Michele to the Mercanzia, the merchants' guild, which oversaw the other guilds of the city. Its niche, which originally contained Donatello's *Saint Louis of Toulouse* (see 3.31), would need a new statue.

The involvement of both Lorenzo the Magnificent and his father, Piero, with the Mercanzia probably influenced the choice of Verrocchio, around 1465, to create a *Doubting Thomas* (**10.9**) for the niche. Although the niche was designed for a single figure, the text of the new work called for two figures—Christ and his apostle Thomas. According to the Gospel of John 20:24–29, the apostles told Thomas that they had seen Christ risen

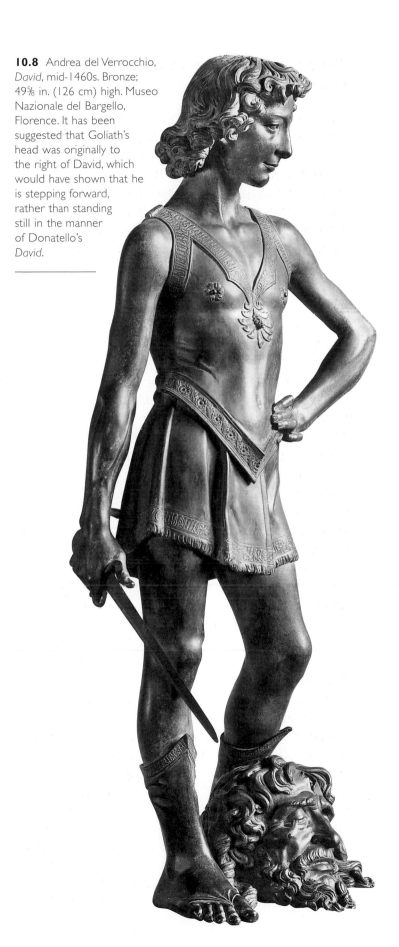

10.8 Andrea del Verrocchio, *David*, mid-1460s. Bronze; 49⅝ in. (126 cm) high. Museo Nazionale del Bargello, Florence. It has been suggested that Goliath's head was originally to the right of David, which would have shown that he is stepping forward, rather than standing still in the manner of Donatello's *David*.

from the dead. Thomas replied that he would not believe without seeing the stigmata and touching the wound in Christ's side. Eight days later, Christ appeared to Thomas and instructed him to do as he wished, whereupon Thomas recognized him.

Verrocchio solved the problem of the narrow space in two ways. First, he cast the figures with open backs, making them lighter in weight than bronze sculptures. Second, he placed Christ inside the niche and Thomas just outside the niche on the edge of the base. Turning necessity into a virtue, Verrocchio organized a dynamic encounter between Christ and his apostle that could be accommodated by the available space.

Christ occupies the more sacred interior of the apsidal niche and, with his right hand raised in a gesture of blessing, stands above Thomas. Thomas turns toward Christ, his own right hand echoing Christ's as he reaches hesitantly and gazes fixedly toward the wound in Christ's side. Both figures are shown in *contrapposto* and swivel slightly, heightening the dramatic moment before physical contact is made. Reflecting the inner tension of the confrontation is the animation of the deep, massive drapery folds.

Combining image with text, Verrocchio inscribed the biblical conversation between Christ and Thomas in Latin on their respective robes. As recognition comes to the apostle, he declares Christ "my Lord and my God." Christ replies, "You have believed, Thomas, because you have seen me: blessed are those who have not seen and still believe." The emphasis on visual and tactile evidence in the narrative corresponds to the form and content of Verrocchio's sculpture in which the relationship between Christ and Thomas is bound precisely through the psychology of sight and touch.

The Tomb of Piero and Giovanni de' Medici Verrocchio worked for three generations of the Medici family. He had designed Cosimo's tomb in San Lorenzo and, in the early 1470s, executed the tomb of Piero de' Medici and his brother Giovanni (**10.10**), which was apparently commissioned by Piero's son Lorenzo. Set in a wall opening so that it is visible from both the Old Sacristy and the chapel of Saints Cosmas and Damian, the tomb and its site are an imposing example of the combination of monumentality with elegance.

The sarcophagus itself is made of red porphyry and green serpentine decorated with chased bronze. Its base is supported, like Pollaiuolo's *Hercules and Antaeus*, by bronze turtles. Here the allusion to Augustus and Constantine is a direct reference to the political position of the family, while the deep red of the porphyry was the imperial color of ancient Rome. The bronze lion's feet of the sarcophagus that merge into acanthus leaves at the corners refer to Florence. Additional bronze acanthus leaves on the lid metamorphose into cornucopia-shaped seashells that may symbolize rebirth. Their associations with abundance also denote the city's prosperity under the Medici. As such, they evoke the myth promoted by the family that Florence enjoyed the revival of a golden age under their rule. Confirming the power of the family is the dominating image of the Medici coat of arms over the arch (not visible in figure 10.10).

Framing the sarcophagus is a round arch of white marble and gray *pietra serena*, decorated at the bottom with antique vases from which rise intertwined vines. At the center of the arch is a diamond, Piero's emblem and a sign of his passion for collecting precious objects. The inside of the arch is filled in with a metal grill in the form of entwined ropes that simultaneously close the space and leave it open. This, like the serpentine disk on which the names of Piero and Giovanni are inscribed, is enclosed by the laurel wreath. The names of the patrons —Lorenzo and Giovanni—are inscribed on the base.

In contrast to the wall tombs of Leonardo Bruni (see 7.1) and Carlo Marsuppini (see 10.6), there is no effigy of the deceased. Verrocchio has substituted the names of Piero and Giovanni for their images instead of making them appear "alive" in the Albertian sense. In thus playing with the motif of written presence and visible absence, Verrocchio captures the very essence of a memorial.

10.9 (opposite) Andrea del Verrocchio, *Doubting Thomas*, c. 1466–1467. Bronze with gilding; Christ: 7 ft. 6½ in. (2.3 m) high; Thomas: 6 ft. 6¾ in. (2 m) high. Or San Michele, Florence.

10.10 Andrea del Verrocchio, tomb of Piero and Giovanni de' Medici. The marble platform under the sarcophagus is dated 1472. Marble, bronze, red porphyry, and green serpentine; height from the floor: 19 ft. (5.82 m). View from the Old Sacristy, San Lorenzo, Florence.

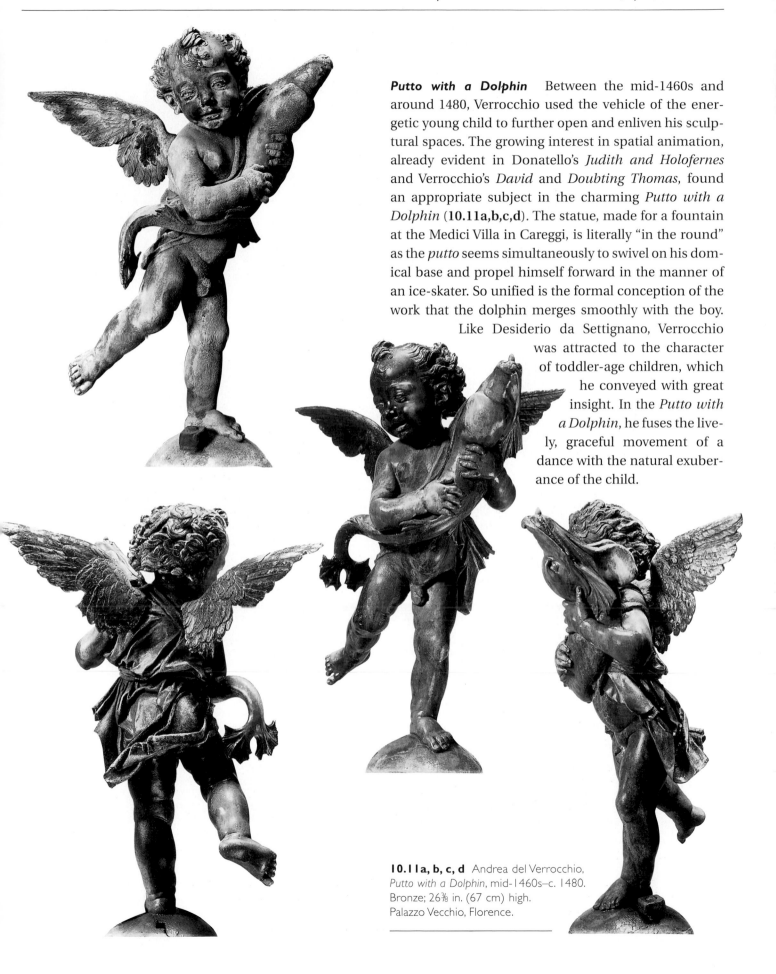

Putto with a Dolphin Between the mid-1460s and around 1480, Verrocchio used the vehicle of the energetic young child to further open and enliven his sculptural spaces. The growing interest in spatial animation, already evident in Donatello's *Judith and Holofernes* and Verrocchio's *David* and *Doubting Thomas*, found an appropriate subject in the charming *Putto with a Dolphin* (**10.11a,b,c,d**). The statue, made for a fountain at the Medici Villa in Careggi, is literally "in the round" as the *putto* seems simultaneously to swivel on his domical base and propel himself forward in the manner of an ice-skater. So unified is the formal conception of the work that the dolphin merges smoothly with the boy.

Like Desiderio da Settignano, Verrocchio was attracted to the character of toddler-age children, which he conveyed with great insight. In the *Putto with a Dolphin*, he fuses the lively, graceful movement of a dance with the natural exuberance of the child.

10.11a, b, c, d Andrea del Verrocchio, *Putto with a Dolphin*, mid-1460s–c. 1480. Bronze; 26⅜ in. (67 cm) high. Palazzo Vecchio, Florence.

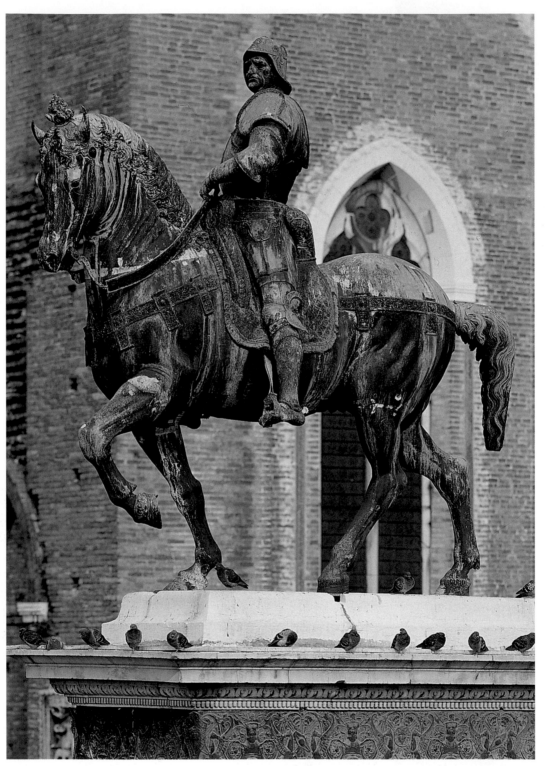

10.12 Andrea del Verrocchio, *Colleoni*, c. 1481–1496. Bronze; approximately 13 ft. (4 m) high. Campo Santi Giovanni e Paolo, Venice. Bartolomeo Colleoni came from a family of soldiers in Bergamo. In his will, he bequeathed funds to the republic of Venice for a bronze equestrian monument to be located in the Piazza San Marco, but the city erected the statue in a less prominent site. Verrocchio won the commission in a competition of 1480, but died before it was completed. His model was cast after his death in 1488.

Colleoni In Venice, Verrocchio's monumental equestrian statue of the *condottiere* Bartolomeo Colleoni (**10.12** and **10.13**) was a fitting successor to Donatello's *Gattamelata* in Padua. As in the *Putto with a Dolphin*, Verrocchio has opened the spaces and increased the viewpoints. The horse raises its left foreleg, rather than resting it on a ball, and turns its head to one side, causing the hide of its neck to ripple naturally. Verrocchio's figure is no longer the timeless guardian of the state represented by the *Gattamelata*. Dressed in contemporary armor, he rears up in the saddle and turns abruptly, as his horse does. A dynamic, vigorous character, Colleoni arches his back and prepares to ride into battle. He is the very embodiment of virile aggressiveness, the image of a fierce fighter, with his intense gaze focused on an unseen enemy. His name,

which in English literally means "big balls," is given pictorial form in three pairs of testicles carved on the coat of arms at the base of the pedestal.

Architecture

In 1466, Piero de' Medici revoked Cosimo's exile of the male members of the Strozzi family, which had lasted from 1434, when Cosimo returned from his own year-long banishment. The shrewd banker Filippo Strozzi (1428–1491) became a political and financial adviser to Lorenzo. In 1489, he commissioned a massive palace, in part as a statement of the family's restored presence in the city.

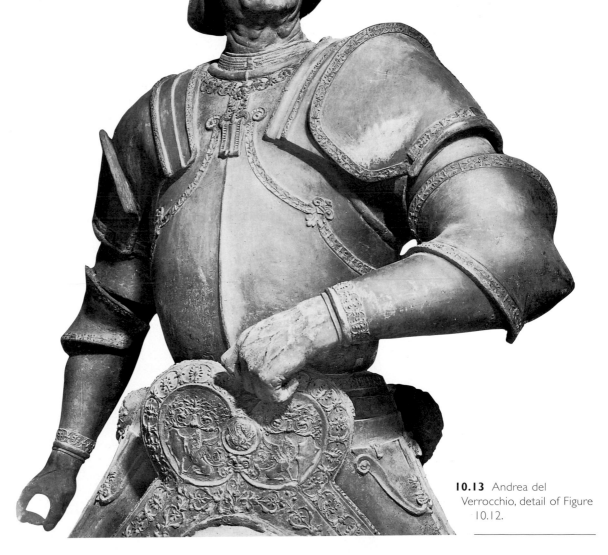

10.13 Andrea del Verrocchio, detail of Figure 10.12.

The Strozzi Palace

Generally attributed to the sculptor and architect Benedetto da Maiano (c. 1442–1497), the Palazzo Strozzi (**10.14**) is rusticated on all three floors, rather than only on the ground floor, as is the Medici Palace. It is not known if Benedetto planned the large cornice projecting from the roof because it was completed later by another architect. As in the Medici Palace, round-arched windows on the upper floors seem to rest on thin stringcourses. The smaller square windows on the ground floor are higher up in the wall for purposes of defense. A single entrance, centrally positioned, accentuates the symmetry and blocklike fortified appearance of the structure. Although the overall conception of the Strozzi Palace shares certain similarities with the Medici Palace, it seems clear that Filippo had in mind a manifest statement of power and wealth, in contrast to the more discreet Medici style.

The rectangular courtyard (**10.15**) is more spacious than Michelozzo's design for the Medici Palace courtyard. It opens up as well as out, with taller columns and larger second-story windows. The round arches are supported by pilasters, rather than colonnettes, and are unrelieved by the smooth spaces of the Medici courtyard walls. The third interior story consists of an open loggia, with Corinthian columns resting on a **balustrade**. Benedetto's plan (**10.16**) is symmetrical, so that each of his two sons could occupy one half of the palace.

10.14 Attributed to Benedetto da Maiano, Strozzi Palace, 1489–1507. Florence. Benedetto belonged to a family of stonecutters from Maiano, near Florence. He worked as a sculptor as well as an architect and was widely admired for his insightful portrait busts.

His patron, Filippo Strozzi, was the son of the enormously wealthy Palla Strozzi, who had commissioned Gentile da Fabriano's *Adoration of the Magi* in the early 1420s. The Strozzi family had maintained their fortune despite the economic crises plaguing Florence in the fourteenth and fifteenth centuries. Filippo's son, also named Filippo, married Clarice de' Medici. In the sixteenth century, faced with dynastic competition from the Medici duke, the younger Filippo led a new exiled faction against Cosimo I de' Medici, but was imprisoned and died in jail. Most of the remainder of his immediate family moved to France.

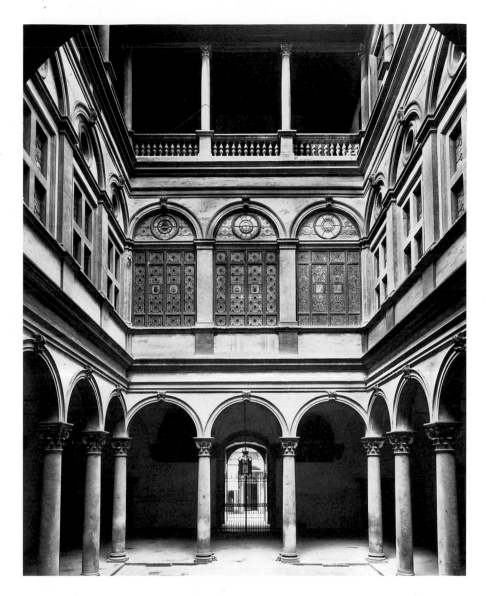

10.15 Benedetto da Maiano, courtyard of the Strozzi Palace. Florence.

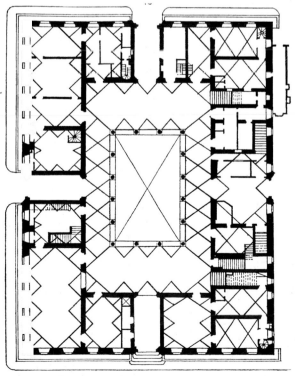

Giuliano da Sangallo

Giuliano da Sangallo (c. 1443–1516) was the leading architect working in and around Florence in the late fifteenth century. His best work was done in the 1480s under the patronage of Lorenzo the Magnificent. It was for Lorenzo that he designed the Medici **Villa** at Poggio a Caiano, near Prato, to the west of Florence (**10.17**). Inspired, like the papal palace at Pienza, by Petrarch's description of Mount Ventoux, the site permitted views of the plain of Prato, the Apennines, and Monte Albano. As in ancient Rome, the Renaissance villa was specifically designed as a retreat from urban tensions. Another fact of urban life in the Renaissance was the danger of plague, of which there were continual outbreaks. Families who could afford it escaped to the countryside.

10.16 *(left)* Benedetto da Maiano, plan of the Strozzi Palace. Florence.

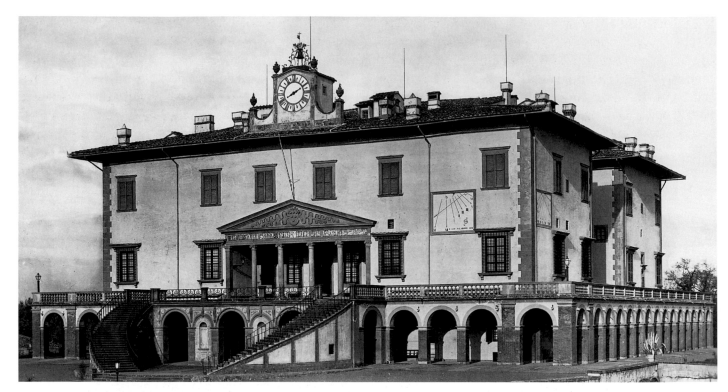

10.17 Giuliano da Sangallo, Medici Villa, Poggio a Caiano, 1480s.

The Medici Villa: Poggio a Caiano

The Medici Villa at Poggio was an imposing structure set on a podium-like base reminiscent of Etruscan and Roman temple design. This one, however, contains a balustrade over an arcade on the ground floor that continues around the building. The upper two stories comprise the rectangular block with projecting eaves and rectangular windows. (The stairway and clock are later additions.) Relieving the appearance of weight in the main block of the villa is its light color, against which the darker windows and corner **quoins** are accented. As a result, the roof seems to float above the walls, as if supported only by the quoins.

The most original feature of the villa is the Ionic portico, the first since antiquity with freestanding columns. Its horizontal plane conforms harmoniously to the proportions of the structure. The exact subject of the **glazed terracotta** frieze has not been identified, but it appears to be a Classical narrative. Where gods and heroes would have decorated the pediment in antiquity, this one represents the Medici arms. Ribbons of decreasing width and progressively smaller curves flow toward the corners.

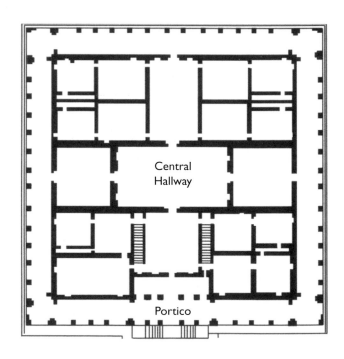

10.18 Giuliano da Sangallo, plan of the Medici Villa. Poggio a Caiano. Giuliano was from a Florentine family of architects who began as carpenters. He studied in Rome, where he drew ancient buildings, and was particularly influenced by the architectural ideas of Brunelleschi and Alberti.

The plan (**10.18**) shows the harmony of Sangallo's design. It was the first villa of the Italian Renaissance in which rooms were arranged symmetrically around a central hallway. The latter had a barrel vault and was the main space used for entertainment and receiving visitors. The private apartments were located at the corners. Like the Medici Palace in Florence, therefore, the Medici Villa was designed to accommodate privacy with the public life of a ruling family.

Santa Maria delle Carceri Lorenzo de' Medici was also involved in supporting Giuliano's work as architect of the church of Santa Maria delle Carceri (Saint Mary of the Prisons) in Prato (**10.19**). For this project,

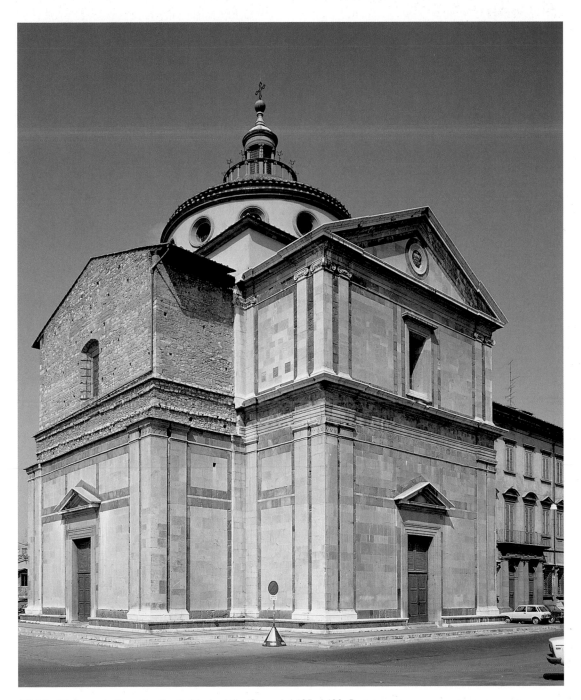

10.19 Giuliano da Sangallo, Santa Maria delle Carceri, 1485–1492, Prato.

Giuliano executed the first fifteenth-century centralized Greek-cross plan, associated in the Renaissance with God's perfection and derived from commemorative **martyria**. The church commemorated a miracle-working image of the Virgin on a prison wall that was believed to have come to life. Its symmetry and balanced relationship of parts to the whole also conform to Alberti's notion that formal harmony is a reflection of divine cosmic harmony.

The exterior is unfinished, but the view in Figure 10.19 shows the clear, regular forms that appealed to Classical taste. Giuliano incorporated the three Greek Orders, using the heavier Doric for the exterior ground level and the Ionic (which is two-thirds the height of the Doric) for the upper level. For the interior (**10.20**) he used the Corinthian Order. Both inside and outside, the walls are light in color, as in the Medici Villa. The pilasters and moldings of green Prato marble accentuate the rectilinear character of the walls and spaces, and reveal the geometric logic of the building. A pediment crowns each of the four arms of the church and is repeated over the entrance.

The interior view shows the dome over the cubic central space visible in the plan (**10.21**). Like Brunelleschi,

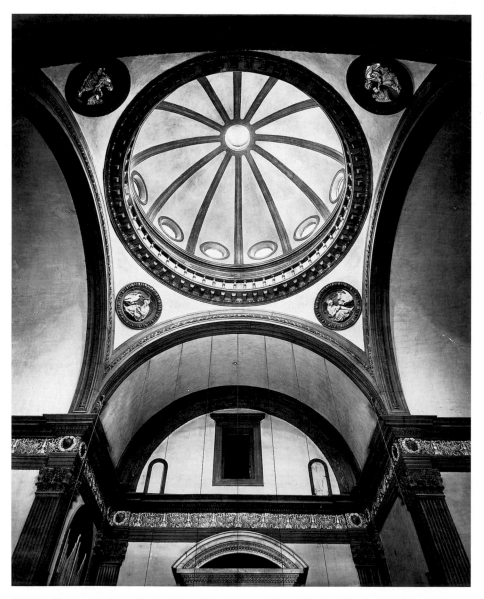

10.20 Giuliano da Sangallo, interior of the dome of Santa Maria delle Carceri, Prato.

Giuliano preferred the simple circle and square arranged in regular ratios. Twelve oculi and twelve ribs encircle the dome, whose drum rests on pendentives. Appearing to float above the central cube, the dome is an image of the divine realm of pure light. A relief tondo in each pendentive repeats the circular oculi and dome. Creating a transition from the curve of the pendentive to the vertical of the Corinthian pilaster at the corners is the horizontal frieze. This, like the Villa Medici frieze, is made of blue and white glazed terra-cotta—here depicting lamps, ribbons, and garlands. The section (**10.22**) shows the degree to which the interior and exterior design of the church correspond.

Sangallo's work of the 1480s, especially under the patronage of Lorenzo the Magnificent, sums up humanist classicism in architecture at the close of the fifteenth century. His interest in the Greek-cross plan heralds church architecture of the High Renaissance, influencing Bramante and Michelangelo (see Chapter 16), with whom he was acquainted.

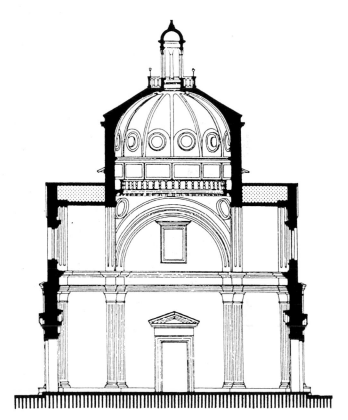

10.21 Giuliano da Sangallo, plan of Santa Maria delle Carceri, Prato.

10.22 Giuliano da Sangallo, section of Santa Maria delle Carceri, Prato.

Painting in Florence after 1450

As with the architecture and sculpture of the latter half of the fifteenth century, the effects of religious and political conflict in Florence are sometimes reflected in paintings. For example, tension is as characteristic of the figures in Pollaiuolo's pictures as it is of his sculpture, though its source is difficult to identify. Botticelli's commission to paint the Pazzi conspirators on the walls of the Palazzo Vecchio indicates his alliance with the Medici family and proximity to political events. His late work seems to have been profoundly influenced by the moral fervor of Savonarola, just as Donatello's seems to have been affected by the preaching of Antoninus. In Botticelli's case Savonarola's impact is confirmed by the artist himself.

Impressed by apocalyptic millenarianism, Botticelli renounced non-Christian subject matter after creating the first large-scale mythological paintings of the Renaissance. Monumental fresco cycles executed by Benozzo Gozzoli and Domenico Ghirlandaio, on the other hand, appear oblivious to contemporary social turmoil, but their iconography is intended to convey a strong political message. All of these artists benefited from Medici patronage and thus could not remain immune to the family's changing fortunes in late fifteenth-century Florence.

As early as the 1450s, plans to overthrow the Medici were discovered and quelled. The family palace was completed in 1457, and in the following August Cosimo's hold on Florence was supported by the army of Duke Francesco Sforza of Milan. By 1459, the Medici Palace was the center of Florentine power and one of only three in the city accorded an interior chapel by the pope. Galeazzo Maria Sforza, Francesco's adolescent son, was Cosimo's guest at the palace. He came in April, along with Sigismondo Malatesta of Rimini, to welcome Pius II, who was beginning a crusade to the Holy Land.

Benozzo Gozzoli: The Medici Chapel Frescoes

In the dazzling frescoes of the Medici Palace chapel, Benozzo Gozzoli (c. 1420–1497) created a *Procession of the Magi*, which is an unusual combination of visionary and political iconography. The chapel itself served the combined function of a place of worship and a reception room for state visitors. Its decoration, which dissolves the walls into Albertian "windows" giving onto vast Tuscan landscapes, was a tribute to Medici wealth, power, and piety. The subject matter of the frescoes was probably chosen because of the family's membership in the Company of the Magi. Although the frescoes may have originally been commissioned by Cosimo, it was his son Piero who oversaw their execution and whose lavish taste they reflect.

The view of the sanctuary in figure **11.1** shows a copy of Filippo Lippi's *Madonna Adoring Christ* (see 5.12) on an altar of red marble (the original is in Berlin). On the ceiling, Christ's monogram appears in a circle emitting solar rays, and the elaborate floor is tiled with red porphyry, green serpentine, and white marble. The walls on either side of the altar depict hosts of angels singing and praying to the newborn Christ in Filippo's painting. Framing the entrance are gilded Corinthian pilasters and pastoral scenes—the shepherd at the left occupies

11.1 Benozzo Gozzoli, view of the Medici Chapel sanctuary, 1459. Medici Palace, Florence. Benozzo di Lese di Sandro, known as Benozzo Gozzoli, came from a family of landholders. He moved to Florence in the 1420s, but his education and artistic training are undocumented. He worked with Fra Angelico, whose style clearly influenced him, as well as with Ghiberti. Benozzo married the daughter of a mercer and had nine children, two of whom became artists. Before painting the Medici Chapel frescoes, he worked in Florence, Orvieto, and Rome, and afterward in San Gimignano, Pisa, and Pistoia. Benozzo's father was a tailor, a trade in which the artist distinguished himself in the Medici Chapel frescoes, except that he wove clothing with paint and gold leaf instead of with threads.

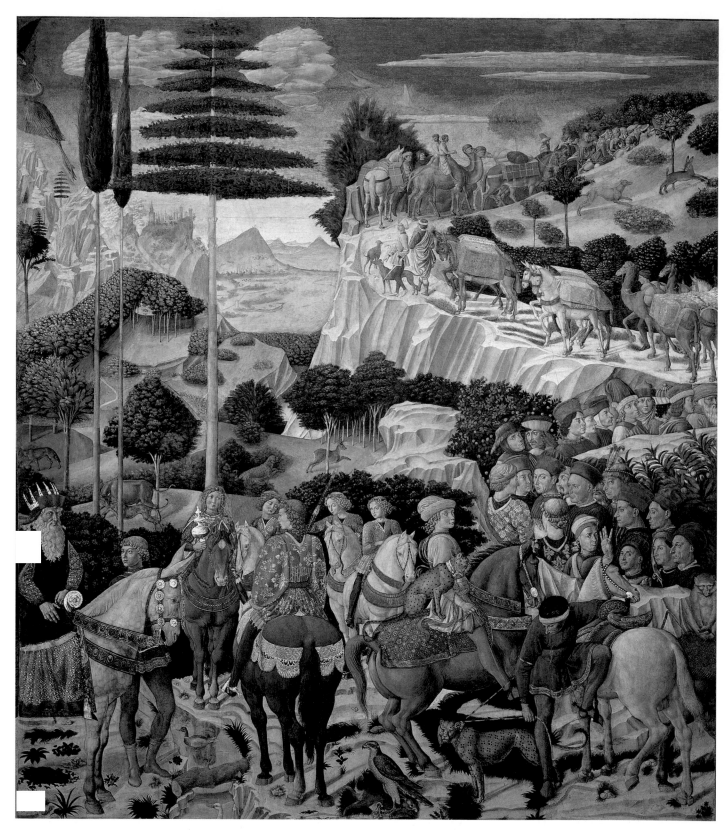

11.2 Benozzo Gozzoli, *Procession of the Magi*, 1459. Fresco. West wall of the Medici Chapel, Medici Palace, Florence. Surviving letters between Benozzo and Piero de' Medici as well as between their go-betweens detail the interaction between the artist and his demanding patron. Piero insisted on his own tastes and withheld payment when not entirely satisfied. Benozzo's communications detail the necessity for buying expensive materials such as gold leaf, and his frustration at not being paid on time.

a pose derived from Classical statuary. The juxtaposition of the ox and ass with shepherds alludes to the Annunciation to the Shepherds, who, like the Magi, travel to Bethlehem, as well as to the site of the Nativity. Through the presence of Filippo's altarpiece, the Adoration is re-created at the end of the Magi's journey.

The scene on the west wall (**11.2**) depicts the front of the procession with the oldest king, Melchior, at the far left. His white mule has stopped and gazes down at the log spanning a little stream. This might allude to the typological pairing of the Magi with the Queen of Sheba, who stops on her way to King Solomon's Temple and recognizes that a bridge is the future wood of the Cross. On the other side of the stream, the procession has come to a halt. Horses have stopped and turn in various directions. One man holding the leash of an odd-

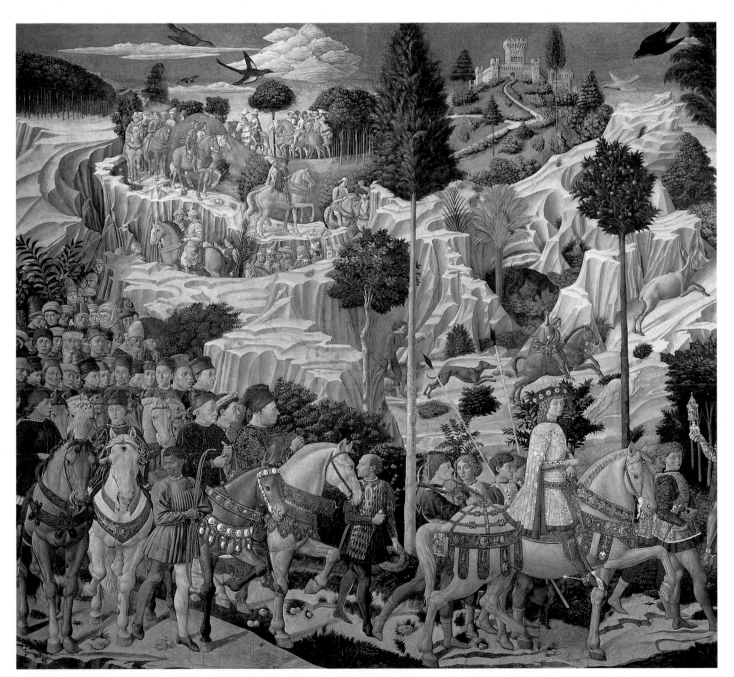

11.3 Benozzo Gozzoli, *Procession of the Magi*, 1459. Fresco. East wall of the Medici Chapel, Medici Palace, Florence.

looking feline dismounts. Behind him, among a semicircular group of figures, the artist waves to the viewer. He symbolically signs off on the work, accentuating his hand as that of the painter. At the right edge of the scene sits a little ape, possibly referring, at the end of Benozzo's tour de force, to the traditional iconography of the painter as "ape of nature."

The Medici family's special identification with the Magi is evident in the scene on the east wall (**11.3**). There the procession is led by the youngest Magus, Caspar, whose horse trappings are decorated with the gold balls of the Medici. Family portraits and those of key political figures appear in Caspar's retinue. Cosimo is simply attired and rides a mule, also decked out with Medici *palle*. This is a sign of his humility as well as his identification with Christ, who entered Jerusalem on a mule. Next to Cosimo on a white horse is Piero, whose bright brocade cloak is consistent with his luxurious tastes.

Between Cosimo and Piero is Carlo, Cosimo's illegitimate son by a Circassian slave, who was raised as a member of the family. The following year, he became bishop of Prato (see 5.13). Riding the pair of horses at the left are Galeazzo Sforza (on the white horse) and Sigismondo Malatesta (on the brown horse), both prominently depicted as Medici allies. Just behind Galeazzo and slightly to the left are Piero's young sons— six-year-old Giuliano and ten-year-old Lorenzo with his distinctive flattened, curved nose. Directly above Giuliano is another self-portrait of the artist. He again gazes out of the picture, but here he has signed on his hat OPUS BENOTII—"the work of Benozzo," which can also be read as "the work of the notable [painter]."

Pollaiuolo

Pollaiuolo worked for the Medici family, as may be seen from fragmentary copies of his lost series of the Labors of Hercules. Although few of Pollaiuolo's pictures survive in good condition, they, like his bronze *Hercules*

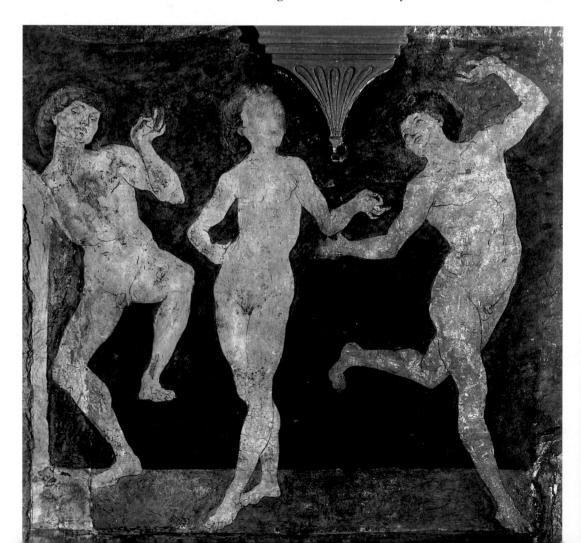

11.4 Antonio del Pollaiuolo, *Dancing Nudes*, 1470s. Detail of frescoes at Villa La Gallina, near Florence.

and Antaeus (see 10.7), reveal his taste for powerful form and underlying human anatomy. The detail in figure **11.4** is from frescoes of dancing nudes on the wall of the Villa La Gallina on the hill overlooking Florence to the southwest. Most of the paint has worn away, leaving only the underdrawing. The lively action of the twisting bodies elevates the figures in the exuberance of their dance.

Nudes in a more violent context occur in Pollaiuolo's unusual engraving the *Battle of the Ten Nudes* (**11.5**), generally dated, like the *Dancing Nudes*, to the early 1470s. He accentuates the musculature of the figures with line and depicts them in various energetic poses. They are devoid of armor—two shields and a helmet lie on the ground—and they fight fiercely with swords, daggers, a bow and arrow, and an ax. The white bodies stand out against a richly patterned foliate backdrop

that is reminiscent of tapestry, which is consistent with Pollaiuolo's reputation for designing embroideries. The work is signed on a plaque at the left. As with the *Dancing Nudes*, the actual subject of the *Battle* is not known.

Pollaiuolo's *The Martyrdom of Saint Sebastian* of around 1441 (**11.6**) is his major extant painting. It was commissioned as the altarpiece for the Pucci family chapel dedicated to the saint in the church of Santissima Annunziata. The complexity of this picture resides in both its figural movement and in its layers of iconographic meaning. In this case, the text for the work is well known; Sebastian was a member of the elite praetorian guard in charge of protecting the Roman emperor Diocletian. When Sebastian's secret faith in Christ was discovered, Diocletian begged him to renounce it and worship the Roman gods again. Sebastian refused

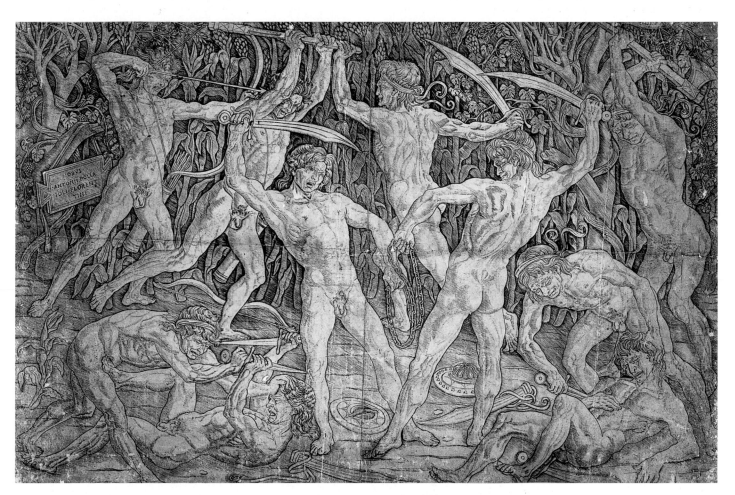

11.5 Antonio del Pollaiuolo, *Battle of the Ten Nudes*, early 1470s. Engraving: 15⅛ × 23¼ in. (38.4 × 59.1 cm). Metropolitan Museum of Art, New York; Joseph Pulitzer Bequest, 1917.

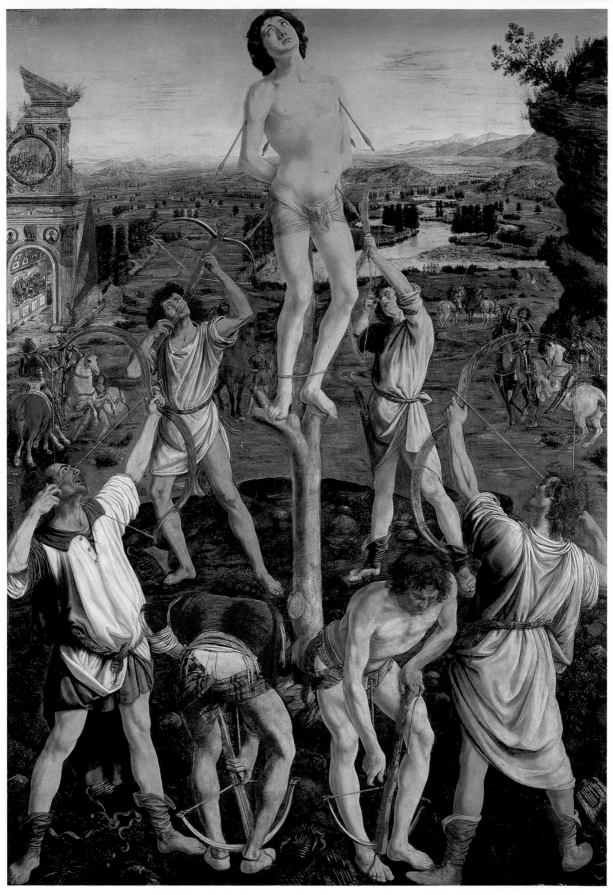

11.6 Antonio del Pollaiuolo, *The Martyrdom of Saint Sebastian*, c. 1441. Tempera on panel; 9 ft. 7 in. × 6 ft. 8 in. (292 × 203 cm). National Gallery, London. Antonio's younger brother, Piero, was also a painter, and it is possible that Antonio collaborated with him on the *Saint Sebastian*.

and was condemned to death. He was tied to a stake, shot through with arrows, and left for dead. But he survived and returned to Rome to declare his faith openly. At this, Diocletian had him beaten to death and his body disposed of in the Roman sewer. Later, he was buried in the catacombs. Eventually, Sebastian became a plague saint and was invoked against the disease because of the traditional belief that Apollo's arrows caused the sores that accompany plague. (Plague sores were also viewed as the result of God raining down arrows upon a sinful humanity.)

In Pollaiuolo's picture, Sebastian is tied to a tree stump and surrounded by six archers; the two bending figures are paired, the two other foreground archers and the one at the right in the rear appear to be the same figure viewed from different angles, whereas the sixth archer (rear left) has no exact counterpart. Sebastian's serene and slightly saddened expression and his relaxed, idealized form are in stark contrast to the tensed, bent archers in the foreground who struggle with their crossbows. Their contorted physiognomies are signs of their evil intent. The tight unity of purpose conveyed by the poses is accentuated by chromatic repetitions of red, blue, and gray in the archers' clothing.

The configuration of the archers, arranged around Sebastian, alludes to the original context of the painting—on the main altar within a semicircular apse. Sebastian's martyrdom—like the Crucifixion itself—takes place on a hill, indicated by the sudden shift to the middle ground and distant view of the Arno Valley. Here, however, Pollaiuolo has conflated Florence with Rome. The arch at the left is broken, signifying the decline of the empire and the eventual triumph of Christianity.

Botticelli

Sandro Botticelli (1445–1510) was clearly affected by the millenarian sermons of Savonarola in the late fifteenth century. At a certain point in his career, a radical shift in his style and content parallels aspects of Donatello's late work. Botticelli trained with Filippo Lippi, whose delicate style and taste for light filtering through transparent or translucent materials he shared.

The *Madonna of the Pomegranate* (**11.7**) is one of Botticelli's many impressive images of the Virgin and Child with angels. Mary is seated, although we do not see her throne, and she is symbolically crowned by a heavenly oval of light. Her large size, denoting her role as the Church building, provides ample support for Christ and seems to expand along with the curve of the round frame. In an image devoid of architectural elements, the figures themselves become architecture. The angels form a figural apse around Mary, who is herself Christ's throne. All exist in a circle of pale blue, with no identifiable context other than the mystical light from above.

The Madonna and Christ—as well as the angels—have sad expressions, alluding to Christ's death; the pomegranate, which is filled with seeds, signifies his rebirth through resurrection. Arranged in a symmetry that is somewhat varied by pose and expression, the angels are simultaneously detached from, and engaged with, the central figures. The two at the back gaze off to the sides, the next two hold open books, while the pair in the foreground carry floral symbols of the Virgin—lilies and roses. Embroidered in the gold edging of the red drapery of the angel at the left are the words that, like the flowers, are identified with the Virgin: AVE GRAZIA PLENA—"Hail [Mary] full of grace."

Botticelli's *Adoration of the Magi* (**11.8**), containing portraits of his contemporaries as well as a generally accepted self-portrait, was probably executed in the 1470s. The scene takes place in a shed with a broken stone wall at the right. New branches emerging from the blocks of stone, like the peacock, denote rebirth and immortality. Referring to Christ's death, on the other hand, is the traditional mourning pose of Joseph, who stands behind the Virgin and Christ under the radiant star of Bethlehem. The elevation and setting of Mother and Child replicate that of the altarpiece,

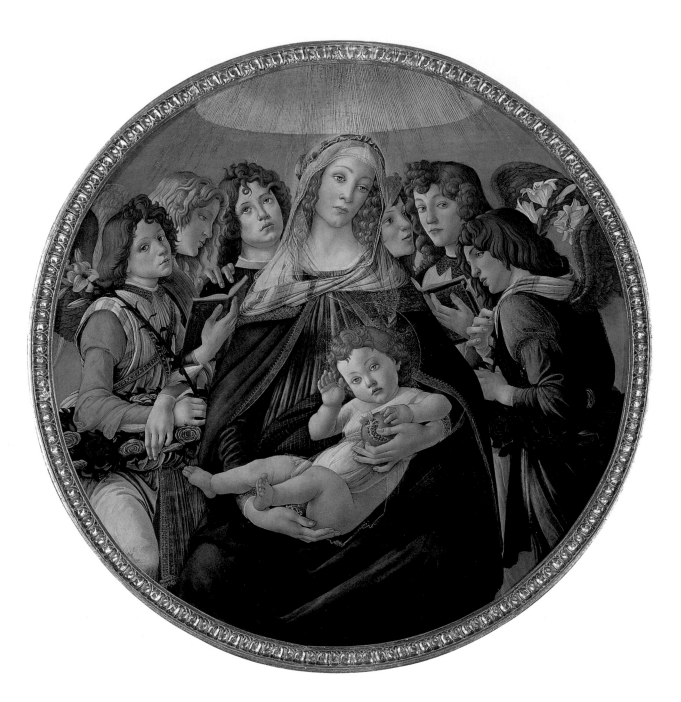

11.7 Sandro Botticelli, *Madonna of the Pomegranate*, c. 1480. Tempera on panel; 4 ft. 8½ in. (143.5 cm) diameter. Galleria degli Uffizi, Florence. Botticelli was named Alessandro by his father, Mariano Filipepi, who was a tanner. His elder brother, Giovanni, was a broker, dubbed *il Botticello*, or "the little keg." Alessandro was known as the ward of Botticello and later "Botticelli." Another brother, Antonio, was a goldsmith.

itself elevated on the altar in the chapel. The crumbling arches at the far left signify the decline of pre-Christian Rome.

Writing in the sixteenth century, Vasari claimed that Medici portraits appeared among the Magi and their retinue. Cosimo, in the guise of the eldest Magus, is accorded the place of distinction. He holds the feet of Christ, which he covers with a veil in the manner of a priest with the monstrance containing the wafer of the Eucharist. At the left, Cosimo's grandson Lorenzo the Magnificent is recognizable from his distinctive physiognomy. Posing prominently in the

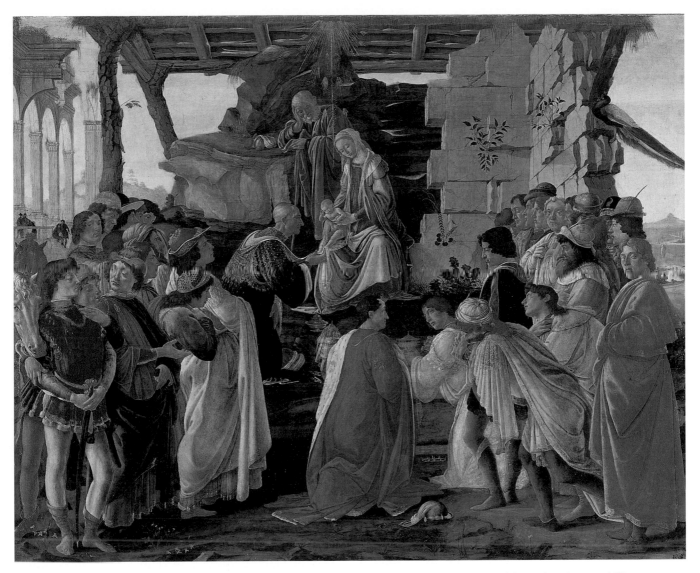

11.8 Sandro Botticelli, *Adoration of the Magi*, 1470s. 43¾ × 52¾ in. (111 × 134 cm). Galleria degli Uffizi, Florence. This was the altarpiece for the funerary chapel of Guaspare di Zenobio del Lama in Santa Maria Novella. It was dedicated to the feast of the Epiphany, celebrated on January 6. The patron had made a fortune through business connections with the Medici and his position as broker for money changers.

foreground, he is accompanied by figures identified as the humanists Angelo Poliziano and Giovanni Pico della Mirandola, with the patron, Guaspare del Lama, slightly behind them.

Cosimo's association with the eldest Magus reinforces the image of the Medici hold on political power, despite assertions of republican sentiment. Standing to the far right is a young man in yellow who gazes out of the picture. This is a convention of self-portraiture in the Renaissance, and the figure has thus been assumed to depict Botticelli.

Perhaps Botticelli's two best-known paintings are the large *Primavera* (**11.9**) and *Birth of Venus* (**11.10**), which, although not documented as such, were almost certainly a Medici commission. They are among the artist's major mythological works, and their meaning has been the subject of extensive scholarly debate. They have been read in the context of Neoplatonism, as references to the Medici family, and as illustrations of Ovid, Horace, Seneca, and contemporary poems.

The *Primavera*, or *Springtime*, depicts Venus at the center of a lush, tapestry-like bower. Above her,

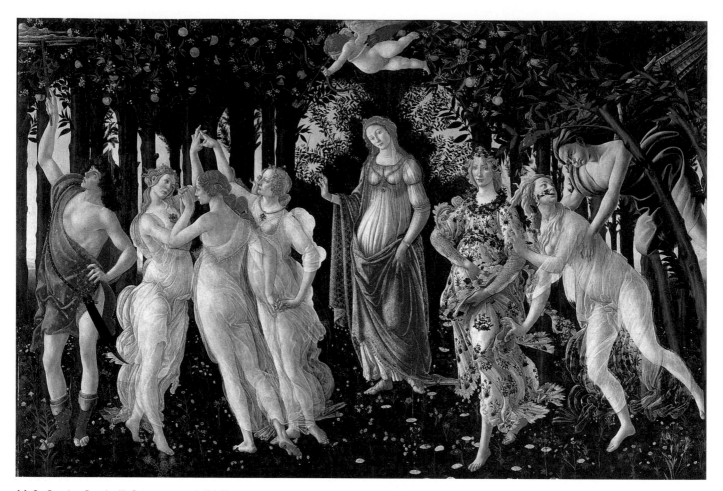

11.9 Sandro Botticelli, *Primavera*, c. 1480. Tempera on wood; 6 ft. 8 in. × 10 ft. 4 in. (2.03 × 3.14 m). Galleria degli Uffizi, Florence.

a blindfolded Cupid aims his arrow toward her attendants, the three Graces (identifiable by the configuration of their poses). Their elongated forms and diaphanous, flowing draperies are characteristic of Botticelli. The young man at the left has been identified as Mercury because of his attributes—winged boots, a helmet, and the caduceus in his right hand. The abundance of oranges, the *mala medica*, also a feature of Uccello's *Battle of San Romano* (see 6.9), clearly alludes to the Medici.

To the right of Venus is Flora, the personification of Spring, wreathed in flowers and wearing a floral dress. The nymph and wind god behind Flora are generally identified as Chloris and Zephyr, respectively. In Greek myth, Zephyr raped Chloris and married her; she, in turn, became a goddess. Whatever texts inspired the painting, its themes are apparently love and fertility in the context of a luxurious, imaginary setting.

In the *Birth of Venus*, Botticelli has created a dreamlike image that contains recognizable elements but the precise meaning of the image remains elusive. It illustrates the mythological birth of Venus from the union of the severed genitals of Uranus and the sea. The goddess, in the *contrapposto* pose of the Hellenistic *Venus pudica* (see 4.15), floats ashore on a giant scallop shell. Personifications of light breezes or wind propel her toward land, while a figure sometimes identified as an Hora (one of three mythological personifications of the seasons—probably Spring) prepares to cover her when she disembarks. The roses and myrtle are symbols of Venus, and the trees, as in the *Primavera*, are orange trees.

Considered as a pair, these paintings depict two aspects of Venus. In one, she is just born, and the trees have not yet produced their fruit. The goddess is in transition—between the sea's womb and the land; she is at

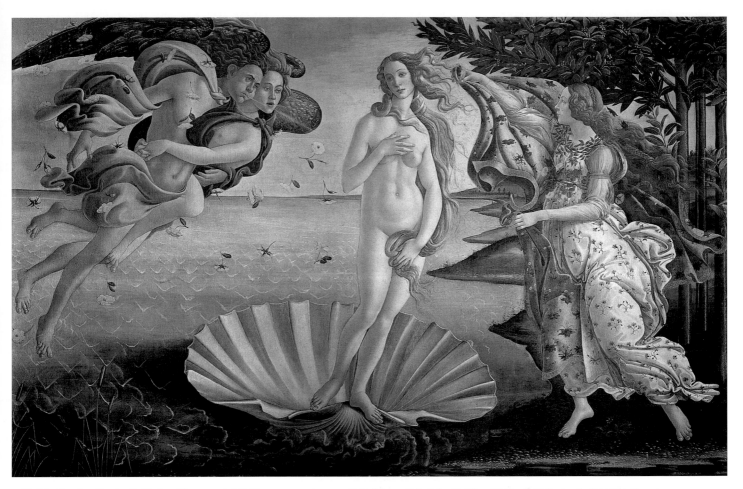

11.10 Sandro Botticelli, *Birth of Venus*, c. 1480. Tempera on canvas; 5 ft. 9 in. × 9 ft. 2 in. (1.73 × 2.77 m). Galleria degli Uffizi, Florence.

once exposed and aloof, not yet of the world awaiting her arrival. In the other, she presides over an explosion of fruit and flowers, and her connection with the Medici is made explicit in the iconography. In neither case, however, has it been possible to arrive at a consensus of meaning.

In the *Man with a Medal* (**11.11**), whose identity is unknown, Botticelli created an unusual portrait. The

The Platonic Academy

Humanists gathered informally at the Medici Villa in Careggi. They conversed in the style established by Plato that led to the literary form in which philosophical positions are arrived at through dialogue. Cosimo was an early supporter of the humanists, and he commissioned Marsilio Ficino to translate all of Plato's known writings from Greek into Latin. By 1468–1469, Ficino had completed the work, which was published in 1484. He began his *Theologica Platonica* in 1469, the same year that Lorenzo established the Platonic Academy in Florence. Ficino also translated early Neoplatonists such as Plotinus and Hermes Trismegistus, as well as the Orphic texts. His *De chris-*

tiana religione of 1473–1474 reflects the Neoplatonic aspiration to merge Platonism with Christianity and the notion that Greek myth could be read in the light of Christian allegory.

In the *Commentary on Plato's Symposium*, Ficino discusses the two natures of Venus—divine and earthly—which has been considered by some scholars as having influenced Botticelli's depictions of the goddess. The former aspect of Venus is intellectual and spiritual, the latter physical and procreative. This same duality is found in Botticelli's combination of spiritual, even mystical, qualities with a manifest taste for the material textures of the physical world.

juxtaposition of the head-on view of the sitter and the bird's eye view of distant landscape reflects the influence of Northern painting. In contrast to the delicate flesh and dreamy detachment of Botticelli's women, this figure has a chiseled physiognomy and a direct gaze. His long, bony fingers frame the medal, which is based on an actual medal of Cosimo and is on prominent display. It is of gilded stucco relief inserted into the panel. The inscription includes Cosimo's name and the initials "PPP," possibly referring to him as the "first [*primus*] father [*pater*] of his country [*patriae*]," a designation awarded him after his death in 1464. The painting, like

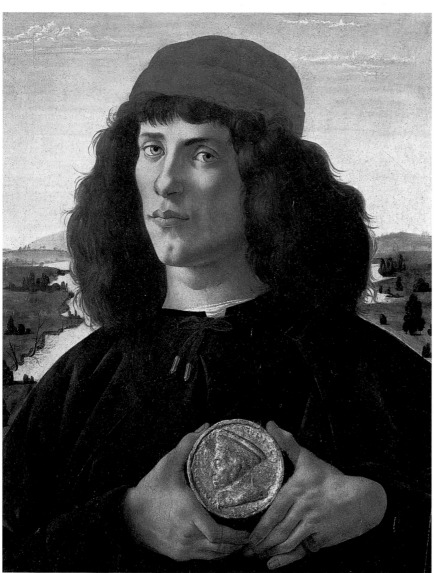

11.11 Sandro Botticelli, *Man with a Medal*, late 1460s or early 1470s. Tempera on panel; 22⅝ × 17⅜ in. (57.5 × 44 cm). Galleria degli Uffizi, Florence.

Renaissance medals generally, is thus both celebratory and commemorative.

Sometime after Botticelli completed the monumental mythologies, his style strikingly increased in religious fervor. This can be seen by comparing two works depicting *Saint Augustine in His Study* from two different decades of his life. The first (**11.12**), painted in 1480, is Botticelli's earliest surviving fresco. It was for the church of the Ognissanti in Florence and was a pendant to Ghirlandaio's (see below) image of Saint Jerome because it represents Augustine's vision of Jerome. The patrons were members of the mercantile family, the Vespucci, whose coat of arms hangs on the molding (see caption).

The lowered viewpoint of the painted space monumentalizes Augustine, who is enveloped by a massive orange robe. The saint's meditation has been interrupted by a vision, his disturbed reaction manifest in his expression and the agitation of his right hand. In his left hand, he holds an inkwell, alluding to his prominence as an author. That Augustine is both a scholar and a bishop is shown by the jeweled miter, the heavy tomes (one of which is opened to a page of Euclidian theorems), and instruments of measurement. The clock face at the upper right with twenty-four hours in Roman numerals indicates that the hour is sunset. This corresponds to the time of the vision itself, which, according to Augustine, occurred on the day of Saint Jerome's death. Botticelli's taste for elegant color—the reds, greens, blues, and oranges—and illusionism—the open drawer and the astrolabe—are given full play in this fresco. Despite the spiritual content, the execution reflects a delight in material textures and weighty form.

The exuberant monumentality of the Ognissanti fresco is gone in the later version of the *Saint Augustine in His Study* (**11.13**), in which the saint occupies a bare cell. Now he is withdrawn emotionally and spatially from the foreground. He sits at a plain, wooden desk in a darkened

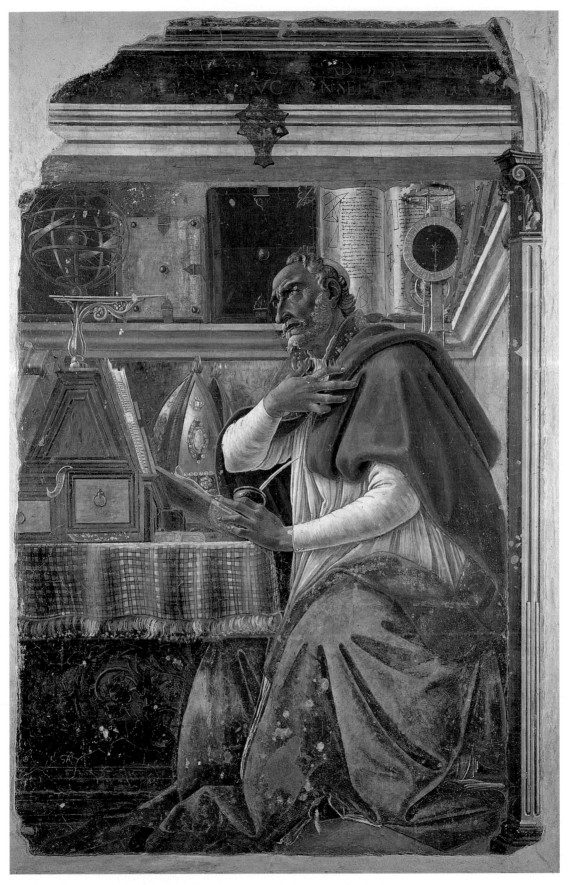

11.12 Sandro Botticelli, *Saint Augustine in His Study*, 1480. Fresco; 5 ft. × 3 ft. 7 in. (152 × 112 cm). Ognissanti Church, Florence. The Vespucci were acquainted with the Medici; in 1494 Amerigo Vespucci left Florence to work for the Medici trading company in Seville. Four years later, he sailed from Spain to the South American coast. His name is the origin of the word *America*.

room devoid of all but a few books. The one-point perspective construction of the barrel-vaulted study removes Augustine from the viewer and accentuates his isolated, monastic existence. The wreathed Classical busts outside the arch notwithstanding, Augustine is formally related to the interior lunette on the back wall that echoes the curve of his halo and depicts the Virgin and Christ. In contrast to the earlier emphasis on Augustine's interest in intellectual inquiry and real-world instruments of measurement, the later figure is engaged in the effort of sacred writing. Botticelli shows this by the twisted pieces of paper strewn on the floor of Augustine's cell. On the one hand, they reflect the artist's continued taste for illusionistic display and, on the other, the saint's struggle to translate spiritual inspiration into pages of text.

Botticelli's stylistic change corresponded to the upheaval in Florence in the 1490s. Lorenzo the Magnificent died in 1492. His son Piero, twenty-two at the time, was a poor politician, a disloyal ally, at odds with his own relatives, and unable to maintain the Medici hold on power. In 1494, the French King Charles VIII invaded Italy. In Milan, Galeazzo Maria Sforza—depicted as an adolescent among the Medici in Benozzo Gozzoli's *Procession of the Magi*—was murdered in 1476. Because Galeazzo's son, Giangaleazzo, was only seven years old at the time, his uncle, Lodovico il Moro, took over the government and, after 1476, became duke. Lodovico supported the French, who entered Florence in November

1494, by which time the Medici had been expelled from the city.

The new ruler of the city was Savonarola, headquartered at the Dominican convent of San Marco. His fanatic control of Florence was short-lived—he was excommunicated in 1497 and executed in 1498—but his impact was considerable. Savonarola believed, with the Renaissance rulers, in the power of imagery. And to some degree he prefigured the Counter-Reformation

11.13 Sandro Botticelli, *Saint Augustine in His Study*, 1490s. Tempera on panel; 16⅛ × 10⅝ in. (41 × 27 cm). Galleria degli Uffizi, Florence.

zealotry that took hold of Catholic Europe after the challenge posed by Martin Luther in the sixteenth century. In Savonarola's view, the visual arts should be austere; they should inspire a spiritual response in the viewer, rather than identification with the humanity of depicted scenes. His emphasis on spirituality interested some of the Neoplatonists, and the fear evoked by his calls for repentance affected certain late works by Botticelli.

The *Mystic Nativity* (**11.14**), for example, shares Savonarola's apocalyptic fervor. It is divided into three

11.14 Sandro Botticelli, *Mystic Nativity*, c. 1500. Tempera on canvas; 42¾ × 29½ in. (108.5 × 74.9 cm). National Gallery, London.

horizontal tiers; the middle shows a kneeling Virgin praying over the infant Christ. Joseph is seated, curled in on himself as he rests his balding head on his arm. Mary's association with the Church is clear from her large size and curved form, paralleling the rocky enclosure. In the distance, the greenish light between the tree trunks is reminiscent of stained-glass windows. The olive bushes at each side of the Holy Family, as well as those carried by the angels, refer to Palm Sunday (known as Olive Sunday in Florence) and to Savonarola himself, who regularly used olive branches in religious processions. Angels gesture toward the scene, revealing the Holy Family to groups who kneel to worship Christ—shepherds on the right and ordinary citizens on the left. Kneeling on the roof of the shed are three angels gathered around a hymnal.

In the foreground, another trio of angels greets three souls who have escaped the clutches of the devils. The gray devil at the left is impaled on a branch, while others in the center and at the far right sink into the ground. In the top tier of the picture, a heavenly circle of gold opens, and a ring of twelve angels dances above the shed. The Greek inscription above the heavenly light identifies the twelfth chapter of the Apocalypse as the text from which Botticelli's iconography is derived: "This picture I, Alessandro, painted at the close of 1500, in the troubles of Italy [that is, the invasion of the French], in the half time after the time, during the fulfillment of the eleventh of John, in the second woe of the Apocalypse, in the freeing of the devil for three and a half years. After that he shall be chained according to the twelfth [chapter of John] and we shall see him … as in this picture."

Filippino Lippi:
Vision of Saint Bernard

Filippino Lippi's (1457/58–1504) *Vision of Saint Bernard* (**11.15**) of around 1485 to 1490 shares the religious mood, but not the fervor, of the *Mystic Nativity*. The son of Filippo Lippi and Lucrezia Buti, Filippino was first taught by his father and then studied with Botticelli. He was commissioned by the Brancacci family to complete

the fresco cycle in Santa Maria del Carmine. But his style, more elegant than Masaccio's, indicates that the tastes of his patrons, and of Florence generally, had changed in the intervening decades.

The *Vision of Saint Bernard* shows the ascetic saint in the wilderness. In contrast to the simple monumentality of Masaccio, Filippino constructs an elaborate setting of rocks, foliage, and architecture. Bernard is seated at a makeshift lectern supported by a tree stump with vines, an allusion to the wood of the Cross and Christ's statement "I am the vine." Numerous books are arranged on the rocky ledge, a metaphor for the Church as the Rock of Ages and its foundation in Scripture.

The saint is interrupted in the act of writing by a sudden apparition of the Virgin, whose graceful depiction and transparent halo reveal the influence of Filippino's father as well as of Botticelli. Bernard's special devotion to her cult is suggested by the open book displaying Saint Luke's account of the Annunciation. The Virgin places her hand on Bernard's text, arresting his pen. As in Botticelli's two versions of *Saint Augustine in His Study*, the relationship of text to divine inspiration is a prominent theme, in which an inner spiritual dialogue is communicated through the written word.

The power of the Virgin and of Saint Bernard's faith is shown in their effect on the devil. In contrast to the light and color accompanying the Virgin and her angels, the devil huddles in darkness under the rocks at the right. He gnaws on his chains and glares angrily at the saint. The owl beside the devil signifies Satan as the Prince of Darkness.

At the upper right, two monks gaze at the divine yellow light heralding the appearance of the Virgin. A second pair converses before a church or monastic building. As in Gentile da Fabriano's *Adoration of the Magi* (see 4.2), the sequence proceeds from the top of the picture plane to the foreground below. Closest to the space of the viewer is the portrait of the patron, probably the cloth merchant Francesco Pugliese. He wears contemporary Florentine dress, his red cape echoing the reds of the Virgin and her angelic retinue. He evokes the viewer's identification with the vision by appearing to have envisioned, through prayer, the vision of the saint.

11.15 Filippino Lippi, *Vision of Saint Bernard*, c. 1485–1490. Panel; 6 ft. 10 in. × 6 ft. 4¾ in. (210 × 195 cm). Originally for the church of Le Campora at Marignolle, outside Florence, and now in the Badia.

Ghirlandaio

In the closing years of the fifteenth century, Domenico Ghirlandaio (1449–1494) was one of the most successful painters in Florence. In addition to individual portraits, he was commissioned to fresco the walls of two major chapels in which contemporary portraits are included in biblical and historical scenes. His *Old Man with a Child* (**11.16**) reflects his predilection for rich color and expressive physiognomy. The old man's character is "mapped" on the surface of his face, and it is likely that Ghirlandaio drew his features while he was on his deathbed. The bulges on his nose and the mole on his forehead echo the bulbous trees in the distant landscape. He gazes intently at the young boy, who literally "looks up to him." The boy's hand resting on his red coat and the old man's simultaneous embrace of the boy are signs of an intimate relationship. Their identity is not known; the fact that their gaze spans a short space, but that generations of time separate them, creates the impression that they are grandfather and grandson.

In the early 1480s, Ghirlandaio was commissioned to execute frescoes illustrating the life of Saint Francis for Francesco Sassetti's burial chapel in the church of Santa Trinità (**11.17**). Kneeling on either side of the altarpiece,

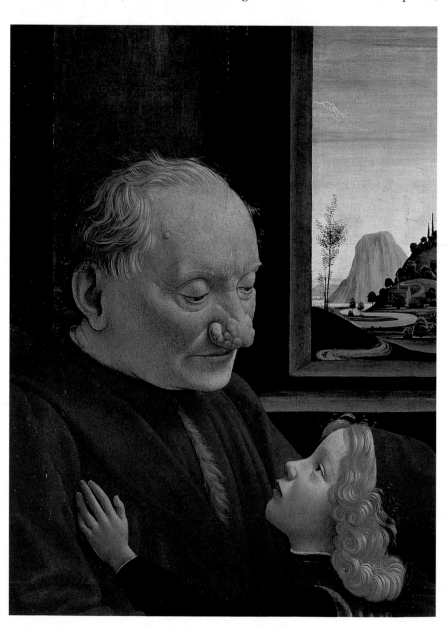

11.16 Domenico Ghirlandaio, *Old Man with a Child*, c. 1480. Panel; 24⅜ × 18⅛ in. (62 × 46 cm). Musée du Louvre, Paris. Domenico Bigordi inherited his father's nickname, Ghirlandaio, meaning one who makes garlands—which is what his father did for a living. Domenico studied metalworking and later, like his brother Davide, became a painter.

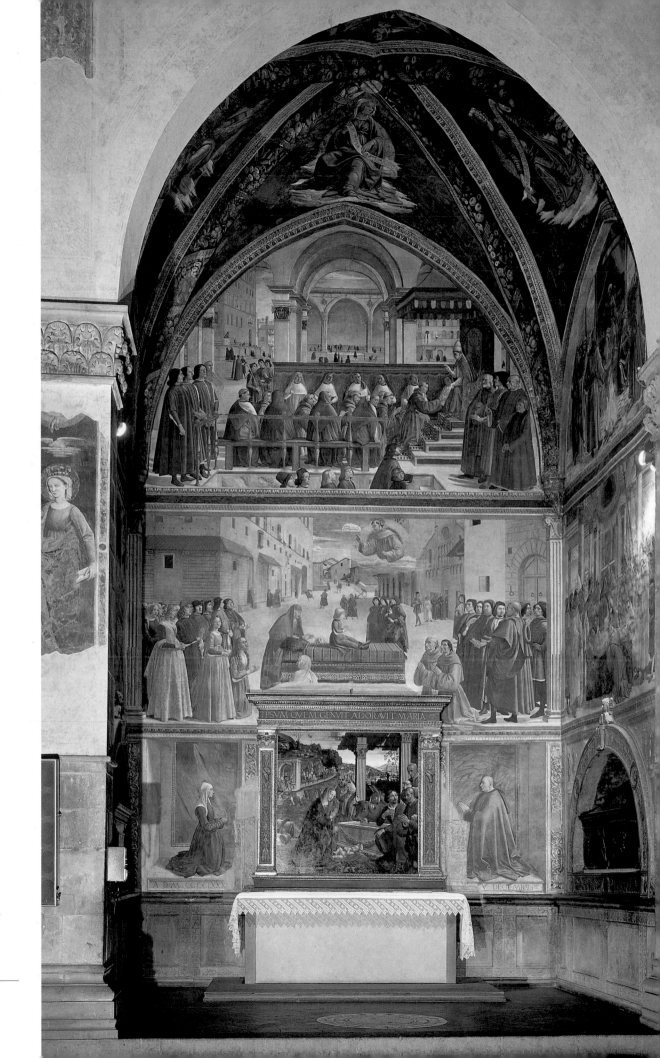

11.17 Domenico Ghirlandaio, view of the Sassetti Chapel, 1483–1486. Santa Trinità, Florence.

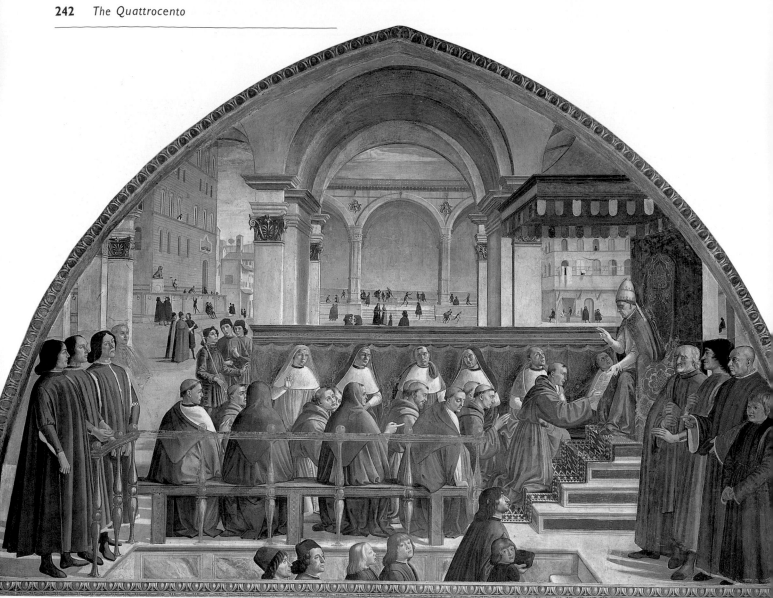

11.18 Domenico Ghirlandaio, *Confirmation of the Franciscan Rule by Pope Honorius III*, 1483–1486. Fresco. Sassetti Chapel, Santa Trinità, Florence.

also by Ghirlandaio (see below), are the donor and his wife; their tombs are behind them on the side walls. The lunette scene on the altar wall is the *Confirmation of the Franciscan Rule by Pope Honorius III* (**11.18**), in which fifteenth-century Florence is merged with thirteenth-century Rome. Kneeling before the pope, Saint Francis, the patron saint of the donor, receives confirmation of his rule.

Ascending the steps in the foreground are Lorenzo the Magnificent's three sons, Piero, Giovanni, and Giuliano, the last named after his uncle killed in the Pazzi Conspiracy. Angelo Poliziano, the primary tutor of the children, leads the way, with Matteo Franco (another tutor) and the humanist poet Luigi Pulci bringing up the rear. At the far right, from left to right,

stand Antonio Pucci (Francesco Sassetti's brother-in-law), Lorenzo himself, next to Francesco Sassetti, and Francesco's son, Federico.

Extending behind the prelates is the urban landscape of Florence, reflecting Ghirlandaio's taste for architectural panoramas and linear perspective. The Palazzo Vecchio at the left, with the gilded *Marzocco*, is a counterpoint to Lorenzo at the right. For despite being the de facto ruler of Florence, Lorenzo, like his father and grandfather, preferred to exercise his power from the Medici residence rather than from the actual seat of government.

Ghirlandaio's altarpiece, representing the *Adoration of the Shepherds* (**11.19**), was inspired by the Portinari Altarpiece (**11.20**) of the Netherlandish painter Hugo

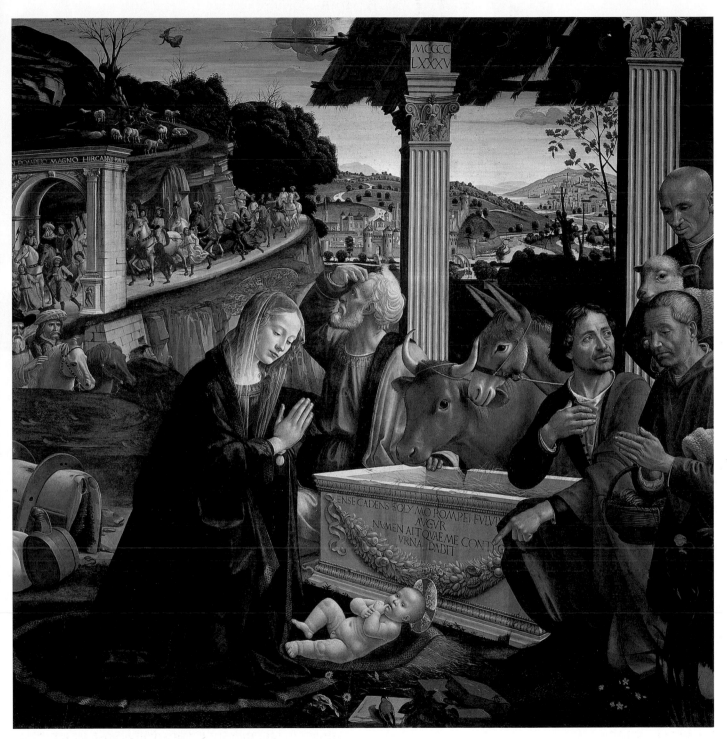

11.19 Domenico Ghirlandaio, *Adoration of the Shepherds*, 1485. Panel; 65¼ × 65¼ in. (165.7 × 165.7 cm). Sassetti Chapel, Santa Trinità, Florence. The sarcophagus bears an inscription identifying its occupant as a prophet who died when Pompey, the Roman general, invaded Jerusalem. He declares that his tomb will be the crib of a new god—in this case, Jesus.

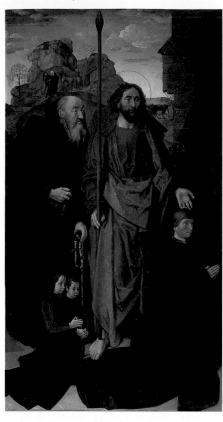

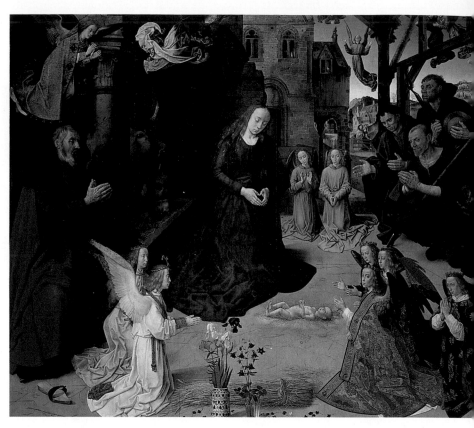

11.20 Hugo van der Goes, Portinari Altarpiece (opened), late 1470s. Oil on wood; center panel: 8 ft. 4 in. × 10 ft. (2.53 × 3.05 m); side panels: 8 ft. 4 in. × 4 ft. 8 in. (2.53 × 1.42 m). Galleria degli Uffizi, Florence.

van der Goes. But whereas Hugo placed the donors on the side panels of a triptych, the Sassetti are painted on the chapel walls flanking a single panel (see 11.17). Despite the somber mood, Northern proportions, and rich surface textures, the Portinari Altarpiece has affinities with Ghirlandaio's more serene, classicizing image. Ghirlandaio's taste for distinctive physiognomy recurs in the rustic shepherds, but his figures do not convey the same sense of agitation as those of Hugo. The Italian version also contains more specific references to antiquity—the sarcophagus (which serves as Christ's crib and denotes the conflation of Christ's birth and death), the Corinthian pilasters (the one on the left is inscribed with the date 1485), and the Roman arch (signifying the triumph of Christ over paganism). The latter identifies Pompey as the conqueror of Jerusalem.

The Portinari Altarpiece was commissioned for the high altar of Sant'Egidio by Tommaso Portinari. He represented the Medici bank in Bruges, whereas Sassetti was general manager of the bank in Florence. The coincidence of the two altarpieces in the late 1470s and 1480s thus reflects commercial as well as artistic ties between Northern Europe and Italy.

Ghirlandaio's last great fresco cycle in the chancel of Santa Maria Novella was commissioned by Giovanni Tornabuoni. It represents scenes from the life of the Virgin and John the Baptist, the latter being Giovanni's name saint. As the brother-in-law of Piero de' Medici, treasurer to the pope, and head of the Medici bank in Rome, Giovanni was a powerful figure in the late fifteenth century. His taste for the appearance of consciously constructed perspective, rich brocades, and Classical architectural details (see caption) is evident in the *Birth of the Virgin* (**11.21**).

At the top of the stairs, the earlier scene in which Anna (Mary's mother) and Joachim (Mary's father) embrace alludes to the apocryphal Meeting at the Golden Gate. The main event takes place in the right foreground and, like the frescoes in the Sassetti Chapel, merges contemporary figures with those of the past. Classical details abound in the pilaster reliefs, the garland frieze (possibly a reference to Ghirlandaio's name) above the molding, and the exuberant frieze of *putti* depicted in *grisaille*.

Anna, reminiscent of Nicola Pisano's monumental Virgin from the *Adoration of the Magi* of the Pisa Baptistery pulpit (see 1.11), has just given birth. She

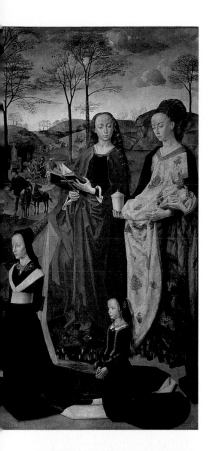

watches intently as water is poured for Mary's first bath. Enhancing the sense of a processional sequence, one of the newborn's attendants turns to look at the group of women entering from the left. Leading the group is Ludovica, the youngest daughter of Giovanni, and at the rear is Lucrezia Tornabuoni, Giovanni's sister, who had died in 1482. Her resemblance to her son, Lorenzo the Magnificent, is striking, for she had the same long, curved, flattened nose.

Despite the message communicated by Ghirlandaio's two fresco cycles, the power of the Medici family was on the wane. From the age of twenty, Lorenzo had continued the lavish artistic patronage begun by his great-grandfather, Giovanni di Bicci, and carried through four generations of the family. He also maintained his hold on the financial and political power of Florence, weathering unrest when his father died in 1469 and following the murder of his brother in the Pazzi Conspiracy of 1478. But Lorenzo's death in 1492 marked the end of an era.

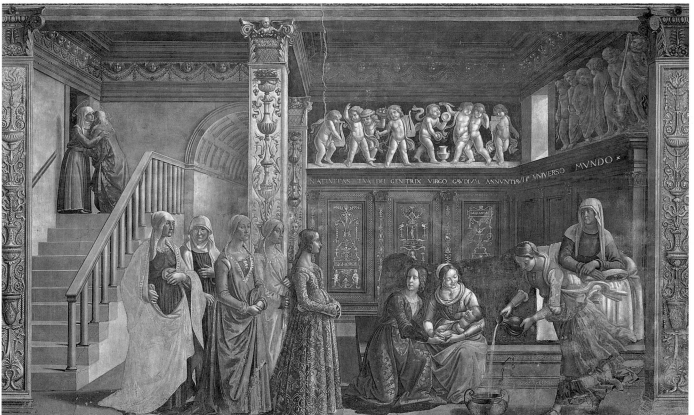

11.21 Domenico Ghirlandaio, *Birth of the Virgin*, 1485–1490. Fresco. Cappella Maggiore, Santa Maria Novella, Florence. Giovanni Tornabuoni's contract with Ghirlandaio and his brother for the frescoes was in Latin; it was signed on September 1, 1485, and guaranteed a base price of 1,200 gold ducats with an additional 200 if the work was satisfactory. An exacting patron, Giovanni stipulated that architectural elements be of marble with gold decoration and that a wide variety of figures, animals, and buildings be included.

12
Fifteenth-Century Developments in Verona, Ferrara, and Mantua

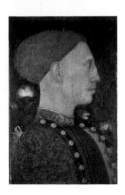

The Medici, unlike many other fifteenth-century Italian rulers, did not officially owe the legitimacy of their position either to the Holy Roman emperor or to the pope in Rome. Outside of Florence and a few other oligarchical states such as Siena, Padua, and Venice, territories were ruled by the courts and their lords or, in the case of the Papal States, by the authority of the pope. Links between the European courts created complex political and cultural connections, and rulers typically used imagery to promote power. Those with humanist leanings used Classical models to reinforce their legitimacy.

In northern Italy, Verona, a center of humanism as well as of Gothic taste, came under the control of the Visconti of Milan in the fourteenth century and of Venice in the fifteenth century. It was the native city of Guarino da Verona (1374–1460), who knew Latin and Greek, and was one of the founders of the humanist curriculum. Under the Este family, Ferrara underwent a Classical revival, a renewal of artistic patronage, and architectural renovation. In fifteenth-century Mantua, the Gonzaga family strove to reinforce its legitimacy through iconography and discerning patronage as well as military and diplomatic skills.

Pisanello in Verona

Antonio Pisano, known as Pisanello ("the little Pisan"), was probably born in Pisa around 1395 (d. 1455). After his father died, he moved with his mother to Verona, where he was in contact with Guarino. Despite working in an International Gothic manner, Pisanello was drawn to Classical themes and was praised by humanist authors in courts where he was employed throughout Italy. Working in Verona in the 1430s, he painted the fresco *Saint George and the Princess* (**12.1**). on the outside of the entry arch leading to the Pellegrini Chapel in the church of Sant'Anastasia. The picture is characteristic of Gothic taste in its chivalric theme, medieval costumes, and elaborate, somewhat fanciful city towers. At the left, below the gallows, is a group of figures with long hair and elaborate mustaches, one of whom resembles a Tartar. Like the *Adoration of the Magi* by Gentile da Fabriano (see 4.2), with whom Pisanello worked, the *Saint George* reflects the artist's delight in material textures, exotic figures, foreshortened horses, and different types of dogs.

Pisanello's interest in animals is evident from his sketchbooks, which provide one of the best surviving collections of drawings from Renaissance Italy. His *Study of a Horse* (**12.2**), for example, shows his skill in rendering compressed three-dimensional form through foreshortening. The crisp, tightly controlled lines of this study of a standing horse contrast with the more expansive wash of the *Cheetah* (**12.3**), whose subject seems to leap across the drawing surface.

A preparatory drawing for the *Saint George* (**12.4**) shows two human figures, one a frontal bust-length man, the other a woman with an elaborate headdress. Above these are two hanged men, the one at the top viewed from four different angles, the other from two

12.1 (*above*) Antonio Pisanello, *Saint George and the Princess*, 1430s. Fresco. Pellegrini Chapel entry arch, Sant'Anastasia, Verona. Pisanello had an extremely successful career as a painter and medallist. He executed frescoes in the Doge's Palace in Venice, worked for Alfonso of Aragon in Naples, the Este in Ferrara, the Gonzaga in Mantua, the Malatesta in Rimini, the duke of Milan, and the pope in Rome.

points of view. They are studies for the gallows outside the city walls in the background of the painting. Like the fourteenth-century figure of Securitas holding a gallows in Ambrogio Lorenzetti's *Effects of Good Government in the City and Country* (see 2.20) and the Pazzi and Albizzi conspirators painted on the exterior walls of, respectively, the Signoria and the Bargello in Florence, these may have been exemplary images, warning citizens not to disrupt the social order. But Pisanello's figures are less idealized than Ambrogio's allegorical image; they convey the gravitational pull by which death is achieved on the gallows and the subsequent distortions of the bodies. In addition, because they are depicted from several different angles (as they are in the final painting), they

12.2 (*right*) Antonio Pisanello, *Study of a Horse* (Vallardi 2378). Pen and ink on paper; 8¾ × 6½ in. (22.3 × 16.6 cm). Musée du Louvre, Paris.

12.3 Antonio Pisanello, *Cheetah* (Vallardi 2426). Pen and ink with watercolors on parchment; 6⁵⁄₁₆ × 9⅛ in. (16 × 23.1 cm). Musée du Louvre, Paris.

12.4 Antonio Pisanello, study for *Saint George and the Princess*, c. 1433. Pen over metalpoint; 11¼ × 7¾ in. (26.6 × 19.7 cm). British Museum, London.

convey the impression that they are in motion, swinging from their ropes as they would in reality.

The date of Pisanello's *Vision of Saint Eustace* (**12.5**) is uncertain, as is the case with much of his work. Its forest setting is a vehicle for the artist's skill in the depiction of animals, textural variety, and the effects of contrasting lights and darks. The scene illustrates the legend of Eustace, a general under the Roman emperor Trajan, who was hunting near Tivoli when he saw a stag with the Crucifix between its antlers. Eustace's richly colored dress and bright, gilded horse trappings, as well as the variety of animals, are characteristic of International Gothic. The dramatic confrontation of the saint and the stag, their gazes bridging the space of a deep chasm, is contrasted with the forest animals that go about their routines. Only Eustace's horse, who pulls back like his rider, and the dog with bared teeth seem aware of the vision. In the foreground, Pisanello has indulged in a decorative, spiraling form that echoes the curvilinear dog in pursuit of a frightened rabbit.

Pisanello and the Este of Ferrara

When Leonello d'Este (1407–1450) came to power in Ferrara in 1441, he established a style of patronage

12.5 Antonio Pisanello, *The Vision of Saint Eustace*, c. 1440 (?). Tempera on panel; 21½ × 25¾ in. (54.5 × 65.5 cm). National Gallery, London. According to the legend, Eustace became a Christian, refused to worship the pagan gods, and was roasted alive by the Romans. There is, however, no evidence that Eustace ever lived, and the account of the stag with the crucifix occurs in connection with other saints as well. The story may have originated in folktales transmitted from the East.

that was determined by his Classical education and courtly tastes. His father, Niccolò III, had hired Guarino da Verona to be his son's tutor and professor at the university of Ferrara. Leonello wrote fluent Latin, corresponded with humanist intellectuals, and, according to Alberti, asked him to write his treatise on architecture. When Leonello decided to erect a monument to his father, he consulted Alberti, who proposed using

the motif of the Roman triumphal arch for the base of the statue.

Throughout his nine-year reign, Leonello followed antique models, particularly that of Julius Caesar, to enhance his political stature. As in the medal of Emperor John VIII Palaeologus (see 7.14) commemorating the 1438 Council of Churches in Ferrara, which was probably an Este commission, Pisanello's medal

The Este of Ferrara

The nobility of the Este dates from the ninth century. They began to emerge as a cultural force in the thirteenth century, when they assumed control of Ferrara. Niccolò III died in 1441, leaving three sons, Leonello, Borso, and Ercole I, each of whom would rule in turn. By a series of advantageous political marriages, the Este linked their family to the house of Aragon and to the Gonzaga of Mantua in the fifteenth century. In the sixteenth century, the Este arranged marriages with the Sforza of Milan, the offspring of the Borgia popes, the German Habsburgs, and the royal family of France. Their long reign has been attributed to their political skill and efficient control of internal unrest. They are also distinguished by a long-standing interest in the arts.

of Leonello (**12.6a** and **b**) uses inscriptions as well as imagery to convey the desired message. It commemorates Leonello's marriage to the illegitimate daughter of Alfonso I of Aragon, identifying Leonello on the obverse as "marquis of Este, lord of Ferrara, Reggio, and Modena [LEONELLUS MARCHIO ESTENSIS D

FERRARIE REGII ET MUTINE] son-in-law of the king of Aragon [GE R AR]."

On the reverse, a Cupid holds a scroll before Leonello's insignia of the lion. That this is both a self-image of Leonello being tamed by love and a homage to Alfonso is evident in the emblems. Alfonso's eagle (also an Este emblem) presides over a rocky ledge in the background, and behind the lion is a pillar with the Este sail and column. The latter is dated 1444 (MCCCCXLIIII). Pisanello signed the work to the right of the column—OPUS PISANI PICTORIS ("The work of Pisano the painter").

In 1441, the year that Leonello came to power, Pisanello painted his portrait at the age of thirty-four (**12.7**). Leonello is shown in strict profile, with the space flattened by a floral background. The refined tastes of the marquis are reflected in his slim proportions and in the elegant brocade and gold buttons of his coat. Like the figure of Saint Eustace, Leonello's head is thrown into relief against a dark background.

When Leonello died, his brother Borso d'Este (named after King Arthur's knight Sir Bors) succeeded him and ruled for twenty-one years. During that time, Ferrara

12.6a Antonio Pisanello, medal of Leonello d'Este, obverse, 1444. Bronze; 4 in. (10.3 cm) diameter. Museo Nazionale del Bargello, Florence.

12.6b Antonio Pisanello, reverse of Figure 12.6a.

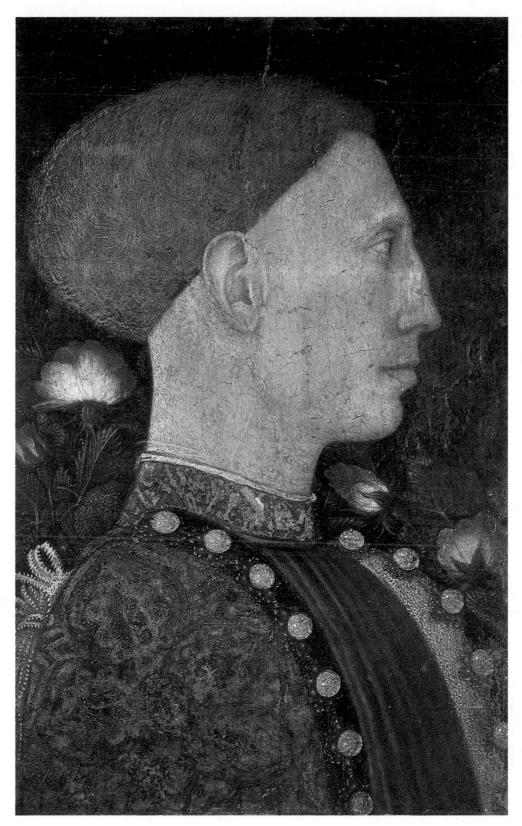

12.7 Antonio Pisanello, *Leonello d'Este*, 1441. Tempera on panel; 11 × 7½ in. (28 × 19 cm). Accademia Carrara di Belle Arti, Bergamo.

12.8 Francesco del Cossa, *April*, late 1460s–early 1470s. Fresco; 13 ft. 2 in. (4 m) wide. East wall of the Hall of the Months, Palazzo Schifanoia, Ferrara. The drawings for the frescoes were provided by Borso's court painter, Cosmè Tura (1429–1495).

became a duchy and Borso its first duke. He launched an extensive campaign of urban renewal and was an avid patron of the arts. His major painting commission, somewhat influenced by his taste for medieval illumination, was the fresco cycle for the Hall of the Months in the newly renovated Schifanoia Palace. The frescoes are mainly by the local artist Francesco del Cossa (active c. 1456–1477) and cover the entire wall surface of the room. Beginning with March, the first month in certain Renaissance calendars, the frescoes depict the twelve months. Each month consists of three sections: a triumph (ultimately based on Petrarch's *Trionfi*) at the top, a sign of the zodiac with the three segments of each month in the middle, and scenes of Borso's court below.

The section in figure **12.8** is *April*. In the top tier, Venus rides a triumphal chariot pulled by swans; an armed figure, possibly Mars tamed by love, kneels at her feet and alludes to peace under Borso's reign. At the right, on a grassy promontory scattered with pomegranates signifying fertility, are the three Graces. Below, on either side of the waterway are bowers of love filled with musicians and amorous couples. The rabbits, symbols of Venus, also denote fertility.

The central tier depicts the star-studded bull of Taurus. The sign of the bull was one of the forceful points in the orbit of the sun; hence the bright sun below the leaping Taurus. The other three sets of figures are the decans (the division into 10 of a zodiacal sign), alluding to nobility and prosperity in the coming spring.

The lower tier represents the courtly world of Borso. At the right, in an imaginary Albertian palace, stands Borso himself. He wears a fur-trimmed gold-leaf tunic and is surrounded by courtiers, dogs, and a thick-headed buffoon to whom he dispenses liberality. This, like Borso's official iconography generally, portrays him as a just and benevolent ruler accessible to his subjects. One of his medals shows the Virtue of Justice on the reverse with the inscription "She [Justice] and you [Borso] are one [and the same]." In another medal with Borso on the obverse (**12.9a**), the reverse (**12.9b**) depicts a unicorn (one of Borso's emblems) dipping its horns in a stream to purify it of vermin. This image refers to the traditional power of a king to heal by his touch, a sign of his identification with Christ and the divine right to rule. The bright sun shedding its rays also signifies Borso's benevolence.

12.9a Jacopo Lixignolo, medal of Borso d'Este, obverse, 1460. Lead; 3¼ in. (82 mm) diameter. National Gallery of Art, Washington, D.C., Samuel H. Kress Collection.

12.9b Jacopo Lixignolo, reverse of Figure 12.9a.

Developments in Mantua

The northern town of Mantua, like Ferrara, was a humanist center in which Classical and chivalric themes reflected the taste of its rulers and were used to project their political image. Mantua's position was greatly enhanced from 1459 to 1460, when Pope Pius II agreed that the Great Congress (convened to institute a crusade against the Turks) would meet there. To a large degree, the ruling marquis, Lodovico Gonzaga (1412–1478), owed the pope's favor to the international influence and royal status of his German wife, Barbara of Brandenburg.

Humanism had been an important force in Mantua since the founding of the school known as La Gioiosa, or La Giocosa, by Lodovico's father, Gianfrancesco Gonzaga, in 1423. With Vittorino da Feltre (1378–1446) teaching humanist principles to the Gonzaga children and those of their courtiers in Gianfrancesco's villa, Mantua also became an educational center. The curriculum was designed, in Roman and Greek fashion, to educate the body as well as the mind; students included both girls and boys, plus talented boys from poor families who could not afford the tuition. One of Vittorino's most distinguished pupils was Federico da Montefeltro (see Chapter 9), who included his former teacher among the portraits of famous men in his Urbino *studiolo* (see 9.14).

The Sala Pisanello Frescoes

Around 1447, Lodovico Gonzaga commissioned Pisanello to paint frescoes for the large reception hall of the Ducal Palace. Their literary source was the prose *Lancelot*, the third in the popular thirteenth-century Arthurian narratives known as the *Vulgate Cycle*. The *Lancelot* recounts tales of the knights of the Round Table and Lancelot's efforts to impress King Arthur's wife, Guinevere.

The frescoes are in a poor, fragmentary state; Pisanello left them unfinished when he went to the Aragonese court in Naples. He had completed the *sinopie* but little of the final painting itself. The walls were plastered over in the late fifteenth century and only rediscovered in the 1960s. One of the best-preserved sections depicts a tournament in which the knights are identified by inscriptions (**12.10**). The tapestry-like field is flattened by the dark blue background, the crowding of the figures, and the row of heraldic

12.10 Antonio Pisanello, wall of the Sala Pisanello, c. 1447–1448. Fresco. Reception hall, Ducal Palace, Mantua.

The Gonzaga of Mantua

The Gonzaga controlled Mantua from 1328. They were elevated to the rank of marquis in 1433 and to duke in 1530. Like the Este, they enjoyed a long and relatively secure succession. Through a series of advantageous marriages, they were able to raise their status both in Italy and abroad. They were condottieri, skilled diplomats, and avid patrons of the arts. With Francesco's elevation to cardinal in the fifteenth century, the family extended its influence to the Vatican. Mantegna worked for three generations of Gonzaga rulers: Lodovico, Federico, and Francesco.

devices at the top. The last represent Lodovico's emblem of the flower and the collar of Germany's Order of the Swan, to which he and his wife belonged. Pisanello's interest in perspective, and particularly in foreshorten-

ing, is apparent in the knights and horses filling the wall (**12.11**).

Aside from reflecting Lodovico's courtly tastes, Pisanello's scenes had a political purpose. Although the Gonzaga had ousted the previous ruling family of Mantua in 1328, the title "Marchese" was not conferred on Gianfrancesco by the Holy Roman emperor until 1433. Lodovico was himself a *condottiere* who led the Milanese troops for several years. As such, he could identify with the knights of King Arthur and, as a ruler, with the notion of the Round Table as an image of just government. In addition, Sir Galahad (Lancelot's son) accomplished the quest for the Holy Grail, the chalice containing Christ's blood. This, too, provided a connection with Mantua, which claimed possession of a few drops of Christ's blood brought to the city by Longinus, the Roman centurion who pierced Christ's side with his lance and became a convert to Christianity.

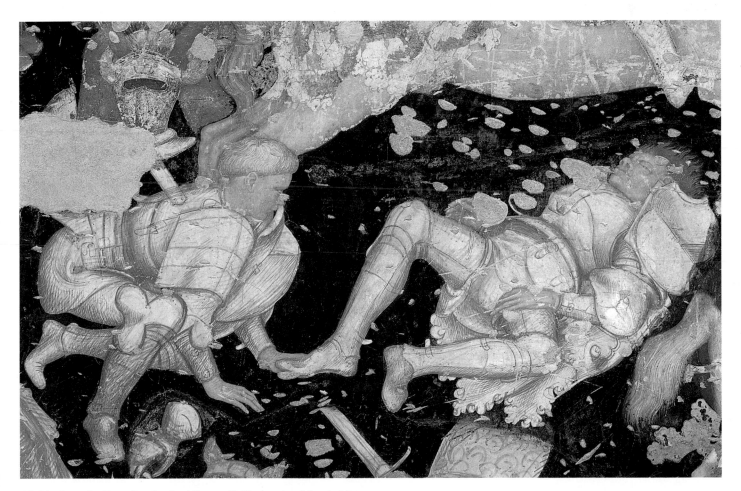

12.11 Antonio Pisanello, detail of Figure 12.10 showing fallen knights.

Alberti in Mantua

In 1459, Alberti was in the retinue of Pius II at the Great Congress. These two humanists influenced subsequent artistic developments in Mantua. The pope, then in the process of restoring Pienza (see Chapter 8), registered his displeasure at the poor condition of the city. This criticism spurred Lodovico to launch much-needed urban renovations. Alberti designed two of his most significant churches, both commissioned by Lodovico, for Mantua. The Classical ideals of Alberti and Pius II, which become manifest in the art and architecture of the city from around 1460, had as their leading exponents Alberti himself and the painter Andrea Mantegna (c. 1430/31–1506).

Alberti's church of San Sebastiano (**12.12** and **12.13**) was planned as a Greek cross, a synthesis of Early Christian and Byzantine church plans with the round temples of ancient Rome. The plan shows Alberti's preference for squares, rectangles, and circles, as well as symmetry, reflecting his belief that regular geometric shapes and balance conform to cosmic harmony. The façade was still incomplete at Alberti's death in 1472, and there is no record of its original design. But it has been convincingly reconstructed as a temple front (**12.14**) inspired by a Roman triumphal arch in the south of France (**12.15**). Both have an entablature and pediment broken by a round arch. In addition, San Sebastiano has five entrances, separated in the reconstruction by six large pilasters. The entire structure, like Roman and Etruscan temples, stands on an elevated base, hence the imposing staircase, as Alberti recommended for church buildings. In contrast to the façades of the Tempio Malatestiano in Rimini and Santa Maria

12.12 Leon Battista Alberti, façade of San Sebastiano, begun 1460. Mantua.

12.13 Leon Battista Alberti, plan of San Sebastiano, Mantua.

12.15 Giuliano da Sangallo, drawing of the triumphal arch at Orange, France. Biblioteca Apostolica, Vatican, Rome Barb. Lat 4424.fol 25r.

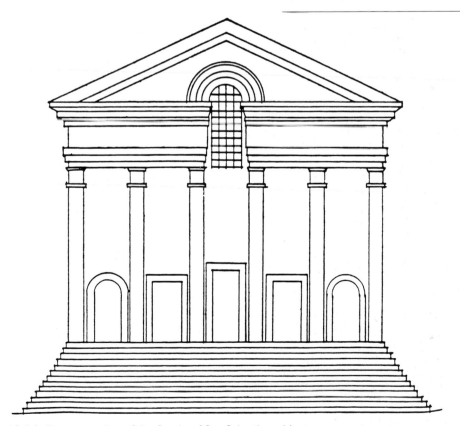

12.14 Reconstruction of the façade of San Sebastiano, Mantua.

Novella in Florence, where Classical elements take precedence, in Mantua Alberti adapts the Roman features to the wall.

The late development of Alberti's style is even more evident in the church of Sant'Andrea, which was begun in 1472. Its location near the Ducal Palace and its possession of the relic of Christ's blood reinforced the pious, chivalric image of the Gonzaga. The plan (**12.16**), in contrast to that of San Sebastiano, is based on the Latin-cross basilica.

The harmonious appearance of the façade (**12.17**) is achieved by the symmetrical design and carefully orchestrated proportions—the height equals the width. Its imposing, majestic quality derives from the combi-

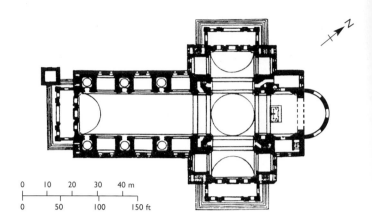

12.16 Leon Battista Alberti, plan of Sant'Andrea, begun 1472. Mantua.

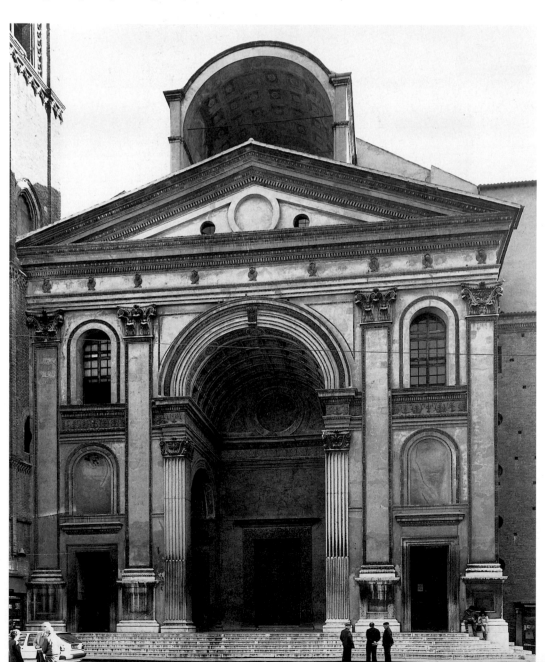

12.17 Leon Battista Alberti, façade of Sant'Andrea, begun 1472. Mantua.

nation of two Classical architectural motifs: the triumphal arch and the temple front. As in the former, the central space is large, and the whole is unified by giant, smooth-shafted Corinthian pilasters resting on **podia**. Supporting the arch are shorter, fluted pilasters that create an impression of greater solidity compared to the soaring planes of the taller pilasters continuing to the entablature. Crowning the façade is a wide pediment with circular surface designs repeating the curves of the arches below. Alberti thus used surface elements to unify and anchor the façade and, as at San Sebastiano, subordinated the ancient features to the wall. Sant'Andrea's elevation, accentuated by the steps, adds to the sense that it dominates the urban space before it. This characteristic of Roman temples signified the concept of the building, like the emperor, as presiding over the city.

The coffered barrel vault of the central arch unifies the exterior with the nave and leads to a **vestibule**—which is also the case in San Sebastiano. Inspired in part by the massive walls of Roman baths, the impressive nave of Sant'Andrea (**12.18**) carries one's view directly

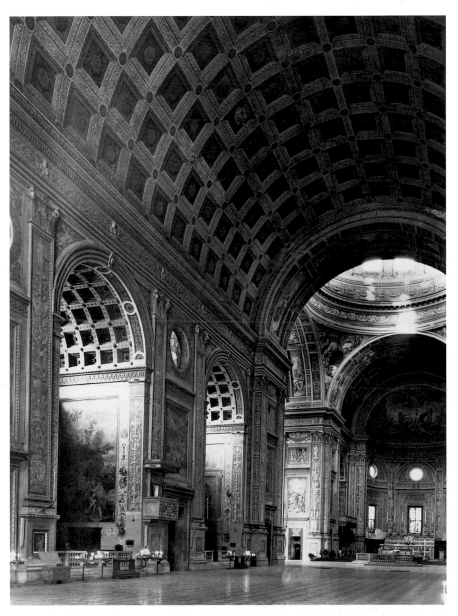

12.18 Leon Battista Alberti, nave of Sant'Andrea, begun 1472. Mantua.

toward the altar. Instead of side aisles, Alberti placed individual chapels between the supporting piers of the nave. Covering the chapels are coffered barrel vaults, possibly derived from the Roman basilica of Maxentius, that unify them both with the ceiling of the nave and with the exterior entry arch.

Andrea Mantegna

Andrea Mantegna was the leading painter in northern Italy in the second half of the fifteenth century. He produced a wide range of work, including portraits, fresco cycles, altarpieces, and individual panels, all of which reflect his sculptural, sometimes archaeological style. Like Andrea del Castagno, Mantegna worked in the monumental tradition of Masaccio and was drawn to the depiction of stone. The psychological insight that pervades Mantegna's imagery was a significant feature of his humanist outlook.

Mantegna was adopted by the Paduan painter Francesco Squarcione (c. 1397–1468), who believed that the status of painting should be elevated to that of a liberal art. He thus referred to his school as a *studium*, or university, rather than as a *bottega*, or workshop, as had been the tradition in the Middle Ages. At some point, Mantegna quarreled with Squarcione over money and struck out on his own. His first important fresco cycle illustrated the lives of Saints James and Christopher for the Ovetari Chapel in Padua's church of the Eremitani. However, most of the frescoes were destroyed during World War II when the church was accidentally hit by bombs from an American plane.

Mantegna's major early altarpiece was for the high altar of the church of San Zeno in Verona (**12.19**). It was commissioned in 1456 by the Venetian humanist Gregorio Correr, who was the abbot of San Zeno's Benedictine monastery and a member of a prominent Venetian family. The altarpiece reflects Correr's Christian humanism—his combination of Christian piety with a taste for Classical forms, which also suited Mantegna.

The frame is of gilded wood; it resembles an ancient temple front crowned by a curved pediment and is integrated illusionistically with the painted architecture.

The columns separate the three main panels, and the podia on which the columns stand frame the predella panels. The painted space is defined as an open loggia, with four of its stone piers directly behind the gilded columns of the frame. In each of the piers, there is a tondo containing a Classical relief. Supported by the piers is the entablature, which is decorated with a frieze of *putti*. Mary's placement in a rectangular architectural setting behind a temple front alludes to the cult statues of antiquity. Mantegna thus achieves a unique synthesis of the Christian and Classical conceptions of the deity.

Mary and Christ, surrounded in the center panel by singing and music-making angels, occupy a stone throne embellished with antique details. Half-hidden by the Persian carpet are two stone *putti* with a laurel-wreath medallion derived from Roman sarcophagi. As such, the medallion heralds Christ's death depicted in the *Crucifixion* directly below. It also echoes the stone circle behind Mary's head that frames her gold halo. Christ's halo, with its gold and bright reds, repeats not only the reds and golds of Mary's costume, but relates to the chromatic harmony created by the arrangement of rich reds, bright yellows, and muted golds throughout the composition. The red coral beads above the Virgin signify rebirth, and the egg-shaped marble weight suspended over the glass lamp may refer to the Immaculate Conception.

On either side of the Virgin's throne are four standing saints. Saint Peter with the keys to Heaven, at the far left, wears a bright yellow cloak and gazes out of the picture. Opposite him on the right is John the Baptist in a *contrapposto* pose based on ancient statuary. He is absorbed in a text and does not communicate with the viewer, but his feet extend illusionistically over the edge of the painted floor.

On Peter's left, Saint Paul also carries a book, and John the Evangelist reads his Gospel. Opposite are Saints Lawrence and Gregory, the latter the name saint of the patron, Gregorio Correr. Farthest back to the left and right, respectively, of Mary's throne are Saints Zeno, to whom the church was dedicated, and Benedict, whose rule was followed at the San Zeno monastery.

Mantegna's small undated painting of *Saint Sebastian* (**12.20**) shows the martyr in the same classicizing pose occupied by John the Baptist in the San Zeno Altarpiece. This is one of the artist's most self-consciously archaeo-

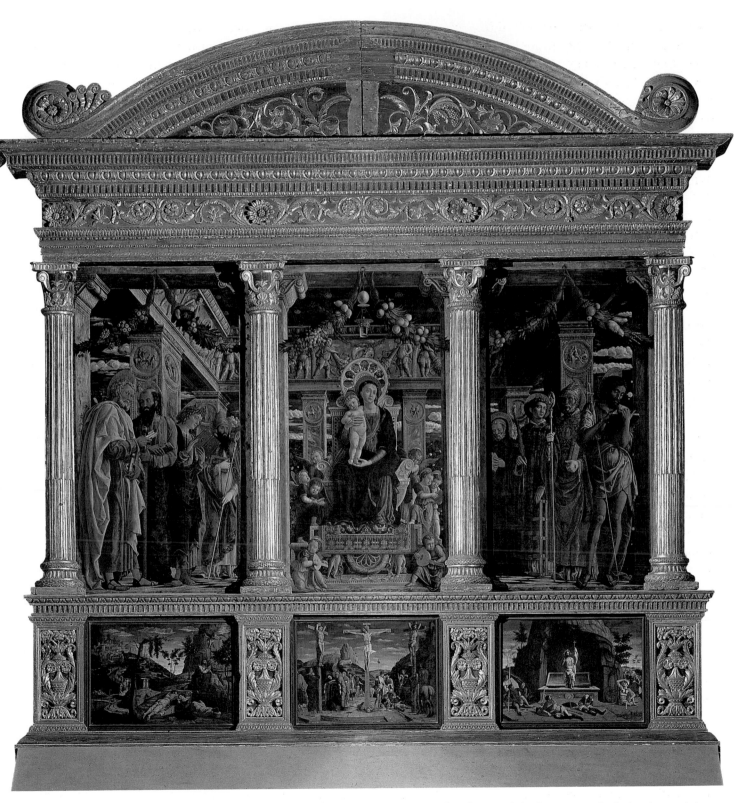

12.19 Andrea Mantegna, San Zeno Altarpiece. 1456. Tempera on panel; 7 ft. 2½ in. (2.2 m) high. San Zeno, Verona. Copies of the predella panels, which are now in museums in France, have been inserted into the original spaces. They depict the *Agony in the Garden*, the *Crucifixion*, and the *Resurrection*. Both the altar and the church were dedicated to San Zeno, a fourth-century saint famous for his oratory and the passion of his sermons. He was born in Africa and became bishop of Verona.

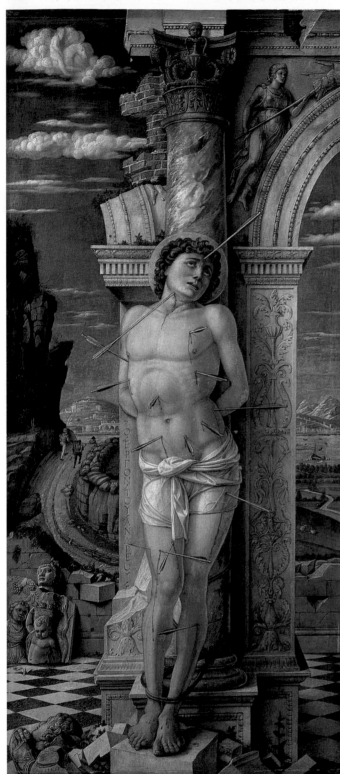

12.20 Andrea Mantegna, *Saint Sebastian*, variously dated 1450s–1470s. Panel; 26¾ × 11¹³⁄₁₆ in. (68 × 30 cm). Kunsthistorisches Museum, Vienna. One of the more puzzling motifs in the picture is the "cloud-man" on horseback at the upper left. This has been identified in a variety of ways, including as an image of Theodoric, king of the Ostrogoths, who is represented on the façade of the church of San Zeno. Another reading argues that it is one of nature's "images made by chance," which are frequently seen in cloud formations.

logical works, for it contains specific examples of ancient architectural and sculptural ruins. It is also signed in Greek to the left of Sebastian—"TO ERGON TOU ANDREOU" [the work of Andrea]—which scholars have seen as an allusion to Mantegna's self-image as a fifteenth-century Apelles.

The saint is bound to a brown-and-white marble column attached to a crumbling triumphal arch. A Victory is carved in relief on the spandrel, and antique decorative motifs cover the pilaster. The brickwork visible at the upper left reveals Mantegna's close study of Roman buildings, which were typically constructed of brick and concrete and then covered with more expensive marble facing. Fragments of sculpture lie at Sebastian's feet, and a group of stone figures with grapes and vines are propped against the wall enclosing the foreground.

Mantegna uses linear perspective to convey the flow of narrative time. The figure of Sebastian is large—it is, like the San Zeno Virgin, a cult image—and elevated above a floor of marble and agate tiles. There is no single vanishing point, but the viewer's eye level is just below the saint's head, as though the viewer were standing on the pavement. The moment represented in Pollaiuolo's *The Martyrdom of Saint Sebastian* (see 11.6) has passed, and Sebastian, already shot through with arrows, gazes heavenward. Climbing the road winding between rocky cliffs are three executioners carrying their bows—one is only partially visible behind the hill. Their tiny size indicates not only that they are disappearing into the distance, but also that time has elapsed.

Mantegna and the Gonzaga of Mantua

In January 1459, the year of the Great Congress, Mantegna officially accepted Lodovico Gonzaga's offer of a monthly salary of fifteen ducats, plus room and board for his family, for the position of court artist. He worked for the Gonzaga for over forty years, although he also accepted commissions from other patrons during that time. Indicating connections with the Medici, for example, and probably painted during a visit to Florence, is the portrait of Carlo de' Medici (**12.21**),

Cosimo's illegitimate son and bishop of Prato. Carlo, like his half brothers, was a humanist and a collector of medals; his portrait is reminiscent of Roman busts. Mantegna shows him as a prelate occupying the office of Protonotary Apostolic. His chiseled bone structure is characteristic of Mantegna's style; the crisp edges of his form and the strong reds of his costume accentuate the sculptural quality of the work.

In 1465, Mantegna began his famous frescoes in the *Camera Picta* (literally "painted room"; also known as the *Camera degli Sposi*, or "bridal chamber") in the Ducal Palace (**12.22**). In contrast to Gozzoli's *Procession of the Magi* in the Medici Palace (see 11.2 and 11.3), Mantegna's frescoes depict the patron's family in the private space of their court rather than as figures in a biblical scene. Two entire walls are illusionistically dissolved as the painted architecture merges with the actual architecture of the room.

The entrance wall depicts pages with horses and hunting dogs, a group of *putti* carrying an inscription over the door, and Lodovico's son, Francesco, to the right of the door. Francesco is shown as a cardinal, a recent and advantageous appointment for the Gonzaga family. With him is his father in white stockings and a gray tunic, and other important political figures. The ancient towns in the far distance recall the background of the *Saint Sebastian* and reflect Mantegna's, as well as Lodovico's, interest in the Classical revival. Illusionistic details abound—for example, the blue curtain, the painted pilasters, and the dogs' feet projecting onto the dado.

Over the fireplace, in a fictive loggia, Lodovico and his wife, Barbara of Brandenburg, are grouped with their immediate family, advisers, and a female dwarf. Courtiers are coming down and going up a flight of stairs, and one, at the far left, gives Lodovico a message, indicating the marquis's involvement in affairs of state. Lodovico's combined role as *paterfamilias*, ruler, and *condottiere* is reflected in the very nature of the *Camera*. It served as a kind of state bedroom, both a private family setting and a place where official visitors were received and documents were signed.

The simulated stucco and gilded ceiling vaults are decorated with antique motifs. Filling the spandrels are mythological heroes, including Orpheus and Hercules, with whom the Gonzaga wished to be identified. Depicted in *grisaille* on a gilded background are the first eight Roman emperors, whose purpose was to reinforce the antiquity and legitimacy of Gonzaga rule. The *putti* supporting the wreaths surrounding each emperor are clearly a motif that appealed to Mantegna.

12.21 Andrea Mantegna, *Carlo de' Medici*, c. 1466. Tempera on panel; 16 × 11⅝ in. (40.6 × 29.5 cm). Galleria degli Uffizi, Florence.

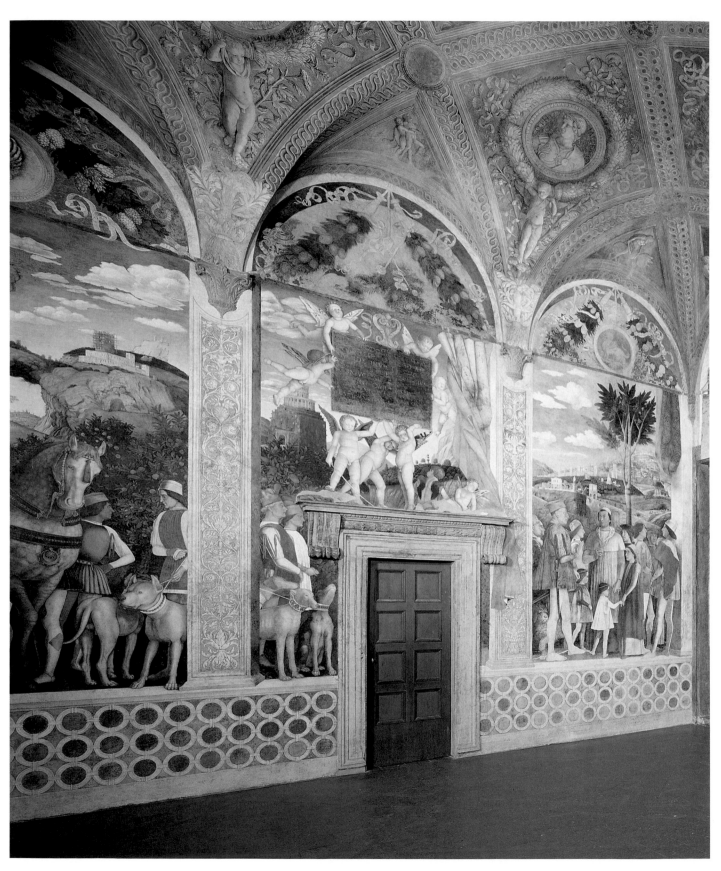

12.22 (*above* and *opposite*) Andrea Mantegna, *Camera Picta*, 1465–1474. Fresco. Ducal Palace, Mantua.

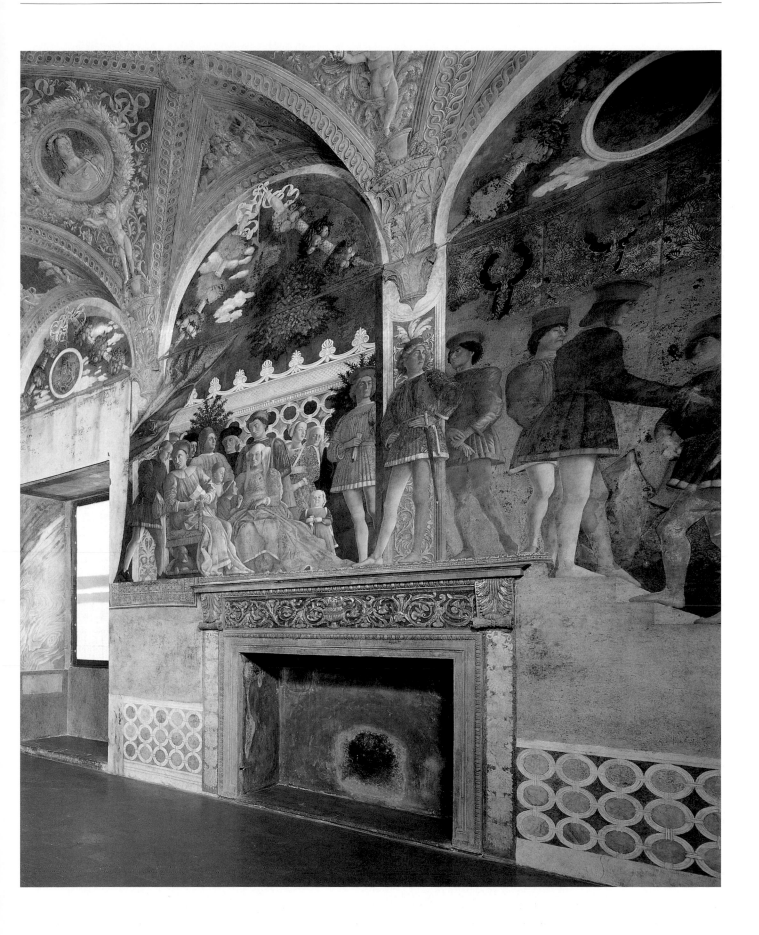

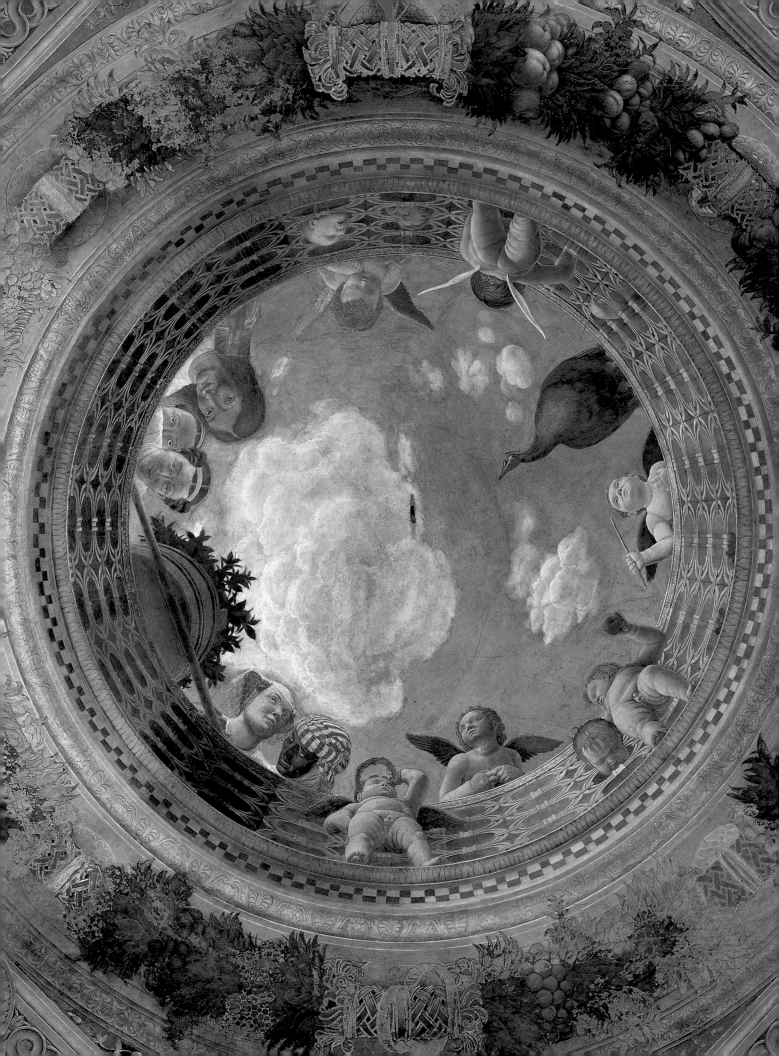

They recur in the humorous oculus at the center of the ceiling (**12.23**), which consists of a foreshortened balustrade opening up to the sky. Groups of women gaze over the top of the balustrade, on which a peacock perches and a pot of plants is precariously held in place by a wooden bar. Some of the *putti* have suffered the consequences of their curiosity and gotten their heads stuck in the balustrade. One is about to drop an apple, a witty counterpoint to one of the children over the fireplace who also holds an apple. In this detail, Mantegna plays with the apple's role in the Fall of Man, here in relation to the role of the *Camera* as a bedroom. By emphasizing the potential fall of the apple itself, Mantegna's visual pun conflates notions of moral and psychological "falling" with the pull of gravity. By the extreme *di sotto in su* viewpoint, he also invites visitors to the *Camera* to look up and participate in the joke.

Lodovico died in 1478, the year of the Pazzi Conspiracy in Florence. Mantegna remained as court artist in Mantua for another two generations of Gonzaga rule. Lodovico's grandson, Francesco II, married Isabella d'Este (1474–1539) of Ferrara. In the 1490s, Mantegna painted for Francesco a *Triumph of Caesar*, now in poor condition, which celebrated the Gonzaga through the vehicle of the ancient Roman triumph. For Isabella, the first woman of the Renaissance to construct and decorate a *studiolo*, Mantegna painted as a pair two complex allegories that reflect her Classical education at the Ferrarese court. Their literary sources have been much debated; their puzzling iconography was probably devised by Mantegna and a humanist adviser working for Isabella.

The so-called *Parnassus* (**12.24**) is apparently set in the mythological realm of Mount Helicon, where Apollo and the Muses sought haven. Identifying the site as Helicon is the winged horse Pegasus with Mercury, at the right. When Pegasus stamped on the ground of Helicon, the fountain of Hippocrene issued from the ground—shown here by the parting of the rocks to reveal a spring. At the far left Apollo plays his kithara,

and in the center the nine Muses dance in a circle. Like Isabella herself, who enjoyed singing and playing the lute for intimate groups of friends, the gods engage in the arts in a private, idyllic enclosure.

Dominating the scene from a natural arch are the mythological lovers, Mars and Venus, both idealized and in Classical poses. As in the Schifanoia *Triumph of Venus*, Mars seems to have been tamed by a version of Plato's celestial Venus. The daughter of their union, Harmonia, is not present, although her spirit seems to pervade the atmosphere of Helicon. Their son is Anteros, the antithesis of Eros, who inspires carnal love. Here Anteros is to the left of Mars blowing a dart at the genitals of Vulcan, Venus's legitimate husband, to extinguish his passion. Vulcan is depicted as an enraged, unidealized figure of mockery. If there is any autobiographical reference to Isabella herself in this iconography, it is by an ironic twist of gender. For, like Vulcan, she suffered the continual infidelities of her spouse.

In contrast to the *Parnassus*, the *Athena Expelling the Vices*, also known as the *Triumph of Virtue* (**12.25**), is dominated by an air of frenzy and panic. The Garden of Virtue, like Helicon a metaphor for Isabella's *studiolo*, has been overrun by the sensual Venus and various Vices. It is ringed by an arcade of foliage shaped like a Roman **aqueduct** and attached to a crumbling wall at the right. Imprisoned in the wall, according to the inscription, is the Cardinal Virtue of Prudence, with which Isabella identified. In the center of the garden, Venus stands on the back of a Centaur in a languid, provocative *contrapposto* pose. Vices struggling through a muddy pool are identified by inscriptions as Avarice, Ingratitude, Ignorance, Sloth, and so forth. To the left, a pair of nymphs, one in blue and one in green, flees the wrath of Athena, along with a female satyr, her children, and a group of flying *putti*; all signify some aspect of lust. Athena, on the other hand, is a warrior, her drapery flowing as she rushes forward, protected by her armor and her virtue. The mother of Virtue at the far left merges into an olive tree, the mythological attribute

12.23 (*opposite*) Andrea Mantegna, ceiling oculus, 1465–1474. Fresco. *Camera Picta*, Ducal Palace, Mantua.

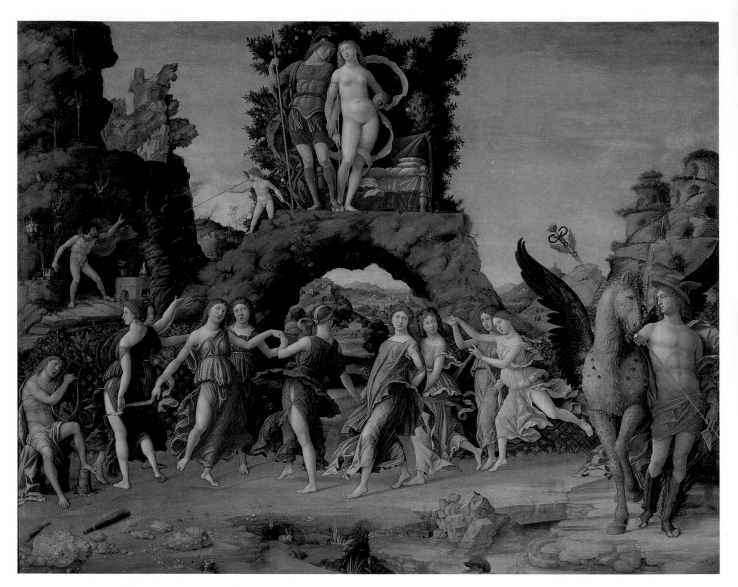

12.24 Andrea Mantegna, *Parnassus*, c. 1499–1502. Tempera on canvas; 5 ft. 3¼ in. × 6 ft. 3⅞ in. (1.6 × 1.9 m). Musée du Louvre, Paris.

of Athena and her gift to the Athenians. A scroll winding around her body is inscribed with a call for help from the gods.

Observing the frantic scene are the remaining Cardinal Virtues (Justice with her sword and scales, Fortitude with her column and club, and Temperance with an amphora in each hand) in an airborne wreath formed by clouds. Other puzzling features of Mantegna's iconography are the profile heads in the cloud formations to the left; these echo the cloud rider in the *Saint Sebastian* and are equally enigmatic.

Regardless of the literary sources and specific iconographic features of the scene, it is clear that virtue is

associated with idealized human form. This conforms to the Classical and Renaissance association of moral virtue with ideal form espoused by Plato and Alberti, and reflected in the humanist art and architecture of fifteenth-century Italy. It also conforms to the notion of the dignity of man. In the Mantua *studiolo*, the idealized and heroic figure of Athena raises the question of Isabella's identification with the female goddess as well as with the Virtue of Prudence. As the goddess of war, wisdom, and weaving, Athena encompassed the aspirations of Isabella herself—her struggle for parity with the Renaissance rulers who built private studies, her intellectual pursuits, and her patronage of the arts.

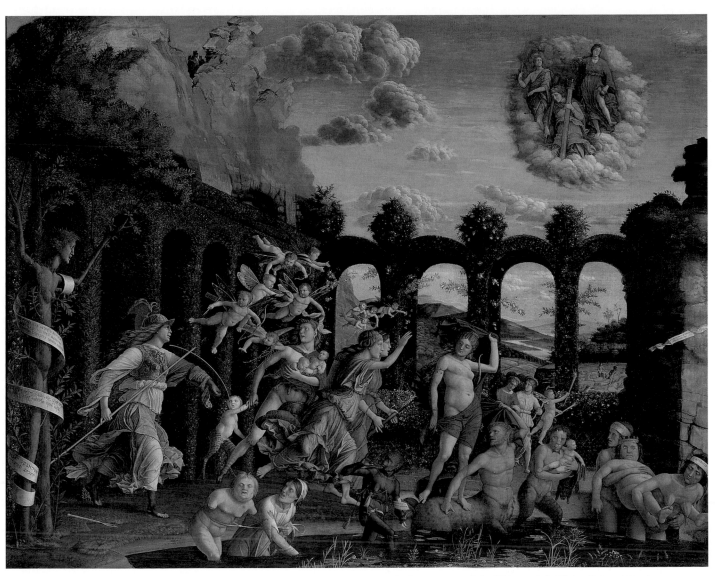

12.25 Andrea Mantegna, *Athena Expelling the Vices*, c. 1499–1502. Tempera and oil on canvas; 5 ft. 3¼ in. × 6 ft. 3⅞ in. (1.6 × 1.9 m). Musée du Louvre, Paris.

13
Developments in Late Fifteenth- and Early Sixteenth-Century Venice

The situation of the arts in fifteenth-century Venice differed in important ways from that of the other leading art centers in Italy. The Venetian republic was, like Florence, an oligarchy. It was ruled by an elected doge (13.1), a Council of Ten, and the Great Council—both councils consisting of patricians. Venice was also a wealthy city, a crossroads between Italy and Byzantium sustained by trade and an empire that extended from the Aegean Sea to parts of Lombardy in northern Italy. Waterways and lagoons were its streets, and these provided a natural defense that was reinforced by a powerful naval fleet.

In the second half of the fifteenth century, following the decline of the Venetian Empire and the fall of Constantinople to the Ottomans in 1453, the city became embroiled in conflicts with other Italian states.

Threats from various quarters, including the dukes of Milan, the pope, and the Holy Roman emperor, threatened the independence Venice had enjoyed for eight hundred years. Partly in reaction to political developments and partly because of its unique setting, the so-called "Myth of Venice" evolved. This was an effort to create the image of a peaceful city run by a stable constitutional government; it was seen as a refuge from tyranny and internal unrest. The resulting civic harmony encouraged citizens to participate willingly in their government and fostered social tolerance. In the early decades of the sixteenth century, the Myth of Venice gained new conviction when external threats were successfully quelled and a lasting peace restored.

Artistically as well as politically, Venice was conservative. Because of its links to the East, the influence of the

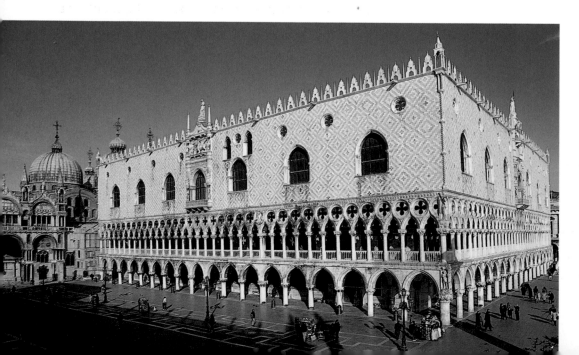

13.1 View of the Doge's Palace, 1340s–1438. Venice.

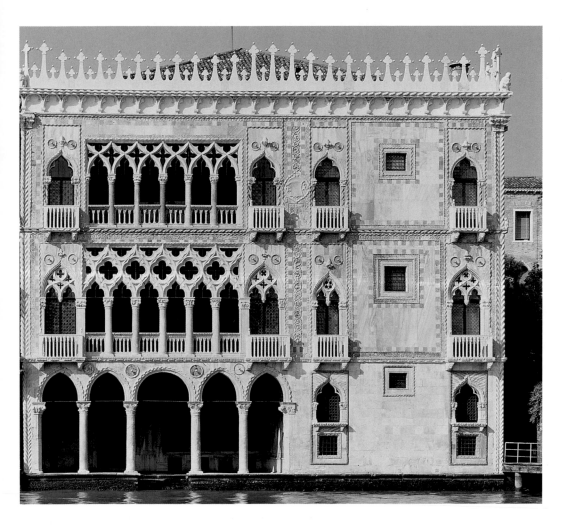

13.2 Giovanni and Bartolomeo Bon, with loggia tracery by Matteo Raverti, Ca' d'Oro (Contarini Palace), 1421–1437. Venice.

Byzantine style persisted longer in Venetian art than elsewhere in Italy. Palace architecture, for example, was more elaborate in the use of rich materials and more likely to be decorated with Byzantine and Gothic elements than in Florence.

A comparison of the Medici Palace (see 7.18) in Florence with the Ca' d'Oro (**13.2**) in Venice exemplifies the different approaches to private residences in the two cities. Whereas the Medici Palace was massive, defensive, and simplified, the Ca' d'Oro façade is lavishly decorated and brightly colored with red and white marble and gilded details. Cosimo de' Medici's choice of an understated but imposing palace was intended to minimize the envy of his fellow Florentines while reminding them of his power. In contrast, Marino Contarini, who commissioned the Ca' d'Oro, wished to project an image of grandeur, wealth, and nobility. Both the loggias on the upper stories, with their Gothic quatrefoils, and the arcade on the ground floor are open,

reflecting the peacefulness of Venice in the first half of the fifteenth century.

Although monumental Florentine artists such as Uccello, Castagno, and Donatello worked at times in Venice, their impact on mainstream developments was at first minimal. The International Gothic artists Gentile da Fabriano and Pisanello also came to Venice from other parts of Italy; their primary official commission was the decoration of the Great Council Hall. Patronage in Venice, more so than in Florence, was likely to come from institutions such as the Doge's Palace or the *scuole* (see below) rather than from private individuals. As a result, the personality of the patron, whether the ruler of a humanist court or a wealthy individual, did not affect the character of the city as strongly in Venice as in other regions.

Another aspect of Venetian conservatism was the persistence of the family-workshop tradition, which reinforced the medieval status of the artist as a crafts-

man. In the fifteenth century, the most significant artistic family were the Bellini—Jacopo (c. 1400–1470/71) and his two sons, Gentile (c. 1429–1507) and Giovanni (c. 1435–1516). In 1453, Jacopo's daughter, Nicolosia, married Andrea Mantegna, whose style influenced Giovanni's early work. More than any other Venetian artists, the Bellini brought the Renaissance style to the city and laid the foundation of the High Renaissance in the sixteenth century.

Jacopo Bellini

Jacopo Bellini studied with Gentile da Fabriano and went to Florence when Gentile was there in the early 1420s. His style reflects not only Gentile's International Gothic influence, but also that of the early fifteenth-century Florentine innovators. He worked for a time in Ferrara, where, in 1441, he defeated Pisanello in a portrait competition at Leonello's court. It is possible that Jacopo produced drawing studies for the equestrian monument of Niccolò III, and likely that he was in contact with Alberti, who was also present at the Este court. The humanist atmosphere in Ferrara and the adherence to ancient Roman models, as well as Brunelleschi's perspective theories that Jacopo encountered in Florence, informed his subsequent work in Venice.

Jacopo was commissioned to paint large scenes for several of the city's *scuole*. Few of his paintings are extant, but his drawings survive in two collections, one in the Louvre and the other in the British Museum. The drawings reflect Jacopo's study of dramatic architectural perspective and landscape as well as his interest in antiquity.

The timber skeleton of the shed in the *Adoration of the Magi* (**13.3**), generally dated to the 1450s, is a self-conscious perspective study. It draws the viewer toward itself, past the Holy Family and the kneeling king, who are the focal point of the procession. Behind the shed looms a rocky landscape, around which the procession winds until, as in Gentile's Strozzi Altarpiece, it comes to a halt in the foreground, where the foreshortened horses and dismounted figures arrest its movement. Like Gentile, Jacopo was fascinated by armor, costumes, and horse trappings, all of which are minutely rendered

The Venetian *Scuole*

Beginning in the thirteenth century, lay confraternities, usually under the auspices of a patron saint, were organized in Venice. They were given some independence from the ruling patricians and allowed to organize as minor states-within-the-state and elect their own officers. This has been seen as an important contribution to civic harmony, for it gave ordinary citizens the right to govern themselves within an established organization. From the mid-fourteenth century, the *scuole* were both protected and monitored by the Council of Ten. The five *scuole grandi* were restricted to males but included all types of trade and profession. By 1500, there were over two hundred *scuole piccole*, many of which had women as well as men as members. These differed from confraternities in other Italian cities by their political involvement in the larger fabric of society. The *scuole* had large meeting halls, whose long walls provided ideal surfaces for narrative paintings.

by means of delicate lines and softened shading. At the right, he deals with the ox and ass in the traditional manner; the ox peers around the corner of the shed to view the Adoration, whereas the ass continues to munch hay.

A work of the following decade, the *Way to Calvary* (**13.4**), possibly a study for a painting in the Scuola di San Marco, delights in the details of Jerusalem's medieval fortified walls. The eclectic—and fanciful—architecture of the buildings inside the city includes freestanding fluted Corinthian columns that indicate Jacopo's study of the Greek Orders. Emerging from the city gate in a horizontal procession typical of many paintings for Venetian *scuole* are the citizens of Jerusalem who have come to witness Christ's departure for Calvary. Christ has stopped in the midst of the procession. That he is reluctant to continue is shown by the space on either side of him and the man prodding him from behind. Revealing his inner conflict in the manner of Alberti's *istoria* is his *contrapposto* pose as he turns toward his tormentor. The two thieves, their presence signaled by the two additional crosses, proceed with the crowd. At the head of the procession is a cavalcade of trumpeters and standard-bearers carrying the narrative forward beyond the right edge of the picture plane.

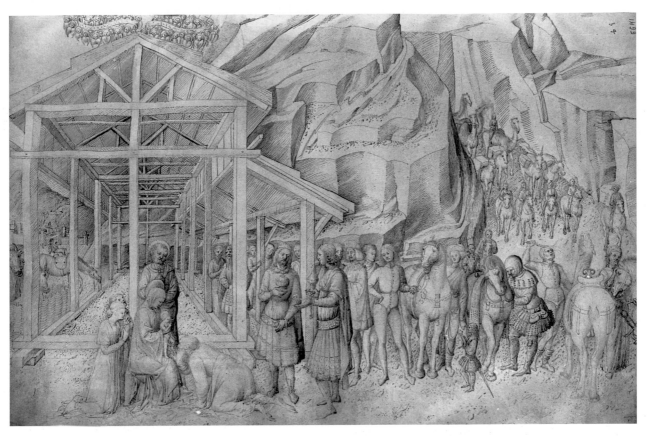

13.3 Jacopo Bellini, *Adoration of the Magi*, 1450s. Drawing on parchment, Louvre Album, fol. 31 (Louvre Inv.R.F.1499). Paris.

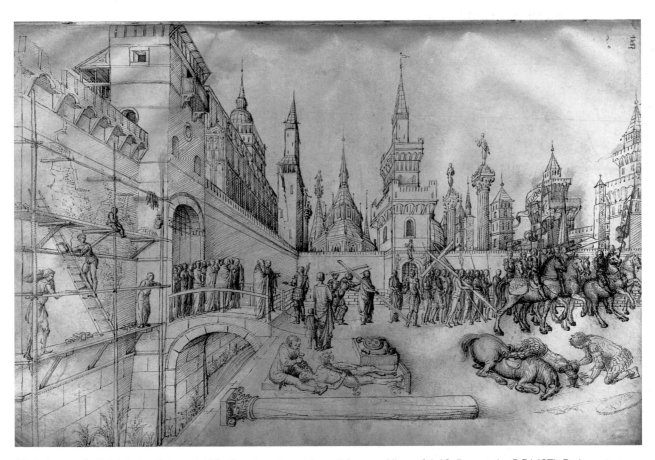

13.4 Jacopo Bellini, *Way to Calvary*, 1460s. Drawing on parchment, Louvre Album, fol. 19 (Louvre Inv.R.F.1487). Paris.

A seemingly casual group of motifs occupying the foreground of Jacopo's drawing creates an ironic juxtaposition with the momentous historical event in the distance. At the far left, masons working on the city wall are oblivious to the significance of Christ's impending execution. Instead, they stop to look at the fallen horse and rider at the far right, who, in turn, are a counterpoint to the cavalcade. In the middle foreground, a sculptor, seated between a column and its base, is carving the statue of a man.

In the *Knight on a Horse with Fanciful Armor* (**13.5**), Jacopo conveys vigorous movement and monumental form. Curiously, despite the fact that the horse's back feet are firmly planted on the ground, it appears to be galloping at great speed. This impression is reinforced by the position of the rider, who leans forward as he would on a galloping horse. His determined expression and focused character reflect Jacopo's talent for portraiture that won him the competition at Leonello's court. His genius for rendering patterns and materials is conveyed by the softly textured drawing of the horse's hair and flapping blanket as well as by the ornate linear design of the fanciful armor.

Jacopo trained his two sons, who became the leading Venetian artists of the latter half of the fifteenth century. Both Gentile and Giovanni remained in Jacopo's *bottega* until 1460. Nevertheless, despite adhering to the medieval-workshop tradition, all three received official honors that reflected the beginning of a change in the social status of the artist. Jacopo himself was celebrated by the humanist poets, who compared him with Phidias, Polykleitos, and Apelles.

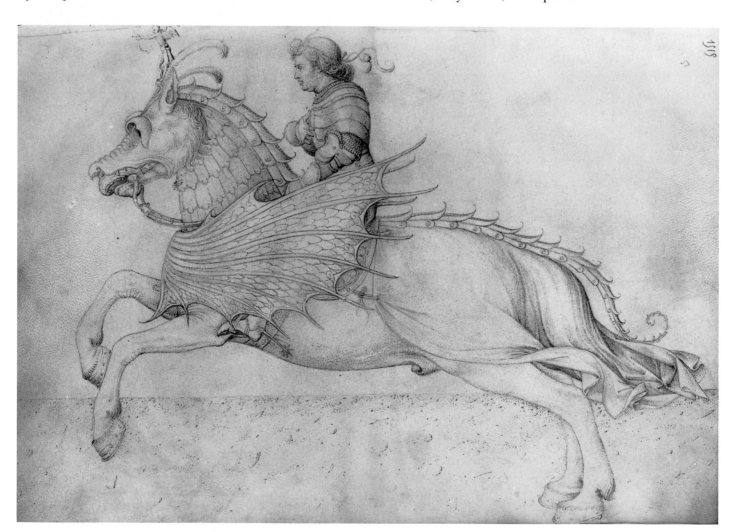

13.5 Jacopo Bellini, *Knight on a Horse with Fanciful Armor*. Drawing on parchment, Louvre Album, fol. 47 (Louvre Inv.R.F.1515). Paris.

Gentile Bellini

In 1479, Gentile's work for the Great Council Hall was interrupted when Sultan Mehmet II requested that a Venetian portrait painter be sent to his court in Constantinople. This came after a peace treaty signed in April of that year between Venice and the sultan. Gentile arrived with the collection of his father's drawings that would later comprise the Louvre Album. While at court, Gentile painted the sultan's portrait (**13.6**), a work that shows the influence of Jacopo's taste for surface design and soft textures.

Mehmet II is framed by a round arch with classicizing motifs on the square columns and a patterned Islamic cloth draped over the ledge. The folds of his turban are rendered in gradually shaded *chiaroscuro*, as are his features. His long, pointed nose and beard and the weight of his robe convey the sense of a serious, thoughtful personality. The three crowns on the portrait are repeated on the reverse of the sultan's medal (**13.7a** and **b**), which was cast by Gentile on his return to Venice. He recorded his own knighthood in the signature around the crowns and identified the imperial sultan on the obverse.

13.6 Gentile Bellini, *Portrait of Sultan Mehmet II*, 1479–1480. Oil on canvas; 27¾ × 20⅝ in. (70.5 × 52.4 cm). National Gallery, London. While at the sultan's court, Gentile was given a gift of a gold chain as well as expensive articles of clothing, and was named a knight of the Ottoman Empire.

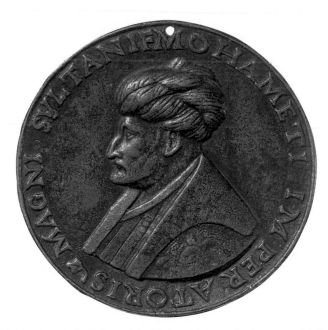

13.7a Gentile Bellini, medal of Sultan Mehmet II, obverse, c. 1480. Bronze; 3⅝ in. (9.2 cm) diameter. National Gallery of Art, Washington, D.C., Samuel H. Kress Collection.

13.7b Gentile Bellini, *Three Crowns: Constantinople, Inconium and Trebizond*, reverse of Figure 13.7a.

Sometime around 1490, the Scuola di San Giovanni Evangelista, a confraternity of flagellants, commissioned Gentile to paint three of nine canvases planned for the interior of their meetinghouse. The *scuola* had received a relic of the True Cross in the fourteenth century as a gift from the grand chancellor of Cyprus. Since then, a number of miracles were attributed to the relic, which became an important feature of the *scuola*. Gentile's large painting, the *Procession of the Reliquary of the True Cross in Piazza San Marco* (**13.8**), commemorates one such miracle that occurred in 1444 during the annual procession (held on April 25) for the feast of Saint Mark.

The setting is a panoramic view of Piazza San Marco, dominated in the background by its ornate Byzantine basilica. This center of religious life in Venice is accentuated by the location of the vanishing point on the central lunette. The middle ground reflects the notion, propagated by the Myth of Venice, of civic harmony achieved by the peaceful coexistence of different social groups, local people, and foreigners. Occupying the vast expanse of the foreground is the procession of the reliquary, accompanied by members of the Scuola di San Giovanni in white habits. Kneeling to the right of the reliquary is Jacopo de' Salis in a red robe. A merchant from Brescia, de' Salis was informed that his son was dying of a fractured skull and stopped to pray for him. When de' Salis returned home, his son had recovered.

Carpaccio's *Miracle at the Rialto*

Also engaged in the True Cross paintings for the Scuola di San Giovanni Evangelista was Vittore Carpaccio (c. 1460–1526), known for his meticulous depictions of contemporary Venice. In the *Miracle at the Rialto (Healing of the Possessed Man)* (**13.9**), he shows the commercial center of the city—the Rialto. On the right, the space recedes along the Grand Canal, below the members of the confraternity crossing the old

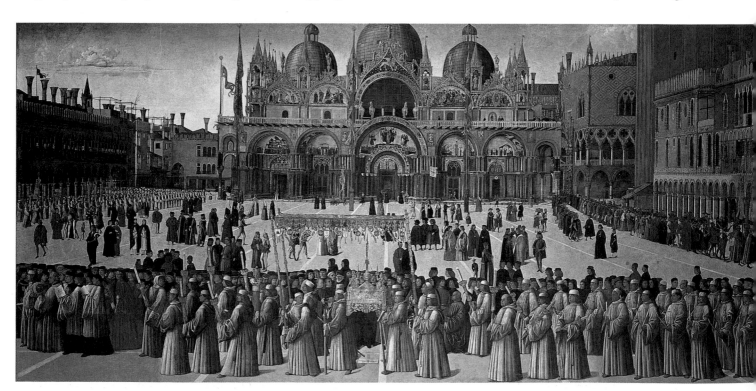

13.8 Gentile Bellini, *Procession of the Reliquary of the True Cross in Piazza San Marco*, 1496. Oil on canvas; 12 ft. ½ in. × 24 ft. 5¼ in. (3.67 × 7.45 m). Gallerie dell'Accademia, Venice. The damp climate of Venice made it difficult for fresco painting; plaster did not dry fast or thoroughly enough, which prevented the colors from fusing with the wall. As a result, frescoes in the large halls and palaces of the city were gradually replaced by oil paintings on canvas.

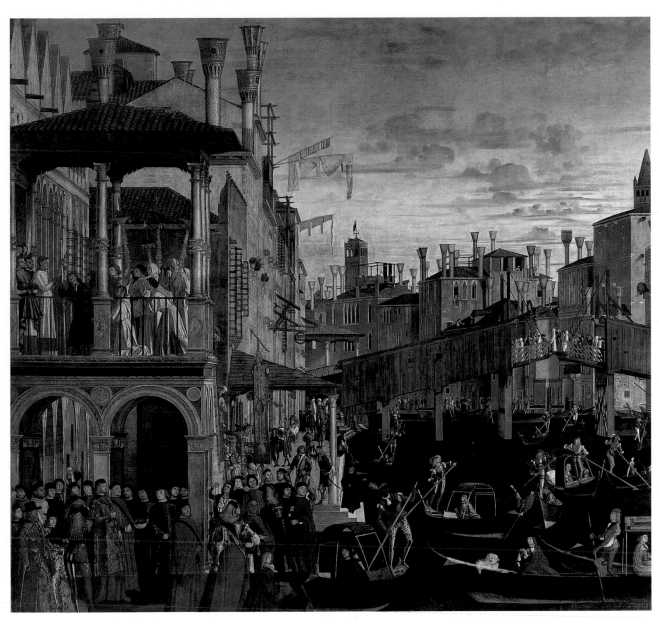

13.9 Vittore Carpaccio, *Miracle at the Rialto (Healing of the Possessed Man)*, c. 1494. Oil on canvas; 11 ft. 11¾ in. × 12 ft. 9¼ in. (3.65 × 3.89 m). Gallerie dell'Accademia, Venice.

wooden bridge. Filling the canal with a sense of activity are gondolas steered by gondoliers wearing brightly colored costumes.

Carpaccio, like Gentile, delights in the observed details of Venetian life. But Carpaccio's scenes are generally more lively than Gentile's, who foregrounds the solemn procession of the reliquary. Carpaccio also shows the city as a melting pot of different social and national groups living together in harmony. But the *Miracle at the Rialto* takes place on the upper story of

the portico at the left and is incorporated into the urban fabric of Venice. The patriarch holds the reliquary of the True Cross above the head of a possessed man, identified by his black robe, rolling eyes, and contorted expression. Reacting to the miracle are members of the *scuola* in white robes; their amazement is conveyed by the tilting of their giant gold candlesticks. On the street below, only a few of the figures are aware of the miracle; most continue to pursue their daily activities and prefer to watch the colorful gondoliers.

13.10 Antonello da Messina, *Portrait of a Man*, 1460s. Oil on panel; 14 × 10 in. (35.6 × 25.4 cm). National Gallery, London.

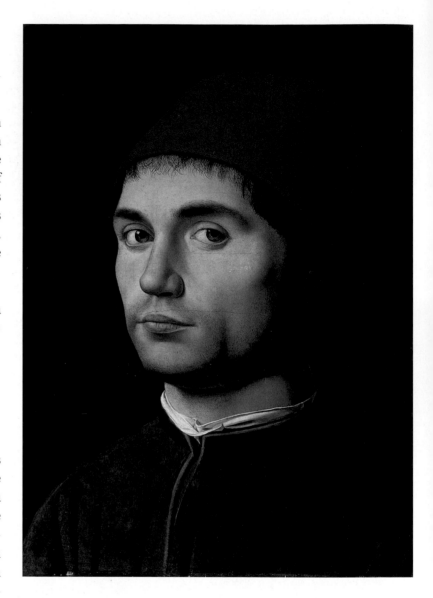

In the large views of Venice, most of which were institutional commissions, the city is given precedence over the individual citizen. The humanist measure of man is less a feature of such images than man's subordination to ideals of civic and religious harmony. Human figures in these scenes are small and the city vast, their respective scales denoting their relative importance.

Two artists who brought Venetian painting into a new era were Antonello da Messina (1431?–1479) and Giovanni Bellini.

Antonello da Messina

Antonello da Messina (Antonio di Giovanni) was born in Sicily and worked in Messina, where he owned a house. Although Sicily did not have a strong tradition of painting, Antonello became one of the most compelling late fifteenth-century artists. He was apparently in contact with works by Netherlandish painters in southern Italy, particularly in Naples. In 1475, he is documented as working in Venice, to which, it has often been claimed, he introduced an awareness of Northern style and technique. The influence of Netherlandish painting on his pictures—as well as on those of Giovanni Bellini—is palpable.

Painted before his arrival in Venice, Antonello's *Portrait of a Man* (**13.10**) reflects the Netherlandish interest, first seen in individual portraits by van Eyck, in textured surfaces. Gradual shading maps the physiognomy, with facial hair visibly emerging from the flesh. Each individual hair is separately painted—around the mouth and neck, the eyebrows, and emerging from under the bright red cap. Compared to the sculptural figures of Mantegna (for example, the *Carlo de' Medici*, 12.21) and Castagno, this one is composed of flesh and blood. The sideways gaze and the slightly tensed jaw convey the sense of an inner self, which, together with powerful form, is consistent with the humanist centrality of man. In contrast to the intimate, anecdotal *Old Man with a Child* by Ghirlandaio (see 11.16), Antonello's figure radiates a sense of dynamic energy that is within the tradition of the most monumental fifteenth-century artists.

Antonello's *Saint Jerome in His Study* (**13.11**) also shows the influence of artists such as van Eyck in the attention to precise interior textures . Open and closed books are carefully arranged on the wooden bookshelves, a white towel hangs from the wall, and plants grow in pots by the desk. The saint himself is reading on a stagelike platform in the middle of an interior

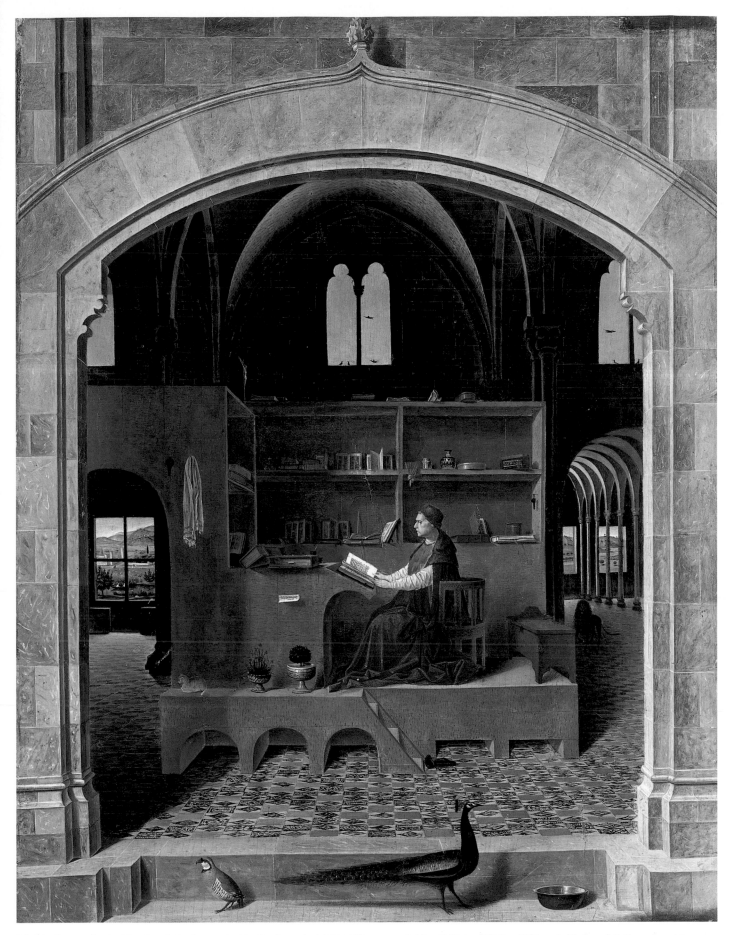

13.11 Antonello da Messina, *Saint Jerome in His Study*, early 1470s. Oil on panel; 18 × 14⅛ in. (45.7 × 36.2 cm). National Gallery, London.

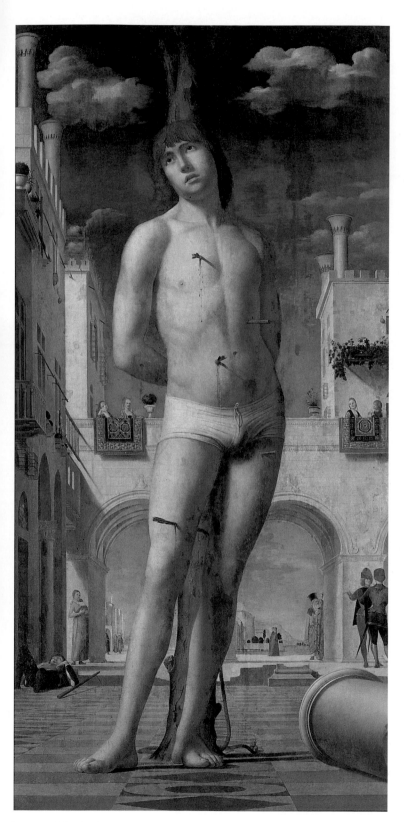

13.12 Antonello da Messina, *Saint Sebastian*, c. 1475–1476. Oil on canvas (transferred from panel); 67¼ × 33⅞ in. (171 × 85 cm). Gemäldegalerie, Dresden.

setting that resembles a church. His characteristic red cardinal's hat is placed on the chest behind him. On either side of the platform, the space recedes past the back wall onto a distant landscape; standing at the right under the arcade is the lion attribute of Saint Jerome. Details such as the peacock, quail, and brass bowl on the step in front of the archway, the floor tiles, and the heavy, angular folds of the red cloak recall Netherlandish painting. The effects of the oil medium, with its rich color and possibilities for subtle illumination that are evident in the *Saint Jerome*, would become characteristic of Venetian painting in the late fifteenth and early sixteenth centuries.

Around 1475, when he was in Venice, Antonello painted his dramatic *Saint Sebastian* (**13.12**), with its radical foreshortening and *di sotto in su* viewpoint. We look up at Sebastian, who is tied to a tree—possibly an allusion to the Tree of the Cross and thus to the martyr's association with Christ. The tree seems to grow from the tiles of a Venetian piazza, bordered by crenellated buildings and an arcade. Softened textures define the clouds and the figure of Sebastian, which assumes a Classical pose.

As in the large paintings of Giovanni Bellini and Carpaccio, Antonello includes details of contemporary life. Several Venetian ladies appear on the balustrade, over which hang two Persian carpets. A patriarch and two other figures in Venetian costume are visible at the right, while a woman and child and a sleeping man are depicted to the left. The ironic juxtaposition of the broken column in the foreground and the foreshortened figure is reminiscent of Jacopo Bellini's *Way to Calvary*. In contrast to the panoramas of earlier Venetian painters, however, Antonello monumentalizes the main character, for whom the city functions as a backdrop and a stage.

Giovanni Bellini

Considering the importance of Giovanni Bellini and his renown among his contemporaries, there is remarkably little documentary evidence for his life, and very few of his works are securely dated. In 1479, he was working with Gentile, who left for Constantinople; Giovanni

then took over the commission himself. With a genius for stylistic synthesis, Giovanni Bellini assimilated the monumental tradition of the early fifteenth century with the oil technique of the Netherlandish painters and the soft textures and subtle lighting of Antonello. He also eliminated the decorative surface patterning that had characterized Venetian art. His subject matter was primarily Christian, and he imbued the mother-child relationship with a new psychological power. In addition, he produced insightful portraits, allegories, and mythological scenes.

Mantegna's early impact on Giovanni can be seen in the *Madonna Adoring the Sleeping Child* of around 1455 (**13.13**). Although it has suffered damage, it is clear

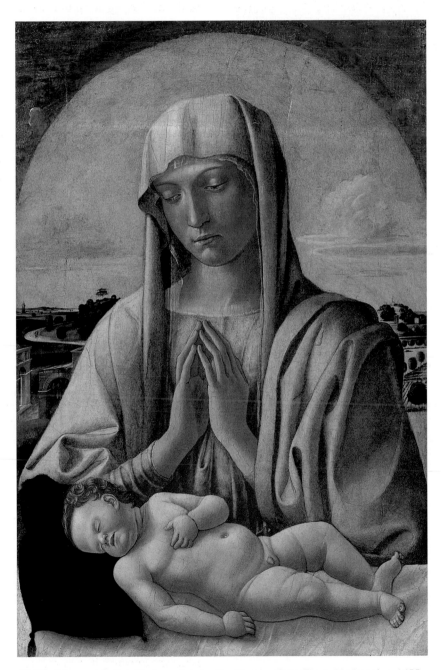

13.13 Giovanni Bellini, *Madonna Adoring the Sleeping Child (Davis Madonna)*, c. 1455. Tempera on panel; 28½ × 18¼ in. (72.4 × 46.3 cm). Theodore M. Davis Collection, Metropolitan Museum of Art, New York; Bequest of Theodore M. Davis, 1915.

that the cool colors, crisp edges, and sense of volume have affinities with Mantegna. At the same time, the transparent veil beneath the Virgin's mantle suggests an interest in filtered light and delicate textures similar to that of Filippo Lippi. For the most part, however, the drapery is weighty, structured, and sculptural. Symbolically and formally, Mary is an architectural metaphor, her praying hands creating an arch over the sleeping Christ. Her role as the Church building is indicated by her gesture as well as by the arched frame over her head and her monumental size. Denoting Christ's future death is his sleep, his relaxed pose reminiscent of Hellenistic sculptures of the sleeping

Eros. Mary's foreknowledge of the Crucifixion is shown in her saddened gaze.

Christ's nudity confirmed both his humanity and the fact that death was his destiny. The configuration in which he sleeps, with his head propped on a pillow, has been likened to tomb effigies—compare, for example, the Florentine tombs of Leonardo Bruni (see 7.1) and Carlo Marsuppini (see 10.6). Christ's position, slightly turned toward the picture plane and the viewer, alludes to the rite of the Eucharist performed at the altar.

The attention to landscape, which is minimal in this work, expands in Bellini's later pictures. The *Madonna of the Meadow* (**13.14**), painted some fifty years after the

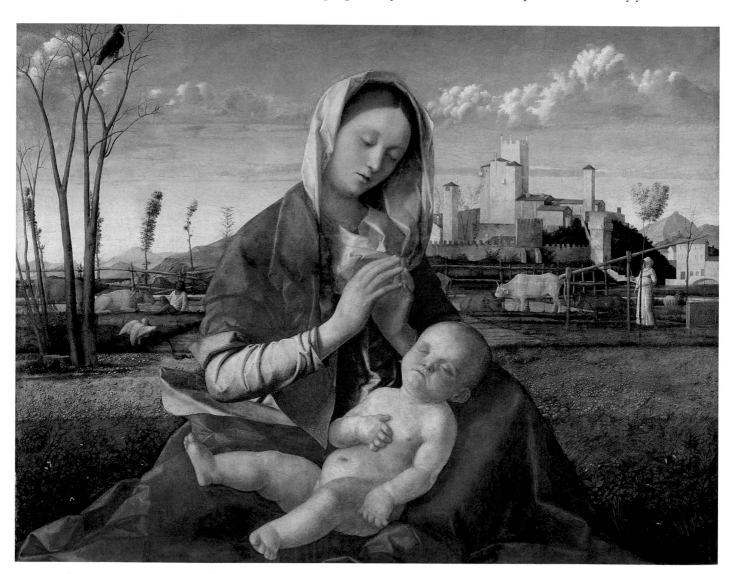

13.14 Giovanni Bellini, *Madonna of the Meadow*, c. 1500–1505. Oil and tempera on panel; 26½ × 34 in. (67.3 × 86.4 cm). National Gallery, London.

Madonna Adoring the Sleeping Child, depicts a similar theme in a new way. Landscape is now the setting, and the figures are bathed in a more suffused light characteristic of Antonello da Messina. Mother and child are also softened, less sculptural, and the colors are richer. Mary is seated on the ground as a sign of her humility; her role as the Church is more subtly conveyed as her form seems to expand and envelop Christ. The pyramidal configuration is related to images of the *Pietà*, which was a more common motif in Northern Europe than in Italy. In Bellini's version, Mary is shown simultaneously as the womb and tomb of Christ, reflecting the human necessity advanced by Saint Augustine of having to die before being reborn.

Allusions to death, such as the dead trees and the crow, are woven into the fabric of the landscape. Mary and Christ are simultaneously related to the landscape and distinct from it. The rolling clouds, for example, pass behind Mary's white head cloth, and the triangular hills echo her form. Reiterating her architectural role as the House of God is the distant hill town. As in certain works by Mantegna, Antonello, and Jacopo, Giovanni juxtaposes the passage of earthly time (the shepherds tending their animals, the green and dry trees, and the changing sky) with the timeless iconic image in the foreground.

Giovanni Bellini's original approach to the monumental altarpiece can be seen in two examples, one dating to the 1470s and the other to 1505. The earlier, depicting the *Coronation of the Virgin* (**13.15**) in an unusual large square panel, was commissioned for the high altar of the church of San Francesco, in Pesaro. As in Mantegna's San Zeno Altarpiece (see 12.19), the framing of the panels is integrated formally and iconographically with the painted images.

The structure of the frame is related to the Greek temple front, with two Corinthian square columns supporting an entablature. The central image of the Coronation is "reframed" by the back of the throne, which echoes the form of the outer frame. In place of the elaborate gold foliate pattern outside, however, the entablature of the throne is decorated with classicizing relief sculptures. Visible through the inner frame, the fortified city alludes to the Heavenly Jerusalem and to the sacred space of the choir, in front of which the altar is located.

The heavenly vision continues around the top of the throne, with blue and red cherubim and seraphim on either side and the Holy Ghost in a blaze of red seraphim and a yellow glow emerging from a darkened sky. In the arrangement of the saints flanking the throne, Giovanni creates a somber *sacra conversazione*. All four carry weighty tomes; Saints Peter and Jerome are engrossed in their texts, whereas Saints Paul and Francis gaze abstractedly into space. The halos are rendered in a new type of light—a suffused, transparent yellow.

Additional saints are embedded in the shafts of the square columns. This is a visual metaphor equating the founding Christian saints with the architectural supports of the heavenly "temple." Each column is supported by a miniature podium, a motif derived from the Roman triumphal arch; on the left Saint George slays the dragon and on the right a meditative Terentius, the patron saint of Pesaro, holds a model of the city. Between the podia are four predella panels depicting scenes from the lives of the saints around the throne. The central predella contains the *Nativity* and was originally directly below a *Pietà* (now in the Vatican Museum) at the top of the altarpiece. Mary's Coronation as the eternal Queen of Heaven was thus aligned vertically with the human span of Christ's life.

Giovanni's late San Zaccaria Altarpiece (**13.16**) is his last monumental *sacra conversazione*. Instead of the motif of the frame-within-the-frame, a space opens up between the actual frame and the painted apse. This identifies the apse as an independent structure, related to its context in the church. The oil lamp and egg-shaped stone weight hanging in front of the semi-dome may refer to the Virgin birth, while the outdoor trees, visually and structurally related to the Corinthian pilasters, remind worshipers of Christ's death on the Cross.

Compared with the Pesaro Altarpiece, this one amplifies the space and the figures. Saints Peter and Jerome turn toward the picture plane, the red of Jerome's voluminous cloak repeated in the cover of Peter's book. The female saints, Lucy and Catherine, with their attributes and palms of martyrdom, shift the viewer's gaze toward the central throne. Christ is the most illuminated figure—the Light of the World—standing on Mary's lap and raising his right hand in a gesture of blessing.

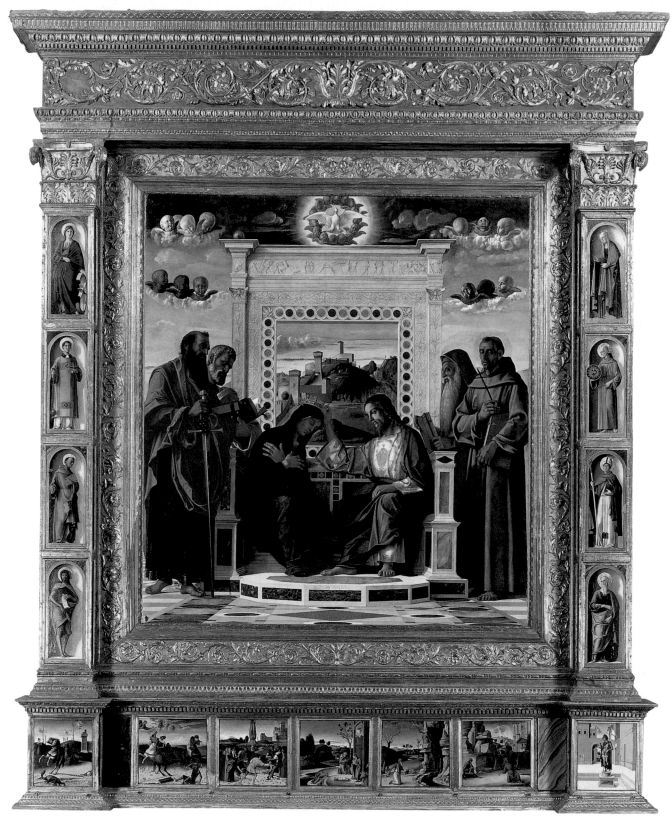

13.15 Giovanni Bellini, *Coronation of the Virgin* (Pesaro Altarpiece), 1470s. Oil on panel; 8 ft. 7 in. × 7 ft. 10½ in. (262 × 240 cm). Museo Civico, Pesaro.

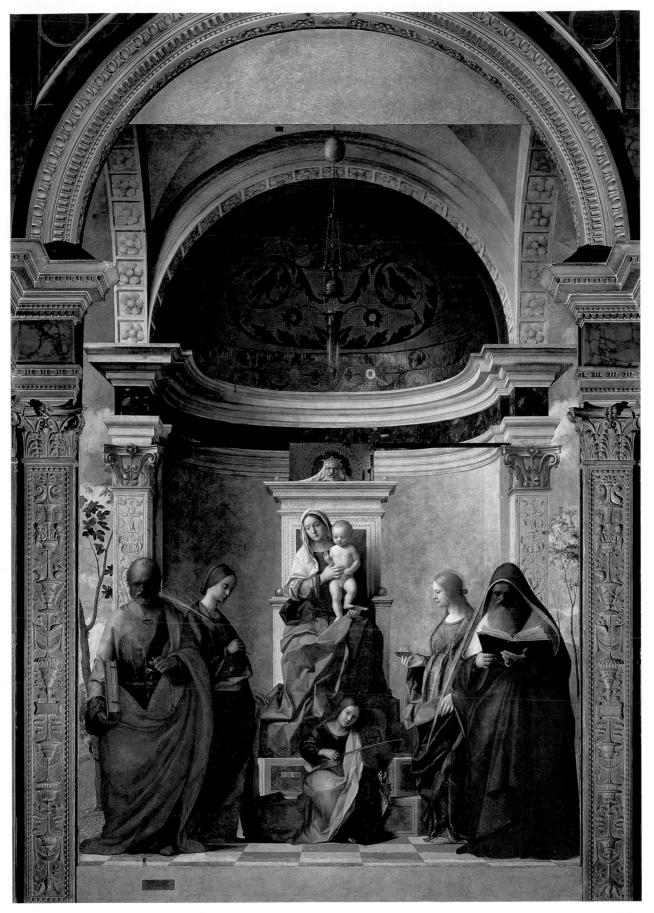

13.16 Giovanni Bellini, San Zaccaria Altarpiece, signed and dated 1505. Oil on canvas transferred from panel; 16 ft. 5 in. × 7 ft. 8½ in. (500 × 235 cm). San Zaccaria, Venice.

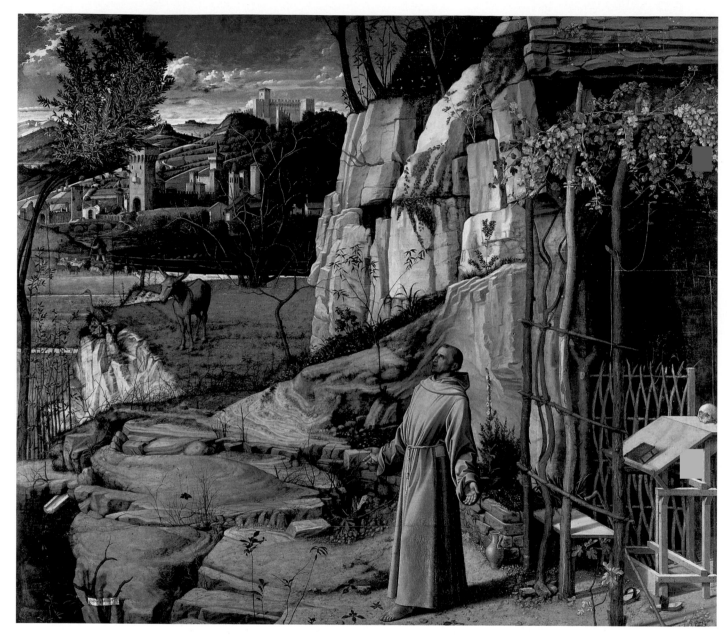

13.17 Giovanni Bellini, *Saint Francis*, c. 1485. Oil and tempera on panel; 48½ × 55 in. (123 × 140 cm). Frick Collection, New York.

Completing the group are the music-making angel at the base of the throne and the frontal stone head of a king, possibly David, above the throne. Just to the left of the angel, Bellini left enough room on the step to tack on an illusionistic piece of paper containing his signature and the date 1505.

This work shows Giovanni's development toward broad, simplified forms. His use of glaze enriches the color and suffuses the lighting even more than in his early works. In the succession of lights and shadows and the subtle shading, Giovanni arrives at a new pictorial vocabulary that became the foundation of the High Renaissance in Venice.

The influence of Northern painting on Bellini's style is perhaps most apparent in his enigmatic *Saint Francis* (**13.17**). The picture has been read in a number of ways: as a *Stigmatization*, as *Saint Francis in Ecstasy*, as *Saint Francis Singing His Own "Hymn to Brother Son,"* and as just plain *Saint Francis*. According to the saint's biography, he received the stigmata on Mount

La Verna, and the miracle was witnessed by his companion, Brother Leo. The absence of Leo and of the traditional crucified seraph emitting the rays that cause the stigmata expands the meaning of the picture beyond the mere illustration of a text. Despite such specific elements as the animals, the book and skull on the lectern, the distant city, and the shepherd tending his flock, the impact of the scene elevates it to a level of mythic power.

Rock formations and details of foliage are the result of contacts with Northern work. At the same time,

nature is part and parcel of the character of Saint Francis and his teachings. His belief that God imbued nature with its own spirituality is consistent with the celebration of nature reflected in the painting. Behind Francis, the rock curves in response to his outstretched arms, possibly alluding to the curve of the apse. Francis thus combines the image of Christ on the Cross in the apse with the notion of Adam in a state of communion with nature before the Fall. In so doing, he fuses time, typologically merging Adam and Christ with his own image.

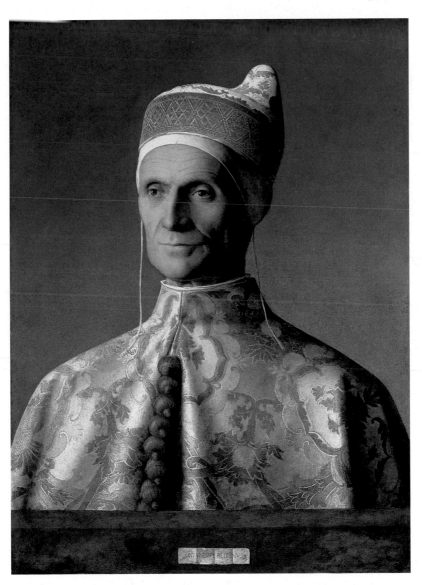

13.18 Giovanni Bellini, *The Doge Leonardo Loredan*, c. 1501–1502. Oil on panel: 24¼ × 17¾ in. (61.6 × 45.1 cm). National Gallery, London.

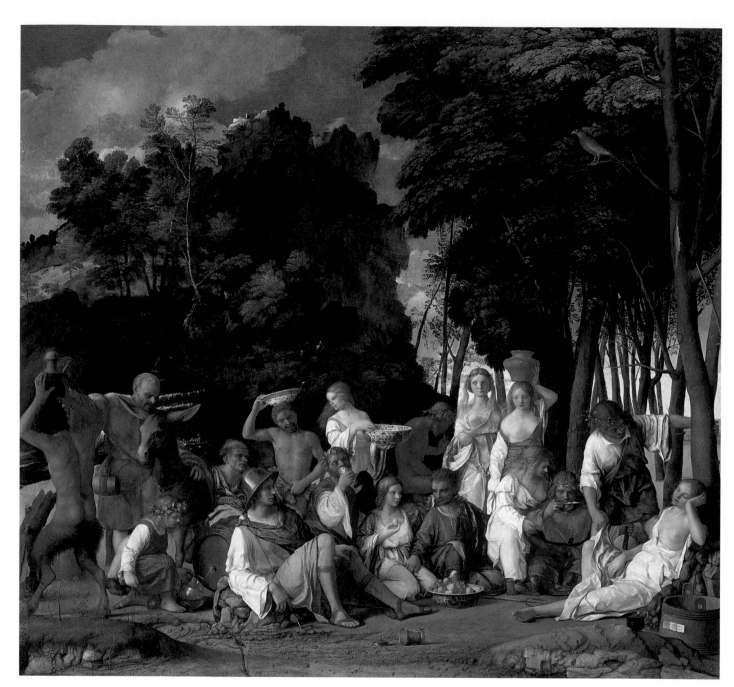

13.19 Giovanni Bellini, *Feast of the Gods*, 1514. Oil on canvas; 5 ft. 7 in. × 6 ft. 2 in. (170 × 188 cm). National Gallery of Art, Washington, D.C., Widener Collection. As in *Saint Francis* and the portrait of the doge, Bellini signed the painting on an illusionistic piece of paper; here it is attached to the wooden tub at the right. Because Bellini's patron was Ferrarese and he himself was Venetian, he emphasized his nationality in the signature: *Joannes bellinus venetus MDXIIII* (Giovanni Bellini of Venice, 1514).

The miraculous yellow light at the upper left seems to have a divine origin, casting a warm glow over Saint Francis and the rocks. Nature is literally the Church of Saint Francis in this painting—that he stands barefoot indicates that he is on holy ground—where the presence of God is everywhere palpable. As in the San Zaccaria Altarpiece, Bellini reminds the viewer of his own presence by incorporating his signature into the main image. Here he signs on the paper attached to the branch at the lower left.

In the portrait of Doge Leonardo Loredan (**13.18**), Bellini's signature is even more prominently displayed—on the wooden ledge in the foreground. He thus literally inserts himself into the role of painter placed between the viewer and the painting. The doge himself is the embodiment of a patrician, removed formally (by the ledge) and psychologically (by the aloof expression) from the average citizen. This is also an image of political stability and moral rectitude, for Loredan's impassive gaze, firm, upright pose, and near symmetry convey an impression of formal equilibrium and noble equanimity. His costume is that of his office, and his face is mapped with the lines and sagging flesh of maturity and experience. The physiognomy, like the material textures of the brocade and the visible gold threads of the buttons, are evidence of Netherlandish influence.

In the *Feast of the Gods* (**13.19**) of 1514, Giovanni produced one of his rare mythological scenes. It was commissioned by Duke Alfonso d'Este, Isabella's brother, for his *studiolo* in Ferrara. Like Isabella, for whom Giovanni also painted a lost Madonna, Alfonso preferred mythological subjects for his private study. And although by 1514 mythological iconography was well-established in much of Italy, it was still rare in Venice.

The *Feast* is a scene of revelry, a celebration of youth created in Giovanni's old age. Its iconography is a matter of debate, but it is generally agreed that it is based on Ovid. At the right, Priapus is about to molest the sleeping nymph Lotis. Among the gods and voluptuous goddesses eating and drinking are lascivious satyrs and an ass.

Another reading of the painting is based on a fourteenth-century gloss of Ovid which is allegorical. In this case, the painting depicts a Theban feast of Bacchus and the attributes of the gods are a later addition—whether by Bellini or another artist is not known. But X-ray analysis of the work confirms that changes were made. Giovanni was over seventy when he painted the *Feast*, but his creativity was in no way diminished. The rich chromatic and textural variety as well as the lusty figures are those of an artist at the height of his power. The contrast between the light colors of the figures and the darker background is the result of overpainting by Titian after Giovanni's death (see Chapter 17). Although the light visible between the trees is characteristic of Bellini, the trees, hills, and sky are those of Titian.

With Giovanni's late work, the beginning of High Renaissance Venetian style enters the history of art and will be taken up in Chapter 17.

Ovid and the Renaissance

Publius Ovidius Naso (43 B.C.–A.D. 18), known as Ovid, was a Roman poet in the era of Augustus. His poetry includes the *Amores* (love poems), the *Fasti* (elegiac poems on events connected to the Roman calendar), the *Heroides* (in which legendary heroines write letters to their husbands and lovers), and the *Metamorphoses* (describing the transformations of the gods). In A.D. 8, Ovid was banished by the emperor to Tomis, on the Black Sea, where he wrote his treatise on the art of seduction, the *Ars amatoria*. During the Middle Ages, Ovid's writings were sometimes moralized and applied to Christian themes. As part of the Classical revival in the Renaissance, authors and artists used Ovid as "the Bible of the Poets."

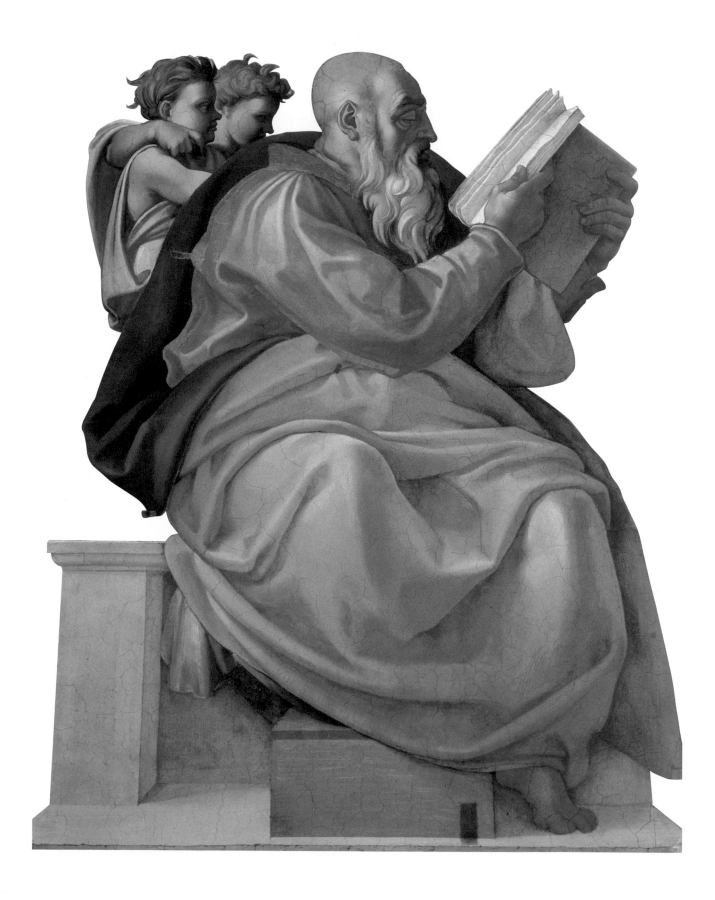

THE CINQUECENTO

The term *High Renaissance* roughly comprises the late fifteenth century to about 1520. Like all art-historical categories, it is a fluid one. Nevertheless, it has come to be associated with a few powerful artistic personalities, particularly Leonardo da Vinci and Donato Bramante, who worked in Florence, Milan, and Rome; Raphael and Michelangelo, who produced their greatest work in Florence and Rome; and the Venetians Giorgione, Titian, and Veronese (born in 1528), who is sometimes referred to as a late Renaissance artist.

The period itself was brief; by 1520, Bramante, Leonardo, Raphael, and Giorgione were dead. With the new generation, new styles—notably Mannerism—began to evolve, and there has been much scholarly debate over the nature of the interplay between Mannerism and the late styles of Michelangelo and Titian. Patronage during the High Renaissance also assumed a somewhat different character than it had had in the quattrocento, when artists were struggling to emerge from their medieval status as craftsmen. The reinstated Medici in Florence, Popes Julius II and Leo X in Rome, and the Sforzas in Milan comprised a new generation of powerful patrons. And Rome, rather than Florence, became the center of innovative artistic production.

The High Renaissance was thus a period of enormous artistic achievement and continuing political turmoil. After the Medici were expelled from Florence in 1494, Savonarola controlled the city for four turbulent years. When the Medici returned in 1512, their rule was autocratic, and by 1530 the city was dominated by the kingdom of Spain and its Habsburg rulers. In Milan, under the sway of the ruthless and despotic Sforzas, there was internal tension as well as the perpetual threat of invasion from France. Rome was sacked in 1527, when the Holy Roman emperor Charles V invaded Italy.

Sixteenth-century Italy, like the rest of Europe, was profoundly affected by the religious upheaval known as the Protestant Reformation. The German Augustinian monk Martin Luther spearheaded the challenge to the Catholic Church. In 1517, he nailed to the door of a church in Wittenberg his *95 Theses* in which he outlined his moral objections to the practice of selling indulgences (letters of credit against one's sins) as a paradigm of Church corruption. The subsequent establishment of the Protestant Church dealt a severe blow to Catholic domination of Europe.

The reaction to the Reformation, the Counter-Reformation, was swift. It was the Church's effort to stamp out internal corruption as well as heresy. To this end, the Inquisition, an official body formed in the thirteenth century, began a campaign to rid the visual arts of content it considered heretical. The Council of Trent was convened from 1545 to 1563; it established rules of visual imagery which the Inquisition tried to enforce. Such momentous changes in the established religious institutions of western Europe could not but affect artists and patrons of the period.

14

Leonardo and Bramante:
Late Fifteenth- and Early Sixteenth-Century
Developments in Florence and Milan

Leonardo da Vinci: Florence

Leonardo da Vinci (1452–1519), the illegitimate son of the notary Ser Piero and a peasant girl known only as Caterina, was born in the village of Vinci, outside Florence. A genius of monumental proportions, he inherited the mantle of Alberti as "uomo universale" — "Renaissance man." Leonardo was expert in the sciences of his day, as well as engineering and map making, and he practiced alchemy. He was a gifted musician—he played the lyre—and was one of the greatest painters who ever lived, although he produced very few finished works. Two of his paintings, the *Last Supper* and the *Mona Lisa*, have become icons of Western art. He left thousands of pages of notebooks in which he wrote on a wide array of topics, often illustrating his ideas with some of the most masterful drawings ever made. His career took him to Florence, Milan, Rome, and France, where he died in the employ of the French king, Francis I.

When Leonardo was around eleven years old, his father apprenticed him to Verrocchio, who ran a *bottega* of painting and sculpture in Florence. As was the practice in fifteenth-century workshops, Leonardo would begin by preparing surfaces and mixing pigments, and eventually, after several years, he would be allowed to contribute a portion to one of the master's pictures.

Sometime around 1470, Verrocchio executed a *Baptism of Christ* (**14.1**), which contains Leonardo's first known painted figure—the kneeling angel holding Christ's clothing at the far left. The scene shows Christ standing in the river Jordan as John the Baptist pours water over his head. Hovering above Christ, as if just released from the hands of God, is the dove of the Holy Spirit emitting divine rays. Its cruciform configuration, which echoes the red cross on Christ's halo, prefigures the Crucifixion. Likewise, the black bird at the right, which flies in the direction of John's Cross, is probably a symbol of death. At the same time, the structured character of the rock behind John denotes the future role of the Church as the Rock of Ages. The palm tree identifies the setting as the Holy Land.

If the painting's generally assigned date of 1470 is correct, then Leonardo would have been eighteen when he painted the angel. The figure shows Leonardo's taste for sculptural drapery and softened physiognomy. Also distinctively Leonardesque is the delicate golden light on the angel's blond curls. At the same time, however, Verrocchio's interest in rock formations and vegetation as well as emphasis on the underlying bone structure of the figures would have a lasting impact on his pupil's mature style.

After completing his apprenticeship with Verrocchio, Leonardo joined the Company (Compagnia) of Saint Luke, a subgroup of the Medici e Speziali. He was known as a reclusive, somewhat odd character who was hand-

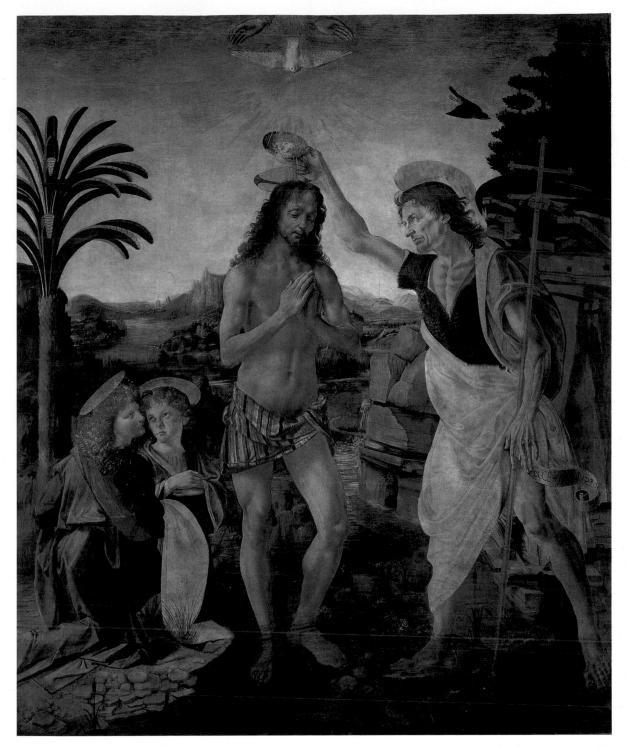

14.1 Andrea del Verrocchio, *Baptism of Christ*, c. 1470. Oil on panel; 69½ × 59½ in. (1.77 × 1.51 m). Galleria degli Uffizi, Florence. According to a popular anecdote related by Vasari, when Verrocchio saw Leonardo's angel, he realized that his student had surpassed him and renounced painting altogether. This story fuses two anecdotal conventions popular in the Renaissance: in one, as had been the case with Giotto and Cimabue, the pupil triumphs over his teacher and obscures the latter's fame; in the other, the artist is confronted with greatness he cannot match and renounces that aspect of his own art.

some, refined, and elegant. The latter qualities are consistent with his defense of painting in comparison to sculpture (so-called *paragone*) in a passage of his treatise on painting. Arguing that painting should be elevated to a liberal art, he points out that painters are more dignified than sculptors, who are covered in clay and plaster dust and surrounded by the constant din of the hammer and chisel. The painter, on the other hand, can dress like a gentleman, sitting quietly and listening peacefully to music while he works.

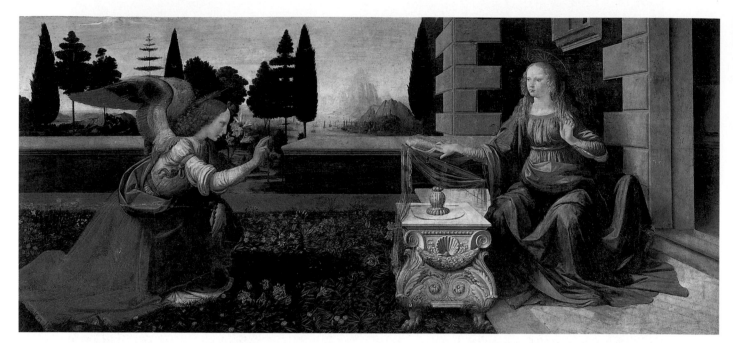

14.2 Leonardo da Vinci, *Annunciation*, 1470s. Panel; 38¾ × 85½ in. (98 × 217 cm). Originally in the church of San Bartolomeo a Monteoliveto, outside of Florence. Now in the Galleria degli Uffizi, Florence.

Leonardo's refined tastes are evident in an early painting—one of the few well-preserved works he completed—generally dated to the 1470s. The *Annunciation* (**14.2**), like many of his works, has unusual iconographic elements that have been difficult to decipher. Gabriel arrives at the left carrying the lilies signifying Mary's purity and interrupts her reading. She shows her surprise by pose and gesture, marking her place in the text. The sculptural quality of her blue drapery and the suffused yellow light of her hair are reminiscent of Leonardo's angel in Verrocchio's *Baptism*. She herself is a formal echo of the building; the three pyramidal shapes formed by her drapery repeat the corner of the building framed by the lighter quoins. The openness of Mary's pose, despite its expression of surprise, echoes the open doorway and indicates her receptivity to the procreative Word of God.

The garden setting, painted with attention to the scientific precision of the foliage, alludes to the *hortus conclusus* of the Song of Songs and is a metaphor for the Virgin. In the distance, the waterway, referring to Mary as the Star of the Sea, merges into a light blue mist enveloping the mountains. This is rendered with Leonardo's characteristic **sfumato** technique, a term that literally means "lost in smoke." In the middle

ground, the dark, nearly silhouetted trees are typical of the Tuscan landscape.

The most curious element is the relief decoration on the foreshortened sarcophagus, which is also an allusion to Mary—as the womb and tomb of Christ. The scallop shell of rebirth and resurrection is prominently displayed above foliate forms and two lion's feet. Turned slightly outward, the feet echo Mary's pose; in being leonine, they may refer typologically to King Solomon's lion throne. But they are also a visual signature of Leonardo (Leo), as were the lion symbols of Leonardo Bruni and Alberti. In addition, the imagery of Leonardo's sarcophagus reflects that of Verrocchio in the San Lorenzo Medici tomb (see 10.10).

Leonardo's drawing the *Hanging of Bernardo di Bandino Baroncelli* (**14.3**), the assassin who killed Giuliano de' Medici in the Pazzi Conspiracy, confirms his ties to the Medici family. It can be dated to 1478–1479 on the basis of the event itself and shows Baroncelli hanging from the Bargello after his public execution. Leonardo was greatly admired by Lorenzo the Magnificent, who would later recommend him to the duke of Milan. But the drawing also illustrates Vasari's assertion that the artist liked to follow condemned criminals to the scaffold to draw their terrified

14.3 Leonardo da Vinci, *Hanging of Bernardo di Bandino Baroncelli*, 1478–1479. Drawing on paper. Musée Bonnat, Bayonne. Because Leonardo was left-handed, the hatching in his drawings invariably goes from upper left to lower right. The accompanying notes are written backward so that they have to be read in a mirror. To date there is no satisfactory explanation for Leonardo's mirror writing.

14.4 Leonardo da Vinci, *Child Playing with a Cat*. Drawing. British Museum, London.

expressions. The sheet contains a somber face at the lower left, in addition to the main image, which is a study in gravity and gravitas—in Baroncelli's expression as well as in the physical pull of the figure.

Leonardo's drawings are not only preparatory studies for future paintings, they are an imprint of his remarkably associative style of thinking. They record his ability to work out ideas through line as well as the interplay of image and text that is one of the distinctive qualities of his voluminous notebooks. In the drawing *Child Playing with a Cat* (**14.4**), for example, the child and the cat are continually in the process of becoming each other. Leonardo also shows the inevitable tension of such intense identification; at the lower right, the cat splayed on the ground and the seated child are merged—in the torso, we see the underside of the cat

14.5 Leonardo da Vinci, *Saint Jerome*, c. 1480–1481. Panel; 40½ × 41⅜ in. (103 × 105 cm). Vatican Museum, Rome.

14.6 Leonardo da Vinci, *Embryo in the Womb*, c. 1510. Pen and brown ink; 11¾ × 8½ in. (29.8 × 21.6 cm). Royal Collection, Windsor Castle, Royal Library, ©2000 Her Majesty Queen Elizabeth II.

and the boy from the rear. At the same time, there is a merger of play and struggle, which is a feature of childhood psychology reflected in Vasari's accounts of Leonardo's predilection for aggressive pranks and jokes.

One of the most powerful expressions of Leonardo's metaphorical thinking is his unfinished *Saint Jerome* (**14.5**). In contrast to the soft textures, interior details, and illusionism of Antonello's *Saint Jerome* (see 13.11), who is shown reading in the comfort of his study, Leonardo's is an image of penance and self-denial. Even the lion seems to register surprise as the saint prepares to strike himself with a rock.

The motif of the rock is the basic metaphor of the picture. On a literal level, it is the instrument of Jerome's self-inflicted punishment and the stark setting in which he is located. Metaphorically, it is the church building faintly visible through the opening at the upper right and also the saint's own body. Leonardo's comparison of the human body to the earth in his notebooks equates flesh with soil, the blood supply with waterways, and bones with rock. Aside from a light, bluish *sfumato* in the distance, the painting remains **monochromatic**, as if Leonardo intentionally preserved the sense of harsh, rocky surfaces. By not completing the figure of the saint, Leonardo left the skeleton and musculature forever exposed—a reflection of the artist's lifelong interest in anatomy.

The unfinished *Saint Jerome* is as close as Leonardo came in a painting to his numerous anatomical drawings. These were a logical development of the Classical revival and the humanist view of man's centrality, beauty of form, and superior intellect. At first, artists such as Pollaiuolo (see Chapter 11) studied anatomy as a means of improving the accuracy of their work. But Leonardo went beyond purely artistic motives and became engaged in an investigative obsession with the way the body works. Following the views of Galen, the Greek physician, Leonardo believed that animal anatomy was similar to human anatomy and that by dissecting animals, he could draw conclusions about people. Further, because it was difficult to obtain human cadavers, many of his drawings were based on animals. Nevertheless, as time went on, especially in early sixteenth-century Rome, Leonardo gained access—largely through hospitals—to human dissections.

In one series of anatomical drawings, Leonardo studied the origins of life, which was a subject that always preoccupied him. Figure **14.6** shows a uterus that has been neatly divided to reveal a fetus in the breech

position. The blood vessels are delineated on the left half of the uterus, and the umbilical cord shows the child's attachment to the mother's blood supply. According to Leonardo's notes, he knew that fetuses do not breathe in the uterus and that they are fed by the mother. He did not know, however, that the fetus's heart beats (the circulation of blood had not yet been discovered) or what the function of the placenta in the birth process is.

Leonardo and Bramante in Milan

Around 1482, Leonardo left Florence for Milan, the capital city of Lombardy. He had written to the Milanese ruler, Lodovico Sforza (1451–1508)—called "il Moro" (the Moor) either because of his dark complexion or because his second name was "Mauro"—proposing himself for the position of military engineer. Leonardo described his skill as a painter, sculptor, and architect, and offered to design the equestrian monument to Francesco Sforza (Lodovico's father). The great bronze statue had been conceived previously by Galeazzo Maria Sforza, Lodovico's dissolute older brother, but was never executed.

When Leonardo arrived in Milan, he found a city quite different from republican, mercantile Florence. Milan was a military state, ruled by despots with ties to France, Germany, and various regions of Italy. The administrative complexity of the court, its huge size and webs of intrigue notwithstanding, there was a strong humanist tradition in Milan.

Politics and Humanist Patronage

When Giangaleazzo Visconti died in 1402 on the verge of invading Florence (see Chapter 3), Milan was beset by internal strife. Giangaleazzo's son, Filippo Maria (1392–1447), did not succeed in restoring order until around 1412, by which time Venice had gained in importance, creating a buffer between Milan and Florence in Lombardy. In 1443, Filippo Maria's daughter, Bianca Maria, married the *condottiere* Francesco Sforza, who assumed the rule of Milan from 1450 to 1466. The Sforza, like the Visconti, employed humanist

artists and writers to enhance their political image. And, although few significant works of humanist literature were produced in Milan, the city was an influential force in the spread of humanism.

The University of Pavia, in particular, had been an important intellectual center since acquiring Petrarch's library in the late fourteenth century. Petrarch himself spent eight years in Milan. The scholar Gasparino Barzizza (1360–1430) of Bergamo studied at Pavia, was acquainted with the Visconti, and later became Alberti's teacher in Padua. In 1431, Barzizza was succeeded by Lorenzo Valla as professor of rhetoric. Antonio Beccadelli ("il Panormita"), whose *Hermaphroditus* was written in Naples and dedicated to Cosimo de' Medici, was professor at Pavia and court poet to Filippo Maria from 1429 to 1434.

Perhaps the most important humanist in fifteenth-century Milan was Francesco Filelfo, who worked for both the Visconti and the Sforza. He was commissioned by Francesco Sforza to write the *Sforziade*, a literary glorification of the Sforza modeled on the *Iliad*. Filelfo worked on the *Sforziade* until 1475, at which time he

14.7 Antonio Averlino (Filarete), plan of Sforzinda, c. 1461–1462. From the *Treatise on Architecture*. Filarete's treatise was originally dedicated to Francesco Sforza, but the two men had a falling out and Filarete left Milan. He went to Florence and rededicated the work to Piero de' Medici.

left Milan and the text was incomplete. But he had taught an entire generation of students, who continued to publish Greek and Latin texts.

Francesco Sforza hired the Florentine architect and goldsmith Antonio Averlino, known as Filarete (c. 1400–1469), to design the ideal city of Sforzinda, named after himself. The social and political structure of Sforzinda was based on the *Laws* of Plato. Its plan (**14.7**), which is in the shape of an eight-pointed star inscribed in a circle, appears in Filarete's *Treatise on Architecture* (c. 1461–1462). Streets radiate from a central market; buildings include schools, prisons, residences, a so-called House of Virtue and a House of Vice, and the ruler's palace. Dominating the latter was a tall tower twenty stories high, surmounted by a dome, that symbolized the power of the Sforza (**14.8**). The influence of the antique is evident in the use of Corinthian pilasters, entablatures, and round arches. Although never actually realized, Sforzinda was the earliest expression of Alberti's conception of a city plan based on the ideal of the circle.

Francesco Sforza died in 1466, and his son Galeazzo Maria Sforza increased Milanese ties to France by marrying the sister-in-law of the French king. Galeazzo Maria was assassinated in 1476, and his young son (Giangaleazzo Sforza) was named duke. Lodovico Sforza (Giangaleazzo's uncle and Galeazzo Maria's younger brother) became regent for Giangaleazzo, maneuvered to have his mother imprisoned and beheaded, and, in 1494, may also have had his nephew killed. The Holy Roman emperor Maximilian I then named Lodovico duke, which was the most important step to date in legitimizing Sforza power. Given Lodovico's tenuous claim to the duchy, he set about using his considerable skill as a patron to further his political aims.

One of his major architectural commissions was the completion of the façade of the Certosa (Carthusian monastery) near Pavia (**14.9**), which had been begun by Giangaleazzo Visconti. Following ancient Roman practice, the brick core was refaced with marble. The decoration, enlivened with sculptures and classicizing architectural motifs, was characteristic of the Milanese taste for animated wall surfaces. The magisterial impression of the façade is conveyed by its carefully orchestrated geometric symmetry and the imposing triumphal-arch motif at the entrance. This, in turn, is

14.8 Antonio Averlino (Filarete), tower of Sforzinda's lord, c. 1461–1462. From the *Treatise on Architecture*.

14.9 Cristoforo Mantegazza and Giovanni Amadeo, Certosa, 1473–1490s. Brick core with marble facing. Pavia.

accentuated by the second-story window and pediment that seem to have incorporated elements of Albertian church façades. Planned as the burial site of the Visconti, the Certosa exemplifies the efforts of the Sforza to establish their legitimacy by identification with the goals of the Visconti.

In contrast to his *condottiere* father, Lodovico was a humanist by education and a patron of the arts by nature. He collected gems, books, and medals, and commissioned monumental works of art. The primary goal of his patronage, which was imbued with imperial Roman themes, was the endorsement of his political power. The two major artists who worked for Lodovico were Donato Bramante (c. 1444–1514) and Leonardo.

Lodovico and Bramante

Bramante was born outside Urbino and learned painting before working as an architect. Little is known of Bramante's early career, but it is virtually certain that he was influenced by Piero della Francesca and Mantegna.

Although he was older than Leonardo by nearly a decade and established in Milan before Leonardo's arrival, there is disagreement over the degree to which the two artists knew and influenced each other. It appears that Bramante's architecture was influenced by Leonardo's drawings of centralized church plans (**14.10**), which, like Sforzinda, reflect the circular ideal. Leonardo himself advised Lodovico Sforza on architecture and had assimilated Brunelleschi's plans for the centralized church of Santa Maria degli Angeli in Florence. The humanist underpinnings of the notion that the circle was the ideal shape derived from Vitruvius, who related the symmetry of man to the harmony of architecture. Leonardo's drawing of *Vitruvian Man* (**14.11**) depicts Vitruvius's view that if a man stands inside a circle and/or square with his hands and feet extended to the circumference, his navel will fall at the center.

The plan of Bramante's church of Santa Maria presso San Satiro (**14.12**) shows the influence of Leonardo's taste for regular geometric shapes, which he shared with Brunelleschi and Alberti. San Satiro was a ninth-

14.10 Leonardo da Vinci, plans and perspective views of domed churches, c. 1490. Pen and ink. Institut de France, Paris.

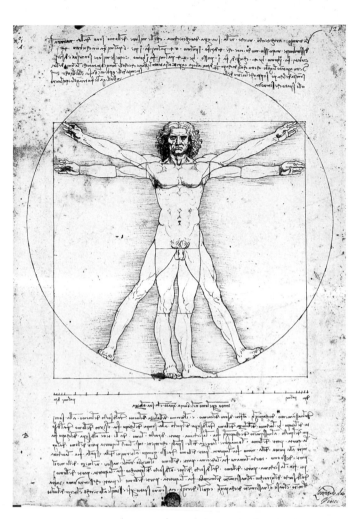

14.11 Leonardo da Vinci, *Vitruvian Man*, c. 1485–1490. Pen and ink; 13½ × 9⅝ in. (34.3 × 24.5 cm). Gallerie dell'Accademia, Venice.

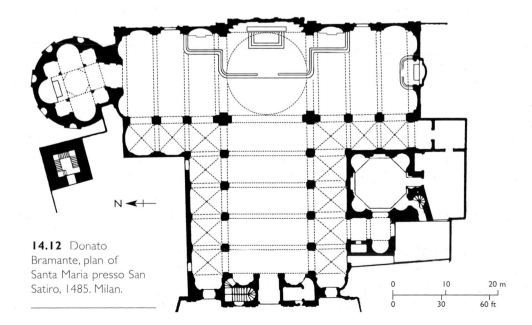

14.12 Donato Bramante, plan of Santa Maria presso San Satiro, 1485. Milan.

century church remodeled by Bramante, who appropriated the Early Christian Greek-cross plan for the baptistery. The dome, characteristic of Early Christian design, is inscribed in a square at the crossing, and the large, coffered barrel vaults are supported by the piers of the nave. The choir (**14.13**), which at first glance appears to recede a normal distance beyond the crossing, is only a few inches in depth—blocked by the street outside. Dealing with the existing space in an original way that made use of his talents as a painter, Bramante used stucco relief to create an illusionistic choir.

Around 1492, Lodovico Sforza commissioned a new apse and transept for the existing Dominican Gothic church of Santa Maria delle Grazie, which housed his family chapel and was to be his burial place. It is generally assumed that the conception is Bramante's, although none of the commission documents survives and other architects, including Leonardo, are thought to have assisted him. The plan (**14.14**) is more centralized than that of Santa Maria presso San Satiro, and the choir is deeper. But the shapes are regular, and the crossing is a large cube surmounted by a dome and flanked by symmetrical apses. The view of the interior (**14.15**), as in the earlier building, shows the circular surface decorations—wheellike windows that seem capable of rotating—on round arches to create an effect of lightness and expanding space.

In 1499, the French invaded Milan and Bramante left for Rome, where he laid the foundation of High Renaissance architecture.

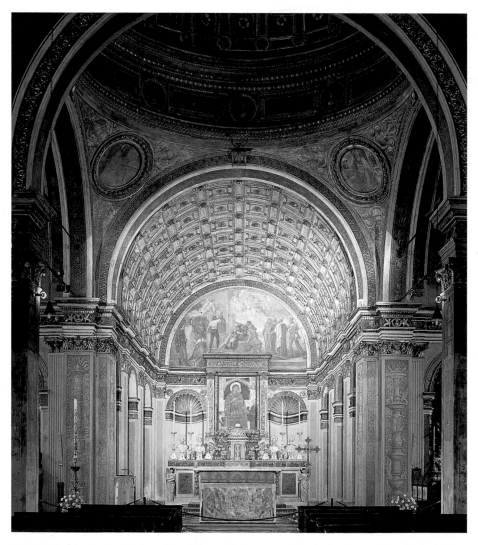

14.13 Donato Bramante, interior of Santa Maria presso San Satiro toward the choir, 1485. Milan.

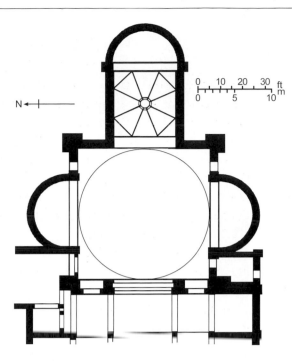

14.14 Donato Bramante, plan of Santa Maria delle Grazie, begun 1492. Milan.

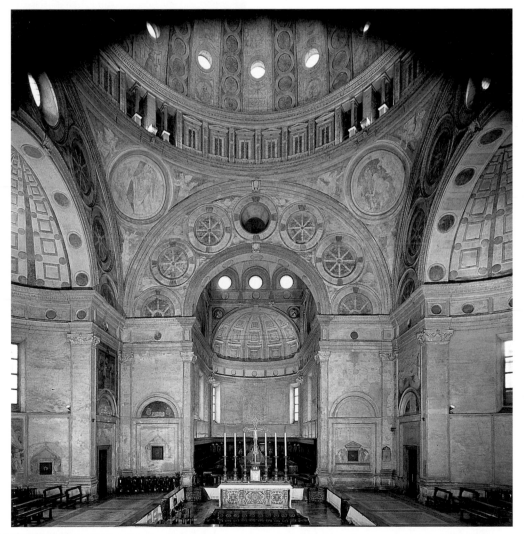

14.15 Donato Bramante, interior of Santa Maria delle Grazie toward the choir, begun 1492. Milan.

Lodovico and Leonardo

As Lodovico's court artist, Leonardo's duties included constructing theatrical devices for pageants and designing weapons that could be used against the enemies of Milan—including the artist's Florentine compatriots. Such constructions appealed to Leonardo's inventive mind, and also satisfied his demanding patron. His design for a catapult (**14.16**), for example, shows a formidable war machine on wheels, which could fire up to a hundred pounds of stone. It was operated either by tripping the lever or by striking the trigger (at the left) with a hammer (at the right).

Leonardo was justly renowned for his skill in portraiture, in which he conveys the sense of an interior character just as his *Saint Jerome* depicts the anatomical interior. Around 1483, shortly after his arrival in Milan, Leonardo painted the *Cecilia Gallerani (Lady with an Ermine)* (**14.17**), Lodovico's well-educated and noble sixteen-year-old mistress. Cecilia's refinement matches Leonardo's; her dress, hairstyle, and necklace are precisely, even primly, rendered with emphasis on material textures.

The three-quarter view, with the head turned sharply to the right, is a departure in late fifteenth-century portraiture. Mirroring Cecilia's pose, in a related

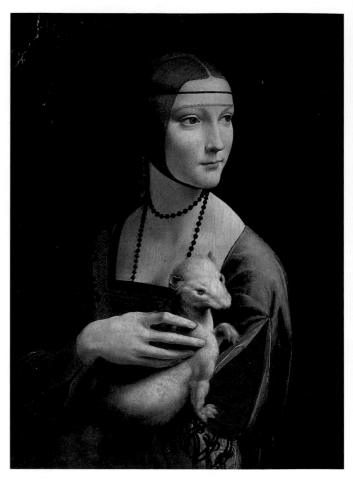

14.17 Leonardo da Vinci, *Cecilia Gallerani (Lady with an Ermine)*, c. 1483–1485. Oil on panel; 21 × 15½ in. (53.4 × 39.3 cm). Czartoryski Museum, Cracow.

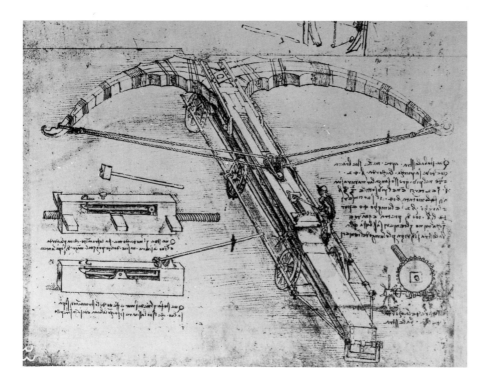

14.16 Leonardo da Vinci, design for a catapult, c. 1487–1490. 8 × 10⅞ in. (20.3 × 27.5 cm). Biblioteca Ambrosiana, Milan.

but more "finished" way than the cats in the drawing of the *Child Playing with a Cat* (see 14.4), is the ermine. Its pointed snout, directed gaze, and delicate paws repeat the crisp features, gaze, and gesture of the woman. Cecilia's identification with the aristocratic ermine (its fur was highly prized in the Renaissance, and it was a popular heraldic device) is contained in the pun on its name—*galé* being the Greek word for "ermine."

In the large mural of the *Last Supper* (**14.18**), Leonardo produced a monumental study of *istoria* in which pose and gesture create narrative and reveal psychology. It was commissioned by Lodovico for the north

wall of the oblong refectory of Santa Maria delle Grazie, from which it originally faced a *Crucifixion* on the south wall. At every meal, the Dominicans could thus meditate on the image of Christ's Last Supper. The illusionistic extension of the room beyond the wall is in the tradition of Masaccio's *Trinity* (see 4.7) and Castagno's *Last Supper* (see 6.16).

Leonardo records a sequence of moments in which the apostles react to Christ's announcement that one of them will be his betrayer. Each apostle responds according to his biblical character. Saint Peter grabs a knife in anger, reflecting his quick temper and foreshadowing

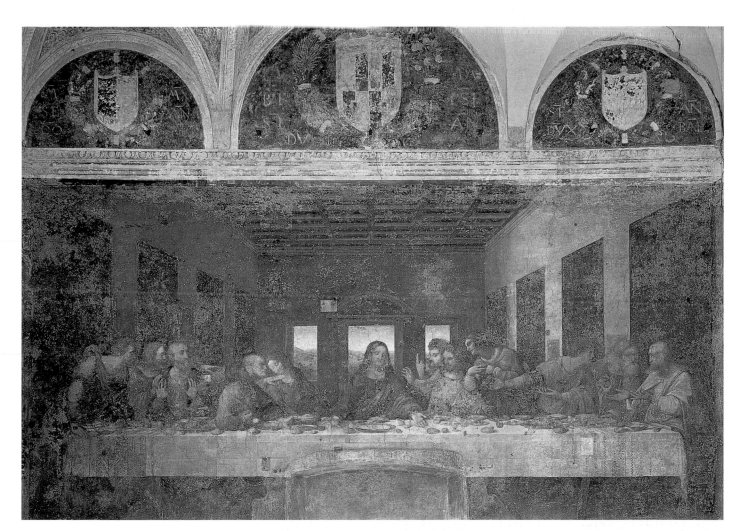

14.18 Leonardo da Vinci, *Last Supper,* c. 1495–1498. Fresco, oil, and tempera on plaster; 15 ft. 1⅛ in. × 28 ft. 10½ in. (4.6 × 8.6 m). Santa Maria delle Grazie, Milan. The recent completion of a twenty-year restoration project has left several figures with little or no facial features, which were subsequently repainted. This photograph precedes the latest restoration and shows the damaged state of the picture. Leonardo himself is partly responsible for this state of affairs: unable to maintain the speed of execution necessary to fresco painting, he applied oil and tempera to dry plaster, which failed to bond with the wall. Not long afterward, the paint began to flake.

the Kiss of Judas, when he angrily cuts off the ear of the servant Malchus. The youthful Saint John falls toward Peter in a faint, and Judas leans away from Christ, forming a sharp diagonal. To the right of Christ, Doubting Thomas, grouped with Saints James the Less and Philip, points heavenward in a gesture of questioning. All the apostles, including Judas, who is usually opposite the others, are on the same side of the table.

The focus on Christ is accentuated by the correspondence of perspective with content. His head is framed by the central window, its round arch a symbolic halo. Symmetry in form and color is maintained throughout; the apostles are arranged in four groups of three—there are three windows on the back wall and four tapestries on each side wall. The orthogonals, visible in the ceiling beams, direct the viewer toward the vanishing point at Christ's head. But they can equally be read in reverse, as lines of sight radiating *from* the head of Christ as a source of divine light.

Echoing this perspectival configuration are Christ's outstretched arms, which also create a triangle, referring to the Trinity. The related gesture made by James the Less recalls the biblical statement that he is the Lord's brother (Galatians 1:19). Both gestures allude to the Crucifixion, Christ's by deliberate action, James's

by instinctive *re*-action. The table itself, with still-life objects including bread and wine, is a metaphor for the altar—here the altar on which Christ both announces his own sacrifice and enacts it by the visual metaphor of his pose and gesture.

Repeating the round arch over the window are the actual lunettes on the real wall. These bear the names and arms of Lodovico Sforza and his wife, Beatrice d'Este, who married him in 1491, when she was fifteen. Six years later, before Leonardo had completed the *Last Supper*, she died.

Another commission of great importance to Lodovico was the equestrian monument of his father, which Leonardo mentioned in the letter offering his services in Milan. The idea had first occurred to Galeazzo Maria, but he was assassinated before it could be realized. Leonardo produced many drawings and models for the so-called *Horse*, which would require around 200,000 pounds of bronze. The drawing study in figure **14.19** shows the dynamic movement of horse and rider, with each turned in an opposing direction. Below the rearing horse lies a fallen enemy, which had also been a feature of the *Marcus Aurelius* in Rome (see 6.5). Not only would the *Horse* have been much bigger than either Donatello's *Gattamelata* (see 7.8) or Verrocchio's *Colleoni* (see 10.12), it would, at this stage of Leonardo's thinking, have been more expansive, conveying a greater sense of vigorous movement in space. In fact, however, French troops invaded Milan in 1499, and Lodovico left the city. He returned the following year, only to be imprisoned at Loches, in France, where he died in 1508. French soldiers destroyed the large model of the *Horse*, and the bronze was used to cast a cannon.

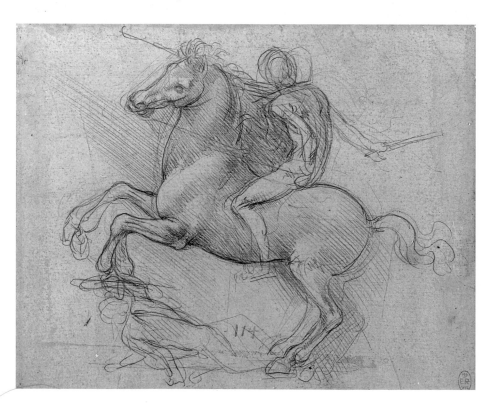

14.19 Leonardo da Vinci, study for the monument to Francesco Sforza, c. 1488–1490. Royal Collection, Windsor Castle, Inv. 12358, ©2000 Her Majesty Queen Elizabeth II.

Leonardo's Later Work

After the death of Lodovico Sforza, Leonardo returned to Florence, although he traveled back and forth to Milan until 1513, at which time he went to Rome to work for the Medici pope Leo X. While in Florence, Leonardo began two of his most enigmatic works: the *Madonna and Child with Saint Anne* (**14.20**) and the *Mona Lisa* (**14.21**). The former depicts three generations in a type of pyramidal composition first devised by Leonardo. Saint Anne, the mother of Mary, is the figural foundation on which her daughter seems precariously perched. Mary, in turn, reaches out toward Christ, who

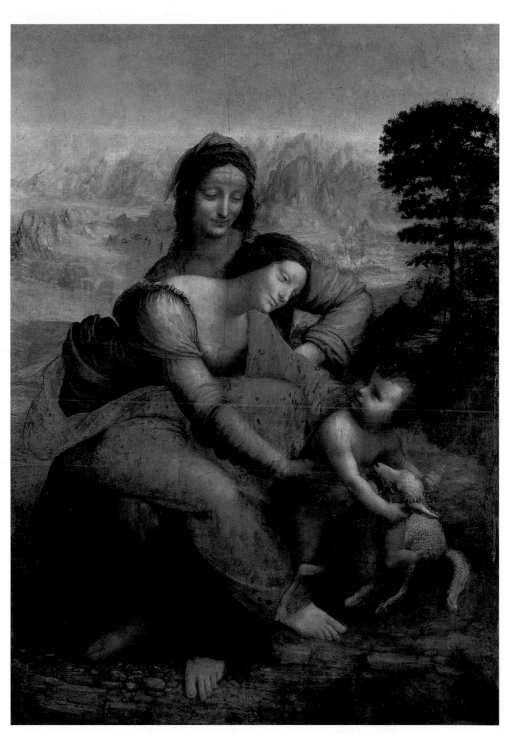

14.20 Leonardo da Vinci, *Madonna and Child with Saint Anne*, 1503–1506. Panel; 5 ft. 6⅛ in. × 3 ft. 8 in. (1.68 × 1.12 m). Musée du Louvre, Paris.

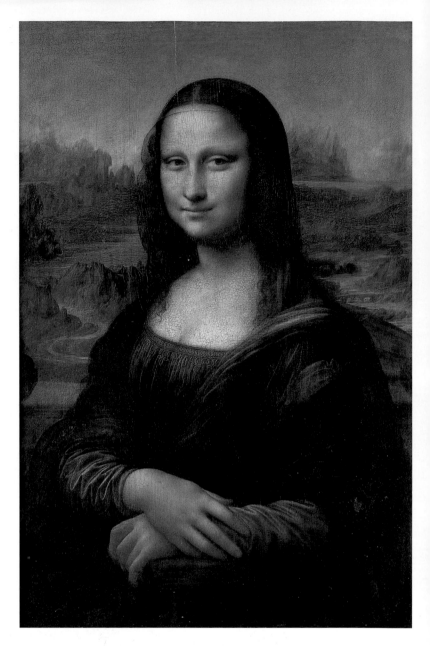

14.21 Leonardo da Vinci, *Mona Lisa*, c. 1503–1515. Oil on wood; 30¼ × 21 in. (76.8 × 53.3 cm). Musée du Louvre, Paris. In 1911, the *Mona Lisa* was stolen from the Louvre by an Italian housepainter who believed that her rightful place was Florence, her city of origin. The picture was, for a short time, exhibited in the Uffizi and visited by hordes of people, many of whom had never before seen the inside of a museum. It was then returned to the Louvre, where *Mona Lisa* was accorded a heroine's welcome. When the painting later crossed the Atlantic to be exhibited in New York City's Metropolitan Museum, it occupied a first-class stateroom and was accompanied at all times by an armed security guard.

returns her intent gaze while mounting a lamb. This alludes to Christ's acceptance of his sacrifice, but it is not clear whether Mary is holding him out toward the lamb or pulling him back. Nor is the odd smile of Anne readily explicable.

The detailed depiction of the foreground rocks is reminiscent of Verrocchio's *Baptism* and reflects Leonardo's close observation of nature. In the background, Leonardo used the misty blue *sfumato* he recommends for horizons in his treatise on painting, whereas a muted yellow light softens the flesh tones of the figures. *Sfumato* itself requires the use of oil paint and glaze, which in the background produces a dreamlike quality. As in the *Saint Jerome*, there is a correspondence between the figures and their setting; here, the blue-gray shapes of the mountains echo the figures, and the filtered light in the mist is repeated in Saint Anne's veil. In contrast to the substantial weight of the figures, the distant landscape has a quality of lightness and unreality found again in the background of the *Mona Lisa*.

One of the most intriguing features of the *Madonna and Child with Saint Anne* is the similarity in age between Anne and Mary, who would in reality have been far apart in age. This has been a matter of some controversy, first sparked by Freud in his 1910 psychobiography of the artist (see Box, p. 311). Freud explained the two young mothers as projections of Leonardo's childhood experience; at first he spent time exclusively with his natural mother, Caterina, but five years later his father married Donna Albiera and brought Leonardo into his household. The two young mothers in the painting would thus represent Leonardo's own childhood reality.

The enigmatic *Mona Lisa* (14.21) has been one of the most controversial images in the history of art. According to Vasari, the woman in the picture was the wife of a Florentine aristocrat, Francesco del Giocondo (hence "La Gioconda," or the "smiling woman"). But it is not entirely certain that she is smiling; it could be that the slight upward movement of the shading at the corners of the lips, reinforced by the shading at the corners of the eyes, only creates the *impression* of a smile. In the latter case, Leonardo would have himself enhanced the merest hint of a smile, just as Vasari claims that he hired jesters to keep his sitter amused.

Rendered in pyramidal form and three-quarter view to below her waist, Mona Lisa is seated on a balcony between two columns that have been cut about an inch

on either side. As in the *Madonna and Child with Saint Anne*, Leonardo uses a different **palette** for the foreground and background light, the former being primarily a muted yellow-gold and the latter a blue *sfumato*. The imaginary landscape—it does not resemble any known location—corresponds formally to Mona Lisa herself, reflecting once again Leonardo's metaphor equating the human body to the earth. Her shape repeats the distant triangular mountains, and her veil, like the mist, filters light. At the left, the spiral road winding toward the figure echoes the folds of her sleeves and the edges of her fingers. To the right, the aqueduct curves into the drapery over Mona Lisa's left shoulder. The fact of such correspondences is not new —they were used for political purposes in Piero della Francesca's diptych portraits of Battista Sforza and Federico da Montefeltro (see 9.19). But Leonardo elevates the image to a mythic level by metaphor that eludes a textual underpinning. There is no identifiable political subtext, as in Piero's portraits; nor is there a Christian story, as in the *Saint Anne*, to which the image can be related. Furthermore, little is known of the identity of either the sitter or the patron.

The power of the *Mona Lisa* is reflected in the fact that each succeeding generation of viewers, critics, writers, artists, and scientists has read her expression according to their own time and place. Critics such as Walter Pater saw her as sinister and aloof in the manner of the nineteenth-century "belle dame sans merci." Pater described Mona Lisa as "older than the rocks among which she sits; like the vampire, she has been dead many times, and learned the secrets of the grave. . . ."

In 1910, Freud read her smile as a memory of the smile of Leonardo's mother. Later in the twentieth century, a physician claimed that her pose and air of contentment indicated that she was pregnant. And a computer-generated image of the painting was cited to prove that she was actually Leonardo's self-portrait. She has been turned into a Dada icon by Marcel Duchamp, who added a beard and mustache to a reproduction of her, and into a Pop Art multiple by Andy Warhol. She has been the subject of poems, songs, jokes, and, between art historians and psychoanalysts, on-going methodological debate.

Leonardo's passion for the earth as a synthesis of art and science is apparent in his maps. Figure **14.22**

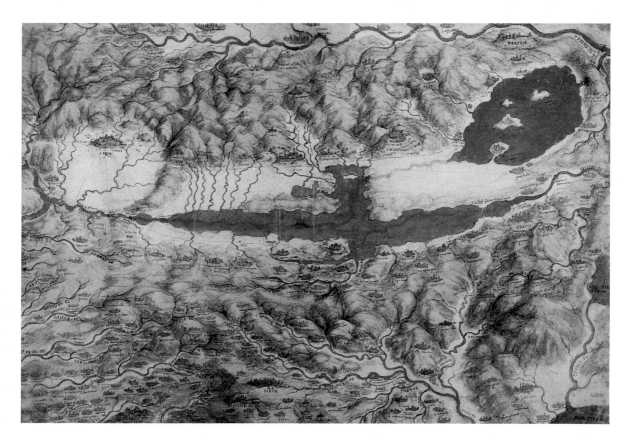

14.22 Leonardo da Vinci, bird's eye map showing Arezzo, Borgo San Sepolcro, Perugia, Chiusi, and Siena, c. 1502–1503. Pen, ink and color; 10¾ × 15¾ in. (27.3 × 40 cm). Royal Library, Windsor.

is a map of parts of central Italy, including Arezzo, Perugia, Cortona, and Siena. It is one of the first relief maps that use shading to indicate surface altitudes, with the darker areas denoting lower-lying terrain and the lighter the hilltops. Such maps could serve as military aids and as guides for irrigation and agriculture. They reflect contemporary global exploration and discovery as well as Leonardo's continual creative experimentation with nature.

In his drawing *Old Man Contemplating the Flow of Water Around a Stake* (**14.23**), Leonardo makes explicit his metaphorical thinking and his ability to merge words and images, lines and shapes in ways that convey his visual imagination. Here the notion of flowing water is condensed with an image resembling flowing hair. The waves of each are precisely indicated by lines of varying density. The old man's presence and his contemplative pose endow the drawing with a philosophical cast, indicating that he uses his mind as well as his vision to discover correspondences between nature and the human figure. The visual metaphors that are manifest in drawings such as this one are reworked in the *Mona Lisa* and embedded in the more

complex technique of a finished painting. As a result, they become latent content and are more difficult to unravel. In a work such as the *Saint Jerome*, on the other hand, the unfinished character of the picture is transitional between drawing and painting, and the latent content of the anatomy is allowed to remain visibly manifest.

For the last ten years of his life, Leonardo produced mainly drawings and inventions. In 1506, he returned to Milan, summoned by Giangiacomo Trivulzio, originally a *condottiere* in the employ of Lodovico Sforza. But Giangiacomo switched sides when the French invaded and led the troops of the French king. He commissioned Leonardo to execute another equestrian monument—to himself—which never progressed beyond the stage of drawing studies. In 1513, Leonardo was invited to Rome by Pope Leo X and spent the next four years traveling back and forth to Florence. In 1517, he went to France and worked for King Francis I. He lived at Cloux, near the king's château at Amboise, drawing and entertaining the king. The *Mona Lisa*, still in Leonardo's possession at his death, became part of the French royal collection, housed today in the Louvre.

14.23 Leonardo da Vinci, *Old Man Contemplating the Flow of Water Around a Stake (An old man seated in profile: four studies of swirling water)*, c. 1500. Drawing. Royal Collection, Windsor Castle.

CONTROVERSY

Freud, Leonardo, and Art History: A Methodological Squabble

The ongoing debate between art historians and psychoanalysts about Freud's 1910 psychobiography of Leonardo is largely methodological. Freud noted that in all of Leonardo's notebooks, there is only one reference to his childhood; the psychoanalyst used his reading of it to explain the *Mona Lisa*'s smile. Leonardo recalled a bird alighting on his cradle and striking his lips with its tail feathers. To this Leonardo attributed his lifelong interest in birds, particularly the kite, which was the bird in question.

Using the principles of psychoanalysis, Freud interpreted this event as a type of screen memory—that is, a vivid early memory (before the age of seven)—in which a later memory "screens" an earlier event. Comparing psychoanalysis to archaeology, Freud believed that the remembered event is like the fragment of an ancient object and the actual event like the reconstructed object. Just as the archaeologist writes cultural history from the physical remains of a site, so the psychoanalyst reconstructs childhood by interpreting mental artifacts such as dreams, memories, fantasies, mistakes, and symptoms. In all such cases, the present yields clues to the past.

Freud interpreted Leonardo's memory as a homoerotic fellatio fantasy because of the artist's passivity in relation to the phallic bird (in Italian, *uccello*, meaning "bird," is slang for "phallus"). He concluded that Leonardo had become a type of "ideal" homosexual character and had sublimated his sexuality into his work. This, he said, was made more likely by the absence of Leonardo's father during his first five years and by an intensified closeness to his mother. Further, Freud related Leonardo's scientific investigations and his obsession with the origin of children to his absent father and his youthful ignorance of the father's role in procreation.

With regard to Leonardo's work, Freud addressed both his working procedure and his iconography. The artist's obsessiveness, according to Freud, slowed him down and partly explains the unfinished pictures, the investigative experimentation, and the inability to work in fresco that led to the deterioration of the *Last Supper*. Leo X, according to Vasari, became so frustrated by Leonardo's obsessive working procedures that he declared, "Alas! this man will never do anything, for he begins by thinking of the end of the work, before the beginning." With regard to Leonardo's iconography, Freud identified Mona Lisa's smile as the reawakened memory of his mother's smile and noted that it recurred in other paintings of women such as the *Madonna and Child with Saint Anne*.

In the 1950s, these views were vigorously attacked by art historian Meyer Schapiro. Taking Freud to task for failing to do his research, Schapiro discovered that Freud had used a mistranslation of the species of Leonardo's bird; it was, in fact, a kite, whereas Freud believed it to have been a vulture. Freud argued that vultures are devoted and nurturing mothers and that Leonardo had been overstimulated by his mother's seductive attentions. Schapiro pointed out that kites are just the opposite and, thus, Leonardo would have viewed his mother as negative and destructive. He explained the smile as inspired by Verrocchio's sculptures of smiling children rather than by a memory trace of Leonardo's past. And he disagreed with Freud's reading of the youthful mothers in the *Madonna and Child with Saint Anne*.

Most art historians agreed with Schapiro in rejecting Freud's methodology, although the English critic Kenneth Clark found the reading of the *Madonna and Child with Saint Anne* to be convincing. Then in 1961, psychoanalyst Kurt Eissler revisited the issue and published a resounding rebuttal of Schapiro. While acknowledging Schapiro's corrections of Freud's historical errors and mistranslation of the bird, Eissler observed that the dynamics of Freud's interpretations were not changed by them. He argued that mothers who are seductive or aggressive toward their male infants can encourage homosexual identifications, as can the absence of a father. Eissler noted that Schapiro's art-historical insistence on manifest facts ignored the underlying operation of human ambivalence and dynamic tension.

Leonardo himself, especially in his metaphorical drawings, bears out Eissler's (and Freud's) view that man is a system in conflict. There is, in fact, no better illustration of that fact than the very conflict between traditional art history, which deals primarily with manifest content, and psychoanalysis. For the latter, what is manifest is the tip of the iceberg, whether one is dealing with living people or their creative products.

15
Michelangelo and Raphael:
The Late Fifteenth Century to 1505

The next two giants of High Renaissance art to follow Leonardo in the monumental traditions of the fifteenth century were Michelangelo (1475–1564) and Raphael (1483–1520). Michelangelo produced his major early works in Florence and Rome; Raphael's were made in Urbino, Perugia, and Florence. In both instances, the artists gravitated primarily to Florence and Rome, which were the major centers of patronage.

Florence, however, had undergone considerable changes beginning with the expulsion in 1494 of Lorenzo de' Medici's ineffectual son. After Savonarola's execution in 1498 and in the absence of the Medici, the city set about trying to restore the image of a stable republican government. To this end, Florentines elected the patrician Piero Soderini (1452–1522) to a life term as *Gonfaloniere*. Following the model of the Medici, imagery would be a primary medium of the new government's desired political message.

Some of the most important works from the Medici collection were confiscated by the Signoria and transferred to the Palazzo Vecchio. These included Donatello's *Judith and Holofernes*, which was placed outside the front entrance of the Signoria. Exhibited inside were Pollaiuolo's paintings of the *Labors of Hercules*, Uccello's *Battle of San Romano*, and Donatello's bronze *David*. All had had political significance that had previously enhanced the republican image of the Medici, and in their new context they conveyed a similar, even more overt, political meaning. In addition, from Leonardo and Michelangelo the Signoria commissioned large scenes depicting famous battles between Florence and its enemies for the walls of the Great Council Hall. Although spurring a sense of competition between Leonardo and Michelangelo, neither commission progressed much beyond the drawing stage.

Private individuals in Florence also continued to employ the leading artists, whose work reflects the interplay of mutual influence among them. This is particularly evident in the influence of the work of Leonardo on Raphael, although there is little documentary evidence of their acquaintance with each other.

Michelangelo: Florence and Rome

Michelangelo Buonarroti was born in the Apennine village of Caprese; his father was a minor civil servant with social pretensions. The subject of three major biographies, two by Vasari and one by Ascanio Condivi, Michelangelo's life is relatively well documented. In addition to working as a painter, sculptor, and architect, Michelangelo wrote poetry, which provides another avenue of access to his mind and character. At his birth, he was sent to live for two years with a wet nurse and her husband, who was a stonecutter. This circumstance led the artist to tell Vasari that he had imbibed the tools of his trade with the milk of his nurse, a notion that has autobiographical meaning and also reveals Michelangelo's view that genius is innate.

When Michelangelo was six years old, his mother died. His early ambition to become a sculptor was opposed by his father, who considered sculpting to be low-class manual labor. He relented only partially when, in 1488, he apprenticed his son to the popular painter Domenico Ghirlandaio. The apprenticeship, however, was brief, for Michelangelo's real teachers were Giotto and Masaccio. The young Michelangelo spent hours in Santa Croce and Santa Maria del Carmine drawing the painted figures of his monumental predecessors.

In a variation on the conventional discovery story, tradition has it that Michelangelo found a surrogate father who immediately appreciated his genius. This was none other than Lorenzo the Magnificent, who invited the fifteen-year-old artist to reside at the Medici Palace, where he could study the ancient statues in the Medici garden and participate in the humanist dis-

course of the Medici circle. Michelangelo shared with the humanists a profound belief in the dignity of man and an interest in Neoplatonism.

Throughout his life, Michelangelo thought of himself as a sculptor, whose work, in contrast to Leonardo's view, he defended as superior to painting. This he applied particularly to marble carving on the grounds that it is a subtractive, rather than an additive, process, as are modeling, bronze casting, and painting. For Michelangelo, the essence of artistic creation was the ability to reveal the form immanent in an existing block of stone and not to build up form on a surface. Even his painted figures appear carved from stone.

The early relief sculpture, executed just before Lorenzo's death and depicting the Greek mythological *Battle of the Lapiths and Centaurs* (**15.1**), illustrates the radical difference in Michelangelo's approach to

15.1 Michelangelo, *Battle of the Lapiths and Centaurs*, c. 1492. Marble; 33¼ × 35⅝ in. (84.5 × 90.5 cm). Casa Buonarroti, Florence.

the plane of a relief compared to that of Donatello (see 3.26). By carving the figures nearly in the round, Michelangelo obscures the background, which corresponds to the picture plane of a painting. Aside from the chisel marks in the rectangular space framing the scene, the viewer barely notices that the figures are not quite independent of the original stone. As a result, there is little sense of spatial context, and the image is all-over figures.

Because of the violent event depicted—the Lapiths are hurling large stones at the struggling Centaurs, who have disrupted a Lapith wedding by attempting to rape both the bride and the guests—the figures are a writhing mass of intertwined forms. Michelangelo's mastery of the human figure, evident even here at around the age of seventeen, is consistent with humanist philosophy and the Classical revival. Some of the Lapiths seem derived from ancient art, notably the third from the left who resembles dancing figures on vase paintings and sarcophagi. The only female, seen from the back and third from the right, is probably Hippodamia, the Lapith bride. The subtext of the myth, which Michelangelo would have known through Ovid, Boccaccio, and his contemporary, Angelo Poliziano, all of whom wrote about it, equates the impulsive behavior of the Centaurs to their animal nature. The Lapiths were Greeks and, therefore, associated with human reason. Michelangelo, emphasizing the dignity of man, mitigates the depiction of the lower, horse-half of the Centaurs' bodies by making them nearly invisible to the casual observer.

Lorenzo's death in 1492 ended Michelangelo's residence at the Medici Palace. The artist left Florence, traveling to Venice and Bologna before settling, around the age of twenty-one, in the Rome of Pope Alexander VI. Michelangelo's first major Roman work was the marble *Bacchus* (**15.2**), a pagan subject reflecting his involvement with humanists in that city. It was commissioned by Cardinal Raffaelle Riario, a nephew of Pope Sixtus IV, and ended up in the possession of the wealthy Roman banker Jacopo Galli. Galli selected the work for his garden collection of statues inspired by antiquity.

Michelangelo depicts the wine god as a monumental nude, holding a wine cup and staggering slightly from drink. The effete fleshiness, which is untypical of Michelangelo's approach to the nude, and the

15.2 Michelangelo, *Bacchus*, 1496–1497. Marble; 6 ft. 8 in. (2.0 m) high. Museo Nazionale del Bargello, Florence.

clusters of grape leaves and grapes in Bacchus's hair may have been related to ancient accounts of Bacchanalian orgies. Likewise, the youthful satyr savoring a bunch of grapes entwined in Bacchus's leopard (or panther) skin signifies lust.

Indicating Bacchus's drunken state is the unsure *contrapposto* pose and the sharp backward thrust of the upper torso countered by the forward diagonal of the head and lower torso. The bent leg wavers as Bacchus seems to test the ground with his right foot. Michelangelo has thus transformed the

conventional Classical pose of the standing male, also used by Donatello for his bronze *David* (see 3.8), into an image of erratic—and erotic—instability.

It is likely that Jacopo Galli was instrumental in arranging Michelangelo's second major commission in Rome. The French ambassador to the Holy See, Cardinal Jean Bilhères de Lagraulas, signed a contract in November 1497 for a *Pietà* that would be the most "beautiful marble statue in Rome" (**15.3**). A subject more popular in Northern Europe (especially Germany) than in Italy, the image of

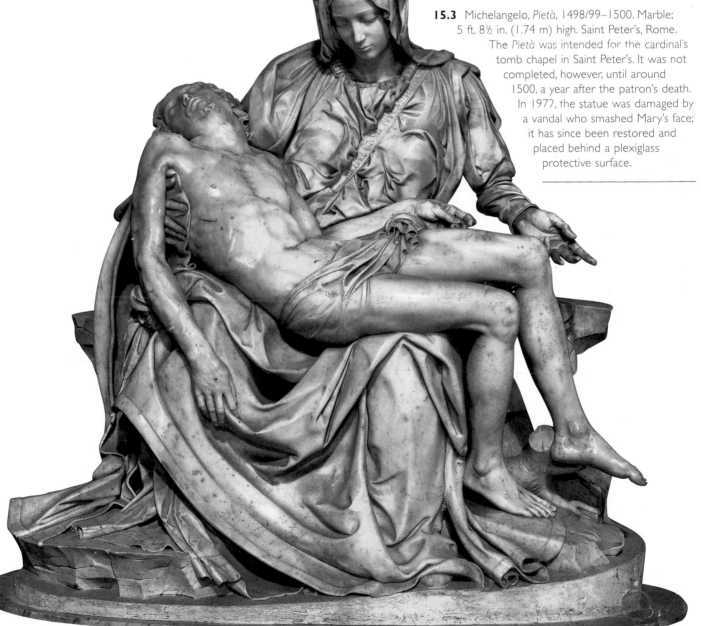

15.3 Michelangelo, *Pietà*, 1498/99–1500. Marble; 5 ft. 8½ in. (1.74 m) high. Saint Peter's, Rome. The *Pietà* was intended for the cardinal's tomb chapel in Saint Peter's. It was not completed, however, until around 1500, a year after the patron's death. In 1972, the statue was damaged by a vandal who smashed Mary's face; it has since been restored and placed behind a plexiglass protective surface.

the dead Christ stretched across Mary's lap was probably the choice of the patron. But Michelangelo changed Christ from a gaunt figure in the throes of rigor mortis and Mary from a middle-aged matron into the classically idealized forms of the Italian Renaissance.

In contrast to the Northern versions of the *Pietà*, Christ's body does not extend stiffly outward on either side of Mary's lap. Instead, Mary has been enlarged and Christ made smaller so that his form blends harmoniously with hers. He also retains his living muscle tone, appearing to be sleeping rather than deceased. Mary's expansive pyramidal form and the unity of her limbs and drapery with Christ's pose solve the problem of fitting a grown man on a woman's lap. When asked about Mary's youthfulness—she would have been in middle age at Christ's death—Michelangelo allegedly replied that chasteness preserves the body's youth.

By ignoring the historical reality of age, Michelangelo elevates the figures above the sequential time of the viewer and transports them into a timeless realm. This corresponds to the future role of Christ and Mary as the eternal King and Queen of Heaven.

The *Pietà* is signed on the strap across Mary's chest, the only known signature on any of Michelangelo's works. This has often been related to his metaphor of drinking in the hammer and chisel with his wet nurse's milk and seems to reflect his special interest in the statue. Not only was the *Pietà* his first monumental religious work, which he executed at the remarkably young age of twenty-three, but it was the one he most carefully polished. In contrast to many of his other sculptures, this one is "finished" in every respect.

By May 1501, Michelangelo was back in Florence, possibly for a commission in Siena Cathedral. He

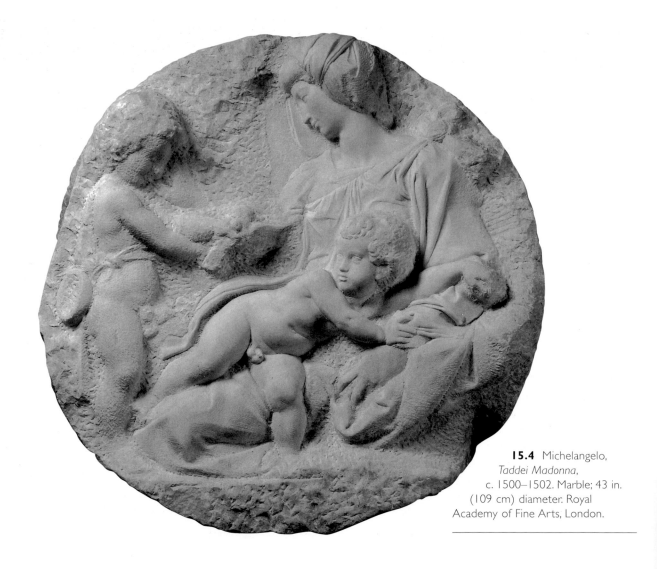

15.4 Michelangelo, *Taddei Madonna*, c. 1500–1502. Marble; 43 in. (109 cm) diameter. Royal Academy of Fine Arts, London.

remained until 1505. Among his works during his Florentine stay was the *Taddei Madonna* (**15.4**), which reveals his development in relief sculpture after the *Battle of the Lapiths and Centaurs* (see 15.1). In the later work, the surface is less animated and the tension is expressed psychologically rather than through physical violence. Its subject, the Madonna and Christ, was one that preoccupied Michelangelo throughout his career. The unusual iconography of the relief shows John the Baptist, his baptismal cup at his back, holding out a bird toward Christ. Christ, in turn, registers apprehension and runs for the safety of Mary's lap. Mary also gazes at the bird, of which she seems to be more accepting than is Christ. Michelangelo, like Leonardo, thus depicts aspects of the underlying ambivalence regarding Christ's earthly mission—here, it is Christ's ambivalence; in Leonardo's *Madonna and Child with Saint Anne* (see 14.20), it is the Virgin's—and possibly Saint Anne's—as well as Christ's. John the Baptist sets into motion the events leading to Christ's Crucifixion when he baptizes him (with the cup) and hands him the bird, probably the goldfinch that symbolized Christ's Passion. Michelangelo's assimilation of Neoplatonism from contact with the Medici circle of intellectuals is evident in the derivation of Christ's pose from a Classical Medea sarcophagus.

In contrast to the *Battle of the Lapiths and Centaurs*, the plane of the *Taddei Madonna* relief is very much present. Chisel marks create a sense of process, enhanced by the lower relief of the figures, who seem, as in many of Michelangelo's unfinished works, to be literally in the process of emerging from the stone. This is one of many works that Michelangelo would leave unfinished.

CONTROVERSY

Michelangelo and the "Marble Breast"

The *Taddei Madonna* became a source of methodological controversy when the psychoanalyst Robert Liebert read it in terms of the artist's biography. Based on clinical experience, he argued that Michelangelo would have felt doubly abandoned by his mother—first when he was sent to a wet nurse, and then when she died. The use of a Medea sarcophagus as a source for the tondo, in Liebert's view, reflected Michelangelo's image of a murderous mother, which he projected onto the Madonna of the tondo. Further, his image of a cold mother evoked his own oral rage, which led him to choose marble as a medium. In working the marble, according to this reading, Michelangelo symbolically and sadistically retaliated against her for twice deserting him.

Vehemently objecting to this particular psychoanalytic approach to the artist, the art historian Leo Steinberg pointed out that Michelangelo would not have known that the subject of the sarcophagus was Medea even if he had known the sarcophagus itself. It was not identified as a Medea sarcophagus until the eighteenth century, and the children on it are playing ball, not fleeing in terror. Steinberg also rebutted the concept of the "cold breast" and its relationship to Michelangelo's preferred medium. He noted that there is not enough information about the artist's childhood to conclude that he felt rage toward his mother. He might, according to Steinberg, have had a good time with his wet nurse and been doted upon by his mother when he returned home. In addition, he points out,

there is no evidence of a connection between marble and Michelangelo's feelings about his mother.

The problem with reading the aloof Madonnas of Michelangelo as his own projection of abandonment—as those of Giovanni Bellini have also been read—is that the text of Christianity accounts for such iconography. Mary had foreknowledge of Christ's sacrifice, and her downcast, distant expression became a conventional way of prefiguring her mourning. At the same time, however, artists create out of their own experience as well as from convention, and certain artists may have been more drawn to the aloof characterization of the Madonna than others. It is also true that Christ's ambivalence is part of the Christian text. Since Renaissance artists depicted human psychology as well as human form, they inevitably delved into the latent emotions of their figures.

Another important issue in Michelangelo studies is his *non-finito*, or habit of leaving works unfinished, as he did the *Taddei Madonna*. It has been suggested that because he was more likely to abandon sculptures than paintings, he was identifying with his father's objection to his becoming a sculptor. But Steinberg believes that later frustrations and a preference for working under a deadline have more to do with the *non-finito* than his relationship to either of his parents. This continues to be a puzzling aspect of Michelangelo's career as well as of Leonardo's, and in general art historians and psychoanalysts approach the issue from very different methodological angles.

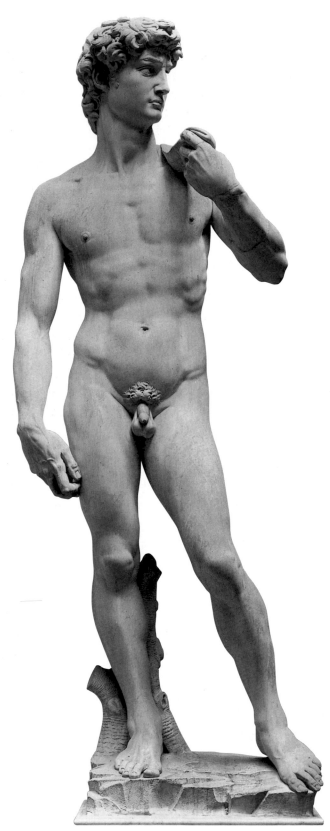

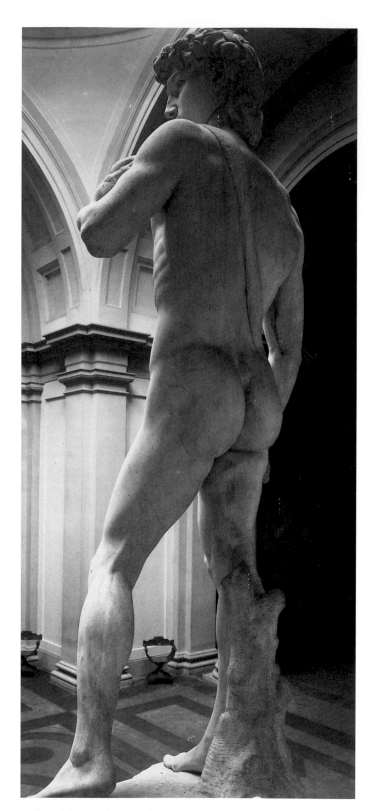

15.5a and **b** Michelangelo, *David*, 1501–1504. Marble; approximately 17 ft. 1½ in. (5.22 m) high. Gallerie dell'Accademia, Florence. Michelangelo's identification with the character of the biblical David, as well as with his own sculpture, has been

deduced from a drawing sheet containing a study of the arm. He wrote on the sheet, "David with the sling and I with the bow, Michelangelo." The bow, or *arco*, refers to the drill he used on the marble.

During the same period, Michelangelo completed the marble *David* (**15.5a** and **b**), easily the most significant statue commissioned during the period of the republican revival after the expulsion of the Medici. The original commission of 1501 from the Arte della Lana was for a marble *David* on the exterior of Florence Cathedral. But when the statue was finished in 1504, it was decided instead that it would replace Donatello's *Judith and Holofernes* (see 10.3 and 10.4) at the entrance to the Palazzo Vecchio. This politically motivated decision reflected the importance of the biblical David as a symbol of the Florentine state.

Carved from a 14-foot block of marble known as "the Giant," Michelangelo's figure exemplifies the humanist dignity of man. It is a powerful, monumental conception of the hero who had been represented as a smug, effete adolescent by Donatello and as a gawky teenager by Verrocchio. The pose of the marble *David*, like the earlier versions, is inspired by Classical sculpture; but the proportions and sense of physical tension are Hellenistic. At the back, the tree-trunk support is intentionally reminiscent of ancient Roman copies of Greek sculptures.

In contrast to the *Davids* of his predecessors, Michelangelo's is represented at a moment *before* his victory over Goliath. He carries the sling in his left hand, the stone in his right, and frowns slightly as if sighting his enemy. Goliath's severed head is, therefore, absent and David's watchfulness required. He is a new embodiment of the Florentine state, related to traditional guardians such as Hercules and the *Marzocco*. He is prepared for, but not yet engaged in, combat, implying that the city is, for the moment, at peace. Its enemies have become the new Goliath, and Florence itself is protected by the timeless alertness of a powerful *David*.

During the same early period in Florence, Michelangelo carved the so-called *Bruges Madonna* (**15.6**), which was purchased by a Flemish wool merchant and taken to Bruges. Drawing studies indicate that Michelangelo originally conceived of the work as a Madonna with the nursing infant (the *Madonna lactans*) but changed it to show a different characterization of the Child. Christ is insightfully depicted as a toddler-age child who simultaneously seeks independence from, and holds onto, his mother. Sliding somewhat hesitantly from her lap, Christ clings to Mary, his developmental apprehension a metaphor for his ambivalent relationship to his earthly mission—death on the Cross.

Formally, the figure of Mary is related to that of the *Pietà*. She is young and meditative, her form envelops Christ, and her base is the rock that alludes to the future Church. Although she is less weighty in form and drapery than in the *Pietà*, there is a similar taste for mass and volume, and, as with the *David*, a sense of mythic power in the herculean figure of Christ. Mary's sad expression, as in Michelangelo's Madonnas generally, reveals her foreknowledge of the Crucifixion.

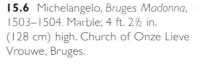

15.6 Michelangelo, *Bruges Madonna*, 1503–1504. Marble; 4 ft. 2½ in. (128 cm) high. Church of Onze Lieve Vrouwe, Bruges.

One of Michelangelo's few paintings was also commissioned around 1503 during his early Florentine period. The *Doni Madonna* (**15.7**) depicts the Holy Family as a powerful triad compressed into a tight foreground space. Mary sits on the ground, a reference to her humility and her role as the closed garden; she twists sharply back toward another herculean Christ, who seems to be supported by Joseph. The massive, chiseled appearance of the draperies is as characteristic of Michelangelo's paintings as it is of his sculptures,

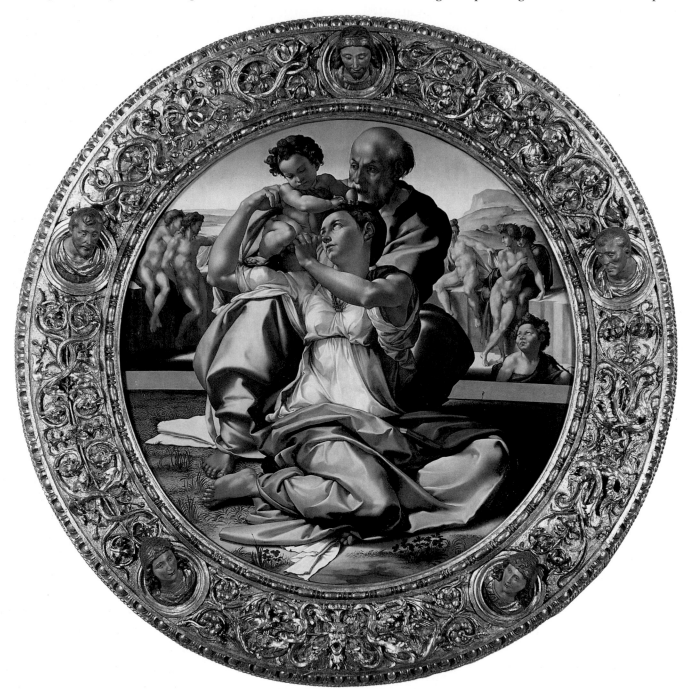

15.7 Michelangelo, *Doni Madonna*, c. 1503. Panel; 47¼ in. (120 cm) diameter. Galleria degli Uffizi, Florence. The elaborate frame is decorated with the arms of the Strozzi family in honor of Maddalena Strozzi, who had married the patron, Angelo Doni, around the time of the commission. According to Vasari, Michelangelo initially charged 70 ducats, but Angelo sent him only 40 when he received the picture. In response, Michelangelo doubled the price, which Angelo agreed to pay.

and their sharp-edged quality is enhanced by the strong color.

In the background, a child John the Baptist gazes toward the Holy Family, and five nude youths pose by a wall. The energy inherent in the poses, draperies, and monumental forms of Mary, Christ, and Joseph contrasts sharply with the languid background nudes. These have been variously identified in the light of Neoplatonism, juxtaposing paganism with Christianity, and as an image of salvation. In fact, however, the iconography of the work has remained elusive.

In 1505, Michelangelo was summoned to Rome by the della Rovere pope, Julius II, to design and carve his tomb. The fate of this venture is discussed in the next chapter.

Raphael: Urbino, Perugia, and Florence

Raphael Sanzio was born in Urbino a year after the death of Federico da Montefeltro. Raphael's father, Giovanni Santi, was court poet and painter as well as the author of an epic biography—the *Cronaca*, or rhymed *Chronicle*—of Federico. Although Federico's son and heir, Guidobaldo, was not as effective a ruler as his father, the Urbino court retained its position as a dazzling and efficiently run cultural and artistic center. In this, Guidobaldo was assisted by his well-educated wife, Elisabetta Gonzaga of Mantua.

In contrast to Michelangelo, Raphael was raised in one of the most enlightened, humanist environments of late fifteenth-century Italy. His father followed the avant-garde recommendations of Alberti in *Della famiglia* and insisted that Raphael be breast-fed by his own mother instead of by a wet nurse. The political contacts Raphael made at the Urbino court remained useful to him throughout his career.

By the time Raphael was eleven, his parents had died and he was apprenticed to Pietro Vanucci (c. 1445–1523), known as Perugino, the leading painter in Umbria. His name indicates that he was from the ancient Etruscan city of Perugia, which kept its medieval character during the Renaissance. Perugino influenced the High Renaissance style through his gifted pupil.

Literary Figures at the Court of Guidobaldo da Montefeltro

Baldassare Castiglione (1478–1529), diplomat and author of *The Courtier (Il cortegiano)* and poems in Latin and Italian, studied in the Milan of Lodovico Sforza and worked for the Gonzaga of Mantua and the Montefeltro in Urbino. *The Courtier* depicts the culture of the Montefeltro court—which Castiglione described as a "little city"—in the early years of the sixteenth century. The work became a model of writing on manners and etiquette.

Il Bibbiena, Bernardo Dovizi (1470–1520), was elected to the cardinalate as a result of supporting Giovanni de' Medici's rise to the papacy as Leo X. Celebrated by Castiglione for his elegant wit, Bibbiena was the author of a popular Renaissance comedy in which a boy dressed as a girl makes fun of contemporary manners.

Pietro Bembo (1470–1547), very much admired by Castiglione as a courtly gentleman and poet, was raised in a noble Venetian home. He received a humanist education, was fluent in Latin, and knew some Greek. An advocate of Petrarch and Boccaccio, Bembo also became a cardinal (in 1539). His courtly, platonic passions for women included platonic relationships with Maria Savorgnan (whose family supported Venice against threats from Austria and the Turks) and Lucrezia Borgia (daughter of the corrupt pope Alexander VI and the duchess of Ferrara through her marriage to Alfonso d'Este). Bembo's more earthly relationships with women produced three children.

Perugino's *Crucifixion* (**15.8**), painted around 1485, conveys a mood of serene resignation. The slim proportions, slight forms, and repetitive gestures of the figures lack the dramatic engagement with Christ's death that is seen in the more innovative Renaissance artists. By opening up the distance and lightening the sky, Perugino creates a sense of expanded space extending far into the background. Details of foliage and rock formations, as well as the tiny lion behind Saint Jerome, reflect the influence of Northern painters working for the Montefeltro in Urbino.

The influence of Perugino is evident in Raphael's earliest signed painting, executed when he was around nineteen years old. Originally an altarpiece for the church of San Domenico in Città di Castello, in Umbria, Raphael's *Crucifixion* (**15.9**) depicts similar figural types, delicate physiognomies, and a taste for landscape

stretching toward the horizon. Despite the decorative flourishes of the angels' streamers and their toes poised on slim horizontal clouds, however, Raphael's draperies are more substantial, his figures have a sense of underlying anatomical structure, and they interact more dramatically with the context than do Perugino's.

Perugino's monumental fresco *Christ Giving the Keys to Saint Peter* (**15.10**) in the Sistine Chapel, in Rome, reflects the Classical revival more strongly than his

Crucifixion. The draperies have more volume, and the figures engage with the event in a manner suggestive of Alberti's *istoria*. As in the *Crucifixion*, however, the expansive character of the space—here the tiled piazza—directs viewers away from the dramatic event taking place in the foreground. The orthogonals lead to the central domed structure, which has been associated with the Dome of the Rock, identified in the Middle Ages as Solomon's Temple. Extending sideways

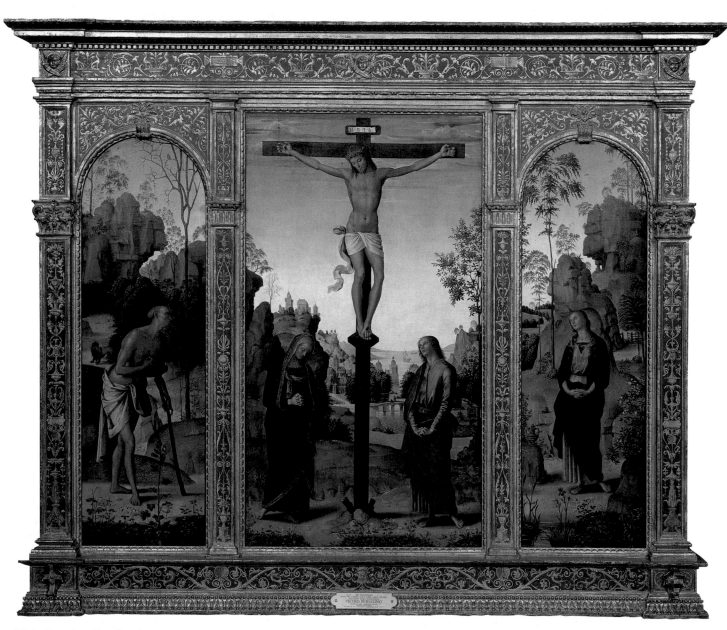

15.8 Perugino, *The Crucifixion with the Virgin, Saint John, Saint Jerome and Saint Mary Magdalene*, c. 1485. Oil on panel transferred to canvas; center panel: 40 × 22¼ in. (101.6 × 56.5 cm); side panels: 37½ × 12 in. (95.3 × 30.5 cm). National Gallery of Art, Washington, D.C., Mellon Collection.

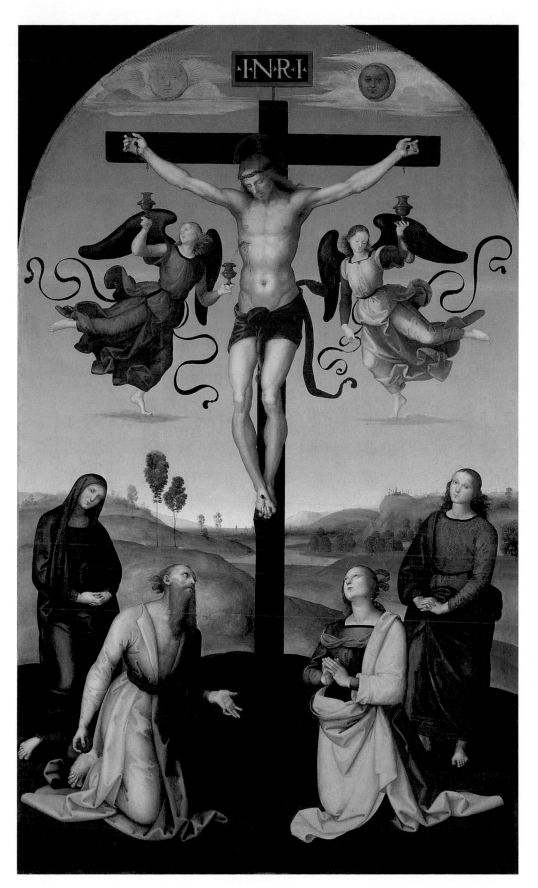

15.9 Raphael, *The Crucified Christ with the Virgin Mary, Saints and Angels* (*The Mond Crucifixion*), c. 1502–1503. Oil on wood; 9 ft. 2½ in. × 5 ft. 5⅜ in. (2.8 × 1.7 m). National Gallery, London.

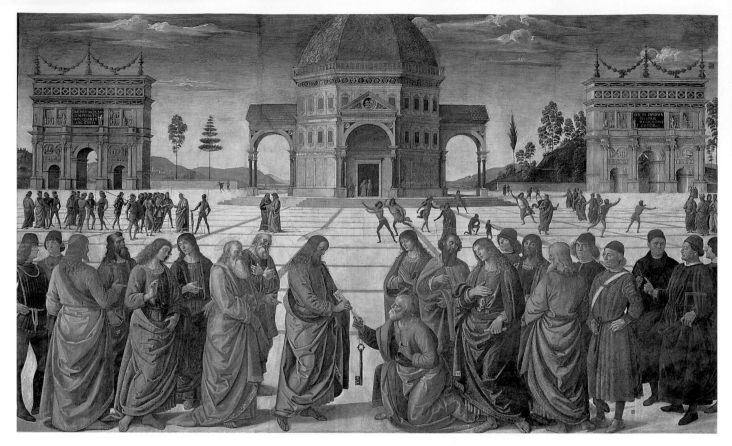

15.10 Perugino, *Christ Giving the Keys to Saint Peter*, 1481. Fresco; 11 ft. 5½ in. × 18 ft. 8½ in. (3.5 × 5.7 m). Sistine Chapel, Vatican, Rome.

from the core of the building are two round-arched porticoes that, like the piazza, divert the viewer from a central focus.

At the center of the foreground scene, Christ hands Saint Peter the keys to the Kingdom of Heaven. The large vertical key, silhouetted against the light pavement, is on the central axis of the fresco. Time is compressed in the middle-ground scenes, which take place at earlier times in the life of Christ. At the right, Christ miraculously walks through his own stoning, his upright posture contrasting with the animated diagonals of the stone throwers and signifying his moral righteousness. This resonates ironically with Christ's admonition to those who condemned the adulteress: "Let he who is without sin cast the first stone." The left-hand scene is generally read as a *Tribute Money*—Perugino would certainly have known Masaccio's version in the Brancacci Chapel. This is the point at which Christ says, "Render unto Caesar that which is Caesar's and unto God that which is God's." Both of the middle scenes are thus significant in their relationship to Christ's words, just as is the main scene, where he announces his intention to build the Church.

The symmetrical Roman triumphal arches on either side of the central building have inscriptions comparing

Pope Sixtus IV, patron of the Sistine Chapel and its decoration, with King Solomon, both being responsible for great works of architecture. Furthermore, the Sistine Chapel was itself built according to the proportions of Solomon's Temple in Jerusalem as it is described in the Book of Kings. Typologically, Solomon and Sixtus IV are paralleled with Christ, who builds his Church on the "rock" of Saint Peter. Sixtus IV thus participates in the continuity of the papacy begun by Peter, while Christ's New Law typologically fulfills the Mosaic Law of Solomon. In contrast to Christ and Peter, Sixtus and Solomon are present in the fresco "in name only"—another textual basis for Perugino's iconography. But the actual builders of the Sistine Chapel, reflecting Perugino's prominence as a portrait painter, are shown. They appear among the foreground onlookers at the far right; the architect (in a dark robe and hat) holding a compass and the supervisor (wearing a red robe) a square. In this iconography, Perugino creates a symbolic architectural genealogy: beginning with Solomon, continuing through Christ and Sixtus IV, and concluding with the two builders in contemporary dress.

Raphael's *Marriage of the Virgin* (the *Sposalizio*) (**15.11**) has affinities with Perugino's fresco but is more dramatically focused. As in *Christ Giving the Keys to*

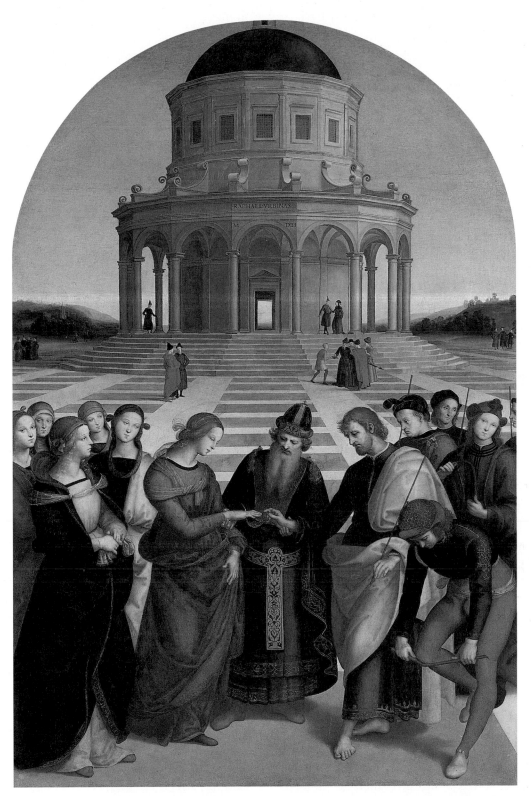

15.11 Raphael, *Marriage of the Virgin* (the *Sposalizio*), 1504. Oil on wood; 5 ft. 7 in. × 3 ft. 10½ in. (1.70 × 1.18 m). Pinacoteca di Brera, Milan. The work was commissioned by the Albizzini family for the altar of the Saint Joseph Chapel of San Francesco in Città di Castello. The nearby city of Perugia possessed a relic of Mary's wedding ring. Raphael signed and dated the painting—Raphael of Urbino, 1504—on the exterior entablature above the open doorway.

Saint Peter, the *Sposalizio* is divided into three distinct planes laid out on a *piazza*. The main event takes place in the foreground, with smaller groups of figures occupying the middle ground. A building similar to Perugino's—also probably representing Solomon's Temple—dominates the center.

In contrast to the Perugino, however, there is a reduction in the number of figures and a greater concentration of space. The marriage ceremony is based on the account in the *Golden Legend* in which Mary's suitors bring rods to the Temple. Only Joseph's rod flowers, indicating that he is God's choice for her earthly spouse, whereas the youthful rejected suitor at the lower right breaks his barren rod in anger. Symmetrically flanked by groups of men and women, Mary and Joseph are the dramatic focus of the event. The priest holds Mary's wrist and guides Joseph in placing the ring on her finger. The diagonals of his long beard direct the viewer toward the dramatic moment of union, and, at the same time, the cross-shaped embroidery on his robe refers forward in time to Christ's Crucifixion.

Spatially, too, Raphael's picture is more tightly organized than Perugino's. The orthogonals of the piazza tiles lead more clearly to a central vanishing point at the open doorway of the building, which corresponds to the circular architectural

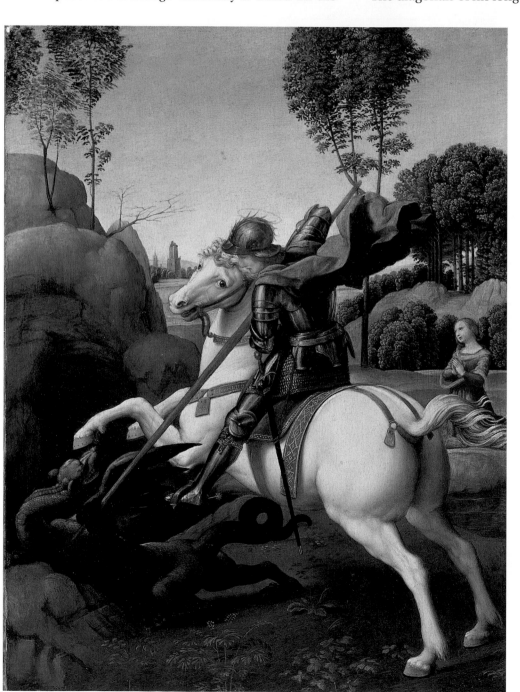

15.12 Raphael, *Saint George and the Dragon*, 1504–1505. Oil on panel; 11⅛ × 8½ in. (28 × 22 cm). National Gallery of Art, Washington, D.C., Mellon Collection. Tradition has it that this painting was commissioned by Guidobaldo da Montefeltro after Henry VII of England named him a member of the Order of the Garter and that it was delivered in person by Castiglione. This, however, has been disputed by some scholars. Nevertheless, Saint George is the patron saint of England, and in the painting he wears the emblem of the Order. Raphael signed the work on the bridle.

ideal of antiquity and the Renaissance. Aligned with the central axis is the ring, merging form and content, and Raphael's signature over the door that declares his own centrality in the conception and execution of the work.

Raphael, like Leonardo, was interested in vigorous movement as well as in conveying the essence of a dramatic moment. In the *Saint George and the Dragon* (**15.12**) of around 1504 to 1505, this is achieved by the counterthrusts of several opposing diagonals—the horse, the lance, and the dragon. The soft lighting and variety of textures, the precisely depicted details of the leaves, the mail of the saint's armor, and the gold embroidery on the horse's trappings are characteristic of works in oil and also reflect Netherlandish influence.

About 1505, Raphael went to Florence, where he spent three productive years working mainly on paintings of the Madonna but also on portraits and numerous drawing studies. These show his remarkable ability to synthesize contemporary artistic developments—notably, the work of Leonardo—to assimilate antiquity, and to work quickly and efficiently. His career was marked by rapid success and an early death.

The *Madonna of the Meadow* (**15.13**), one of many surviving versions of the Madonna and Christ from this period—with and without John the Baptist—shows the

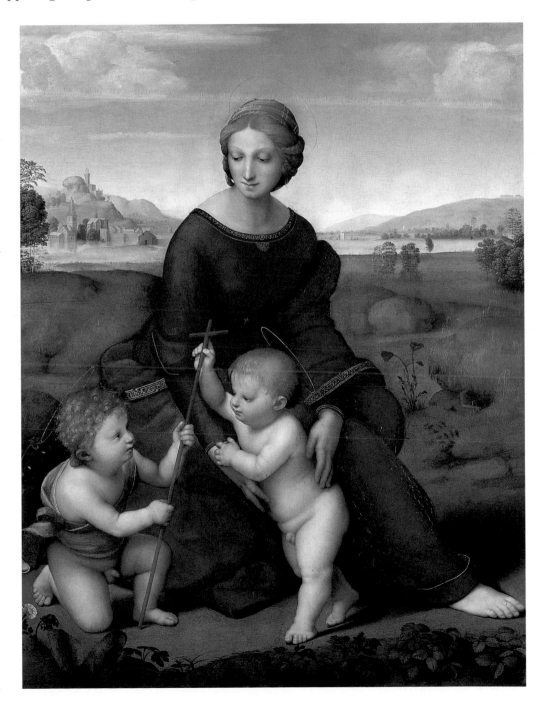

15.13 Raphael, *Madonna of the Meadow*, c. 1505. Oil on panel; 44½ × 34¼ in. (113 × 88 cm). Kunsthistorisches Museum, Vienna.

15.14 Raphael, study for the *Madonna of the Meadow*. Pen and brown ink over stylus underdrawing; 9¹⁵⁄₁₆ × 7⅝ in. (25.2 × 19.4 cm). Chatsworth 723, England.

the painting. The relationship of Christ to Saint John has also changed; instead of embracing Christ, his baptismal cup visible as in the *Taddei Madonna*, John is distanced, and they are joined by the cross. Three other figures are present in the drawing, all showing Raphael's careful observation of children. He used the walking figure at the upper left for the final version of Christ but turned him to face in the direction of the standing figure at the lower right. The latter reverses the pose of Michelangelo's *David*.

The child at the upper right, shown seated on Mary's lap, is clearly derived from the *Taddei Madonna*. It is probably no coincidence that the Florentine merchant and patron of Michelangelo, Taddeo Taddei, commissioned the *Madonna of the Meadow*. The drawing shows Raphael's habit of assimilating from other artists—in this case Michelangelo—and his search for figural solutions. In the final painting, however, he rejected the elements inspired by the *Taddei Madonna* and created a more Leonardesque image. This choice would prove to be prophetic, for Raphael continued to admire Leonardo, whose influence, like that of Michelangelo, appears throughout Raphael's career. Relations with Michelangelo, on the other hand, would be continually strained by intense rivalry.

influence of Leonardo's pyramidal compositions and psychological ambiguities on Raphael's early style. Mary dominates a landscape extending far into a distant blue-gray horizon, as recommended by Leonardo. Christ is between her knees, holding onto her right hand and grasping the wooden cross offered by John the Baptist. He is at once walking toward John and protected by his mother. This image of ambivalence on Christ's part is echoed by Mary herself, who embraces him while gazing on John. She, in turn, is excluded from the gaze of the children, whose own relationship to the cross alludes to Christ's future.

A drawing study (**15.14**) for the *Madonna of the Meadow* shows something of Raphael's evolution in planning the painting. Mary, whose head is constructed as a geometric oval in the drawing, is more upright in

Perhaps the most obvious example of Leonardo's impact on Raphael's early style is the portrait of Maddalena Strozzi (**15.15**), wife of Angelo Doni. Her pose is virtually identical to that of the *Mona Lisa* (see 14.21), although her proportions are fleshier. She has some formal relation to the landscape but is more specific and, therefore, not as mythical as Mona Lisa. The treatment of the distance is again a bluish mist, and the strands of loose hair silhouetted against the sky echo the wispy trees in the background.

As with the *Cecilia Gallerani* (see 14.17), a great deal of attention has been paid to the precision of costume texture. Raphael elaborates the heavy brocaded sleeves, the transparent veil, gold buttons, rings, and pearl necklace. In both instances, the sitter's status is indicated by a self-confident pose and materials denoting wealth.

Neither, however, evokes the air of ambiguous mystery that characterizes the *Mona Lisa*.

Around 1508, Raphael left Florence for Rome, where his style matured. There, Leonardo's influence persisted, along with that of Bramante and, to some degree, Michelangelo, all of whom worked in Rome.

15.15 Raphael, *Maddalena Doni*, c. 1505. Oil on panel; 24¾ × 17¾ in. (63 × 45 cm). Galleria Palatina, Pitti Palace, Florence.

16

Bramante, Michelangelo, Raphael: Developments in Rome to 1520

With the death of Lorenzo the Magnificent and the changing atmosphere in Florence, Rome became the most powerful center of patronage in Italy. Whereas in the fifteenth century artists had gone to Rome to study ancient ruins, in the sixteenth century they went for commissions. Although many of these came from bankers and other wealthy individuals, the most important patrons were the popes. Under Julius II, the nephew of Sixtus IV, Roman patronage became the most extensive in western Europe. It was one of the greatest periods in Western history of successful collaboration between a patron and the artists who worked for him.

Subsequent popes such as Leo X and Paul III continued the tradition of monumental patronage, but they did not measure up to Julius in political acumen or intellectual and military achievement. Nor were they as shrewdly insightful as Julius, who not only knew how to choose the best artists, but created the humanist atmosphere in which they produced their greatest works.

Bramante in Rome

In 1499, with the downfall of the Sforza in Milan, Bramante moved to Rome. His first architectural commission in that city, begun in 1500, was the cloister of Santa Maria della Pace (**16.1**). It reflects his assimilation of imposing form derived from antiquity, in which there is a sense of dynamic tension between solid and void. The austere walls on the ground floor consist of simple round arches. Plain Ionic pilasters rest on miniature podia and are surmounted by an entablature. The shorter upper story consists of rectangular spaces framed by Corinthian pilasters alternating with columns, which

16.1 Donato Bramante, cloister of Santa Maria della Pace, 1500–1504. Rome.

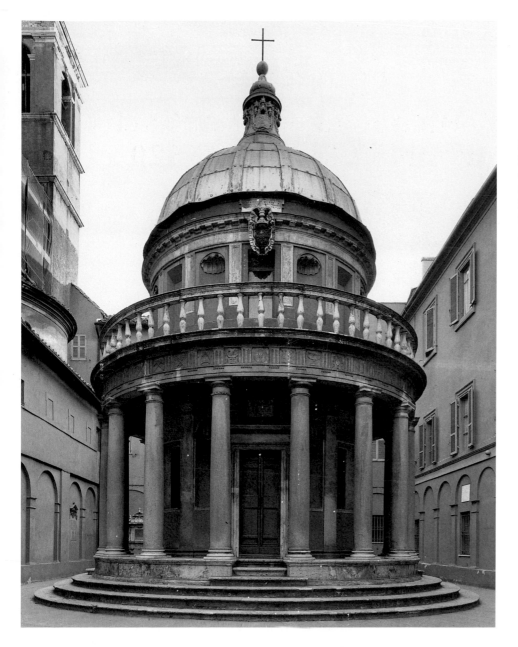

support a second entablature. This use of a different Order on each floor, already a feature of certain fifteenth-century palaces in Florence, was a characteristic of the Roman Colosseum.

Bramante's most original and influential building in Rome was the Tempietto (**16.2**). Located on the traditional site of Saint Peter's martyrdom, the Tempietto (literally, "little temple") was a martyrium. Bramante thus combined the traditional circular plan of martyria with round temples he had seen at Tivoli, near Rome, and in Rome itself. He further conformed to the theoretical positions of Vitruvius and Alberti, who believed that temples to such gods as Mars and Hercules should be round. This was also consistent with the fiery, heroic character of Saint Peter.

The Tempietto itself is too small to hold more than a few pilgrims and was thus seen mainly from the outside.

Its circular **cella** is surrounded by steps and a **peristyle**. The columns are in the Roman Doric (Tuscan) Order, used for the first time since antiquity; the shafts are of granite; and the bases and capitals are of marble. Divided into **triglyphs** and metopes, the Doric frieze is decorated with instruments of the Christian liturgy that are inspired by pagan ritual objects known from the ancient Roman temple of Vespasian. The balustrade, dome, and lantern (a later addition, although one intended by Bramante) are characteristic features of Renaissance churches.

The harmonious relationship of each part to the other and of each to the whole, as required by Classical and Renaissance art theory, is evident, for example, in the fact that the distance from the ground to the base of the drum equals its width. The Tempietto is now in a cramped space, which makes it difficult to view.

16.3 Donato Bramante, elevation of the Tempietto, 1500–1502. San Pietro in Montorio, Rome.

16.4 Donato Bramante, plan of the Tempietto, 1500–1502. San Pietro in Montorio, Rome.

Its elevation (**16.3**) and original plan (**16.4**) were recorded in the sixteenth-century architectural treatise of Sebastiano Serlio. These show the carefully planned symmetry of the building and its site—the courtyard of San Pietro in Montorio—as well as the regular, ordered arrangement of each part.

The Patronage of Julius II

In 1503, Giuliano della Rovere was elected pope and launched Rome's greatest period of patronage. His vast ambitions included internal Church reform, the recapture of papal territory outside Rome, and political control of the nobility in Rome itself. He took the name Julius as a reflection of his identification with the Caesars, which also conformed to his humanist interest in the revival of antiquity.

In the arts, his influence is still felt today. He initiated the rebuilding of Saint Peter's Basilica, which was over a thousand years old and in disrepair. It was the main European pilgrimage site, second in importance only to Jerusalem. He further planned the renovation of all ancient ruins in Rome and used the arts, as well as the sword, to wield power.

Julius recognized in Bramante the ability to assimilate ancient and modern forms, and Christian and pagan iconography. These were the very combinations that characterized the fabric and history of Roman culture. Julius thus named Bramante his papal architect and commissioned him to redesign Saint Peter's. Construction began in 1506, when Julius laid the foundation stone. Little of Bramante's design remains, but surviving drawings and the foundation medal make it possible to establish the original plan and façade. Located on the traditional site of Saint Peter's burial and the apse of Constantine's basilica, the history of the building reflected the history of Rome.

Old Saint Peter's had been designed according to a longitudinal Latin-cross plan with a long nave, side aisles, and a transept. This was preferred by the clergy

as being more suited to the liturgy and able to accommodate large crowds and processions. But both Julius II and Bramante rejected the traditional view and, influenced by the Classical revival and Leonardo's studies of centralized churches, opted for the Greek-cross plan (**16.5**). In essence, Saint Peter's, like the Tempietto, was a martyrium but on a vast scale.

Bramante's plan shows a huge central square with a dome on pendentives, the dome measuring 136 feet in diameter, only slightly smaller than the Pantheon (although its height is greater). The dome was supported by four enormous piers whose barrel vaults carried its thrust. Circling around the piers is the **ambulatory**, which connects them with the apses at the end of each of the four arms. Connecting the apses are smaller, domed, Greek-cross chapels; two of the apses of each chapel adjoin the arms of the main cross. The four

towers, one in each corner, are connected to the bays by open loggias.

The foundation medal, cast in 1506, illustrates Bramante's plan for the façade of the New Saint Peter's (**16.6**). Two enormous towers flank a central arrangement of regular, alternating forms. Above the pediment over the door of the portico rises a dome. Behind it rises another, giant portico, its pediment framing the lantern of the dome over the entrance. Finally, the balustrade of the huge central dome repeats the columns at the lower levels, while the dome itself crowns the entire structure. Between the towers and the central area, the smaller domes are visible. The strict geometric symmetry envisioned by Bramante was in keeping with both Albertian theory and the Classical aesthetic.

Julius died in 1513, and Bramante's death followed in 1514. By that time only the piers, the barrel vaults connecting them, and parts of the wall had been completed. Several artists, including Raphael, Antonio da Sangallo, and Michelangelo, would work on Saint Peter's. Nevertheless, Bramante's foundations determined the general size and shape of the final building.

1 Dome
2 Apse
3 Pier

16.5 Donato Bramante, plan of Saint Peter's, 1506–1514. Rome. Julius II decided to finance the rebuilding of Saint Peter's with the sale of indulgences. Originally, under the fourteenth-century pope Clement VI, one could obtain indulgences through good works and then by giving alms to the poor. Later, when the Church needed to raise money, the practice was corrupted and indulgences were sold to those who feared for their salvation. It was against this latter practice, carried out in Germany with a vengeance by the Dominican Johannes Tetzel, that Martin Luther protested in 1517. In so doing, he launched the Protestant Reformation, causing a religious and political upheaval that Julius did not live to see.

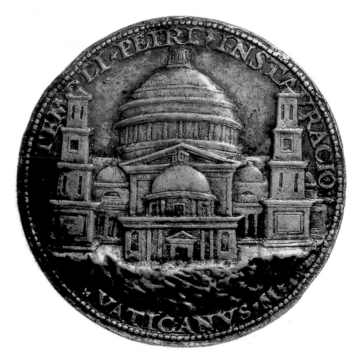

16.6 Cristoforo Foppa Caradosso, medal with Bramante's design for the façade of New Saint Peter's, 1506. Bronze. British Museum, London.

The Evolution of Saint Peter's

According to Vasari, Bramante arranged for Raphael to succeed him as papal architect and overseer of Roman antiquities. Raphael designed a longitudinal plan for Saint Peter's; but with the onset of the Reformation in 1517, followed by the artist's death three years later, and the Sack of Rome in 1527, construction was intermittent. In 1520, the new Medici pope, Leo X (papacy 1513–1521), appointed Antonio da Sangallo the Younger (1485–1546), the nephew of Giuliano da Sangallo who had worked for Leo's father (Lorenzo the Magnificent), architect of the New Saint Peter's. Sangallo's plan (**16.7**) lengthened the nave by extending the eastern (entrance) arm of Bramante's Greek cross. But very little of his plan was executed before his death in 1546. The following year, Pope Paul III (papacy 1534–1549) appointed Michelangelo to the task.

Michelangelo's plan (**16.8**) revived Bramante's compact Greek cross, adding more support for the dome and thickening the walls. He also simplified the four small Greek-cross sections by removing the arms and retaining only the domes. Effecting a compromise with the advocates of a Latin-cross plan, Michelangelo added a portico at the entrance and an imposing flight of steps. The portico consisted of an outer row of four columns and a second row of ten columns. Seen from the south (**16.9**) the giant Corinthian pilasters Michelangelo planned for the exterior walls are visible.

His dome, as planned, was originally a hemisphere. But after his death in 1564, Giacomo della Porta (c. 1537–1602) elongated the dome slightly to reduce the force of its thrust. The entire structure and its piazza were not finished until

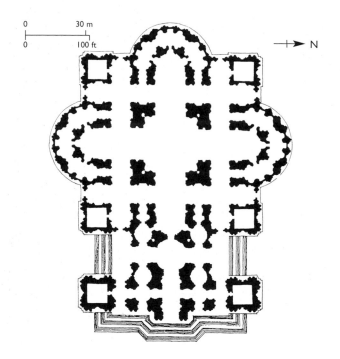

16.7 Antonio da Sangallo the Younger, plan of Saint Peter's.

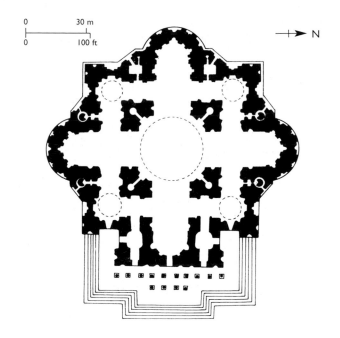

16.8 Michelangelo, plan of Saint Peter's, 1537–1550.

Michelangelo: The Tomb of Julius II

In 1505, as the construction of the New Saint Peter's was about to begin, Julius commissioned Michelangelo to design his monumental tomb in Old Saint Peter's. Michelangelo thus left Florence, his work for the Signoria unfinished, and traveled to Rome. He produced many designs for the tomb, which was not com-

pleted until 1545 and then in a very different form. The first plan of 1505 has been reconstructed as shown in figure **16.10**.

The tomb, which has been a subject of scholarly discussion, was conceived of in imperial-Roman terms, with Julius's sarcophagus at the summit. His effigy, thought by some to have surmounted the sarcophagus, would reflect his self-image as a new Caesar. Below,

the **Baroque** period in the seventeenth century. In the final execution, the eastern end was more elongated than in Michelangelo's plan. As such, it conformed to seventeenth-century views of church design, accommodating the large crowds and making possible the dramatic celebration of the liturgy envisioned by the Counter-Reformation.

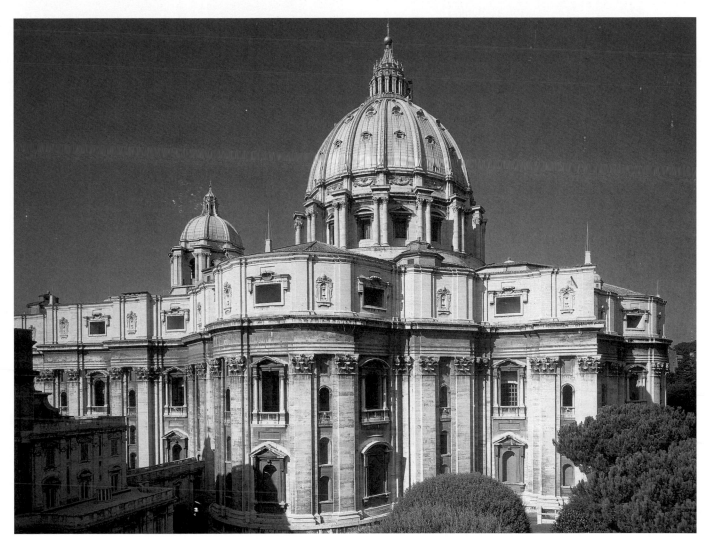

16.9 Michelangelo, view of Saint Peter's from the south.

one entered the oval tomb chamber through a doorway, alluding to the ancient "door of death." Enclosing the tomb chamber was a structure three stories high, decorated with some forty individual statues. On the ground floor, figures identified as Victories and Captives have been variously read as reflecting a Neoplatonic view of the earthly life, as personifications of the liberal arts, and as symbols of the pope's military conquests. The second-story statues depict Moses and Saint Paul, typologically paired as the Old and New Laws, respectively. They are accompanied by Neoplatonic personifications of the active and contemplative life.

The muscular, patriarchal *Moses* (**16.11**), completed around 1515, is the most monumental of those on the finished tomb. It now resides in the church of San Pietro in Vincoli (Saint Peter in Chains), in Rome. The *Moses*

16.10 Michelangelo, reconstruction of the tomb of Julius II as planned in 1505.

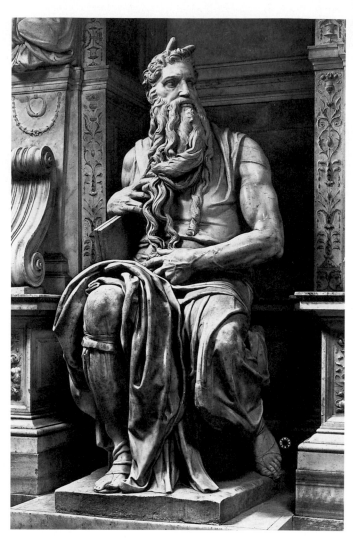

16.11 Michelangelo, *Moses*, c. 1515. Marble; 7 ft. 8½ in. (2.35 m) high. San Pietro in Vincoli, Rome. The horns emerging from Moses's head became an iconographic convention when the Latin word for "rays of light" was misread as "horns." The rays refer to the radiance emanating from Moses after he had seen God on Mount Sinai.

exemplifies Michelangelo at his most powerful, both as a carver of marble and as a psychologist. He has represented Moses in a moment of anger, which is generally thought to be when he sees the Hebrews defying God and worshiping the golden calf. According to this reading, Moses has descended from Mount Sinai with the Tables of the Law and confronts the discrepancy between the lofty aims of the Ten Commandments and human disobedience. His disturbance is revealed in the agitated curves of the beard and in his right arm catching the Tables as they begin to slip from his grasp. Reflecting the sense of urgency is the suddenness of his spatial turn; he swivels at the waist, gazing to his left and preventing the Tables from falling with his right elbow.

In the *Moses*, Michelangelo both fulfills Alberti's concept of the *istoria*—by matching pose and gesture to the figure's inner state—and transcends it. For Michelangelo does not adhere to the biblical text (Exodus 32:19), and Moses does not "cast the tables out of his hands, and brake them beneath the mount." Instead, Michelangelo writes his own *istoria*, revising history and creating a Moses who controls his rage and saves the text of the Law. In so doing, the artist comments on the character of his patron and himself, both known for a *terribilità* that combined a fiery, powerful temper with high intelligence and genius.

The Sistine Ceiling

In 1506, Julius angered Michelangelo by interrupting his work on the tomb. He wanted him to paint the ceiling of the Sistine Chapel—named for his uncle, Pope Sixtus IV. Michelangelo responded by going to Florence and then to Bologna. There he cast a huge bronze portrait of the pope, which was destroyed three years later. By 1508, Julius had prevailed and Michelangelo signed the contract for the Sistine ceiling.

Figure **16.12** is the view of the chapel toward the altar wall, showing the side walls with their fifteenth-century

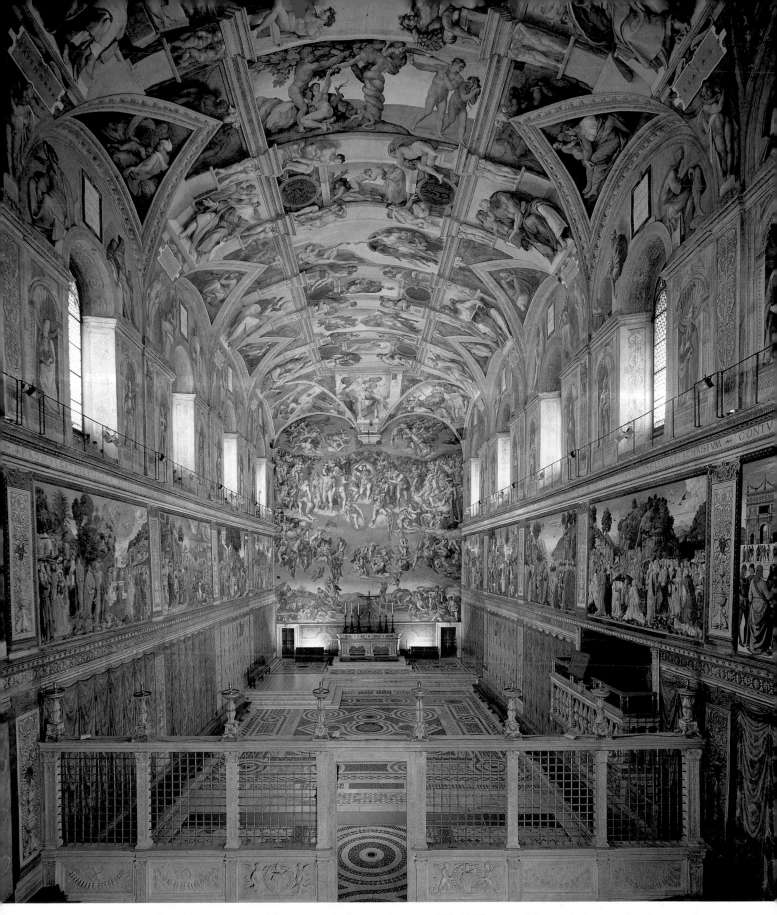

16.12 View of the Sistine Chapel. Vatican, Rome (after restoration). The *Last Judgment* on the altar wall was not commissioned until 1534. Michelangelo completed it in 1541, by which time he was sixty-six years old. The zealous Counter-Reformation pope Paul IV (papacy 1555–1559) wanted the work destroyed, and eventually the Inquisition (which he had reorganized) ordered draperies added to the nude figures.

decorations, executed under the patronage of Sixtus IV, the ceiling, and the altar wall (see the caption). In preparation for the work, Michelangelo did many drawing studies and built his own scaffold. In 1509, he began painting at the level of the windows, which are shown in the diagram in figure **16.16**.

Michelangelo's program for the frescoes differed from traditional typology based on prophecy and fulfillment, and represented instead the revelation of God's plan for human redemption. The lunettes and spandrels over the windows depict the ancestors of Christ enumerated in the opening genealogy of the Gospel of Matthew. Between the spandrels on the side walls, Old Testament prophets alternate with pagan sibyls, whose utterances were interpreted as having prophesied the coming of Christ.

This arrangement juxtaposes two types of predecessors: those who comprise Christ's biological ancestry with those who had foreknowledge of his divinity. In a similar vein, the two prophets on the entrance

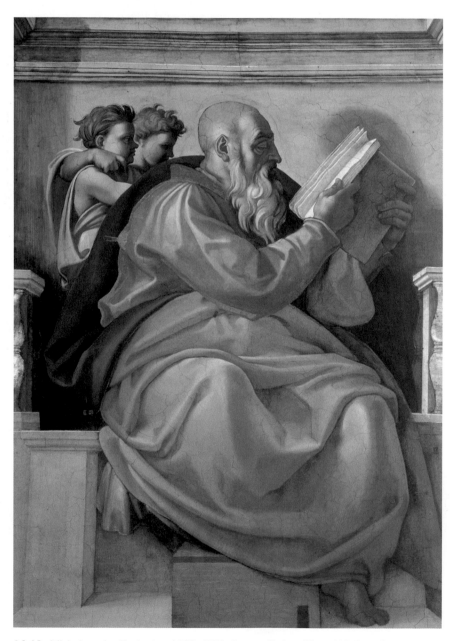

16.13 Michelangelo, *Zacharias*, 1509–1512. Fresco. Sistine Chapel, Vatican, Rome.

and altar walls juxtapose prophecy with typology. Zacharias, depicted over the entrance (**16.13**), foretold the coming of a man called "the Branch," who would spring from the earth and build God's temple (Zacharias 6:12). And Jonah, who appears over the altar (**16.14**), was swallowed by the whale and stayed in its belly for three days, prefiguring Christ's Entombment and Resurrection. Michelangelo's Zacharias, like several of the prophets and sibyls, is engrossed in a written text. These allude to the revealed Word of God, which is transmitted to humanity through the oracles of antiquity and Old Testament prophecy. Relating Zacharias's prophecy to Jonah-as-precursor is the prominent green branch curving behind Jonah's head.

The corner spandrels also have typological meaning. Located over the altar wall, the *Death of Haman* was a type for the Crucifixion, and Christ himself compared the story of Moses and the Brazen Serpent to lifting up the soul of man. *David and Goliath*, over the entrance

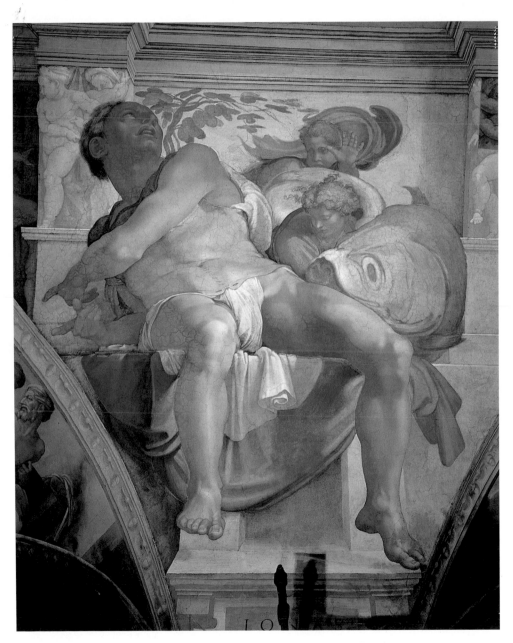

16.14 Michelangelo, *Jonah*, 1509–1512. Fresco. Sistine Chapel, Vatican, Rome.

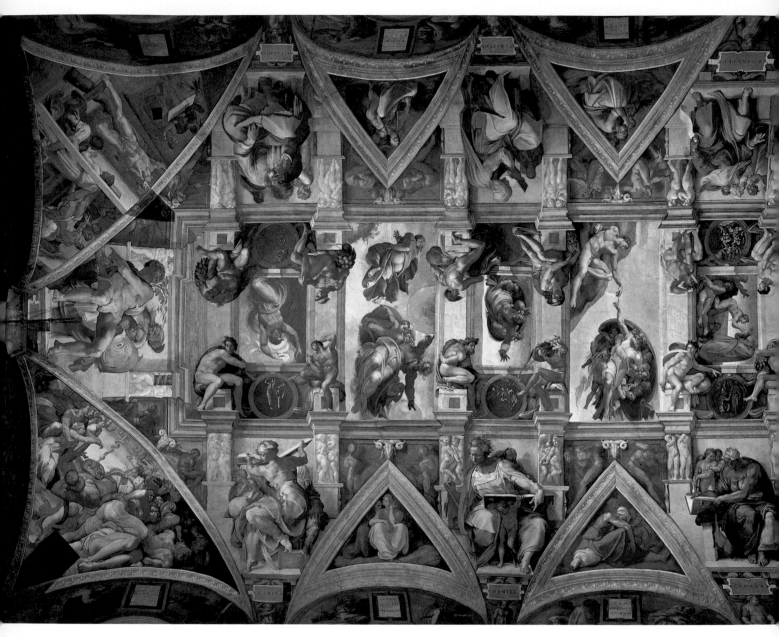

16.15 Michelangelo, view of the Sistine ceiling frescoes, 1509–1512. Vatican, Rome.

16.16 (*right*) Diagram of Michelangelo's Sistine ceiling frescoes.

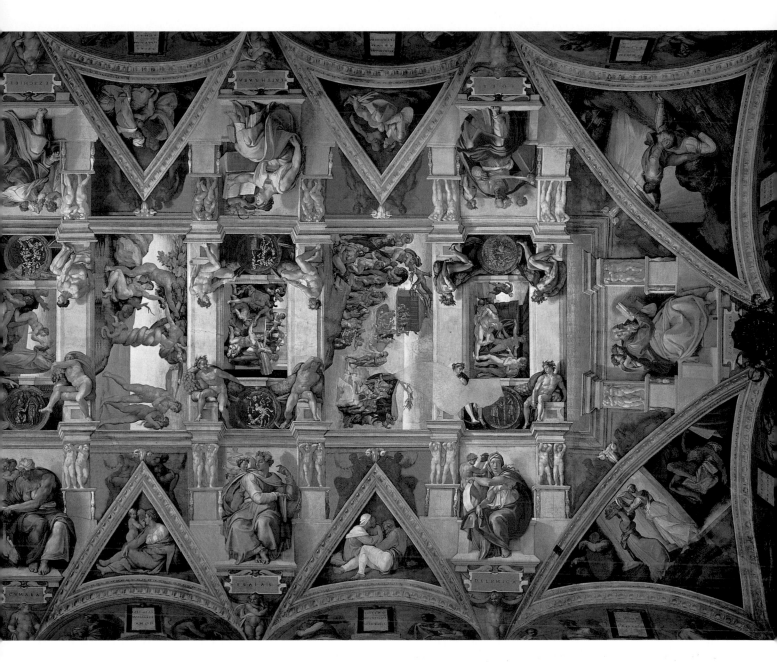

wall, was paired with Christ's victory over Satan, as was *Judith Slaying Holofernes.*

Along the center of the vault of the Sistine ceiling (**16.15**), Michelangelo depicted nine narrative scenes from Genesis spanning the time from Creation to the Drunkenness of Noah. All precede the Law of Moses, which is the theme of the fifteenth-century frescoes on the left side wall. Five smaller scenes with nude youths (the so-called *ignudi*) in strong *contrapposto* at each corner alternate with larger scenes. Some of the *ignudi* hold oak leaves, alluding to the della Rovere family of Sixtus IV and Julius II (*rovere* means "oak" in Italian). Framing each of the narrative scenes and tying them visually to the space occupied by the prophets and sibyls is an illusionistic cornice that appears to project from the painted surface.

Michelangelo painted the Genesis scenes in reverse chronological order, beginning and ending with two smaller frescoes: the *Drunkenness of Noah* and *God Separating Light and Dark*, respectively. As viewers entered the chapel, therefore, they saw the beginning of creation at the greatest distance from themselves and the renewal of work and spectacle of human frailty in the Noah scene closest to themselves. In 1510, the first five scenes of the ceiling were completed, unveiled, and the scaffold removed. The last four scenes to be painted, all creation scenes, are endowed with a new, monumental power that seems to reflect the *terribilità* of Michelangelo himself.

In the *Creation of Adam* (**16.17**), God is a monumental patriarch, related in form and character to the *Moses*. His creative power extends across the picture

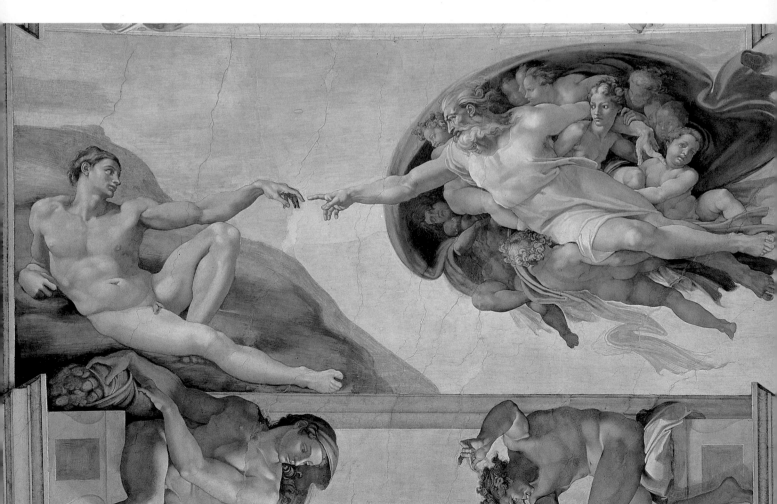

16.17 Michelangelo, *Creation of Adam*, 1510. Fresco. Sistine Chapel, Vatican, Rome.

plane as he reaches out to give Adam life. Adam's languid pose identifies the moment represented as just prior to his "birth," for his finger has not yet made contact with God's. The reclining pose is reminiscent of Classical sculpture (see 7.12), whereas, as with the *David*, the proportions and prominent muscle structure resemble Hellenistic style. The minimal landscape, indicating that the earth, like man himself, is a new creation, surrounds Adam and mirrors the red drapery swirling around God. (There has been considerable debate, but no consensus, on the identity of the figures enclosed by God's drapery.)

The last scene to be painted depicts the beginning of time, when God sets in motion the revolutions of day and night (**16.18**). Here, too, he is a powerful force of creative energy, swiveling in a whirlwind of his own making. He shapes the heavens into light and dark, which is the origin of seeing as well as of time. As such, Michelangelo's God is identified with the artist as a creator of visible form.

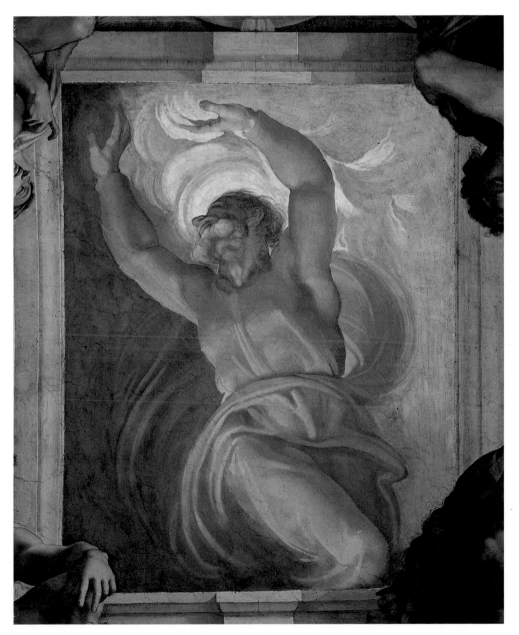

16.18 Michelangelo, *God Separating Light and Dark*, 1512. Fresco. Sistine Chapel, Vatican, Rome.

Raphael: The *Stanza della Segnatura*

As Michelangelo was beginning work on the Sistine ceiling, Raphael arrived in Rome and received the commission to decorate the *Stanza della Segnatura*, the private papal library in the Vatican (**16.19**). (It is called "della Segnatura" because of its function as the meeting room of the supreme papal tribunal, or *Signatura Curiae*.) The iconographic program of Raphael's decora-

tion of the ceiling consisted of four Allegories (*Theology, Poetry, Philosophy,* and *Jurisprudence*), two mythological scenes, and two Old Testament scenes. On the walls, four large lunettes, each under its corresponding Allegory, depict Christian and Classical scenes. This arrangement reflects the humanist views of Julius II, who must have recognized that Raphael's genius for assimilation and synthesis was well suited to such a program.

16.19 View of the *Stanza della Segnatura*. Vatican, Rome (after restoration).

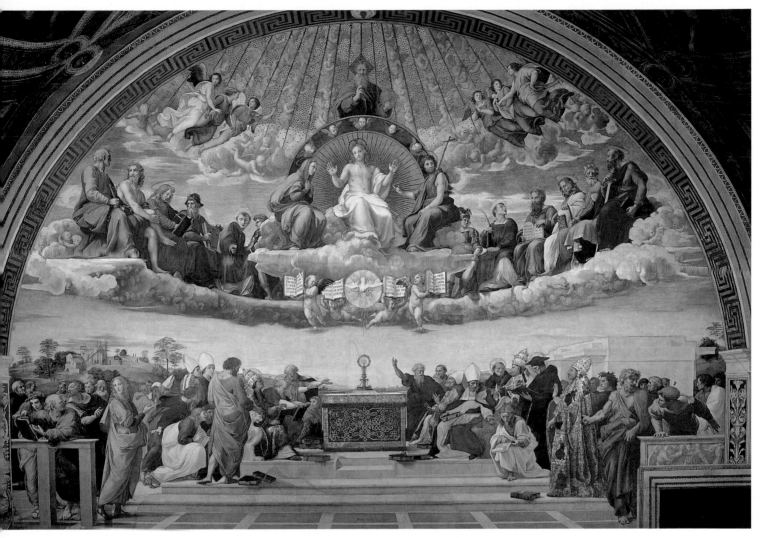

16.20 Raphael, *Disputation over the Sacrament* (or *Disputa*), 1509–1511 (after restoration). Fresco; width at base: 25 ft. 3 in. (7.7 m). *Stanza della Segnatura*, Vatican, Rome.

The two main frescoes facing each other across the room are the *Disputation over the Sacrament*, or *Disputa* (**16.20**), and the *School of Athens* (**16.21**), the former a Christian scene and the latter Classical.

Disputation over the Sacrament (or Disputa) The *Disputa* depicts two planes of existence—earthly and heavenly. On the earthly plane, theologians discuss the doctrine of Transubstantiation, according to which the wafer and wine of the Eucharist are literally the body and blood of Christ. The discussants, together with various onlookers, are arranged in a large semicircle corresponding to the curved edge of the lunette.

Placed on the altar is the monstrance (the liturgical object with a ring enclosing the wafer), which, like the wedding ring in the *Sposalizio* (see 15.11), is on the central axis of the picture. Here it is also the location of the vanishing point. It is directly below the dove of the Holy Spirit, enclosed in a circle of gold. Above this, Christ sits on a platform of clouds before a golden circle framed by a blue ring containing cherubim and seraphim. He is flanked by the Virgin and John the Baptist in the manner of the *deësis*, and on the sweeping platform of clouds below, Old and New Testament figures alternate. Crowning the entire circular configuration is God the Father with

a blue globe. He is surrounded by the circular light of Heaven itself.

In the left background, building activity alludes to the construction of the Church. This iconography suggests that Julius II considered Transubstantiation a foundation of Christian doctrine. Throughout the fresco, there is a recurring focus on the written word as the textual foundation of the Church. (Texts were also of interest to Raphael, for he hired scholars to translate the Classical authors.) The Ten Commandments, a cornerstone of the New Law, are inscribed in Hebrew and displayed by Moses (seated to the left of Christ). On either side of the Holy Ghost, four angels hold open the Gospels.

On the earthly plane, figures are also shown reading and writing, with books lying prominently on the steps. All are intended to provide a textual (and historical) basis for Church doctrine. Four doctors of the Church who were prolific writers flank the altar: Jerome and Gregory the Great to the left, Ambrose and Augustine to the right. Dante, too, is present; he wears the ancient laurel wreath, symbolizing literary triumph. As the author of the *Divine Comedy*, in which he is escorted through Hell, Purgatory, and Heaven by Virgil, he was writing on the threshold of the Renaissance revival of Classical texts.

Directly in front of Dante is Sixtus IV, wearing an elaborate gold robe and the papal tiara. As the patron of the Sistine Chapel who was associated with Solomon as builder of the Temple, Sixtus is allied with the architectural metaphor inherent in the *Disputa*. Likewise, the great contemporary architect, Bramante himself, leans over a railing in the left foreground and points to a book. His prominent position alludes not only to his role as Raphael's mentor, but also to his plans for the New Saint Peter's.

School of Athens The *Disputa* is imbued with Christian significance, whereas the *School of Athens* is entirely devoid of Christian content. As in the *Disputa*, however, texts are a central feature of the iconography. The setting of the *School of Athens* is inspired by ancient Roman architectural forms as assimilated by Bramante; large barrel vaults define the ceiling, and there is a presumed, if not demonstrable, dome between the first two vaults. Stone statues of Apollo with his lyre (on the

left) and Minerva with her Gorgon shield (on the right) stand in niches at either end of the lunette. They are most likely present in their aspects as arts gods, Apollo of music and Minerva of weaving. They are also engaged with the sense of sight that would have appealed to Raphael as a painter. As the sun, Apollo is the source of the world's light, which makes seeing possible. The Gorgon myth is about intelligent seeing, for it is not until Perseus follows the wise advice of Athena to observe the Gorgon indirectly through her reflection on his shield that he is able to slay her. It is likely, given the visible presence of Apollo and Athena, that the unseen niche figures along the side walls are meant to represent other Greek gods.

In contrast to the flesh-and-blood figures populating the Christian Heaven of the *Disputa*, the gods in the *School of Athens* are statues. They represent the past and endure because they are stone, whereas Heaven lives in the present and, by implication, in the future. Assembled in the vast architectural setting of the *School of Athens* are the leading philosophers of Greek antiquity. Here, again, books and writing are a significant iconographic feature, which reflects the textual basis of the Classical revival. Many of the philosophers are merged with Raphael's contemporaries, although not all the portraits have been identified.

The two central figures, located on either side of the vanishing point, are Plato and Aristotle. Plato, who resembles a known self-portrait of Leonardo, points upward to the realm of ideas, the same gesture as that made by Doubting Thomas in Leonardo's *Last Supper* (see 14.18). Plato carries his *Timaeus*, the Dialogue in which he identifies the circle as signifying cosmic perfection. To left of Plato is the snub-nosed Socrates and, in Athenian armor, his beloved Alcibiades. To Plato's right, Aristotle carries the *Ethics*. He extends his arm toward the earthly world of the viewer, reflecting his emphasis on empiricism.

To the left, on the level of the floor, Pythagoras illustrates his system of proportions to students, among whom is the turbaned Arabic scholar Averroës. Zeno the Stoic and Epicurus are behind Averroës. Sprawled on the steps is Diogenes the Cynic, who proverbially roamed the streets of Athens looking for an honest man. A group in the right foreground surrounds Euclid, a portrait of Bramante, drawing with his compass. His bald

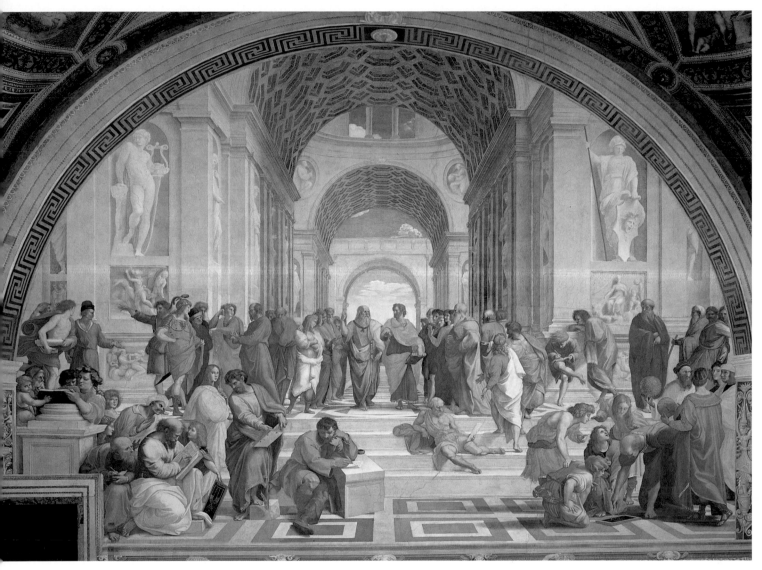

16.21 Raphael, *School of Athens*, 1509–1511 (after restoration). Fresco: 26 × 18 ft. (7.92 × 5.49 m). *Stanza della Segnatura*, Vatican, Rome. The "Michelangelo" is actually a quotation of Michelangelo's own style. More muscular and sculpturesque than the other philosophers in the painting, he is related to the figures on the Sistine ceiling. This is consistent with Vasari's anecdote in which Michelangelo accused Bramante of secretly allowing Raphael into the Sistine Chapel before its completion and alleged that Raphael had stolen his style.

head echoes the central dome as well as the earthly and starry globes. Carrying the earthly globe is the Greek geographer Ptolemy, while the Persian Zoroaster raises up the starry globe.

Raphael's rival artist, Michelangelo, was a late addition to the fresco. He wears stonecutter's boots and is depicted in the guise of Heraclitus. His pose and gesture mirror the either-or character of Heraclitus's obscure philosophy—for he is shown simultaneously thinking and writing. The isolation of the brooding figure corresponds to Michelangelo's reputation as an irascible loner, whereas Raphael's self-portrait appears in the group of figures at the right. The man in white has been identified as Sodoma, Leonardo's follower and the artist who had first received the commission for the *stanza*. Raphael stands deferentially behind Sodoma and gazes from the picture at the viewer. His presence among his contemporaries, in contrast to Michelangelo's detachment, reflects his more sociable, diplomatic nature.

Raphael After 1511

The *Stanza della Segnatura* was completed in 1511. Shortly thereafter, Raphael received a commission from the wealthy Sienese banker Agostino Chigi (1465–1520) for a fresco of Galatea (**16.22**) in the grand salon of what later came to be called the Villa Farnesina. Chigi was financier to the pope and an important patron of the arts in Rome who was partial to Classical iconography.

Galatea

According to Greek myth, the Cyclops Polyphemos killed Galatea's lover Acis out of lust for Galatea— he is shown in the adjacent fresco; Raphael's *Galatea* is a scene of erotic pursuit. Looking apprehensively over her shoulder at her unwelcome suitor, Galatea rides a seashell chariot pulled by a pair of dolphins. One of them bites an octopus that turns pale, a detail borrowed from Classical texts on the nature of animals.

This confirms Raphael's reputation for consulting ancient authorities as sources for his iconography. Similarly, the wooden propeller attached to the shell reveals Raphael's acquaintance with more practical knowledge. It has been identified as being derived from the fourteenth-century invention of the paddle wheel to propel ships—a subject that had recently interested scientifically minded artists such as Leonardo and Giuliano da Sangallo.

Surrounding the fleeing Galatea are amorous sea gods and Centaurs sounding trumpets and grasping at nymphs.

16.22 Raphael, *Galatea*, c. 1512. Fresco; 9 ft. 8½ in. × 7 ft. 4 in. (2.96 × 2.24 m). Villa Farnesina, Rome. Vasari reported that despite having agreed on a price for the *Galatea*, Raphael asked for an additional amount after starting work. Chigi's accountants objected, whereupon Raphael produced Michelangelo to testify on his behalf. Michelangelo said that he himself would charge 100 scudi per head, at which Chigi told his accountants to pay. "Be polite and keep him happy," Chigi reportedly said, "because we'd be ruined if he made us pay for the draperies."

16.23 Raphael, *Fire in the Borgo*, begun 1514. Base width: 22 ft. 1 in. (6.7 m). *Stanza dell'Incendio*, Vatican Palace, Rome.

Three Cupids aim their arrows of love at Galatea, while a fourth gazes at the scene from a cloud. A sense of rapid motion is created by the flying drapery, the vigorous diagonals, and the rippling muscles of the sea creatures.

When Raphael had finished the picture, Castiglione complimented him on Galatea's beauty. Raphael replied with his famous comment that in order to paint a beautiful woman, he either had to see many of them, from whom he would extract various features, or he would follow an *idea* of beauty. This alludes to the Platonic notion of the "idea" in the sense of the ideal essence of a thing. It is consistent with Raphael's genius for assimilation—in this case, for the purpose of arriving at an image of female perfection.

Fire in the Borgo

After Bramante's death in 1514, Raphael was appointed papal architect by Leo X (papacy 1513–1521), who was the son of Lorenzo the Magnificent. Leonardo was also in Rome at the time, working for Leo, but he produced mainly scientific drawings and studies. Raphael had begun work on another set of frescoes in the Vatican, which were completed under Leo. He also began decorating the *Stanza dell'Incendio*, named for the subject matter of one of the frescoes.

The monumental *Fire in the Borgo* (**16.23**) shows the influence of Michelangelo's muscular nudes and sculptural draperies. The frenzied gestures and contorted poses also herald the change from the Classical restraint of the *School of Athens* to the beginnings of Mannerism, which would develop in the course of the sixteenth century. The scene represents an event from the life of the ninth-century pope Leo IV, when he miraculously extinguished a fire in front of Old Saint Peter's (an area known as the Borgo) with a gesture of blessing. This is depicted in the background, whereas the scene of panic among the citizens, possibly inspired by Michelangelo's *Flood* on the Sistine ceiling, occupies the foreground.

On the right, several women, whose poses are derived from Greek sculptures and vase paintings, carry water to an Ionic building. In the center they attempt to protect their children. One woman at the left hands her swaddled infant over the wall to a man who is fully clothed, while a muscular nude hangs from the wall. Behind both figures is a receding Corinthian colonnade.

Emerging from the building engulfed by flames in the left foreground is a direct visual quotation from an ancient sculpture. It also conforms to Virgil's description of Aeneas escaping the burning city of Troy with his father, Anchises, on his shoulders and his son, Ascanius, carrying the household gods—the Lares and Penates. In Raphael's version, the boy appears to be holding a suitcase. Because the *Aeneid* was specifically written to connect Augustan Rome with the gods—through Aeneas's mother, Venus—Raphael's quotation

must have been intended to remind viewers of the mythic history of Rome.

Pope Leo X with Cardinals Giulio de' Medici and Luigi de' Rossi

Raphael had been a consummate portraitist from early in his career. In 1517, he painted *Pope Leo X with Cardinals Giulio de' Medici and Luigi de' Rossi* (**16.24**), which reveals his genius for capturing the characters of his sitters. The pope, seated before a gold bell, is about to turn the page of an illuminated manuscript that he himself owned. He holds a magnifying glass, reflecting his passion for poring over the objects he collects. He is depicted in a way that emphasizes his rotund proportions, accentuated by the rounded velvet hat and voluminous robes of his office.

Here, as in the *Fire in the Borgo*, there are intimations of a stylistic change. The lighting is more somber and the gradations more subtle than in many of Raphael's previous works, and the faces seem to emerge from the darkened atmosphere of the room. There is also an increased emphasis on surface textures, not only the velvet and silk of the clothing, but also in the skin tones. The brass knob on the chair contains a mirrorlike reflection of the room and, some scholars argue, of Raphael as well.

What distinguishes the *Leo X* from earlier portraits is its disturbing quality, created in part by the apprehensive expressions. The figures do not appear to communicate and seem joined by proximity rather than by compatibility. Each gazes in a different direction as if preoccupied with some inner tension. This, together with the unusual combination of reds and the slight tilt of the chair and desk, contributes to the sense of unease and the decreasing spatial clarity as compared with the *School of Athens*.

16.24 Raphael, *Pope Leo X with Cardinals Giulio de' Medici and Luigi de' Rossi*, 1517. Panel: 60½ × 47 in. (153.7 × 119.4 cm). Galleria degli Uffizi, Florence.

16.25 Raphael, *Transfiguration*, 1517–1520. Oil on panel; 13 ft. 5½ in. × 9 ft. 2 in. (4.1 × 2.79 m). Musei Vaticani, Rome. Giulio never transferred the painting to Narbonne. He kept it instead in San Pietro in Montorio, in Rome. When Raphael died, the *Transfiguration* was placed over his tomb in the Pantheon.

Transfiguration

Cardinal Giulio de' Medici, the future Pope Clement VII, was the illegitimate son of Giuliano de' Medici, Lorenzo's brother, who had been killed in the 1478 Pazzi Conspiracy. He was bishop of Narbonne, France, when, around 1517, he commissioned Raphael to paint a *Transfiguration* (**16.25**) for its cathedral.

The painting actually represents two different biblical events in which formal light and dark merge with

351

16.26 Raphael, study for the *Transfiguration*, c. 1518.
Black chalk; 19⅝ × 14⅓ in. (49.9 × 36.4 cm). Ashmolean
Museum P II 568, Oxford.

16.27 Raphael, study for Saint Andrew and another apostle, c. 1518.
Red chalk; 13 × 9⅛ in. (32.9 × 23.2 cm). Chatsworth, England.

narrative. At the top Christ is transfigured on Mount
Tabor in a white, heavenly light. He is flanked by Moses
and Elijah, who witness his transfiguration in a dream-
like, weightless space. In the distance, the dimmed nat-
ural light of the sunset is a reminder of earthly time and
space. The three apostles—Peter, John, and James—who
accompanied Christ are very much earthbound and
shield their eyes from his radiance. In the lower scene,
unable to cure the possessed boy at the right, the
remaining apostles are in darkness (Matthew 17:1–20).
They gesture helplessly, possessed by their own desire to
drive out the boy's demons. When Christ returned from
the Mount, he immediately effected a cure.

The drawing study in figure **16.26** shows Raphael's
intense focus on the gazes of the figures and the charac-
terization of their tormented reactions. The old man

pulls back, seeming to push away what he sees with his
powerful, foreshortened hands. The youth leans for-
ward energetically, riveted by the sight of the boy whose
possession causes him to roll his eyes and open his
mouth in a trance-like state. His entire body is overtak-
en by an uncontrolled spasm that echoes Christ's own
pose, juxtaposing spiritual transfiguration with posses-
sion—the latter, paradoxically, often connected with
divine states of being.

The study for the elderly Saint Andrew at the lower
left (**16.27**) shows Raphael's technique of making pre-
liminary nude drawings and then clothing them in
the finished painting. Andrew leans sharply forward; the
muscularity of his arms and torso are carefully delineat-
ed. Because of certain distortions, such as the discrep-
ancy in the length of the arms, some scholars have

attributed this drawing to Raphael's student Giulio Romano (c. 1492–1546). Giulio completed the painting, which was unfinished at Raphael's death, and eventually became one of the leading **Mannerist** artists. But already in the *Transfiguration* there are elements of Mannerism—notably, the bright, sometimes jarring color and the contorted poses that seem to reflect an inner state of agitation.

Domestic Architecture

The Villa Madama

Raphael's main private architectural commission was for Giulio de' Medici. From around 1515, he designed the large and complex Villa Madama on Monte Mario, north of the Vatican. The building was not completed by Raphael, but his plan has been reconstructed (**16.28**) and his intentions are recorded in a lengthy letter. He planned an imposing, two-story façade. A Doric portal, flanked by towers, would lead to a rectangular courtyard, a vestibule, and a large central round courtyard. A theater was planned to the east of the central courtyard, and a loggia, garden, and fishpond to the southwest. Raphael's use of Vitruvian terms in his letter reflects his reliance on ancient texts for structural as well as aesthetic correspondences with antiquity. The orientation of the villa took into account weather conditions, including the direction of the wind at various times of year, and, in the spirit of Petrarch and Pius II, views of the countryside.

Raphael also designed the interior of the loggia (**16.29**), which opened toward the garden. The grand scale of the narrow barrel vaults, apsidal spaces, massive piers with Tuscan pilasters, and the dome on pendentives reflects Bramante's influence. The

16.28 Raphael, reconstructed plan of the Villa Madama, begun c. 1515. Outside of Rome. The villa is known as the Madama, after Margaret of Austria, called "Madama." She acquired the villa when she married Alessandro de' Medici in 1536.

16.29 Raphael, Villa Madama, interior of the loggia, c. 1515–1521.

harmonious arrangement of the parts to each other is consistent with Alberti's aesthetic. The villa was unfinished when Raphael died, and the interior was completed by Giulio Romano. Nevertheless, Raphael designed the delicate stucco work and fresco decoration of the loggia. This was inspired by the ruins of Nero's Golden House that had come to light in the early years of the sixteenth century. The exterior of the Villa Madama was finished by Antonio da Sangallo the Younger around 1521.

The Farnese Palace

Antonio da Sangallo the Younger, who worked on the plan of the New Saint Peter's, also designed a Roman palace for the Farnese pope, Paul III. In this case, as in Saint Peter's, Michelangelo altered aspects of Antonio's

design. Nevertheless, the Farnese Palace is more characteristic of Antonio da Sangallo than of Michelangelo. Both the plan (**16.30**) and the façade (**16.31**) emphasize the symmetry and regularity of Renaissance taste.

Like fifteenth-century Florentine palaces, the Farnese is planned around a central courtyard; it consists of three stories crowned by a projecting cornice (added by Michelangelo). But, as is characteristic of High Renaissance style, the façade has a broader extension, and the ground-floor windows, rather than being small for defensive purposes, are large. Their sills are visually linked by a connecting stringcourse, which accentuates the strong horizontal plane of the building. The walls are smooth, with quoins at the corners and rustication around the central door. In contrast to the identical second- and third-story windows of the Rucellai and Strozzi palaces in Florence (see 7.21 and

16.30 Antonio da Sangallo the Younger and Michelangelo, plan of the Farnese Palace, 1530s–1550. Rome.

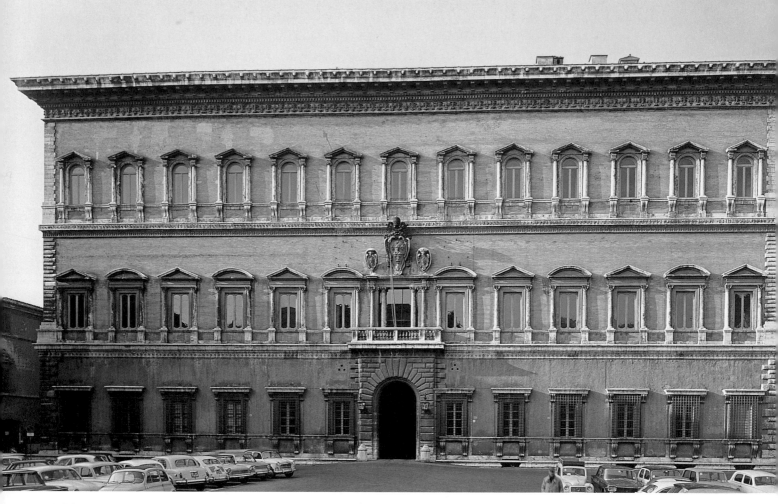

16.31 Antonio da Sangallo the Younger and Michelangelo, façade of the Farnese Palace, 1530s–1550. Rome.

10.14, respectively), the Farnese Palace's second-story windows alternate between having round and triangular pediments. Those on the third story have round arches, and the pediments are uniformly triangular. The patron's coat of arms appears prominently over the entrance between the second and third stories.

After 1520, new artistic trends began to arise, particularly toward Mannerism. The death of Raphael cut short his potential contribution to these developments, although in his later works there is evidence of Mannerist inclinations. These would be pursued in the next generation by his student Giulio Romano (see Chapter 18). Michelangelo, who outlived Raphael by over forty years, did produce work with a distinctly Mannerist flavor. In Venice, the subject of the next chapter, the High Renaissance also evolved into Mannerism.

17

Venice in the Sixteenth Century

The High Renaissance in Venice coincided with the decline of the empire and the threat that the city would lose the independent status it had enjoyed for eight hundred years. Formidable foreign powers such as the French and Spanish kings, the pope, the Holy Roman emperor, and the rulers of Milan united against Venice and formed the League of Cambrai in 1509. They took most of the Venetian territory, including the important city of Verona, but not Venice itself. By 1529, peace was restored along with most of the territory, and Venice propagated the myth of its uniqueness in having survived so great a threat.

The two giants of High Renaissance painting in Venice, Giorgione and Titian, studied with the Bellini. They developed the innovative style of Giovanni Bellini, explored new forms of figural composition, increased the subtleties of lighting and texture, and produced a new language of landscape painting. Giovanni's *Saint Francis* (see 13.17) is perhaps the seminal work in the evolution of landscape, which he fuses with the meaning of the picture and its *istoria*. The landscape in the *Saint Francis*, as in Leonardo's *Mona Lisa* (see 14.21), is more than a backdrop; it explains and is explained by the figure. As such, it embodies the humanist notion of man in nature and of the unity between the two.

The **painterly** surfaces and technique of building up color with many layers of glaze that had characterized late fifteenth-century Venetian painting continued in the sixteenth century. Compared to painting in Florence and Rome, Venetian artists preferred fuller, fleshier figures and softer, more atmospheric lighting. The crisp sculptural contours of Michelangelo's forms and the Classical restraint and proportions of Raphael were less congenial to the Venetians. According to Vasari, Giorgione was influenced by Leonardo, whose own technique was also more painterly than either Raphael's or Michelangelo's.

In contrast to the Florentines, Giorgione painted directly on the canvas without making preliminary drawings. For this, Vasari accused him of disguising poor draftsmanship under the beauty of his colors. In Vasari's view, drawing was a necessary means of working out one's ideas and preserving them. A drawing, as well as nature, could then serve as a model for the finished work. In fact, however, since Giorgione used oil paint, which dries slowly, it would have been easier for him to make revisions as he went along than for an artist working in fresco and tempera.

Writing about art and interest in art theory emerged in Venice later than in Florence and Rome. But in the sixteenth century, an intense theoretical quarrel between the proponents of line and the proponents of color, the former championed by Vasari and the latter by the critic Pietro Aretino (1492–1556), arose in intellectual circles. Aretino praised the qualities of Venetian painters, particularly Titian, whose career he promoted. Vasari, who was devoted to Michelangelo personally and professionally, preferred line and composition (*disegno*), whereas Aretino defended Titian's more painterly qualities (*colorito*). In 1557, in response to the first edition of Vasari's *Lives*, Lodovico Dolce published *Dialogo della pittura* [*Dialogue of Painting*], called the *Aretino* after the critic and espousing his point of view. To Vasari's designation of Michelangelo as *il divino*, Aretino countered by applying the same epithet to Titian.

Painters working in Venice in the late sixteenth century could hardly avoid the influence of Titian. Some, like Tintoretto, whose work reflects the requirements of the Counter-Reformation, are clearly Mannerist. Veronese's work has a pronounced Classical character with some Mannerist features. In the architecture of Palladio, there are new, unclassical juxtapositions of form and structure, although individual features are derived from the Greek Orders.

Giorgione da Castelfranco

Giorgione (c. 1475/77–1510) was born in the village of Castelfranco, northwest of Venice. Having died of plague in his thirties, he left a body of work fraught with problems of attribution, chronology, and meaning. The iconography of several of his paintings has been hotly debated by scholars, and connoisseurs disagree over a number of attributions. According to Vasari, Giorgione was sociable, musical, and a popular member of the Venetian humanist circle led by Raphael's friend Cardinal Pietro Bembo.

Enthroned Madonna with Saints Liberalis and Francis

Giorgione's early altarpiece now in the cathedral of Castelfranco, the *Enthroned Madonna with Saints Liberalis and Francis* (**17.1**), is clearly related to the type of *sacra conversazione* of Giovanni Bellini's San Giobbe Altarpiece (**17.2**). The similarities and differences between these two works are instructive. For Giorgione has assimilated Bellini's altarpiece and also taken it in new iconographic and chromatic directions. The poses and gestures of Saint Francis, for example, are mirror images of each other. Both invite the viewer into the picture's sacred space. But whereas Bellini's is enclosed by the architecture of the apse and the lighting is interior, Giorgione throws open the scene to the outdoors. He elevates the Virgin to a height that contrasts with the greater intimacy between the viewer and Bellini's Madonnas.

On the one hand Giorgione distances the Virgin and Christ, compared with Bellini, and on the other he creates a crescendo of color and pattern—especially in the rich green cloth and red and green rug—leading the eye toward them. He also separates the figures from the viewer by the two rows of floor tiles in the foreground, whereas Bellini's space is more compressed and the viewer confronts the figures more directly.

Giorgione's intention to relate figures with nature is evident in the division of the background. Behind Saint Francis, the landscape that corresponds to his character is peaceful; it leads to a port that evokes Mary's role as the Star of the Sea. Behind the soldier, on the other hand, a hill leads to a fortress, to which the viewer is drawn by the banner. War and peace would thus seem to be a subtext of Giorgione's painting, placing Mary and Christ in the role of intermediaries between these two features of Renaissance life and art.

Saint Liberalis was the patron saint of Castelfranco's cathedral, his gleaming armor a favorite motif of the artist. Its high degree of shine may be associated with Giorgione's account of the superiority of painting over sculpture, one of the *paragoni*, or quarrels, over the relative merits of the two categories of image making. In this view, Giorgione was in agreement with Leonardo, who had emphasized the peaceful, gentlemanly nature of painting in contrast to the noise and dust of stone carving.

In his *Life* of Giorgione, Vasari reports that the artist preferred painting because it could be grasped more readily by a viewer than could sculpture. Conversely, since sculpture is three-dimensional, it is capable of showing all sides of a figure, which is not the case with a picture. Vasari's reply to this argument asserts that Giorgione painted:

> a naked man with his back turned, at whose feet was a most limpid pool of water, wherein he painted the reflection of the man's front. At one side was a burnished cuirass that he had taken off, which showed his left profile, since everything could be seen on the polished surface of the piece of armor; and on the other side was a mirror, which reflected the other profile of the naked figure; which was a thing of most beautiful and bizarre fancy, whereby he sought to prove that painting does in fact, with more excellence, labor, and effect, achieve more at one single view of a living figure than does sculpture.[1]

17.1 Giorgione, *Enthroned Madonna with Saints Liberalis and Francis*, c. 1500–1505. Panel, 78¾ × 60 in. (2.00 × 1.52 m). Cathedral, Castelfranco. Because this was originally painted for Saint George's Chapel in the church of San Liberale, the warrior saint has been identified both as Saint George and as Saint Liberalis. In any event, the presence of the warrior is probably related to the patron, Tuzio Costanzo, who was himself a mercenary soldier. His coat of arms is prominently displayed on the lower step between the two saints.

17.2 Giovanni Bellini, San Giobbe Altarpiece, c. 1478–1480. Oil on panel; 15 ft. 4 in. × 8 ft. 4 in. (4.67 × 2.54 m). Gallerie dell'Accademia, Venice.

Tempest

Giorgione's best-known work is also his most enigmatic. The *Tempest* (**17.3**) of around 1509 has been the subject of extensive scholarly debate. Its manifest content is clear: a man in contemporary Venetian dress stands at the left gazing to the right at a nearly nude woman nurs-ing an infant. The architectural forms behind the man seem related to his vertical, tectonic stance, in contrast to the thick bower of foliage around the woman. A bolt of lightning flashing through the dark clouds lights up a city in the background.

To some scholars, it seems that the figures must have an identity, although there is little agreement on who

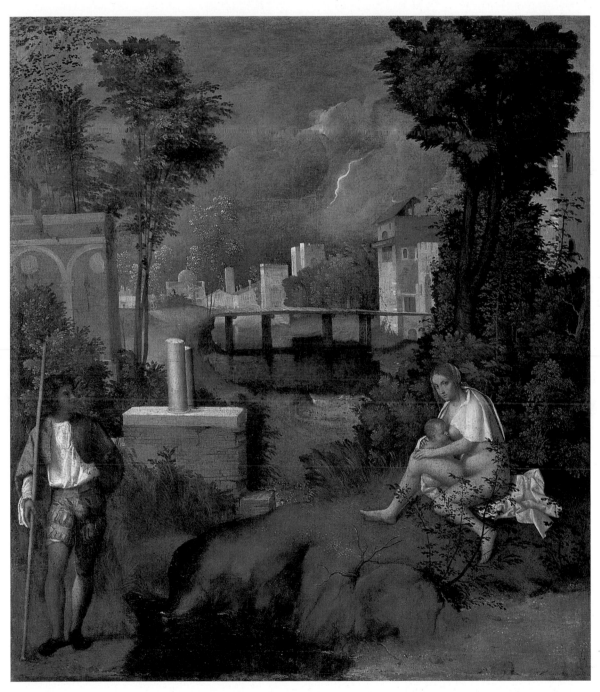

17.3 Giorgione, *Tempest*, c. 1509 (?). Oil on canvas; 31 ¼ × 28¾ in. (79.4 × 73 cm). Gallerie dell'Accademia, Venice.

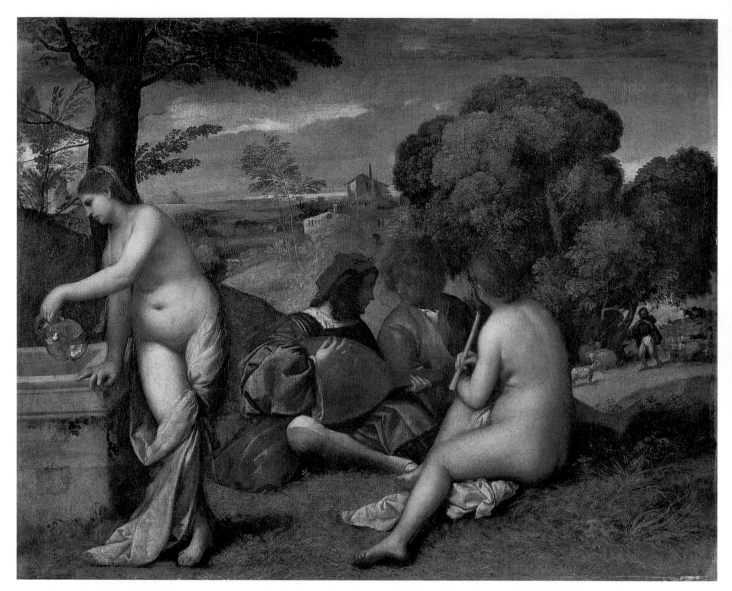

17.4 Giorgione, *Fête Champêtre* (*Pastoral Concert*), c. 1510. Oil on canvas; 43¼ × 54⅜ in. (110 × 138 cm). Musée du Louvre, Paris.

they are. X-ray analysis of the picture has shown that a second nude woman was once bathing where the soldier now stands. Sources proposed for the iconography have ranged from Greek myth, to the Bible, to allegory, to Venetian politics, to the artist's biography. Other scholars believe that the painting has no subject, meaning that it does not illustrate a text. But most would agree that the work has a powerful mythic quality created in part by the atmospheric sky and the unexplained relationship between the man and the nude. Nor does the history of the painting shed light on the problem. It is first documented in 1530, when it was in the collec-

tion of Gabriele Vendramin, a Venetian nobleman. At the time, the picture was described as a landscape with a storm, and the two figures were identified as a soldier and a gypsy. But the inventory does not clarify the matter further.

Fête Champêtre

Another iconographic puzzle of Giorgione's oeuvre is the so-called *Fête Champêtre*, or *Pastoral Concert* (**17.4**), which is generally, but not universally, attributed to him. (It has also been attributed to Titian—see below).

The scene clearly falls within the pastoral tradition, but it would be difficult to say just what it means. Three figures in the foreground—two clothed men and one nude woman—seem about to play music as a second nude woman pours water into a well. In the distance, a shepherd tends his flock. Even more so than the woman in the *Tempest*, these nudes are voluptuously fleshy, their softness surpassing anything produced in Florence and Rome, including Leonardo's figures. As in the *Tempest*, nature and humanity seem to be one. The rich reds of the lute player unite the work chromatically by way of the warm orange tones infiltrating and illuminating the flesh, sky, and landscape.

Sleeping Venus

A similar merging of figure and landscape characterizes Giorgione's *Sleeping Venus* (**17.5**) of around 1510.

Owned by Girolamo Marcello of Venice, this was perhaps a marriage picture. The theme of the reclining nude was a convention of Italian *cassoni*, or dowry chests. Here again, however, there have been several different readings of the image, including territorial allusions to Venice-as-Venus (*Venezia* is Italian for "Venice," and *Venere* is Italian for "Venus") at a time when the republic was fighting for its existence, a bride preparing to receive her mate, and an illustration of a bucolic dream. A Cupid added by Titian—and since removed—at the feet of the figure identifies her as Venus.

Formally, the reclining woman echoes, and is at one with, the landscape. A light yellow illumination, the result of many layers of glaze and the discoloration of varnish, plays over her form, slightly tinting the silvery sheet. Her languid diagonal is repeated in the gently sloping hills, her soft contours carried as far as the billowing cloud stretching across the sky.

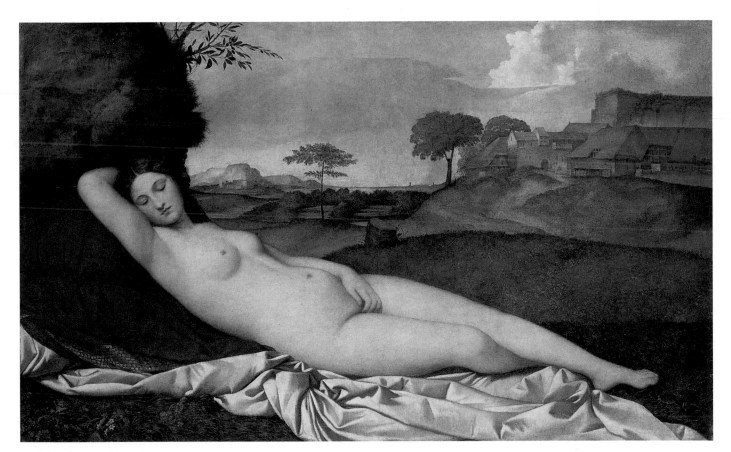

17.5 Giorgione (completed by Titian), *Sleeping Venus*, c. 1510. Oil on canvas; 42¾ × 69 in. (1.08 × 1.75 m). Gemäldegalerie, Dresden.

Portrait of an Old Woman (Col Tempo)

In a very different approach to the female figure, Giorgione created his unusual *Portrait of an Old Woman* (**17.6**). In contrast to the smooth flesh and impassive features of his youthful women, this one has suffered the ravages of age and knows it. She gazes at the viewer from behind a parapet, her bedraggled gray hair, missing teeth, and loose clothing betraying her insight into her own condition. She points to herself as if to confirm the message on the paper in her hand—"*Col Tempo*" [With Time]. Here Giorgione provides the text for his iconography; indeed, he writes it into the image, and it is easy to imagine the woman herself speaking the message.

Giorgione and Titian worked together and shared a similar aesthetic. When Giorgione died, therefore, it seems

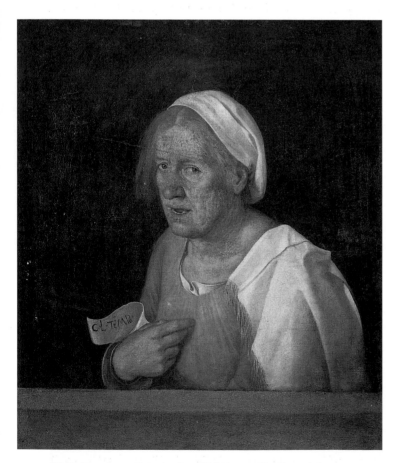

17.6 Giorgione, *Portrait of an Old Woman (Col Tempo)*, early 16th century. Oil on canvas; 26¾ × 23¼ in. (68 × 59 cm). Gallerie dell'Academia, Venice.

that Titian continued his innovations, developing them over the next sixty-five years. Titian's large output and prodigious genius dominated the first three-quarters of sixteenth-century Venetian painting.

Titian

Titian (Tiziano Vecelli; c. 1485–1576), who was born in the village of Pieve di Cadore, went to Venice at the age of nine to live with his uncle and study painting. He studied first with Gentile and then with Giovanni Bellini, and worked with Giorgione for a time. Little is known of his early life; he married a barber's daughter from his hometown and had two sons and two daughters, one of whom died in infancy. Like Giorgione, according to Vasari, Titian was interested in music. He traveled widely in Italy and in 1548 spent time at the Habsburg court of Charles V, who had sacked Rome in 1527. Titian's patrons were among the most influential of the time; they included members of the nobility, Philip II of Spain, as well as Charles V, who knighted him in 1533. In the course of his long and successful career, Titian dominated the High Renaissance in Venice. His subject matter covered a wide range of iconography, including altarpieces, individual Christian works, mythological scenes, allegories, and portraits. Influenced by Giovanni Bellini and Giorgione, Titian's pictures are characterized by an unusual richness of color, the use of glazes, and many varieties of warm reds.

Sacred and Profane Love

Titian's *Sacred and Profane Love* (**17.7**) of around 1514 has a pastoral flavor enhanced by an atmospheric sky that is reminiscent of the *Fête Champêtre*. It is most likely an allegory, and it is generally agreed that the two women represent the two types of Venus and, therefore, the two types of love frequently discussed in humanist Neoplatonic circles (see Box, p. 28). The nude is identified as divine love, and the woman in sumptuous silks and satins, wearing gloves and holding flowers, is thought to represent earthly love. Her association with fertility is suggested by the rabbits in the distance behind her as well as by the abundance of flowers and

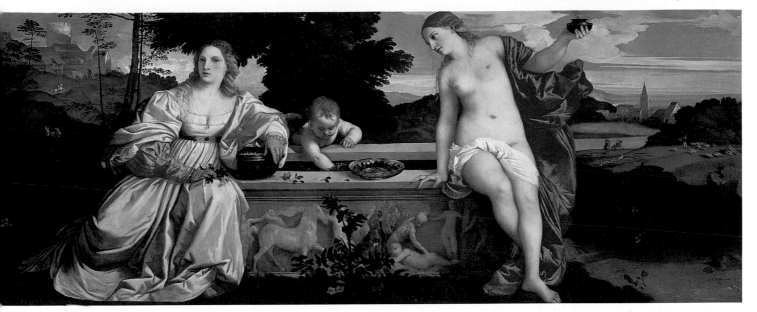

17.7 Titian, *Sacred and Profane Love*, c. 1514. Oil on canvas, 46½ × 109⅞ in. (118 × 279 cm). Galleria Borghese, Rome. Niccolò Aurelio's coat of arms is displayed on the sarcophagus, and that of his bride, Laura Bagarotto, is shown on the inside of the silver bowl. The couple were married in 1514.

foliage. Midway between the two women is a little Cupid reaching into the marble sarcophagus that serves as a fountain.

The patron, Niccolò Aurelio, vice-chancellor of Venice, commissioned the picture to celebrate his marriage (see caption). As such, its fertility motifs allude to his wish for heirs. In addition, the formal resemblance of the fountain/sarcophagus (with a relief derived from antiquity) to a *cassone*, or dowry chest, combines contemporary custom with the Classical revival.

Assumption of the Virgin

Whereas the *Sacred and Profane Love* is still very much influenced by the atmospheric landscapes and mysterious sunset skies of Giorgione, Titian's colossal *Assumption of the Virgin* (**17.8**) for the high altar of the Franciscan church of Santa Maria Gloriosa dei Frari is a new departure. The natural landscape has given way to a series of lighting systems that correspond to the miraculous character of the event. In the lower, darkened third of the picture, the apostles gesture excitedly as they witness the Virgin being physically elevated toward Heaven. The red garments of two of the apostles find an echo in Mary's red dress and God's cape. They are separated from her formally by a pale horizontal of natural light-blue sky and spiritually by the shadows enveloping them.

Mary rises on a cloud filled with angels. Surrounded by an intense, heavenly golden light, she raises her arms and gazes toward God. He, in turn, gazes down at her, spreading his arms in a broad gesture of welcome. His foreshortened form creates a triangle of dark power that seems to emerge from the miraculous light, uniting him with Mary. Titian has orchestrated Mary's ascent so that the worshiper in the church stands just below the level of the apostles. They evoke our identification with their wonderment because we, like them, are in shadow but, by witnessing the miracle of the Assumption, are shown salvation. With the unveiling of this painting, Titian's only work on a colossal scale to date, his power as an artist became evident to his contemporaries. From then until his death, he was esteemed as the leading Venetian painter of the High Renaissance.

The Pesaro Altarpiece

In the Pesaro Altarpiece (**17.9**), Titian also produced an innovative composition, this time in terms of spatial organization. It was commissioned for the Pesaro Chapel, also in the church of the Frari, and contains theological and political allusions as well as members of the donor's family. As in Giorgione's Castelfranco Altarpiece, the Virgin is elevated, but the point of view has changed. The architectural setting is at an oblique angle, placing the steps in the foreground and accentuating Mary's role as the Stairway to Heaven. Anchoring the composition is a pair of giant columns.

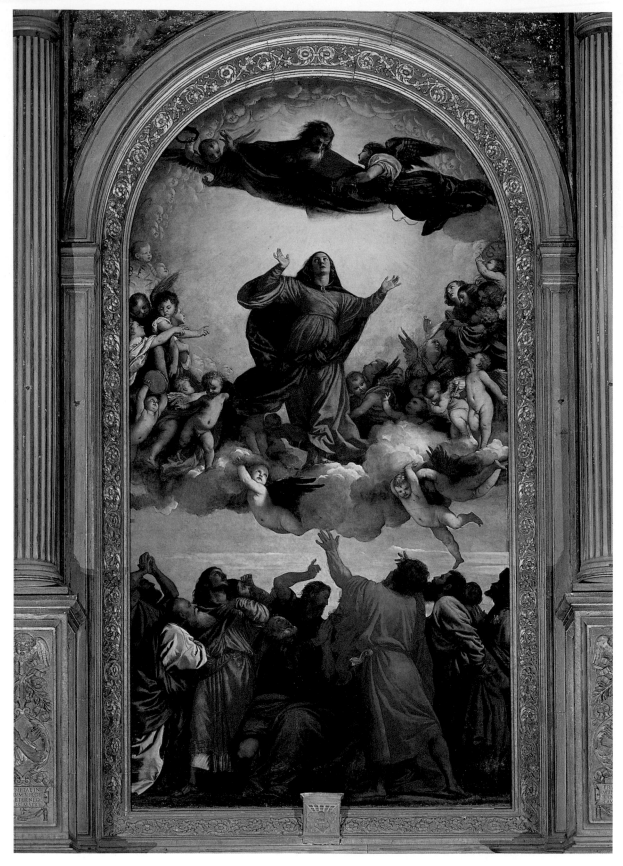

17.8 Titian, *Assumption of the Virgin*, 1516–1518. Oil on panel; 22 ft. 7½ in. × 11 ft. 9¾ in. (6.9 × 3.6 m). Santa Maria Gloriosa dei Frari, Venice. The unveiling of the *Assumption* took place on May 19, 1518, and it was consecrated the following day, on the feast of the Sienese Franciscan San Bernardino. His zealous sermons, particularly his sermon on the Assumption, and spiritual passions are consistent with the character of Titian's painting. He was also a patron of Venice.

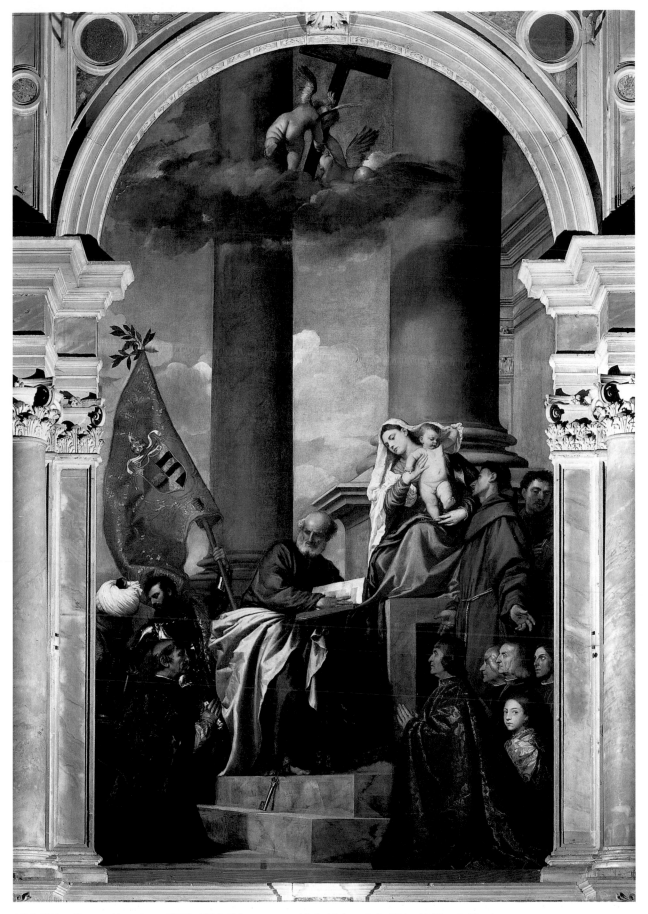

17.9 Titian, *Pesaro Altarpiece*, 1519–1526. Oil on canvas; 15 ft. 11 in. × 8 ft. 10 in. (4.85 × 2.69 m). Santa Maria Gloriosa dei Frari, Venice.

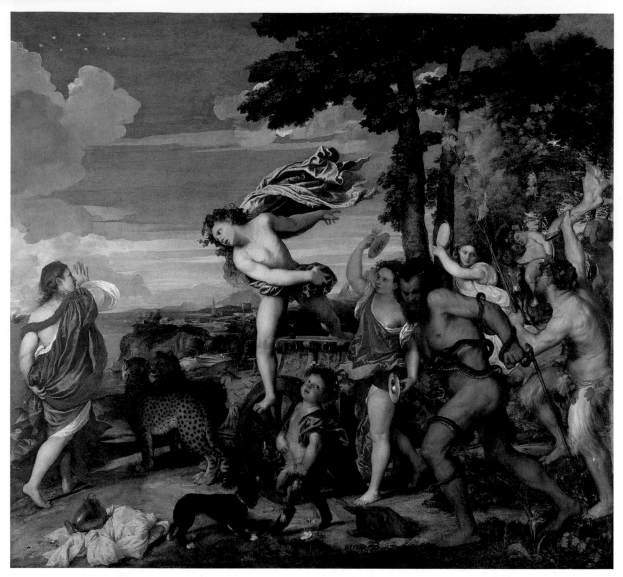

17.10 Titian, *The Meeting of Bacchus and Ariadne*, 1522–1523. Oil on canvas; 5 ft. 9 in. × 6 ft. 3 in. (1.75 × 1.90 m). National Gallery, London. Alfonso's *studiolo*, or *Camerino d'Alabastro* (small alabaster room), was commissioned following the completion of his *Studio di Marmi* (study of marble). The study was decorated with imposing mythological scenes in marble intended to convey the conventional humanist impression that Ferrara was a new Athens. The *studiolo*, on the other hand, was to be a place of relaxation and, therefore, decorated with erotic, bacchanalian scenes. Its iconographic program was the conception of the court humanist of Alfonso's sister (Isabella d'Este) at Mantua.

Allusions to the future appear in the angels struggling with the Cross on a platform of clouds and in Saint Peter's key prominently located on the step. He himself, with his opened book, functions as a formal intercessor between the kneeling donor, Jacopo Pesaro, and the Virgin and Christ. The turbaned figure denoting the triumph of Christianity over the Muslims is being led before the throne by a Christian soldier. The latter carries an impressive red banner bearing the arms of Pope Alexander VI, in whose employ Jacopo defeated the Turks in 1502.

At the right, Saint Francis displays his stigmata as he gazes at the infant Christ. As the family's intercessor and name saint of Francesco Pesaro (in the lavish red cloak), Francis creates a formal and spiritual transition between them and Christ, with whom he identified. Christ seems to take a step toward the saint, while drawing Mary's white cloth—a matrimonial allusion to Mary as the bride of Christ—over his head.

Meeting of Bacchus and Ariadne

Titian creates a very different mood in his exuberant *Meeting of Bacchus and Ariadne* (**17.10**). It was commissioned by Alfonso d'Este as a companion to Giovanni Bellini's *Feast of the Gods* (see 13.19) for his *studiolo* in

the Ducal Palace of Ferrara. According to the Greek myth, Ariadne had rescued Theseus from the Minotaur's labyrinth on Crete and had then been abandoned by him on the island of Naxos. In this scene, *her* rescuer is Bacchus. In a frenzy of passion, the wine god leaps from his chariot to greet Ariadne. In a dancelike motion, she rushes toward him, their union implied by the pair of cheetahs (which Alfonso had acquired for his menagerie) who draw the chariot. Bacchus's entourage is shown in a state of orgiastic revelry, transported by food, wine, and music. Erotic excitement is enhanced by the medley of reds—worn by Ariadne, Bacchus, and the child satyr. In the background, one satyr brandishes the severed leg of a steer—an echo of the detached steer's head in the foreground—and an obese Silenus rides an ass. The bearded nude entwined with snakes is a visual

quotation from the Hellenistic statue of *Laocoön*, which had been excavated in Rome in 1506.

Venus of Urbino

Known for his voluptuous nudes, Titian painted this theme in various guises, most often in a mythological context. His so-called *Venus of Urbino* (**17.11**) was commissioned by Guidobaldo della Rovere, duke of Urbino, hence the name of the painting. In fact, however, the sensuous reclining nude, which is inspired by Giorgione's *Sleeping Venus*, is more likely meant to represent a Venetian woman. Despite certain attributes of Venus such as the roses she holds and the myrtle plant on the windowsill, the setting is a contemporary aristocratic interior. As with the Giorgione, there have been a

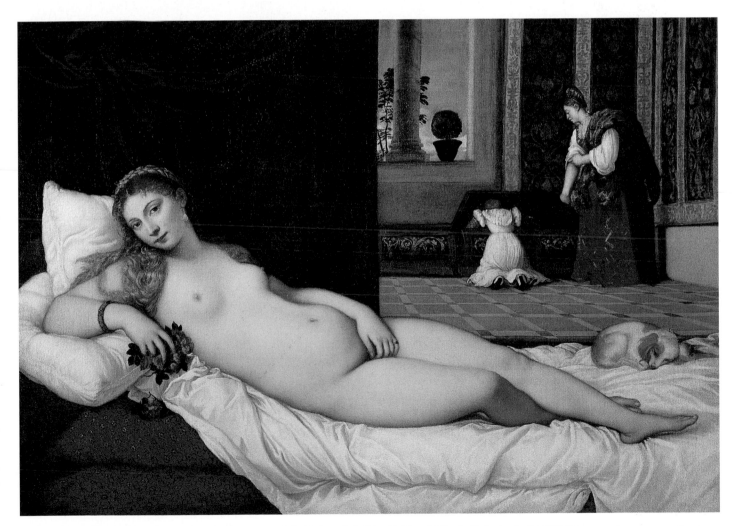

17.11 Titian, *Venus of Urbino*, c. 1538. Oil on canvas; 3 ft. 11 in. × 5 ft. 5 in. (1.19 × 1.65 m). Galleria degli Uffizi, Florence.

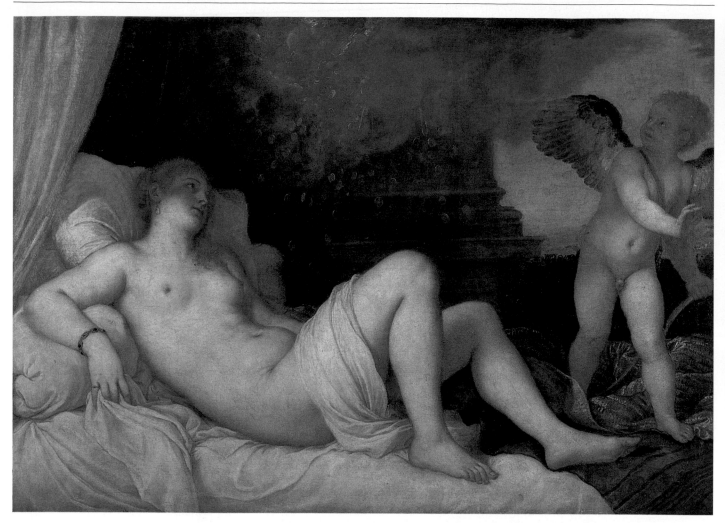

17.12 Titian, *Danaë*, 1545–1546. Oil on canvas; 46 × 27 in. (117 × 69 cm). Museo di Capodimonte, Naples.

number of different interpretations of this work, ranging from reading the woman as a courtesan to a bride preparing for her husband. Contradicting the latter are the two servants removing clothing from a *cassone*, which suggests that the woman is about to get dressed. In any event, the presence of the *cassone* alludes to marriage. Nevertheless, one of the intriguing aspects of this work is its ambivalent character and the questions it raises: Is the woman in the business of romance, or is she a faithful spouse? Is she a real woman or a goddess? Even the dog contributes to the enigma, for although it is a traditional symbol of fidelity, it can also signify lust. In a letter, the duke of Urbino referred to the woman simply as "*la donna nuda*" [the nude woman].

Danaë

Titian's *poesie*, which he painted for Philip II of Spain, are based on an identifiable text—namely, Ovid's *Metamorphoses*—in particular, the loves of the gods. Titian also painted such scenes for his Italian patrons, sometimes in more than one version. He painted two versions of *Danaë*, one for Philip and one for Cardinal Alessandro Farnese (**17.12**). According to Vasari, around 1545 to 1546 Titian showed this painting—which he brought to, or painted in, Rome—to Michelangelo; Titian was, at the time, working for the Farnese family, with whom he had established close ties. Michelangelo reportedly admired the style and color of the work, but regretted that the Venetians were not skilled in drawing.

In contrast to the *Venus of Urbino*, the identity of Danaë is known. She was locked up in a tower by her father in order to elude the prophecy that his grandson would kill him. But Zeus disguised himself as a shower of gold and impregnated Danaë, who subsequently gave birth to the hero Perseus. When Perseus became an adult, he accidentally killed his grandfather with a discus, thereby fulfilling the prophecy.

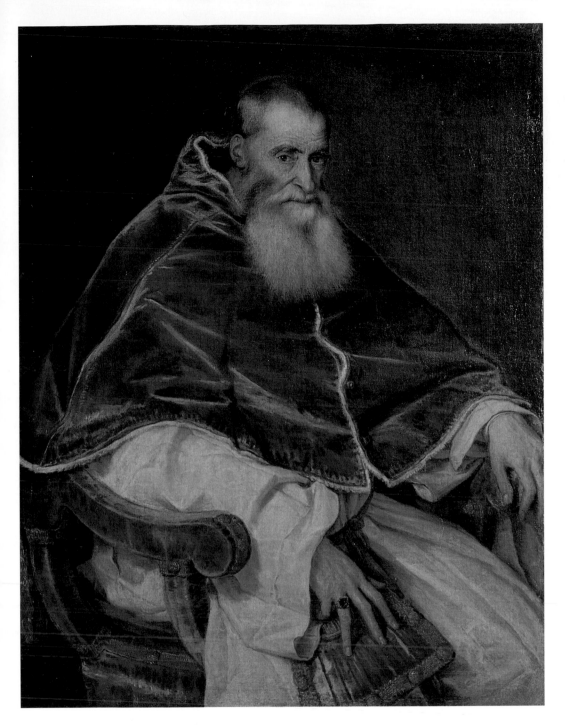

17.13 Titian, *Pope Paul III*, c. 1543–1546. Oil on canvas; 3 ft. 5¾ in. × 2 ft. 9½ in. (106 × 85 cm). Museo di Capodimonte, Naples.

In Titian's picture, the antique setting is indicated by the large column. The moment depicted is Zeus's appearance to Danaë, casting a warm golden-red light on her soft flesh. Despite the gentle curves of the sheet and slightly rumpled pillows, Danaë herself reclines, like the Venus in figure 17.11, in a languid, receptive pose, gazing at her divine lover. In contrast to her air of repose, the little Cupid, set off against the rich blue sky, is shown in a state of conflict. Although a perpetrator of love, Cupid takes his bow, steps over Danaë's red garment, and begins to exit the picture. At the same time, however, reflecting Titian's careful observation of children, he turns to gaze at the shower of gold. His pose

reflects his ambivalence—he is coming and going simultaneously—and his wide-eyed expression and parted lips betray his apprehension.

Pope Paul III

While Titian was in Rome, invited because of his renown in portraiture, he produced one of his most impressive images of Pope Paul III (**17.13**). Painted when the pope was seventy-five, this portrait shows a man slightly bowed by age who is also a powerful physical and intellectual presence. His form fills nearly the entire picture plane. His position in space, together with the alertness

of his gaze, brings him into direct contact with the viewer. The long nose and gray beard merging into the red of the cape accentuate his posture. He leans forward slightly, pressing against his purse with bony fingers. In contrast to such indications of a gaunt frame, the pope is enveloped by massive robes. The red velvets of the cape, chair upholstery, and purse are depicted in varying degrees of richness and with minute differences in texture and chromatic intensity. The loose brushwork and worn appearance of the materials correspond to the aging character of the figure.

Although Titian studied the ancient sculptures and ruined buildings of antiquity during his stay in Rome, his style was not significantly affected by his visit. Elements of classicism are evident in his work before 1545, and his generally humanist outlook seems to have been well established in Venice. Whatever he did assimilate from his Roman trip, he integrated with an individual style whose power readily absorbed and dominated external influences.

Pietà

Titian's last painting, the *Pietà* (**17.14**), was painted for his tomb (but never installed) in Santa Maria Gloriosa dei Frari, where two of his most innovative works were housed (see 17.8 and 17.9). It was unfinished at his death and completed by Palma Vecchio (c. 1480–1528), a leading Venetian painter whose style was strongly indebted to both Giorgione and Titian.

The *Pietà* is both a culmination of Titian's career and a reflection of his old-age preoccupation with time, death, and salvation. In a grand sweep of history, Titian represents stone statues—indicating that they are past but also enduring—of Moses with the Tables of the Law at the left and the Hellespontine sibyl pointing to the Cross at the right. Both figures are typologically related to Christ, Moses as the bearer of God's commandments and the sibyl as an oracle who prophesied the coming of Christ. Both stand on lion pedestals, which allude to the lion throne of King Solomon, also a type for Christ.

Moses and the sibyl are outside the sacred space of the abbreviated apse containing the central image of the *Pietà*. The triple **voussoirs** denote the Trinity, and the pelican in the golden semidome pierces her breast with her bill to feed her young—a metaphor for Christ's blood sacrifice. The winged Victories in the spandrels symbolize the triumph of Christianity over the pagan world, and the airborne *putto* carries the lighted torch of eternal life. Mary's role as the Church building is condensed with the notion of her lap as the altar on which Christ's sacrifice is ritually enacted. The fig leaves to the left of the pediment refer to the Fall of Man and thus to Mary's role as the new Eve and to Christ as the redeemer of Adam's sins.

The Virgin and Christ form part of the broad diagonal across the picture from Mary Magdalen's right hand through the left leg of Joseph of Arimathea (sometimes identified as Saint Jerome). The Magdalen's open gesture appeals to the viewer, her pose borrowed from the mourning figure of Venus on a Roman sarcophagus. To her left is a little *putto* holding her ointment-jar attribute. In contrast to the Magdalen, Joseph, who embalmed Christ, turns toward the illuminated figure of Christ. He wears the signature red of Titian and is the artist's self-portrait. As such, the figure is unusual in turning away from the viewer, here to gaze on the face of death. Titian's hope for salvation is thus directed toward the Savior, whereas his hope for the continuity through earthly time of his own family is indicated by the two **votive** plaques below the lion pedestal at the right.

The first plaque depicts a second *Pietà*, before which Titian and his son, Orazio, are shown kneeling in prayer. Behind this is a second plaque containing the Vecelli coat of arms. By this device, Titian links the genealogy of his family with the genealogy of Christ. The latter, as Michelangelo had shown on the Sistine ceiling, is made explicit in the opening list of generations in the Gospel of Matthew. But in the typological revision of history that evolved with Christianity, there is another, timeless genealogy based on prophecy and fulfillment. In his last painting, therefore, Titian has

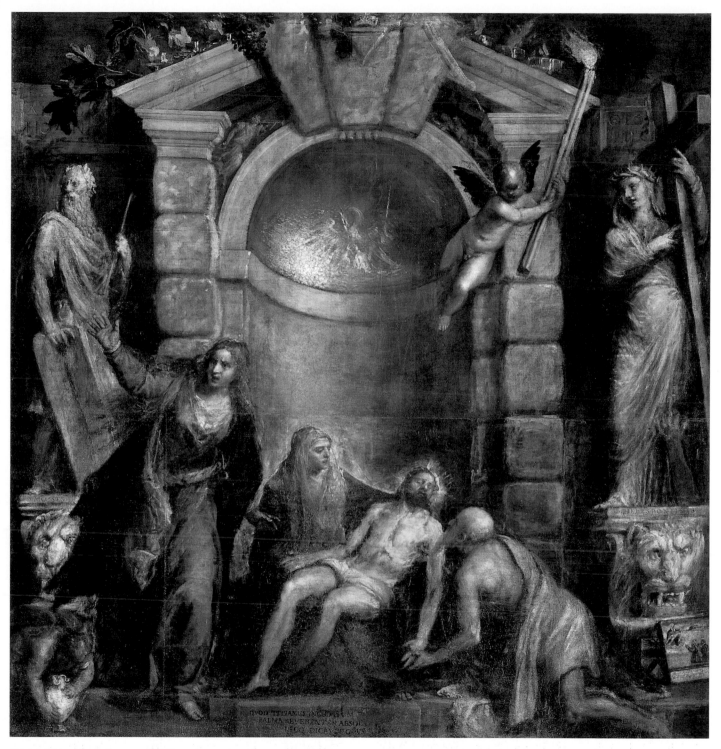

17.14 Titian, *Pietà*, begun c. 1570 and completed by Palma Vecchio. Oil on canvas; 11 ft. 6⅜ in. × 12 ft. 9¼ in. (3.51 × 3.89 m). Gallerie dell'Accademia, Venice.

created a monumental humanist image of Jewish, pagan, and Christian history, merged with autobiography and self-portraiture.

Scholars have discerned elements of Mannerism in Titian's work, but these are never as pronounced as in late Raphael or his students. At a certain point in his career, the influence of Giulio Romano, who was working in Mantua, becomes apparent. But stronger strains of Mannerism are discernible in Michelangelo and Raphael, and more so in their students, than even in Titian's latest pictures.

Later Sixteenth-Century Developments and Mannerist Trends

The power of Titian's style can be seen in the authority it continued to wield over subsequent Venetian painters. Two of these, Tintoretto and Veronese, exemplify two trends of late sixteenth-century style in Venice. Tintoretto's work emphasizes the spiritual quality of his scenes through mystical lighting, dark shadow, and loose, textured brushwork. Veronese, in contrast, imparts a more Classical flavor to his compositions. His forms are generally crisper than Tintoretto's, and his application of paint subordinates the brushstrokes to the illusion of material texture.

Tintoretto: *Last Supper*

According to Tintoretto's (1518–1594) biographer, Carlo Ridolfi, the artist entered Titian's studio but remained only a few days. Following a convention of artists' biographies, Ridolfi claims that Titian's envy was aroused when he saw the young Tintoretto's talent and had him immediately dismissed. Apart from that brief encounter, there is no record of Tintoretto's training. As a mature artist, he produced an enormous number of works, made possible in part by the assistants in his large workshop and the fact that he himself drew and painted rapidly. He worked for several of the Venetian *scuole*, including the Scuola di San Rocco,

where he decorated the walls and ceilings with vast narratives on canvas. When Titian died, Tintoretto succeeded him as the official painter to the republic of Venice.

At the end of his life, Tintoretto painted a dramatic *Last Supper* (**17.15**) for the chancel of the church of San Giorgio Maggiore. The recession of the table diagonally dividing the picture plane is characteristic of Tintoretto and creates an illusion of rapid spatial movement. The exaggerated poses of the apostles have a Mannerist quality, and the sharp twist of the servant in blue at the lower right, a pose first seen in Raphael's Vatican frescoes, is related to the typical Mannerist *figura serpentinata*.

Tintoretto's work satisfied the requirements of the Council of Trent. It was designed to evoke the viewer's identification with the spirituality of saints and martyrs, and they, in turn, were to be identified by such features as halos. In the *Last Supper*, the holy figures—consisting of Christ, his apostles, and angels—are primarily to the left of the long table. They are illuminated by light depicted with thin, flickering yellow brushstrokes that create a mystical glow. The earthly figures, most of whom are to the right of the table and therefore distanced from Christ and his apostles, are in shadow and they appear unaware of the significant event in their midst. Isolated and brooding on the opposite side of the table from Christ is the darkened figure of Judas.

Veronese: *Apotheosis of Venice*

Paolo Caliari (1528–1588), called Veronese because he was born in Verona and studied there before arriving in Venice in 1553, was more interested in the display of rich, colorful materials and massive architectural forms than in mystical effects. This was enhanced by the depiction of the silks, satins, brocades, and gleaming armor worn by his figures. In the 1570s, fires had destroyed much of the interior of the Doge's Palace. Around 1585, therefore, Veronese, along with other artists, was commissioned by the republic to produce pictures glorifying Venice on the ceiling of the Great Council chamber.

Of the two paintings executed by Veronese for the Great Council, the huge and impressive *Apotheosis*

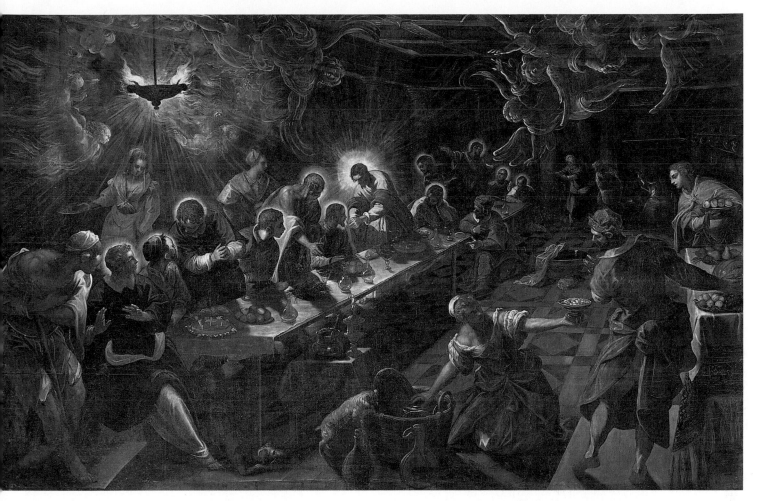

17.15 Tintoretto, *Last Supper*, 1592–1594. Oil on canvas; 12 ft. × 18 ft. 8 in. (3.66 × 5.69 m). San Giorgio Maggiore, Venice. Jacopo Robusti was known as Tintoretto, or "little dyer," after his father's profession. He had two children, Domenico and Marietta, both of whom worked as his assistants and also had independent careers. His daughter, who was best known for her portraits, died at the age of thirty.

of Venice (**17.16**) personifies Venice as a triumphant queen of the sea. She is enthroned between the towers of the Arsenal, past which Venetian ships had to sail when they departed the city on naval missions. The personification of Venice is crowned by a winged Victory, flanked by allegorical figures, and elevated on a cloud, all of which denote her deification, despite the progressive decline in the power of the republic. At the very top, the winged figure of Fame, amidst billowing clouds, carries a trumpet. Reinforcing the impression of the city's might are the massive architectural forms and their iconographic implications. A classicizing cornice and a projecting pair of pulsating twisted columns on either side of the towers frame Venice. Such columns, believed

to replicate those of Solomon's Temple, associate Venice-as-queen to the wealthy, powerful, and wise Old Testament king.

On the parapet underneath the clouds, contemporary aristocrats gaze in various directions over a sturdy balustrade. One couple holds a small boy over the ledge, his foreshortened pose reminiscent of Mantegna's *putti* in the ceiling oculus of the *Camera Picta* in Mantua (see 12.23). Below, in deeper shadow, are dramatically posed soldiers and horses, and at the base of the oval a nude man, derived from Michelangelo's *ignudi*, with a dog. The horses allude to the horses of San Marco, and the stone winged lion in the center is the symbol of Saint Mark and, therefore, of Venice itself.

17.16 Paolo Veronese, *Apotheosis of Venice*, c. 1585. Canvas; 29 ft. 8 in. × 19 ft. (9.04 × 5.79 m). Ceiling of the Hall of the Great Council, Doge's Palace, Venice.

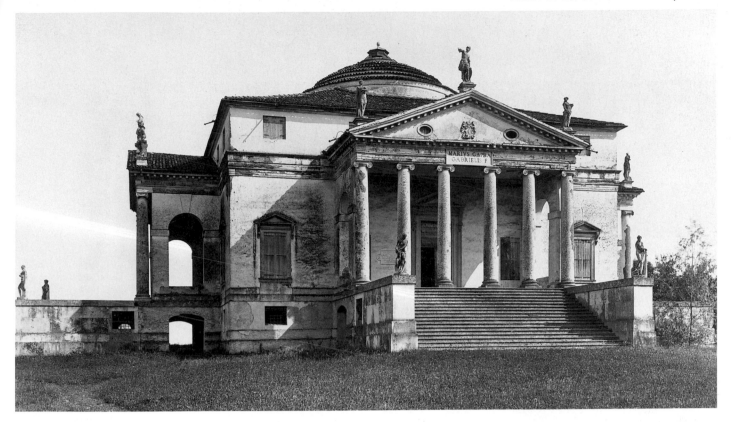

17.17 Andrea Palladio, Villa Rotonda, begun late 1560s. Vicenza.

Palladio: Developments in Architecture

Andrea di Pietro (1508–1580) was named Palladio by his teacher and mentor after Pallas Athena as an allusion to his Classical education. He was the leading architect in northern Italy during the latter part of the sixteenth century. In 1570, he published his influential treatise on architecture, the *Quattro libri dell'architettura*, echoes of which are seen in eighteenth-century England and in the American Federal style of Thomas Jefferson. Although it is difficult to call Palladio's architecture Mannerist, it nevertheless has certain non-Classical features and innovative combinations that strike some scholars as evolving away from Renaissance practice.

Among his more than forty villas around Vicenza, the Villa Capra, known as the Villa Rotonda (**17.17** and **17.18**), is a symmetrical building overlooking the landscape in four directions. Each direction corresponds to a cardinal point of the compass and is marked by an Ionic temple front. Approaching each of the four porticoes is a flight of steps flanked by a short wall. At the ends of the walls and on the pediments are statues, which animate the spaces in a way that becomes typical of Baroque architecture in the seventeenth century.

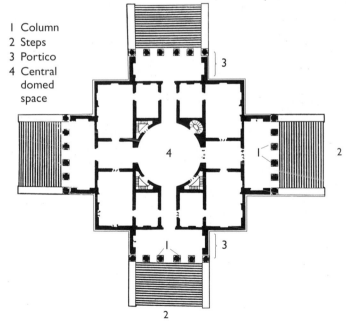

1 Column
2 Steps
3 Portico
4 Central domed space

17.18 Andrea Palladio, plan of the Villa Rotonda, late 1560s. Vicenza.

The rotunda is located at the center of the villa; it is the focal point of the interior, which was used solely for recreation and entertainment. In designing a rotunda for a private villa, Palladio departed from Alberti's view that such features be reserved for temples and churches. At the same time, however, the symmetry of the plan

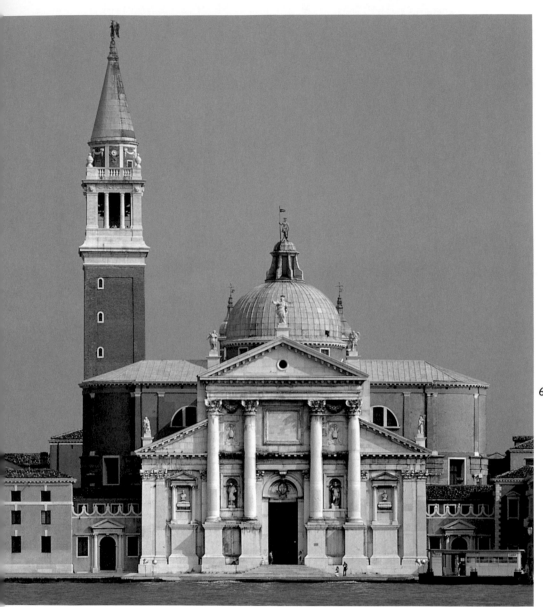

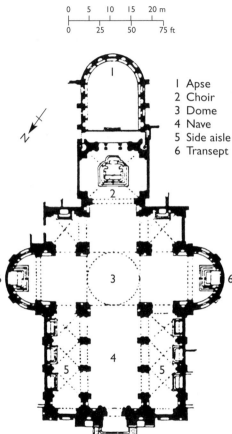

17.19 (*left*) Andrea Palladio, San Giorgio Maggiore, begun 1565. Venice.

1 Apse
2 Choir
3 Dome
4 Nave
5 Side aisle
6 Transept

17.20 (*above*) Andrea Palladio, plan of San Giorgio Maggiore. Venice.

and the centrality of the rotunda, which was the main space, is reminiscent of Leonardo's *Vitruvian Man* and the Classical notion of man as the measure of things.

Palladio's church of San Giorgio Maggiore (**17.19** and **17.20**), begun in 1565, is located on an island in Venice. Following the recommendations of the Council of Trent, the plan is a Latin cross with a nave and side aisles. The dome at the crossing is the main source of light, which illuminates the space before the altar. In accordance with the rules of the council, Palladio placed the altar in front of the apse to give worshipers a clear view of the priest as he celebrated Mass. Tintoretto's *Last Supper* (see 17.15) hangs on the wall to the right of the altar.

In the design of the façade, Palladio had to solve the problem of unifying a wall at the end of a tall nave and shorter side aisles—a problem that had also faced Alberti at Santa Maria Novella (see 7.23). Although completed after his death, the façade of San Giorgio conforms to Palladio's design. His solution—which was related to Alberti's—entailed the superimposition of a tall portico over a shorter, wider one. Unifying the two is the consistent Order: four engaged Corinthian columns resting on podia on the tall portico and Corinthian pilasters on the short one. Such juxtapositions reflect new formal solutions that herald the dissolution of Renaissance classicism.

18
Michelangelo after 1520 and the Transition to Mannerism

With Raphael's untimely death in 1520, Michelangelo's towering genius, matched only by that of Titian in Venice, had no equal in Florence or Rome. At the same time, new artistic trends, particularly the Mannerist style, began to emerge in force, although their beginnings can be discerned earlier. To what extent the arts mirrored the political turbulence of the first half of the sixteenth century is difficult to establish. Nevertheless, there does seem to be a correspondence between the prevailing mood of the period and its artistic products.

In 1513, Leo X, son of Lorenzo the Magnificent, was elected pope. In that same year, Niccolò Machiavelli wrote *The Prince* (*Il principe*), which was based on his experience of contemporary political intrigue and which became a classic in its field. A strong supporter of Soderini, Machiavelli was suspected of anti-Medicean activity and forced to retire to the countryside.

Four years later, Martin Luther launched the Protestant Reformation, challenging and disrupting papal authority throughout Europe. Leo's death in 1521 was followed by the brief tenure of a conservative Dutch pope, Adrian VI. Two years later, at the end of 1523, Giulio de' Medici (Leo X's cousin) became Pope Clement VII. He was forced to flee when Charles V sacked Rome in 1527 and the Medici were again ousted from Florence. When Clement VII agreed to crown Charles V Holy Roman emperor, Charles reinstated the Medici in Florence and appointed them dukes. Under the leadership of Cosimo I de' Medici, who assumed power in Florence in 1537 and was an avid patron of the arts, Mannerism came into its own.

Mannerism evolved as the Classical ideals of the High Renaissance began to dissolve and artists sought new ways of approaching traditional subjects. On the one hand, the Mannerists continued to produce religious works and public sculptures with political meaning. And, on the other, they responded to a shift in patronage that included obscure, sometimes perverse, iconography intended to appeal to the personal tastes of an individual patron. The germs of the style can be seen in the moody, atmospheric backgrounds of Leonardo and Giorgione, the tense, contorted postures of Michelangelo's *ignudi* on the Sistine ceiling, and in the

Machiavelli

Niccolò Machiavelli (1469–1527) was a humanist author of dramas and political tracts. In 1498, he joined the republican government in Florence led by Soderini and became expert in the arts of statecraft. He traveled to various courts on diplomatic missions but was ousted from his position in 1512, when the Medici returned to power. While living on his farm south of Florence, he wrote *The Prince* (published in 1532 and dedicated to Duke Lorenzo de' Medici of Urbino), *Discourses on the First Decade of Livy* (published around 1517), *The Art of War* (1519–1520), and *The History of Florence* (1520–1525). Known for his political realism, Machiavelli believed that lessons of history can be useful in contemporary situations. He also argued that in times of peace and assuming an educated citizenry, republicanism is superior to the rule of princes.

spiraling poses of the figures in Raphael's *Fire in the Borgo* and *Transfiguration*.

Mannerism began in Rome, where it was connected with elite literary circles, which may account for the enigmatic, indecipherable meanings of certain Mannerist images. The term itself comes from the Italian *maniera*, originally meaning simply *style*. Eventually, however, *maniera* came to refer to a kind of refined elegance that is not seen before the High Renaissance. There is a new virtuosity and self-conscious artifice in Mannerism, which produces complex, often bizarre combinations of form and jarring color. Mannerist poses and gestures generally do not conform to Alberti's notion of the *istoria*. Rather than expressing narrative meaning and revealing the inner emotions of characters, Mannerist figures assume poses and produce gestures that can appear artificial, creating a disjunction between them and their context.

The extent to which Michelangelo's works after 1520 can be called Mannerist has been a matter of considerable scholarly debate. What is certain, however, is that they reflect both the tension of the times and the vitality of Michelangelo's genius for invention and innovation. Under the Medici popes, he produced some of his most powerful and original works. That they looked forward to the emerging style of Mannerism and that the Mannerists assimilated some of his artistic ideas are consistent with the dynamic character of stylistic development.

Michelangelo: The Medici Chapel

Around 1519, Leo X and his cousin Giulio (later Clement VII) proposed the construction of a new sacristy (the Medici Chapel) for the family church of San Lorenzo in Florence. The two young Medici dukes, who were generals in the papal army, had recently died—Giuliano, duke of Nemours, in 1516 and Lorenzo, duke of Urbino, in 1519. Neither left a male heir, although Lorenzo's month-old daughter, Catherine, would become the famous Medici queen of France.

The original plan for the Medici Chapel called for four tombs, two for the dukes and one each for Lorenzo the Magnificent and his brother, Giuliano. The New Sacristy was planned as a pendant to Brunelleschi's Old Sacristy (see 3.17), which contained the tombs of Giovanni di Bicci, founder of the family fortune and the Medici bank, and his wife, Piccarda de' Bueri. It was thus conceived as a monument to the continuity of Medici power in Florence.

The architecture of the New Sacristy (**18.1**) is innovative in the animation of its walls and their sculptural plasticity, whereas the use of gray *pietra serena* as a framing device emulates the Old Sacristy (see 3.17). The view opposite the altar in figure 18.1 shows the division of the wall into three stories: the lower one divided vertically into three bays by large, fluted Corinthian pilasters. A similar division marks the shorter second story, whereas the third consists of a large lunette flanked by the pendentives of the dome. The eight doors, only four of which function as such, are surmounted by large niches with **broken pediments** that would become a staple of Baroque architecture in the seventeenth century. Bases within the niches appear intended for sculptures but are too narrow to hold them. Scrolled **brackets** under the base of the niche (which also serves as the **lintel** over the door) are decorative rather than functional. The ambiguity of the brackets—it is not clear if they are to be read as supporting the base or hanging from the lintel—is typical of Mannerism. The fact that the niches seem heavier than the doors below them also departs from the Classical model of order and logic, signaling a shift away from Renaissance architectural theory.

A similar arrangement appears on the side walls containing the tombs of the dukes (**18.2** and **18.3**). **Blind niches** with round pediments apparently, but not actually, supported by brackets flank the sculptures. The animation at the top of the wall defies the Albertian view that the decorative elements of a wall should reflect the structural logic of greater weight at the base.

Both dukes wear antique armor with fanciful details consistent with their status in the papal army. Below each duke is his sarcophagus, with personifications of times of day on the double volutes of the lid. There is a Mannerist quality in the unstable slant of these figures, who seem as if they might slide off the lids at any moment. Two river gods planned for the spaces on either side of the bases of the sarcophagi were never

executed, nor were the mourning figures intended to flank the dukes.

Giuliano (18.2) is represented as a powerful, alert, and active personality, with the figures of Day and Night on his tomb. The sleeping female is Night. She wears a moon and a star in her hair; these, with her two attributes—an owl and a mask—denote nighttime. Michelangelo left a piece of uncarved marble for a mouse, which he never executed. It was meant to symbolize Time gnawing away at life as a mouse gnaws its food. The figure of Day is, like Giuliano, awake and alert. *Day's* muscular frame, which is characteristic of Michelangelo, is incomplete, and the chisel marks remain visible. He seems, like many of the unfinished sculptures, to be literally emerging from the unpolished marble. As such, he evokes the sense of a work in the process of becoming, a quality that appealed to Vasari as well as to later writers on the artist.

Lorenzo (18.3) is pensive, his fantastic leonine helmet accentuating the sense that he is weighed down by thought. He leans his left elbow on a money box, a reference to the Medici fortune. Its lion's head relief probably alludes to Florence and the continuity of Medici rule.

Below Lorenzo are personifications of Dusk and Dawn, the more transitional times of day. *Dawn* is a languid woman in the process of waking and *Dusk* a man in a meditative mood, appearing to be sinking into

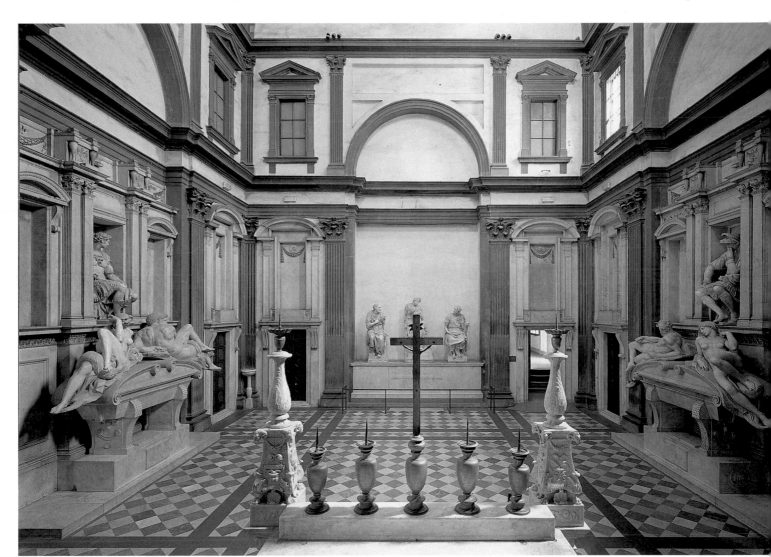

18.1 Michelangelo, view of the Medici Chapel, 1519–1534. Church of San Lorenzo, Florence.

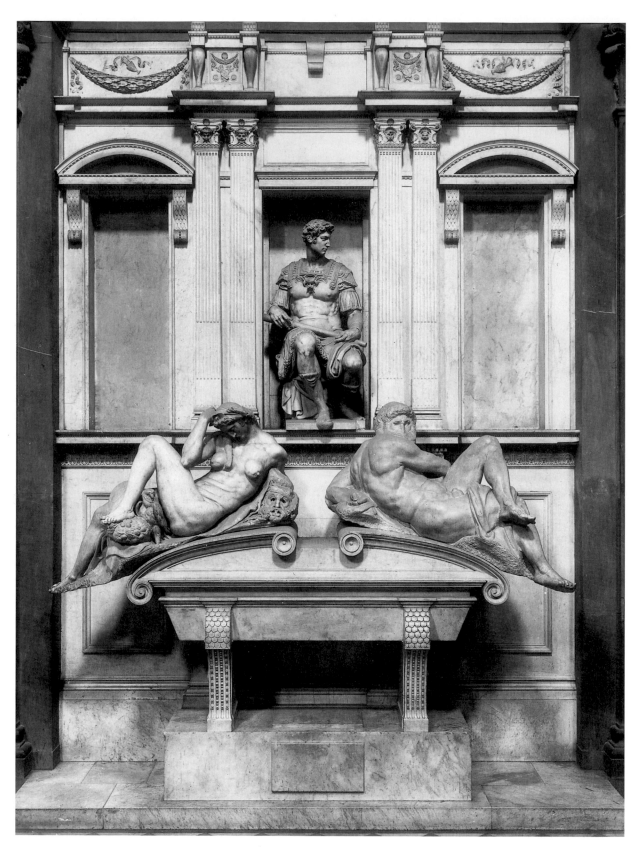

18.2 Michelangelo, tomb of Giuliano de' Medici, 1520s. Marble. Medici Chapel, San Lorenzo, Florence.

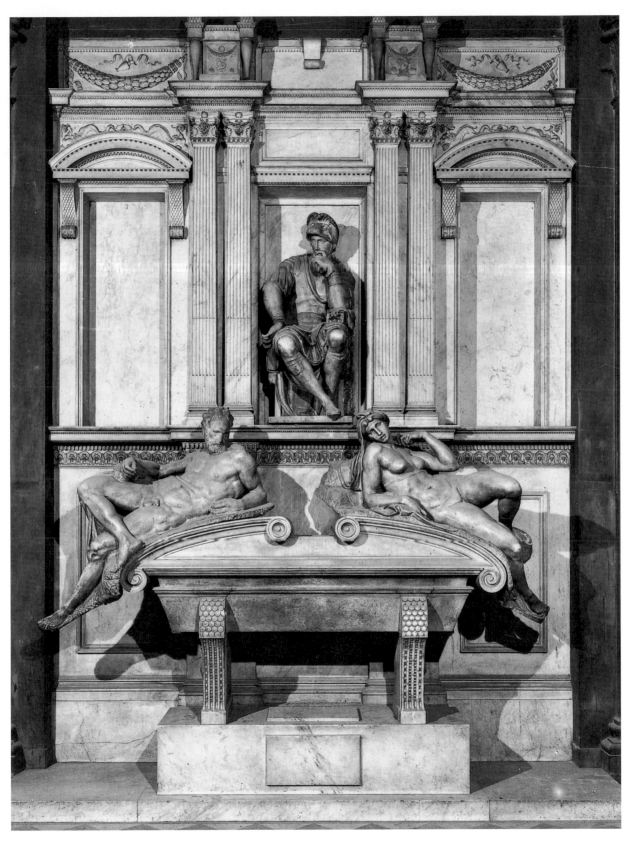

18.3 Michelangelo, tomb of Lorenzo de' Medici, 1520s. Marble. Medici Chapel, San Lorenzo, Florence.

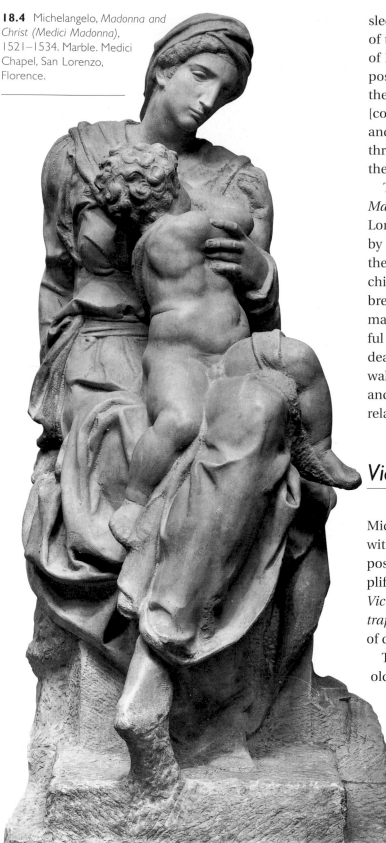

18.4 Michelangelo, *Madonna and Christ (Medici Madonna)*, 1521–1534. Marble. Medici Chapel, San Lorenzo, Florence.

sleep. They, like the *Day* and *Night*, echo the character of their respective duke. Although the precise meaning of Michelangelo's iconography has been disputed, it is possible that he merged the Neoplatonic opposition of the *vita attiva* [active life] and the *vita contemplativa* [contemplative life] with the depictions of Giuliano and Lorenzo. Both dukes gaze toward a corner door through which one originally entered the chapel from the church.

The *Madonna and Christ*, the so-called *Medici Madonna* (**18.4**), is now on the unfinished tomb of Lorenzo the Magnificent and his brother, and is flanked by the Medici saints Cosmas and Damian. Christ, as in the *Bruges Madonna* (see 15.6), is shown as a herculean child; but here he twists around toward his mother's breast. The Virgin, though youthful, has a somewhat masculinized form, with broad shoulders and a powerful frame. Her wistful expression alludes to Christ's death, which is celebrated on the altar at the opposite wall. In her spiraling pose, the abrupt twist of her neck, and her tilted head, there is a new dynamism that is related to Mannerist tastes.

Victory

Michelangelo's first work that can be readily identified with Mannerism is his *Victory* (**18.5a** and **b**). Its spiraling pose, more so than that of the *Medici Madonna*, exemplifies the Mannerist *figura serpentinata*. As such, the *Victory* is a formal evolution of the relaxed Classical *contrapposto* pose; but balance is now attained by a series of dynamic, **asymmetrical** spatial turns.

The *Victory*'s depiction as a youth dominating an old man in an uncomfortably contorted position has iconographic as well as formal meaning. If the victim is not Michelangelo's self-portrait, which it resembles, then it is surely a self-image. Despite possible philosophical underpinnings such as the notion that youth triumphs over age, there is a hint of the perverse in the figures' relationship to each other. This, like the stylish affectation of the youth's pose and the elongated proportions of the figure, is characteristic of Mannerism.

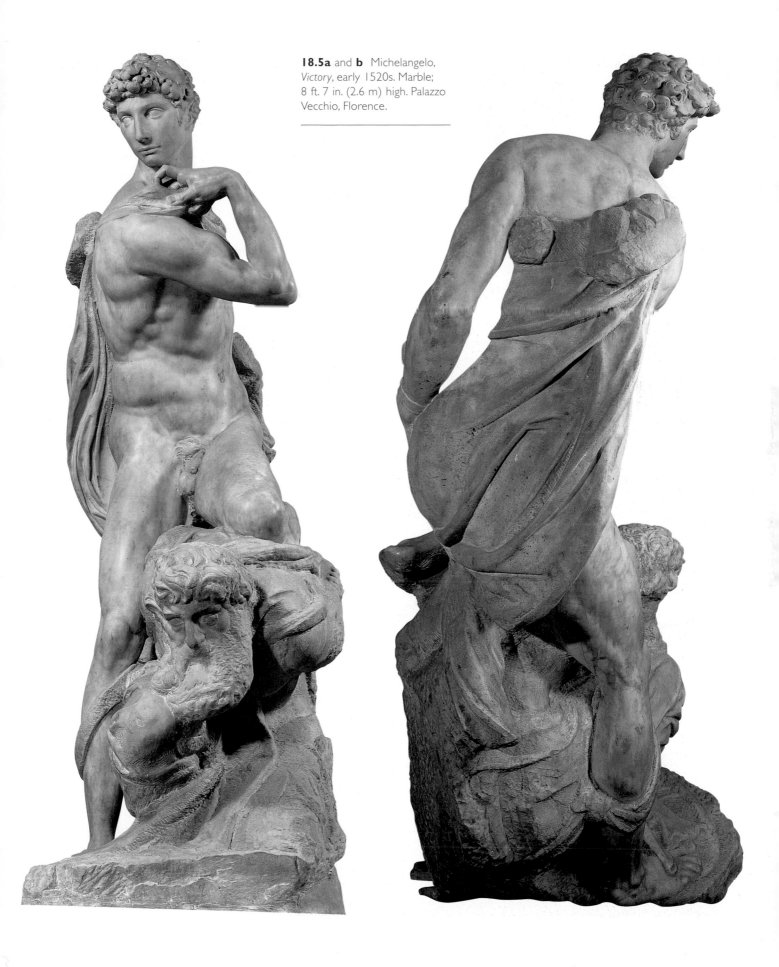

18.5a and **b** Michelangelo, *Victory*, early 1520s. Marble; 8 ft. 7 in. (2.6 m) high. Palazzo Vecchio, Florence.

Last Judgment

In 1534, Michelangelo left Florence and spent the rest of his life in Rome. Clement VII died in September of that year; but before his death he proposed that Michelangelo paint a *Last Judgment* on the altar wall of the Sistine Chapel. The commission was finalized by Clement's successor, Paul III, who was himself a patron of the arts and of Michelangelo in particular. Later he would have Michelangelo decorate the Vatican's Pauline Chapel, named for himself, with scenes from the lives of Saints Paul and Peter.

In the monumental *Last Judgment* (**18.6**), Michelangelo produced an overwhelming vision of the end of time. The lunettes at the top of the fresco depict angels carring the instruments of Christ's Passion. Below is Heaven, dominated by the central figure of Christ. He is highlighted from behind by a yellow glow as he turns to raise his hand against the damned. Crouching beside Christ is Mary, turning toward the saved. Heaven is populated by saints and martyrs accompanied by the instruments of their martyrdom. At the right, Saint Catherine bends over the wheel on which she was tortured; next to her, Saint Sebastian kneels and holds out the arrows with which he was shot by Roman soldiers for being a Christian. Saint Peter, extending large gold and silver keys, turns toward Christ; and Saint Bartholomew (see 18.7), seated on a cloud, holds a knife in one hand and a limp, flayed skin in the other. All of these figures, whose bodies were tortured and mangled in death, have regained their flesh for eternity.

Below Heaven, at the left (Christ's right), angels welcome the saved as they climb from their tombs and begin their rise. In the center, a group of angels sounds the Last Trump. At the right (Christ's left), the damned descend, dragged down by devils and horrified by the future awaiting them. Michelangelo's conception of Hell is unprecedented, for he has superimposed on it an image of the Classical Hades. Charon, the mythological boatman of Hades, ferries the damned across the river Styx and forces them from the boat with his oar. They tumble toward their destiny, which is darkness, fire, and eternal torture. Satan, at the lower right corner, has been merged with a monstrous figure of Minos, the mythological tyrant of Crete, and is entwined by a giant serpent.

A comparison of Michelangelo's *Last Judgment* with Giotto's in the Arena Chapel in Padua (see 2.6) juxtaposes early and late Renaissance styles. It also exemplifies the changing mood of the two periods and reflects the temperaments of the two artists. Although the general design of the works is similar, Giotto's is relatively sedate and ordered, and his figures, except for the damned, are clothed in classicizing draperies. Michelangelo's wall, in contrast, heroizes the monumental nude that reflects the Renaissance dignity of man. All traces of the formal ease and humorous details found in Giotto's image have disappeared. The tension pervading the Sistine Chapel's *Last Judgment* is created by the massing of layers of figures, their twisting bodies, and vigorous gestures. In its energetic power conveying the drama of the end of earthly time and the transition to eternity, Michelangelo's image can be seen to fulfill Alberti's notion of *istoria* on a vast scale. But such features as Mary's *figura serpentinata* and the pulsating surface of the wall have a Mannerist quality.

The detail of Saint Bartholomew (**18.7**) contains a telling autobiographical message. The martyr, who was flayed alive, turns vigorously toward Christ and displays the knife with which his flesh was removed. In his left hand, he holds out a flayed skin, the sign of his own martyrdom and also of the artist's emotional state. For the skin contains a self-portrait of Michelangelo, dangled precariously above the angels of the Last Trump and Charon's boat. Michelangelo's identification with martyrdom—which is consistent with the plight of the old man in the *Victory*—is nowhere more apparent than in this detail. Not only does he emphasize the tortures of the saints as well as of the damned, but he shows himself as a flayed skin, in stark contrast to the powerfully muscular figures populating his fresco.

To what degree Michelangelo's emotional state reflected the turmoil of the times is impossible to pin down. Nevertheless, contemporary reaction to the *Last Judgment* was itself not without tension and conflict. Pietro Aretino, for example, his championship of Titian and admiration for Michelangelo notwithstanding, wrote to Michelangelo accusing him of blasphemy and impiety. He pointed out that in his own writing he

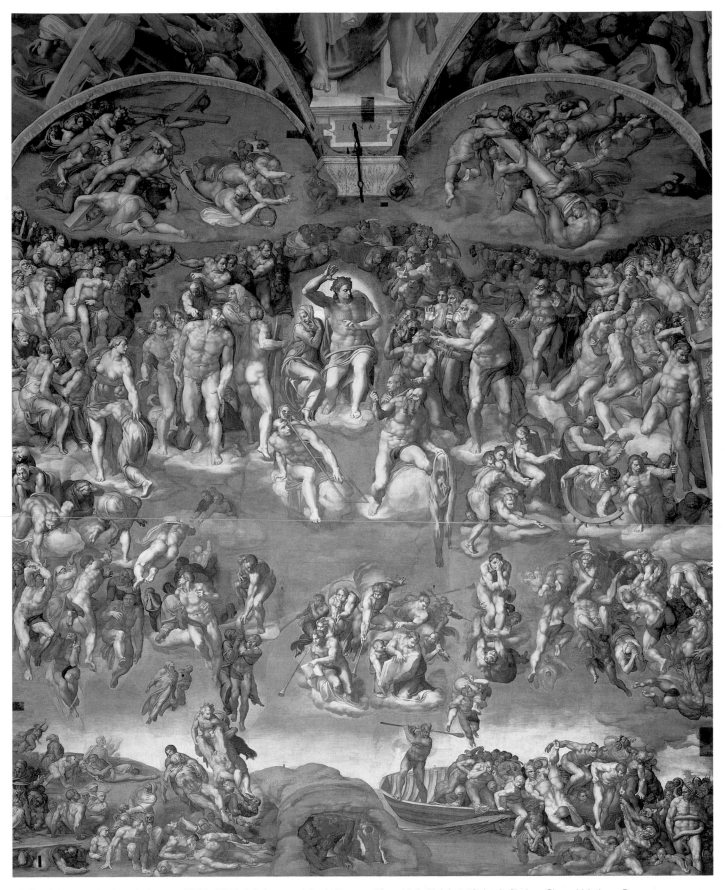

18.6 Michelangelo, *Last Judgment*, 1534–1541 (after restoration). Fresco; 48 × 44 ft. (14.6 × 13.4 m). Sistine Chapel, Vatican, Rome.

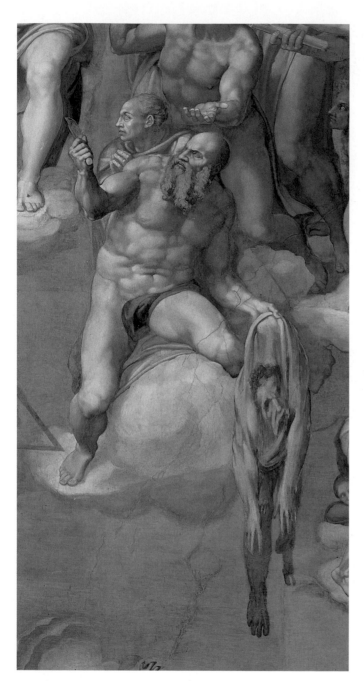

18.7 Michelangelo, detail of Figure 18.6 (after restoration).

cloaked the presentation of immodest subject matter in attractive language, whereas Michelangelo was indecorous in his depiction of the saints and martyrs. The fresco, according to Aretino, would have been more appropriate for a bath house (*bagno*) than for the pope's chapel. And furthermore, he added, the indecency was exacerbated by the fact that Michelangelo was himself a Christian.

In 1555, Paul IV (d. 1559) was elected the first Counter-Reformation pope and was an avid supporter of the Inquisition. If he had had his way, the entire *Last Judgment* would have been erased. As it was, shortly after Michelangelo's death in 1564, loincloths were painted over the nudes. They remained until the most recent, controversial restoration of the chapel.

Michelangelo's Later Architecture

In 1523, when Giulio de' Medici became Pope Clement VII, he commissioned Michelangelo to design a library to house the Medici collection of manuscripts. Clement wanted to make the collection, previously located in the Medici Palace, accessible—and visible—to the public. It is also likely that he was inspired by the example of Michelozzo's library of San Marco (see 5.7), which had been the conception of Cosimo de' Medici nearly a century earlier. The Sack of Rome intervened, however, and little was done before Clement's death. Most of the work was carried out from Michelangelo's designs after his departure for Rome in 1534.

The Vestibule of the Laurentian Library

The most original part of the library is the vestibule, or *ricetto* (**18.8**). This has been seen as both a precursor of Baroque and, in the personal quality of the architectural choices, the use of artifice, and the disruption of Classical order, an outright expression of Mannerism. Here Michelangelo developed further the innovative juxtapositions of the Medici Chapel. The same gray *pietra serena* is used to frame and accentuate areas of the light wall. The wall is divided into two levels. The upper level contains a form of heavy Doric column with concave abaci set into recesses and continuing to the lintel. The latter breaks over the columns and follows the recess of the wall. At the corners, the columns flank a pier whose corner juts out between them. The molding below the columns does not convey an impression of support, and the brackets on the lower level of the wall seem to hang from the columns rather than to support them.

18.8 Michelangelo, view of the Laurentian Library vestibule and staircase, 1524–1559. San Lorenzo, Florence.

Between pairs of columns are blind niches with round and triangular pediments and pilasters that taper toward their bases. In so doing, they defy structural logic, as do the large columns over the brackets. Above the niches are purely decorative, slender moldings that have the quality of picture frames. The interiors, however, like the niches below, are blank, which increases the impression of artifice.

The most dramatic feature of the tall, 35-foot-square vestibule is the large, triple stairway (**18.9**). Nearly as much a piece of sculpture as an architectural element, the stairway consists of three flights of steps. They lead to a single doorway capped by a broken triangular pediment. The central flight is composed of oval steps, three at the bottom and one at the top, and segments of ovals ending in scrolls in between. Wide banisters with thick **balusters** separate the center steps from the rectangular side flights. These have no banister and end at a broad scroll on a square landing. At this point, a visitor mounting the side flight must turn and continue up the central stairs.

With this staircase, Michelangelo arrived at a new conception of architectural plasticity. He also rejected Alberti's recommendation that interior staircases

18.9 Michelangelo, aerial view of the Laurentian Library staircase. San Lorenzo, Florence.

occupy as little room as possible. In contrast to the clear, open spaces and regular shapes of fifteenth-century design, therefore, Michelangelo has introduced formal variety and non-Classical juxtapositions, and has challenged Renaissance ideals of making structural logic a visible presence.

The Campidoglio

Michelangelo used oval and trapezoid shapes in his plan for the renovation of the Campidoglio (the Capitoline Hill), in the heart of modern Rome (**18.10**). The history of the Campidoglio stretches back to antiquity; it was imbued with religious and political significance that continued through the Middle Ages.

But by the time of Paul III's election to the papacy, the site had deteriorated, and the pope wanted it restored to its former glory.

Michelangelo retained the trapezoidal piazza and inscribed in it a large oval design. At the center of the oval, Paul III placed the second-century A.D. bronze equestrian statue of the Roman emperor Marcus Aurelius. This was a tribute to Rome's dual image as *umbilicus mundi* and *caput mundi*—"navel of the world" and "head of the world"—as well as an attempt to identify its contemporary status with its ancient imperial power.

Two buildings were already standing at the time that Michelangelo designed the ensemble. At the far end was the Palazzo del Senatore, which he dignified with an

imposing double stairway, begun in 1544. He also added giant pilasters and niches as frames for the windows. The twelfth-century tower was moved to the center of the building so that it was aligned with the statue and the ramplike stairs leading from the street to the piazza.

At the right, as one faced the Palazzo del Senatore, stood the fifteenth-century Palazzo dei Conservatori. As at Saint Peter's, Michelangelo added giant Corinthian pilasters, vertically unifying the façade. Smaller Ionic columns frame the bays of the loggia and support an entablature that creates a horizontal unity continuing behind the pilasters. A large projecting cornice surmounted by a balustrade with statues heralds developments in Baroque architecture.

Across from the Conservatori, Michelangelo placed another building in order to balance the total design and to maintain the trapezoidal shape of the piazza. As a result of the diagonal disposition of these two buildings, the piazza seems to open up toward the visitor ascending the main ramp. On either side of the entry point is a statue of one of the Dioscuri, the famed horse tamers of antiquity and the twin sons of Zeus (in Greek, *kouroi*, or "boys," plus *Dios*, "of Zeus").

The Campidoglio was not completed until after Michelangelo's death, but his plans were followed with relative accuracy. His late works, which were decades later than Raphael's late works, overlapped and, to a large extent, influenced the development of Mannerism. Whereas Raphael's impact on Mannerism consisted of a new gracefulness, attention to material opulence, and complex figural arrangements, Michelangelo imposed powerful, innovative combinations of form onto the Classical precedents of the Renaissance.

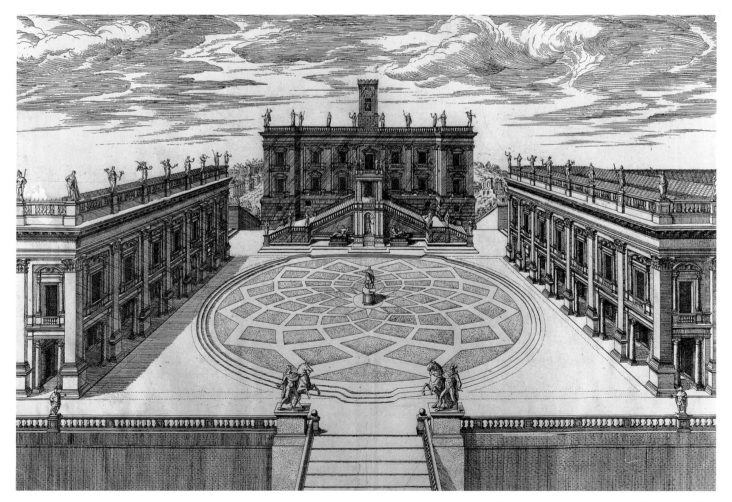

18.10 Michelangelo, design for the Campidoglio, the Capitoline Hill, begun 1538 (engraving: 1569). Rome.

Towards Mannerism

Correggio and Parmigianino

The influence of both Raphael and Michelangelo on the new generation of artists was extensive. In Parma, for example, the High Renaissance artist Correggio (1494–1534) came first under the influence of Leonardo and then of Raphael, although he had never been to Rome. His *Jupiter and Io* (**18.11**), one of a series depicting the loves of Jupiter in the early 1530s for Federico Gonzaga, duke of Mantua, shows the impact of both artists. The moody, atmospheric sky and constantly changing cloud into which Jupiter has transformed himself (see the caption) have echoes of Leonardo's *sfumato*. At the same time, however, the changing color, texture, and form of the cloud have affinities with Mannerist ambiguity even though these elements are called for by the text of the myth. The emergence of Jupiter's face, barely touching Io's, has a perverse quality mitigated only by the painter's delicate rendering of the encounter. Equally odd is the massive cloudy paw that encircles Io in a surreal embrace. She, in turn, leans back rather precariously in a state of erotic ecstasy. The dramatic shifts in light and dark, the softness of the flesh, and the pose are all derived from Raphael's late style.

The transition to Mannerism can be seen by comparing Correggio's picture with the *Madonna and Christ with Angels* (*Madonna of the Long Neck*) (**18.12**) by Girolamo Francesco Mazzola (1503–1540), known as Parmigianino ("the little fellow from Parma"), who also lived and worked in Parma. In Rome, from 1524 until his return to his native city, he absorbed Raphael's style to such a degree that he was often referred to as the new Raphael. In the *Madonna of the Long Neck*, begun in 1534, the proportions can no longer be considered Classical.

The figures are elongated and endowed with a new elegance that appealed to courtly patrons. In this case, the patron was a noblewoman of Parma who wanted the painting for her chapel in Parma's church of Santa Maria dei Servi. Odd spatial juxtapositions—such as the small scale of the man with the scroll in the background compared with the foreground figures—strong shifts from light to dark, the *figura serpentinata* pose

18.11 Correggio, *Jupiter and Io*, early 1530s. Oil on canvas; 64 × 29½ in. (163 × 75 cm). Kunsthistorisches Museum, Vienna. In Greek mythology, Io was the daughter of the king of Argos and a priestess of Hera. Zeus (Jupiter) appeared to her in a dream and invited her to Lerna, where he seduced her in the guise of a cloud. It is possible, given the proximity of Parma and Mantua, that the face in Correggio's cloud might have been partly inspired by the cloud man in Mantegna's *Saint Sebastian* (see 12.20).

18.12 Parmigianino, *Madonna and Christ with Angels (Madonna of the Long Neck)*, begun 1534. Oil on panel; 85 × 52 in. (216 × 132 cm). Galleria degli Uffizi, Florence. The artist's life seems to have paralleled certain perverse aspects of his painting. According to Vasari's life of Parmigianino, he was "unkempt … melancholy and eccentric." He was obsessed with alchemy to the degree that he renounced painting to pursue the conversion of base metal into gold. When Parmigianino died, he was, at his own request, buried naked with a cross on his chest—a reflection of his psychotic identification with Christ's Crucifixion.

of the Madonna, and the metallic color of her costume are typical of Mannerism. The background column, which serves no support function, is probably an allusion to Mary's role as the Church building. In the fifteenth century, following a medieval metaphor, Piero della Francesca had compared Mary to a column in the Arezzo *Annunciation* (see 9.11). Here, in contrast, it is Mary's neck that is implicitly paralleled with the columnar form—derived from medieval sources as well as from contemporary poetry.

The character of the figures in Parmigianino's painting are also Mannerist in their sensuality, even lasciviousness. Mary calls attention to her breast, which is accentuated by the arrangement of the drapery. One of the group of androgynous angels gazes longingly at her breast, another seems to gaze down upon the nude Christ, and two others leer slyly at the viewer. A fifth angel, except for the highlight of light on his face, is covered in shadow.

Giulio Romano

Raphael's student Giulio Romano (c. 1492–1546) also worked for Federico Gonzaga. Beginning in 1527, he spent seven years designing and decorating the suburban villa in Mantua known as the Palazzo del Tè. It served as a place of entertainment and a horse farm for the court. The inner wall of the courtyard façade (**18.13**) illustrates several artifices of Mannerist architecture. The pediment over the central door, for example, rests on brackets instead of columns or pilasters. In the pediments over the blind niches, the horizontal base is absent, opening and animating the space. At certain intervals, the Doric triglyphs seem to be falling through the lower border of the entablature. These devices disrupt the Classical rules of order and harmony, while using Classical features to do so. Animating the surface of the wall are the heavy rustication and the wide spaces between each block of stone.

In the interior, the so-called *Sala dei Giganti* contains frescoes depicting the battle between the gods of Olympos and the Titans. In the large scene showing the *Fall of the Giants* (**18.14**), colossal temple columns crumble and fall as the Giants cower beneath them in contorted Mannerist poses. The iconography of the battle, like the details of the courtyard wall, alludes to the destruction of one generation by a succeeding one. In the former case, the Olympians bring a new order to the universe; and in the latter, the Mannerist architect defies the humanist classicism of Renaissance theory.

18.13 Giulio Romano, Palazzo del Tè, 1527–1534. Mantua.

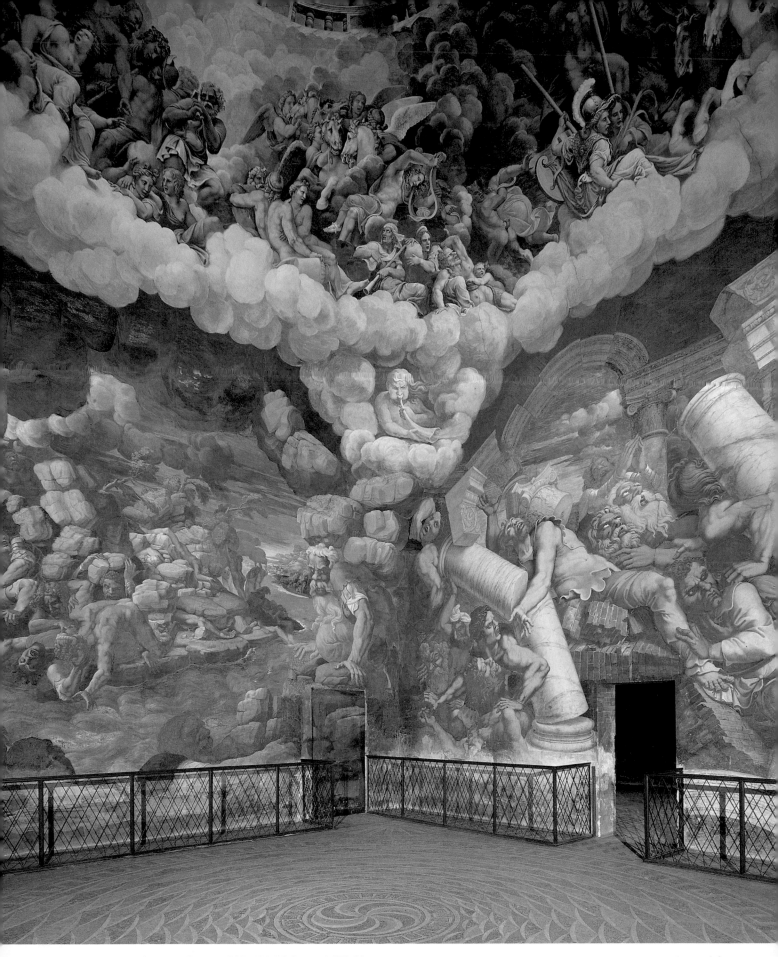

18.14 Giulio Romano, *Sala dei Giganti*, 1527–1534. Palazzo del Tè, Mantua.

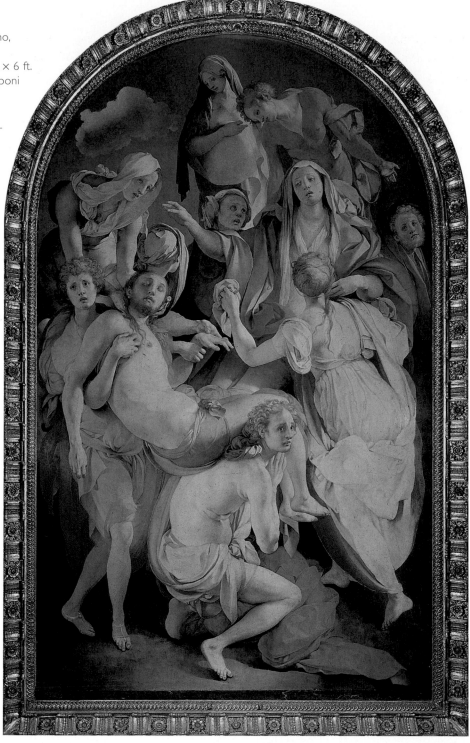

18.15 Jacopo Pontormo, *Deposition*, 1525–1528. Oil on panel; 10 ft. 3 in. × 6 ft. 4 in. (3.1 × 1.9 m). Capponi Chapel, Santa Felicità, Florence.

Pontormo

In contrast to Correggio's *Jupiter and Io*, Pontormo's *Deposition* (**18.15**) of around 1525 to 1528 has assimilated the crisp edges, muscular figures, and sculptural draperies of Michelangelo. But unlike the figures on the Sistine ceiling or the *Doni Madonna* (see 15.7),

the setting is contradictory. Aside from a cloud, there is no reference to landscape, and the figures appear to occupy an architectural floor. They are arranged ambiguously, and it is not possible to account for their positions in space. The icy colors—mainly pinks and blues—are unusual, and the poses are not always consistent. For example, the youth in blue

carrying Christ twists in a dancelike motion that is at odds with lifting the weight of a dead body. Both he and the crouching youth gaze fixedly out of the picture, but it is not clear what they see. Nor is the subject itself entirely clear; the picture has been called both an *Entombment* and a *Deposition*. In fact, Christ has just been moved from Mary's lap for burial; her large pyramidal form is reminiscent of Michelangelo's *Pietà* in Rome (see 15.3). There is no sign of the Cross, although the blond, bearded man at the right may be Joseph of Arimathea, who assists in the Deposition. He is, in any case, Pontormo's self-portrait.

Florence Under Cosimo I de' Medici

With Cosimo I's assumption of power in Florence at the age of eighteen, a new era of patronage began. Duke of Florence from 1537 to 1569 and grand duke of Tuscany until 1574, Cosimo I, like his Medici forebears, understood the political power of imagery. At the same time, when artists worked privately for him, they produced the complex, enigmatic images characteristic of Mannerism. Many of these were created during Michelangelo's lifetime, and the impact of Michelangelo is readily apparent.

Benvenuto Cellini (1500–1571) worked for Francis I of France and then for Cosimo I. While at the French court, he made the famous gold and **enamel** saltcellar (**18.16**), a quintessential Mannerist object. The two main figures are a bearded Neptune seated by a ship and an earth goddess next to an Ionic temple. The ship contained the salt, linking the work to Francis' dominion over the sea, and the temple the pepper, the earth goddess alluding to the king's territories. Both figures occupy unstable poses, leaning so far back that in reality they would topple over. They are also engaged in personal erotic play as Neptune points his trident toward the goddess while she seductively tweaks her breast. Encircling the saltcellar below are personifications of winds and times of day. Their poses are derived from Michelangelo's Medici Chapel sculptures.

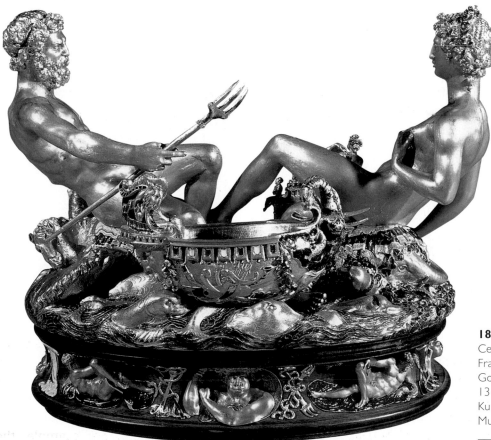

18.16 Benvenuto Cellini, saltcellar of Francis I, finished 1543. Gold and enamel; 10¼ × 13⅛ in. (26 × 33.3 cm). Kunsthistorisches Museum, Vienna.

Cellini's bronze bust of Cosimo I (**18.17**) dates to the mid-1540s, after his return to Florence, and conveys the duke's haughty, aloof character (Cosimo was generally an unpopular ruler). The attention to surface patterning of the beard and hair as well as the fantastic armor designs are characteristic of Mannerism. Cosimo's sharp turn, as if to look down on the viewer (and, implicitly, on his subjects), is also Mannerist in its affectation.

In 1544, Cosimo commissioned Cellini to cast a bronze statue of Perseus (**18.18**) for the loggia adjacent to the Palazzo Vecchio. Cosimo had in mind a pendant to Donatello's *Judith* (see 10.3 and 10.4) and Michelangelo's *David* (see 15.5). The message of the *Perseus* is similar to that of its predecessors—namely, that opponents of the republic come to a bad end.

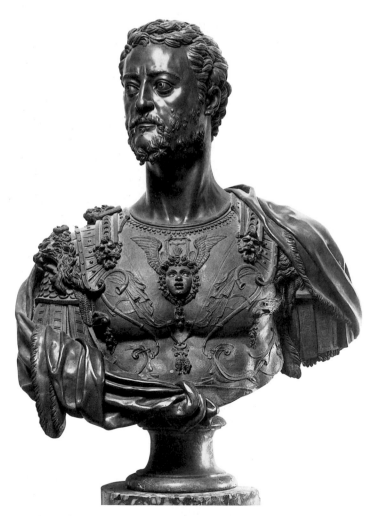

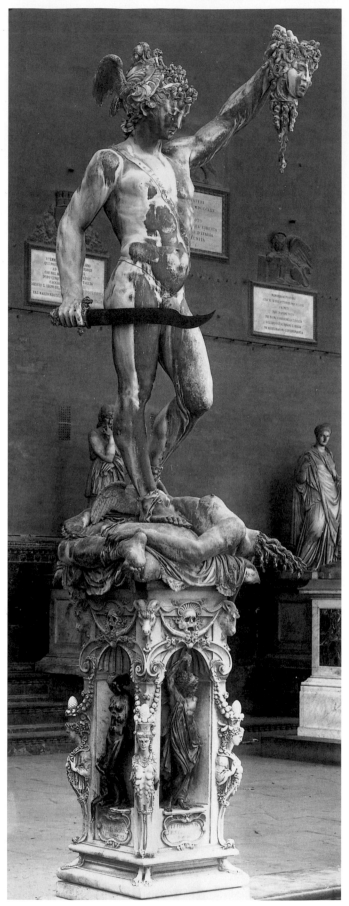

18.17 Benvenuto Cellini, *Cosimo I*, 1545–1547. Bronze; 3 ft. 7¼ in. (1.1 m) high. Museo Nazionale del Bargello, Florence.

18.18 Benvenuto Cellini, *Perseus*, 1545–1554. Bronze; 10 ft. 6 in. (3.2 m) high. Loggia dei Lanzi, Florence.

18.19 Agnolo Bronzino, *An Allegory with Venus and Cupid*, 1540s. Oil on panel; 61 × 56¼ in. (155 × 143 cm). National Gallery, London.

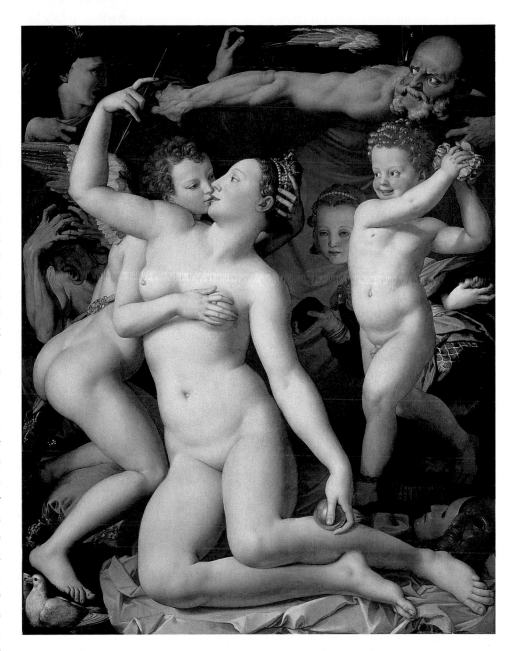

Perseus stands for Florence, holding aloft the severed head of its monstrous enemy. The surface of the hero's torso ripples with Mannerist patterns, his winged helmet and drawn sword opening up and animating the space compared to the relatively closed forms of Donatello and Michelangelo. Not only does the blood flowing from Medusa's neck congeal into grotesque, serpentine waves, but Perseus stands on her contorted body.

The *Perseus* was a public sculpture, but Cosimo also commissioned portraits of his family and private, enigmatic works. One of the most complex of these is Bronzino's *Allegory with Venus and Cupid* (**18.19**), which was intended as a gift for Francis I. The two central figures are engaged in a perverse, incestuous embrace. An adolescent Cupid kisses his mother (Venus) on the lips and fondles her breast. Their poses, like that of the *putto* preparing to pelt them with roses, conform to the Mannerist *figura serpentinata*, and their porcelain skin textures enhance the affectation. An old hag tears her hair at the left, and the sphinx-like figure on the right has been identified as Fraud. Her lower body is serpentine and clawed, and her human hands reverse right and left. Angrily revealing the incestuous couple is the powerful figure of Time, the old man with a wing and an hour glass. He exposes the crime of incest as a violation of time, for it denies the generational difference between mother and son.

Bronzino's depiction of rich material textures, jewels, and masks was designed to appeal to the tastes of the French court. The iconography is personal and literary, although the text on which it is based is unknown. Like Cellini's saltcellar, and in contrast to the *Perseus*, the *Allegory* was a private commission. As such, it did not have to submit to the scrutiny of Counter-Reformation censors.

By the latter part of the sixteenth century, Renaissance style was a thing of the past. Mannerism would soon evolve into Baroque, which would dominate the arts of seventeenth-century Europe and parts of the New World.

Timeline 1200–1399

ARTS AND LITERATURE

- Campanile of Pisa Cathedral (1174–1271)
- Church of St. Francis, Assisi (1228–53)
- Nicola Pisano, Marble Pulpit, Pisa Baptistery (c. 1260)
- Giovanni Pisano, Siena Cathedral façade (1284–99)
- Cimabue, *Enthroned Madonna and Child* (c. 1285)
- Duccio di Buoninsegna, *Rucellai Madonna* (1285)
- Palazzo Vecchio, Florence (1299–1310)
- Giotto, Crucifix (c. 1300)
- Giotto, Arena Chapel frescoes (c. 1305–10)
- Duccio, *Maestà* (1308–11)
- Dante Alighieri's *Divine Comedy* completed (1321)
- Simone Martini, *Annunciation* (1333)
- Ambrogio Lorenzetti, *Allegories of Good and Bad Government* (1338–39)
- Doge's Palace, Venice (1340s–1438)
- Giovanni Boccaccio's *Decameron* completed (1353)
- Andrea di Cione (Orcagna), Strozzi Altarpiece (1354–57)
- Francesco Petrarca's *Famous Men* published (1379)
- Geoffrey Chaucer's *The Canterbury Tales* begun (1387)

PEOPLE AND EVENTS

- Cambridge University founded (1200)
- Fourth Crusade; Sack of Constantinople (1201–04)
- St. Dominic founds Dominican Order (1206)
- St. Francis founds Franciscan Order (1209)
- King John signs Magna Carta (1215)
- Gold florins minted in Florence (1252)
- Sorbonne founded, Paris (1254–57)
- St. Thomas Aquinas, *Summa Theologica* (1266–74)
- Marco Polo travels to China and India (1271–95)
- End of Crusades; Turks expel Christians from Holy Land (1291)
- Visconti assume power in Milan (1295)
- Papacy moves from Rome to Avignon (1309–78)
- Hundred Years' War between England and France (1337–1453)
- Failure of Bardi and Peruzzi banks in Florence (1346)
- Black Death (1347–50)
- The Nine lose power in Siena (1355)
- Dukes of Burgundy become rulers of Flanders (1384)
- Giangaleazzo Visconti named Duke of Milan (1395)
- Medici bank founded in Florence (1397)

Timeline 1400–1449

ARTS AND LITERATURE

- Competition for Baptistery doors, Florence (1401)
- Jacopo della Quercia, Ilaria del Carretto tomb monument (c. 1406–08)
- Donatello, *Saint Mark* (1411–13)
- Lorenzo Ghiberti, *John the Baptist* (1412/13–17)
- Lorenzo Monaco, *Coronation of the Virgin* (1414)
- Nanno di Banco, *Four Crowned Saints* (1414–16)
- Filippo Brunelleschi, Interior of Old Sacristy, San Lorenzo (1418–28)
- Filippo Brunelleschi, Hospital of the Innocents (begun 1419–21)
- Masaccio/Masolino, Brancacci Chapel frescoes (1420s)
- Gentile da Fabriano, *Adoration of the Magi* (1423)
- Masaccio, *Trinity* (c. 1425–28)
- Lorenzo Ghiberti, East Baptistery Doors (1425–52)
- Pisanello, *Saint George and the Princess* (1430s)
- Jan van Eyck, *Man in a Turban* (1433)
- Jan van Eyck, *Arnolfini Portrait* (1434)
- Filippo Brunelleschi, Santa Maria degli Angeli (begun 1434)
- Jan van Eyck, *Madonna with Chancellor Nicolas Rolin* (c. 1435)
- Paolo Uccello, *Sir John Hawkwood* (1436)
- Sassetta, *Saint Francis in Ecstasy* (1437–44)
- Antonio Pisanello, Medal of John VIII Palaeologus (c. 1438)
- Fra Angelico, San Marco frescoes (1438–45)
- Donatello, *David* (1440s)
- Paolo Uccello, *Battle of San Romano* (1440s)
- Bernardo Rossellino, Tomb of Leonardo Bruni (begun 1444)
- Michelozzo, Exterior of Medici Palace (1444–60)
- Domenico Veneziano, Saint Lucy Altarpiece (c. 1445)
- Donatello, *Gattamelata* (c. 1445–56)

PEOPLE AND EVENTS

- Development of scientific perspective in Italy (c. 1400)
- Venice gains control of Padua (1406)
- Thomas à Kempis, *Imitatio Christi* (1414)
- Introduction of the *catasto* (property tax) in Florence (1427)
- Joan of Arc burned at the stake (1431)
- Cosimo de' Medici becomes ruler of Florence (1434)
- Leon Battista Alberti, *On Painting* (c. 1435)
- Council of Churches, 1438
- First record of the suction pump (1440)
- Eton College and King's College, Cambridge, founded (1441)
- Cosimo de' Medici founds *Biblioteca Medicea Laurenziana* (1444)

Timeline 1450–1499

ARTS AND LITERATURE

- Leon Battista Alberti, Tempio Malatestiano (c. 1450)
- Piero della Francesca, Cappella Maggiore frescoes, Arezzo (1450s)
- Triumphal Arch of Alfonso I of Aragon (1453–71)
- Donatello, *Mary Magdalen* (1454–55)
- Filippo Lippi, *Madonna and Child* (c. 1455)
- Andrea del Castagno, *Niccolò da Tolentino* (1456)
- Leon Battista Alberti, façade of Santa Maria Novella (1458–70)
- Benozzo Gozzoli, Medici Chapel frescoes (1459)
- Jacopo Bellini, *Way to Calvary* (1460s)
- Antonello da Messina, *Portrait of a Man* (1460s)
- Antonio Averlino (Filarete), plan of Sforzinda (c. 1461–62)
- Bernardo Rossellino, Plan of Pienza (c. 1462)
- Andrea del Verrocchio, *David* (mid-1460s)
- Andrea Mantegna, *Camera Picta*, Mantua (1465–74)
- Francesco del Cossa, *April* (late 1460s–early 1470s)
- Andrea del Verrocchio, *Baptism of Christ* (c. 1470)
- Andrea del Verrocchio, Tomb of Piero and Giovanni de' Medici (1470s)
- Giovanni Bellini, *Coronation of the Virgin* (1470s)
- Piero della Francesca, *Battista Sforza and Federico da Montefeltro* (c. 1472)
- Leon Battista Alberti, Sant'Andrea, Mantua (begun 1472)
- Cristoforo Mantegazza and Giovanni Amadeo, Certosa, Pavia (1473–1490s)

- Hugo van der Goes, Portinari Altarpiece (late 1470s)
- Giovanni Bellini, San Giobbe Altarpiece (c. 1478–80)
- Gentile Bellini, *Portrait of Sultan Mehmet II* (1479–80)
- Sandro Botticelli, *Madonna of the Pomegranate* (c. 1480)
- Sandro Botticelli, *Birth of Venus* (c. 1480)
- Leonardo da Vinci, *Saint Jerome* (c. 1480–81)
- Giuliano da Sangallo, Medici Villa (1480s)
- Perugino, *Christ Giving the Keys to Saint Peter* (1481)
- Andrea del Verrocchio, *Colleoni* (c. 1481–96)
- Domenico Ghirlandaio, Sassetti Capel, Santa Trinità, Florence (1483–86)
- Perugino, *Crucifixion* (c. 1485)
- Domenico Ghirlandaio, *Adoration of the Shepherds* (1485)
- Giovanni Bellini, *Saint Francis* (c. 1485)
- Filippino Lippi, *Vision of Saint Bernard* (c. 1485–90)
- Giuliano da Sangallo, Santa Maria delle Carceri (1485–92)
- Leon Battista Alberti, *On Architecture* (1486)
- Vittore Carpaccio, *Miracle at the Rialto* (c. 1494)
- Leonardo da Vinci, *Last Supper* (c. 1495–98)
- Gentile Bellini, *Procession of the Reliquary of the True Cross* (1496)
- Michelangelo, *Pietà* (1498/99–1500)
- Andrea Mantegna, *Parnassus* (c. 1499–1502)

PEOPLE AND EVENTS

- Francesco Sforza becomes Duke of Milan (1450)
- Vatican Library founded (1450)
- Gutenberg produces first printed bible at Mainz (1453–55)
- Turks capture Constantinople; end of Byzantine Empire (1453)
- End of Hundred Years' War between England and France (1453)
- Turks conquer Athens (1456)
- Erasmus of Rotterdam, humanist (1465–1536)
- First printed music (1465)
- Lorenzo de' Medici, "the Magnificent," rules Florence (1469–92)
- Nicolaus Copernicus, European astronomer (1473–1543)
- William Caxton prints first book in English (1474)
- Medici family become bankers to the papacy (1476)

- Pazzi conspiracy to overthrow the Medici fails (1478)
- Revival of Inquisition in Spain (1478)
- Richard of Gloucester claims English throne as Richard III (1483)
- Diaz rounds Cape of Good Hope (1486)
- Spain finances voyage of Columbus to New World (1492)
- Medici expelled from Florence (1494)
- Charles VIII of France invades Italy (1494–99)
- François Rabelais, French writer (1494–1553)
- Imperial Diet opens at Worms (1495)
- Cabot reaches east coast of North America (1497)
- Severe famine in Florence (1497)
- Savonarola executed in Florence (1498)
- Vasco da Gama discovers sea route to India (1498)

402

Timeline 1500–1599

ARTS AND LITERATURE

- Sandro Botticelli, *Mystic Nativity* (c. 1500)
- Giovanni Bellini, *Madonna of the Meadow* (c. 1500–05)
- Michelangelo, *David* (1501–04)
- Donato Bramante, Tempietto (1502)
- Leonardo da Vinci, *Mona Lisa* (c. 1503–15)
- Giovanni Bellini, San Zaccaria Altarpiece (1505)
- Raphael, *Madonna of the Meadow* (c. 1505)
- Donato Bramante, Plan of Saint Peter's (1506–14)
- Giorgione, *Tempest* (c. ?1509)
- Raphael, *Disputa* (1509–11)
- Raphael, *School of Athens* (1509–11)
- Michelangelo, Sistine Ceiling frescoes (1509–12)
- Giorgione, *Sleeping Venus* (c. 1510)
- Giovanni Bellini, *Feast of the Gods* (1514)
- Titian, *Sacred and Profane Love* (c. 1514)
- Titian, *Assumption of the Virgin* (1516–18)
- Raphael, *Pope Leo X with Cardinals Giulio de' Medici and Luigi de' Rossi* (1517)
- Raphael, *Transfiguration* (1517–20)
- Michelangelo, Medici Chapel, San Lorenzo (1519–34)
- Titian, *The Meeting of Bacchus and Ariadne* (1522–23)
- Michelangelo, Laurentian Library (1524–59)
- Pontormo, *Deposition* (1525–28)
- Giulio Romano, Palazzo del Tè (1527–34)
- Correggio, *Jupiter and Io* (early 1530s)
- Parmigianino, *Madonna of the Long Neck* (begun 1534)
- Michelangelo, *Last Judgment* (1534–41)
- Michelangelo, Plan of Saint Peter's (1537–50)
- Titian, *Venus of Urbino* (c. 1538)

- Agnolo Bronzino, *An Allegory with Venus and Cupid* (1540s)
- Benvenuto Cellini, Saltcellar of Francis I (finished 1543)
- Titian, *Pope Paul III* (c. 1543–46)
- Palladio, San Giorgio Maggiore (begun 1565)
- Palladio, Villa Rotonda (begun late 1560s)
- Titian, *Pietà* (begun c. 1570)
- Veronese, *Apotheosis of Venice* (c. 1585)
- Tintoretto, *Last Supper* (1592–94)

PEOPLE AND EVENTS

- Amerigo Vespucci sails to South America (1501)
- Erasmus's *Praise of Folly* published (1509)
- Medici family returns to power in Florence (1512)
- Machiavelli writes *The Prince* (1513)
- Thomas More's *Utopia* published (1516)
- Martin Luther issues 95 theses; beginning of the Reformation (1517)
- Magellan begins circumnavigation of the globe (1519)
- Charles V crowned Holy Roman Emperor (1520)
- Diet of Worms condemns Luther (1521)
- Troops of Charles V sack Rome (1527)
- Castiglione's *Book of the Courtier* published (1528)
- Henry VIII renounces authority of the pope, founds Anglican Church (1534)
- Cosimo I de' Medici assumes power in Florence (1537)
- Ignatius Loyola founds Society of Jesus (Jesuits) (1540)
- Copernicus's *On the Revolution of Heavenly Bodies* published (1543)
- First Protestants burned at the stake by Spanish Inquisition (1543)
- Council of Trent introduces Counter-Reformation policies (1545–63)
- Vasari's first edition of *Lives of the Artists* published (1550)
- Elizabeth I Queen of England (1558–1603)

- Palladio's *The Four Books of Architecture* published (1570)
- Turkish fleet defeated by Spain and Venice at Battle of Lepanto (1571)
- Veronese appears before the Inquisition (1573)
- Shakespeare, *Romeo and Juliet* (1596)

Glossary of Art-Historical and Stylistic Terms

The terms that are **boldfaced** within definitions also appear as entries.

Abacus (pl. **abaci**): the square slab forming the top of a **capital**.

Aerial perspective: a **perspective** technique in which the illusion of depth is created by making distant forms less distinct than nearer forms. Also called atmospheric perspective.

Aisle: a passageway. (See also **Side aisle**.)

Altar: (1) a structure on which a sacrifice or ritual is performed; (2) in the Christian church, a tablelike structure where the ritual of the Mass (the Eucharist) is performed.

Altarpiece: a painting or sculpture that stands on or behind an **altar**.

Ambulatory: the curved passageway in the **apse** of a church.

Apron: on a crucifix, the horizontal or vertical rectangular extensions.

Apse: a projecting, usually curved section of a building.

Aqueduct: a structure that carries water. In ancient Rome, aqueducts could carry water over long distances.

Arcade: a series of **arches**.

Arch: a curved architectural feature that spans an opening. (See also **Pointed arch, Round arch, Trilobed arch**.)

Architrave: the lowest horizontal element of an **entablature**, which rests on the top of a **column**.

Arriccio: the preliminary coat of plaster in the preparation of a fresco.

A secco: see **Fresco**.

Asymmetry: an absence of **symmetry**.

Atmospheric perspective: see **Aerial perspective**.

Attribute: an identifying characteristic.

Baluster: the upright supporting element of a **balustrade**.

Balustrade: a series of upright elements supporting a rail.

Baptistery: a Christian building, usually round or octagonal, where baptisms are performed.

Baroque: a style prevalent in the seventeenth century.

Barrel vault: a vault made by the extension of a **round arch**, which resembles half a barrel or the inside of a tunnel. Also called a tunnel vault.

Base: that part of a **column** on which the **shaft** rests.

Basilica: a large, oblong Roman building with a **nave** and **side aisles** used for administrative purposes. It was adapted to the structure of Early Christian churches.

Bay: one of a series of sections into which a building is divided.

Blind niche: a **niche**, usually a purely decorative feature of a wall.

Bracket: an architectural projection that may have a support function.

Broken pediment: a **pediment** whose **cornice** is interrupted either by a space or by an intervening element.

Bronze casting: a process in which molten bronze is poured into a mold; when the bronze hardens, the mold is removed and the solid bronze has formed into the shape of the mold.

Buon fresco: See **Fresco**.

Bust: an image of a person's head, neck, and shoulders.

Buttress: an architectural support that counteracts a lateral thrust against a wall.

Byzantine: (1) the name of a style prevalent in parts of Europe and the Middle East from the sixth through the fifteenth centuries; (2) the name of an empire with its capital at Constantinople, now Istanbul, in modern Turkey.

Campanile: Italian for "bell tower," usually a freestanding structure next to a church or **cathedral**.

Cantilever: a system of architectural support in which a horizontal beam or truss projects from a base at one end only.

Capital: the top of a **column** or **pilaster**, consisting of specific elements, depending on the **Order**.

Cartoon: a preparatory drawing the same size as the projected painting.

Carving: a subtractive technique of sculpture in which the image is formed by removing sections of the original **medium**.

Cassone (pl. *cassoni*): Italian for a "marriage chest" or "dowry chest."

Cathedral: literally, the "seat of a bishop"; the main church of a district under the supervision of a bishop.

Cella: the main room of a temple that usually houses the cult statue of a god.

Centering: a temporary wooden scaffolding supporting **arches, domes**, or vaults during the construction process.

Chancel: the section of a church reserved for the clergy and choir.

Chasing: modeling surface decorations on metal sculpture.

Chiaroscuro: Italian for "light-dark"; gradual **shading** to create the illusion of **three-dimensional** form.

Choir: the section of the **chancel** reserved for singing and chanting by the clergy.

Chromatic: having color.

Cimasa: Italian for **finial**.

Cire-perdue: see **Lost-wax**.

Classical: (1) the style of ancient Greece from c. 450–c. 400 B.C.; (2) used more generally to refer to Greek and Roman antiquity.

Coffer: a decorative geometric panel that is recessed in a ceiling.

Colonnade: a series of **columns**.

Colonnette: a little **column**.

Column: a vertical support consisting of a **base, shaft**, and **capital**, depending on the **Order**.

Composite Order: a combination of the **Ionic** and **Corinthian Orders**.

Contour: the edge or outline of a form.

Contrapposto: a twist at the waist resulting from a shift in the stance of the human body.

Convention: a generally accepted and recognized practice or form.

Corbel: a projection from a wall that functions as a support.

Corinthian Order: the architectural system in which the **column** consists of a **base**, **shaft**, and leaf-shaped, or **foliate**, **capitals**.

Cornice: uppermost projecting element of an **entablature**.

Course: a layer of stone lying in a horizontal plane on a building.

Crenellation: a series of openings along the top of a wall or battlement, usually for defense.

Crocket: a decorative, leaf-shaped architectural element that projects in a series from **gables**, spires, or **pinnacles**.

Crossing: the section of a church or **cathedral** in which the **nave** crosses the **transept**.

Cupola: a **dome** crowning a building.

Curvilinear: consisting of curving lines.

Cycle: a group of painted scenes or reliefs that form a cohesive narrative, as in a **fresco** cycle.

Dado: a strip of architectural molding.

Diptych: a two-paneled painting.

Di sotto in su: Italian for a viewpoint from below.

Dome: a round, convex structure, usually hemispherical and made by rotating an arch 180 degrees, that often crowns a building. It is also called a **cupola**.

Donor: one who donates a work of art to a church or other institution.

Doric Order: an architectural **Order** consisting of three steps, a **column** having a **base**, **shaft**, **capital** (consisting of an **abacus** and an *echinus*), and a **frieze** consisting of **triglyphs** and **metopes**.

Drum: a round wall supporting a **dome**.

Elevation: the system by which a wall is constructed.

Elongated: having long or extended **proportions**.

Embossing: a technique for creating metal relief.

Enamel: fired glass fused with metal.

Entablature: the upper horizontal of an **Order**, consisting of the **architrave**, **frieze**, and **cornice**.

Façade: the front of a building.

Figura serpentinata: Italian for "serpentine figure"; an S-shape pose characteristic of **Mannerism**.

Finial: a small decorative detail at the top of an architectural element.

Flute: a vertical groove in the **shaft** of a **column** or **pilaster**.

Foliate: leaf-shaped.

Foreshortening: representing a form in **perspective** so that it appears to recede **three-dimensionally** on a **two-dimensional** surface.

Formal: relating to line, shape, **plane**, balance, composition, color, light, and dark.

Forum: an open square of an ancient Roman town consisting of temples, markets, and administration buildings.

Fresco: a painting technique in which water-based **pigments** are applied to damp lime plaster and bond with the wall as the plaster dries. It is also called *buon fresco*, or true fresco. In *fresco secco*, the paint is applied to dry plaster and is less durable than true fresco.

Frieze: the central horizontal element of the **entablature**.

Frontal (frontality): facing front.

Gable: a triangular section of a roof formed by the intersection of two diagonal **planes**.

Gesso: a medium consisting of white chalk, plaster, and size that coats the surface of a painting and creates a smooth **ground**.

Gilding: a gold coating on a sculpture or painting.

Giornata: Italian for "day" or "a day's work"; referring to that part of a **fresco** prepared and painted in one day.

Glaze: in painting, a translucent varnish, a technique generally used in **oil painting**.

Gold leaf: thin hammered gold applied to paintings for decorative purposes; also the **ground** in certain **Byzantine** Renaissance paintings.

Gothic: referring to the European style that immediately preceded the Renaissance in western Europe. It generally includes the mid-twelfth through the sixteenth centuries, depending on the region.

Greek-cross plan: a building **plan** that replicates the shape of a Greek cross, in which all four arms are of equal length.

Grisaille: grayish, monochromatic painting frequently used to simulate sculpture.

Ground: the surface of a support prepared for painting.

Hellenistic: referring to the style of Late Greek antiquity, approximately 323 B.C.–A.D. 31.

Icon (Iconic): a sacred image.

Iconography: the study of an image based on the meaning of its subject matter.

Idealization: depicting forms according to an ideal standard.

Illuminated manuscript: a book written by hand and decorated with paint and gold leaf.

Illusionism: the technique of making an image appear real.

Impost block: a block on which an **arch** rests.

Inlay: a surface decorated by imbedding one material with pieces of a different material.

Intarsia (pl. *intarsie*): the decoration of wood surfaces with **inlay**.

Intonaco: a coat of fine plaster applied on top of the *arriccio* in the preparation of a **fresco**.

Ionic Order: the **Order** of architecture consisting of a **column** (having a round **base**, a **shaft**, and a **volute**, or scroll-shaped, **capital**) and an **entablature**. The Ionic **frieze**, in contrast to the alternating **triglyphs** and **metopes** of the **Doric**, is continuous.

Lancet: a tall, narrow, **arched** window.

Lantern: the element on top of a **dome** that usually allows light to enter the interior.

Latin-cross plan: a building **plan**, based on the shape of the Latin cross, in which the vertical, or longitudinal, element is longer than the two arms, or horizontal element.

Linear: having the quality of line.

Linear perspective: a system of **perspective** in which diminishing scale creates the impression of distance on a flat surface.

Lintel: the horizontal element over an opening.

Loggia: a covered gallery open on at least one side.

Lost-wax (*cire-perdu*): a technique of **bronze casting** in which a form is first modeled in wax. Then a plaster mold is formed around the wax, and molten bronze is poured into the mold through holes in the plaster. This melts the wax, which then runs out of the mold. When the bronze has solidified, the plaster mold is cracked open leaving the bronze to be polished and **chased**.

Lunette: a crescent-shaped section of a wall.

Mandorla: an oval of light around the body of a holy person.

Maniera: Italian for "manner" or "style"; later related to the style of **Mannerism**.

Mannerism: a sixteenth-century style in western Europe.

Mannerist: having the qualities of **Mannerism**.

Manuscript: a handwritten book, especially one produced in the Middle Ages or Renaissance.

Martyrium (pl. **martyria**): a building erected over the tomb of a martyr.

Masterpiece: the work submitted at the end of an apprenticeship for entry into a guild.

Mausoleum (pl. **mausolea**): a large tomb building, named after the Hellenistic ruler Mausolus because of his elaborate tomb at Halicarnassus.

Medallion: a round architectural ornament.

Medium: the material of which a work of art is made.

Metope: the square element of the **Doric frieze** that alternates with the **triglyphs**.

Mezzanine: an intermediate short story of a building.

Monochrome: consisting of only one color.

Monumentality: very big or having the appearance of being very big.

Mosaic: a medium in which the artist uses small colored tiles, *tesserae*, to create an image, usually on a floor, wall, or ceiling.

Mullion: (1) the vertical stone dividing medieval windows; (2) a vertical or horizontal supporting strip in a window.

Naturalism: the representation of things as they appear in nature.

Nave: the central **aisle** of a church or Roman **basilica**.

Nave arcade: the row of **arches** separating the **nave** from the **side aisle** of a church or **cathedral**.

Niche: a recess in a wall.

Oculus (pl. **oculi**): a round opening, usually at the center of a **dome** or in a wall.

Oil paint: a medium in which **pigments** are mixed with an oil binder.

One-point perspective: a **perspective** system in which the **orthogonals** converge at a single **vanishing point**.

Opus reticulatum: a diamond-shape pattern of Roman brickwork that is both decorative and a structural reinforcement. It was used in ancient Rome and revived in the Renaissance.

Orders of architecture: see **Composite Order, Corinthian Order, Doric Order, Ionic Order, Tuscan Order**.

Organic: lifelike.

Orthogonal: in the system of **one-point perspective**, a line perpendicular to the **picture plane** leading to a **vanishing point**.

Painterly: a style of painting in which the texture of the brushwork is readily apparent.

Palette: (1) the range of colors in a particular work or in the work of an artist generally; (2) the tablet used by the artist for mixing color.

Patron (**patronage**): one who commissions a work of art.

Pediment: the triangular element at the end of a **gable** roof.

Pedimented: having a **pediment**.

Pendentive: a spherical triangle that creates a transition from a round **dome** to a rectangular base of a building.

Peristyle: a row of **columns**, or a **colonnade**, that surrounds a building.

Perspective: a system for creating the illusion of depth on a flat surface. (See **Aerial perspective**, *Di sotto in su*, **Linear perspective, One-point perspective**.)

Picture plane: the surface of a **two-dimensional** image.

Pier: a vertical, usually thick rectangular architectural support.

Pigment: in painting, the powdered material mixed with a binder that produces color.

Pilaster: a vertical rectangular strip having the same elements as a **column**.

Pinnacle: a small, decorative vertical detail at the top of an architectural form.

Plan (also **ground plan**): a diagram showing the structure of a building at ground level.

Plane: a flat surface having a direction in space.

Plasticity: the quality of **three-dimensional** volume.

Podium (pl. **podia**): (1) the large stone base of a building, usually a temple; (2) a pedestal.

Pointed arch: an **arch** whose curved sides converge at a point.

Polyptych: a painting, often an **altarpiece**, with more than three panels.

Portal: an elaborate entrance to a building.

Portico: a roofed entrance to a building. A **Classical** portico consists of **columns** supporting an **entablature** crowned by a **pediment**.

Portrait: a likeness of a specific individual.

Pounce: a powdered material rubbed into a writing surface to whiten it or to reduce its shine.

Pouncing: a technique for transferring an image from a **cartoon** to the support of a finished painting by rubbing or dusting **pounce** through holes pricked in the contours of the cartoon.

Predella: the base of an **altarpiece**, often decorated with small narrative scenes.

Program: the overall composition of a group of related images as well as the meaning of their content.

Proportion: relative size or scale.

Pulpit: a raised platform, usually enclosed, from which a preacher addresses the congregation.

Quarry-faced ashlar: irregular, uncut stone masonry blocks.

Quatrefoil: usually a frame or architectural feature in the shape of a four-leaf clover. (See also **Trefoil**.)

Quoin: a large stone block, or series of blocks, reinforcing the corner of a masonry wall.

Radiating chapel: chapels projecting from the **ambulatory** of a church or **cathedral**.

Relief sculpture: a category of sculpture in which the image is raised from its original material. In low relief, the image is raised slightly from its background; in high relief, it stands out farther; in sunken relief, the image is below the surface of the background material.

Rib: the **arch** used in **Gothic** rib vaults.

Romanesque: referring to the style in western Europe that preceded **Gothic**, roughly dating from the year 1000 to the mid-twelfth century.

Rotunda: a round building, often surmounted by a **dome**.

Round arch: a semicircular **arch**.

Roundel: a decorative round element in architecture.

Rustication: rough masonry blocks with beveled edges and recessed joints.

Sacristy: the room in a church where the priest's robes and various sacred objects are kept.

Sarcophagus (pl. **sarcophagi**): a rectangular stone coffin.

Saturation: the intensity of a color.

Schiacciato: Italian for "squashed"; a type of low **relief sculpture** in which the very slight gradations of depth create an image having a pictorial quality.

Scriptorium (pl. **scriptoria**): a room in a monastery or convent where **manuscripts** are made.

Self-portrait: a likeness of oneself.

Sfumato: Italian for "vanished in smoke"; a technique for creating form with very slight shifts in **shading**.

Shading: gradual gradation of light and dark to create the illusion of **three-dimensional form**.

Shaft: the vertical element of a **column** or **pilaster**.

Side aisle: the passageway on either side of the **nave** in a church or **cathedral**.

Silhouette: (1) in its pure form, a clear outline separating two areas of black and white in a **two-dimensional** image; (2) more generally, a strong contrast of light and dark separated by a relatively precise edge.

Sinopia (pl. *sinopie*): (1) the preparatory underdrawing of a **fresco**; (2) a reddish-brown pigment named for Sinope, on the Black Sea.

Size (**sizing**): glue and resin combined to coat the surface of a painting.

Spandrel: the curved, triangular section of wall between two **arches** in an **arcade**; the section of wall between the curve of the **arch** and the keystone.

Springing: the inward curve of an **arch**, which seems to "spring" upward at this point.

Stained glass: pieces of colored glass held together by lead strips, most often used for windows in **Gothic** churches and **cathedrals**.

Stela (pl. **stelae**): an upright stone, generally of a commemorative character.

Stringcourse: a decorative horizontal band running the length of a wall.

Stucco: a plaster mixture of sand and lime cement used to coat a masonry surface.

Studio: a private study.

Studiolo: a small private study.

Style: a characteristic manner or type of representation.

Stylized (**stylization**): a non**organic** surface detail.

Symmetry: a type of balance in which forms are arranged as mirror images of each other on either side of a central axis. See also **Asymmetry**.

Tapestry: a woven fabric, usually decorated and meant to hang on a wall.

Tempera: a water-based paint thickened with egg yolk.

Terra-cotta: literally "cooked, or baked, earth"; unglazed clay that has been fired or the color of such an object.

Three-dimensional: a form that has height, width, and depth.

Tondo: a round painting or **relief sculpture**.

Tool (**tooling**): mark the surface of a sculpture with the artist's tools.

Tracery: a decorative interlaced design.

Transept: the crossarms of a **Latin-cross** church that crosses the **nave** at right angles.

Trefoil: having the form of a three-leaf clover. (See also **Quatrefoil**.)

Triglyph: three verticals alternating with the **metopes** in the **Doric** **frieze**.

Trilobed arch: an **arch** forming a triple curve at the top.

Triptych: a three-paneled painting or **relief sculpture**, often an **altarpiece**.

Triumphal arch: a freestanding stone **arch** constructed in ancient Rome to commemorate victories.

Trompe-l'oeil: literally, "fool the eye"; an illusionistic image that appears real. (See also **Illusionism**.)

Tuscan Order: a later form of **Doric**, having a smooth **shaft** and a plain **frieze**.

Two-dimensional: having height and width, but no depth.

Type: in the system of **typology**, a figure who prefigures or stands for another figure.

Typology (**typological**): a Christian historical system in which personages and events before the birth of Christ are believed to have prefigured those following the birth of Christ.

Vanishing point: in **one-point perspective**, the point at which the **orthogonals** converge.

Varnish: a usually clear protective coating on the surface of a painting.

Vestibule: an entrance hall.

Villa: a large country house.

Volute: the scroll that decorates the **capital** of the **Ionic column**.

Votive: (noun) a devotional object; (adj.) having a devotional quality.

Voussoir: a wedge-shaped stone used in the construction of an **arch**.

Wing (of an altarpiece): the side panel of an **altarpiece**.

Select Bibliography

Books

Ackerman, James S. *The Architecture of Michelangelo*. 2 vols. London, 1964.

———. *Palladio*. New York, 1978.

Adams, Laurie Schneider. *Art and Psychoanalysis*. New York, 1993.

———. *The Methodologies of Art*. New York, 1996.

———. *Key Monuments of the Italian Renaissance*. Boulder, Colo., 2000.

Ahl, Diane Cole. *Benozzo Gozzoli*. New Haven and London, 1996.

Alberti, Leon Battista. *On Painting*. Translated by John R. Spencer. New Haven and London, 1966.

———. *The Family in Renaissance Florence*. Translated by R. N. Watkins. Columbia, S.C., 1969.

———. *On the Art of Building in Ten Books*. Translated by J. Tykwert, N. Leach, and R. Tavernor. Cambridge and London, 1988.

Ames-Lewis, Francis. *Drawing in Early Renaissance Italy*. New Haven and London, 1981.

Antal, Frederick. *Florentine Painting and Its Social Background*. Boston, 1965.

Barasch, Moshe. *Giotto and the Language of Gesture*. Cambridge, 1987.

Barolsky, Paul. *Infinite Jest: Wit and Humor in Italian Renaissance Art*. Columbia, Mo., 1978.

———. *Walter Pater's Renaissance*. University Park, Pa., 1987.

———. *Michelangelo's Nose: A Myth and Its Maker*. University Park, Pa., and London, 1990.

———. *The Faun in the Garden*. University Park, Pa., 1990.

———. *Why Mona Lisa Smiles and Other Tales by Vasari*. University Park, Pa., and London, 1991.

———. *Giotto's Father and the Family of Vasari's Lives*. University Park, Pa., 1992.

Baron, Hans. *The Crisis of the Early Italian Renaissance*. Princeton, 1966.

———. *In Search of Florentine Civic Humanism*. 2 vols. Princeton, 1988.

Battisti, Eugenio. *Filippo Brunelleschi*. New York, n.d.

Baxandall, Michael. *Giotto and the Orators, Humanist Observers of Painting in Italy and the Discovery of Pictorial Composition 1350–1450*. Oxford, 1971.

———. *Painting and Experience in Fifteenth-Century Italy*. Oxford, 1988.

Beck, James. *Jacopo della Quercia*. 2 vols. New York, 1991.

——— (with Michael Daley), *Art Restoration*. New York, 1994.

———. *Three Worlds of Michelangelo*. New York, 1999.

———. *Italian Renaissance Painting*. Köln, 1999.

Bennett, Bonnie A., and David G. Wilkins. *Donatello*. Oxford, 1984.

Bertelli, Carlo. *Piero della Francesca*. New Haven and London, 1992.

Blunt, Anthony. *Artistic Theory in Italy: 1450–1600*. New York, 1956.

Bober, Phyllis Pray, and Ruth O. Rubinstein. *Renaissance Artists and Antique Sculpture*. New York, 1987.

Borsi, Franco, and Stefano Borsi. *Paolo Uccello*. Translated by Elfreda Powell. New York, 1994.

Borsook, Eve. *The Mural Painters of Tuscany from Cimabue to Andrea del Sarto*. 2d rev. ed. Oxford, 1980.

Brown, Patricia Fortini. *Venetian Narrative Painting in the Age of Carpaccio*. New Haven and London, 1988.

———. *Venice and Antiquity*. New Haven and London, 1996.

———. *Art and Life in Renaissance Venice*. New York, 1997.

Brucker, Gene A. *Renaissance Florence*. New York, 1969.

Burkhardt, Jacob. *The Civilization of the Renaissance in Italy*. Translated by S. G. C. Middlemore. London, 1950.

———. *The Architecture of the Italian Renaissance*. Edited by Peter Murray. Translated by James Palmes. Chicago, 1983.

Butterfield, Andrew. *The Sculptures of Andrea del Verrocchio*. New Haven and London, 1997.

Calvesi, Maurizio. *Piero della Francesca*. New York, 1998.

Campbell, Lorne. *Renaissance Portraits*. New Haven and London, 1990.

———. *The Fifteenth-Century Netherlandish Schools*. London, 1998.

Castiglione, Baldassare. *The Book of the Courtier*. Translated by G. Bull. Harmondsworth, 1967.

Cennini, Cennino d'Andrea. *The Craftsman's Handbook*. Translated by D. V. Thompson, Jr. New Haven, 1933.

Chastel, André. *The Sack of Rome*. Translated by Beth Archer. Princeton, 1977.

Cheles, Luciano. *The Studiolo of Urbino: An Iconographic Investigation*. University Park, Pa., 1986.

Christiansen, Keith. *Gentile da Fabriano*. Ithaca, NY, 1982.

Clark, Kenneth. *Leonardo da Vinci*. Harmondsworth, 1963.

———. *The Art of Humanism*. New York, 1983.

Cole, Alison. *Virtue and Magnificence: Art of the Italian Renaissance Courts*. New York, 1995.

Cole, Bruce. *Giotto and Florentine Painting, 1280–1375*. New York, 1976.

———. *Sienese Painting from Its Origins to the Fifteenth Century*. New York, 1980.

———. *The Renaissance Artist at Work*. New York, 1983.

———. *Italian Art 1250–1550*. New York, 1987.

———. *Titian and Venetian Painting*. Boulder, Colo., 1999.

Collins, Bradley. *Leonardo, Psychoanalysis, and Art History*. Evanston, Ill., 1997.

Condivi, Ascanio. *The Life of Michelangelo.* Translated by Alice Wohl and Hellmut Wohl. Baton Rouge, La., 1976.

Cox-Rearick, Janet. *Dynasty and Destiny in Medici Art.* Princeton, 1984.

DeWald, Ernest T. *Italian Painting 1200–1600.* New York, 1961.

Didi-Huberman, Georges. *Fra Angelico.* Translated by Jane Marie Todd. Chicago, 1995.

Edgerton, Samuel. *The Renaissance Rediscovery of Linear Perspective.* New York, 1979.

———. *Pictures and Punishment.* Ithaca, N.Y., and London, 1985.

Eisenberg, Marvin. *Lorenzo Monaco.* Princeton, 1989.

Eisler, Colin. *The Genius of Jacopo Bellini: The Complete Paintings and Drawings.* New York, 1989.

Eissler, Kurt. *Leonardo da Vinci: Psychoanalytic Notes on the Enigma.* New York, 1961.

Ettlinger, Leopold D. *Antonio and Piero Pollaiuolo.* Oxford and New York, 1978.

Fischel, Oskar. *Raphael.* Translated by B. Rackham. 2 vols. London, 1964.

Focillon, Henri. *Piero della Francesca.* Paris, 1952.

Freedberg, David. *The Power of Images.* Chicago and London, 1989.

Freedberg, Sidney J. *Painting of the High Renaissance in Rome and Florence.* 2 vols. Cambridge, Mass., 1961.

———. *Painting in Italy, 1500–1600.* Baltimore, 1983.

Freud, Sigmund. *Leonardo da Vinci and a Memory of His Childhood* (1910). Translated by Alan Tyson. Vol. IX of the Standard Edition. Edited by James Strachey. New York, 1964.

Gere, J. A., and Nicholas Turner. *Drawings by Raphael from the Royal Library, the Ashmolean, the British Museum, Chatsworth and Other English Collections.* London, 1983.

Gilbert, Creighton. *Italian Art: 1400–1500—Sources and Documents.* Evanston, Ill., 1980.

———. *Michelangelo on and off the Sistine Ceiling.* New York, 1994.

Goffen, Rona. *Spirituality in Conflict: Saint Francis and Giotto's Bardi Chapel.* University Park, Pa., 1988.

———. *Giovanni Bellini.* New Haven and London, 1989.

———. *Titian's Women.* New Haven and London, 1997.

———, ed. *Titian's Venus of Urbino.* Cambridge, 1997.

———, ed. *Masaccio's Trinity.* Cambridge, 1998.

Goldberg, Edward L. *Patterns in Late Medici Art Patronage.* Princeton, 1983.

Goldthwaite, Richard A. *The Building of Renaissance Florence.* Baltimore, 1980.

———. *Wealth and the Demand for Art in Italy, 1300–1600.* Baltimore, 1993.

Gombrich, Ernst. *Norm and Form: Studies in the Art of the Renaissance.* London, 1966.

———. *Symbolic Images.* London, 1972.

———. *The Heritage of Apelles.* Ithaca, N.Y., 1976.

———. *New Light on Old Masters: Studies in the Art of the Renaissance IV.* Oxford, 1986.

Greenstein, Jack M. *Mantegna and Painting as Historical Narrative.* Chicago, 1992.

Hall, Edwin. *The Arnolfini Betrothal.* Berkeley and Los Angeles, 1994.

Hall, Marcia, ed. *Raphael's School of Athens.* Cambridge, Eng., 1997.

Harbison, Craig. *The Mirror of the Artist: Northern Renaissance Art in Its Historical Context.* New York, 1995.

Hartt, Frederick. *A History of Italian Renaissance Art.* 4th ed. Revised by David Wilkins. New York, 1994.

Hatfield, Rab. *Botticelli's Uffizi "Adoration": A Study in Pictorial Content.* Princeton, 1976.

Hauser, Arnold. *Mannerism: The Crisis of the Renaissance and the Origin of Modern Art.* Cambridge, Mass., 1986.

Hersey, George L. *The Aragonese Arch at Naples: 1443–1475.* New Haven and London, 1973.

———. *High Renaissance Art in St. Peter's and the Vatican: An Interpretive Guide.* Chicago and London, 1993.

Heydenreich, Ludwig H. *Leonardo: The Last Supper.* London, 1974.

Hibbard, Howard. *Michelangelo.* New York, 1974.

Hibbert, Christopher. *The House of Medici: Its Rise and Fall.* New York, 1980.

Holmes, Megan. *Fra Filippo Lippi.* New Haven and London, 1999.

Hood, William. *Fra Angelico at San Marco.* New Haven and London, 1993.

Horster, Marita. *Andrea del Castagno.* Ithaca, N.Y., 1980.

Humfrey, Peter. *The Altarpiece in Renaissance Venice.* New Haven and London, 1993.

———. *Painting in Renaissance Venice.* New Haven and London, 1995.

Jacks, Philip. *The Antiquarian and the Myth of Antiquity.* Cambridge, 1993.

Janson, H. W. *The Sculpture of Donatello.* Princeton, 1963.

———. *Sixteen Studies.* New York, n.d.

Joannides, Paul. *The Drawings of Raphael.* Berkeley and Los Angeles, 1983.

Jones, P. J. *The Malatesta of Rimini and the Papal State.* Cambridge, 1974.

Jones, Roger, and Nicholas Penny. *Raphael.* New Haven and London, 1983.

Kaftal, George. *The Iconography of the Saints in Tuscan Painting.* Florence, 1952.

Kemp, Martin, ed. *Leonardo on Painting.* New Haven and London, 1989.

———. *Behind the Picture: Art and Evidence in the Italian Renaissance.* New Haven, 1997.

Kempers, Bram. *Painting, Power, and Patronage: The Rise of the Professional Artist in the Italian Renaissance.* London, 1992.

King, Margaret L. *Women of the Renaissance.* Chicago and London, 1991.

Krautheimer, Richard. *Lorenzo Ghiberti.* Princeton, 1970.

Kris, Ernst, and Otto Kurz. *Legend, Myth, and Magic in the Image of the Artist.* New Haven, 1979.

Ladis, Andrew. *The Brancacci Chapel, Florence.* New York, 1993.

———, ed. *Giotto, Master Painter and Architect.* New York and London, 1998.

Land, Norman. *The Viewer as Poet.* University Park, Pa., 1994.

Lavin, Marilyn Aronberg. *Piero della Francesca: The Flagellation.* London, 1972.

———. *Piero della Francesca's Baptism of Christ.* New Haven and London, 1981.

Lee, Rensselaer W. *Ut Pictura Poesis: The Humanistic Theory of Painting.* New York, 1967.

Lewine, Carol F. *The Sistine Chapel Walls and the Roman Liturgy.* University Park, Pa., 1993.

Liebert, Robert. *Michelangelo: A Psychoanalytical Study.* New Haven and London, 1983.

Lightbown, Ronald. *Sandro Botticelli.* 2 vols. Berkeley and Los Angeles, 1978.

———. *Mantegna.* Berkeley and Los Angeles, 1986.

———. *Piero della Francesca.* New York, 1992.

Lotz, Wolfgang. *Studies in Italian Renaissance Architecture.* Cambridge, Mass., 1983.

Machiavelli, Niccolò. *Florentine Histories.* Translated by Laura F. Banfield and Harvey Mansfield, Jr. Princeton, 1988.

Mack, Charles Randall. *Pienza: The Creation of a Renaissance City.* Ithaca, N.Y., 1987.

Maginnis, Hayden B. J. *Painting in the Age of Giotto.* University Park, Pa., 1997.

Mann, Nicholas, and Luke Syson, eds. *The Image of the Individual: Portraits in the Renaissance.* London, 1998.

Martindale, Andrew. *The Rise of the Artist.* New York, 1972.

———. *Simone Martini.* New York, 1988.

Martinès, Lauro. *Power and Imagination: City-States in Renaissance Italy.* New York, 1979.

Meiss, Millard. *Painting in Florence and Siena After the Black Death.* Princeton, 1951.

———. *Giotto and Assisi.* New York, 1960.

Moskowitz, Anita. *The Sculpture of Andrea and Nino Pisano.* Cambridge, 1986.

Murray, Linda. *The High Renaissance and Mannerism.* London, 1977.

Murray, Peter. *Renaissance Architecture.* New York, 1976.

Norman, Diana. *Siena and the Virgin.* New Haven and London, 1999.

O'Malley, Charles D., ed. *Leonardo's Legacy.* Berkeley and Los Angeles, 1969.

O'Malley, Charles D., and J. B. de C. M. Saunders. *Leonardo da Vinci on the Human Body.* New York, 1982.

Panofsky, Erwin. *Renaissance and Renascences in Western Art.* Stockholm, 1960.

———. *Problems in Titian, Mostly Iconographic.* New York, 1969.

———. *Early Netherlandish Painting.* 2 vols. New York, 1971.

———. *Perspective as Symbolic Form.* New York, 1991.

Paoletti, John T., and Gary Radke. *Art in Renaissance Italy.* New York, 1997.

Pater, Walter. *The Renaissance: Studies in Art and Poetry.* Edited by D. L. Hill. Berkeley, 1980.

Partridge, Loren. *The Art of Renaissance Rome.* New York, 1996.

Partridge, Loren, and Randolph Starn. *A Renaissance Likeness: Art and Culture in Raphael's Julius II.* Berkeley and Los Angeles, 1980.

Pedretti, Carlo. *Leonardo: Studies for the Last Supper.* Cambridge, 1983.

Pernis, Maria Grazia, and Laurie Schneider Adams. *Federico da Montefeltro and Sigismondo Malatesta: The Eagle and the Elephant.* New York, 1996.

Pope-Hennessy, John. *The Portrait in the Renaissance.* Princeton, 1966.

———. *Raphael.* New York, 1970.

———. *Cellini.* London, 1985.

———. *The Sculpture of Donatello.* New York, 1993.

Posner, Kathleen Weil Garris. *Leonardo and Central Italian Art: 1515–1550.* New York, 1974.

Praz, Mario. *The Romantic Agony.* Oxford and New York, 1983.

Rabil, Albert, Jr., ed. *Renaissance Humanism.* 3 vols. Philadelphia, 1988.

Ridolfi, Carlo. *The Life of Tintoretto and of his Children Domenico and Marietta.* Translated by Catherine Enggass and Robert Enggass. University Park, Pa., and London, 1984.

Roover, Raymond de. *The Rise and Decline of the Medici Bank, 1397–1494.* Cambridge, Mass., 1963.

Rosand, David. *Titian.* New York, 1978.

———. *Painting in Cinquecento Venice: Titian, Veronese, Tintoretto.* New Haven and London, 1982.

Rosenberg, Charles M. *The Este Monuments and Urban Development in Renaissance Ferrara.* Cambridge, Eng., 1997.

Rubin, Patricia Lee, and Alison Wright. *Renaissance Florence: The Art of the 1470s.* London, 1999.

Rubinstein, Nicolai, ed. *Florentine Studies.* London, 1968.

Ruda, Jeffrey. *Fra Filippo Lippi.* New York and London, 1993.

Ruggiero, Guido. *Violence in Early Renaissance Venice.* New Brunswick, 1980.

———. *The Boundaries of Eros: Sex, Crime and Sexuality in Renaissance Venice.* New York, 1985.

———. *Binding Passions: Tales of Magic, Marriage, and Power at the End of the Renaissance.* New York, 1993.

Ruyder, A. F. C. *Alfonso the Magnanimous: King of Aragon, Naples and Sicily, 1396–1495.* Oxford, 1990.

Saalman, Howard. *Filippo Brunelleschi: The Buildings.* University Park, Pa., 1993.

———. *The Transformation of Buildings and the City in the Renaissance 1300–1550.* Champlain, N.Y., 1996.

Santi, Bruno. *Botticelli and Florence.* New York, 1991.

Saslow, James M. *Ganymede in the Renaissance: Homosexuality in Art and Society*. New Haven, 1986.

———, ed. and trans. *The Poetry of Michelangelo*. New Haven and London, 1991.

Saxl, Fritz. *A Heritage of Images*. London, 1970.

Schneider, Laurie, ed. *Giotto in Perspective*. Englewood Cliffs, N.J., 1974.

Seidel, Linda. *Jan van Eyck's Arnolfini Portrait: Stories of an Icon*. Cambridge, 1993.

Settis, Salvatore. *Giorgione's Tempesta*. Chicago, 1990.

Seymour, Charles, Jr. *Michelangelo's David: A Search for Identity*. Pittsburgh, 1967.

———. *The Sculpture of Verrocchio*. Greenwich, Conn., 1971.

———, ed. *Michelangelo: The Sistine Chapel Ceiling*. New York, 1972.

———. *Jacopo della Quercia*. New Haven, 1973.

Seznec, Jean. *The Survival of the Pagan Gods*. Translated by B. F. Sessions. Princeton, 1972.

Shearman, John K. *Mannerism*. London, 1967.

Smart, Alastair. *The Assisi Problem and the Art of Giotto*. Oxford, 1971.

———. *The Renaissance and Mannerism in Italy*. London, 1971.

———. *The Dawn of Italian Painting, 1250–1400*. Ithaca, N.Y., 1978.

Smythe, Craig. *Mannerism and Maniera*. New York, 1963.

Snyder, James. *Northern Renaissance Art*. New York, 1985.

Spike, John T. *Fra Angelico*. New York, 1996.

———. *Masaccio*. New York, 1996.

Starn, Randolph. *Ambrogio Lorenzetti: The Palazzo Pubblico, Siena*. New York, 1994.

Steinberg, Leo. *The Sexuality of Christ in Renaissance Art and in Modern Oblivion*. Chicago and London, 1996.

Stubblebine, James, ed. *Giotto: The Arena Chapel Frescoes*. New York, 1969.

———. *Duccio di Buoninsegna and His School*. 2 vols. Princeton, 1979.

Tafuri, Manfredi. *Venice and the Renaissance*. Translated by Jessica Levine. Cambridge, Mass., 1995.

Thomas, Anabel. *The Painter's Practice in Renaissance Tuscany*. New York, 1995.

Thomson, David. *Renaissance Architecture: Critics, Patrons, Luxury*. Manchester and New York, 1993.

Tolnay, Charles de. *Michelangelo*. 5 vols. Princeton, 1938–1960.

Trachtenberg, Marvin. *The Campanile of Florence Cathedral*. New York, 1971.

Trachtenberg, Marvin, and Isabelle Hyman. *Architecture from Prehistory to Post-Modern*. New York, 1986.

Trexler, Richard C. *Public Life in Renaissance Florence*. Ithaca, N.Y., and London, 1980.

Turner, Richard. *The Vision of Landscape in Renaissance Italy*. Princeton, 1966.

———. *Inventing Leonardo*. Berkeley and Los Angeles, 1992.

———. *Renaissance Florence*. New York, 1997.

Valentiner, W. R. *Studies of Italian Renaissance Sculpture*. London, 1950.

Vasari, Giorgio. *Lives of the Most Eminent Painters, Sculptors, and Architects*. 2 vols. Translated by Gaston du C. de Vere. New York, 1979.

Verdon, T., and J. Henderson, eds. *Christianity and the Renaissance*. Syracuse, 1990.

Verheyen, Egon. *The Paintings in the Studiolo of Isabella d'Este at Mantua*. New York, 1971.

Wackernagel, Martin. *The World of the Florentine Renaissance Artist: Projects and Patrons, Workshop and Art Market*. Translated by Alison Luchs. Princeton, 1981.

Wallace, William. *Michelangelo at San Lorenzo*. Cambridge, 1994.

Weiss, Roberto. *Pisanello's Medallion of the Emperor John VIII Paleologus*. Oxford, 1966.

———. *The Renaissance Discovery of Classical Antiquity*. Oxford, 1969.

Welch, Evelyn. *Art and Authority in Renaissance Milan*. New Haven, 1995.

———. *Art and Society in Italy 1350–1500*. Oxford and New York, 1997.

Wethey, Harold E. *Titian*. 3 vols. London, 1969.

White, John. *The Birth and Rebirth of Pictorial Space*. London, 1967.

———. *Duccio: Tuscan Art and the Medieval Workshop*. London, 1979.

———. *Art and Architecture in Italy: 1250–1400*. 3d ed. New Haven, 1993.

Wilde, Johannes. *Michelangelo: Six Lectures*. New York, 1978.

———. *Venetian Art from Bellini to Titian*. Oxford, 1981.

Wind, Edgar. *Pagan Mysteries in the Renaissance*. New York, 1968.

Wittkower, Rudolph. *Idea and Image: Studies in the Italian Renaissance*. New York, 1962.

———. *Architectural Principles in the Age of Humanism*. New York, 1965.

Wohl, Helmut. *The Paintings of Domenico Veneziano*. New York and London, 1980.

Wölfflin, Heinrich. *Renaissance and Baroque*. Translated by Kathrin Simon. Ithaca, N.Y., 1966.

———. *Classic Art: An Introduction to the Italian Renaissance*. Translated by Linda Murray and Peter Murray. New York, 1968.

Woods-Marsden, Joanna. *The Gonzaga of Mantua and Pisanello's Arthurian Frescoes*. Princeton, 1988.

Ziegler, Philip. *The Black Death*. London, 1969.

Articles

Alpatoff, Michel. "The Parallelism of Giotto's Paduan Frescoes." *Art Bulletin* 29, no. 3 (1947): 149–154.

Beck, James. "Ser Piero da Vinci and His Son Leonardo." *Source: Notes in the History of Art* 5, no. 1 (fall 1985): 29–32.

Davis, Howard McP. "Gravity in the Paintings of Giotto." Reprinted in *Giotto in Perspective*, edited by Laurie Schneider. Englewood Cliffs, N.J., 1974.

Fabbri, Nancy Rash, and Nina Ruttenburg. "The Tabernacle of Orsanmichele in Context." *Art Bulletin* 63 (September 1981): 385–405.

Janis, Carroll. "Leonardo's Eye: Visionary Images in *The Last Supper*, Part I." *Source: Notes in the History of Art* 5, no. 1 (fall 1985): 33–37.

Jones, Ernest. "The Madonna's Conception Through the Ear." In *Essays in Applied Psychoanalysis*. Vol. 2. New York, 1964.

Ladis, Andrew. "The Legend of Giotto's Wit and the Arena Chapel." *Art Bulletin* 68 (1986): 581–596.

Maginnis, Hayden B. J., and Andrew Ladis. "Assisi Today: The Upper Church." *Source: Notes in the History of Art* 18, no. 1 (fall 1998): 1–6.

Meiss, Millard. "Masaccio and the Early Renaissance: The Circular Plan." Reprinted in *The Painter's Choice*. New York, 1976.

———. "Raphael's Mechanized Seashell: Notes on a Myth, Technology and Iconographic Tradition." Reprinted in *The Painter's Choice*. New York, 1976.

Mitchell, Charles. "The Imagery of the Tempio Malatestiano." *Studi romagnoli* 2 (1951): 77–90.

———. "Il Tempo Malatestiano." *Studi Malatestiani* (1978): 71–103.

Mommsen, Theodor E. "Petrarch's Conception of the 'Dark Ages.'" *Speculum* 17 (1942): 226–242.

Offner, Richard. "Giotto, Non-Giotto." *The Burlington Magazine* 74 (1939): 259–268 and 75 (1939): 96–113.

Schapiro, Meyer. "Two Slips of Leonardo and a Slip of Freud." *Psychoanalysis* 2 (1955): 3–8.

———. "Leonardo and Freud: An Art-Historical Study." *Journal of the History of Ideas* 17, no. 2 (April 1965): 147–178.

Schneider, Laurie, and Jack Flam. "Visual Convention, Simile and Metaphor in the *Mona Lisa*." *Storia dell'Arte* 29 (1977): 15–24.

Schneider, Laurie. "Donatello's Bronze *David*." *Art Bulletin* 55, no. 2 (June 1973): 213–216.

———. "Some Neoplatonic Elements in Donatello's *Gattamelata* and *Judith and Holofernes*." *Gazette des Beaux Arts* (1976): 41–48.

———. "Shadow Metaphors and Piero della Francesca's Arezzo *Annunciation*." *Source: Notes in the History of Art* 5, no. 1 (fall 1985): 18–22.

———. "Leon Battista Alberti: Some Biographical Implications of the Winged Eye." *Art Bulletin* 77, 2 (June 1990): 261–270.

Steinberg, Leo. "The Metaphors of Love and Birth in Michelangelo's *Pietàs*." In *Studies in Erotic Art*. Edited by Theodore Bowie and Cornelia V. Christenson. New York, 1970.

———. "Leonardo's Last Supper." *Art Quarterly* 36 (1973): 297–410.

Watkins, René Neu. "L. B. Alberti's Emblem, the Winged Eye, and His Name, Leo." *Mitteilungen des Kunsthistorischen Institutes in Florenz* 9 (1960): 256–258.

Watson, Paul. "The Cement of Fiction: Giovanni Boccaccio and the Painters of Florence." *Modern Language Notes* 99, no. 1 (January 1984): 43–64.

Wittkower, Rudolf. "A Symbol of Platonic Love in a Portrait Bust by Donatello." *Journal of the Warburg Institute* 1 (1938): 160 ff.

Zucker, Mark. "Raphael and the Beard of Pope Julius II." *Art Bulletin* 59 (1977): 524–533.

Notes

Chapter 2
1. Dante, Alighieri, *Purgatory 11*, 91–96, in Millard Meiss, *Painting in Florence and Siena After the Black Death* (Princeton, 1951), p. 5.
2. See Hayden B. J. Maginnis and Andrew Ladis, "Assisi Today: The Upper Church," *Source: Notes in the History of Art*, 18, no. 1 (Fall 1998): 1–6.

3. In Randolph Starn, *Ambrogio Lorenzetti* (New York, 1994), p. 69.
4. *Ibid.*, p. 40.

Chapter 7
1. Cited in Richard Krautheimer, *Lorenzo Ghiberti* (Princeton, 1970), p. 14.

Chapter 17
1. Giorgio Vasari, *Lives of the Most Eminent Painters, Sculptors, and Architects*, trans. Gaston du C. de Vere, 2 vols. (New York, 1979), p. 796.

Picture Credits

Index